THE OXFORD HISTORY
OF ENGLISH ART

Edited by T. S. R. BOASE

THE OXFORD HISTORY OF ENGLISH ART

Edited by T. S. R. BOASE

President of Magdalen College, Oxford

Plan of Volumes

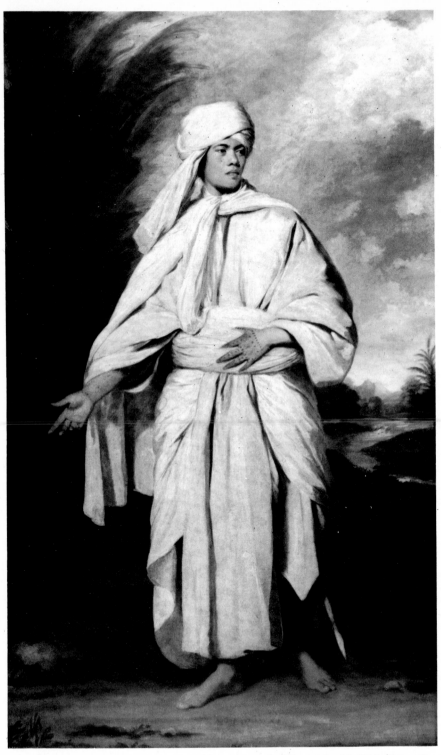

SIR JOSHUA REYNOLDS: OMAI. R.A. 1776. (Canvas: 236×146 in.)

ENGLISH ART

1714–1800

—

JOSEPH BURKE

OXFORD

AT THE CLARENDON PRESS

1976

Oxford University Press, Ely House, London W. 1

GLASGOW NEW YORK TORONTO MELBOURNE WELLINGTON
CAPE TOWN IBADAN NAIROBI DAR ES SALAAM LUSAKA ADDIS ABABA
DELHI BOMBAY CALCUTTA MADRAS KARACHI DACCA
KUALA LUMPUR SINGAPORE HONG KONG TOKYO

ISBN 0 19 817209 5

© *Oxford University Press 1976*

*Printed in Great Britain
at the University Press, Oxford
by Vivian Ridler
Printer to the University*

PREFACE

IN the preceding volume of this series Margaret Whinney and Oliver Millar defined the central problem of the historian of art in the Stuart period as 'the English reaction to the full baroque style of the Continent'. Previously the Editor in his General Introduction had selected three great artists, Inigo Jones, Van Dyck, and Christopher Wren, as having 'brought England once more to the level of European achievement'. It would be a proper and indeed it is a welcome task to continue this theme of a creative reaction to Continental art in the eighteenth century, which witnessed the golden age of the Grand Tour. Even those artists who never left England were conscious that they had to compete with a sustained influx of foreigners as well as those talented countrymen who had pursued their studies in Italy in the hope of assuming leadership on their return.

The possibility of a history of Georgian art in terms of the Grand Tour and its influence was brilliantly opened up as long ago as 1948 by F. Saxl and R. Wittkower in *British Art and the Mediterranean*, the headings of its eighteenth-century sections providing a comprehensive scheme under which most aspects of art during this period could be embraced. This publication and its antecedent collection of specialist articles, *England and the Mediterranean Tradition: Studies in Art, History, and Literature* (1945), edited by the Warburg and Courtauld Institutes of the University of London, provided the necessary guidance for an intensive study of Grand Tour itineraries and three visits to Italy in 1952, 1962, and 1964–5. On two of these visits it was possible for me returning to England from Australia to work on the Continent first, so that the English contribution was seen as subsidiary to the European achievement. It was after this salutary experience that the force of the indigenous traditions established in the seventeenth century became apparent, and an alternative choice for a central theme suggested itself: the interaction of classical and anti-classical movements of taste between the Palladian

Revival and the second wave of enthusiasm for antiquity, neo-classicism with its *embarras de richesse* provided by archaeological discovery.

It has always been recognized that the originality of English art and literature in the second half of the eighteenth century owes as much to the anti-classical as to the classical. But this is also true of the first half. The Burlington Dictatorship of Taste authorized the creation of the landscape garden, a true spearhead of romanticism. Baroque survival swells into something like a baroque revival in the 1730s and 1740s. The English rococo dominates the interregnum between the age of Burlington and the age of Adam in all those areas of taste where so ornamental and free a style was acceptable. *Le style Louis Quinze*, it is true, was never wholly assimilated, but its impact on the evolution of the 'Chinese' and 'Gothick Tastes' was a pervasive one. The devotees of the Sublime invoked classical authority, but its romantic aspects have always been noted by historians of art and literature. The vogue for the picturesque prompted the construction of a new aesthetic theory and a debate which centred on the problem of justifying its anti-classical principles, the solutions proposed being not so much an attack on the values of antiquity as on the allowance of an alternative set of criteria, thus introducing a dichotomy where before there had been at least lip-service to a single Rule of Taste in high art. Finally, neo-classicism itself becomes at the end of the century the vehicle for expressing increasingly romantic attitudes. The great age of English classicism, when the fervour for antiquity reached its zenith, was accompanied at every stage by a contrasting movement, until what began as a pleasing foil ends as a serious challenge.

Few errors have more obscured the understanding of English art in this period than the notion that its painting can be studied largely in terms of portraiture. No scholar of repute today upholds this error, which is nevertheless firmly lodged in popular opinion. When George I ascended the throne Sir James Thornhill was almost wholly relieved from the drudgery of painting portraits, and well before the end of the century Benjamin West enjoyed even stronger support for his labours as a history painter

from the monarchy, the Church, public institutions, and private patrons. Reynolds, Gainsborough, and Romney placed the highest value on their inventive subject pictures, and the same can be said of many lesser artists still chiefly regarded as portrait and/or landscape painters. Before the era of exhibitions and the reproductive print export boom opened up a lucrative market artists frequently complained of the neglect of history painting by patrons. But this did not prevent strenuous activity in seeking outlets for ideal art ranging from book illustration to the momentous projects for decorating Vauxhall Gardens and the Foundling Hospital.

A striking phenomenon of the century is the proliferation of genre in its second half. Genre in the sense of realistic paintings from everyday life was never out of demand, although its practitioners had always to struggle against the depreciation of the category and its exclusion from high art. A subsidiary theme of the account of painting in this volume is the elevation of genre that culminates in the age of Wright of Derby. By a more general definition genre embraces a wide variety of branches—animal, sporting, and theatrical genre to mention but three. It is not surprising that so open an arena should have become a battleground of styles, invaded by practitioners from every anti-classical camp and sometimes by the classicists as well. 'Beginning around 1760,' observes Robert Rosenblum, 'Western art becomes so hydra-headed that the historian who attacks it from a single approach is sure to be defeated.'[1] The hydra-headed appearance of genre has presented the most difficult of all the analytical tasks that had to be faced in the course of writing this history. So far as was possible, the diversity of genre has been related to the central argument, and if some of the problems appear to have been evaded, it can perhaps be pleaded that further research by specialists is a prerequisite for their solution.

Ideally, an analytical framework provides a kind of scaffolding which should disappear in the course of writing a history. There are really no such things as the rococo, the picturesque, and neo-classicism, convenient and indeed necessary labels for identifying movements of taste which by their nature are complex and

[1] *Transformations in Late Eighteenth Century Art*, Princeton, N.J., 1967, viii.

incessantly shifting. Artists, in this respect the best judges, justi-
fiably feel irritated when they are classified. But imprecise terms
are capable of a precise application by specifying a context, and
it is hoped that by endeavouring to observe this principle and by
being as concrete as possible some of the pitfalls of classification as
a guide to grouping and arrangement have been avoided. Certainly
it has been my intention to adduce precise and generic sources, to
say nothing of influences, borrowings, affinities, and parallels, not
so much to establish resemblances and even links, as to reveal
originality and invention by a process of subtraction, and thus
support a narrative which is based primarily on the individual
achievement of artists.

This achievement mirrored the ideals of a society dominated by
a landowning oligarchy deeply conscious of its territorial influence
and the rivalry of its two main parties for political power and its
rewards. The confidence of the ruling class and its image of itself
as politically advanced and independent, together with the expan-
sion of mercantilism and empire, were important factors in pro-
moting what was conceived from the time of Shaftesbury as a
national revival of the arts. The age of Burlington and the age of
Adam correspond roughly with Lecky's classic division of the
century between the age of the Whigs and the age of the Tories.
The ethos of this aristocratic society is singularly consistent, but
much of the originality of English art in the period can be related
to the confidence of the middle class, of whose values Hogarth
was so energetic a champion, and the expansion of markets for art
which was one of the consequences of the Industrial Revolution.
At the beginning of the century aristocratic patronage was all-
important for the artist; at its close, the sales and profits from
exhibitions and reproductive prints, and remuneration from
teaching drawing and water-colours to amateurs provided alter-
native sources of income which supported originality among
artists practising in what were still regarded as inferior categories.
The correlation between the increasing diversity and complexity
that have been stressed and social change can only be indicated in
very broad lines in a non-specialist history, but it is hoped that an
account which has deliberately stressed the subject picture rather

than the portrait, the value of which as a social document has been so splendidly demonstrated by the National Portrait Gallery and the learned publications of its staff, will provide some additional clues to the rich material which is available to social and economic historians interested in the evidence of the arts.

It is a natural weakness of historians to become enamoured of the period in which they specialize, and sometimes to err in making claims on its behalf. Addison's *Cato* is not the equal of Sophocles' *Ajax*, any more than Reynolds's *Infant Hercules strangling the serpents* rivals Michelangelo's *Last Judgement*. In so far as this history has an aesthetic argument in commendation of the eighteenth century, it is that its reputation for elegance and civilized recreation should take a lower place than its claim to artistic excellence in the sphere of wit inspired by humanitarian sympathy. From Swift and Pope through Hogarth to Bewick and Blake, one of the wittiest poets of his age, England made a notable contribution to the larger epoch of Molière, Voltaire, and Goya, an epoch from which our highest standards of humane wit and irony in art and literature derive.

'We have not trod in the path of others,' wrote the Adam brothers in the Preface to their *Works*, 'nor derived aid from their labours.' So far from echoing this claim, I am deeply conscious of the debt I owe to others. In architecture, painting, and sculpture respectively the volumes in the Pelican History of Art by Sir John Summerson, Sir Ellis Waterhouse, and Dr. Margaret Whinney provide authoritative accounts to which the reader must be constantly referred. The second volume of Edward Croft-Murray's magisterial *Decorative Painting in England 1537–1837* appeared too late to influence this study, although some of its findings have been incorporated. Its wealth of new material establishes beyond doubt that history painting was a central goal of artistic endeavour throughout the century. The history of the crafts with their vast specialist literature has been largely subsumed under movements of taste, each of which has had its distinguished historian, to whom acknowledgement has been made in the main bibliographical reference to the appropriate section. Neo-classicism, which has emerged as a central topic of debate amongst art

historians in the second half of this century as Mannerism was in the first, has been the subject of numerous and widely scattered recent publications, but the major studies of Robert Rosenblum, David Irwin, and Hugh Honour fortunately appeared in time for me to include some reference to their important findings.

In many cases sections on particular topics and artists and sometimes whole chapters have been read by leading authorities whose suggestions and corrections have proved invaluable. If these are not named, this is not due to ingratitude, but simply because I do not wish to silence my critics or involve scholars of the highest reputation in my own shortcomings and errors. Whether in planning itineraries or constructing bibliographies Mr. Howard Colvin, Professor W. G. Constable, Mr. Edward Croft-Murray, Mr. John Harris, the late Ian Lindsay, Sir Nikolaus Pevsner, Sir Ellis Waterhouse, the late Professor Geoffrey Webb, and Dr. Margaret Whinney have given generously from their knowledge and time. My deepest debt amongst scholars is to the General Editor, the late Dr. T. S. R. Boase, without whose encouragement, patience, and many kindnesses during the course of a long correspondence this task could never have been completed.

Distance may have lent a certain perspective as well as enchantment to the view, but its disadvantages could only be overcome by special facilities for returning to study on the spot during sabbatical and in one case special leave. I am deeply grateful to the University of Melbourne for making this possible, and for generous assistance from the Nuffield Foundation and the Carnegie Corporation, the former for grants on two occasions and the latter for enabling me to extend a visit to the United Kingdom and the U.S.A. to include a tour of American collections with English works I had not seen during the tenure of a Henry Fellowship at Yale University in 1936–7. In both countries galleries and learned institutes were invariably helpful, but I am under special obligations to the staffs of the Courtauld and Warburg Institutes, the National Trust, the National Buildings Records, the Victoria and Albert Museum, the Tate Gallery, the National Gallery, the National Portrait Gallery, the Royal Institute of British Architects, the Barber Institute of Fine Arts, and the Mellon Foundation.

Her Majesty the Queen has generously given permission to reproduce works in the Royal collections. One of the happiest memories associated with this task has been the generosity and personal kindness of private collectors and owners, to whom the acknowledgement made in the list of illustrations indicates only a fraction of the help that has been given.

Finally I have to thank the colleagues and seminar students of my Department, notably Mrs. Prudence Lee for her invaluable assistance in obtaining illustrations; Miss Edna Shaw, Mrs. Marjorie Tipping, Miss Josephine Nielsen, and Mrs. Myra Dickman Orth, who have given me assistance with bibliography, research, and checking; and Mrs. Valda Lane, who not merely typed the final manuscript but read it with a vigilant eye for inconsistencies. At the last stage, I owe a deep debt to the Printer and his staff for corrections and guidance which went far beyond what I could have reasonably expected.

J. B.

University of Melbourne
June 1973

CONTENTS

CONTENTS

PART FOUR
THE INDUSTRIAL REVOLUTION AND THE PROVINCIAL ENLIGHTENMENT

LIST OF ILLUSTRATIONS

PLATES

Frontispiece: SIR JOSHUA REYNOLDS: OMAI. R.A. 1776. The Hon. Geoffrey Howard, Castle Howard. [Canvas: 236×146 in.]

At end

FIGURE

ABBREVIATIONS

A. of P.	Horace Walpole, *Anecdotes of Painting in England*, ed. the Revd. James Dallaway and R. N. Wornum, 3 vols., 1888
Arch. Rev.	*Architectural Review*
Art Bull.	*Art Bulletin*
B.E.	The Buildings of England, ed. Sir Nikolaus Pevsner, 1951–
B.M.	British Museum
Burl. Mag.	*Burlington Magazine*
C.L.	*Country Life*
Conn.	*Connoisseur*
D.E.A.	H. M. Colvin, *A Biographical Dictionary of English Architects 1660–1840*, 1954
D.N.B.	*Dictionary of National Biography*
Edwards, *Dictionary*	Percy Macquoid and R. Edwards, *The Dictionary of English Furniture*, 3 vols., 1954
E.G.	Christopher Hussey, *English Country Houses: Early Georgian 1715–1760*, 1955
Farington, *Diary*	*The Farington Diary*, ed. James Greig, 8 vols., 1922–8
Gunnis, *Dictionary*	R. Gunnis, *Dictionary of British Sculptors 1660–1851*, 1953
H.M.S.O.	Her Majesty's Stationery Office
J.W.C.I.	*Journal of the Warburg and Courtauld Institutes*
L.C.C.	London County Council
L.G.	C. Hussey, *English Country Houses: Late Georgian 1800–1840*, 1958
M.G.	C. Hussey, *English Country Houses: Mid Georgian 1760–1800*, 1956
N.G.	National Gallery
N.P.G.	National Portrait Gallery
O.H.E.A.	Oxford History of English Art
R.A.	Royal Academy
R.C.H.M.	Royal Commission on Historical Monuments
R.I.B.A. Jnl.	*Journal of the Royal Institute of British Architects*

V. & A.	Victoria and Albert Museum
V.B.	Colin Campbell, *Vitruvius Britannicus*, 3 vols., 1715, 1717, 1725
Vertue	The Notebooks of George Vertue in *Walpole Society*, I. xviii (1930); II. xx (1932); III. xxii (1934); IV. xxiv (1936); V. xxvi (1938); Index, xxix (1947); VI. xxx (1950)
Wal. Soc.	The Annual Volumes of the Walpole Society, 1912–
Whitley	W. T. Whitley, *Artists and their Friends in England 1700–1799*, 2 vols., 1928
Yale ed.	The Yale edition of Horace Walpole's Correspondence, ed. Wilmarth S. Lewis, 1937–

PART ONE

THE AGE OF BURLINGTON
1714–1753

I

THE PALLADIAN REVIVAL
AND THE
RULE OF TASTE

IN 1715 Colin Campbell published the first manifesto of a new movement in English architecture, the preface to Volume I of *Vitruvius Britannicus, or, The British Architect*, dedicated to George I. 'The grief of my soul', wrote Bolingbroke on the occasion of his dismissal after Queen Anne's death, 'is this; I see plainly that the Tory party is gone.'[1] The Elector of Hanover who was crowned at Westminster on 31 October 1714 was determined to resist his absolutist and Catholic enemies on the Continent, and any Tory sympathizers with them he might discover in the British Isles. An attack on baroque art, which had served so admirably the ideals of the absolute church and state in seventeenth-century Europe, was appropriately announced in the year following his accession:

How affected and licentious are the Works of *Bernini* and *Fontana*? How wildly extravagant are the Designs of *Boromini*, who has endeavour'd to debauch Mankind with his odd and chimerical Beauties...

It is then with the Renowned *Palladio* we enter the Lists to whom we oppose the Famous *Inigo Jones*: Let the *Banquetting-House*, those excellent Pieces at Greenwich with many other Things of this great Master, be carefully examined...

While the Italians are condemned as now 'entirely employed in capricious Ornaments, which must at last end in the *Gothick*', the architects of the English compromise with the baroque, Wren, Vanbrugh, Archer, Talman, and Hawksmoor, are praised as 'learned and ingenious'. In opposition to baroque extravagance,

[1] Cited by W. E. H. Lecky, *A History of England in the Eighteenth Century*, 1878, I. 225.

licentiousness, and caprice Campbell upholds three standards: Classical Antiquity, the Renaissance, and the post-Renaissance achievements of 'the *British* Nation'. For each he selected an outstanding authority or hero: Vitruvius, Palladio, and Inigo Jones.

In 1711 and 1719 Alexander Pope and Jonathan Richardson the Elder published similar programmes for a classical reformation of literature and painting.[1] Like Campbell, each took his standards from the three main phases of the classical tradition, and nominated heroes for each. Because Pope set out to codify for all the arts, he constantly stressed the parallel:

> A *Raphael* painted, and a *Vida* sung!
> Immortal *Vida*! on whose honour'd Brow
> The Poet's *Bays* and Critick's Ivy grow . . .[2]

Vida was an inescapable choice by the logic of a strict parallelism, even if his writings were unfamiliar to most English readers. Richardson first prescribed for painting in *The Theory of Painting* (1715), published in the same year as Campbell's manifesto. But it is the *Two Discourses* of 1719 that inaugurate the era of connoisseurship as distinct from that of virtu in the previous century.[3] In the second the term 'connoissance' was introduced from France to describe the new science on the recommendation of his friend Matthew Prior.[4] In the *Theory of Painting* Poussin had been eulogized as 'truly great, and graceful, and justly stiled the French Raffaele',[5] but Richardson's patriotic fervour now led him to champion as a portrait painter Van Dyck, who took his place

[1] *An Essay on Criticism, written in the year 1709*, 1711, and Richardson's *Two Discourses on the Art of Criticism in so far as it related to Painting, and the Science of a Connoisseur*, 1719, viz. *The Connoisseur: An Essay on The whole Art of Criticism as it relates to Painting* and *A Discourse on the Dignity, Certainty, Pleasure and Advantage of the Science of a Connoisseur*.

[2] *The Twickenham Edition of the Poems of Alexander Pope*, 1939-62, *An Essay on Criticism*, I, verses 704–6.

[3] Cf. W. E. Houghton, 'The English Virtuoso in the Seventeenth Century', *Journal of the History of Ideas*, 1942, 51–73 and 190–219.

[4] *The Works of Jonathan Richardson*, 1792, 198–9. This Strawberry Hill edition was dedicated to Sir Joshua Reynolds.

[5] Ibid. 87.

alongside Inigo Jones in art and Dryden in literature to form a trinity of national heroes.[1]

The Georgian Rule of Taste, the programme of which was so clearly outlined for literature, architecture, and painting in three publications appearing in the same decade, may be defined as a tripartite canon of antiquity, the Renaissance and seventeenth-century classicism, modified by a predilection for the national achievements in the third phase and governed by the moralizing 'good sense' of the Augustans. Although Richardson speaks of 'a system of rules',[2] the actual rules were either general principles deduced from Classical Antiquity or its revivals, or limited to specific formulas, e.g. in architecture, the three principal orders and the proportions associated with them.[3] The escape-clause that did so much to foster originality in interpretation was the licence to admire national achievement even when it showed affinities with the Continental baroque, or involved romantic and anti-classical associations.

A steady growth of minority opinion had prepared the way for a Jones Revival, which precedes the Palladian one. Among Campbell's predecessors was Henry Aldrich (1648–1710) whose *Elementa Architecturae Civilis* took Vitruvius and Palladio as its authorities.[4] Aldrich's severe Peckwater Quadrangle at Christ Church, Oxford, built by William Townesend between 1706 and 1714, follows very closely the elevational system of Lindsey House (*c.* 1638–40) in Lincoln's Inn Fields, then attributed to Jones.[5]

[1] Van Dyck, he wrote, 'may perhaps take place of Raffaele himself in that kind of Painting', i.e. portraiture. Ibid. 116.

[2] Cf. Peter Murray, 'L'Architecture de Burlington et de Kent' in *Utopie et institutions au XVIIIᵉ siècle*, La Haye–Paris, 1963, 49–54, which cites Pope's *Fourth Moral Epistle*, 1731, dedicated to Lord Burlington, for the parallel trinity of Vitruvius, Palladio, and Inigo Jones. [2] *Works*, 112.

[3] Cf. John Gwynn, *The Art of Architecture, A Poem in Imitation of Horace's Art of Poetry* (1742), 42: 'The *Greeks* to three, confined the stated Rules.'

[4] Left incomplete at his death, published in 1750, and translated by the Revd. Philip Smyth in 1789. For the architectural activities and connections of Aldrich see W. G. Hiscock, *Henry Aldrich of Christ Church*, Oxford, 1960, and H. M. Colvin, 'The Architects of All Saints Church Oxford', *Oxoniensia*, XIX, 1954.

[5] Sir John Summerson, *Architecture in Britain 1530–1830*, 1953, 102, 192. For its Palladian sources see Howard E. Stutchbury, *The Architecture of Colin Campbell*, Manchester, 1967, 16.

It was praised as a square,[1] and as such inaugurated in England the idea of uniting a group of separate residences behind a single palace-front with a central pediment. The unit could be matched on the other sides of a square, or stand as an isolated block overlooking a park. Few innovations have had such far-reaching influence. In 1707 appeared the second edition of Roland Fréart de Chambray's *A Parallel of the Antient Architecture with the Modern*, with Evelyn's dedication (1664) to Charles II, who is praised for his care of buildings by Jones. About three years later, *c.* 1710, William Benson, who was to become Surveyor-General of the Board of Works, began Wilbury House, Wiltshire, on the model of John Webb's Amesbury Abbey in the same county, again believed to be designed by Jones.[2] In 1711 the architect John James argued before the Bishop of London that 'the Beauty's of Architecture may consist with ye Greatest plainness of the Structure' and praised 'our famous Mr. Inigo Jones'.[3]

In 1715 the Venetian Giacomo Leoni, who had been encouraged to settle in England, published the first volume of the edition of Palladio on which he had been working for several years.[4]

[1] 'The beautiful square, called Peckwater-quadrangle, which is esteemed a regular and compleat piece of architecture' is the description in the article on Dean Aldrich in *Biographia Britannica* (1747), I. 96. Horace Walpole referred to it as 'the square called Peckwater' in the *Anecdotes of Painting*, 1771, IV. 43.

[2] *V.B.* I, plates 52, 52. Campbell stated that the house was built in 1710. As Stutchbury has pointed out, there is a contradiction between the two plates published in 1715. The elevation is pure neo-Jonesian, the plan precociously Palladian and therefore probably a proposal for the revision of the original one by Campbell. In the event the house was finished later in another form. See Stutchbury, op. cit. 11–13, and Pevsner, B.E. *Wiltshire*, 510–11.

Pevsner in B.E. *Leicestershire and Rutland*, 1960, 289, has drawn attention to John Lumley's Burley House, 1694–1705, for Daniel Finch, 2nd Earl of Nottingham, which is a Palladianized revision of Clarendon House, Piccadilly, by Roger Pratt, 1664–7, a masterpiece of the Jones School. Little is known about Lumley.

[3] Cited by Colvin. *D.E.A.* 315.

[4] *The Architecture of A. Palladio, Revis'd, Design'd and Publish'd by Giacomo Leoni, a Venetian: Architect to his most Serene Highness the Elector Palatine*, 2 vols., 1715–16. Leoni's main research was concentrated on the illustrations, not the text, which was translated by Nicholas Dubois. See Peter Collins, 'The McGill Leoni', *Journal of the Royal Institute of Architects of Canada*, no. 377, vol. 34 (1957), 3–4; B. Weinreb, *Architecture, Books and Drawings: Catalogue One*, 1961, 47; and the observations of Stutchbury, op. cit. 5–6.

When Campbell opposed 'Famous' Jones to 'Renowned' Palladio in friendly rivalry, he must have known that his own publication would appear almost simultaneously. In the event the English reaction against the baroque, which takes place a little later than the rococo reaction against the baroque classicism of Louis XIV in France, marshalled its forces under the banner of the Italian architect and not the national hero. A circumstance which particularly favoured Palladio was his far more extensive practice in country-house architecture. No other part of Europe was so thickly studded with country houses, or had been so intensively cultivated by a humanist oligarchy, as the Venetian hinterland. An expanding overseas trade, the growth of large estates, and the advantages of consolidating the political influence of these once the power of the Crown had been decisively limited, provided the English ruling class with the means and incentive for an investment in their country residences similar to that made for different economic reasons by the patricians of Venice in the sixteenth century.[1]

A middle-class Palladian architecture is a contradiction in terms. Those who originally promoted the style directed their appeal to the circles of high patronage. Behind the patrons and practitioners stands the immensely influential figure of Anthony Ashley Cooper, 3rd Earl of Shaftesbury (1671-1713), who provided the high philosophical background of the Rule of Taste.[2] The first popular writer unequivocally to advocate a rule of taste was Joseph Addison in 1711: 'the Taste is not to conform to the Art,

[1] In Venice the transfer of wealth to the land came about partly as a result of declining commerce. See Gino Luzzato, *Storia economica dell'età moderna e contemporanea*, Padova, 1950, I. 80-1.

[2] See E. Cassirer, *The Philosophy of the Enlightenment*, translated F. C. A. Koelln and J. P. Pettegrove, Boston, Mass., 1955; Benjamin Rand, *The Life, Unpublished Letters and Philosophical Regimen of the Third Earl of Shaftesbury*, 1900; R. L. Brett, *The Third Earl of Shaftesbury*, 1951; N. Wells, 'Shaftesbury and Paolo de Matteis', *Leeds Art Quarterley*, Spring 1950; E. Wind, 'Shaftesbury as Patron of Art', *J.W.C.I.* II, 1938-9; and J. E. Sweetman, 'Shaftesbury's Last Commission', *J.W.C.I.* XIX, 1956.

The importance of Shaftesbury for the Rule of Taste is discussed in Christopher Hussey's introduction to Margaret Jourdain, *The Work of William Kent*, 1948. See also John Steegman, *The Rule of Taste from George I to George IV*, 1936, a stimulating introduction to the subject.

but the Art to the Taste.'[1] 'Strength with Politeness, Ornament with Simplicity, Beauty with Majesty' were the merits claimed by Campbell for the Banqueting House.[2] They were also the merits to which Augustan prose aspired in its elevated forms.[3] The middle classes had always prided themselves on their sobriety and good sense, and the traditions of Dutch classicism, which expressed these values, were strongly entrenched in bourgeois architecture. An amalgamation of Palladianism with the native vernacular follows the attempts to establish the former at the highest level, and was based on shared ideals.

Campbell's first bid was to capture the patronage of Church and State.[4] *Vitruvius Britannicus* I opens with St. Paul's Cathedral, St. Peter's, Rome, Campbell's own design for a new and enormous church in Lincoln's Inn Fields, Archer's St. Philip's, Birmingham, and Jones's Banqueting House, Whitehall; that is, four ecclesiastical buildings and one royal one. *Vitruvius Britannicus* II (1717) opens with Jones's Whitehall Palace, the same architect's Church and Piazza at Covent Garden, the Royal Exchange, Wren's Bow Steeple, and a second design for a new church 'in the Vitruvian stile' by Campbell. In each volume the architect introduced his own work with an ecclesiastical project.

The design for a Church in Lincoln's Inn Fields [1712: plate 3A] was inscribed to the Revd. Dr. Lancaster, Vicar of St. Martin-in-the-Fields, Archdeacon of Middlesex, and Provost of Queen's College, Oxford; the second [plate 3B] to the Archbishop of Canterbury. The significance of the former inscription lies in the fact that Dr. William Lancaster had successfully petitioned Queen

[1] *Spectator*, no. 29, 3 Apr. 1711. [2] *V.B.* I. 3.

[3] George Saintsbury, *The Peace of the Augustans*, 1916, gave an account of the underlying ideals of Augustan prose which is singularly applicable to the architecture.

[4] The authoritative study of Campbell is Howard E. Stutchbury, *The Architecture of Colin Campbell*, Manchester, 1967, with a full bibliography. Horatio F. Brown in 'Inglesi e Scozzesi all'Università di Padova dall'anno 1618 sino al 1765', *Monografie Storiche sullo Studio di Padova*, Venice, 1922, was the first to report the entry of a Scotsman, Colinus Campbell, in a Visitors' Book at Padua University under the date 1697. The identification with the architect was questioned by S. Lang in 'English Architects and Dilettanti in Padua', *Arch. Rev.* CXXII (1957), 344, but without supporting evidence. That Campbell had studied Palladio's architecture at first hand in Italy is demonstrated by Stutchbury, op. cit. 18.

Anne to make the Vicar and Churchwardens of St. Martin's a corporate body, so that they could demolish adjacent buildings on their land to widen the road and build a workhouse and girls' charity school, the first move towards an ambitious project to rebuild the decaying medieval church in the royal parish.[1] It was in fact to be the most important ecclesiastical commission of the new reign.

By placing his design immediately after St. Paul's and St. Peter's Campbell ambitiously invited comparison with the two most famous works of the Renaissance in Italy and the post-Renaissance in England. In his explanation of the plates of St. Peter's, the only foreign building illustrated in any of the volumes, he drew attention to the baroque additions of Carlo Maderno, and it is as a correction of a baroque plan and elevation by classicist principles that his own design was meant to be read [plate 3A]. 'The Plan is reduced to a Square and Circle in the Middle, which, in my weak Opinion, are the most perfect Figures.' Campbell was well aware that this opinion, which had the authority of Vitruvius and Palladio, was held by Michelangelo, and the note of modesty was perhaps intended to soften the implied criticism of Wren. The hexastyle portico, which commands the front, is regular: the parts are 'all in certain Measures of Proportion'; and these parts are carefully distinguished in contrast to the baroque principle of coalescence, the flanking towers being removed 'at such a distance that the great *Cupola* is without any Embarrass'. The whole is 'dress'd very plain, as most proper for the sulphurous Air of this City, and indeed, most conformable to the Simplicity of the Ancients'. In plates and commentary he demonstrated the points made in the preface and illustrated the four corner-stones of Palladian classicism: a regular or correct imitation of classical forms; the revival of mathematical proportion; the order or harmony of distinct parts; and ancient simplicity.

Campbell's second design in the Vitruvian style [plate 3B] reproduced the Maison Carrée at Nîmes. The Ionic order was substituted for the Corinthian and a Venetian window inserted

at the east end. Nothing distinguishes the church externally from a classical temple except this window, the figures on the acroteria, and the pedimental relief of the Baptism of Christ. At a single stroke English classicism had been advanced further than that of the Continent, for not even a Renaissance architect had reproduced a pagan model so completely for a modern purpose.

The innovation did not commend itself to the Church of England, for neither was the church built nor one like it. 'There are not many English churches', writes Whiffen, 'which can properly be called Palladian.'[1] Many of these were significantly at the expense of private individuals or groups. In 1732 John Wood I began the first of Bath's many proprietary chapels, St. Mary's Chapel, Queen Square (demolished c. 1875), with a portico reminiscent of Jones's St. Paul's Church, Covent Garden.[2] Between 1744 and 1746 an unknown architect built Mereworth Church, Kent, for the seventh Earl of Westmorland, with a basilican interior.[3] The aisles are divided from the barrel-vaulted nave by a Roman Doric colonnade, and the ceilings painted in imitation of stone coffering. A Diocletian window with straight mullions crowns the east end. 'The whole', comments Whiffen, 'has the air of being a careful and learned reconstruction of some building of classical antiquity.'[4] Externally, however, its most conspicuous feature is a steeple copied from St. Martin-in-the-Fields, so tall, according to Horace Walpole, that 'the poor church curtseys under it, like Mary Rich in a vast high-crown hat'.[5] The borrowing from Gibbs in a church designed to harmonize with Mereworth Castle is a striking example of the spell cast by his modernization of a Wren motif. Elsewhere the Venetian window at the

[1] Marcus Whiffen, Stuart and Georgian Churches: the Architecture of the Church of England outside London 1603–1837, 1947–8, 28. For the London churches of the period see John Summerson, Georgian London, 1945. Whiffen's pioneer study can be supplemented by the accounts and illustrations of churches in the monographs on Georgian Bath, Bristol, Edinburgh, and Dublin by Walter Ison, A. J. Youngson, and Maurice Craig. The liturgical background of the Georgian church is authoritatively discussed in chapters V and VI of G.W.O. Addleshaw and Frederick Etchells, The Architectural Setting of Anglican Worship, 1948.

[2] Walter Ison, The Georgian Buildings of Bath from 1700 to 1830, 1948, 72.

[3] Whiffen, op. cit. 42. [4] Ibid.

[5] Letter to Richard Bentley, 5 Aug. 1752.

east end becomes the hallmark of a Palladianized church, but there are no counterparts in Georgian England to *Il Redentore* or other churches by the Italian Mannerist.

In Shaftesbury's *Letter of Design*, dated from Naples on 6 March 1712, the philosopher attacked Queen Anne's Board of Works and pointed out that 'there remain yet two of the noblest subjects for architecture; our Prince's Palace and our House of Parliament' to be undertaken by the moderns.[1] Campbell gave spectacular prominence to Charles I's project for a royal palace by placing the folding plates of the Whitehall designs at the head of his second volume, in which the emphasis shifts from Church to State. He followed these with Inigo Jones's Covent Garden, thus drawing attention to a further opportunity for large-scale secular building, urban development. Subsequently Burlington pushed William Kent for State commissions, so that Campbell was no more fortunate than he had been with his plans for the Church. Kent's pearwood model of a Royal Palace at Richmond [early 1730s; plate 4A] was the forerunner of many attempts to capture one of the two prizes which haunted the imagination of architects throughout the century. On 14 March 1733 the House of Commons offered to defray the cost of 'a more spacious and convenient edifice' for their deliberations, but the project hung fire until the War of the Austrian Succession rendered it impracticable.[2]

The palace idea found an indirect outlet in Campbell's second secular priority, urban development. John Wood's Queen Square, Bath [1729–36; plate 4B], was a conscious appropriation:

From the *Square*, we now come to the Buildings fronting it, which were so contrived, that those facing the North, East and West Sides

[1] *A Letter concerning the Art, or Science of Design to My Lord John Somers* was first published in the fifth edition of Shaftesbury's *Characteristicks* (1732), but was intended by the author to be the first treatise in his 'Second Characters'. See B. Rand, *Second Characters or The Language of Forms*, Cambridge, 1914, which reprints the text.

[2] See Fiske Kimball, 'William Kent's Designs for the Houses of Parliament 1730–40', *R.I.B.A. Jnl.*, 6 Aug. and 10 Sept. 1932, 737, and M. Jourdain, *The Work of William Kent*, 1948, 46–8. For the projects by James Adam see John Fleming, *Robert Adam and his Circle in Edinburgh and Rome*, 1962, 303–9; and for those by William Chambers see John Harris, 'Two Lost Palaces', *C.L.* 19 Nov. 1959, 916–18. Cf. also the design for a royal palace made at Rome by John Soane in his *Designs for Public Improvements in London and Westminster*, 1827.

should have the Appearance of a Palace of five hundred Feet in Extent, when view'd from the Center of the Building fronting the South Side . . . And as the Aspect of this Pile of Building is direct South . . . so it has all the Advantage possible of Light and Shadow from the Sun, to make it picturesque.[1]

'The Appearance of a Palace' on three sides of a square when viewed from a fourth had, we have seen, already been fore-shadowed by Peckwater Quadrangle. Aldrich's idea had been partially taken up in Grosvenor Square, c. 1727, but both here and on the Cavendish–Harley estate there was a lack of unifying control. Wood, too, had to modify his scheme, but he was the first to realize the palace idea so magnificently in an urban as distinct from a collegiate setting. Thereafter it was never lost sight of, until it culminated in the great sequence of palatial units that John Nash imposed on London from Carlton House Terrace to Regent's Park, an exploitation of the grandiose idea for corporate residences without parallel in Europe.[2]

The architect's invocation of 'the picturesque' throws light on a feature which has been stressed by Wittkower in his account of English variations on Palladian themes, namely, the change to two-dimensional patterns for scenic effect. 'An English 18th century building should be seen from a distance like a picture.'[3] When William Kent used the palace front for the Horse Guards, Whitehall [begun in 1750 by John Vardy and William Robinson after the architect's death; plate 4C], it had already been associated with spacious landscape settings at Holkham and other country houses. Kent's own leading role as landscape gardener equipped him admirably to exploit the picturesque possibilities of an open court facing a park. Even today, when its taller neighbours ac-

[1] John Wood, An Essay towards a Description of the City of Bath, Two Parts, 1742 and 1743, part II, 14.

[2] For Wood's association with Edward Shepherd, who planned the north side of Grosvenor Suare, see John Summerson, Heavenly Mansions, 1949, 'John Wood and the English Town-Planning Tradition'. For the modifications of his scheme see Walter Ison, The Georgian Buildings of Bath, 127–33.

[3] R. Wittkower, 'Pseudo-Palladian Elements in English Neo-Classical Architecture', in England and the Mediterranean Tradition, edited by the Warburg and Courtauld Institutes, 1945, 153.

centuate the toy-like scale satirized by Hogarth, the Horse Guards create a panoramic effect unrivalled in the heart of London.[1]

Vitruvius Britannicus III (1725) does not include a single ecclesiastical building or project, and illustrates very few public ones, although it opens with Wren's Greenwich Hospital. Burlington is now the hero, 'not only a great Patron of all Arts, but the first Architect', and the country house with its gardens is the splendid theme that he celebrates. The Whig oligarchy had not had to wait on Church and State to carry out their ideals on their own estates. Between 1720 and 1724 there had been a boom in building country houses,[2] so that this third or supplementary volume could be presented as a proud review of actual achievement by the Palladians. This time Campbell chose to oppose to the grand manner of the English baroque a classicist model with a compact villa-like plan, namely Houghton, which he placed immediately after Burlington House and Chiswick House, respectively the headquarters and playground of the Palladian Revival [plates 2A and 2B].

'In a Government where *the People* are sharers in Power', wrote Shaftesbury, 'but no Distributors or Dispensers of Rewards, they expect it of their *Princes* and *Great Men*, that they shou'd supply the generous Part.'[3] He appealed to 'the Honour of our *Nobles* and *Princes*' to facilitate 'this happy Birth, of which I have ventur'd to speak in a prophetick Style'.[4] He called not on professional architects, but 'Potentates and GRANDEES', and conjured up the image of some 'Hero or Statesman' who was not 'absolutely unconcern'd for his Memory, or what came after him'.[5]

The champion who in the interval between the first and third volumes of the *Vitruvius Britannicus* had assumed the leadership of the movement possessed every qualification and attribute that

[1] For Hogarth's satire, showing the coachman attempting to drive the royal coach through the arch and having his head knocked off, see the signpost in *Canvassing for Votes* (1757), plate II of the Election Entertainment.

[2] John Summerson, 'The Classical Country House in 18th-Century England', *Journal of the Royal Society of Arts*, CVII, July 1959, 541.

[3] *Treatise III. viz. Soliloquy: or Advice to an Author*, first printed in 1710, here cited from the *Characteristicks*, 1727 ed., I. 227.

[4] Ibid. I. 223.

[5] Ibid. I. 225. In this passage Shaftesbury expresses an ironical doubt, a characteristically rhetorical device to excite the sympathies of his reader.

Shaftesbury as prophet had proclaimed. In April 1715 Richard Boyle, 3rd Earl of Burlington and 4th Earl of Cork (1694–1753), fresh from the Grand Tour, celebrated his coming of age.[1] He was the owner of great estates in Yorkshire, Ireland, and Middlesex, and George I had made him a Privy Councillor while still a minor. At the threshold of his career he was appointed Lord Treasurer of Ireland, Vice-Admiral of the County of York, and Lord Lieutenant of the East and West Ridings. Travelled, a student of antiquity and the Renaissance, artistically gifted, and with a high sense of duty, he set himself to play the serious part.

The first choice of an architect for the remodelling of Burlington House, his mansion in Piccadilly, was James Gibbs, probably commissioned by his mother the Countess Juliana. Within two years the latter was superseded by Campbell.[2] As early as 1717 Burlington designed a bath-house at Chiswick, 'wholly dependent, in style, on Campbell'.[3] By 1717 the latter was carrying out the refronting of the town house. In the summer of 1719 Burlington set out a second time for Italy. His goal was Vicenza, for he was now making a Palladian pilgrimage. He had also a practical aim, to equip himself as an architect as well as a patron after the success of his trial experiment.

Horace Walpole, an adept in conferring analogical titles, was later to describe Burlington as 'the Apollo of arts', with William Kent as his 'proper priest'.[4] The momentous meeting with Kent took place during the first visit to Italy. The cheerful Yorkshireman who so quickly gained his confidence was then neither an

[1] A valuable appreciation of Burlington in the light of recent research is by James Lees-Milne, *Earls of Creation*, 1962, chapter III, 'Richard Boyle, 3rd Earl of Burlington'. He succeeded to most of his titles at the age of ten, see Stutchbury, *Campbell*, 33.

[2] London County Council and London Survey Committee, *Survey of London*, XXXII, *The Parish of St. James* (1963). This source describes in detail the remodelling of Burlington House and the development of the Burlington Estate north of Piccadilly, and identifies what has survived intact. See also Stutchbury, *Campbell*, 33 ff.

[3] Summerson, *Architecture in Britain*, 201. For a full discussion of the later relationship between Campbell and Burlington see Stutchbury, *Campbell*, particularly his account of Burlington's acquisition of the Jones–Webb drawings and the Palladio drawings at Maser.

[4] *A. of P. in England*, ed. the Revd. James Dallaway and Ralph N. Wornum, 1888, III. 56. Cf. Marcus Whiffen, 'Apollo's Proper Priest', *Arch. Rev.*, Oct. 1948.

architect nor a Palladian. His conversion followed that of the
patron, and was the outcome of their later intimacy in London.

Just before Burlington's second absence a successful attempt had
been made to capture the Board of Works by Campbell and his
sponsors. 'And there arose a King that knew not Joseph' was
Wren's pregnant comment on his dismissal from the office of
Surveyor-General in 1718.[1] Vanbrugh had every right to the
succession, but he was excluded from promotion, and Hawksmoor
was turned out of his posts as Secretary to the Board and Clerk of
the Works at Whitehall.[2] The Jonesian enthusiast Benson was put
in as Surveyor and Campbell as Chief Clerk of the King's Works
and Deputy-Surveyor. The first official triumph of the neo-
Palladians was shortlived, for Benson was dismissed on 4 August
1719 for an incompetent report, and Campbell shared in his
master's disgrace. But there was no reversion to the School of
Wren.[3] The Surveyor-Generalship continued to be held by
Whig gentry with seats in Parliament, and their sympathies were
with the revival. What distinguishes the second stage of the assault
was the preference shown to what Lord Chesterfield aptly called
the 'schola' of Burlington. William Kent was introduced as Master
Carpenter in 1726, 'Burlington Harry' Flitcroft as Clerk of the
Works at Whitehall, Westminster, and St. James's at the same
time, Roger Morris, the favourite architect of Burlington's friend
the Earl of Pembroke, as Clerk of the Works at Richmond New
Park Lodge in 1727; Isaac Ware, whose edition of Palladio (1738)
was corrected by Burlington, as Surveyor in 1728, and John Vardy,
also entrusted with publications for the School, as Clerk of the
Works at Greenwich in 1736. Once in, promotion or plurality
of offices followed. The final capture of the stronghold was
effected during the same key Surveyorship (1726–37) of Richard
Arundell, when William Kent was appointed Master Mason and
Deputy Surveyor (1735) and Isaac Ware Secretary (1736).

[1] He characteristically added: 'And Gallio cared for none of these things.' The
passage was written for private consolation in Greek. See Glorney Bolton, *Sir
Christopher Wren*, 1956, 154, and Stephen Wren, *Parentalia*, 1750, 45.

[2] Hawksmoor's reactions are discussed in Kerry Downes, *Hawksmoor*, 1959, 33.

[3] The office-holders in the Board of Works and the dates of their appointments
are listed in the appendix to H. M. Colvin, *D.E.A. 1660–1840*, 757–66.

The political campaign was accompanied by a vigorous programme of publication, one of Burlington's keenest interests. The first priority was to establish a corpus of Palladian and Jonesian models. The full list is too long to be given here, but four may be chosen as the keystones of important developments. Palladio had either reproduced the external features of classical architecture on the inside or allowed scope for independent decoration by painters and craftsmen, whose original contribution he singled out for praise. The first step to provide a grammar of interior decoration and ornament was Kent's *Designs of Inigo Jones, with some Additional Designs* (by Burlington and himself), 2 vols., 1727. Secondly, Robert Castell's *The Villas of the Ancients Illustrated* (1728) assembled classical texts and added reconstructions of plans both to clarify Palladio's categorization of villas and, more important, to supplement his somewhat meagre descriptions of gardens. In 1730 Burlington published for private circulation *Fabbriche antiche disegnate da Andrea Palladio Vicentino*, reproducing Palladio's original drawings for the restoration of the Roman *thermae*, a vital and influential addition to the corpus. Fourthly, Isaac Ware's *The Four Books of Architecture of Andrea Palladio*, 1738, with Burlington's imprimatur, provided patrons, architects, builders, and tradesmen generally with an official textbook, closer in the plates to the original.

The three types of country residence modelled in Italy on those of antiquity, or rather their literary descriptions, were the *casa di villa* in the sense of a country seat on an estate, the *villa rustica*, understood by Castell as a gentleman's residence combined with a farmhouse, and the *villa suburbana* as a place of leisured retirement on the outskirts of a city. All three were somewhat confused in England as a result of the classical and Italian texts' being collected without a strict historical attention to time and place of origin. Palladio used the term *casa di villa* generally for the country house, and some of his examples were little short of country palaces, e.g. the Villa Mocenigo.[1] In England there was a clear distinction

[1] See John Summerson, 'The Idea of the Villa', in his Three Cantor Lectures, 'The Classical Country House in 18th-Century England', *Journal of the Royal Society of Arts*, CVII, July 1959, 570. His analysis deals especially with sources and the evolution

between country seat and recreational annex at the outset, but the initial ambiguity between *casa di villa* meaning a seat on an estate and *villa* meaning a house in the country must be borne in mind in tracing the evolution of both greater and lesser country houses. The modern meaning of villa derives from the *villa suburbana*, but the first translators of Palladio had no hesitation in calling his country palaces villas, instead of country houses or *case di villa*.

The decisive steps in designing both country houses and villas were taken by Campbell. Just as he had gone to the top in inscribing his Maison Carrée project for a church to the Archbishop of Canterbury, so in the same volume he dedicated the boldest of his temple designs for a country house to 'Mr. Walpole'.[1] The plan is square, like Palladio's palatial villa at Montagnana for Francesco Pisani, from which it derives, but this time the entire central block is contained under one roof surmounting a temple front, its enormous span requiring a frontal intercolumniation of seven bays. Straight wings connect the temple body with end pavilions housing the Chapel and Library in front and offices behind. The Chapel in one wing of the house was orthodox English usage, but un-Palladian, as was the Library in the space likewise reserved by the master for husbandry, granaries, and domestic services. But by this late date in England the medieval integration of the gentleman's residence with the farmhouse, so strongly entrenched in Scotland, was largely a thing of the past.

The Prime Minister was not persuaded to the idea of living in a temple with Palladian wings, any more than the Archbishop of Canterbury was to that of worshipping in one with a Venetian window. But he did choose Campbell as his architect. Preceding both the proposal and Houghton as built is the first and greatest of Campbell's known commissions after he left Scotland, Wanstead House, Essex, built *c.* 1714–15 for Sir Richard Child, later created Earl Tylney, one of the financial architects of Walpole's

of country-house and villa types, and is of the first importance for the study of the subject. The three articles will be subsequently cited as *Cantor Lectures*.

[1] *V.B.* II. 4 and plates 83, 84.

regime.[1] The series of great houses that it inaugurates reveals the inescapable power of tradition and Vanbrugh. The 'faults' of the past were corrected by simplicity, proportion, and the 'staccato' or ordered distinction of parts, but the hankering after the magnificent remained. In the third design of 1720 [plate 6A] he added flanking towers, the omission of which gave the building a somewhat truncated appearance. If they had been built, and the central cupola of the second design retained, Wanstead would have been seen more clearly for what it was: a classical revision of Castle Howard.

In 1721 'Mr. Walpole' resumed the offices of First Lord of the Treasury and Chancellor of the Exchequer, thus virtually creating for himself the office of Prime Minister in the modern sense of being the leader of a majority instead of a royal nominee acceptable to the majority. 'Personally', wrote John Richard Green in what is still a widely read history, 'he was free from corruption; and he is perhaps the first great English statesman who left office poorer than when he entered it.'[2] So far from this being true, he acquired in office much of the great wealth that enabled him to build Houghton and spend more than £40,000, equivalent perhaps to half a million today, on one of the greatest of English collections, its greater part purchased by the Empress Catherine of Russia when Parliament refused to buy it for the nation in 1777.[3] Nevertheless, the means he employed were generally acceptable to the code of honour of the day, as the candid admissions of his son Horace, whose own share of the pickings enabled him to build Strawberry Hill, ingenuously reveal.[4]

[1] For Wanstead I see *V.B.* I, plates 21, 22; for Wanstead II, *V.B.* I, plates 23–6; for Wanstead III, *V.B.* III, plates 39–40. The building of the house was completed by 1722, see F. Kimball and I. Dunlop, 'Wanstead House Gardens', *C.L.* CVIII, 1950, 296. All three designs are reproduced in John Summerson's *Cantor Lectures*, 557. See also the analysis of R. Wittkower in 'Pseudo-Palladian Elements', *England and the Mediterranean Tradition*, 145.

[2] *A Short History of the English People* (1st ed., 1874), Everyman's Library, 1926, 687.

[3] Gerald Reitlinger, *The Economics of Taste: the Rise and Fall of Picture Prices 1760–1960*, 1961, 21–2. For the total spent by Walpole see the letter by his son Horace to the Revd. William Cole, 12 July 1779 (Yale ed. II. 168).

[4] 'Account of my Conduct relative to the Places I hold under Government, and towards Ministers', in Horace Walpole's *Works* (5 vols. 1798), II. 363–70, also reprinted

Houghton [plate 6B] was a striking symbol of Parliamentary status, in its turn related to territorial influence. For the obscurer gentry, who like Walpole rose to high office in government, did so with the support of the great landowners and their carefully manipulated connections. It is significant that the reign of George I did not give birth to a spate of great town houses comparable to that which distinguishes the Paris of the Régence and Louis XV.[1] In the British system of government regional status amongst landowners was more important than status at Court. Walpole in Arlington Street was close to the Palace of St. James's, but he treated his town house contemptuously as an office. His heart lay elsewhere, in Orford House with its gardens at Chelsea, Houghton, and later Richmond as well.[2]

Houghton, where he entertained generously to extend his influence among his neighbours and his class, has been described as a 'compression' of Wanstead.[3] The model for the east front was Wilton as designed by Isaac de Caux with Jones's advice. To this he added wings curving to large end pavilions, thus enclosing the west front with its temple theme. The formula of the fully fledged Palladian country house was now realized: a large rectangular central block with a regular temple front; towers at the side (later optional); wings culminating in end pavilions notably larger than Palladian ones; framing Venetian windows; and an unadorned wall surface isolating the openings. External stairs were originally planned for both sides. Walpole later employed Gibbs to redesign the towers from a baroque source, a happy inspiration, for the baroque feeling for mass and movement is not wholly suppressed at Houghton and the Wilton towers always tended to dominate the composition, as may be seen at Houghton's

in Peter Cunningham's *Letters of Horace Walpole*, I (1891) as 'Memoir respecting his Income', LXXXIV–XCI.

[1] The main Palladian ones were Burlington House, William Kent's Devonshire House (1734–5; demolished 1924–5), and Isaac Ware's Chesterfield House (1748–9; demolished 1937). Spencer House, without a forecourt, belongs to a different category.

[2] J. H. Plumb, *Sir Robert Walpole*, London: Cresset Press, II (1960), 207. This well-documented work is one of the key sources for the political function of the country house.

[3] Summerson, *Cantor Lectures*, 561.

derivative, Hagley Hall, Worcestershire, built 1753–60 for Sir George, later first Baron Lyttelton, to designs by Thomas Prowse.[1]

The great rival of Houghton is Holkham Hall, also in Norfolk, built 1734–64 for Thomas Coke, Lord Lovell, later created Earl of Leicester, and the *tour de force* of the Burlington School proper [plate 6c].[2] For Lord Lovell discussed the planning with Burlington and chose Kent to draw up the designs, the actual execution being entrusted to Matthew Brettingham. The result is a fascinating amalgam of Burlington's obsession with Roman grandeur and Kent's feeling for the scenic. 'There is no grander architectural prospect in England', writes Hussey, 'than the south front of Holkham from near Kent's obelisk, the point from which the building was conceived to be first discovered.'[3] The debt of this south front to Houghton with its original Wilton towers is unmistakable. But the changes are equally remarkable. It is not a *casa di villa* with colonnaded wings, but a country palace with lowered flanks, in this respect not unlike Kent's contemporary pearwood model for a royal palace at Richmond. These lowered and villa-like flanks have triple pediments, a design which Burlington seems to have originated. Also characteristic of Burlington is the long alignment of Venetian windows with relieving arches on the north front. The abstract play of contrasted geometric shapes is subtly three-dimensional and more characteristic of Vanbrugh than Campbell.[4] Holkham is the neo-Palladian reaction

[1] A. E. Richardson in *An Introduction to Georgian Architecture*, 1949, was the first to point out the striking similarity between Gibbs's cupolas and a design in Paul Decker's *Fürstlicher Baumeister*, Augusta, 1711–16. Summerson, *Cantor Lectures*, 560–2, has noted and illustrated an alternative source in a free sketch design for a country house among Wren's drawings at All Souls College, Oxford, possibly by Wren himself.

[2] Matthew Brettingham's *The Plans, Elevations and Sections of Holkham in Norfolk*, 1761, credits 'the general idea' to the Earls of Leicester and Burlington, assisted by Kent, and identifies the Palladian and Roman sources in detail. This is an almost classic text for illustrating the architect's claim to status not by originality but by a precise identification of his learned borrowings. Cf. Hussey's article on Holkham in *E.G.* 131, and Summerson, *Cantor Lectures*, 562. [3] Hussey, *E.G.* 137.

[4] Cf. the observations of Emil Kauffmann, *Architecture in the Age of Reason*, 1955, 20, 21. I have been unable in this survey to do justice to Kauffmann's thesis that English Palladianism, influenced by Vanbrugh, prepares the way for revolutionary changes in neo-classical architecture.

to Blenheim, as Wanstead was the neo-Palladian reaction to Castle Howard.

The interior approach to the state apartments is through a grand Hall terminating in an apse [plate 7]. Its sources are a description of the Roman basilica in Vitruvius, book V, chapter I, 'Of the Forum and Basilica', a passage to which Palladio had drawn attention; Palladio's Egyptian Hall; a Jones drawing for the compartmented ceiling; and Desgodetz's *Édifices antiques de Rome* (1682), from which the frieze, coffered cove, and Ionic colonnade (from the Temple of Fortuna Virilis) are taken. The flight of steps is spectacularly placed at the focal point of the apse. The imitation of a Roman basilica introduced an altogether different conception of the entrance hall from the square room deriving from the Queen's House. Its longitudinal drive compelled movement and could not be reconciled, as at Houghton, with the purposes of a living room. Although not as correct as the Assembly Rooms at York, and conceived as a gallery for the display of sculpture rather than an Egyptian Hall for festivities, it fulfils even more splendidly the functional purpose that Burlington had in mind, namely, to remind those who passed through it that they had inherited the legacy of Rome.[1]

The first neo-Palladian series of country houses in the grand manner reaches its climax in that apotheosis of Wanstead with wings, the east front of Wentworth Woodhouse, Yorkshire, rebuilt from *c.* 1734 by 'Burlington Harry' Flitcroft for Thomas Watson-Wentworth, Lord Malton, later created Marquess of Rockingham [plate 6D].[2] It may here be pointed out that those who invested the surplus and sometimes drained the capital of their fortunes in building great country houses which were centres of regional political activity were not infrequently amongst those to receive high promotion in the House of Lords, then a valuable political asset. The extent as given in the 1734 engraving

[1] Sir William Chambers recognized the palatial character of Holkham when he used it as a model for his own design for a royal palace. See John Harris, 'Two Lost Palaces', *C.L.* 19 Nov. 1959, 918.

[2] See the article on Wentworth Woodhouse in Hussey, *E.G.* 147–54, and A. Booth, 'The Architects of Wentworth Castle and Wentworth Woodhouse', *R.I.B.A. Jnl.*, 25 Nov. 1933.

is 606 feet, which may be compared with 850 feet for Blenheim and 660 feet for Castle Howard, in the plans published in *Vitruvius Britannicus* I, plates 62, 63. At no stage of its immense lateral extension is the skyline lowered to the normal height of a Palladian wing, a palatial exploitation of horizontal mass which is baroque classicist rather than Palladian.

In 1753, when the series was complete, Hogarth declared that 'were a modern architect to build a palace in Lapland, or the West-Indies, Paladio must be his guide, nor would he dare to stir a step without his book'.[1] In fact the decisive type for the colonies was the villa, which evolves *pari passu* with the palace. Once again Campbell appears in the role of initiator. In 1718 he built Ebberston Lodge, Yorkshire, for William Thompson M.P. in a shallow valley some miles from the owner's principal seat [plate 8A].[2] It is a reduction of the *casa di villa* with wings, its elements deriving from Jones. Early paintings show a central cupola and smaller ones over the end pavilions, not unlike a child's toy based on Castle Howard and corrected by the new principles. Among the Jonesian borrowings are the doorway adapted from the gateway of Beaufort House, Chelsea, later one of the treasures of Burlington's garden at Chiswick, and on the north or water-front a miniature *palazzo* façade deriving from Scamozzi's Villa Molin via the Queen's House at Greenwich.

The enchanting bagatelle is obviously closer in function to the hunting-lodge or the Italian casino for summer retreat than the farmhouse villa. A spectacular waterworks ran down the valley to the north front and continued further south on the same axis. In the nineteenth century it became the home of the celebrated sportsman Squire Osbaldeston, who was attracted to 'the mere château in the Italian style of architecture' by its access to a range of shooting over 10,000 acres of moorland and 4,000 acres of

[1] *Analysis of Beauty*, ed. Joseph Burke, Oxford, 1955, 62.

[2] See *V.B.* III, plate 47; Stutchbury, *Campbell*, 45–6; and the articles by Arthur Oswald, 'Ebberston Hall, Yorkshire', in *C.L.*, 7 Oct. and 14 Oct. 1954, where the sources are discussed. For villa antecedents generally in England see Stutchbury, *Campbell*, 76, where he notes that Campbell's first known house, Shawfield, Glasgow, 1712, has points of resemblance with Palladio's Villa Emo at Fanzolo.

tillage, as well as the trout in the large fishponds.[1] Its importance lies in its completely recreational character. It is detached from the cares of the estate, as the country house proper was detached from the cares of the city.

Campbell's second recreational house dates from after Burlington's second return from Italy, and was his first wholehearted attempt in the Palladian as distinct from the Jonesian style. Mereworth Castle, Kent [plate 8B], roofed in 1723, was built for Colonel the Hon. John Fane, later 7th Earl of Westmorland, and reproduces the Villa Rotunda in an English setting.[2] The house was within reach of Tunbridge Wells and, although the rich farmland was cultivated, it was used by the owner principally for summer residence and entertaining. The idea of a country house divorced from utility was alien to Palladio, who actually placed the Rotunda in his chapter on town houses.[3]

The architect made no claim to originality, save in adapting the interior by some practical features to local conditions. One of these features, the chimney flues, accounts for the difference most readily detected by the eye, the steeper elevation of the dome in which they are incorporated. But by one simple device Campbell made a radical if not so immediately obvious change in the appearance of the building. Palladio planned the Rotunda to realize completely the third dimension. Silhouetted against the sky on the crest of a hill, its four porticoes and flights of steps stand four-square to the elements. Mereworth faced the axis of an avenue, continued behind the house by a valley stretching out into rising hills. This central axis is expressed externally *by omitting the lateral steps*. To anyone who visits Mereworth with the Rotunda fresh in his mind, it is as if the latter had been translated into a landscape painting. Mereworth is a masterpiece of scenic effect, achieved by a deliberate sacrifice of the third dimension.

[1] *Squire Osbaldeston: His Autobiography*, ed. E. D. Cuming, introduction by Sir Theodore Cook, 1926, 16.

[2] See *V.B.* III, plates 35–8, Hussey, *E.G.* 58–65, and Summerson, *Cantor Lectures*, 571–2.

[3] Book II, chapter III. Palladio's functional concept of the villa is well brought out by Georgina Masson, 'Palladio's Villas as Rural Centres', *Arch. Rev.*, July 1955.

The planning of the interior departs from the model in accordance with the change just noted in the exterior. The two halves correspond exactly on either side of the longitudinal axis. A prized if not original feature of baroque planning had been the effect of climax obtained by the lateral grandeur of the state apartments arranged *en suite* on either side of the central entrance. At Mereworth Campbell occupied the whole of the garden front with a magnificent saloon eighty-two feet in length.

Palladio had combined both the temple types of Roman antiquity, the rectangular and the round, in the Rotunda, and his plan expressed the Vitruvian ideal of a circle within a square. From the outside it looks as if two long rectangular or Parthenon-type temples had been driven through a square block enclosing a miniature Pantheon. No other building combined so spectacularly the 'temple beauties' of the ancients in a single formulation for domestic architecture, and in choosing it for his model Campbell must have intended to create the same illusion of identification with Rome as was achieved later and more authentically by the Assembly Rooms at York and the Great Hall at Holkham. That the reconstruction was a fallacy, based on Palladio's theory of the origins of the temple from the ancient house, was happily unknown to his age.

Mereworth both raised the status of the recreational house and helped to establish the characteristically English villa plan of a square or near square, with its back and front divided into a one–three–one rhythm of bays. Its Rotunda plan was less successful. There are only four Georgian derivatives from it.[1] A secondary influence of Mereworth was on the great house, which separated the Pantheon type from the Parthenon one, but found room for

[1] Mereworth; Chiswick House, begun *c.* 1725; Nuthall Temple, Nottinghamshire, by Thomas Wright, 1754, demolished 1929 (*V.B.* IV, 1767, plates 56, 57, and *C.L.*, 18 Apr. and 5 May 1923); and Foots Cray Place, Kent, *c.* 1754, burnt down 1950, possibly by Isaac Ware (*V.B.* IV, plates 8, 9, 10). The square Burton Constable Hall, Yorkshire, by John Carr, built *c.* 1762–8 (*V.B.* IV, plates 36–7, and Pevsner, B.E. *Yorkshire: the North Riding*, plate 53) and the circular Belle Isle, Westmorland, by John Plaw, 1774–5 (Hussey, *M.G.*, fig. 25) are not true derivatives. Cf. Dorothy Stroud, 'Four Palladian Villas: the Villa Capra, Vicenza, and its English counterparts', *C.L.* CIV, 8 Oct. 1948, 728–31.

both plans in its interior enclave. The alternation or criss-cross between villa and great house henceforth becomes one of the most fascinating problems for the art historian to explore.

The second derivative from the Rotunda is Burlington's villa at Chiswick, built to his own design from *c.* 1725 [plate 2B].[1] The Jacobean mansion that he had inherited assumed a special importance in his eyes after his first return from Italy. It enabled him to indulge his taste for gardens. In this respect the villa stood in the same relationship to Burlington House as the Villa Doria-Pamphili to the Palazzo Doria in Rome.[2] It was not so close for the convenience of sharing domestic staff, but he retained the old seat, which he refaced with triple pediments. In the layout of the gardens he used every device to isolate the recreational annexe.

The idea of a casino-villa was so novel in English eyes that its function was at first misunderstood, as may be illustrated by Lord Hervey's *bon mot*, that the house was 'too small to inhabit, and too large to hang to one's watch'.[3] The size of the Rotunda was diminished, and many changes were made in the design. The front and back façades were sharply distinguished, a notable advance on Mereworth's frontality. The dome was boldly uplifted on an octagonal drum with four Diocletian semicircular windows. Wittkower has listed the eclectic sources, all taken from the canon: the Villa Malcontenta for the rusticated ground floor, of the entrance front; the Temple of Castor and Pollux, illustrated by Palladio, for the capitals of the portico; Scamozzi for the octagonal drum with Diocletian windows; and two drawings in Burlington's own collection, probably by Scamozzi but attributed to Palladio, for the garden front.[4] The most original feature was the

[1] See J. Charlton, *A History and Description of Chiswick House and Gardens*, H.M.S.O., 1958, and R. Wittkower, 'Lord Burlington and William Kent', *Archaeological Journal*, CII, 1945, 151 ff.

[2] Knyff's drawing of the old home engraved by Kip and Rocque's plan of 1750 are reproduced in R. Phené Spiers, 'Chiswick House', in *Memorials of Old Middlesex*, ed. J. Tavernor-Perry, London, 1909.

[3] *A. of P.* III. 55. Dallaway's note also cites the verses of Lord Chesterfield, making the same criticism of uselessness.

[4] In *British Art and the Mediterranean*, section 54, and 'Diffusioni dei Modi Palladiani in Inghilterra', *Bollettino del Centro Internazionale di Studi d'Architettura Andrea Palladio*, Vicenza, 1959, I. 57.

spatial complexity of the suite of three rooms facing the garden: a rectangular central room with apses at either end leading on one side into a circular room and on the other into an octagonal one. For a sequence of differently shaped rooms *en suite* Burlington had the authority of Palladio's reconstructions of Roman *thermae*. The design of the villa was meant to be read in conjunction with that of the garden, a similar repertory of classical forms. The spatial excitement in so small a compass was unprecedented, and its lesson was not lost on those who built greater houses.

The dominant or standard type of Georgian villa derives from a third design by Campbell, Stourhead, Wiltshire, built for Henry Hoare between 1721 and 1725.[1] Its closest source in Palladio is the Villa Emo at Fansolo. The definitive formulation was achieved at Marble Hill, Twickenham, in part the gift of George II, then Prince of Wales, to his mistress Henrietta Howard, whose husband succeeded in 1731 to the earldom of Suffolk.[2] Unfortunately, the history of this key Thames-side villa is obscure, and raises the problem of collaboration. It was probably designed by 1723 and completed in 1729. The Earl of Pembroke, who was in a strategic position as Lord of the Bedchamber and whom Horace Walpole praised as a better architect than Burlington or Kent, approved the bills, his protégé Roger Morris receipted them. It is best taken as the first work of a notable partnership between amateur and professional. The surprising thing about Marble Hill [plate 9A] is that one of its points of departure was the Mauritshuis at the Hague by Jacob van Campen, designed *c.* 1633. The entrance front resembles very closely the water-front of the Dutch building, which the Prince must have known, and was itself based on a Palladian source, Palladio's design of

[1] See Hussey, *M.G.* 234–8; Summerson, *Cantor Lectures*, 572; and *V.B.* III, plates 41–3.

Stutchbury, *Campbell*, 49–50, points out that Campbell's Newby Park, Yorkshire, for Sir William Robinson, 1720–1, is the earliest securely dated example of the neo-Palladian villa formula of a 1–3–1 ratio.

[2] Marble Hill is fully discussed in James Lees-Milne, *Earls of Creation*, 1962, 79–92. See also H. Clifford Smith, *Marble Hill House*, published by the Georgian Group of the Society for the Protection of Ancient Buildings, 1939.

George gave £12,000 to the cost of building the new house, a sum greatly exceeded, Lees-Milne, op. cit. 80.

a palace for Giulio Capra in Vicenza. The changes now made all show a stricter attention to Palladian or Jonesian motives: the pyramidal shape of the roof, the reduction of the third storey with its shorter fenestration, and the raising of the ground floor, emphatically rusticated at the centre, to serve as a more impressive podium to the order.

The revised design pleased both the Prince and the Palladians. On 16 March 1727 Roger Morris was appointed Clerk to the Works to erect a new hunting-lodge in Richmond Park, and in the same year George became King. In 1728 the architect's kinsman, Robert Morris, the leading theorist of the Palladian revival, published an almost identical design to illustrate an ideal house in his *Essay in Defence of Ancient Architecture*. Oddly enough, he reinstated the framing pilasters of the Mauritshuis, which appear neither in Marble Hill nor in Palladio's reconstruction of the ancient house for Barbaro's edition of *Vitruvius* (1556). In the Royal or White Lodge at Richmond the same scheme was adopted by Pembroke and Morris, but a Venetian window was inserted in the central bay of the temple front and a Jonesian arcade in the podium.[1] Despite these flourishes, the White Lodge faithfully adheres to the Marble Hill formula: a compact rectangular villa with a one–three–one rhythm of bays, three horizontal divisions into (a) ground storey as a base, (b) *piano nobile*, and (c) shorter third storey, with a temple front as centre-piece.

A solution twice approved by George, elevated to an imaginary authenticity by a theorist and appealing to traditions of Dutch classicism strongly rooted in England, proved irresistible. When Isaac Ware built Clifton Hill House in Bristol between 1746 and 1750 for the merchant Paul Fisher he omitted the order but exploited a steep hill site by adding a flight of steps on the raised garden front, thus achieving one of the most striking of great merchants' villas.[2] Finally, the adaptability of a compact design without an expensive Rotunda or wings made it an admirable intermediary between aristocratic Palladianism and the middling house. Innumerable echoes of it are to be found among Georgian

[1] See J. Lees-Milne, *Earls of Creation*, 70.
[2] Walter Ison, *Georgian Buildings of Bristol*, 1952, 177–81.

merchants' and doctors' residences, rectories, and even farm-houses.[1]

One of the predecessors of the White Lodge was Campbell's house for Lord Herbert in Whitehall (1724), a villa with a river prospect in an urban setting.[2] Between 1756 and 1765 John Vardy built Spencer House [plate 9B] for Lord Spencer to a design possibly suggested by Colonel, later General, Sir George Gray, and certainly approved by him.[3] Its garden elevation derives from Palladio's Palazzo Iseppo de' Porti in Vicenza. The distinctive feature is a pediment covering five of the seven bays. By widening the pediment Vardy was able to assert the dominance of the temple front over the compact block, a feature which occurs in Palladio's country houses but seldom his town ones. Spencer House both overlooked and had immediate access to Green Park, which accounts for its unique impact as an enlarged villa amongst London town houses. Its bay sequence is incorrect by the English standard: one–five–one instead of one–three–one. But the villa idea is unmistakable, and furnishes a classic instance of the interaction of types.

The innovations of the English Palladians were most fruitful when they were attached to native seventeenth-century types. The standard terrace town house derives from Lindsey House in Lincoln's Inn Fields (c. 1638–40), attributed by Campbell to Jones, which was taken for the model of Queensberry House (1721) built on the Burlington estate by Giacomo Leoni. In both the section of a Palladian palazzo was applied to the requirements of terrace or row housing, and the horizontal division is identical with that finally favoured for the villa. Its advantage was that the

[1] One advantage was that the temple front could be omitted without spoiling the appearance. Cf. the recommendation of John Gwynn, *The Art of Architecture*, 1742, 8.

> The Dress of *Temples* suits not with a Grot.
> The *Palace* and the *Villa* differ wide.

An apt vernacular illustration is reproduced immediately below the White Lodge in Nathanial Lloyd, *A History of the English House*, 1951 (1st ed., 1931), fig. 249.

[2] *V.B.* III, plate 48; Stutchbury, *Campbell*, 59; and J. Lees-Milne, *Earls of Creation*, 69–70.

[3] Colvin, *D.E.A.* 641; *V.B.* IV, plates 37–40, and Spencer House, *Survey of London*, XXX, 1960, part 1, 518–31.

order could be omitted in plainer buildings.[1] The ideal place for the order, preferably with a pediment, was in the centre of a block, but unfortunately the development of the great estates in London seldom matched the unifying control exercised by the Woods in Bath or later by the planners of the New Town in Edinburgh. Additional storeys were a further cause of dissonance, but the formula at least supplied a common ground of good manners which enabled the squares and streets of Georgian London to preserve a civilized character.

Civic architecture in the provinces provided the Burlingtonians with their best opportunities to match the grandeur of imperial Rome. Burlington in York realized the dream of Campbell in London, to reproduce a classical building in its entirety. His idea was to reconstruct the Egyptian Hall or Oecus as described in Vitruvius, book VI, chapter V, a logical choice for the civic Assembly Rooms [1731–2; plate 5A] because this variant of the Roman basilica was associated with festivals and entertainments. Palladio had illustrated a cross-section and part of the plan; for the rest, Burlington was guided by the statement of Vitruvius that such halls 'had the appearance of basilicae' and by Palladio's reconstruction of the ancient basilica.[2] By using the width of six columns from Palladio's Egyptian Hall, and the length of eighteen columns from his basilican reconstruction, he obtained the proportion of one to three. Above the narrow aisles thus formed is the upper-storey balcony, with its 'uncover'd pavement' from which 'one might see into it' through the clerestory windows.

When in 1736 Francis Drake, F.R.S., published his *Eboracum, or the History and Antiquities of York*, he emphasized the all-important part played by association in an enthusiastic dedication to Burlington:

For, where should the history of an ancient *Roman* city in Britain, find greater favour, or meet with a better reception, than from a

[1] Summerson, *Architecture in Britain*, 102, 231–2.

[2] Book II, chapter X, 'Of Egyptian Halls'. Cited from *The Four Books of Architecture by Andrea Palladio*, translated by Isaac Ware, 1738, 45. Cf. 'The Earl of Burlington and William Kent', *York Georgian Society's Occasional Papers*, no. 5. 1948; 'Burlington and his Work in York', *Studies in Architectural History*, ed. W. A. Singleton, London and York, 1954; and *The History of the York Assembly Rooms*, The York Corporation, n.d., all by R. Wittkower.

nobleman, whose particular genius, almost, speaks him of *Roman* extraction.... For York, by your means, is now possessed of a structure, in a truer and nobler taste of architecture, than, in all probability, the *Roman* Eboracum could ever boast of. Your Lordship's great knowledge in this art, soars up to the *Augustan* age and style; and that Praetorian palace, one in old EBORACUM, made ever memorable for the residence of two *Roman* emperors, and in all likelihood, for the birth of a third, must, if now standing, have given place to your *Egyptian* hall in our present York.

As Burlington paced up and down the completed hall, he may well have felt that old Rome, if not old Greece, had at last been 'transplanted to England'.[1] For the solitary visitor, with notes of the proportions taken from the two texts in his hands, the Assembly Rooms constitute the central shrine of classicism in England. As an aristocratic *palais de danse*, for the term 'Egyptian' was used by the Romans like the French phrase in nineteenth-century England to impart an exotic flavour to recreation, it was open to certain objections. Sarah, Duchess of Marlborough, indignantly pointed out that 'nobody with a hoop petticoat' could pass through the columns, and that the open aisle-roof loggia was so 'very high' that the people who ascended to it in order to watch the dancers could 'see nothing but the tops of their heads'.[2] Conveniency, however, was studied in the long row of '11 glass branches, each holding fifteen glass handles', given by Lord Burlington at a cost of £50; in the ante- and serving-rooms; and the original portico which, it was claimed, could hold two hundred servants.[3]

'The members of the English Parliament', wrote Voltaire after his visit to England during the very decade in which the Burlingtonians set about the capture of the Board of Works, 'are fond of comparing themselves to the old Romans.'[4] The most ambitious scheme for reviving the splendours of imperial Rome

[1] The phrase 'to transplant Old Greece into England' was coined by Henry Peacham in the second edition of *The Compleat Gentleman* (1634) in a eulogy of the Earl of Arundel, chapter 12, 107–8.

[2] Cited by R. Wittkower in *The History of the York Assembly Rooms*, 8, 18.

[3] For the gift of chandeliers see John Nichols, *Literary Illustrations*, 1818, III. 702.

[4] *Voltaire's England*, edited by Desmond Flower, 1950, 37.

was conceived not for the Parliament at Westminster but a pro-
vincial spa. In 1725–6 John Wood I prepared two designs for the
development of Bath, based on alternative sites:

And in each Design, I proposed to make a grand Place of Assembly,
to be called the Royal Forum of Bath; another Place, no less magni-
ficent, for the Exhibition of Sports, to be called the Grand Circus;
and a third Place, of equal State with either of the former, for the
Practice of medicinal Exercises, to be called the Imperial Gymnasium
of the City, from a Work of that Kind, taking its Rise at first in Bath,
during the Time of the Roman Emperors.[1]

He thus forestalled Burlington with a proposal based on func-
tional analogy and the imperial associations of place. What resulted
was not a Roman civic centre, but a sequence of planned spaces
serving the same residential purpose as the fashionable squares of
London. One fragment of the original programme survives: the
Circus, adapted from the Colosseum, begun in 1754 [plate 5B].
Matthew Bramble in Smollett's *Humphrey Clinker* (1771) noted
its most remarkable feature: it 'looks like Vespasian's amphi-
theatre turned outside in'.[2] This is exactly what it was. The three
orders, Roman Doric, Ionic, and Corinthian, were identically
superimposed and the spaces in between filled with windows and
doors, a change drastic enough to disguise the borrowing from
many modern eyes, but immediately detected at the time. The
arena of the Caesars was in the event translated into nothing
more alarming than an ambulatory for convalescents.

The neo-Palladian interior was the joint achievement of Bur-
lington and Kent, the former putting the latter to the task of
creating a grammar of interior design and ornament from Jonesian
models. Five principal sources may be distinguished: Roman
external architecture applied to the interior; Jones and his
followers; the English baroque architects, notably Vanbrugh;
Dutch seventeenth-century classicism; and contemporary Italian

[1] Cited by Walter Ison, *The Georgian Buildings of Bath*, 31. Cf. the observations of
N. Pevsner on this passage in B.E.: *North Somerset and Bristol*, 1958, 92. The citation
comes from John Wood's *Description of Bath*, 1742–3.

[2] Cited by Bryan Little in *The Building of Bath 47–1947: An Architectural and Social
Study*, 1947, 85.

decorative styles practised by immigrant craftsmen. In this min-
gling of influences the baroque element is very strong. It was
allowed in by the Burlingtonian principle of contrast between the
plainness of the exterior and the richness of the interior, carried to
an extreme by Lord Lyttelton at Hagley: 'we are pretty indifferent
about the outside, it is enough if there be nothing offensive to
the eye.'[1] A similar tendency can be noted in the contempor-
ary French rococo, which preferred a chaste classicist exterior as
a foil to the interior.

In accordance with his programme Burlington promoted Kent
as an interior designer well before he took him up as an architect.
In 1720 Kent writes of having made a sketch in colours for 'the
great room on the front of Burlington House'.[2] This was followed
by the royal commissions to be discussed in the context of baroque
survival.

The interiors at Chiswick (from *c.* 1727) and Houghton reveal
his mature style based on the Jonesian assignment. This taught
him to use the plain wall surface, to isolate parts, and to impose
a geometric order on the ensemble. But he still hankered after
baroque effects, especially the ascending crescendo of forms, and
was more stimulated by the grandeur of Roman baths than by the
elegance of Palladian saloons.

The Stone Hall at Houghton [1734–7; plate 10B] was a Jonesian
design by Campbell which gave full scope to Kent's genius for
theatric display.[3] A collection of Roman imperial portrait busts
stamps the august character of the room. The level alignment is
broken only once, by Rysbrack's bust of Sir Robert Walpole,
placed centrally and in a higher position on the mantelpiece, so
that the Norfolk squire who had become Prime Minister of
Britain takes command of a regiment of Roman emperors.[4] The

[1] Letter to Sanderson Miller, June 1752, printed in *An Eighteenth-Century Corre-
spondence*, ed. Lilian Dickins and Mary Stanton, 1910, 284.

[2] Letter to Burrell Massingberd, 19 Jan. 1720, cited by M. Jourdain, *The Work
of William Kent*, 1948, 68.

[3] See M. I. Webb, *Michael Rysbrack, Sculptor*, 1954, 127–9, and M. Jourdain,
The Work of William Kent, 63. The former authority was the first to identify the
sources of the bas-reliefs in Montfaucon and Bellori's *Veteres Arcus Augustorum*.

[4] Cf. Henry Peachman, *The Compleat Gentleman*, 2nd ed., 1634, 107–8: 'King

bas-reliefs by Rysbrack were arranged round the room to support the Roman associations: without exception they illustrate scenes from Roman life, generally with a sacrificial theme, e.g. the Sacrifice of the Bull from Montfaucon's *L'Antiquité expliquée* (1719–24). The place of honour above Walpole's head is occupied by the *Sacrifice to Diana* [plate 10A], a goddess to whom the Prime Minister showed scant respect in his conversation. The choice of Diana may have been an allusion to Queen Elizabeth and the glories of her reign, as well as an invocation of Roman virtue. 'Well, you are to be an old Roman, a patriot?' he is reported to have said to young idealists, 'You'll soon come off that and grow wiser.'[1] This pose of cynical detachment from the fantasies of Anglo-Romanism concealed a superb consciousness of his own achievement, amply commemorated by other details of the scheme. On the Roman drapery of his bust is proudly pinned the Star of the Garter, the symbol of his monarch's esteem and gratitude. The emblem is repeated in the spandrels of the ceiling, separated from the rest of the room by Artari's putti, a baroque device for distinguishing between the celestial and terrestrial spheres. At the summit of the ceiling, in the space traditionally reserved for apotheosis, is depicted the Walpole coat of arms.

The justification of this somewhat confident iconography appears outside the room, above the pediment over the central window, originally designed by Campbell to be approached by an external flight of steps. Neptune and Britannia, reclining in positions reminiscent of Michelangelo's Medici tombs, flank a cartouche of the Walpole coat of arms, adorned with the inevitable Garter Star.[2] The elderly Neptune, who in antiquity merely presided for all practical purposes over the Mediterranean, directs a reverential gaze to a young lady, Britannia, who now rules the waves of wider oceans.

Charles . . . hath amply testified a Royall liking of antient statues, by causing a whole army of old forraine Emperours, Captaines and Senators . . . to come and doe him homage, and attend him in his palaces.'

[1] From the character of Walpole by Chesterfield, published in John Bradshaw, *The Letters of Philip Dormer Stanhope, Earl of Chesterfield, with the Characters*, 1892, III. 1418.

[2] For Walpole's obsession with the Garter Star see J. H. Plumb, *Sir Robert Walpole*, II. 101.

The sequence Campbell–Burlington–Kent illustrates the main stages of a classical revival which shifted its emphasis from Jones to Palladio under the leadership of Campbell and Burlington, but throughout its course incorporated English baroque motives and types. The other architects of the Scuola may be divided into two groups: those who got into the Board of Works with Campbell in the first assault of 1718–19, and the associates of Kent after his first appointment in 1726. If by the virtue of seniority Leoni is included in the first group and Dubois, Master Mason 1719–35, is added, and the Earls of Burlington and Pembroke are enrolled as amateurs in the second, the two lists read: Benson, Campbell, Dubois, and Leoni; Burlington, Pembroke, Kent, Roger Morris, Flitcroft, Ware, and Vardy. These are the principal figures apart from the regional architects like John Wood I of Bath and John Strahan of Bristol, and before the generation of Paine and Taylor.

Ware figures later in the story because he showed a marked sympathy in his practice with the rococo, conspicuous by its absence from the Burlingtonian repertory. Flitcroft, who was a personal discovery of Burlington, had a wide practice ranging from churches to garden temples. One of his more original designs was the stable quadrangles at Woburn (1757), where he worked for the Duke of Bedford from 1747 to 1761.[1] The isolation of stables for a spectacle or in his own words as 'objects' was not new, but the spatial arrangement of the quadrangles, with their straight alignment broken in the centre by a wide court, like the river front at Greenwich, is highly effective. Venetian and Diocletian windows and two cupolas borrowed from Chiswick, each raised above a pedimented Doric arch, provide the necessary ennoblement of the appropriately severe façade with its vast lateral extension.

The main landmarks of country-house architecture had been achieved by 1746, when Consul Smith in Venice commissioned Antonio Visentini and Francesco Zuccarelli to execute a series

[1] Illustrated in Hussey, E.G. 29–30. For John Carr's comparably grand stables at Wentworth Woodhouse and Castle Howard see R. B. Wragg, 'Stables Worthy of Stately Homes', in C.L., 1 Nov. 1962.

of *capricci* of British Palladian buildings to match thirteen over-door paintings of 'the most admired Buildings at Venice' by Canaletto.[1] In showing them to his friends he must have been well aware that they also matched a contemporary Palladian revival led by Andrea Tirali, Francesco Muttoni, Giorgio Massari, and other Venetians.[2] The connection between the two revivals has not been fully explored, but the Italian one was in fact under way before the English. Smith included Inigo Jones in his programme, thus following Campbell in opposing him in friendly rivalry to Palladio.

Horace Walpole on returning from his Grand Tour in 1741 noted that '*middling* houses' were peculiar to the English and matched the distinction of '*middling* people'. 'How smug they are!' he wrote of the houses, in a passage generally misquoted with the substitution of 'snug'.[3] A spate of builders' manuals, notably those of William Halfpenny (d. 1755) and Batty Langley (1696–1751), followed in the wake of the aristocratic corpus.[4] Special prominence was given to specifications for those parts which required detailed draughtsmanship and could accurately be reproduced from the copybook by skilled craftsmen: doorways, windows, chimney-pieces, and staircases. It is this excellence of

[1] See A. Blunt, 'A Neo-Palladian Programme executed for Consul Smith', *Burl. Mag.*, Aug. 1958, and Frances Vivian, 'Joseph Smith and the Cult of Palladianism', *Burl. Mag.*, Apr. 1963.

[2] See John Fleming, 'The Palladian Revival in Italy', *C.L.*, 3 May 1962, 1030–3. The Venetian Palladio Revival goes back to *c.* 1690; its influence on Campbell and Burlington, who almost certainly met Muttoni in Vicenza in 1719, has not yet been determined. If we accept two streams of Palladian influence in England, one via Jones and Campbell, the second via Tirali and Leoni, they were brought together by Burlington's two acquisitions of drawings: the drawings by Jones and Palladio bought from John Talman, and the Roman Baths drawings procured at Maser. See P. Fraser and J. Harris, 'A Catalogue and History of the Burlington–Devonshire Collection, Part I, the Jones, Webb and Burlington Drawings', R.I.B.A., 1959 (typescript).

[3] To Mann, 13 Sept. 1741, in Yale ed. XVII. 142.

[4] See Katharine A. Esdaile, 'The Small House and its Amenities in the Architectural Handbooks 1749–1827', *Transactions of the Bibliographical Society*, XV, 1917–19. Publications catering for *cheap* houses begin in 1749.

For the bibliographical sources in this section see Lola L. Abel, Ph.D., 'A Bibliography of some 18th Century Books on Architecture (British Palladians) 1715–1780', thesis submitted to the School of Librarianship, University of London.

the parts combined with harmonious arrangement that so distinguishes Georgian architecture as a whole. The client could take his pick from first-class models. *Simplex munditiis* was the preferred ideal: 'there must be sufficient places left plain.'[1] The writers of these manuals must have known that the grand manner of English Palladianism was suited neither to the tastes nor to the purses of their clients, but the first publications were surprisingly ambitious in their demands on labour and skill. What happened in many cases was that the local builders observed the good taste of Queen Anne in which they had been brought up, and constructed simpler units, often with the happiest results.

The Palladianism of the vernacular followed the general evolutionary trend of modernizing inherited types, the Venetian window, that prized relic of Palladian nobility, especially becoming a status symbol.[2] The dominant classical principle was mathematical proportion, on which the manuals insisted with almost fanatical fervour. In some cases the writers were not afraid to extend the Palladian rules. William Salmon, a carpenter of Colchester who wrote several manuals for builders, tradesmen, and carpenters, claimed to have worked out a new and improved system:

A New Method, to show what Light is proper for any *Room*, and the *Proportion* that the Windows, *Chimnies* and *Funnels* ought to have by a Universal *Rule*.

To know what Light is proper for any *Room*, the *Rule* is, Let the dimensions of the *Room* be given, viz. The Length, Breadth and Height, multiply the Length and Breadth of the *Room* together, and the product by the Height, the Square Root of their Product is the Quantity of *Light* required.

[1] Cited from Abraham Swan by Arthur Stratton, *Some XVIIIth Century Designs for Interior Decoration*, 1923, in a collection of extracts from his prefaces, notably *Collection of Designs in Architecture*, 2 vols., 1757. S. Switzer invoked *Utile dulci* and *Simplex munditiis* in *Ichnographia Rustica*, 1718, Preface XV ff.

[2] Cf. John Gwynn, *The Art of Architecture*, 1742, 25:

> The *Modern* Artists, all their Genius show
> In a *Venetian-Window*, or a Bow.
> The *Cell*, the *Temple*, *Palace*, *Villa*, all
> Must have a Window They *Venetian* call.

The application of this rule may be illustrated by his second example:

> Suppose, a *Room* is a *Cube*, or perfectly *Square*, i.e. equal in Height, Length and Breadth, and admit that to be 12 Feet, which being Multiplied each by the other as before, the Product will be 1728, whose Square Root will appear to be 41 Feet 6 Inches and an half near, and should have 2 Windows therein, containing 20 of 9 Inches and a Quarter Superficial in each, and this *Rule* is universal for all *Rooms* whatsoever.[1]

In the *Palladio Londiniensis* (1st ed., 1734) Salmon boldly criticized the 'deficiencies' in Vitruvius, Palladio, Scamozzi, and Vignola, and referred to 'the very best Rules I ever saw' in the manuals of Halfpenny and Batty Langley.

It would be impossible to determine how far the mathematical ratios prescribed by the manuals were followed in vernacular practice without measuring a vast number of buildings. Today the Georgian Rule of Taste is widely associated with the simplicity of shapes and instinctive tact of proportion in middling architecture, merits already found in the reigns of William and Mary and Queen Anne. From the same period was inherited the sensitiveness to plain surfaces of red brick and their restrained enhancement by ornamental white stone borders. A notable change in the theoretical literature of the Palladian Revival is the association of mathematical proportion with taste instead of the divine order of the universe. Shaftesbury, it is true, was committed to the old classical and Renaissance theory of a universal harmony: '*Virtue* has the same fix'd standard. The same *Numbers*, *Harmony* and *Proportion* will have place in *Morals*; and are discoverable in the *Characters* and *Affections* of Mankind.'[2] Robert Morris, the chief intermediary between the high theorists and the writers of the pattern books, also shows a grasp of the philosophical doctrine which must have been above the heads of the empirical builders, craftsmen, and carpenters for whom he prescribed in a number of practical manuals, as well as *The Modern Builder's Assistant*, 1742, 2nd ed.,

[1] *The Country Builder's Estimator: or, the Architect's Companion*, 3rd ed. by E. Hoppus, 1746, 118–20.
[2] *Characteristicks*, 1727 ed., I. 353.

1757, in co-authorship with William and John Halfpenny and Thomas Lightoler. At one time in the service of his kinsman, Roger Morris, he had access to the ideas of the Burlington circle. His *Lectures on Architecture consisting of Rules founded upon Harmonick and Arithmetical Proportions in Building*, 1734–6, were delivered monthly at a 'Society for the improvement of knowledge in Arts and Sciences' which he had established about 1730. These constitute the nearest approach to an aesthetic of the Rule of Taste. Thereafter his references to cosmic harmony are summary. In *Select Architecture* (1753) he wrote: 'Beauty in all objects, springs from the same unerring Law in Nature, which, in *Architecture*, I would call Proportion.'[1]

But in *The Architectural Remembrancer*, 1751, he was content with the simple assertion: 'The chiefest skill required in the Designer is *Proportion*, and proper Bearings, that the Ornaments are not inconsistent, too petite, or gross . . .'[2] The architecture of humanism in its Indian summer in the age of reason rejected mysticism, but did not divorce itself from noble ideas. Its vision of antiquity was always heroic. But the new rationale of taste, which spread its influence so widely, also deprived it of its supreme sanction in the divine perfection. It was therefore with some poetic justice that later in the century a clergyman who championed the picturesque on religious as well as aesthetic grounds should write scornfully of Sansovino and Palladio as 'these modern legislators of the art' and the age of Burlington as 'fettered . . . too much by orders, and proportions'.[3]

[1] p. 78. [2] Preface, vii.

[3] The Revd. William Gilpin, *Observations relative chiefly to Picturesque Beauty, made in the Year 1772, on several parts of England, particularly The Mountains and Lakes of Cumberland and Westmoreland*, 2nd ed., 2 vols., 1788, I. 26.

II

THE CREATION OF THE
LANDSCAPE GARDEN

IN 1709 Shaftesbury used the device of imaginary letters to record and comment on some philosophical conversations between English gentlemen, thinly disguised by Greek names, during a series of walks in the countryside.[1] Among his classical predecessors is Pliny the Younger, who more than any other writer of antiquity anticipates the new attitude to the garden. He has little taste for the vainglorious garden of Regulus, with its immense porticoes and profusion of statues.[2] 'You would imagine', he writes of the setting of his Tuscan villa, 'that not a real, but some painted landscape lay before you, drawn with the most exquisite beauty and exactness.'[3] The natural enhances the artificial: 'beyond the wall lies a meadow that owes as many beauties to nature, as all I have been describing *within* does to art.'[4] At Laurentinum both the dining room and a withdrawing room command magnificent views, while 'a detached building, which I call my *favourite*' is no less fortunately placed and yet so retired that he can fancy himself a hundred miles from his own house.[5] The features of the villa landscape that he lists for admiration are the sea, mountains, hills, vineyards, meadows, fields interspersed with thickets, and 'the crystal Canal so agreeably winding along its flowery banks, together with the charming Lake below, that serves at once the purposes of use and beauty'.[6] Man himself can

[1] *The Moralists, a Philosophical Rhapsody. Being a Recital of certain Conversations on Natural and Moral Subjects*, 1709. Reprinted as the Fifth Treatise in *Characteristicks of Men, Manners, Opinions, Times* (1st ed., 1711).

[2] *Pliny, Letters*, tr. by William Melmoth, revised by W. M. L. Hutchinson, The Loeb Classical Library, 1915, I. 277.

[3] Ibid. 381. [4] Ibid. 383. [5] Ibid. 161–3.

[6] Ibid. 7 and 379. The 'crystal canal' refers to the villa of his friend Caninius Rufus (ibid. 7) and the statement about its winding is the translator's embellishment. The Latin says simply 'euripus viridis et gemmeus'.

assist in the creation of landscape, as 'when on a sudden, in the midst of this elegant regularity you are surprised with an imitation of the negligent beauties of rural nature'.[1]

These passages are quoted from William Melmoth's translation, which first appeared in 1746. By this date the Kentian Revolution had been accomplished, and Melmoth made free use of its typical vocabulary in interpreting Pliny's accounts of his own villas and those of his friends.[2] So free a translation, with its heightened evocation of the picturesque, is scarcely conceivable in 1709. But Pliny also appealed to pursuits more firmly established among English landowners than that of landscape enjoyment: hunting, the collection of works of art, especially portraits, and the formation of libraries. At his Tuscan estate he 'keeps my mind in proper exercise by study and my body by hunting'.[3] The villas of Silius Italicus, he tells us appreciatively, were 'furnished with large collections of books, statues and portraits, which he more than enjoyed, he even adored'.[4] His charming picture of the Roman gentleman finding relaxation from the cares of state on his country property, and at the same time occupied with the improvement of agriculture and the welfare of his workers, must have struck the Whig oligarchy, of which Shaftesbury was a spokesman, as peculiarly relevant to their own condition and tastes.

Shaftesbury's study of the Cambridge Platonists, his Italian travels, and sympathy with the rising English school of nature poetry combined to prepare him for his role as the first philosophical sponsor of a new movement in gardening.[5] *The Moralists*

[1] Pliny, *Letters*, tr. Melmoth, rev. Hutchinson, I. 391.

[2] *Gestatio* is translated as *allée*, *praediolum* as a country 'box', trees in the plural as a 'plantation'. Wherever he can, Melmoth introduces a contemporary equivalent familiar to his readers.

[3] Ibid. 395. [4] Ibid. 211.

[5] For the ethical background, so important for the associations of the garden, see F. J. Powicke, *The Cambridge Platonists*, 1926; R. L. Colie, *Light and Enlightenment: a Study of Cambridge Platonists*, Cambridge, 1957, and C. A. Moore, 'Shaftesbury and the Ethical Poets in England', *P.M.L.A.* XXI, 1916.

For the relation to nature poetry throughout the history of the landscape garden, see Edward Malins, *English Landscaping and Literature 1660–1840*, Oxford, 1966, and cf. Cecil Moore, 'Return to Nature in English Poetry of the Eighteenth Century', *Studies in Philology*, XIV (1917), 243–91.

develops Pliny's conception of the country estate as a setting for the exercise of social virtues and the peaceful enjoyment of humane studies, but places greater stress on the inducements to virtuous living. In a well-known passage, which provided a favourite theme for later writers, Shaftesbury denounced 'the formal Mockery of princely Gardens' in far stronger terms than Pliny's humorous deprecation of the ostentatious display of Regulus.[1] By way of contrast he listed a series of wilderness images taken not from his classical sources but the Italian baroque garden which he knew at first hand.[2]

Three years later, on 25 June 1712, Joseph Addison followed up Shaftesbury's attack with a revolutionary query:

But why may not a whole estate be thrown into a kind of a garden by frequent plantations, that may turn as much to the profit, as the pleasure of the owner? . . . Fields of corn make a pleasant prospect, and if the walks were a little taken care of . . . a man might make a pretty landskip of his own possessions . . .

Our British gardeners . . . instead of humouring nature, love to deviate from it as much as possible. Our trees rise in cones, globes and pyramids. We see the marks of the scissars upon every plant and bush.[3]

Addison's context was a series of letters on the pleasures of the imagination, and the witty shafts he directed at the formal garden served a high but agreeable ideal, which he defined as 'a nobler and more exalted kind of pleasure'. With remarkable prescience he appealed to four movements of taste, out of which the English landscape garden was in fact to evolve: the new attitude to nature; the growing appreciation of landscape painting; the cult of China; and the tendency towards 'artificial rudeness' in the gardens of Italy. Only the rococo is missing from the list of formative agencies, but then he was writing in 1712 and from an Augustan standpoint.

So little attention has been given to the Continental origins of *le jardin anglais* that Addison's reference to gardens 'in France and Italy, where we see a large extent of ground covered over with

[1] *Characteristicks*, 4th ed., 1727, II. 394. [2] Ibid. 393.
[3] *Spectator*, no. 414.

an agreeable mixture of garden and forest', requires some explanation. Coke had defined 'forest' as a safe preserve for wild animals of the chase.[1] Both in France and in Italy many seats adjoined tracts of open country reserved for hunting. In Italy the view had been stressed by Renaissance writers from Alberti onwards, and Palladio had specified the charms of cultivated as well as wild country. Mannerist gardens, particularly those of the hillside villas of Tivoli and Frascati so frequented by English travellers, were planned on the site with a keen eye for the vistas they commanded. In the seventeenth century picturesque elements from the 'forest' but not the farm had invaded the architectural framework: 'al resecatto netto succede un poco l'impreciso, al definito l'incerto . . . gli alberi fanno bosco, e si lascia loro la forma che la natura ha loro dato.'[2] The grotto with its elemental associations became a spearhead of wild nature. Carlo Maderno's *Fontana dell' Aquila* in the Vatican gardens anticipates the 'Chinese' mountains at Stourhead by more than a century.

In France Bernard Palissy advocated a union of the garden with nature as early as 1563.[3] Châteaux were traditionally built on an eminence or on the banks of a river, so that the view extended beyond the formal precinct. Heretical voices were sometimes heard within the camp of formalist orthodoxy. François Blondel protested against the sacrifice of trees to parterres, and 'Monsieur, à Saint Cloud, laissait même des arbres au milieu des escaliers'.[4] But Addison had no need to cite exceptions that prove the rule, for his stay in Paris coincided with an abortive movement of taste which went far beyond the bounds of such occasional nonconformity.

The leader of the French movement towards greater naturalism in gardens was Charles Dufresny de la Rivière (1654–1724),

[1] Sir Edward Coke, *The First Part of the Institutes of England, or, a Commentary upon Littleton*, ed. by Francis Hargreaves and Charles Butler, 1788, II. 233 (1st ed., 1628).

[2] Luigi Dami, *Il giardino italiano*, Milano, 1924, 26.

[3] Bernard Palissy, *Le Jardin delectable* (1563) in *Œuvres complètes de B. Palissy*, Paris, 1800.

[4] The most fully documented account of the French garden is L. Hautecœur, *Histoire de l'architecture classique en France*, V (1953), and id., *Les Jardins des dieux et des hommes*, Paris, 1959.

today chiefly remembered as a dramatist.[1] The principal gardens designed by this man of letters were Mignaux near Poissy, one for the Abbé Pajot near Vincennes, and two in the Faubourg Saint Antoine in Paris. They date from the turn of the century. 'Il ne travoilloit avec plaisir', writes the author of his life, 'et pour ainsi dire, à l'aise, que sur un terrain inégal et irrégulier. Il lui falloit des obstacles à vaincre; et quand la nature ne lui en offroit pas, il s'en donnoit à lui-même; c'est à dire, que d'un emplacement régulier et d'un terrain plat, il en faisoit un monteux, afin, disoit-il, de varier les objets en les multipliant; et pour se garantir des vues voisines, il leur opposoit des élévations de terre, qui formoient en même tems des belvédères.'[2] Dufresny submitted two different plans for gardens at Versailles to Louis XIV, but these were not accepted.[3]

In 1712, the year of Addison's essay, an advanced French treatise on gardening appeared in an English translation. This was *La Théorie et la pratique du jardinage* (1709), generally attributed to Le Blond but actually by Antoine Joseph Dézallier d'Argenville.[4] Its translator was the architect John James, an early admirer of Inigo Jones, who held office at the time as Assistant Clerk of the Works at Greenwich Hospital. The dedication was addressed to the Honourable James Johnston, who had been King William's Secretary for Scotland and was associated with Addison in politics. Colin Campbell was to single out Johnston's gardens at Twickenham for praise in 1715 as 'extreme curious, the Plantations most

[1] The claim that Dufresny invented the landscape garden before Kent was made by the anonymous translator of Thomas Whately's *Observations on Modern Gardening*, London, 1770, in the *Discours préliminaire* to *L'Art de former les jardins modernes*, Paris, 1771.

[2] Ibid., *Discours préliminaire*, vi, citing an early life of Dufresny. Although Arsène Houssaye had observed in *Galerie du XVIIIᵉ siècle*, Paris (6th ed.), 1858, 11, 4, 'Les jardins anglais nous viennent, non pas des Anglais, mais de Dufresny', his importance has been overlooked by later general historians, although noted by Christopher Tunnard, *Gardens in the Modern Landscape*, 1950 (1st ed., 1938).

[3] Ibid. vii–viii.

[4] The first edition, published in Paris by J. Mariette, simply gave the initials L.S.A.J.D.A. The second was published with the name of Alexandre Le Blond on the title-page. For a full discussion on the authorship see *Journal of the Royal Horticultural Society*, CXXIV. 256.

artfully disposed'.[1] Pope became his neighbour in 1719. These connections are of more than superficial interest. 'The strange fact (overwhelming at a single glance)', writes Gothein, 'is that this movement [towards the landscape garden] occurred in the very heart of English classicism—that the leaders were the very same who upheld and carried out the classical ideals in literature.'[2]

It is possible that the famous passage about a pretty landscape of his own possessions was prompted by the following statement by Dézallier d'Argenville: 'For my own part, I esteem nothing more diverting and agreeable in a Garden than a fine View, and the Prospect of a noble Country. The Pleasure of seeing, for four or five Leagues around, a vast Number of Villages, Rivers, Hills and Meadows, with a thousand other Varieties that make a beautiful landscape, exceeds all that I can possibly say of it.'[3] The novel idea of the English essayist, at least to his fellow countrymen, was the artificial creation of landscape. The ground had been partly prepared in England by Sir William Temple, who in his essay *Upon the Gardens of Epicurus and of the Gardens in the Year 1685*, published in 1695, first introduced into English gardening literature the principle of Sharawadgi, a word which the Chinese were alleged to have used to describe a hidden and irregular beauty in their asymmetrical gardens.[4] The theory of a Chinese origin has tempted many writers, but is misleading.[5] Temple expressly warned the English reader against imitating the Chinese practice. Shaftesbury ignored China altogether. Addison only invokes the country as a sanction, Pope never mentions it in discussing his layout at Twickenham. Walpole, whose opinion on the movement must always be treated with respect, was prompted by

[1] *V.B.* I. 3. For his gardens see Miles Hatfield, 'John James and the Formal Garden', *Conn.*, Jan. 1959.

[2] Marie Louise Gothein, *A History of Garden Art* (1st German ed., Jena, 1914), ed. W. P. Wright, translated by Mrs. Archer-Hind, 2 vols, 1928, II. 279.

[3] Cited from the translation by John James, *The Theory and Practice of Gardening . . . Done from the French Original, printed at Paris, Anno 1709*, 1712, 13.

[4] See Hugh Honour, *Chinoiserie : the Vision of Cathay*, London, 1961, chapter VI, for both a summary of the etymological derivation and the most informed account of the Anglo-Chinese garden.

[5] The case for a Chinese origin is argued in A. O. Lovejoy, 'A Chinese Origin of a Romanticism', *Journal of English and Germanic Philology*, Jan. 1933, 1–20.

reading Spence, who wrote in the heyday of Chinoiserie, to investigate the evidence and decided against the latter's explanation.[1]
The visual imagery of the Chinese garden appears after Kent had
leaped the fence and coincides, as we shall see, with the impact of
the rococo.

On 6 September 1712 Addison followed up his plea for naturalism with an account of his own garden at Bilton.[2] It is humorously
represented as 'a confusion . . . altogether after the Pindaric
manner'. The champion of Milton linked the classical with the
sacred text: 'a garden was the habitation of our first parents before
the fall.' Filling the mind with calmness and tranquillity, it 'gives
us a great insight into the contrivance and wisdom of Providence,
and suggests innumerable subjects for meditation'. The passage is
the classic statement of the associative principle, so important for
the later imitators of Claude. But the garden itself was not Claudian.
Moreover, the description suggests a certain poetic licence, for
Addison specifically mentions his parterre and kitchen garden.[3]

On 29 September 1713, in no. 173 of the *Guardian*, Alexander
Pope, the last of the great literary figures who directed the
theoretical phase of the movement, entered the lists with an
imaginary account of 'my garden' closely modelled on Addison.
His special contribution was to restore the classical ideals of
Shaftesbury by identifying 'the amiable simplicity of unadorned

[1] Isabel Chase, *Horace Walpole: Gardenist*, Princeton, N.J., 1943, 20–1. The title
conceals the fact that this is the *editio princeps* of Walpole's *The History of the Modern
Taste in Gardening*, first printed in the last volume of the *Anecdotes of Painting* in
1771, but withheld from publication until 1780.

Thomas Gray reacted no less strongly against the theory of a Chinese origin in his
letter to William Taylor How, 10 Sept. 1763: 'it is very certain, we copied nothing
from them.' See his *Correspondence*, ed. Paget Toynbee and Leonard Whibley,
1935, II. 814.

[2] *Spectator*, no. 477. For Bilton Hall, where the summer-house is still in position,
see P. Smithers, *Joseph Addison*, Oxford, 1954.

[3] Dorothy Stroud in 'Eighteenth Century Landscape Gardening', *Studies in Architectural History*, ed. W. A. Singleton, York Institute of Architectural Study, 1954,
37, notes that the Kit-Kat Club became the earliest centre of concerted interest in
landscape gardening. Among its members Addison, Vanbrugh, Congreve, Steele,
and the Dukes of Grafton and Newcastle all supported the movement.

At a lower social level some of Addison's ideas were taken up in J. Lawrence,
The Clergyman's Recreation, 1714. See the preface and chapter III especially.

Nature' with 'the taste of the ancients in their gardens', specifically those described by Homer and Vergil, thus concentrating on the strongest of all arguments for the reception of the new taste by the neo-Palladians.

Between this essay and the attempt to put its ideas into practice at Twickenham six years later lies the poet's decisive association with professional artists and gardeners. In 1713, the year of its publication, he reported that he was daily taking lessons in painting from Charles Jervas.[1] He met Charles Bridgeman, who, like Kent later, became a lifelong friend. Last but not least, he was the hero of a group of great landowners who were gardening enthusiasts. Pope was the hub of this circle, and his letters show that he was eager to teach and ready to learn at the same time.

These connections are important because patrons and their professional advisers were moving in the same direction as the men of letters, but along a different path, the exploitation of a baroque inheritance. Leonard Knyff or Leindert Kniff (1650–1721), a topographical draughtsman influenced by Philips Koninck and the 'platts' of military engineers, has left in the plates for Johannes Kip's *Britannia Illustrata* (published in parts from 1707 to 1726) bird's-eye depiction of gentlemen's seats, in which the state of English gardening in the first decades of the century is comprehensively recorded.[2] The old 'heroic' school of London and Wise is in undisputed ascendancy. Many of the seats command extensive views of the adjacent 'forest' and farmland, but he nowhere illustrates the crucial conversion of 'prospect' into 'landscape'.[3] In short, Knyff depicts the *status quo*. The dawn of change appears in the grandiose double-plates of the third or 'garden' volume of Colin Campbell's *Vitruvius Britannicus*, illustrating the works of Sir John Vanbrugh. Vanbrugh was 'an Architect who composed like a Painter'[4] and sometimes submitted pictures of garden

[1] Letter to Sir William Trumbull, 30 Apr. 1713, in Pope's *Works*, ed. W. Elwin and W. J. Courthope, VI (1871), 7.

[2] Hugh Honour, 'Leonard Knyff', *Burl. Mag.*, Nov. 1954.

[3] Cf. *The Works of William Shenstone*, 1764, II. 129: 'Landskip should contain variety enough to form a picture upon canvas.'

[4] Sir Joshua Reynolds, *Discourses on Art*, ed. Robert R. Wark, Huntington Library, San Marino, Calif., 1959, 244.

projects instead of plans. On a memorable occasion he tried to preserve the old manor of Woodstock at Blenheim because it would make 'One of the most agreeable objects that the best of Landskip Painters can invent'.[1] In 1715 he was appointed first Surveyor of Gardens and Waterworks belonging to the Royal Palaces, a post created in emulation of Le Nôtre's at Versailles.

Unfortunately, there is no clear guide through the maze of Vanbrugh's relations with the professional gardeners who worked with him: London and probably Switzer at Castle Howard (begun 1699); Wise, Switzer, and Bridgeman at Blenheim (begun 1705); Bridgeman at Stowe.[2] The historian is therefore forced to fall back on the compulsive evidence of Vanbrugh's pictorial imagination at work in the extrovert handling of these ambitious designs. No one could possibly mistake the gardens of Castle Howard or Blenheim, even in their original and stricter formality, for the work of his contemporaries in France or his predecessors in England. At Blenheim the great avenue advanced like a Roman Road across the immense park. Le Nôtre was a master of the railroad vista stretching into infinity, but never isolated a gigantic formal element in the open 'forest'.[3] The grand design of Castle Howard from the north shows a series of projecting platforms arranged along the perimeter of the formal garden, each commanding the rolling countryside like a bastion.[4] A bird's-eye perspective of the gardens at Stowe c. 1720–5 [plate 12A] is similarly extrovert and even more marked in its centrifugal emphasis at the boundary.[5] The boldly projecting Rotunda both closes internal vistas and commands external ones. Nelson's seat,

[1] *The Complete Works of Sir John Vanbrugh*, IV (ed. Geoffrey Webb), 1928, 30.

[2] For Vanbrugh's associates see Laurence Whistler, *The Imagination of Vanbrugh and His Fellow-Artists*, 1954, and David Green, *Blenheim Palace*, 1951, and *Gardener to Queen Anne* (H. Wise), Oxford, 1956.

Christopher Hussey, *English Gardens and Landscapes 1700–1750*, London: Country Life, 1967, a monograph which valuably supplements earlier histories of the landscape garden, has discussed the associates in detailed relation to the theoretical literature.

[3] See Jules Guiffrey, *Le Nôtre*, 1912, and for the extension of the royal avenue at Versailles J. Fennebresque, *Versailles royal*, 1910, 8–9.

[4] *V.B.* III, plates 5–6.

[5] Cf. Michael Mounsey, 'Two Hundred Years of a Noble Avenue', *C.L.*, 29 Dec., 1960.

named after an obscure Cobham connection, looks beyond a peripheral obelisk to the smaller park. There is also a preference for the oblique viewpoint, culminating in the vast design for the outer park. One is here reminded of Wren's plan for the City of London with its baroque garden elements of star and *rond-point*.[1] In one notable case Vanbrugh's handling of a garden project is uncomplicated by the problem of collaboration. His Belvedere Temple at Castle Howard (begun 1725) is seldom cited as a successful adaptation of Palladio's Villa Rotunda, but it is in fact the only English version to preserve the three-dimensional power of the original with its four temple-front porticoes; for the temple, like the villa, stands on a hilltop open to the four winds. The architect aligned it frontally to the garden door of the distant saloon and preserved the winding route of an old lane in a walk from the mansion. Vanbrugh worked on a heroic scale. By contrast, Addison and Pope were miniaturists.

Of his two principal associates Switzer and Bridgeman, the former is easier to assess because he published his views in a treatise on gardening, *Ichnographia Rustica*, in 1718.[2] In his preface he upholds 'La Grand Manier' but patriotically cites Castle Howard as the perfect example of 'Natural and Polite Gardening'. He goes on to eulogize what he calls 'Forest, or in a more easie Stile, *Rural Gard'ning*'. He denounces 'Interlacings of Box-work, and such like trifling Ornaments', and pleads that 'our whole country might have been at this time as one great Garden' under a proper system of 'improvement'. *Simplex munditiis* and *utile dulci* are the appropriate Latin tags for this type of garden. 'Two, Three or Four Hundred Pounds *Per Annum* will do great things in Small Undertakings; and Six, Seven or Eight Hundred wil be sufficient in the greatest of all.'[3] Switzer is not yet prepared to take up an uncompromising position, although his sympathies are progressive, and he prepares the way for the later categorization of gardens. His most advanced proposal is a new principle, the '*Natura-*

[1] Reproduced in Viktor Fürst, *The Architecture of Sir Christopher Wren*, 1956, 6–7.
[2] 3 vols., 1718. It was an enlargement of the *Nobleman, Gentleman and Gardener's Recreation*, 1715.
[3] Ibid., Preface, xxxii.

Linear', which marks for the first time in theory if not in practice the impact of the rococo on the landscape movement.

Switzer's context is 'Natural and Rural Gard'ning', where Nature is 'by a kind of fortuitous Conduct pursued through all her most intricate Mazes, and taught even to exceed herself in the *Natura-Linear*'.[1] What Switzer meant by this term may be ascertained from Batty Langley's *Practical Geometry* (1726), where the 'arti-natural' line is not only recommended 'in designing gardens after the rural manner', but fortunately illustrated.[2] The line turns out to be a well-known motive of rococo arabesque, transferred from the parterre to the garden walk. Langley describes it as 'not entirely new' in 1726; and it can be traced back at least as far as the aerial perspective of the Vanbrugh–Bridgeman gardens at Stowe [plate 12A]. But it is unlikely that Switzer would have advocated the line in 1718 if it had not been in use earlier. The serpentine line is as important as the ha-ha in the evolution of the landscape garden, and derives from two sources: the rococo motive just described, and the naturalistic winding walk, of which Wise's plan for Blenheim preserves an early professional example of about 1705.

There is a vital distinction between the original French *ah, ah* and its revolutionary English development. The French form was taken from the science of fortification and designed as a strictly regular gap or gateway in the garden boundary: 'At present we frequently make *Through Views* call'd Ah, Ah, which are openings in the walls without Grills, to the very Level of the Walks, with a large and Deep Ditch at the Foot of them, lined on both sides to sustain the Earth, and prevent the getting over, which surprises the Eye upon coming near it, and make one cry Ah! Ah!, from whence it takes its name.'[3] The English ha-ha was a continuous invisible ditch, aptly described by Walpole as a sunk fence. It did more than open up the view at a particular point; it obliterated the entire boundary between park and garden.

[1] Ibid. I. 87. [2] Plate XIII, fig. XXV, and text, 101–2.

[3] John James's translation of Dézallier d'Argenville, *The Theory and Practice of Gardening*, 1712, 77. Cf. also another passage in *La Théorie et la pratique du jardinage*, 1709, Première Partie, ch. III, 27: 'Le but de ce terrasse est terminé par une claire-voie qu'on appelle autrement un *ah, ah*, avec un fossé sec au pied.'

Even so, the device would have been ineffective without the serpentine line acting as a principle of formal unification on both its sides. Once they were combined, the garden became an integral part of the landscape composition, with its planned foreground merging into the distant prospect.

Charles Bridgeman, who employed both devices, but not in conjunction, is the key professional figure between Vanbrugh and Kent. Walpole discerned in his work 'the dawn of modern taste' and described the 'great lines' of his straight walks as diversified asymmetrically on either side of the park by wilderness.[1] He does not allow for the influence of Vanbrugh, against whom he was strongly prejudiced. He also dismissed the claims of Pope's friend Earl Bathurst.[2] Oakley Great Park, Cirencester, laid out by Bathurst from 1716, went further than any previous plan in its insertion of a Le Nôtre-type skeleton in a great and irregular 'forest'.[3] In 1719 Bridgeman was in consultation with Pope about the Prince of Wales's garden at Richmond Lodge, where, in accordance with Addison's precept, 'he dared to introduce cultivated fields, and even morsels of a forest appearance'.[4] Walpole's use of the word 'morsels' is revealing, because he too was a miniaturist.

In the same year Pope bought a house and five acres at Twickenham and almost immediately began to put into practice the ideas he had so long been discussing with his friends. At first sight the engraved *Plan of Mr. Pope's Garden as it was left at his Death*, that is 1744, by his gardener John Searle, is somewhat disappointing [plate 12B]. The scheme with its long central axis is regular enough, and there is little to suggest Claude, still less Salvator

[1] *On Modern Gardening*, in the edition of Isabel Chase, *Horace Walpole: Gardenist*, 1943, 24, henceforth cited as Chase.

[2] F. W. Hilles and P. B. Daghlian (ed.), *Anecdotes of Painting in England*, Volume the fifth and last, New Haven, Conn., 1937, 159. This contains the material collected by Walpole for a supplementary volume, but left incomplete at his death. The tribute to Bathurst in *A. of P.*, ed. Dallaway and Wornum, III. 86, was a footnote by James Dallaway to the essay and has been wrongly attributed to Walpole.

[3] Justice has been done to Bathurst as a pioneer by James Lees-Milne in *Earls of Creation*, 1962, chapter I, 'Allen Bathurst, 1st Earl Bathurst', with a plan and illustrations of the park. See also the chapter on Cirencester Park in Hussey, op. cit.

[4] Chase, op. cit. 24.

Rosa. Such virtues as appear seem largely negative. There is no parterre, no topiary work, nor does one half of the garden exactly reflect the other. But Walpole's description pays tribute to an unmistakably pictorial charm: 'The passing through the gloom from the grotto to the opening day, the retiring and again assembling shades, the dusky groves, the larger lawn and the solemnity of the termination at the cypresses that lead up to his mother's tomb, are managed with exquisite judgement.'[1]

Axial symmetry is not a formula of Italian landscape painting. But Pope uses one important device to counteract symmetry. This is the oblique viewpoint. In reading Searle's plan it is important to reconstruct the way Pope showed his garden to his friends. The main approach from the house was by the diagonal grotto path under the road. Its conclusion was blocked by regular plantations of trees. Access to the avenue itself was thus confined to the sides. Add to this a slight but definite twist in the vista itself, together with the winding walks in the flanking groves, and the total effect must have been more picturesquely irregular than the plan suggests at first glance. Finally, the tomb of his mother introduced the elegiac note: *Et in Arcadia ego.*

For all its tentative character, Twickenham was in one respect highly original. Absurd as it may sound to the classical scholar today, Pope was trying to reconstruct the Homeric garden according to his own interpretation published in 1713.[2] The Garden of Alcinous covered four acres; Horace Walpole described Twickenham as 'a spot of five acres'. Homer's trees were 'standard, and suffered to grow to their full height'; Pope accordingly banished 'the various tonsure' from his foliage. In place of 'the bed of greens mentioned . . . at the extremity of the enclosure of Alcinous', the poet planted a kitchen garden and, in keeping with his authorities but in defiance of the English climate, a considerable vineyard. Fortunately, he now had the means to indulge a taste for that most expensive of eighteenth-century luxuries, the simplicity of the ancients.

[1] Ibid. 28, 29. The fullest account of the garden is Hussey, op. cit., chapter V, 'The Poet and the Painter'.

[2] *Guardian*, no. 173, 29 Sept. 1713.

At this stage of crucial innovation, Walpole informs us, 'appeared Kent, painter enough to taste the charms of landscape, bold and opinionative enough to dare and to dictate, and born with a genius to strike out a great system from the twilight of imperfect essays'.[1] William Kent, 'the father of modern gardening', who 'invented an art that realizes painting and improves nature', was put in charge of the interiors at Chiswick in or shortly after 1726, when a dated drawing shows that their decoration was being considered.[2] In 1728 appeared Richard Castell's *Villas of the Ancients*, with a dedication to Burlington, who liberally assisted its publication. It is a document of the first importance as representing ideas current in the Burlington circle during the formative years of the casino garden. The reconstructed plan of Pliny's garden at Laurentinum, with its scattered pavilions and summer-houses, *rond-points* and winding walks, combines formality in the vicinity of the villa with landscape planning in the outskirts, where the eye is first 'surprised with an imitation of the negligent beauties of rural nature'.[3] This is precisely the formula of the gardens at Chiswick, which thus belong to the same category of classical reconstruction as the villa itself or the Assembly Rooms at York later, to say nothing of Pope's experiment at Twickenham.

As with the villa, the lack of archaeological evidence was supplied by post-Renaissance models. Many writers have commented on the Italianate character of the formal setting, which included in the main exedra antique statues of Caesar, Pompey, and Cicero, brought from Hadrian's villa at Tivoli [plate 15A].[4] The treasures from Hadrian's villa must have reinforced the notion of authenticity. But the closest parallels are with existing gardens designed for the display of classical ornaments and statues. Without suggesting that Burlington–Kent had a particular model in mind, certain resemblances to the gardens of the Villa Mattei may be noted: the circus-shaped *prato*, the obelisk, and the straight vistas leading to

[1] Chase, op. cit. 25.

[2] R. Wittkower, 'Lord Burlington and William Kent', *Archaeological Journal*, CII, 1946, and Hussey, *E.G.*, 20.

[3] Pliny, *Letters*, tr. W. Melmoth, The Loeb Classical Library, 1915, I. 391.

[4] R. Phéné Spiers, 'Chiswick House', in *Memorials of Old Middlesex*, ed. J. Tavernor-Perry, 1909, 181, and O. Siren, *China and the Gardens of Europe*, New York, 1950, 24–5.

architectural conclusions, the Inigo Jones gateway placed laterally (in 1737) to the casino, like the *Arca de Tritone* to the Roman villa.[1]

Kent's sketches of the gardens and settings for ornamental buildings are at this stage close to the stylistic conventions of Italian garden picture-books, published under the title of *Fontane*. G. J. Rossi's *Nuova racolta di fontane di Roma, Tivoli e Frascati* (1618) or G. B. Falda's *Le fontane di Roma* (1667), to name only two, must have been delightful souvenirs of a Grand Tour which from Addison onwards highlighted excursions to gardens, and it would have been quite natural for the painter to consult them as an *aide-mémoire*. The similarity of Kent's grotto at Chiswick with its tripartite division, tiered cascades, and heavy framework of wild boscage to Rossi's plate of the *Fontana nel Giardino di Belvedere* in Frascati may be due to a direct borrowing or to recollection or a sketch of the original or one like it.[2] An attachment to the stage effects of Mannerist and baroque garden architecture persists throughout his career. Venus's Vale at Rousham recalls the upper cascade at the Villa Aldobrandini at Frascati, just as the Cold Bath evokes the *fontana nel bosco* at the Villa Lante at Bagnaia. At Stowe the Temple of British Worthies and the Temple of Venus, for all the difference of style, develop the motives of the curved theatre and *teatro d'acqua*, of which he could have seen examples at the Villa Mondragone and the Villa Piccolomini Lancelloti at Frascati, the Boboli Gardens at Florence, and the Villa Doria-Pamphili at Rome. The eye-catcher can similarly be traced back to the device, so popular in the Venetian hinterland, of closing an architectural vista with a two-dimensional screen.

At Chiswick Kent hung his first landscape compositions, so to speak, outside the formal garden. His next step was to unify the two by the serpentine line. 'His ruling principle', writes Walpole, 'was, that *nature abhors a straight line*.'[3] Fortunately this step can be dated fairly precisely. In 1732 the Prince of Wales bought

[1] The plan of the Villa Mattei is reproduced in Luigi Dami, *Il giardino italiano*, 1924, plate CVII.

[2] G. J. Rossi, *Nuova racolta di fontane nel alma città di Roma, Tivoli, Frascati*, 1618, plate 17.

[3] Chase, op. cit. 30.

Carlton House and commissioned Kent to design the gardens.[1]
Even if Henry Pelham had called him in at Esher Park a year or
two earlier, it was the gardens at Carlton House that established
his reputation.[2] In 1734 Sir Thomas Robinson wrote to Lord
Carlisle: 'There is a new taste in gardening just arisen, which has
been practised with so great success at the Prince's garden in
Town, that a general alteration of some of the most considerable
gardens in the Kingdom is begun, after Mr. Kent's notion of
gardening, viz. to lay them out, and work without level or line.'[3]
Robinson added that 'the celebrated gardens of Claremont,
Chiswick and Stowe are now full of labourers, to modernise the
expensive works finished in them, ever since everyone's memory'.
Between 1732 and 1740 the following had joined the company
of Kent's clients: Lord Townshend at Raynham, Thomas Coke
at Holkham, Lord Cobham at Stowe, the Duke of Grafton at
Euston, the Duke of Bedford at Woburn, Colonel Tyrrell at
Shotover Park, and General Dormer at Rousham. The Kentian
Revolution was thus the achievement of the decade 1730–40.

The basis of the revolution's success was the substitution of
seventeenth-century Italian landscape painting for literary authori-
ties as the inspiration of design. Neither Addison nor Pope mentions
Claude or specific painters in their essays on gardening. It is known
that Kent possessed paintings by Gaspard Poussin and Salvator
Rosa.[4] Horace Walpole borrowed the language of the painter and
not the villa enthusiasts of antiquity to define his method: 'The
great principles on which he worked were perspective, and light

[1] Carlton House was bought by the Prince of Wales in 1732 from the Dowager
Countess of Burlington, Lord Chesterfield acting as negotiator. See the note in
J. Wilson Croker's edition of Lord Hervey's *Memoirs of the Reign of George the Second,*
1884, III. 266.

[2] Cf. John Harris, 'A William Kent Discovery: designs for Esher Place, Surrey',
C.L., 14 May 1959. H. F. Clark, *The English Landscape Garden,* 1948, 15, gives *c.* 1729
as the starting date of Esher.

Hussey, op. cit. 46, dates the evolution of Kent's landscape style to 1729–32 on the
basis of firmly dated architectural commissions. This seems sound, in view of Kent's
itch to have a hand in improvements of any kind.

[3] Cited by M. Jourdain, *The Work of William Kent,* 57, from *Hist. MSS. Comm.
15th Report,* 1897, Appendix part VI.

[4] M. Jourdain, op. cit. 76.

and shade.'[1] But Kent's gardens only reveal the true seventeenth-century majesty of scale when he was working on a baroque inheritance. Walpole sharply criticized his clumps as 'puny'. And there is indeed a play between large and small in his garden landscapes. The general effect of his designs may be described as a Claudian setting not for majestic architecture but architectural ornaments.

In assuming the leadership Kent did more than finalize the experiments of Addison and Pope; he evolved a formula which bridged the gap between the miniaturists and the associates of Vanbrugh, and was wholly acceptable to the Burlington circle, thus making possible 'the period's greatest contribution to the visual arts—the synthesis of classical mansion and park landscape'.[2] Palladio had not published garden designs, but his references were wholly compatible with the values of Pliny and the English theorists. He stressed the advantages of prospect, and singled out the Villa Rotunda by virtue of its 'most beautiful views, some of which are limited, some more extended, and others that terminate with the horizon'.[3] The gentleman repairs to his country villa for the dual purpose of improving his estate 'by industry and the art of agriculture' and of comforting his mind 'fatigued by the agitation of the city' with the study of letters and contemplation.[4] Palladio did not recommend anything so proto-romantic as landscape design, although he showed himself a master of siting in practice and must be given the main credit for spatially integrating the country house by the device of curved wings with the formal garden opening into the landscape foreground.[5] Fortunately, the neo-Palladians had already admitted the principle of contrast between the classical plainness of the exterior and the semi-baroque richness of the interior. There remained the need for a unifying agency to combine interior, exterior, and picturesque landscape. This overriding agency was provided by classical association.

[1] Chase, op. cit. 26. [2] C. Hussey, E.G. 10.
[3] The Four Books of Andrea Palladio, translated by Isaac Ware, 1738, bk. II, chapter III.
[4] Ibid., ch. XII.
[5] Cf. the analysis of Palladio's villas in Sir Nikolaus Pevsner's Outline of European Architecture (1st ed., 1943): 'here for the first time in Western architecture landscape and building were conceived as belonging to each other, as dependent on each other.'

As H. F. Clark, to whose analysis the student constantly returns, points out, the English landscape garden was in its first phase a garden of association, an eighteenth-century Elysium.[1]

At Stowe Vanbrugh, Bridgeman, Gibbs, Kent, and 'Capability' Brown were successively employed, so that a single garden resumes the history of the English movement.[2] To the Continental observer Stowe was both the English Versailles and 'un modèle parfait de ce qu'on appelle un jardin Anglais'.[3] Among the many foreign visitors who made the pilgrimage to Buckinghamshire was Rousseau, whose compliment in *Julie, ou la nouvelle Héloïse* (1759) is a left-handed one, for he contrasts its profusion of ornaments with the simplicity of his imagined Elysée of Julie, without man-made structures.[4] In sarcastically drawing attention to 'l'assemblage' he hit upon its distinctive feature. The iconographic programme of the gardens at Stowe is incomparable. The term 'programme' implies a consistent policy, in this case the combining of three streams of association: Classical Antiquity, the Middle Ages, and British History. The garden buildings are grouped in three main areas: the first is the domain of Vanbrugh and is illustrated in the Vanbrugh–Bridgeman plan of the early 1720s [Plate 12A]; the open acres to the east of the Elysian valley belong mainly to Gibbs; while the Elysian Fields themselves are the creation of Kent [plate 12C].[5] The three streams can all be

[1] This is the main point stressed by H. F. Clark, 'Eighteenth Century Elysiums: The Role of "Association" in the Landscape Movement', in *England and the Mediterranean Tradition*, edited by the Warburg and Courtauld Institutes, 1945.

[2] For the gardens at Stowe see Laurence Whistler, 'The Authorship of the Stowe Temples', *The Stoic*, vol. XIV, no. 4, Dec. 1950, reprinted with slight additions from *C.L.*, 29 Sept. 1950; his *Guide to Stowe Garden* (1st ed., 1956); and the account in N. Pevsner, B.E. *Buckinghamshire*, 1960.

[3] See the 'Description détaillée des jardins de Stowe, par le traducteur', in *L'Art de former les jardins modernes*, translated from Thomas Whately, Paris, 1771, 348–404. This is by far the best contemporary account of Stowe, for the author not only incorporated all the material in the English guides but had a gift for observation and spirited comment.

The chapter on Stowe in Hussey, *English Gardens and Landscapes*, draws richly on its historical associations.

[4] *Julie ou la nouvelle Héloïse*, 1759, part IV, letter XI. Cited by Fiske Kimball, 'Romantic Classicism in Architecture', *Gazette des Beaux-Arts*, XXV, 1944, 102.

[5] Laurence Whistler, *The Stoic*, Dec. 1950, 181.

traced back to Vanbrugh. The Rotunda or Temple of the Winds, Dido's Cave, and the Temple of Bacchus were his; so, too, the original Park Keeper's Lodge in the miniature form of a medieval dungeon and possibly the Witch's House as well. Nelson's seat announced by tactful quotation the British imperial theme that distinguishes Stowe from all the other contemporary gardens of association. The lines, taken from the Arch of Constantine, commemorated an empire extending beyond the Euphrates and the Tigris to the Pacific Ocean.[1] The Restoration dramatist also introduced the erotic jest, shortly taken up so enthusiastically by the age of the rococo. Aeneas and Dido were depicted in the latter's cave, with the laconic but suggestive line of Vergil: 'Speluncam Dido dux et Trojanus eandem deveniunt.' Outside the Temple of Sleep, or sleeping parlour, the visitor was playfully admonished, 'Cum omnia sint in incerto, fave tibi.'

Both Gibbs and Kent were set to memorialize the patriotic theme alluded to by the Constantinian inscription. The former designed the Temple of Friendship in honour of the 'Boy Patriots', Cobham's circle of distinguished Whigs who met in it to extol 'English Liberty'; the triangular Gothic fane, significantly called 'the Temple of Liberty'; and the Cobham monument. On this sound basis of family pride in national service was built up a characteristically Whig interpretation of British history. Great Britain, in Slaughter's painted allegory inside the Temple of Friendship, proclaimed her anti-Jacobitism by rejecting the emblems of James II in disdain. The first two Hanoverian monarchs were commemorated in the Elysium, but the Tory George III later excluded. Kent's Temple of British Worthies [plate 13A] marks the climax of the patriotic theme, for it is a Whig Pantheon with its appropriate canonizations retrospectively ratified by 'the Congress at Stowe'.[2] The portrait gallery, of which the Illustrious Men of the Lake at San Vigelio on Lake Garda preserves so beautiful an example, had sometimes been displayed in a garden

[1] It commenced 'Ultra Euphratem et Tigrim usque ad Oceanum propagatâ ditione' and concluded 'comitantibus Pietate et Abundantiâ In arcu Constantini'.

[2] The phrase was coined by Pitt. See *Hist. MSS. Comm., Report on the Manuscripts of Earl Bathurst*, 1923, 48, William Pitt to Earl Bathurst, 1 July 1805.

theatre, but I know of no precedent for a miniature but comprehensive national portrait gallery set in the open. Alfred the Great heads the list as the semi-historical Jupiter of Whig mythology. Alfred was both king and scholar, and thereafter the selection follows the Renaissance division between the active and the contemplative life, with Shakespeare, Milton, and Newton inevitable choices amongst the latter. Kent and the sculptor Rysbrack were here following the cult of British Worthies, of which Vertue gives so many examples. Although Gothic had already been associated by Gibb's Temple with Magna Carta rather than monasticism, the architectural setting here preferred clearly associated the national heroes with the Roman past.

In the same sense of a parallelism between the old Roman law and the new British dispensation the Temple of Concord and Victory extols the great aim of Whig foreign policy, imperial expansion at the expense of France, in a building borrowed from Rome [plate 13B]. Scheemaker's pedimental sculpture shows the Four Quarters of the Globe bringing their fruits to Great Britain. Inside, the bas-relief medallions represent a selection from the famous battles of British history: without exception these are victories against the French.[1] It is scarcely surprising that a French visitor of liberal opinions should regard these scenes as 'honteux pour l'humanité' by perpetuating 'les haines nationales'.[1] The same writer, like Voltaire before him, was more sympathetic to the Whig struggle for political liberty, which Stowe so richly commemorates. On the whole he thought the gardens a delicious spectacle for those who loved humanity and were sensible of 'la gloire', and ranked them on these grounds as highly as 'le temple auguste de Westminster'.[2]

The comparison with the national Valhalla was not inappropriate. Stowe reveals even more forcibly than the eighteenth-century monuments in Westminster Abbey that the self-conscious identification of the great landowners with the classical past, already repeatedly stressed, had political undertones. The national

[1] 'Description détaillée des jardins de Stowe' in L'Art de former les jardins modernes, 1771, 376.

[2] Ibid. 386.

images and inscriptions were meant to be read in the context of
Greece and Rome; the Temple of Ancient Virtue with its statues 'un
peu gigantesques' of Homer, Lycurgus, Socrates, and Epaminondas,
prepared the way for the Temple of British Worthies.

A surprising number of the grander images from Gray's *Elegy*
can be matched in Lord Cobham's seat; surprising, that is, until
we recall that the poem might never have been written but for
its author's friendship with the Dowager Lady Cobham. 'When
Lady Cobham resided at her house at Stoke, Mr. Gray was at no
great distance in the same parish.'[1] On his return from Stoke
House, which he constantly visited, the poet was obliged 'to pass
by the churchyard, which was almost close to the house, and he
would sometimes deviate into it, and there spent a melancholy
moment'.[2] There must have been a frequent exchange of news
with Stowe, and the gardens were a topic likely to interest Gray
keenly. Like Cowper, he often had a private audience in mind as
well as the world outside, and during the formative years of the
Elegy his most immediate social contacts were with 'Lady Cobham
and her friends'. Moreover, the *Elegy* is sometimes interpreted as
an early document of radicalism, and Gray himself refers to the
fact that the Dowager Lady Cobham was sometimes criticized
for her democratic friendliness.[3]

The same spirit of Whig liberalism breathes over garden and
poem. The Temple of British Worthies [plate 13A] places on
opposite sides Hampden and Milton, and the name of Milton
follows that of Hampden in the *Elegy*, which likewise observes
the classic distinction between the man of action and the thinker.
The Protector who had overthrown absolutism was omitted
from the Stowe Pantheon. The poem supplies the reason: 'Some
Cromwell, guiltless of his country's blood'. As is well known, the

[1] Jacob Bryant's 'Recollections of Gray' published in the *Life* by the Revd. J.
Mitford, *The Poetical Works of Thomas Gray*, the Eton edition, 1863, 94.

[2] Ibid. 95.

[3] In *A Long Story*:

> Decorum's turned to mere civility;
> Her air and all her manners show it.
> Commend me to her affability!
> Speak to a commoner and poet!

church at Stoke Poges is conspicuously lacking in impressive monuments. In the temples and gardens at Stowe the illustrious dead were conjured up at every turn, and the manorial church was enclosed by the gardens in a position of singular privacy.

Gray's central antithesis between the mausolea and memorials of the great and the graves of the poor in a humble country churchyard receives from the formal monuments at Stowe the weight on the side of 'Grandeur' and 'Ambition' that is absent from Stoke Poges. When the poet writes 'th' applause of listening senates to command', he conjures up the scene of the Roman legislature besides that of the British Parliament. The lines,

> To scatter plenty o'er a smiling land
> And read their hist'ry in a nation's eyes,

might have been read by the Temples, Grenvilles, and Lytteltons as applicable to their own mission and circumstance. To the world at large the contrast of the poem is between the parish church of a small village, albeit attached to a manor, and the pompous splendour of aristocratic sepulchral monuments, as grandly erected in nobleman's chapel or church on his estate as in Westminster Abbey; between the procession of villagers through the churchyard and those magnificent obsequies where the music of praise swelled through 'the long-drawn aisle and fretted vault'. The poet drew deeply on his personal experience, on memories of King's College Chapel, Cambridge, as well as Stoke Poges. But the gardens at Stowe are also elegiac, and nowhere else had a great family identified itself so proudly with the vanished glories of the past. To visit Stowe after Stoke Poges is to prepare the mind for a heightened reception of the poem's meaning by freshly stocking it with vivid impressions of the images and associations that Gray intended to evoke.

The historical position of Stowe is unique, and so is the richness of minds that wove its pattern. The genius of Kent is best studied at Rousham, for here he had the entire gardens at his disposal. Like Burlington, General Dormer wanted a garden which was also an open-air theatre for the display of sculpture, his collection finally including copies of the Venus de Medici, the Barberini

Faun, a somewhat free version of Giovanni da Bologna's Mercury, the Capitoline dying Gaul, and an impressive Colossus.[1] Pride of place on the terrace was given to a replica of the Capitoline Horse and Lion, the original of which later fired the imagination of Stubbs to paint his famous series. The seven-arched portico or Praeneste [plate 11B] overlooking the river is one of Kent's happiest conceptions, while 'the whole is as elegant and antique as if the Emperor Julian had selected the most pleasing solitude about Daphne to enjoy a philosophic retirement.'[2] But the Emperor would have been mystified by the Gothic Temple of the Mill, which anticipates Queen Marie Antoinette's Watermill Hamlet in Le Petit Trianon, and the eye-catcher or sham ruin on the crest of the hill.

In 1747 Joseph Spence published in *Polymetis* the only systematic attempt to provide an iconographic programme for the landscape garden.[3] In his ideal scheme he lists six main repositories for sculpture: a Rotunda for the celestial deities; a colonnade outside for 'milder deities relating to the human mind and civil life', Fidelity, Concord, etc.; down the hill from this, a Temple of the Sun and Stars, in which the Celestial Bodies, Times, and Seasons could be depicted; an octagon Temple of the Winds; two temples below, for the deities of the Waters and Earth respectively, and finally a Temple of Infernal Beings, with the Vices on the outer colonnade. The garden that most closely corresponds with this scheme, providing for most of the ancient gods who govern the forces of nature or preside over the affairs of men, is Stourhead in Wiltshire, where Henry Hoare, a wealthy banker with a cultivated taste for antiquity, had begun the conversion of grounds outside the formal garden shortly before *Polymetis* was published.[4]

[1] See the chapter on Rousham in Hussey, *English Gardens and Landscapes*, and his earlier studies in *E.G.* 155–60 and 'A Georgian Arcady' in *C.L.*, 14 June 1946.

[2] Chase, op. cit. 29.

[3] Spence prefaces his programme with an imaginary conversation in the library of a villa, a device borrowed from Shaftesbury.

For Spence's relations with Pope see the introduction by John Underhill to *Spence's Anecdotes, Observations and Characters of Books and Men*, London: Walter Scott [n.d.].

[4] Kenneth Woodbridge in 'Henry Hoare's Paradise', *Art Bulletin*, Mar. 1965, has written the classic account of an English landscape garden. His central theme is its Vergilian conception, but he has documented many new findings, notably the

A Pantheon [plate 15B], a Temple of the Sun, a Temple of Flora, and a grotto for the water-deities provided between them symbolic offices for the dual superintendence of the gods over human activity and natural forces. A lover of Vergil and Vergilian landscape as interpreted by Claude, he was not averse to unclassical associations, and a Druid's cell, a Turkish tent, a Chinese bridge, alcove, and parasol, and 'Chinese' mountains were added to introduce other remoteness of time and place. A vista is opened at one corner of the garden to take in a real Gothic church.

To carry out his intentions he employed Henry Flitcroft, the Burlingtonian architect, so that the gardens provide yet another example of collaboration between amateur and professional. With a fine sense of drama and elemental mystery, John Cheere's most baroque masterpiece, the River God, was sited to give an almost frightening shock at a turn of the tunnel leading down into the central chamber of the lakeside grotto [plate 14B]. Here, lit by a single shaft of light reflected from the water's surface, an idea was borrowed from Pope to sound the most moving note in the history of the landscape garden. Pope had translated certain Latin verses for a statue which he wished to secure for his own grotto at Twickenham but could not afford. Hoare had both the money and the imagination to realize the poet's intention. He placed the copy of the Sleeping Ariadne in the Vatican well back in a niche against the cavern wall from which drips one of the many hillside sources of the Stourhead lake [plate 14A]. The white marble dimly catches the light that falls directly on these lines inscribed on the floor:

> Nymph of the Grot, these sacred springs I keep
> And to the murmur of these waters sleep;
> Ah, spare my slumbers, gently tread the cave,
> And drink in silence, or in silence lave.[1]

amateur–professional partnership of Hoare and Henry Flitcroft. Its starting-point as a lake-landscape may, as Georgina Masson has suggested, derive from Pliny's *Letters*, bk. 8, viii. See Hussey, *English Gardens and Landscapes*, 159 and also K. Woodbridge, 'The Sacred Landscape: Painters and the Lake-Garden of Stourhead', *Apollo*, Sept. 1968.

[1] For the classical source see Otto Kurz, 'Huius Nympha loci', *J.W.C.I.* XXI, 1953, 171.

The grotto is a fake grotto; the statue is a copy of a Hellenistic derivation; the poet's verses are only a translation. It is difficult to imagine a party of eighteenth-century guests drinking in silence. But the spirit of poetry obeys mysterious laws, and may invade a world even as artificial as this.

The plan of the lake resembles in shape the outline of a well-known type of rococo girandole mirror [plate 12D]. The serpentine line runs everywhere, along path and water's edge. Every vista, from temple to bridge, from bridge to grotto, is taken at an angle. Watteau could have painted another *Embarcation from Cythera* on the slope before the Temple of the Sun. Whereas Stowe has the breadth of at least a fragment of the Roman campagna, Stourhead is Vergilian landscape on a miniature scale; it is rococo Claudian.

Stourhead realizes the neo-Palladian dream of Arcadia in its purest form, but lacks a Palladian bridge to complete its mimetic repertory. The motive of a colonnade above an arch had not been restricted by antiquity to the bridge. It occurs notably in the façade of the Emperor Diocletian's palace at Spalato, the identical context to which Sir William Chambers later restored it at Somerset House.[1] Palladio's design of his own invention (book III, chapter XIII) was on a colossal scale, and carried three streets, with shops on each of the sides. His elevation followed the formula of a palatial façade: a temple-front centre-piece linked by colonnaded wings to end pavilions. This palace-front formula was to inspire one of the most grandiloquent of Piranesi's imaginary Roman views and later still to be reduced by Robert Adam into the toy-like elegance of Pulteney bridge at Bath.

Essential to any variation on the Palladian palace bridge is the pedimented central piece. The Palladian bridge erected by Roger Morris for the Earl of Pembroke in Wilton omits this crucial feature [plate 17A].[2] Pevsner has noted that the design is taken

[1] G. Niemann, *Der Palast Diocletians in Spalatro*, Vienna, 1910, plate XVII.

[2] See chapter VI, 'Palladian Bridges', in Hussey, *English Gardens and Landscapes*. The evidence of Vertue (V. 130) that the Earl of Pembroke designed the bridge is not to be taken lightly, for he was recording the information he got at Wilton. Nevertheless, the bridge is signed by Roger Morris, see M. Whinney in *Archaeological Jnl.*, 1948, 173.

from a Palladian drawing in the Burlington–Devonshire collection at the R.I.B.A., published in Bertotti–Scamozzi's edition of Palladio. But an earlier authority for an open and unpedimented gallery above the arches is Plate 50 in Leoni's *Alberti* (1726).[1] A level gallery is now flanked with units which exactly reproduce the pedimented entrances to the sides of Palladio's palace-bridge design. The result must rank as one of the happiest inventions of the Burlington circle. Strangely enough, his kinsman Robert Morris published several Palladian bridge designs which were invariably true to the palace-front scheme of the original.[2]

At Wilton the Palladian bridge was thrown over a rapidly flowing stream [plate 17A]. An interesting attempt was made to vary the Alberti motive at Stowe by substituting a wall for one side of the colonnade, thus providing an area for mural decorations, but this bridge was either remodelled or, more probably, substituted by the existing replica of the Wilton one.[3] About 1755 John Wood the Elder borrowed the design for his ornamental bridge at Prior Park.[4] It served the dual purpose of landscape object and scenic platform from which the mansion could be viewed, and as at Stourhead the vistas, from house to bridge and bridge to house, are taken at an angle.

In all the gardens of the Kentian Revolution so far considered the presiding geniuses are Poussin and Claude, attended by the sylphs of the rococo. But once romanticism had taken root, the growths rivalling antiquity began to spread. One of these,

[1] *Ten Books on Architecture* by Leone Battista Alberti, translated into Italian by Cosimo Bartoli and into English by James Leoni, edited by Joseph Ryckwert, London: Tiranti, 1955, plate L.

[2] In *The Architectural Remembrancer*, 1751.

[3] Mr. Wilmarth S. Lewis kindly showed me at Farmington his copy of *A Description of Stowe*, 1768, with the following autograph note by Walpole: 'This was originally closed up on one side with paintings, in which was Fame drawing a veil over the sign of George 2nd, but this was taken away on Lord Temple's coming into place.'

An anonymous sketch of this walled version was published by Laurence Whistler in 'Stowe in the Making', *C.L.*, 11 Jul. 1957. The wall was adorned with a relief carved by Scheemakers, flanked with paintings by Sleter. Hussey, *English Gardens and Landscapes*, follows Whistler in ascribing the variation to Gibbs.

[4] Walter Ison, *The Georgian Buildings of Bath*, 1948, 143.

Chinoiserie, had already been noted at Stourhead. In 1735 Phillip Southcote purchased Woburn Farm, and began to 'improve' thirty-five acres out of an estate of a hundred and fifty.[1] As the first example of *la ferme ornée* or ornamental farm, his garden had an important influence, particularly on William Shenstone's *The Leasowes*, which entranced the age as the opposite of Stowe, for here the country gentleman had modest means and could not afford an Albano glut of temples. Rousseau did not visit *The Leasowes*, but might well have been attracted by its natural simplicity and use of a favourite device, the surprising inscription discovered without the aid of an architectural monument. Shenstone was an engaging and lucid writer, who in his *Unconnected Thoughts on Gardening* (*Works*, 1764) seems to have invented the term 'landskip, or picturesque-gardening'. The wealthier Hon. Charles Hamilton followed shortly afterwards by introducing at Pain's Hill imitations of Salvator Rosa as well as Poussin. At Hagley Lord Lyttelton placed a notable emphasis on the Gothic; his artificial ruins, according to Walpole, had 'the true rust of the Barons' Wars'.[2] This phrase, 'the Barons' Wars', reveals that the Protestant Whig landowner used the same political justification for identifying himself with the Middle Ages as with the Rome of the Senators, for if he was the foe of the Papacy he saw himself as the trustee of *Magna Carta*.

The cult of the Middle Ages was more consequential for the future of romanticism than that of Claude or Chinoiserie, although it may be mentioned that Claude can always be read in two ways, as Vergilian or romantic, and had very nearly promoted a medieval image in one of his most famous paintings, *The Enchanted Castle*, which evokes a Gothic fortress in a classical idiom. In the case of gardens, the long history of the medieval revival is provided with one of its most important links by the excursion garden, the germ of which can be traced back to Kyrle's Walk eulogized by Pope.[3] A strong claimant to first place is Studley Royal in

[1] H. F. Clark, op. cit. 160.

[2] Letter to Richard Bentley, Sept. 1753. Cited in *An Eighteenth-Century Correspondence*, ed. Lilian Dickens and Mary Stanton, 1910, 297.

[3] See Pope's *Works*, ed. Elwin and Courthope, III (1881), 150 note.

Yorkshire, where John Aislabie, Chancellor of the Exchequer in 1718, planned an impressive garden setting for a new house after a fire in 1716.[1] A mile away lay the ruins of Fountains Abbey. A scheme was put in hand for approaching the ancient relic along ornamental gardens and waterworks separated by parkland from the formal gardens round the mansion [plate 17B]. Aislabie was friendly with Colin Campbell, John James, and Vanbrugh, with whom he stayed at Baldersby. His basic idea may be described as an amalgam of Vanbrugh's scheme to preserve the relic of Woodstock Old Manor as a landscape object with the design of the vale waterworks at Campbell's Ebberston Lodge, itself an excursional annexe.

Aislabie was occupied with his scheme until his death in 1742, when his son William took over. It was not, however, until 1768 that William Aislabie was able to overcome the last obstacle to the fulfilment of his father's ambition by purchasing that part of the adjoining estate on which the Abbey ruins stood. Once again when an originating step is taken there is a shadowy connection with Vanbrugh behind his superb confrontation between a grandiose fragment, so to speak, of the waterworks at Versailles and an even more grandiose fragment of the Middle Ages. The excursion garden *par excellence* is Rievaulx Terrace, laid out by Thomas Duncombe in 1758,[2] and between it and the inception of Studley Royal in 1718 lies the separation of garden from house at Pope's Twickenham and Henry Hoare's Stourhead, where the landscape garden round the lake is invisible from the house. In 1952 old inhabitants in the village nestling below Duncombe Park could still recall nineteenth-century processions of carriages, with guests and footmen, as they wound their way past farms and meadows to a picnic on the Terrace, the two temples of which had provided every convenience in the eighteenth century 'for liberally entertaining Mr. Duncombe's guests'.

[1] For the gardens at Studley Royal see two articles by Geoffrey Beard in the *Leeds Art Calendar*, no. 48, 1961, 10–16, and *C.L.*, 10 Aug. 1961, and C. Hussey, *English Gardens and Landscapes*, chapter XV, the fullest account.

[2] According to *A Descriptive Account of the Fresco Paintings in the Pavilion on Rievaulx Terrace*, n.d. The *Gentleman's Magazine* 1810, part I, 601, says 'shortly before 1758'.

The *Gentleman's Magazine*, in the early notice just quoted, described the Terrace as itself 'a noble object, being near half a mile long, of a spacious breadth, and forming a handsome lawn, backed by thick plantations, intermixed with flowering shrubs, which project forward in semi-circular sweeps'. Below lay a village, the river and its bridges, a variety of well-wooded and verdant enclosures, and the Abbey. At one end of the Terrace stood the circular Tuscan Temple, at the other the porticoed Ionic Temple, ornamented with paintings by 'Burnice, an Italian artist', some original, some from Guido Reni, notably the *Aurora*. Surprisingly little is changed today.

At this point where *tempietti* on a landscaped terrace salute a natural landscape and an authentic relic of the Middle Ages, an account of the creation of the landscape garden and its role as a spearhead of romanticism may appropriately come to a close. When Sir Walter Scott attacked Kent's gardens as showing 'the rouge of an antiquated coquette', thus reacting with a hostility not unlike that of Rousseau to the artificiality of Stowe, he was isolating, perhaps unconsciously, the rococo element in their classicism.[1] But like other romantics, the poet who so admired Melrose Abbey by moonlight owed a debt to the yearnings of an age which saw both Rievaulx Abbey and sham temples in a Claudian afterglow, and mingled its zest in creating a garden Elysium with deeper sensations.[2]

[1] Cited by S. T. Prideaux, *Aquatint Engraving*, 1909, 179, from Scott's 'Essay on Landscape Gardening', *Quarterly Review*, 1828.

[2] It is impossible to do justice to the extensive bibliography of the landscape garden in a general survey. In addition to the authorities cited above I have found the following valuable: O. Siren, *China and the Gardens of Europe*, New York, 1950, a beautifully illustrated and scholarly study; Christopher Tunnard, *Gardens in the Modern Landscape*, 1938, with many perceptive observations; Eleanor von Erdberg, *Chinese Influence on European Garden Structures*, Cambridge, Mass., 1936; Marcel Mayer, *Nicholas Michot, ou l'introduction du jardin anglais en France*, Paris, 1942; C. V. Deane, *Aspects of Eighteenth Century Nature Poetry*, 1935; the article 'Eighteenth Century Gardens and Fanciful Landscapes' by Jurgis Baltrusaitis in *Magazine of Art*, Apr. 1952; and Marjorie Williams, 'William Shenstone and his Friends', *The English Association*, Pamphlet no. 84, Apr. 1933. But books and articles of equal value have accumulated round many of the protagonists, notably the men of letters like Shenstone and William Mason, and acknowledgement must always be made to pioneers like Sprague Allen and the classic monograph of Elizabeth Wheeler Manwaring,

Italian Landscape in Eighteenth Century England: a Study chiefly of the Influence of Claude Lorrain and Salvator Rosa on English Taste 1700–1800, first published London, 1925, second impression 1965. The view that Elizabeth Manwaring overstated the case for pictorial influence is I believe based on a misinterpretation of her thesis.

Like Siren, C. Hussey in *English Gardens and Landscapes*, 1967, has built his study round gardens which survive, and visual enjoyment always informs his lucid exposition of the background of ideas.

III

THE SURVIVAL OF THE BAROQUE
IN ARCHITECTURE

THE rise of the Burlingtonians was not accompanied by an immediate decline of the English baroque. On the contrary, some of its greatest achievements fall within the reign of the first two Georges. In ecclesiastical architecture the tradition established by Wren and his associates proved to have far greater vitality than any attempts by the neo-Palladians to provide a substitute. Between the Tory Act of 1711 for building 'Queen Anne's Churches' in London and the Church Building Act of 1818 there is a continuity of development which must be taken into account in tracing certain resemblances between the second great wave of Anglican Church building in London and the first.[1] Burlington did not secure a single important commission for his protégés in the universities, and when Ware was employed at Oxford in the middle of the century, it was to design the town hall and market for the city. The new era had inherited a legacy of memorial undertakings, a task which on the whole it faithfully discharged. The principal impact of a building is made when it is completed, and it is noteworthy how many major English baroque instances of this occur after the accession of George I. Walpole, while sympathetic to the personal character of a king who possessed the virtues of 'the honest English private gentleman', described him as 'void of taste, and not likely at an advanced age to encourage the embellishment of a country, to which he had little partiality, and with the face of which he had few opportunities of getting acquainted'.[2] Nevertheless, the

[1] For the two phases of Church building see John Summerson, *Georgian London*, 1945, chapters VI and XVI. The Wren Churches and Queen Anne's Churches may be described as a single wave, because they were designed by Wren and his School.

[2] *A. of P.*, ed. Dallaway and Wornum, II. 260.

completion of so many vast and costly projects gives an architectural lustre to both his reign and that of his successor.

Fortunately, the baroque legacy of uncompleted works to the Georgian era was identifiable with the Glorious Revolution and its victorious aftermath. The oldest, St. Paul's and Greenwich Hospital, had been started under a Stuart, but purified from this contamination by their spectacular continuation under William and Mary, whom Wren likewise served. The painted decoration of St. Paul's was still to be done when George became King. Blenheim Palace was conceived as a national monument to the hero who had humbled the armies of Louis XIV. Queen Anne had become the symbol of the divine right of a Protestant succession, although her seventeen children had all died before her. Hawksmoor's Queen's College at Oxford, begun in 1709, is her principal and most distinctive memorial, while the 'fifty new churches' commenced in her reign were likewise described by Vanbrugh as 'monuments to posterity of her piety and grandure'.[1]

At Greenwich the Chapel was begun in 1715 and the dome erected in 1735; the Upper Hall of the Painted Hall was decorated by Thornhill between 1717 and c. 1725; and Queen Mary's Court completed by Ripley 1729–50.[2] In 1725, when the Carlisles and the Vanbrughs together visited Woodstock, the former to call at and the latter to be refused admittance to Blenheim, an entire range of buildings was visible but the west court was still unfinished.[3] At Castle Howard it fell to Sir Thomas Robinson to design and erect a wing on Palladian lines as late as the 1750s. So far from Vanbrugh's practice falling off in the new reign, he was busier than ever before, and the majority of his great houses were started within it. No single Palladian architect could

[1] Cited by H. M. Colvin *D.E.A.* 638, from the Bodleian Library copies of the proposals Gibbs submitted to the Commissioners. They are printed in *Arch. Rev.*, Mar. 1950.

[2] These dates have been taken from Margaret Whinney and Oliver Millar, O.H.E.A. VIII. 328, and Christopher Lloyd, 'The Decoration of the Royal Hospital, Greenwich. I. The Painted Hall', *Transactions of the Lewisham Antiquarian Society*, V. 1957, and E. Croft-Murray, *Decorative Painting in England, 1537–1837*, I (1962), 265.

[3] *The Complete Works of Sir John Vanbrugh*, IV. *The Letters*, ed. Geoffrey Webb (1928), 167.

point to a more impressive list of Whig patrons, and any danger that the English baroque might be identified with Toryism, or Catholic or absolutist sympathies, was thereby lessened.

The survival of the Georgian baroque in Georgian England may be traced in two main streams. The first and purer one closes up after the death of its original masters, notably Vanbrugh in 1726 and Hawksmoor in 1736, although its provincial backwaters continue to trickle on for decades and indeed scarcely dry up. The second was carried forward by a younger generation influenced by neo-Palladianism but either not wholly converted to it or prepared to cater for different tastes. The outstanding figure here is James Gibbs.

The Associates of Wren were a society of individualists who continued to develop on original lines to the very end. For this reason their Georgian work warrants a separate scrutiny. By isolating the abstract elements of their style Kaufmann has placed them at the head of the Georgian *avant-garde*. They show a preference for elementary geometric forms, they aggregate rather than concatenate these, and their antithetical handling of three-dimensional shapes is bolder than the neo-Palladian staccato or separation of façade units in a pictorial unity stressed by Wittkower.[1] In two other ways they added to the weight of incoming tides of taste. They were nonconformist classicists and occasional Palladians, who approached the originals independently, and sometimes caught their Mannerist spirit with an insight which eluded the doctrinaires. They were also precursors of the Gothic Revival and the picturesque, the former being outside the range of strictly neo-Palladian sympathies and the latter taken up, as we have seen, as a garden by-product of Burlington's original programme.

A striking example of an inventive exploitation of a classical source is Hawksmoor's proposal for a monument based on Pliny's description of the Sepulchre of Lars Porsenna, an idea which

[1] Emil Kaufmann, *Architecture in the Age of Reason*, Cambridge, Mass., 1955; R. Wittkower, 'Pseudo-Palladian Elements in English Neo-classical Architecture', in *England and the Mediterranean Tradition*, ed. Warburg and Courtauld Institutes, 1945.

had already fascinated Wren.[1] But Hawksmoor's Romanizing, medievalism, and love of boldly contrasted geometric shapes have already been authoritatively discussed.[2] The point to be noted here is that the most conspicuous examples of classical imitation by the masters of the English baroque fall within the Georgian era with its renewed fervour for antiquity. St. Anne, Limehouse (1714–24), with its vestibule and tower rising in a truly fantastic ascension of contrasts and its lantern evoking both Wren and the Middle Ages, is not a Georgian design. St. George, Bloomsbury (1720–30), also by Hawksmoor, was built well after the accession and has as good a right as any church to be identified with the reign of the monarch whose name it bears. Its Corinthian portico, probably inspired by Baalbek, cannot have prepared the Palladian-trained eye for a steeple designed in licentious imitation of the Mausoleum at Halicarnasus, but the conjunction introduces the associations of antiquity as boldly as any other building in London. 'Hawksmoor hardly cared about unity', writes Kauffmann, 'but presented a pattern of unconnected motives, which became frequent in French revolutionary architecture.'[3]

It has already been suggested that Vanbrugh, who sought out the masters' texts, understood certain aspects of Palladio which were closed to the neo-Palladians, especially his plastic monumentality. A study of the classical interests of the Associates of Wren as a whole points to the same conclusion in the context of antiquity. They were no less uninhibited by dogma in their attitude to Gothic. Two perspective drawings of a design for the North Quadrangle of All Souls College, Oxford (before 1715), have been attributed by Colvin to John James, a key figure in the relationship between the circles of Wren and Burlington [plate 18A].[4] They announce a dilemma which was henceforth to remain with

[1] For Hawksmoor's interest in the Sepulchre of Lars Porsenna and his attempts at an imitation see Kerry Downes, *Hawksmoor*, 1959, 223. Cf. *Wren Society*, XIX, 143–5.

[2] By Margaret Whinney and Oliver Millar, O.H.E.A. VIII. 343–51, and in the authoritative monograph by Kerry Downes, cited above, *passim*.

[3] Op. cit. 20.

[4] H. M. Colvin, *A Catalogue of Architectural Drawings of the 18th and 19th Centuries in the Library of Worcester College, Oxford*, Oxford, 1964, no. 30 and plate 49, also introduction, xviii–xix.

English architecture, culminating in the debates of the Victorian Age. The same design could be dressed in either the classical or Gothic style. Which was to be preferred?

The choice was almost invariably made by the patron, just as Lord Palmerston later overruled Sir George Gilbert Scott.[1] An exception was when the architect was his own client. A comprehensive history of architects' own houses has never been written, but a memorable example for demonstrating their *avant-garde* character is Vanbrugh Castle [plate 18B], 1717–c. 1726. On land leased on Maze Hill, Greenwich, in 1717, he built a symmetrical Gothic residence with battlements and tower. Later additions converted symmetry into irregularity, so that the house 'has the honour of being the first picturesque villa ever built, asymmetrical in plan'.[2] The asymmetrical afterthought introduced a principle too revolutionary to bear immediate fruit. It is a landmark, but an unusual one, for it does not point to the first or ornamental phase of the Gothic Revival. As Lord Clark has observed, Vanbrugh exploits medieval mass not detail. What Vanbrugh himself called 'the Castle Air' is in keeping with the dignified and ceremonial age of the full-bottomed wig.[3]

Thomas Archer's church of St. John, Smith Square (1714–28), is just as exceptional an example of ecclesiastical baroque as Vanbrugh Castle is of secular Gothic [plate 19A]. It is, or rather was until gutted by fire in the Second World War, the most surprising of London's many surprising churches. The design lends itself to an interpretation in terms of Mannerist fantasy.[4] The outside clearly expresses a Greek-cross plan, over the centre of which one expects to find a dome. The interior was converted into a nave by closing off the north and south arms of the cross. No other post-Wren church made a bolder use of concatenating forms: the pilasters of the portico were continued upwards by the columns of the flanking towers, and the lines of both architrave and cornice

[1] Pevsner, *The Cities of London and Westminster* (B.E. XII), 1957, 479.

[2] Pevsner, *London except the Cities of London and Westminster* (B.E. VI), 1952, 25. The same authority, 156–7, describes it as 'the first private house ever designed consciously to arouse associations with the Middle Ages'.

[3] Kenneth Clark, *The Gothic Revival*, 1950 (1st ed., 1928), 21–2.

[4] Cf. the observations of John Summerson in *Architecture in Britain 1530–1830*, 189.

flowed uninterruptedly round the building. The masses were thus tied together, but alternated the rectangular and the curved. The towers were unnaturally high, and added to the centrifugal pulls of the composition. Both in its form and in its emotional impact it was the most uncompromisingly Italianate church of its day, and yet it broke with the fundamental baroque principle of subordinating the parts to a climactic central motive.

For a short period it looked as if Anglican Church architecture was being uprooted from the Wren tradition by the hands of the very men who had been trained in it. The younger architect who both restored this tradition and brought it back into the main stream of evolution was a Scotsman, James Gibbs (1682–1754), who in November 1713 succeeded William Dickinson as Hawksmoor's fellow surveyor for Queen Anne's Churches, in spite of Vanbrugh's opposition.[1] In 1715 he was replaced by John James, but the association with the Wren circle and personal encouragement by Wren himself lasted long enough to give him an insight into a style very different from the one he had been taught to admire in Italy. Most of Gibbs's innovations were based on what he observed happening amongst both Wren and Burlington circles, and this ability to compromise is one of the reasons for his influence in those regions of architecture, ecclesiastical and University, which the neo-Palladians failed to capture.

The son of a Roman Catholic merchant of Aberdeen, he was sent to the Scots College in Rome to train for the priesthood. Offended by the notorious intransigence of the Italian Jesuit Rector, Fr. Giovanni Battista Naselli, he took up painting and in order to finance his studies drew for British Grand Tourists and accepted pupils.[2] The precise conditions under which he became a pupil of Pietro Franceso Garroli (1638–1716) and Carlo Fontana

[1] For Gibbs see Bryan Little, *The Life and Work of James Gibbs 1682–1754*, London, 1955; Suzanne Lang, 'Gibbs: a bicentenary review of his architectural career', *Arch. Rev.*, July 1954; J. H. Field, 'The Sources of James Gibbs' Architecture and his Connections with the Commissioners' Churches', M.A. thesis for the Courtauld Institute, 1958, and id., 'Early Unknown Gibbs', *Arch. Rev.*, May 1962, and H. E. Stutchbury, 'Palladian Gibbs', *Transactions of the Ancient Monuments Society*, 1960, 43–52. A definitive study is at present being undertaken by T. Friedmann.

[2] Little, op. cit. 13–15.

(1634–1714), the Pope's *capo architetto*, are unknown. The former was a leading teacher of architectural perspective, the latter numbered among his pupils Johann Lukas von Hildebrandt and Johann Bernhard Fischer von Erlach.

There is a consistency in Gibbs's character which is perhaps best illustrated by the terms of his remarkable will.[1] His residuary legatee was a rich Catholic merchant in Soho, John Kerr, thus avoiding breaking the law against bequests to specifically Catholic causes. His other legacies included three Protestant institutions, Marylebone Church where he was buried after receiving the last rites in the Catholic communion, St. Bartholomew's Hospital, and the Foundling Hospital. No stage of his career with its personal obligations seems to have been forgotten. He left his house to a fellow Aberdonian, the painter Cosmo Alexander. A hundred pounds went as a tribute to his Oxford sponsor, Dr. William King of St. Mary Hall, but a much larger sum, £400, to his principal draughtsman. Lord Erskine, whose fortune had suffered from the Jacobite folly of his house, received three of his Marylebone houses, together with a legacy of £1,000 'in gratitude for favours received from his father', the Earl of Mar. His library, with both the Authorized and Douai Versions of the Bible, went to the Radcliffe Camera at Oxford. The loyal and liberal man who devised so noble a will was not unworthy to give architectural expression to the ideals of the Anglican *via media*.

St. Mary-le-Strand (1714–17), consecrated January 1724, was the first public building Gibbs designed after his return from Italy. It is therefore contemporary with Archer's St. John's, Smith Square. His original intention, he tells us, was to dispense with a steeple, substituting a small campanile or bell turret over the west end, and as the church was 'situated in a very public place', to erect a gigantic column, surmounted by a statue of Queen Anne, 250 feet high at a distance of 80 feet from the west front. This would have introduced into London the Roman-piazza formula of an obelisk or a column aligned on a church, but he was ordered to erect a steeple instead. This led him to study the steeples of Wren and try his hand at no less than six variations, an experience

[1] Ibid. 157–62.

which led to the following observation: 'Steeples are indeed of a Gothick Extraction; but they have their Beauties, when their Parts are well disposed, and when the Plans of the several Degrees and Orders of which they are compos'd gradually diminish, and pass from one Form to another without confusion, and when every Part has the appearance of a proper Bearing.'[1] Hogarth, who knew Gibbs well, was later to make a similar observation: 'St. Bride's in Fleet Street diminishes sweetly by elegant degrees, but its variations, tho' very curious when you are near them, not being quite so bold, and distinct, as those of Bow, it too soon loses variety at a distance.'[2] Elsewhere the painter stated that 'a gradual lessening is a kind of varying that gives beauty', after stressing that 'variety uncomposed, and without design, is confusion and deformity'.[3] These remarks, taken in conjunction with those of Gibbs, accurately define the formal ideal for which the architect was striving.

The west front is taken even more closely from a Wren model, the front of the south transept at St. Paul's. The circular arch of the central west window, however, and the combination of engaged columns and pilasters in the upper storey of the façade show that he had used his first-hand knowledge of the prototype, Pietro della Cortona's Santa Maria della Pace in Rome. Tapié has pointed out that the interior apse [plate 20A] is framed by a triumphal arch,[4] but the handling of this Roman theme is very much in the spirit of Wren, whose great arches in the interior of St. Paul's strike a comparable note of Roman grandeur. For his lateral elevations Gibbs chose as his model an early sixteenth-century building in Rome attributed to Raphael, the Palazzo Branconio dall'Aquila.[5] It is the most striking feature that remains of the originally Italianate conceptions, but few are conscious of

[1] A Book of Architecture containing Designs of Buildings and Ornaments, 2nd ed., 1739 (1st ed., 1728), viii.

[2] The Analysis of Beauty (1753), ed. Joseph Burke, Oxford, 1955, 64.

[3] Ibid. 35.

[4] Victor-L. Tapié, The Age of Grandeur (1st French ed., 1957), London, 1960, note to fig. 139.

[5] Architecture in Britain, 189. Gibbs can only have known the design from an engraving.

the palace theme until it is pointed out, so adept was Gibbs in fusing eclectic motives into a personal synthesis.

In 1719–20 Gibbs replaced the wooden cupola of St. Clement Danes with another steeple of his own design, but still 'a graceful essay in Wren's style'.[1] Walpole, who 'never saw a beautiful modern steeple', for all his distaste, correctly defined their original Gothic merit as 'the solid dignity of towers', or 'the airy form of taper spires'.[2] By combining the dignity of Wren with the 'airy form' of the medieval spire Gibbs made his steeples a symbol of continuity, a fact which may well have counted in his favour when he secured the commission to design St. Martin-in-the-Fields, a decisive set-back to Campbell's hopes of capturing the patronage of the church for the Palladian Revival.

In 1720, when he submitted his designs, he took the committee on a tour of the city churches. His first project with a completely circular body was rejected on the score of expense, but its publication in his *Book of Architecture* (1728, later editions 1739, 1753) was to have a delayed impact later in the century. The solution finally approved and placed proudly at the head of his published works was the most influential architectural innovation of the century [plate 22, built 1722–6].[3] Wren had always respected the medieval distinction between the narrow-towered vestibule and the broad body of the church. A temple-front portico of regular dimensions could only be applied to the body by shifting the tower to the side, as Hawksmoor did at St. George, Bloomsbury. Gibbs now conceived the daring idea of placing the tower and steeple *within* the rectangular framework of the church, so that they rise from the gable of the roof behind the portico. Wren in his Warrant Design for St. Paul's had surmounted the dome with a steeple, and at Pembroke College Chapel, Cambridge, had placed a little cupola on the roof. Closer still is John James's St. George, Hanover Square (1712–24), with its baroque cupola rising behind a Corinthian portico. But these antecedents do not account for his daring integration of the two most famous

[1] Ibid. 210. [2] *A. of P.* II. 180.
[3] Marcus Whiffen, 'The Progeny of St. Martin-in-the-Fields', *Arch. Rev.*, July 1946.

motives of medieval and classical architecture, the steeple and the temple front.

The incongruity of a steepled temple has inspired a pejorative literature of considerable distinction on the part of the purists. Gibbs widened the body of the church by a bay on either side of the portico, but this and the high base on which it was built only added to the ease with which the two features can be read together. This ease of reading is really his justification. The visual success with which he reconciled the two great architectural traditions exactly suited the taste and temper of a Protestant society obsessed with the secular heritage of antiquity but loyal to its religious faith. Gibbs's synthesis completely eclipsed the uncompromisingly classical designs published in the *Vitruvius Britannicus*, and for this reason St. Martin-in-the-Fields, standing at the heart of the Empire and expressing both the religious and the secular ideals of the age, is the supreme symbol of Georgian architecture in its imperial phase.

The interior is an ingenuous attempt to solve one of the most difficult problems raised by the auditory churches of Wren. Gibbs disliked galleries, which 'as well as Pews, clog up and spoil the Inside of Churches'.[1] Wren had tried a number of devices by which wooden galleries and built-in pews could be unified with the structure of the church. At St. Antholin, Watling Street, demolished in 1875, he had raised the pillars of the nave on bases well above the height of a standing figure, thus fitting the pews into the lowest zone without obscuring the order. The abrupt median intersection of the colonnade by the gallery, so noticeable at St. Bride's, was avoided at St. James, Piccadilly, by the lowering of the latter so that the main order rises above it. At Christ Church, Newgate Street, the gallery was sprung from the same level as the columns. In every instance, however, the spectator is conscious of the two systems. Gibbs accepted the median intersection but painted both galleries and side walls white to match the columns. At the same time he walled the pews as a continuation of the base of the columns.

[1] *Book of Architecture*, 2nd ed. viii. The interior is reproduced in Summerson, *Architecture in Britain*, pl. 124B.

For the order, he chose the single columns which St. Bride's had proved less obstructive than double ones. So that the congregation should be able to hear the preacher as well as see him, he made the barrel vault elliptical like that of St. Mary-le-Bow, having found by experience that this shape was 'much better for the Voice than the Semi-circular, tho' not so beautiful'.[1] In short, at every stage he showed that he had carefully studied Wren's solutions and mastered the principles they embodied. The most Italianate feature is the decoration, for which he employed a small army of craftsmen, headed by 'Signori *Artari* and *Bagutti*, the best Fret-workers that ever came into *England*'. Because he never allowed his use of colour to subtract from the dominance of white, he introduced into the London church an unprecedented effect of lightness.

Gibbs's third London church, St. Peter, Vere Street (1723–4), known as the Oxford or Marylebone Chapel, is a plain brick building with a centralizing Venetian window, a concession to Palladianism which he first made at St. Martin's. It is contemporary with the far more ambitious All Saints, Derby, now the Cathedral (1723–5), where he used the same giant order as at St. Martin's, with its slices of entablature denounced by Fergusson,[2] and to his delight was able to dispense with clogging galleries. Because they were church Universities, Oxford and Cambridge naturally favoured architects who had won their laurels in the ecclesiastical field, and by this date Gibbs had received the commission to build the new Senate House at Cambridge (1722–30), quickly followed by another for King's College New Buildings (1724–49). In designing the Senate House [plate 19B] he was associated with the amateur architect James Burrough, later Master of Gonville and Caius College, whose role in Cambridge was similar to that of Aldrich and Clarke in Oxford.[3] The original scheme, never carried out, was for a central Royal Library with the Senate House and Consistory or Register Office attached as

[1] Gibbs, op. cit., Preface, v.

[2] James Fergusson, *History of the Modern Styles of Architecture*, 3rd ed. revised by Robert Kerr, 1891, I. 61.

[3] Colvin, *D.E.A.* 108, where the evidence for Burrough's share is summarized.

wings, the whole enclosing a court.[1] Only the Senate House was built, a fine example of Gibbs's flair for handling the giant order. The plan for the quadrangle of King's College was even more ambitious, no less than a great piazza, with the long body of the Chapel, 'a beautiful Building of the Gothick Taste, but the finest I ever saw', filling the north side.[2] Opposite was to stand the climactic unit of Hall, offices, and Provost's Lodge, with a magnificent octastyle portico. The west and east sides were to be occupied by two identically matching blocks, each containing twenty-four apartments of three rooms and a vaulted cellar for the Fellows. Only the west block of the Fellows' Building was executed. Gibbs took special pride in its central feature, to which he devoted a whole plate: an archway grander than the one through which Charles I rides in his equestrian portrait by Van Dyck.[3] It is framed by a Doric portal and surmounted by a Diocletian window, the whole sheltered by the pediment of the central block. 'This decidedly Mannerist composition', observes Summerson, 'has a Venetian air', as does indeed its proximity to courtly Gothic.[4]

In only one of his great public commissions was Gibbs able to realize completely his original conception. This was the Radcliffe Library or Camera (1737–49) at Oxford, where he was again working in a predominantly Tory climate of opinion [plate 23]. He was provided with his favourite site, a piazza, this time behind St. Mary's Church with University buildings already occupying the other three sides, so that he knew exactly how the whole would look. His designs included both rectangular and circular alternatives, but he was fortunately able to persuade his patrons to prefer the latter. His Roman training and continental travels now bore fruit in a work which ranks with Georg Baehr's Frauenkirche in Dresden (1726–38) as one of the two finest Protestant essays on the theme of the centralized domed building. The coupling of the Corinthian columns in the peristyle can be paralleled in the drum of St. Peter's, the concave buttresses supporting the drum in Longhena's Sta Maria Della Salute, and the hooded circular lights of the dome in several of Fontana's designs. But Gibbs was also

[1] *Book of Architecture*, ix and plate 36. [2] Ibid. x and plates 32–5.
[3] Ibid., plate 34. [4] *Architecture in Britain*, 213, and pl. 126A.

heavily indebted to the work of his English predecessors, notably Wren and Hawksmoor. The chief obstacle to the Renaissance dream of the circular church as the supreme symbol of divine perfection had been functional, as witness the addition of Maderno's nave to St. Peter's. In post-Renaissance England most of the attempts to follow the same path by enclosing the circle with a square or octagon to preserve its ideal character had remained on paper. But Gibbs was clearly aware of Wren's design (1678) for a Mausoleum of Charles I at Windsor.[1] Hawksmoor had actually built a mausoleum at Castle Howard between 1729 and 1738, and designed a circular domed structure for the Radcliffe Trustees as early as 1715.[2] Fortunately, a circular Library, unlike a large church, posed no functional difficulties. The acceptance of a plan hitherto rejected for Protestant churches in England but permissible for mausolea was wholly appropriate to a commission which had a memorial character. It may be noticed in passing that the English baroque was nearly always favoured, at this time, for works which had a retrospective character.

Summerson has detected a Mannerist perversity of alignment in the design.[3] In contrast to baroque concatenation, the buttresses do not rise above the double columns, nor the columns above the main projections of the rusticated base. But this interruption of the vertical drive is surely designed to separate and strengthen the horizontal sweep and massiveness of the concentric stages, rising tier above tier. 'In a largely Gothic area', writes Peter Murray, 'it combines something of Ancient Rome with still more of the Rome of the Rennaissance and the Baroque—which Gibbs had known at first hand—and it adds to this an indebtedness to Wren that never lapses into servile imitation; this, perhaps, is no bad epitaph on Gibbs himself.'[4] The Radcliffe Camera is the last masterpiece of the classicizing English baroque, which concludes with an evocation of Roman grandeur as Augustan as anything built more strictly to rule by the Burlingtonians.

[1] Viktor Fürst, *The Architecture of Christopher Wren*, 1956, 108–9 and fig. 123.
[2] Summerson, *Architecture in Britain*, 213.
[3] Ibid. 215.
[4] *A History of Architecture*, Part I by Peter Kidson, Part II by Peter Murray, 1962, 194.

In his domestic architecture Gibbs showed himself more than willing to come to terms with the Palladian revival, although his first steps were conservative. After his brief association with Burlington House his most important commission came from James Brydges, Duke of Chandos, Marlborough's Paymaster, by whom he was employed at Canons, Middlesex, between 1716 and 1719.[1] This was the last great country house in England to be undertaken as a palatial baroque project. Among the architects successively called in were Talman, James, Vanbrugh, Gibbs, and John Price. The list of mural painters included Bellucci, Laguerre, Kent, Thornhill, Francesco Sleter, Roberto and Antonio Grisoni. Chandos was no less lavish in his employment of sculptors and stuccadores, including Artari and Bagutti, Serena, Isaac Mansfield, Montigny, Van Nost, and Carpentière. When to this record is added his munificent encouragement of musicians, including Pepusch and Handel, he appears as the leading patron in the opposite camp to Burlington, and as such he became a target for attack.[2] A grandiose feature which lent itself to comment was a projected avenue of approach three miles long. The house was demolished about 1750, but in any case Chandos was unable to stem the tide of taste by a patronage which harked back to the glories of the past and showed a marked preference for foreign artists.

The Chapel at Canons was by Gibbs, and possibly the unpedimented east front, which reverted to the massive effect of lateral extension so often favoured in baroque classicism. In spite of the final rupture he must have profited from the experience of working with so splendid a circle of artists and craftsmen. Between 1720 and 1725 he was employed by George, 2nd Earl of Lichfield, a Catholic Tory, on Ditchley, the finest of his surviving country houses. Francis Smith of Warwick, the architect of Stoneleigh,

[1] The history of this great house is documented in C. H. Collins Baker and Muriel I. Baker, *The Life and Circumstances of James Brydges, First Duke of Chandos, Patron of the Liberal Arts*, Oxford, 1949. See also I. Dunlop, 'Canons, Middlesex, a conjectural reconstruction', *C.L.* CVI, 1949, 1950–4.

[2] Pope's satire on Timon and his villa in his fourth moral essay, *Of Taste: an Epistle to the Earl of Burlington*, 1731, may not have been originally aimed at Chandos, but was quickly applied to him.

was the mason contractor and surveyor, and it has been suggested that Gibbs revised his original design.[1] Like Canons, the house belongs to a baroque classicist type which provided a favourite alternative to strict Palladianism in the first half of the century: a massive rectangle of two main storeys of approximately equal height, with basement and attic, the horizontal roof line again unbroken by a pediment. Kent painted the ceiling of the Olympians in the Great Hall. The scheme of the Hall with its isolated festoons, busts, roundels, and reliefs, has much in common with Kent's later manner, and has indeed been attributed to him. But Kent came later on the scene. The Octagon at Orleans House, Twickenham (1720) [plate 24] for James Johnston is one of the most successful interiors of the period. A similarity with the pavilions in German palaces has been noted, and the continuation of the lines of the wall divisions through the cornice into the ceiling has a marked baroque flavour, as does also the repetition of large-scale curvilinear motives.[2] This is one of the few English decorative schemes that can vie with the lightness of the late baroque in south Germany and Austria, and fortunately the stucco work of Artari and Bagutti, with pale blue-grey panels on white to offset the gilding, is here seen at its best. In the upper regions the shapes can be read in two ways, as applied decoration and reserved space. Last but not least, the flow of the movement is beautifully sustained within the regular scheme.

A grand and most ambitious interior which can now be securely attributed to Gibbs was the great hall at Ragley, Warwickshire (from 1750), for the Earl of Hertford, where the verticals are thrust through dividing horizontal members [plate 25].[3] By omitting the gallery he accentuated the upward sweep of the walls, and by cutting the cover that supports the ceiling he introduced

[1] See *C.L.*, 9 and 16 June 1934, and Bryan Little, *Gibbs*, 96–7, for a discussion of the problems.

[2] See John Fleming, 'Architecture and Interior Decoration' in *The Early Georgian Period 1714–1760*, ed. Ralph Edwards and L. G. G. Ramsay, 1957, 30–1.

[3] C. Hussey, *E.G.* 18 and plate 1. The documentary evidence is Gibbs's own note that he 'gave directions for the repair of Ragley' and a plan of the principal floor in B.M. Add. MS. 31323, W³, described by Colvin, *D.E.A.* 235, as almost certainly by Gibbs.

one of the most striking effects of his church interiors. The later rococo decoration is enlarged in scale to harmonize with so baroque a conception. The omission of any violently projecting feature, like a gallery, which might detract from the monumental enclosure of space can be paralleled in a much earlier building, the Great Hall for St. Bartholomew's Hospital, the new buildings of which he designed in 1728.[1]

Like Adam later, and for the same reason, namely his skill in designing interiors, Gibbs was employed by some of his richest patrons on alterations and additions to existing buildings, e.g. the Chapel and Library that he designed c. 1720 for Edward Harley, Earl of Oxford, at Wimpole. To a separate category belong his designs for minor domestic buildings, the recreational houses for the nobility, like Sudbrooke Park, Petersham, Surrey (1726–8), for the Duke of Argyll, and the residences of the lesser gentry, merchants, and members of the professions. These are distinguished by their sobriety of taste and regular proportions. The doctrine that he preached was an impeccably Palladian one: 'For it is not the Bulk of a Fabrick, the Richness and Quantity of the Materials, the Multiplicity of Lines, nor the Gaudiness of the Finishing, that give the Grace or Beauty and Grandeur to a Building; but the Proportion of the Parts to one another and to the Whole, whether entirely plain, or enriched with a few Ornaments properly disposed.'[2] In adapting Palladian schemes to lesser houses and villas, the latter a favourite term with Gibbs, his method was to provide a repertory of parts and show how they could be amalgamated into a whole which echoed the simplicity not of the ancients, but of the Queen Anne style. A design submitted to Lord Islay for a villa at Whitton, near Hampton Court, plays a chaste variation on the centre-piece of the Villa Pisani at Bagnolo (Palladio, book II, ch. XIV) by placing a Diocletian window above the portico.[3] But the Roman motive is not obtrusive as at Chiswick.

In contrast to Campbell's treatise Gibbs's *Book of Architecture containing Designs of Buildings and Ornaments* (1728) includes orna-

[1] E. Croft-Murray, 'Hogarth's Staircase at Bart's', *C.L.*, 18 Aug. 1960.
[2] *Book of Architecture*, Introduction. [3] Ibid. xvi and plate 62.

ments in its title and provides a wealth of ornamental designs by
an architect whose training had brought him into contact with
the great exponents of ornament in Italy. The tendency of the
modern architectural historian is to neglect ornament, and one
has to go back to Burckhardt for an understanding of its funda-
mental role in the Renaissance and post-Renaissance traditions.[1]
The principle that Gibbs grasped so clearly was that the part,
whether doorway, window, or chimney, has a built-in ornamental
character, so that he thought in terms of ornamental integration
from the very beginning. By giving such prominence to parts,
and providing such clear and simple models, he supplied the
essential complement to the proportional code of the Georgian
Rule of Taste.

Gibbs had no Palladian precedent on which to rely for his
exploitation of the contrast between stone and brickwork. This
contrast was a cardinal feature of his designs directed to 'such
Gentlemen as might be concerned in Building, especially in the
remote parts of the Country, where little or no assistance for
Designs can be procured'. In the event the Gibbsian synthesis of
stone and brick, so contrary to Palladio's avoidance of red with
his white stone and stucco, was to serve as a model to gentlemen
much further afield than the remoter English provinces, with
the happiest results. In the history of Georgian architecture in
its imperial phase the key figure between Wren's Board of
Works and Robert Adams is Gibbs, who Palladianized Wren.[2]
In one respect he was even stricter in his Palladianism than the
Burlingtonians. In none of his published designs does he use the
Venetian window as a framing feature; it is always placed cen-
trally. Perhaps the transference to the sides offended his Italian-
trained eye. Many country and colonial builders followed his

[1] The diatribes of James Fergusson provide a classic example of the misunder-
standing of Renaissance and post-Renaissance attitudes to ornament in the nineteenth
century.

[2] Between the garden front of Mount Airey, Virginia, c. 1756, taken from Plate 58
in the *Book of Architecture*, and Old Government House, Parramatta, New South Wales,
by John Watts, completed in 1816, the examples of Gibbs's influence in the Colonies
are so numerous that his types, if not his ornamental style, may be said to have
survived the Adam Revolution.

example by using the window to give light to a central staircase as well as add dignity to the entrance front.

A healthy element of eccentricity is to be noted in provincial architecture in this period of transition between the old and the new. The west front of Barnsley Park, Gloucestershire (1720–31), built by an unknown architect, possibly John Price, for Henry Perrot (whose wife was a niece by marriage of the Duke of Chandos), shows a gigantic entablature running across the entrance front above the second storey, from which rises a third attic storey crowned by a pediment.[1] This was a common enough breaking-device where a three-bay elevation of three storeys would have otherwise required a single order of unnatural elevation, but the huge ledge-like projection of the entablature is, to say the least, unusual. Even odder is the insertion of a Venetian window in a similarly detached attic storey at Crowcombe Court, Somerset, built for Thomas Carew between 1723 and 1739 by Thomas Parker and Nathaniel Ireson.[2] After 1730 there is a falling off in the number of Georgian baroque mansions built on an imposing scale. But the Rule of Taste continues to be defied in smaller buildings. As late as 1736 Rosewell House in Kingsmead Square, Bath, with its bearded terminal figures and fantastic garlands, incurred the censure of John Wood I: 'nothing, save Ornaments without Taste, to please the Eye'.[3] The same stricture cannot be applied to the charming Widcombe Manor House, just outside Bath, partially rebuilt c. 1727 for Philip Bennet, for here the fluted Corinthian giant pilasters, garlands, and decorated keystones are beautifully arranged to enrich and accentuate the symmetry of the front.

One of the most notable practitioners of Georgian baroque was John Strahan of Bristol, also active in Bath. Even John Wood I was forced to admit that his Beaufort Buildings (after 1727) in the latter city have 'a Sort of Regularity to commend them'.[4] At Redland Court, Bristol (completed 1735), he moved over to

[1] See Hussey, *E.G.* 48–58.

[2] See Pevsner, *South and West Somerset*, B.E. XIV. 142, and plate 54 (b), and Colvin, *D.E.A.* 310.

[3] Cited by W. Ison, *The Georgian Buildings of Bath*, 1948, 134.

[4] Ibid.

Palladianism, his central block flanked by compact pavilions being a fine variation on Campbell's Stourhead.[1] When Wood referred to his 'Piratical Architecture' he coined a term which well expressed the contempt of the orthodox for irregular provincial usages. Redland Chapel at Bristol (1740–3), probably designed by Strahan although finished by William Halfpenny, illustrates, not unpleasingly, a link between the Georgian baroque and one of the most industrious designers to Palladianize the vernacular.[2] Carving by Thomas Paty appropriately enriches the west front and the interior.

In its latest phase the baroque survival is so strongly influenced by Palladianism that it achieves an almost perfect synthesis. A classic example is the Town Hall at Poole, Dorset, a gift to the borough in the election year of 1761 by its two Members, Thomas Calcraft and Joseph Gulston [plate 20B].[3] A boldly curving double stairway extends its sweeping movement across the entire width of the brick front with its stone portico, at once defining and separating the parts in a beautifully proportioned symmetry. The Georgian architecture of Poole, of which this is the climax, invites comparison with the village of Blandford in Dorset, rebuilt after a disastrous fire in 1731, largely by the joiners and architects John and William Bastard. This work, which was completed by their nephews, constitutes an almost perfect example of the dignified vernacular architecture of Georgian baroque in the provinces.[4]

The border line between the baroque and Palladianism was most frequently crossed in the interior. Attention has already been drawn to the baroque cast of William Kent's imagination. In one memorable instance he allowed himself full freedom to indulge his love of the spectacular. The staircase at 44 Berkeley Square, the surprisingly Gibbsian house he built for Lady Isabella Finch between 1742 and 1744, is a *tour de force* of the English baroque, worthy to rank beside Gibbs's contemporary Radcliffe Camera,

[1] W. Ison, *The Georgian Buildings of Bristol*, 1952, 164–70 and plate 30a.
[2] Ibid. 54–61 and plate 4.
[3] Bryan Little, 'Vicissitudes of a Channel Port', *C.L.*, 27 Feb. 1958, 388–91.
[4] H. M. Colvin, 'The Bastards of Blandford', *Archaeological Journal*, CIV, 1948.

constituting the interior masterpiece that rivals the exterior one [plate 21]. The description by Margaret Jourdain can hardly be bettered:

The single theatrical flight of the staircase at 44 Berkeley Square leads to the half landing, where it divides into two, the returns meeting on the main landing. The effective Ionic screen of columns (recessed in the centre) masks a staircase to the second floor in the rear of the main flight. The enriched S scrolls of the balustrade of the main staircase are identical with those of the hall at Holkham. On the walls of the staircase hall are three circular recesses with consoles, which, like the niches below, were originally occupied by busts and statuary, a characteristic device for breaking up the wall surface. The staircase produces the highest possible degree of dramatic effect. Horace Walpole declared it to be 'as beautiful a piece of scenery and considering the space, of art, as can be imagined', showing by his choice of the word 'scenery' his sense that the composition was theatrical.[1]

Photographs give a false impression of the staircase, which is quite small. Kent has used the illusionistic device of sharply diminishing the forms as the eye ascends, a device which recalls the *trompe l'œil* perspectives of seventeenth-century Roman masters of the baroque. On arrival at the upper landing the visitor is astonished by the smallness of the columns which seem so monumental when viewed from below. The staircase serves as a dramatic contrast to the severe dignity of the exterior, and at the same time as a ceremonial introduction to the urbane luxury of the *salon* with its deep coved and coffered ceiling decorated with cameo-like scenes in grisaille.

The 1740s, in which both the baroque masterpieces of Gibbs and Kent were completed, may be regarded as the culminating period of baroque survival in England. Indeed Baroque Revival would not be an unacceptable term for the forties, for it will be seen that these works coincide with equally remarkable manifestations in painting, sculpture, and the decorative arts, as if a reaction against Palladianism was gathering force. While the

[1] *The Work of William Kent*, 1948, 56. For Kent's links with the English and Italian baroque see Hugh Honour, 'John Talman and William Kent in Italy', *Conn.*, Aug. 1954.

prodigal grandeur of the Continental baroque cannot be matched by so Augustan and comparatively restrained a mode, the order and felicity of the English examples place them in the highest aesthetic category. They also serve as stepping-stones to the future. The staircase at 44 Berkeley Square, with its rise and fall, advance and recess of forms, may be cited as one of the many examples which during the heyday of Palladianism constitute a link between the age of Vanbrugh and the age of Adam.

IV

THE HIERARCHY OF CATEGORIES
IN PAINTING

'WE are now arrived at the period in which the arts were sunk to the lowest ebb in Britain'; with this memorable indictment Walpole opened his account of the painters in the reign of George I. He further darkened the picture by disparaging the survival of the baroque in architecture, while sculpture was dismissed in a single sentence: 'Statuary still less deserved the name of an art.'[1]

The continued ascendancy of the portrait painters who were the favourites of Queen Anne and her Court, the 'shadow of Kneller' and his studio factory, the withdrawal of the Venetian history painters, and the extravagant praise bestowed by national prejudice on Charles Jervas and William Kent in the uncritical search for an English Raphael support the general charge against Georgian painting before the advent of Hogarth. But Walpole's verdict was coloured by his dislike of the latest phase of the English baroque, and therefore too sweeping. Kneller did not live on 'only in name, which he prostituted by suffering the most wretched daubings of hired substitutes to pass for his works'. At least a few of his finest portraits were painted after the accession of George I, and the same may be said of Michael Dahl.[2] A native tradition of observant and sober realism, based on sound craftsmanship and elevated by the study of baroque models, was carried forward, notably by the school of Riley; his pupil, Jonathan Richardson the Elder, the father-in-law of Thomas Hudson, in turn the master of Reynolds, transmitted a line of succession by studio. For the first time in the history of English art a native-born painter, Sir

[1] *A. of P.* II. 259, 260.
[2] For the fine late examples by Dahl see Wilhelm Nisser, *Michael Dahl and the Contemporary Swedish School of Painting in England*, Uppsala and London, 1927.

James Thornhill, was almost wholly occupied with history painting comparable for splendour of architectural setting and thematic grandeur with the undertakings of the Old Masters. The minor categories were enriched by immigrant artists who excelled in *fêtes champêtres*, informal portraiture, animal and flower painting, and still life. Watteau came to England in 1719 to receive treatment from Dr. Richard Mead, and left behind in the latter's collection two 'conversations' that were painted in London.[1] The first Academies of Painting were launched to train a native school of history painters. Finally, there was a remarkable growth of aesthetic criticism, particularly in the branch addressed to connoisseurs and artists, and this was to have a profound influence on taste and the practice of painters, supported as it was by a parallel growth in the reproductive print. What Walpole mistook for an ebb-tide was an incoming one.

According to a tradition inherited from Renaissance Italy, the highest of all categories of painting was *istoria*, the term originally used for narrative pictures of state, for which the Bible and classical mythology provided the ideal repertory of subjects. Work in the other categories was esteemed in proportion to its approximation by sacred and classical association and by 'greatness of style'. The landscapes of Poussin and Claude told the stories of the Bible and antiquity, the portraits of Rubens introduced their allegories. The hand of a Hondecoeter could transform a barnyard fight between poultry into a battle-piece, not without humour, but unmistakably in the great style. Topography itself could be dressed in the trimmings of classical landscape. Only one category was excluded from this sliding scale: low-life genre. Such paintings were admired for their skill, ingenuity, and humour, but never confused with high art.

One of the most important changes to be noted in this period of flux is the rise of subordinate categories of painting in estimation. With one exception, the decisive factor is a shift in taste rather than a revolution in doctrine. The exception is portraiture, which was elevated by theoretical argument based on other

[1] *L'Amour paisible* and *Comédiens italiens*. See W. T. Whittley, *Artists and their Friends in England 1700–1799*, 1928, I. 28, and Walpole, *A. of P.* II. 295.

grounds than allegorical association. The best guide to under-
standing this theoretical change is the writings of Jonathan
Richardson.

Most of Richardson's values can be traced back both directly
and through seventeenth-century French sources to the Renais-
sance trilogy of *grazia, grandezza,* and *decoro.*[1] Each of these
terms and their derivatives, however, undergoes an Augustan sea-
change. Whenever he pairs 'grace' and 'greatness', he puts grace
in the key position. 'Elegance' and 'the genteel' add to the polite
associations of grace. 'How infinitely, and divinely great, and
genteel is the Christ in the boat!' in Raphael's *Draught of Fishes.*[2]
The epithet 'genteel' comes as an anticlimax to the modern reader;
such disappointments are generally a sign that the meaning of
words has changed. The Renaissance ideal with its associations
with *decoro* had conferred a graceful dignity on portrait painting.
But this was not what Richardson intended to emphasize in his
general argument. His basic approach was moral.

One of the first English writers to make a substantial contri-
bution to the debate on the moral function of the portrait was
William Aglionby.[3] He outlined its high aim of transmitting to
posterity the virtues of the great and listed as examples the majesty
of Alexander, the genius of Caesar, the calm magnanimity of
Scipio, and the beauty (itself having a moral value) of Cleopatra.
Dryden in the Preface on the parallel between poetry and painting
to his translation (1695) of Du Fresnoy's *De Arte Graphica* had
allowed 'an ingenious Flattery' to the portrait painter. Richardson
gives the reasons:

The business of Painting is not only to represent nature, but to make
the best choice of it: nay to raise, and improve it from what is com-
monly, or even rarely seen, to what never was, or will be in fact,

[1] See the introduction by Wilhelm Nisser, op. cit., for a notable survey of English
aesthetics at the outset of the Georgian period.

[2] *The Theory of Painting* in *Works*, Strawberry Hill edition, 1792, 74. The passage
is a typical example of Richardson's exclamatory style, parodied by Hogarth in his
press advertisements.

[3] *Choice Observations upon the Art of Painting together with Vasari's Lives of the most
eminent Painters from Cimabue to the time of Raphael and Michelangelo with an Explanation
of the most difficult Terms,* London, 1719.

though we may easily conceive it might be. As in a good portrait, from whence we conceive a fitter opinion of the beauty, good sense, breeding, and other good qualities of the person than from seeing themselves, and yet without being able to say in what particular it is unlike: for nature must be ever in view.[1]

According to Richardson, history painting records the great actions of the past, portraiture the men who conceived and executed them. He does not claim equality in so many words, but the impression he leaves is that the portraits of a great master come close to the highest position reserved for Biblical subjects. Richardson may very well have believed that the portraits of British Worthies, inspired to virtuous action by their Christian faith, were entitled to a more serious attention than the amorous exploits of pagan deities. In a revealing passage he shows a bias to the secular history of antiquity: 'When I think of the great action of the Decii, or the three hundred Lacedemonians at Thermopylae, I see them with such faces and attitudes, as Michelangelo or Giulio Romano would have given them . . .'[2] Richardson did not confine his eulogy to the portraits of heroes or famous men: '. . . the picture of an absent relation, or friend, helps to keep up those sentiments which frequently languish by absence, and may be instrumental to maintain, and sometimes to augment friendship, and paternal, filial, and conjugal love, and duty.'[3]

'Pictures of this kind', he adds, 'are subservient to virtue.' For this reason flattery is to be condemned: 'a flattering, mercenary hand may represent my face with a youth, or beauty, which belongs not to me', but if the good qualities are not deserved, the sitter will be a just subject to ridicule.

Most of these ideas, if not their application to portraiture, can be traced back to Shaftesbury. Richardson's treatise appealed to a different audience from students of philosophical ideas. The theme of the elevated portrait that the artist developed so eloquently is central to the history of Georgian painting and sculpture, and ranks second only to the advances made in the humanity of the

[1] *Works*, Strawberry Hill edition, 1792, 176. [2] Ibid. 9.
[3] Ibid. 10. Other key passages from Richardson are aptly cited in David Piper, *The English Face*, 1957, see index.

portrait. Even the latter can be related to the theorist's regard for domestic and social virtues as well as public ones. An account of changes in the categories of painting in this period can follow the orthodox sequence with one alteration, the raising of portraiture to second place and the consequential relegation of landscape to third. This is justifiable both by the theories of Aglionby and Richardson and the failure of any English painter to catch the spirit as distinct from the manner of classical landscape before Richard Wilson. After the landscape comes animal painting with its sanction in antique sculpture, still life with its studio associations, and at the very bottom low-life genre, doubly low because it was neither ideal in style nor elevated in subject. Dryden in his Parallel had left his readers in no doubt about the top and bottom of the scale. The subject of a picture, or of a poem 'must in general be great and noble'. He observed that meaner parts of nature were often depicted:

For, to proceed in the *Parallel*, as *Comedy* is a Representation of humane Life, in inferior Persons, and low Subjects, and by that means creeps into the Nature of Poetry, and is a kind of *Juniper*, a Shrub belonging to the Species of Cedar, so is the Painting of *Clowns*, the representation of a Dutch *Kermis*, the brutal Sport of *Snick* or *Snee*, and a thousand other Things of this mean Invention, a kind of *Picture*, which belongs to *Nature*, but of the lowest *Form*.[1]

Fortunately, George Vertue in a reliable and, in the circumstances of contemporary partisanship, extraordinarily impartial commentary on contemporary art generally specified the category to which paintings belonged in his discussion of their merits and defects, and his remarks may appropriately introduce an account of the new developments in each.

History painting as Vertue understood it did not include scenes with figures from modern history unless they were elevated by allegory, like Verrio's King Charles II 'riding in Triumph ore the Seas with many allegoricall figures'.[2] Whenever he describes a picture which we today would consider historical he never confers the honorific title, but substitutes a descriptive label,

[1] Cited from *The Art of Painting* by C. A. Du Fresnoy, translated by Mr. Dryden, 2nd ed., 1716, Preface, xxviii. [2] *Vertue*, II. 132.

e.g. 'a battle peice', or 'a peice representing Queen Anne giving a charter to ye Duke of Marlboro'.[1] The reason is made clear by Richardson. *Istoria* required higher powers of invention than the documentary picture. Painting relates the histories of the past and present times, the fables of the poets, the allegories of moralists, and the good things of religion.[2] His list is in an ascending scale of importance. The painter of *istoria* must go higher than the historian, and have the talents that make a good poet. Poetry heightens and improves nature. The moralist incites mankind to good actions and to shun vice. Finally, revealed religion conducts the human soul to the gates of Heaven. By invention the painter converts sacred and ancient history into *istoria*, while 'keeping within the bounds of probability'.[3]

Vertue records the sequence of major events in history painting from shortly before and during the period in which he kept a record (1713–54) as follows: the invasion and domination of the Venetians, most of whom were already established when his record begins and whose earlier work was therefore discussed retrospectively; the rise of Thornhill; the consequent withdrawal of the Venetians; Burlington's promotion of William Kent over Thornhill and other rivals; the decline of patronage for high art executed by living artists, and the struggle of Thornhill's son-in-law Hogarth to succeed him as a Bible painter after the tide of taste had turned. He highlights the intrigues to secure royal and ecclesiastical commissions. He repeatedly makes three complaints about the attitude of private patrons. First, noblemen were so intent on collecting Old Masters that they overlooked living talent. It clearly gave him pleasure to tell stories about Sebastiano Ricci's forgeries.[4] Secondly, capable history painters were chiefly valued as restorers. Thirdly, patrons preferred to have their portraits painted, rather than commission decorative paintings with Biblical and classical subjects. In placing the blame on patrons for their indifference or neglect he made it clear that in his own opinion there was no lack of available talent. He hands out the title of history painter to a surprisingly large number of artists whose

[1] *Vertue*, III. 23. [2] *The Theory of Painting* in *Works*, 1792, 9.
[3] Ibid. 21. [4] *Vertue*, IV. 82.

gifts for invention can today be best judged by book illustration, the underground channel by which traditions of *istoria* were kept alive in England at this period when the supply of patrons willing to give over the walls and ceilings of their mansions to grandiose decorative painting was a dwindling one.[1]

The supreme goal of a history painter was to become the first painter of a court. In England the position had been most notably filled by foreigners, in fact if not in title: Holbein, Rubens, Van Dyck, Lely, and Kneller. Since the office of Serjeant Painter had been established in 1511–12, it had been held generally for life or until advancing years made the occupant unfit.[2] With the exception of Rubens, the foreign artists who eclipsed the Serjeant Painters at court had been mainly employed in portraiture. Charles II had appointed the native Robert Streater as his Serjeant Painter. Although Charles preferred conferring honours to paying salaries, he did not knight Streater and gave him little employment. In 1708 the history painters Giovanni Antonio Pellegrini (1675–1741) and Marco Ricci (1676–1729) arrived in England in the suite of the returning British Ambassador to Venice, the Earl of Manchester. In the following year Marco, who had quarrelled with Pellegrini, returned to stay with his uncle Sebastiano Ricci (1659–1734), whom he brought back in 1712. The object was to secure one of the most spectacular prizes Europe then had to offer, the commission to paint the cupola of St. Paul's, a task for which Sebastiano had excellent qualifications.[3]

[1] The leading authority on book illustration by history and genre painters in the eighteenth century is H. A. Hammelmann, whose magisterial research has been mainly published in articles in the *Connoisseur*, *C.L.*, and the *Book Collector* from 1950.

For history painting generally the definitive study is E. Croft-Murray, *Decorative Painting in England, 1537–1837*, 2 vols., 1962, 1970.

[2] See Tancred Borenius, 'The Serjeant Painters', *Burl. Mag.*, Apr. 1944, for a complete list with dates of appointment. The first to have the status of a First Court Painter was probably Robert Streater, appointed in 1679.

[3] For Sebastiano Ricci in England see Benedict Nicolson, 'Sebastiano Ricci and Lord Burlington', *Burl. Mag.*, Mar. 1963; F. J. B. Watson, 'Sebastiano Ricci as Pasticheur', *Burl. Mag.*, Oct. 1948, and O. Osti, 'Sebastiano Ricci in Inghilterra', *Commentari*, II, 1951. For Pellegrini see M. Goering, 'T. Pellegrini-Studien' in *Münchner Jahrbuch der bildenden Kunst*, 1937–8, and for the activities of the Venetians generally see E. Croft-Murray, *Decorative Painting in England 1537–1837*.

A fine decorative painter and magnificent colourist, he had been trained in Bologna and had settled in Venice in 1700, where he was deeply impressed by Veronese, whose style he transmitted to his nephew Marco, Pellegrini, and Tiepolo. The young Tiepolo can be so close to Sebastiano Ricci that the latter's work has sometimes been attributed to him.[1] Neither the Riccis nor Pellegrini belong to the story of Georgian painting.[2] What is historically important in this context is the reason for their departure.

When Sebastiano Ricci lost the commission to paint the ceiling of the Prince of Wales's bedchamber at Hampton Court, Vertue recorded the intervention of Charles Montague, Earl of Halifax, the First Lord of the Treasury, whom Colin Campbell praised as 'the great Maecenas of our age'.[3] The Earl spoke against Sebastiano to the Lord Chamberlain, the Duke of Shrewsbury, as follows: 'His reason was this, that Mr. Thornhill our Country man has strove against all oppositions and dificultys and now had got near the very Top of the Mountain and his grace woud thro' him down and crush all his endeavours, wich woud prevent and discourage all our country men ever after to attempt the like again.'[4] According to Vertue, Pellegrini had made several designs and models for decorating St. Paul's, for which he was paid before he left for Düsseldorf in 1713. This left the field open to Laguerre, Thornhill, and Sebastiano Ricci. If Pellegrini had not withdrawn, it would have been difficult, on grounds of merit, to choose between the two Venetians. As it was, the nationalist party triumphed. Thornhill was chosen on 28 June 1715. In the following year Sebastiano departed in disgust from England with his nephew Marco, 'when he found it was resolvd Mr. Thornhill shou'd paint the Cupolo of St. Pauls for he was in expectation of that work'.[5]

Thornhill finished the eight *Stories from the Life of St. Paul* in September 1719.[6] They are in grisaille, and it is idle to speculate

[1] See Ursula Hoff, *Catalogue of European Paintings before Eighteen Hundred*, National Gallery of Victoria, Melbourne, 1962, 108, for a painting attributed to Tiepolo, now accepted as by Sebastiano Ricci.

[2] Their work has therefore been discussed in O.H.E.A. VIII.

[3] *V.B.* I. 5. [4] *Vertue*, I. 45. [5] Ibid. 39.

[6] Ibid. 62. For the St. Paul's paintings see Croft-Murray, op. cit., and O.H.E.A. VIII, 310 ff.

whether Sebastiano would have secured approval of a scheme in colour. The Englishman was now alone at 'the very Top of the Mountain'. In 1716 when he began he was still engaged on the ceiling at Blenheim; in the year he finished he signed the *Stories from the Aeneid* at Charborough Park. He completed the painting of the Earl of Oxford's Chapel at Wimpole [plate 26B] in 1724. His heroic labours at Greenwich continued until 1727. While his prodigious achievement has been appropriately discussed in the preceding volume, its impact was one of the main artistic phenomena of the reign of George I. The spectacle of an English artist wholly relieved from the drudgery of portrait painting in order to decorate churches and princely buildings with grandiose subjects from the Bible and classical mythology haunted the imagination of artists throughout the century. Hogarth, as an apprentice, was so impressed by the work at Greenwich and St. Paul's that he determined to become a history painter.[1]

Antonio Bellucci (1654–1727) arrived in London in the same year in which the Riccis left. He was employed by the Duchess of Buckingham to decorate a ceiling at Buckingham House, but his principal patron was the Duke of Chandos, for whom he painted the ceiling of the chapel at Canons, completed by August 1720. When the chapel was demolished in 1747–8 the second Lord Foley purchased its decorative fittings and adapted them to the church his father had begun to build at Great Witley [plate 26A]. This small parish church with its rococo decoration in gilt papier mâché by Pietro Martire Bagutti and stained glass windows by Joshua Price after designs by Francesco Sleter has been described as 'a complete and almost untouched example of Venetian *settecento* decoration', all the more valuable because most of the ecclesiastical and much of the domestic decoration undertaken by Venetian artists in England has disappeared.[2]

Bellucci had left England, according to Vertue by July 1722, a victim of gout, and died in Italy five years later.[3] The next

[1] *Analysis of Beauty*, ed. J. Burke, 184, 205.

[2] Francis Watson, 'A Venetian Settecento Chapel in the English Countryside', *Arte Veneta*, Venice, 1954, 295–302, and C. H. Collins Baker and Muriel I. Baker, *James Brydges First Duke of Chandos*, Oxford, 1949, Chapter VI, 'Canons'.

[3] *Vertue*, III. 6.

important Venetian to arrive was Jacopo Amigoni (1675–1752), who worked in England from 1729 to 1739.[1] By this date the star of Kent had succeeded that of Thornhill. At the beginning of March 1722 'a mighty mortification fell on Sr. James Thornhill' when Kent was summoned to paint the King's new apartments at Kensington Palace. Indeed this further evidence that royal patronage was likely to favour Englishmen may have contributed as much as the gout to accelerate Bellucci's departure. Vertue also tells us that Lord Burlington forwarded his protégé's interests at court and 'strenuously oppos'd Sr. James'.[2] The commission was as splendid an opening as any history painter could desire; it led from the decoration of the Cube or Cupola room (1722), intended for royal entertainments in the evening, to the painting of the ceilings of the Presence and Council Chambers (1724), the King's Gallery (1725), the King's and Queen's Drawing Rooms, and the Grand Staircase, perhaps the best-known of all Kent's decorations [plate 27A].[3] The last is an ambitious attempt, at once laboured and slapdash, to handle the Venetian pageant picture of spectators grouped along the balustrade of a palatial gallery, and for this reason all the more conspicuous as an example of the Englishman's inferiority. The medley of courtiers, pages, yeomen of the guard, curiosities of the royal household like Peter the Wild Boy, Ulric the Young Turk, Honest Mahomet, and his fellow servant Mustapha, to say nothing of Kent himself with two of his pupils and an actress with whom he lived on terms of 'peculiar friendship', does limited credit to the reputable iconographic tradition on which it was based.[4] Its chief merits are liveliness and scenic bravura.

The contemporary reputation of Kent, who shares with Charles Jervas and Benjamin West the dubious honour of being

[1] John Woodward, 'Amigoni as a Portrait Painter in England', *Burl. Mag.*, Jan. 1957. He was in Paris in 1736. See also Croft-Murray, op. cit.

[2] *Vertue*, I. 100.

[3] For Kent's paintings at Kensington see M. Jourdain, *The Work of William Kent*, 1948; *Kensington Palace: an Illustrated Guide to the State Apartments*, H.M.S.O., 1958; Trenchard Cox, 'William Kent as a Painter', *Artwork*, 1930, vi. 25; and Croft-Murray, op. cit.

[4] W. H. Pyne, *The History of the Royal Residences*, 1819, II. 32.

hailed as Raphael *redivivus* in eighteenth-century England, was founded on Burlington's patronage.[1] Gay tells us that the Earl's judgement could trace in the painter's stroke 'Titian's strong fire and Guido's softer grace'.[2] But this admiration was shared by others, as the spate of commissions shows. Lord Lichfield chose him to paint the Assembly of the Gods on the ceiling of the Hall at Ditchley (1726) and stories from the *Aeneid* in framed compartments of the wall below; the Prime Minister followed suit with the commission of the Aurora ceiling of the State Bedroom (completed 1731) at Houghton. He executed Fame inscribing the name of Pope on the ceiling of the Hall at Raynham (*c.* 1730) for Lord Townshend, and the Parlour ceiling of Venus, Ceres, and Bacchus for General Dormer at Rousham. None of these deserves to be bracketed in the same class as Pellegrini's mythological canvases (before 1713) let into the wainscoting of the great hall at Sir Andrew Fountaine's seat at Narford in Norfolk, Sebastiano Ricci's work in the chapel at Chelsea Hospital, or Amigoni's series illustrating the story of Jupiter and Io at Moor Park for Mr. Styles.

Vertue described the decoration of the Cupola Room at Kensington Palace as 'a terrible glaring show. & truly gothic', a memorable example of 'gothic' as a term of abuse without any period identification.[3] Hogarth devoted one of his wittiest engravings to ridiculing the altar painting 'with which Kent's evil genius prompted him to decorate St. Clement Dane'.[4] In this he singled out his incompetence as a draughtsman in a Woelfflin-like analysis of the ambiguities of the painterly mode of perception. Walpole, an enthusiastic admirer of Kent for his achievements in gardening and architecture, dismissed him as 'below mediocrity' in painting. But in one respect Kent's decorative work is of crucial importance: it decisively affected the future of history painting

[1] Cf. the eulogy of Kent by John Gay, *Poems on Several Occasions*, 1720, 'Epistle to the Rt. Hon. Paul Methuen':

> There on the walls let thy just labours shine,
> And Raphael live again in thy design.

[2] Ibid. Cited by M. Jourdain, *William Kent*, 69. [3] *Vertue*, III. 19.

[4] Austin Dobson, *William Hogarth*, 1898, 20.

in England by popularizing the typically Kentian interior, widely imitated by others, in which pictorial decoration is eliminated.

The Cupola Room at Kensington Palace is architectural and sculptural, not pictorial, in its decorative scheme. White marble doorways intrude like aedicules into the room, and the projection of the cornice is enhanced by a *trompe-l'œil* shadow painted across the lower part of the north cove. The aedicular motive of the doorways is repeated in niches occupied by gilded statues of gods and goddesses, and above them marble brackets support the frames of a series of portrait busts. It contrasts therefore with Kent's ambitious decorative painting in other rooms. Recent writers have stressed the use of canvas, more suitable to the English climate, as a factor which favoured the reduction of wall-space devoted to pictorial decoration, a process which culminated in the Angelica Kauffmann 'insets' in the mural schemes of Robert Adam. From the very beginning of his career Kent provided his patrons with both pictorial and architectural schemes for decorating rooms of state. His credentials for ceilings and wall paintings were considerable: they included Benedetto Luti as his master, two silver medals from the Pope, the first admission of an Englishman to 'the Duke of Tuscany's Academy of Artists', and the commission to paint the ceiling of San Giuliano dei Fiamminghi in Rome, the largest extant memorial of an English painter's presence in Italy.[1] Despite Vertue's strictures on the Cupola Room, Kent's ornamental schemes were as far above mediocrity as his history paintings were below it. The impact of his success in architectural, as opposed to pictorial, decoration must be taken into account with other factors, the preference for canvas already mentioned, the parallel reduction of pictorial space in rococo decorative schemes, the increasing domination of the architect over the interior, and the need of wall space for portraits of the living as well as the dead, to say nothing of the pictures brought back from overseas. By supplying a non-pictorial decorative alternative of comparable splendour and grandeur of association with history painting, Kent enabled patrons to compare his success in the one

[1] For the ceiling of San Giuliano see E. Croft-Murray, 'William Kent in Rome', *English Miscellany*, I. 1950.

with his failure in the other at a time when he was being put forward by Burlington as the best history painter in the country. Once the Venetians had left there was really very little to choose between the native practitioners, so that the neglect of history painting during this crucial period can be defended on grounds of taste.

Thornhill's competitors for the dome of St. Paul's were two Frenchmen and two Italians.[1] On the whole the Italians did not assimilate as well as the other foreigners, perhaps because they were the most talented and therefore critical, and they played a less active part in the academic movement. The first Subscription Academy was founded by a group headed by Kneller on St. Luke's Day, 18 October 1711, and set the model for later ones.[2] In addition to Kneller as Governor there were twelve Directors, all elected, and some sixty members. Among the Directors were three history painters, Pellegrini, Laguerre, and Thornhill. It ran until 1716, when Kneller resigned and Thornhill took over. It was known as the Great Queen Street Academy, but Vertue sometimes refers to it simply as Kneller's Academy.

Thornhill's Governorship of the Great Queen Street Academy lasted from 1716 to 1720, when he was deposed. He later tried to interest Lord Halifax in a proposal to build an Academy for Paintings.[3] He was the obvious man to be President, for he had been appointed History Painter to George I in 1718 and in 1720 succeeded a nonentity, Thomas Highmore, uncle of the well-known Joseph, as Serjeant Painter. The move was, as one might have suspected, strongly opposed by Kneller. The struggle inside the academic movement at this stage was one of personalities, not principles. Neither Kneller nor Thornhill was acceptable to the artistic profession generally, and each was criticized for being too autocratic.

[1] E. Croft-Murray, *Decorative Painting in England 1537–1837*, I. 72.

[2] For the early history of the subscription academies see the Vertue Index, *Walpole Society*, XXIX, 1947 under 'Academies'; W. T. Whitley, *Artists and their Friends in England*, I, chapters I and II; John Pye, *Patronage of British Art: an Historical Sketch*, 1845, chapter I; and Sidney C. Hutchison, *The History of the Royal Academy 1789–1968*, London, 1968, chapter II.

[3] *Vertue*, III. 74. Although Vertue used the plural, he presumably meant an Academy and not a Gallery.

The party that deposed Thornhill was headed by Louis Chéron (*c.* 1655–1725), a French history painter who had worked in Rome, and the native-born John Vanderbank (*c.* 1694–1739), whose father was born and trained in Paris. This was the end of the Great Queen Street Academy, for they abandoned the rooms there and set up a new Academy in St. Martin's Lane, where Hogarth enrolled in the first year. As a rearguard action Thornhill accepted fee-paying pupils in a school at his own house in Covent Garden. The St. Martin's Lane Academy under Chéron and Vanderbank was run on democratic lines and was sufficiently successful for Thornhill to have second thoughts. In 1724 he converted his fee-paying school into a free Academy. Nevertheless, the St. Martin's Lane Academy is the key body, for a year after Thornhill's death in 1734, Hogarth transferred his equipment to the elective institution and put such new life into it that it became known as Hogarth's Academy. It was through this Academy that the survivors of the French history painters kept the traditions of academic classicism alive.

Two lessons emerge from this sorry story of bickering. Only an Academy under an English leader stood any chance of success, and the major artists had to unite before royal patronage could be obtained. Neither of these conditions was fulfilled until the death of Hogarth in 1764 cleared the way for the acceptance of Reynolds as head of the profession. For Hogarth was violently opposed to the concept of a royal Academy on the French model, which he regarded as tantamount to putting art into the hands of the connoisseurs. But he both grasped and approved the prime function of an Academy, namely to train history painters, and devoted much of his energies to attempts to promote history painting through bodies like St. Bartholomew's Hospital [plate 27B] and the Foundling Hospital, and especially the Vauxhall Gardens project. Characteristically, he was not merely concerned to turn out history painters but wished to ensure that they had an outlet for employment as well.

The story of what Guiseppe Fiocco has described as 'the wandering masters of the new Venetian painting' comes to a conclusion in England with Jacopo Amigoni, who after Thornhill's

death was so vastly superior to the native history painters that his eclipse by Kent is one of the scandals of Burlingtonian patronage.[1] Despite his work at Moor Park and several London houses now demolished, he was forced to turn from *istoria* to portraits, 'tho its not his inclination'.[2] But his practice was profitable and back in Venice with a small fortune he persuaded Canaletto to visit London (1746).[3] In picking a topographical and not a history painter for this friendly advice he made a shrewd assessment of English taste.

The fate of the Venetian painters may be compared with the fortunes of two of the most distinguished architects to seek work in England, the Florentine Alessandro Galilei, who arrived in England in 1714 and stayed for five years, and Filippo Juvarra, who came to London in 1720. Galilei, who in 1732 was to win the competition in Rome for the façade of St. John Lateran, left little trace of his talents in England although he submitted designs for a Royal Palace at Westminster, some for the 'Fifty New Churches' of the Act of 1711, and a number of country houses.[4] England cannot be accused of neglecting the great Turin architect, already 'First Architect' to King Victor Amadeus of Savoy, because his visit was little more than a trip during his journey to Portugal and France in 1719–20. But the opportunity to employ him was presumably available.

With the decline of history painting, the prestige and practice of 'the great style' passed by default into the category of portraiture, for the landscape painters were not in the running to support it. In a notice of Allan Ramsay, George Vertue eulogized 'the

[1] G. Fiocco, *Venetian Painting of the Seicento and the Settecento*, Florence and Paris, 1929, 47–8. Cf. E. Croft-Murray, op. cit.; John Woodward, 'Amigoni as a Portrait Painter in England', *Burl. Mag.*, Jan. 1957, and E. K. Waterhouse, *Painting in Britain*, 91, 94.

[2] *Vertue*, III. 62. A major history painting by Amigoni is *The Return of the Prodigal Son* at Emmanuel College, Cambridge, 1734, with a grandiose architectural background.

[3] *Vertue*, III. 130, 132. For Canaletto and his influence in England see the studies by Hilda F. Finberg in the *Wal. Soc.* IX and X, 1921 and 1922, and W. G. Constable, *Canaletto*, Oxford, 1962.

[4] Ilario Toesca, 'Alessandro Galilei in Inghilterra', *English Miscellany*, ed. M. Praz, III, 1952, and Colvin, *D.E.A.* 220. Galilei also visited Ireland in 1718.

valuable Manner' of Dahl, Kneller, Lely, Riley, Dobson, Van Dyck, Rubens, 'or Titian'.[1] The attempt to trace a genealogy back to Titian was sound historically, but in this case evolution was not progress. In 1731 he even went so far as to describe Dahl, Richardson, and Charles Jervas as 'the three foremost Old Masters'.[2] One of the finest portraits painted by Dahl in the reign of George I is the full length of Nicholas Leake, 4th Earl of Scarsdale (1719), now in the National Museum, Stockholm, but he essentially belongs to the age of Queen Anne. Jonathan Richardson the Elder (1665–1745) in his grander portraits, like *Lord Chancellor Cowper* at Panshanger and John Carmichael, 3rd Earl of Hyndford (1726) in the Scottish National Portrait Gallery, might be described as Kneller moralized, as befitted the theorist of elevated portraiture.[3] Charles Jervas (c. 1675–1739), the weakest of the three, studied under Kneller before going to Italy. His career has points of resemblance with that of Kent, for he had the same gift of talking plausibly about himself and the Old Masters in the same breath. Like most of Kneller's pupils, he was never properly trained to draw, and when Vertue wrote that his work reminded him of fan-painting he drew attention to almost the only merit he had acquired from Van Dyck and Titian, whose fine silks he had assiduously copied.[4]

In tracing the parallel evolution of the elevated and humane portrait it is necessary to avoid the facile conclusion that the first Georgians preached a doctrine of high art that they could not practise. The two modes are interconnected. During the heyday of Richardson the polite mask of the Augustan age underwent a transformation.[5] It is typical of this period that the dressing-gown with its ample folds, the loosely twisted neckcloth, and the cap or

[1] *Vertue*, III. 96. [2] Ibid. 54.

[3] The portrait of Lord Chancellor Cowper is illustrated in Waterhouse, *Painting in Britain*, plate 89.

[4] *Vertue*, III. 17.

[5] David Piper, *The English Face*, London, 1957, chapters 6 and 7. For Horace Walpole's amusing comments on informality versus formality in costume see *A. of P.* III. 242. Cf. R. Rey, *Quelques Satellites de Watteau*, Paris, 1931, 84, who observes that at this time the formal baroque state portrait was translated into a more human and intimate document.

turban are preferred to the peruke and panoply of Court dress, not merely for portraits of artists and men of letters but also for noblemen who wished to be commemorated for their learning or patronage. In other words, the ideal of informality was itself an aristocratic one. In 1718 Richardson's patron, Edward Harley, second Earl of Oxford, paid for his portrait of Matthew Prior now at Welbeck Abbey.[1] In 1738 Richardson painted George Vertue, a tribute from the theorist to the annalist.[2] In both cases the mode chosen was informal. The key to what might otherwise appear as a parting of the ways from the great style is the sobriety of interpretation. In fact, the prototype of the Vertue portrait is Raphael's Baldassare Castiglione, from which Richardson has simply eliminated the base of clasped hands. Informality, what Vertue called a 'natural, easy style', is elevated by *grazia* and *decoro*.

In 1731 Vertue listed the Scotsman John Smibert, already in Boston where he transmitted the Augustan modes to New England, Thomas Gibson, John Vanderbank, Joseph Highmore, Bartholomew Dandridge, and William Hogarth as representatives of 'the next class' after Dahl, Richardson, and Jervas, that is, 'those (generally) that studied in the Accademys here, under Sr. G. Kneller, Sheroon Laguerre Thornhill'.[3] With the exception of Smibert, Gibson, and Vanderbank, who appears to have introduced with John Robinson of Bath portraits of sitters in Van Dyck costume as a fashionable mode in the early 1730s,[4] the members of this second class became highly active as pioneers of the English rococo. Vertue first mentions Thomas Hudson (1701–79) in 1733.[5] In 1746 this successful, if generally somewhat dull, portrait painter presented to the Foundling Hospital a portrait of its architect, Theodore Jacobsen [plate 28B], in a pose which clearly derives from the *Craggs Monument* in Westminster Abbey by Giovanni Baptista Guelfi [plate 28A]. The history of this pose throws an interesting light on the transformation of the great

[1] See *Commemorative Catalogue of the Exhibition of British Art, Royal Academy, 1934*, 1935, 17 and plate XXA.

[2] In the National Portrait Gallery, London. [3] *Vertue*, III. 54.

[4] See J. L. Nevinson, 'Vandyke Dress', *Conn.*, Nov. 1964.

[5] *Vertue*, III. 66.

style into an informal one. Its main source is the Pothos or 'Longing' Statue in the Conservatori Museum, an obvious model in Classical Antiquity for a funerary monument.[1] It had the additional merit of being singled out for praise by Pausanias (I. 43. 6). But Guelfi also made use of another famous masterpiece on the Capitol, the marble satyr attributed to Praxiteles, with its torso leaning on a pedestal and one arm akimbo. It was the Pothos arrangement of the legs, however, that captured the imagination of the Georgians. They are elegantly crossed, with the bent one resting on its toes. What had originally been noted and used in an elegiac context now became a symbol of well-bred negligence. Whereas Craggs is clothed in classical drapery, Jacobsen is dressed like a gentleman of fashion and looks alertly at the spectator, the Richardsonian image of an absent relation or friend brought to mind. Thereafter every major fashionable portrait painter of the age took up the pose, some, like Gainsborough and Reynolds, using it repeatedly. Hudson was not in fact the first to borrow it, but the public and permanent exhibition of his work at the Foundling Hospital must have made it as widely known in painting as the Craggs monument in sculpture. An early candidate for the credit of its introduction into English painting is Allan Ramsay, whose portrait of the Hon. John Bulkeley Coventry was painted *c.* 1740.[2]

At the end of October 1737 Vertue made his longest entry on the most informal of all the new modes of portraiture, the conversation piece, which had come into fashion towards the end of the 1720s. He related the category to its sources by referring to 'conversations done over a hundred years ago—by Teniers, Brower, Breugil, Watteau and some of those Flemish Masters of the Schoolars of Rubens, Vandyke, and indeed some painters lately here'. By this list he correctly identified its sources as informal group portraiture in the Low Countries, on a small scale influenced by genre, and on a large scale influenced by Rubens, and informal group portraiture in France, influenced by the *fêtes galantes* and *fêtes champêtres* of Watteau, himself a follower

[1] Reproduced in Gisela Richter, *A Handbook of Greek Art*, London, 1959, plate 199. I am indebted to Mr. Christopher Uhl for identifying this source.

[2] Alistair Smart, *The Life and Art of Allan Ramsay*, 1952, plate V.

of Rubens and Van Dyck in his youth. He described the conversations of Gawen Hamilton as follows:

peices of Conversations—family peeces—small figures from the life in their habits and dress of the Times. well disposd gracefull and natural easy actions suteable to the characters of the persons and their portraitures well toucht to the likenes and Air, a free pencill good Colouring and ornamented or decorated in a handsom grand manner every way Suteable to people of distinction.[1]

In an entry dated 1736/7, he commented on the informal portrait groups of Philip Mercier, the most important figure among those who practised in the category before Hogarth took it up: 'peices of some figures of conversation as big as the life conceited plaisant Fancies and habits. mixt modes really well done—and much approvd off'.[2]

The term 'conversation piece' derives from *conversazione* in the sense of a party or recreational gathering of persons who are socially connected.[3] Following the observations of Vertue and his many descriptions or titles indicating a recreational and proprietary setting, e.g. a card party, a music party, or a club of virtuosi in a private house, garden, or tavern room, the conversation piece may be defined as an informal portrait group in a familiar private and proprietary setting, with an emphasis on recreation, a precise attention to costume and accessories, and

[1] *Vertue*, III. 81. Vertue does not mention any Italian practitioners, but a notable example is Giulio Pignatta's conversation piece of Sir Andrew Fountaine, s. and d. 1715. An important Dutch predecessor working in England is Egbert van Heemskerk, see F. Saxl, 'The Quaker's Meeting', *J.W.C.I.* VI, 1943, 214–16.

[2] *Vertue*, III. 82.

[3] Cf. 'conversatio mortalium' in C. Cornelius Tacitus and other classical writers in the sense of familiar association; 'conversatio' defined as 'manner of living, behaviour', in J. H. Baxter and Charles Johnson, *Medieval Latin Word-List*, London, 1934, 104, with examples going up to 1549, and the comment in Hachette's *Dictionnaire de la langue française*, 1863 ed.: 'Conversari signifie proprement être retourné fréquemment . . . Converser dans l'ancienne langue n'a que le sens de vivre avec; c'est plus tard qu'il a pris, par une déduction facile à concevoir, celui d'échanger les paroles'.

All Italian dictionaries giving historical usages record the meanings of familiarity and mode of life. Even in modern English the word *conversazione* has survived in the sense of a reception with some form of entertainment, e.g. the annual conversazione held at King's College in the University of London.

frequently some measure of playful invention. Smallness and playful invention are optional for Vertue. Hogarth almost invariably introduced 'conceited plaisant Fancies', whereas others, notably Arthur Devis, rarely did. The distinguishing feature of the English category is the stress on the proprietary. The lady gives a tea party in *her* parlour, the sea captain a drinking party in *his* cabin, the nobleman arranges a fishing party in *his* park, the club of artists or musicians meet in *their* reserved room in the frequented tavern. In many cases the party is simply a family one, with chaplain, tutor, or governess, and perhaps a close relation or intimate family friend. Familiarity among the members of the group is essential, and if possible the place should be familiar as well, in a category which constitutes the supreme visual expression of the cult of informality and recreation among the upper classes in eighteenth-century England.[1]

In 1706 B. Buckeridge in his *Essays towards an English School of Painters* described the late Marcellus Laroon the Elder, who was trained in history painting at the Hague, as 'famed for pictures in little, commonly called conversation-pieces', by which date he probably meant not portrait groups but genre pictures of society as well as low life.[2] His son, Marcellus Laroon, also became a noted practitioner, but the major figure is Philip Mercier (1689–1760), a Huguenot who studied at the Berlin Academy under Antoine Pesne. He settled in London *c.* 1725 and in February 1729 became principal painter and librarian to Frederick, Prince of Wales, a patron who encouraged the *avant-garde*. Mercier engraved after Watteau, and like Gravelot and 'Old' Joseph Nollekens later, did much to associate the category with the French master's iconography and style.

His conversation piece of *Viscount Tyrconnel with members of his Family in the Grounds of Belton House* [plate 29A; 1725–6]

[1] Cf. the observation of Kenneth Clark, Vorwort zum Katalog, *Twee Eeuwen Engelschen Kunst*, Amsterdam, 1968: 'English art in the eighteenth century is a social art.'

[2] This was first published as an addition to De Piles's *Art of Painting* (1706), and is here cited from the third edition, n.d. London, 401. For the Laroons see Robert Raines, *Marcellus Laroon*, London, 1966 (Paul Mellon Foundation Studies in British Art), with a full bibliography.

introduces the favourite rococo motive of the swing.[1] The family party is grouped around the airborne Miss Darrell, whose motion comically distracts the black page attending Lady Tyrconnel in a wheel-chair. Lord Tyrconnel familiarly chats with the artist sketching in the foreground. Belton House, near Grantham, Lincolnshire, an important classicist mansion built between 1685 and 1688, is given pride of place in the background. Like some contemporary French paintings, e.g. by Robert Tournières, the picture shows a party interrupted by the spectator, not posed before the artist.

Bartholomew Dandridge (1691–c. 1754), Joseph Highmore (1692–1780), William Hogarth (1697–1764), Gawen Hamilton (c. 1698–1737), George Knapton (1698–1778), Francis Hayman (1708–76), Charles Phillips (1708–47), and Arthur Devis (1711–87) were the leading native artists to take up the conversation piece in its formative stage.[2] Dandridge is the most purely rococo; Hamilton and Phillips tend to follow the realistic lead of Hogarth, who after 1732 rarely uses in his conversations imaginary baroque accessories, justifying Vertue's early reference to 'a handsom grand manner'. Gawen Hamilton's *A Conversation of Virtuosi* (1735) [plate 29B] is a notable example of the more serious type. As befits a circle of connoisseurs, the scene is framed by imaginary drapery at one side, and the group is posed as a tableau.[3] The group of 'Virtuosis', for Vertue preferred the seventeenth-century term, shows from left to right: Vertue, the engraver and antiquary;

[1] See Ralph Edwards, *Early Conversation Pieces from the Middle Ages to about 1730,* 1954, 166. Other transmitters of French influence mentioned by Vertue are James Parmentier, in England 1676–1730, and Preudhomme, in England c. 1712–26. Maurice Quentin de La Tour visited London before settling in Paris in 1724. For Mercier see also Geoffrey W. Beard, 'A Royal Painter in Yorkshire', *C.L.,* 7 Aug. 1958.

[2] In addition to the monograph of Edwards see G. C. Williamson, *English Conversation Pictures,* 1931; Sacheverell Sitwell, *Conversation Pieces,* 1936; the valuable observations of E. K. Waterhouse in *Painting in Britain,* 140: John Cornforth, 'Intimacy of the Conversation Piece', *C.L.,* 1 July 1965, and the introduction by Rose Harris in *The Conversation Piece in England,* The Iveagh Bequest, Kenwood, 1965. See also M. Praz, *Conversation Pieces* (Eng. trans.), 1971.

[3] Hilda F. Finberg, 'Gawen Hamilton: An Unknown Scottish Portrait Painter', *Wal. Soc.* VI, 1918, 52, discusses the painting at some length. For a sketch and key see *Vertue,* III. 71.

Huysing and Dahl, the 'Old Masters' of portraiture; William Thomas, gentleman and connoisseur; James Gibbs the architect; Matthew Robinson, gentleman and amateur painter; immediately above him, Joseph Goupy, history painter and later art adviser to Frederick, Prince of Wales; Charles Bridgeman, principal gardener to George I; Bernard Baron, reproductive engraver, then a profession of the highest status; Wootton, the landscape painter; Rysbrack, the favourite sculptor of the Burlington circle; Gawen Hamilton, and William Kent. The artist has shown the most subtle attention to personal relationships and professional importance. Gibbs looks towards Vertue and Huysing, and next to Huysing is Dahl, whose widow's will he later witnessed. All four in this group within a group were Roman Catholics. Wootton and Rysbrack figure in the same set as Kent, who imitated landscape painting in his gardens and collaborated with the sculptor.

'Bei Devis', writes T. Sommer of the youngest member of the conversation painters who developed the English category, 'fehlt die Bewegung.'[1] The same absence of movement has been noted in a characteristically colourful passage by Mario Praz:

> Barely more animated are the English conversation pieces where, if the adults have the stylised hauteur of fish in brilliant livery, the little ones of the family, arrested by the painter in playful or light-hearted moments, suggest the image of darting minnows among the motionless intent, mature fish. And these aquariums are lighted by the eighteenth century sun which seemed fated never to set.[2]

There are too many exceptions to justify the generalization, which is nevertheless of value in drawing attention to the mood of a human still life, an *Existenzbild*, in some of the paintings.

The last group in Hamilton's painting appropriately introduces the third category of landscape painting, for Wootton is linked with Bridgeman, the painter with the gardener, by Baron who engraved the former's work. 'I confine the sublime', wrote

[1] See *Die Raumstellung in der englischen Landschaftsmalerei*, Inaugural Dissertation, Albert-Ludwigs-Universität in Freiburg i. Br., 1940, 3–8, for a discussion of the conversation piece. For Devis see Sydney H. Pavière, 'Biographical Notes on the Devis Family of Painters', *Wal. Soc.* XXV, 1937, and id., *The Devis Family of Painters*, 1950.

[2] *An Illustrated History of Interior Decoration from Pompei to Art Nouveau*, London, 1964, 148.

Richardson, 'to history, and portrait Painting.'[1] The struggle to elevate landscape painting was handicapped in English by its associations with Dutch realism and proprietary topography. Nevertheless, the cult of Claude by English collectors was beginning to make its impact.[2] Vertue's system of classification is a very simple one, generic identification with a particular master, a method of historical placing later adopted by Walpole. Vertue was alive to a Gaspardesque influence in Wootton, and in 1722 he described Lambert as imitating the same painter. In 1725 he noted a resemblance between Lambert and Salvator Rosa.[3] The invocation of such august names, like the derivation of Dahl from Titian, Streater from Michelangelo, and Charles Jervas from Raphael, does more credit to the optimism than the judgement of the age. Walpole was more discerning. 'Our painters', he wrote, 'draw rocks and precipices and castellated mountains, because Vergil gasped for breath at Naples, and Salvator wandered amidst Alps and Apennines.'[4] In his eulogy of Lambert he sensibly came down on the side of his faithful and unpretentious renderings of English rural scenes.

Walpole himself could be misled by partiality. Thus he described Peter Angellis (1685–1734) as 'a mixture of Teniers and Watteau, with more grace than the former, more nature than the latter'.[5] Like Vertue, who shaped his attitude to art in more ways than he was perhaps aware, he frequently raised the status of his favourites by Continental association. The professional topographers, like Leonard Knyff (1650–1721) and John Stevens (d. 1722), are briefly dismissed, unless some slight link with Dutch and Italian masters can be established, as in the case of the elder

[1] *Works*, 1792, 115. The passage is from *The Connoisseur: an Essay on the whole Art of Criticism* (1719) and shows that after his first bid to promote portrait painting in *The Theory of Painting* (1715) he claimed it for the highest category.

[2] For the Dutch influence see H. V. S. and M. S. Ogden, *English Taste in Landscape in the Seventeenth Century*, Ann Arbor, Mich., 1955, for an analysis of both collectors' taste and the types of Dutch landscape imported into England, and cf. Frank Simpson, 'Dutch Paintings in England before 1760', *Burl. Mag.*, Feb. 1953; and E. K. Waterhouse, 'British Collectors and Dutch Art', *Museums Journal*, Sept. 1956. For Claude see Elizabeth Wheeler Manwaring, *Italian Landscape in Eighteenth Century England*, 1925, second impression, Frank Cass and Co., London, 1965.

[3] *Vertue*, III. 6, 24. [4] *A. of P.* II. 333. [5] Ibid. 266.

Jan Griffier (*c.* 1645–1718) and his sons Robert (1688–*c.* 1750) and John. He praised Peter Tillemans (1684–1734) for preserving 'all the freedom and spirit' of Teniers, whom he copied.[1] The mixture of modes that Vertue noted in his account of the conversation pieces runs right through all the categories of painting, but is especially marked in the oscillation of landscape between the ideal and the topographical.

The Jan Wyck–Siberechts tradition continued to flourish in topographical painting. The Siberechts formula of a wide panoramic view, with or without trees *en coulisse*, and the horizon at the level of a 'prospect piece' taken from a hill, vied in popularity with the bird's-eye view favoured by Knyff, in which less of the sky is shown. In the first half of the century panoramas of famous or frequented excursion scenes were already in considerable demand; indeed the main outlines of British topographical painting from Hollar and Hendrik Dankerts to Peter de Wint and Turner could be traced in an exhibition of paintings of two of the most famous prospects of the environs of London, those from Greenwich Hill and Richmond Hill.[2] Tillemans, a 'various' painter in Vertue's praiseworthy sense of adaptability and combination—for he practised in animal painting, seascapes, *pasticci* of the masters, stage scenery, and ceremonial crowd painting—executed numerous scenes of Newmarket and a pair of views from One-Tree Hill at Greenwich and Richmond Hill for the Earl of Radnor. A turning-point was the arrival of Canaletto in London in 1746. His influence on the Siberechts tradition may be illustrated by Robert Griffier's *Panorama of the City and South London from Montagu House*, signed and dated 1748 [plate 30A], with features which have been convincingly derived from Canaletto's paintings, especially those at Goodwood for the Duke of Richmond, executed in 1747.[3]

[1] Ibid. 291.

[2] See *Views of the Thames from Greenwich to Windsor*, an exhibition organized by John Jacob at Marble Hill, Twickenham, 1968, and *Richmond and Twickenham Riverside*, at Marble Hill, Twickenham, also a Greater London Council exhibition catalogue, 1967.

[3] See the important article by John Hayes, 'A Panorama of the City and South London from Montagu House of Robert Griffier', *Burl. Mag.*, Sept. 1965, also the account of the Griffier family of painters by Hilda F. Finberg, *Wal. Soc.* IX, 1921, 48.

The London Thames had been a favourite subject, but Canaletto gave it a new splendour as a panoramic setting.

Like Tillemans, John Wootton (c. 1682–1764), who began as the pupil of Wyck and later assisted Siberechts, was a 'various' painter prepared to tackle battle pieces, animal pictures including life-sized horses and dogs, and almost every form of sport.[1] Landscape was his first love, and possibly after a visit to Italy, said to have been financed by the Duke of Beaufort, he added decorative paintings in the manner of Claude and Gaspard Poussin to his repertory.[2] The two extremes of his style may be illustrated by one of the first of Newmarket Heath scenes of the period, *Tregonwell Frampton watching the King's Horses* in the Jockey Club at Newmarket and the *Classical Scene* engraved by Vivares. His mixed mode can be seen at its best in the *Members of the Beaufort Hunt* at the Tate Gallery [plate 30B], showing the future 3rd Earl of Lichfield on horseback and his uncle the 4th Earl with a gun, in the coats of the hunt, against a Gaspardesque backdrop. There is something of the conversation piece in the neatness of the figures and the privacy of a family party associated by their costume with another private group of sporting friends, but the decorative setting excludes the associations with a frequented place and proprietary ownership so characteristic of the strict English mode.

George Lambert (1710–65) founded his style on Wootton's Gaspardesque phase, as Vertue noted in 1722. His evolution towards naturalism reverses the direction taken by Gainsborough later, and seems to have escaped Constable, who may have known only his Italianate works, for he dismissed him as 'another English

[1] The main authority is still George E. Kendall, 'Notes on the Life of John Wootton, with a list of engravings after his Pictures', *Wal. Soc.* XXI, 1933. Cf. Guy Paget, 'John Wootton, Father of English Sporting Painting 1685–1765', *Apollo*, May–June 1944; Denys Sutton, 'John Wootton Recognised at Last', *C.L.*, 4 Dec. 1958, and Oliver Millar, 'John Wootton, William Hogarth and Frederick Prince of Wales', *Burl. Mag.*, July 1961, with the authorities cited. The date of his death is 1764, not 1765 as frequently stated.

[2] Vertue mentions his careful studies of Gaspard Poussin, but not his having been in Italy. The authority for his visit to Italy, Sir Walter Gilbey, *Animal Painters in England*, 1900, cited no reference.

imitator of Italian art, but even below Wooton'.[1] Quite early in his career he became intimate with Hogarth, from whose appearance on the scene Constable dated the rebirth of European painting from its second Dark Age of Degradation. As he is known to have painted landscape backgrounds for Hogarth, Constable may have been giving credit to the latter due to the former.

Lambert also collaborated with Samuel Scott, another member of Hogarth's *avant-garde* set, in an important commission for the East India Company as early as 1732.[2] The link with marine painting is important, for it is here that the most striking advances in naturalism and *plein-air* sketching are made. A school of Thames Estuary painters was formed, the common hero being the elder Van de Velde, who lived at Greenwich to study shipping and called his expeditions in the boat of a Thames waterman, 'going a skoying'.[3] There is a strong bias to topography, supported by the example of the younger Van de Velde, whose bird's-eye views of battles are sometimes almost map-like. There is also an insistence on accuracy of technical detail in portraying ships, characteristic of the seafaring patron. Jane Austen drew on a long line of patron anecdotes when she made Admiral Croft in *Persuasion* exclaim, 'What queer fellows your fine painters must be!'[4] The Thames Estuary School were not fine painters in this pejorative sense. Vertue never applies the criterion of the great style to their work, which he described simply as 'views of shipping'. He praised Peter Monamy (*c.* 1683–1749) for his 'understanding in the forms and buildings of shipping with all the tackles ropes and sails etc.' and for his 'neatness and clean pencilling of sky

[1] Fourth Lecture at the Royal Institution, 1836, printed in C. R. Leslie, *Memoirs of the Life of John Constable*, 1845, 352.

[2] *Vertue*, III. 63, stating that the buildings and landscapes of six Forts and Settlements were by Lambert, the shipping by Scott. For a discussion of the paintings after they passed to the India Office see C. H. Collins Baker and M. R. James, *British Painting*, 1933, 82–3.

[3] The first to recognize the importance of this group was Hilda F. Finberg in her discussion of Thames painters in *Wal. Soc.* IX. 47–54. She notes a further link with the Dutch estuary painters in Jan Griffier the Elder who came from Amsterdam and purchased a boat in which he lived with his family, painting views of the river between Gravesend and Windsor.

[4] Cited by Oliver Warner, *An Introduction to British Marine Painting*, 1948, 7.

and water'.[1] 'The shallow waves that rolled under his window taught Monamy what his master could not teach him', commented Walpole, 'and fitted him to imitate the turbulence of the ocean.'[2] This is going too far; he imitated the mannerisms of the Van de Veldes too pedantically, so that 'there is a faint air of calico about much of his water'.[3] Like his senior Isaac Sailmaker, remarkable more for the appropriateness of his name than the distinction of his work, he was a longshoreman, and the category remained in the hands of the longshoremen until the era of the expeditionary painters headed by William Hodges.[4] The innovations are chiefly to be noted in their *plein-air* sketches, a deservedly famous example being Monamy's water-colour study for a studio oil painting of the *Old East India Wharf* in the Victoria and Albert Museum. In its sure combination of sensitive outline and broad wash the former forecasts the future development of the English water-colour school.

A fascinating document of the interests and attitudes of members of this group survives in Hogarth's *Peregrination*, the name generally given to 'An account of what Seem'd most Remarkable in the Five Days Peregrination of the Five Following Persons viz. Messieurs Tothall, Scott, Hogarth, Thornhill and Forrest. Begun on Saturday May 27th 1732 and Finish'd on the 31st of the same Month.'[5] The antiquarian interests of the lawyer Ebenezer Forrest determined the itinerary down the Thames, cross-country to the Medway Estuary, and across to the Island of Sheppey. Thornhill, son of the great Sir James, was the cartographer; William Tothall, who had made several voyages to Newfoundland and the West Indies and sold rum and brandy at his draper's shop, was appropriately treasurer and caterer. Scott specialized in shipping, Hogarth in topography and caricature. *Embarcation*

[1] *Vertue*, III. 145. [2] *A. of P.* II. 287.

[3] E. K. Waterhouse, *Painting in Britain*, 112. See also the article on Monamy by John Wood, 'Seascapes Worthy of Greater Fame', *C.L.*, 28 May 1959.

[4] The exploration of the Pacific gave artists their main chance to make long-distance voyages. See Bernard Smith, *European Vision and the South Pacific 1768–1850*, Oxford, 1960.

[5] *Hogarth's Peregrination*, edited with an introduction by Charles Mitchell, Oxford, 1952.

from the Isle of Grain by Scott and Hogarth [plate 31B] must have been done from memory or notes taken on the spot, unless an outline was made to be filled in later. For all its crudity, it catches the hilarious mood after stopping for refreshment at the Chequer Alehouse 'kept by Gooddy Hubbard' and before boarding when 'The Sea run High The Wind Blowing Hard at SW and by S'.[1]

Much of the immediacy of the sketches taken on the spot is lost in canvases finished in the studio, but their effect can be gauged from Charles Brookings's *Shipping in a Calm* in the National Gallery, London, for which a date in the 1750s may be suggested [plate 31A]. The vitality of the movement is shown by its influence on the imitators of Canaletto. Samuel Scott's *An Arch of Westminster Bridge* [plate 31C; *c.* 1748/9] both catches a fleeting cloud shadow in the masonry and renders 'the watery quality of the English atmosphere . . . with a feeling very different from Canaletto's Venetian brilliance'.[2] To return to Lambert, he became by working in the two modes both the leading figure in the elevation of topography to landscape and the evolutionary link between Wootton and Wilson. He had the good fortune to become acceptable to the Burlington circle as a recorder of country houses while gaining the admiration of the anti-Burlingtonian Hogarth for his skill in painting the changing tonality of the sky, and the rising and setting sun. In Hogarth's manuscripts there is a long and revealing passage, drafted for *The Analysis of Beauty*, in which the 'gradation' or 'vanishing off of objects' in Lambert's work is contrasted with the destruction of this effect in older pictures by time.[3] *The Landscape with Figures* dated 1757, which he presented to the Foundling Hospital, shows that he turned to the Dutch masters with increasing sympathy in his later years. Finally, *A Coastal Inlet*, signed and dated 1763, in the National Museum of Wales may be taken as representative of his final Claudian manner, in which the new grasp of atmospheric vision and the vivid use of greens, blue-greens, and

[1] Ibid. 9 and 10.

[2] Waterhouse, *Painting in Britain*, 117. For Scott see Hilda F. Finberg, 'Samuel Scott', *Burl. Mag.*, Aug. 1942, and Francis Watson, 'The Samuel Scott Exhibition', *Burl. Mag.*, 1957.

[3] *Analysis of Beauty*, ed. J. Burke, 110, 182.

buttery yellows is very different from his earlier and more scenic imitations.

Animal painting of the type that Reynolds later associated with minute attention to fur and feathers in still life and genre remained during this period largely the province of foreigners, although Charles Collins (d. 1744) deserves honourable mention. The Hungarian Jacob Bogdany enjoyed the principal reputation for 'fowles, birds of all kinds and nations in a pleasant agreable manner. with much beauty and softness. and fruits and flowers' in the reigns of King William and Queen Anne, and carried on until his death in 1720 in Great Queen Street, a favourite address of artists before they moved with success to the more fashionable Covent Garden or Leicester Square.[1] Walpole does not do justice to this fine artist. He was at first known simply as 'the Hungarian', and his immense superiority in the category may well have acted as a deterrent to native competitors. Despite his long domicile, he was apparently regarded as an exotic like much of his subject-matter. From Bogdany to Liotard, who made two visits of two years each, there is a succession of immigrant painters whose work remained as alien as if it had been purchased overseas. A Fleming from Antwerp, Pieter Casteels (1684–1749) perpetuated less skilfully but without comparable originality the more familiar style of Hondecoeter in elevated ornithology, and was highly regarded by Vertue.

The foreign practitioners of genre showed greater capacity to assimilate from their environment than the bird and flower painters, whose subjects were broadly the same in all countries that collected specimens from overseas. A Covent Garden Group in low-life genre takes its place alongside the Thames Estuary School.[2] Among the immigrants who painted Covent Garden scenes were Joseph Van Aken (1709–49), Balthasar Nebot (active in London c. 1729–62), Peter Angellis (1685–1734), and Francis Paul Ferg (1689–1740). Nebot was Spanish, Angellis French,

[1] Vertue, I. 127.

[2] The best source of illustration of the Covent Garden Group is Colonel M. H. Grant, A Chronological History of the Old English Landscape Painters (in oil), I and II, 1926; III, Leigh-on-Sea, 1947, and id., Dictionary of British Landscape Painters from the 16th century to the early twentieth century, Leigh-on-Sea, 1952.

and Ferg an Austrian. The cosmopolitan members (Ferg came from Vienna via the courts of Saxony and Brunswick) practised in different traditions. Angellis painted an elaborate series of the martyrdom of Charles I, copied Rubens and Snyders, and in his excursions into genre retained something of the painterly glow and animation of the baroque. Nebot is closer to the *avant-garde* in his topographical verisimilitude, but his delicacy of touch and the elongated grace of his figures reveal his French sympathies. In many of the genre paintings of this group piles of fruit and vegetables are prominently displayed, whether or not the subject is taken from Covent Garden.

Vertue's vocabulary in recording the works of the Covent Garden Group includes the following epithets and nouns: 'natural', 'curious' (i.e. careful), 'nicety', 'exactness', and 'skilfulness'. *Curiosa felicitas* is opposed to the grand sweep of the ideal tradition, and discovered in subject-matter ranging from the rigging of the ships to the vegetable contents of a market stall. His term for painters of this class is the 'lower Rank of Virtuosi'.[1] In admitting them to the class of the virtuosi albeit in a lower rank, and by his unstinted admiration of their work, Vertue shows that he is both liberal and progressive in his sympathies. His enthusiasm for the contemporary art of his own country was uncritical, but the changes that he noted taking place during his lifetime were to have vital consequences. He deserves credit for his acumen in detecting and describing so precisely the really significant innovations, and his championship of his contemporaries is justified by the foundations they laid for the greater achievements of the next generation. They had challenged by example if not by doctrine the hierarchy of categories, so that when a Royal Academy committed to its restoration was founded the vitality of art was free to flow in other channels than the imitation of the Old Masters.

[1] Cf *Vertue*, II. 129, where he gives the title to painters of genre 'in vogue among the waggish Collectors'.

PART TWO

THE IMPACT OF THE ROCOCO

c. 1740–1760

V

THE IMPACT OF THE ROCOCO
c. 1740–1760

THE ORNAMENTAL STYLES: CHINOISERIE AND
THE GOTHICK TASTE

IN 1712 Alexander Pope published a playful variation on the
most elevated of all literary categories, the epic.[1] The action
of *The Rape of the Lock* centres on the theft of a curl of hair,
which is finally changed into a star. In the first canto the sun rises
on the bedroom of Belinda, in the second gilds a pleasure barge
on the Thames, and in the third sets on a withdrawing room and
card party at Hampton Court. Ariel, the genius of the fable,
counsels the heroine, and directs his company of sylphs to guard
every article of her wardrobe and toilet table.

Three years before Handel composed his Water Music for a
royal party, and five before Watteau painted his *Embarcation from
Cythera*, Pope described the pleasure excursion on the river and
its musical accompaniment:

> While melting Musick steals upon the Sky,
> And Soften'd Sounds along the Waters die.
> (Canto II, pp. 49–50)

The sunset skies and winged cherubs of Boucher could be chosen
still later to match the verses describing the sylphs as they fly:

> Dipt in the richest Tincture of the Skies,
> Where Light disports in ever-mingling Dies;

[1] For Pope and the rococo see J. Isaacs, 'Hogarth's Marriage-à-la-Mode: the
Historical Setting', *Listener*, 24 July 1947: 'Pope, as the herald of the Rococo, re-
placed the bold burlesque of Butler's "Hudibras" by the mock-heroic of the first
rococo epic.' Cf. my article 'Hogarth, Handel and Roubiliac: a note on the inter-
relationship of the arts in England 1730–1760', *Eighteenth-Century Studies*, University
of California Press, Winter 1969, from which parts of this chapter are taken, for
a further discussion of parallels between literature and art in this period.

While ev'ry Beam new transient Colours flings,
Colours that change whene'er they wave their Wings.
(Canto II, ll. 65–8)

Later still, Fragonard or Moreau le Jeune could have erotically illustrated the crucial episode of the stolen lock. The memorable imagery of the mock epic reads like an inventory of those small articles by which the French style was first to invade and then occupy whole areas of taste: Sir Plume's amber snuff-box and clouded cane, the silver vases of Belinda's dressing-table, her casket of Indian gems, combs which unite the tortoise and the elephant, 'China's earth', and 'altars of Japan'. The Homeric banquet is replaced by the drinking of tea, coffee, and chocolate, and the iconography of the boudoir substituted for that of the battle-field. Jove still weighs the scales, but no thunderbolts shatter the illusion of a faery world.

The spirits conjured up by Pope preside over a more feminine, that is, more subjective and irrational world than that of classicism. Deeply indebted to French literary sources, he chose as his theme an episode from the life of an English Court at its recreational palace. The staying power of the poem derives from the psychological depths that lie concealed beneath its sparkling surface, but its immediate success suggests a climate of opinion already favourable to the reception of French influences in all those categories of art that served to adorn the leisure and play of a fashionable society.[1]

Engraving is the key to the interrelationship between the arts and the crafts in this period, and the print was, as much as the portable *objet d'art*, a vehicle for the transmission of decorative influences.[2] Because so many of the French *ornemanistes* were either engravers themselves or associated with engravers, and because English printsellers and booksellers kept in close touch

[1] Many of the observations in Ralph Cohen, 'Transformation in *The Rape of the Lock*', *Eighteenth-Century Studies*, Spring 1969, are relevant to the role of wit in eighteenth-century painting.

[2] For the influence of engraved designs on rocaille ornament in furniture, and an analysis of motives, see Peter Ward-Jackson, *English Furniture Designs of the Eighteenth Century*, London, H.M.S.O., 1958, 'The Rococo Style', 8–14. An important study of a key designer is Helena Hayward, *Thomas Johnson and English Rococo*, London, 1964.

with their suppliers in Paris, every stage of the creation and evolution of the French style could be followed with a negligible time-lag. But motives were more readily borrowed than principles were grasped, and from the very first the rococo in England was assimilated with native forces.

It has already been noted that the School of Burlington did not admit the French style into its grammar of ornament. The emancipation from rigid geometry, under the leadership of Gilles-Marie Oppenord and François-Antoine Vassé, was followed in France by the decisive creation of the asymmetrical *genre pittoresque* by Nicolas Pineau and Juste-Aurèle Meissonnier between 1730 and 1740, that is, during the very period when Burlington and Kent were consolidating an interior decorative system for neo-Palladian architecture.[1] This regular system was never allowed to disintegrate. The most spectacular interiors in the French style were those at Chesterfield House in Mayfair (designed *c.* 1745, built 1748–9; demolished 1937). Philip Dormer Stanhope, 4th Earl of Chesterfield, who chose the Palladian Isaac Ware as his architect, described his boudoir as 'the gayest and most cheerful room' in London, the library as 'the best'.[2] Classical order prevailed in the Library, a room which, if designed by a Cuvilliès, might have modified the course of interior decoration in England. The parallel rows of shelves culminated in cornices exactly aligned with the top dressings of the doors; the portraits of the poets in rococo frames made an unbroken line around the room, as in the library at Narford; above them an inscription from Horace was no less exactly ruled; and the ceiling was divided into boldly projecting compartmental frames. The richly varied ornament crowded in between, alongside, and sometimes over the borders, but never obliterated them. The painted ballroom was the only room he described as altogether *à la française*, but it followed those more conservative French models in which separation of compartment and symmetry of *ordonnance* were still observed.

[1] Fiske Kimball, *The Creation of the Rococo*, Philadelphia Museum of Art, 1943 (reprinted Norton Library, 1964), 'The Creators of *le genre pittoresque*', 152–74 and Conclusions, 224.

[2] For illustrations and an account see *C.L.*, 25 Feb. and 4 Mar. 1922.

If so ardent a Francophil hesitated on the brink of *le genre pittoresque* it is not surprising that the majority of his countrymen preferred the rococo as a strictly subordinated style of ornament. Another factor which limited the influence of the French style was the success of the Italian stuccadores. In the event, the rococo in the English interior flourished chiefly under the sanction of two disguises, the Chinese and Gothick Tastes, but even here the anti-architectural drive of the French style was restricted by baroque and classical predilections.

The continuing vitality of the baroque is richly evident in all the crafts. The gilt chandelier now hanging in the Stone Hall at Houghton [plate 32A; *c.* 1740] has a wide corbelled base to the shaft which supports amorini holding festoons of flowers, and terminates below in a pineapple.[1] It is entirely appropriate to Kent's monumental setting. An added attraction of the baroque alternative was that it could be adapted to the taste for lightness and variety without sacrificing architectural values. Decorative ironwork by a major provincial craftsman like Robert Bakewell had notably developed a surface style which was structurally ex-pressive. The wrought-iron Arbour at Melbourne Hall, Derbyshire (*c.* 1708–11), attributed to Bakewell is a masterpiece of elegance in enclosing spatial volume [plate 32B].[2] It adorns a garden, which comes to rank with the boudoir as a favourite setting for orna-mental innovation. Its novelty does not break abruptly with the past, and points to the dominant trend, which is to lighten or alternate the architectural framework while preserving its articula-tion.

As early as 1717 John Talman recommended the grotesque style to Kent in Italy.[3] In 1724 the latter was paid £300 for paint-ing in this style the ceilings of the Presence and Council Chambers at Kensington Palace, where the flat of the cove is decorated with arabesques divided by diagonal bands centring in a small medal-lion.[4] In these and later arabesque ceilings with miniature pictorial

[1] Percy Macquoid and Ralph Edwards, *The Dictionary of English Furniture*, revised and enlarged by Ralph Edwards, London, 1954, I. 329.

[2] Raymond Lister, *Decorative Wrought Ironwork in Great Britain*, London, 1957, 98.

[3] M. Jourdain, *The Work of William Kent*, 29. Cf. Hugh Honour, 'John Talman and William Kent in Italy', *Conn.*, Aug. 1954. [4] Ibid. 71.

insets, including landscapes, Kent anticipated the taste of the second half of the century. Generally, however, he worked with strongly three-dimensional forms. The Green Velvet State Bed at Houghton [plate 33; 1732] has behind it a Continental tradition splendidly illustrated by Daniel Marot's work at Hampton Court, but stands out by the inventiveness with which its architectural forms and rich colouring are integrated with the structure and decoration of the Bed-Chamber itself.[1] Its gigantic shell in the shape of a peacock's tail is a design of such striking and compulsive power that Kent wisely allowed it to steal the climax from his own painted ceiling. The sumptuous bed, for which the hangings cost £1,219 3s. 11d., ranks amongst those remarkable works which make the 1730s and early 1740s the final flowering period of the baroque in England, notably Rysbrack's Marlborough Monument at Blenheim (1732), the Jerningham–Kandler wine cistern of 1734, Hogarth's history paintings decorating public buildings from 1736, the Radcliffe Camera (begun 1737), and Kent's own staircase at 44 Berkeley Square (1742–4).

In the Society of Antiquaries there is a drawing for the Jerningham–Kandler wine cistern [plate 34B; finished 1734], presented by George Vertue, of which the inscription reads:

The First design or Sketch made. Invented by G. V. [George Vertue] for that large. Famous Silver Cistern exhibited to the publick when finished by Mr. Henry Jerningham and Sold by way of Lottery ... the chance fell to ... Batten Esqu. of Sussex. The Plate working Silver Smith ... Kendelar a German. The Modeller in Wax Mr. M. Rysbrake. For the figures and boss relieves besides several chasers were imploy'd to finish it, to work at least of three years, to compleat it.[2]

This masterwork seems to have set a record for its combination of immense size and elaborate craftsmanship in a single piece

[1] Ibid. 84.

[2] Cited by Dr. N. M. Penzer, 'The Jerningham–Kandler Wine-cooler', *Apollo*, part I, Sept. 1956, part II, Oct. 1956, the authoritative study of the cooler and its history. The Act of Parliament specified a cistern, a term established in contemporary usage and validly retained for wine-coolers of bath-like shape and dimensions. Its capacity in gallons, suggesting a container for decanted wine, should not obscure its proper function of cooling bottles in ice for consumption at banquets.

of decorative plate.[1] It appears to have originated in the ambitious imagination of its entrepreneur, Henry Jerningham or Jernegan, goldsmith and banker, whose investment landed him in financial difficulties when no purchaser willing to cover the outlay could be found. On 2 March 1735–6 Jerningham laid a petition before Parliament to authorize its disposal by lottery in aid of the new Westminster Bridge. This was approved, and the winner, Major William Battine, no doubt favoured by the publicity and the support of Queen Caroline, who had authorized Gravelot's medallion of herself as protectress of the arts to be presented with the tickets, was able to dispose of his prize to the agents of Biron, Duke of Courland, virtually the ruler of Russia as the favourite of the Empress Anne.[2]

One of Jerningham's aims is disclosed by the petition which claims that the cistern had proved that 'the Sculptors and Artificers *of Great Britain* are not inferior to those of other Nations'.[3] Vertue was the only native-born artist associated with the project, Charles Kandler being a German, possibly a relation of Johann Joachim Kaendler, who arrived in England about 1726. The weight of silver, 7,221 troy ounces, the dimensions of 3 feet 3 inches height to edge of rim only by 5 feet $6\frac{1}{2}$ inches length from elbow to elbow of the figures, and the capacity of 60 gallons made its destination in the Russian Imperial Court altogether appropriate. The export of English works of art to Russia is a phenomenon of the eighteenth century, and included the grandest examples of contemporary silversmiths' work, the pick of Sir Robert Walpole's Old Master collection, Sir Joshua Reynolds's most ambitious history painting, *The Infant Hercules*, the heroic industrial paintings of Wright of Derby, and a steady supply of porcelain, culminating in the famous Imperial Service specially commissioned from Josiah Wedgwood.

The monumental design of the wine-cooler is baroque, and its iconographic programme of male and female terms, putti in

[1] *Apollo*, part II. 111.
[2] Ibid. 112.
[3] Ibid. 111. Cited from the *Extracts of the House of Commons Journals*, 1735–6, 601.

Bacchanalian revels, fauns, goats, panthers or leopards, lizards, frogs, shells, and hanging vine-branches with clusters of grapes would not have disgraced the setting of the Farnese Palace. The grand celebration of the cult of Bacchus, however, is lightened by the miniaturist intimacy and playfulness of the side panels, in one of which two putti ride on an open rococo car drawn by domesticated leopards. The appearance of rococo motives in a baroque context is typical of the opening English phase, which is followed by the completely rococo decoration of plastically conceived shapes and may be illustrated by comparing the wine cistern with Matthias Lock's etched design for a table a decade later [plate 34A; 1746].[1]

The ground was well prepared by baroque survival for the activities of the Italian stuccadores, who brought a rococo style which differed from the French in being a true end-phase of the baroque.[2] The leading figures in the first half of the century were Giovanni Bagutti, Giovanni and Giuseppe Artari, Francesco Vassali and his assistant Martino Quadry, Francesco Serena, Giuseppe Cortese and his assistant Guiseppe Tadei, and the brothers Filippo and Paolo Francini. After working in Bath *c.* 1729 the Francini brothers accepted the Earl of Kildare's invitation to work in Ireland in 1739, where they 'introduced the modelling of the human figure in plaster on broad sculptural planes'.[3] Under their leadership Dublin became the outstanding

[1] For this and other designs by Lock see Peter Ward-Jackson, *English Furniture Designs of the Eighteenth Century*, 1958, 38–41.

[2] See Peter Murray, 'Architettura Inglesi e Stuccatori Italiani', in *Arte e Artisti dei Laghi Lombardi*, II, 1964 (*Rivista Archaeologica dell'Antica Provincia e Diocesi di Como*, Como, 1964); G. Beard, 'Italian Stuccoists in England', *Apollo*, July 1964; and C. P. Curran, *Dublin Decorative Plasterwork of the Seventeenth and Eighteenth Centuries*, London, Tiranti, 1967, the last for additional names of Italians who worked in England before settling in Ireland. Desmond Guinness in 'Irish Rococo Plasterwork' reprinted from *The Harp* by the Irish Georgian Society, 1965, makes the original point that Adam designs were so easily cast in a mould that the art of plastering was soon forgotten. The Adam Revolution was thus as damaging to the creative stuccodore as to the large-scale history painter.

The main corpus of illustration is Laurence Turner, *Decorative Plasterwork in Great Britain*, 1927.

[3] C. P. Curran, 'Dublin Plaster Work', *Journal of the Royal Society of Antiquaries of Ireland*, 31 Mar. 1940, 15.

centre for richly decorative plasterwork in Great Britain. The Irish capital also contains what must rank as the mecca of a rococo pilgrimage in the British Isles, the Chapel of the Rotunda Hospital decorated by the otherwise obscure French statuary Bartholomew Cramillion who was employed by Dr. Bartholomew Mosse in 1755 to design and execute the plasterwork of the ceiling and in 1757 the altar-piece. Despite his origin, it is in a more Italianate than French tradition.[1]

Like the Huguenot goldsmiths, the Italian stuccadores were a powerful reinforcement to an already flourishing native school, which they stimulated by their rivalry rather than eclipsed. The great staircase at Powderham Castle, Devon [plate 35], was executed in 1754-6 by one John Jenkins with two assistants, William Brown and Stephen Coney.[2] The rococo repertory of violins, oboes, quivers of arrows, dragons, hour-glasses, tambourines, grapes, and roses, engagingly tied together by bows of ribbon, is handled with complete technical assurance. But Palladian clarity prevails in a system whereby 'each outburst of ornament is segregated in separate panels, symmetrically arranged', while the tendency of the elaborately plastic forms to crystallize or solidify around focal points is reminiscent of Grinling Gibbons rather than Artari or Bagutti.[3] When James Paine published his *Plans, Elevations, Sections and Other Ornaments of the Mansion House at Doncaster* in 1751 he proudly claimed that the rococo plasterwork by Joseph Rose and Thomas Perritt was 'inferior to none of the Performances of the best *Italians* that ever work'd in this Kingdom'.[4] By this date the ascendancy of the Italians was coming to an end, although Francis Vassali executed notable work at Hagley Hall and Croome Court, Worcestershire, as

[1] See C. P. Curran, *The Rotunda Hospital: the Architects and Craftsmen*, Dublin, 1945, and chapter VIII, 'The Rotunda Hospital Chapel', in the same author's *Dublin Decorative Plasterwork*, 1967.

Almost certainly a Frenchman or Walloon, Cramillion executed the work in a South German or Austrian baroque style with both French and Flemish undertones, suggesting that he had either worked outside his native country or studied under an immigrant master.

[2] M. Girouard, 'Powderham Castle, Devon—II', *C.L.*, 11 July 1963.

[3] Ibid. 80. [4] Preface. The stucco decoration was executed in 1747.

late as 1758–60. Among the provincial masters, one of the most personal in style was Thomas Stocking of Bristol, whose floral decorations in the staircase hall at the Royal Fort (*c.* 1760) have some affinities with the designs of Thomas Lightoler published in *The Modern Builder's Assistant* (1754).[1] Here, for once, the influence of *le genre pittoresque* is unmistakable; there are no compartments and the cluster-laden vines rise as waving lines unsupported by a trellis. At the foot of each is a charming pastoral scene distinguished from its neighbours by its animal occupants— a dog, fox, ducks on a pond, sheep, birds, and squirrels resting or disporting in the upper branches. But no one could mistake it for the work of a French craftsman. It is less sophisticated, an abstraction of the rococo rather than the rococo itself, with a feeling for the vacancy of space perhaps inspired by Chinese wallpapers.

The Anglo-Dane Charles Stanley (1703–61; in England 1727– 46) was the most distinguished of all the stuccadores who came from overseas.[2] He had been trained in Denmark by J. C. Sturm- berg, whose baroque classicist influence is clearly discernible in the formal layout of his decorative schemes. He was fortunate in being called on to decorate Palladian interiors less monumental than the Kentian or Gibbsian average, so that his mastery in exploiting the void interval and the delicacy of his plastic contrasts appear to full advantage. At Langley Park, Norfolk (1742–6), his rococo manner has something of the classic elegance of an accom- plished sculptor, which he became. In the ceiling of the Library the central panel shows Diana tranforming Actaeon, who raises his right hand in a surprised gesture while his dogs howl frantically and the agitation of the nymphs spills the water of the basin set in mid-stream.[3] The movements are beautifully controlled despite all this disturbance, and the eye is allowed to repose as well as encouraged to wander.

[1] W. Ison, *The Georgian Buildings of Bristol*, 1952, 192, 195. But the guiding hand in the design may have been Thomas Paty, ibid.

[2] Stanley, who worked with the sculptors Delvaux and Scheemakers in London, subsequently became Professor of Sculpture at the Royal Danish Academy. See Katherine A. Esdaile's two articles on Stanley in *C.L.*, 2 Oct. and 11 Dec. 1937, and Hussey, *E.G.*, under the index for his work in country houses.

[3] See the article on Langley Park in Hussey, *E.G.*

In general, the Rule of Taste was too powerful for the most anti-classical of all the styles that invaded England in the century to challenge its ascendancy. The striking exceptions are the Chinese and Gothick Tastes, because each was by definition outside the Palladian canon. 'The Goths', wrote Isaac Ware in 1756, 'seem to have seized upon pavilions, and the Chinese on rooms of pleasure.'[1] The statement would be equally true if reversed, but has a historical justification, for Chinese wallpapers, hangings, porcelain, and lacquer furniture were introduced long before pagodas were built, and the age of Vanbrugh had memorably adorned gardens with Gothick buildings. The Chinese mania that swept England from the 1740s has been described by a leading authority as reaching a height of popularity in the 1750s which it attained at no other time and in no other country.[2] The ground had been well prepared by men of letters who had been attracted to Chinese civilization. English chinoiserie has rightly been described as rococo.[3] The new taste could not be satisfied by the authentic, a situation which the Chinese realistically accepted by creating a special and spurious export style for the English market.[4] Chinoiserie, as an exotic species of the rococo, quickly became the main outlet for anti-classical tendencies. Here, if anywhere, one might have expected to find an approximation to the French break with architectural traditions. With the exception of papered rooms, however, there is almost always discernible a logical and rectilinear ordering of the main compartments of the interior.

Claydon House, Buckinghamshire, stands in a similar relation to English chinoiserie as the Rotunda Chapel in Dublin to the Italianate rococo, at once its climax and most original manifestation.[5] The interior has been well described as presenting a

[1] *The Complete Body of Architecture*, 2nd ed., 1756, Preface.

[2] Hugh Honour, *Chinoiserie: the Vision of Cathay*, London, 1961, 132.

[3] Ibid., chapter V, 'English rococo chinoiserie', the best account of the Chinese Taste in England.

[4] See Margaret Jourdain and R. Soame Jenyns, *Chinese Export Art in the Eighteenth Century*, London, 1950, and for the Continental background, Michael Beurdely, *Porcelain of the East India Company*, translated from the French by D. Imber, London, 1962.

[5] Honour, op. cit. 135–6, and the article on Claydon in Hussey, *E.G.*

contrast between classical restraint and rococo eccentricity, between Palladianism and chinoiserie. The *tour de force* is the wood-carving in the Chinese Room designed before 1769 by a Mr. Lightfoot, carpenter and architect [plate 37B]. Its dominant feature is a projecting alcove or 'tea-pavilion' with large, fantastically decorated niches. The effect is massive and bold, not miniature and delicate. Elsewhere the decorative enrichment of the room is similarly concentrated on structurally conceived features, mantelpiece, and door-frames. The Great Eating Room, now the North Hall, is as regular in its scheme as any Palladian interior. Classical, baroque, rococo, and Chinese motives are freely combined, but the Chinese taste takes precedence of the others.

Among the exotica of chinoiserie the ho-ho bird perches on pagoda or pavilion as superbly as any Roman eagle on the trophies of imperial antiquity.[1] This remarkable *Fantasie-Vogel* is a hybrid of gold pheasant, phoenix, peacock, and the sun-bird of Indian and Near Eastern mythology, the end-product of this cross-breeding surprisingly resembling a cormorant. Majestic and impossible, it was probably borrowed from porcelain, as it appears early at Meissen and Sèvres, and was quickly taken up at Bow, Chelsea, and Worcester. However, the distinction between the flying dragon, cormorant, and ho-ho bird was not always as strictly observed as it should have been. A splendid example of a fantastic bird appears above the overmantel mirror in the Drawing Room at Crichel, Dorset [plate 36B; *c* 1765].[2] There is a similar confusion of identity between pavilion and pagoda, as may be illustrated by a pagoda-type épergne in the National Gallery of Victoria, with the London hallmarks for 1762–3 and Maker's Mark of Thomas Pitts [plate 36A].[3]

The meeting-ground for the Chinese and Gothick Tastes was the landscape garden, where a Mandarin Arcadia took its place

[1] For the ho-ho bird and its origins see Stanley W. Fisher, 'Birds on Porcelain', *C.L.*, 16 Aug. 1956.

[2] Reproduced in Hussey, *E.G.*, fig. 315.

[3] See David Lawrence, *English Silver from the Sixteenth Century to the Nineteenth Century*, National Gallery of Victoria Booklets, Melbourne, Oxford University Press, 1968. Cf. *C.L.*, 20 June 1963, for a similar example.

alongside what Thomas Gray wittily called the Gothic Elysium.[1]
The earliest recorded chinoiserie garden building of any note
was the House of Confucius at Kew, designed by Joseph Goupy
and built *c*. 1745.[2] By 1752 the demand for models in both tastes
was recognized by the publication of William and John Half-
penny's *Chinese and Gothic Architecture properly ornamented*.[3] The
aim was a series of chinoiserie vignettes inserted in the classical
text of the garden, rather than a separated Chinese world. The
nearest exception was the Chinese Island in Virginia Water, a
folly built in 1759 by the Duke of Cumberland, whose Chinese
junk, *Mandarine*, is recorded by engravings [plate 37A].[4] Such
fantasies were more readily erected in the garden by the masters
of carpenter's Gothic than of stonemason's, and for this reason
chinoiserie structures have fared more badly at the hands of time
than Gothick ones.[5]

The Gothick Taste, unlike the Chinese, was restrained from the
licence of *le genre pittoresque* by a new factor, antiquarianism.[6]
The antiquaries had always admired Gothic architecture, com-
mended without reservation by John Evelyn as early as 1654.
But they had, at first, little influence on scholarship of design.
The English baroque protagonists of the style, like Vanbrugh
and Hawksmoor, worked at a time when Gothic was still very
much a living tradition.[7] They had not been trained in this tradi-

[1] Letter to the Revd. William Mason, 13 Jan. 1758, in Gray's *Letters*, ed. D. C.
Tovey, 1904–12, II. 13. [2] Honour, op. cit. 150 and fig. 8.

[3] William Halfpenny began publishing a series of *New Designs for Chinese Temples*
in 1750. His son John collaborated in numbers 2 to 4 of *Rural Architecture in the Chinese
Taste*, 1750–5. [4] Honour, op. cit. 153 and pl. 104.

[5] The Chinese village (after 1779) in the park at Tsarskoe Selo by Charles Cameron
is perhaps the most ambitious monument of chinoiserie in a European garden.

[6] The following account is much indebted to Kenneth Clark's pioneer study,
The Gothic Revival: an Essay in the History of Taste, London, 1928 (reprinted 1950),
which has stimulated many later writers in the same field. Indeed most subsequent
research can be subsumed under the terms suggested by his chapter headings: the
Survival of Gothic, Literary Influences, Ruins and Rococo, Romanticism and
Archaeology. For Evelyn see Sir Alfred Clapham, 'The Survival of Gothic in
Seventeenth-Century England', *Archaeological Journal*, CVI, supplement 1952, 4–9.

[7] See H. M. Colvin, 'Gothic Survival and Gothick Revival', *Arch. Rev.*, Mar.
1948, an analytical investigation of the part played by the masons in the provinces
and the Board of Works.

tion, nor do they seem to have made much use of the knowledge of its practitioners. A possible exception is Hawksmoor's West Towers of Westminster Abbey, designed in 1734 and completed by John James *c.* 1745, for although unmistakably a Georgian design it blends better with the whole than one would have expected from the architect of St. Anne, Limehouse. The same is true of their neo-Gothic followers in the age of Kent, whose mason contemporaries, the Smiths of Warwick, the Grumbolds of Cambridge, and the Townesends of Oxford, had served a sound apprenticeship. The detached tower of Berkeley Church, Gloucester, which was built in traditional style and by traditional methods by William Clark as late as 1750–2, is one of the very latest examples, possibly the last, of genuine Gothic survival, handed down from generation to generation, in England.[1] It overlaps with the first steps of the antiquaries, so that carpenter's Gothic was never without a contemporary touchstone of comparison.

Even when a direct link between mason and neo-Gothic patron can be established, the former followed the new style rather than the old one in which he had been brought up. The poverty of decoration in the work he had been trained to execute perhaps explains why the enthusiasts felt obliged to make a fresh start. Thus the antiquary James West employed Jonathan Woodward on the reconstruction of Alscot Park in Warwickshire between 1750 and 1764, and also to rebuild the neighbouring church of Preston-on-Stour between 1753 and 1757.[2] For the design of the alterations to his house West went to a partnership of two London master-builders, both carpenters by origin, John Phillips and George Shakespear. For the church Edward Woodward submitted an elevation and plan 'certainly more convincing than anything a sophisticated architect of the Strawberry Hill circle would have provided'.[3] In the event it was built piecemeal in a less ambitious way, and the London carpenter-builders were brought in to design fittings.

[1] Ibid. 94.

[2] M. Girouard, 'Alscot Park, Warwickshire', *C.L.*, 15 May (part I), 22 May (part II), and 29 May (part III) 1958.

[3] Ibid., 29 May 1958, 1186 and fig. 10.

Sanderson Miller (1717–80), the amateur architect, began the Gothic alterations at his home, Radway in Warwickshire, *c.* 1745, and erected a Gothic monument in the style of a castle on the site of the Battle of Edgehill in 1745–9.[1] Their success was such that he was called on to furnish Gothicizing designs for his friends, notably the ornamental castle at Hagley (1747–8) for Sir George, later Lord, Lyttelton and the Great Hall and Gothic Gallery at Lakock Abbey (1754–5) for John Ivory Talbot. His design breaks with carpenter's Gothic, but scarcely merits the encomium of Walpole, that it showed 'the true rust of the Baron's Wars'.[2] Miller captured the imagination of an influential circle, including the Tory Sir Roger Newdigate, who consulted him about the remodelling of Arbury Hall in Warwickshire at least as early as 1750.[3] His prestige and practice as an amateur architect prepared the ground for the professional enthusiast Henry Keene (1726–76), from 1746 Surveyor to the Dean and Chapter of Westminster Abbey, and James Essex (1722–84), the architect most deeply involved with the antiquarian circle, for he was the friend of Gough, Tyson, Bentham, Cole, and Kerrich. A serious student of medieval architecture, Essex contributed a knowledge of Gothic construction that 'remained unique until the ecclesiological movement of the early nineteenth century'.[4]

The *scuola* of Gothic enthusiasts never found a proper priest, but Apollo appeared in the person of Horace Walpole (1717–97), whose villa in the style of a castle-abbey at Twickenham, Strawberry Hill, became to the Gothic Revival what Burlington House and Chiswick House combined had been to the Palladian Revival, its headquarters, playground, clearing-house, and nursery of ideas [plate 38A].[5] In 1749, at the age of thirty-two, the son of

[1] For Sanderson Miller see Colvin, *D.E.A.*, and Lilian Dickins and Mary Stanton, *An Eighteenth-century Correspondence*, 1910, the fullest source of documentation for his life and works.

[2] Letter to Richard Bentley, Sept. 1753.

[3] Hussey, *M.G.* 43. But Keene is the key figure at Arbury, see *D.E.A.* 334.

[4] Colvin, *D.E.A.* 197.

[5] For Strawberry Hill see W. S. Lewis, 'The Genesis of Strawberry Hill', *Metropolitan Museum Studies*, V, 1934, 57–92: id., *Horace Walpole*, London, Hart-Davis, 1961, chapter IV, 'Strawberry Hill'; chapter VIII, 'Strawberry Hill' in Isabel Chase, *Horace Walpole: Gardenist*, Princeton, N.J., 1943; Pevsner, *Middlesex*, 161–6, and for

the great Prime Minister who had provided him while still a youth with two offices of profit under the crown, Clerk of the Estreats and Comptroller of the Pipe, which he was to hold to an advanced age, bought a cottage on a charming site of five acres going down to the Thames.[1] He had previously rented the cottage as a place of retreat, and after considering the Chinese and other exotic styles for his improvements he settled on the Gothic for his alterations and additions.[2] The 'oracle in taste' on The Committee of three he now set up as a planning body was John Chute (1701–76) of The Vyne in Hampshire, an amateur enthusiast almost as active as Sanderson Miller in advising his friends, but with stronger antiquarian credentials. The second member was Richard Bentley (1708–82), son of the famous classical scholar, who had not been brought up to a profession but whose talents as an architectural draughtsman and book illustrator proved superior to those of many professionals. The third was Walpole himself.[3] He was the youngest, but he employed Bentley, who had no regular income, and was more brilliant than Chute. He charmed his seniors, until the rupture with Bentley in 1761, but he also had an iron will.

Walpole was a man of integrity, immensely intelligent and one of the most hard-working men of his age. He has been accused of frivolity. It is not in his case a question of deciding where amusement ends and seriousness begins, for he was capable of

illustrations the article in Hussey, *E.G.*, as well as the many prints, plans, and water-colours reproduced in the Yale edition of his correspondence. All later accounts are heavily indebted to the first study cited above.

[1] Lewis, *Walpole*, 98–9. For Walpole's candid account of the income he received from these and other offices secured by his father see the 'Account of my conduct relative to the places I hold under the Government, etc.' in *Works*, 5 vols., 1798, II. 363–70. [2] Lewis, op. cit. 102.

[3] Walpole reinforced The Committee and its Clerk of Works by several other consultants and assistants, ranging from Thomas Pitt, created Baron Camelford in 1784, who designed the ornaments of the Gallery and Chapel, to Thomas Gayfere, Master Mason to Westminster Abbey, who built the Chapel to Chute's Designs, 1772–4. The leading contributors of designs were Chute, Bentley, Thomas Pitt, and James Essex. Robert Adam makes a brief appearance in 1766. The executive architect William Robinson, Clerk of the Works at Greenwich, was effectively Clerk of the Works from 1749 until 1773.

being amused to the very end. He could be, indeed frequently was, passionately serious where his deepest convictions were involved. But he was not insincere in presenting himself to his friends and posterity as a trifler. He adored trifles, especially the amusing *marginalia* of history. Amusement was to him a vital spark, the integrity of which had to be preserved at all costs. Strawberry Hill is an admirable case in point. It began as a trifle, but in the end was invested with the noble associations of the causes in which he believed: *Magna Carta* and liberty, the heritage of the Middle Ages, the commemoration of the great figures and events of British history. He was aware of all this, he was 'grave in trifles', but he remained amused by his creation.

'I give myself a Burlington-air', he wrote in 1753, 'and say, that as Chiswick is a model of Grecian architecture, Strawberry Hill is to be so of Gothic.'[1] The point of this forecast is that he was well aware that Chiswick was not Grecian, but an inventive variation on classical themes. His own inventive variation on Gothic themes was strongly infused with the spirit of the rococo, although its letter was excluded. One of his favourite epithets was 'little'; his staircase was 'so pretty and so small, that I am inclined to wrap it up and send it you'.[2] 'You must visit my new tower', he wrote to Cole, 'diminutive as it is.'[3] ''Tis the most amusing House', wrote Lady Mary Coke, 'I ever was in.'[4] Gray was delighted with the ceiling of the Holbein Chamber (1759), carved and fretted in star and quatrefoil compartments, with roses at the intersections, all in papier mâché.[5] In a letter to the learned antiquarian Cole, Walpole defended his Gothicizing activities at Strawberry Hill with a characteristic argument: 'It may be trifling, yet it is such trifling, as Ambition never is happy enough to know. Ambition orders palaces, but it is Content that chats for a page or two over a bower.'[6] He declared that he

[1] Letter to Horace Mann, 4 Mar. 1753. Yale ed. XX. 361–2.

[2] Ibid. 361. [3] 27 Feb. 1777.

[4] *The Journal of Lady Mary Coke*, ed. the Hon. James Home, Edinburgh, 1896, IV. 103.

[5] *The Works of Thomas Gray: in prose and verse*, edited by Edmund Gosse, 4 vols., London, 1884. Vol. III, Letters to Wharton, chapter V, 10–11

[6] 9 Mar. 1765. Letter to the Revd. William Cole, Yale ed. I. 91.

wanted to conjure up 'the gloomth of abbeys and cathedrals' in his residence, and set out to introduce the castle and abbey beauties into a villa as the Palladians had introduced the temple beauties into their mansions.[1] His ideal was not 'gloom', which depresses the spirits, but 'gloomth', which raises them.

The cottage subtly changed its character as it grew first into a villa into which he retreated from society and finally into a semi-public museum for which rules of admission had to be printed. The apostle of retirement ended up as the overworked custodian of a place of pilgrimage, like Voltaire's Ferney.[2] Unlike the visitor to Ferney, the aristocratic tourist went to see the house, not primarily to meet the owner. Like another famous building on a higher reach of the Thames, William Morris's Kelmscott Manor, to which it points the way as a headquarters of taste, Strawberry Hill with its press was a hive of editorial activity, designed to influence the ideas and taste of his age. In the evolutionary process the symmetrical Georgian house in the Gothick Taste, indeed in his first sketch almost carpenter's Gothic, became under the Committee of Taste a scenic theatre of Gothic Revival scholarship, and in its final stage a landmark of the Picturesque bordering on Romanticism, 'a very proper habitation of, as it was the scene that inspired the author of the *Castle of Otranto*'.[3] The stages of rococo Gothic, the Gothic Revival, and Picturesque Gothic are all represented in its organic growth without clash or discord, in this respect resembling those greater Gothic cathedrals which took not a lifetime but several generations to complete.

The Round Tower, Great Cloister, and Gallery were added in the decade 1760–70, the Great Bedchamber in 1770, and the Beauclerc Tower in 1776. In the Gallery [plate 39; completed 1763] the vault taken from the side aisle of Henry VII's Chapel in Westminster Abbey obliterated the distinction between wall and ceiling; its inner wall was finished with gold network over

[1] 27 Apr. 1753. Letter to Horace Mann. Ibid. XX. 373.

[2] 'I shudder when the bell rings at the gate.' Letter to the Revd. William Cole, 14 June 1769. Ibid. I. 166. The Tickets and Rules for seeing Strawberry Hill, printed in 1774, are discussed and illustrated in Lewis, *Horace Walpole*, 129–30 and plate 50.

[3] Preface to the 'Description of Strawberry Hill', *Collected Works*, London, 1798, vol. II.

looking-glass, a typically rococo combination; asymmetry pre-
vailed, for the window side did not match the wall one; and
a *horror vacui* completed the resemblance to *le genre pittoresque*
without borrowing any of its motives. The Holbein Chamber
(1759) is less fantastic and more typical in that the parts are clearly
separated and the structure is regularly articulated [plate 38B].
Its fire-place, which Gray believed was a copy of the high altar
in the Cathedral of Rouen, was, Walpole tells us, taken *chiefly*
from the tomb of Archbishop Warham at Canterbury. As Kenneth
Clark has pointed out, it was not a pedantic copy.[1] The exterior
[plate 38A], for all its castle features, ended up by having the
long low spread of the complex of buildings round an abbey,
for although Walpole began with castle and crusades very much
in mind, it was the abbey idea for his villa which finally pre-
dominated.

'Having indulged in the recreation of making laws and voting
millions,' wrote Macaulay, 'he returned to more important pursuits,
to researches after Queen Mary's comb, Wolsey's red hat, the
pipe which Van Tromp smoked during his last sea-fight, and
the spur which King William struck into the flank of Sorrel.'[2]
The best defence of his trifling comes from Walpole himself.
His letters show that his most prized possession at Strawberry Hill
was not Queen Mary's comb, but a Roman eagle, for he never
lost faith in the classical heritage and its inspiration.[3] 'I am sure,'
he wrote to Horace Mann, 'whenever you come to England, you
will be pleased with the liberty of taste into which we are struck.'[4]
In opposing the Liberty of Taste to the Rule of Taste he drew
attention to one of the greatest achievements of the eighteenth
century, the creation of a playground of the imagination.

[1] *The Gothic Revival*, 1928, 79–80.

[2] *Edinburgh Review* (Oct. 1833), cited from *Lord Macaulay's Works*, ed. by Lady
Trevelyan, London, Longman, Green, 1879, vol. VI. Macaulay's list may not be
exact, but was well informed. Thus the Catalogue of the Sale by Mr. George Robins
of Covent Garden, 25 Apr. 1842, lists (p. 154) 'The hair of Mary Tudor, Queen of
France, cut from her head, September 6th 1784, when her tomb at St. Edmundsbury
was opened'.

[3] The eagle was found in the gardens of Boccapadugli, in the precinct of Caracalla's
Baths, in 1742. See Walpole's correspondence, Yale ed. XIX, 1956, 66, note 10.

[4] Letter to Horace Mann, 25 Feb. 1750. Ibid. XX. 127.

A German authority in a perceptive analysis of the role of the Gothic ruin in English literature has described the years from 1750 to 1765 as a decisive period of conflict between the new medievalism and classical ideas.[1] This is the period in which the Gothick, Chinese, and Modern Tastes were presented as alternatives to traditional styles, 'modern' being used by Chippendale as an exact synonym for the French rococo. The poet Collins visualized the British Temple of Liberty not as a conflict between medieval and classical styles, but their synthesis:

> In Gothic pride it seems to rise!
> Yet Grecia's graceful orders join
> Majestic through the mix'd design.[2]

Many patrons saw no inconsistency between a Gothic exterior and a classical interior, or in other ways alternating the two styles, but the composite was generally avoided. In 1744 the third Duke of Argyll decided to build Inveraray Castle, designed externally in the Gothic Taste by Roger Morris, the first step in an ambitious scheme which was to make the castle, the newly sited Royal Burgh on a charming waterfront site below the castle, outlying farms, woods, and bridges a landmark in the Utopian planning of noblemen's estates.[3] The first buildings of the new town were entrusted to John Adam, whose Georgian waterfront with its later and sympathetic additions by Robert Mylne survives as a particularly charming example of the Georgian skill for composing on a miniature scale. Mylne's neo-classical transformation of the

[1] Dr. Reinhard Haferkorn, *Gotik und Ruine in der englischen Dichtung des achtzehnten Jahrhunderts*, Leipzig, 1924, Kap. 5, 'Die Zeit von 1750 bis 1765', 120.

[2] *Ode to Liberty*, 1746.

[3] Mary Cosh, 'Georgian Capital of Argyle: Inveraray, an early example of town planning', *C.L.*, 17 Aug. 1967. The site was the courtyard of the existing house, not the old ruined castle.

Inveraray seems to be quite exceptional in its early date. It is perhaps significant that later model villages in England were designed by Scottish architects. For William Chambers's part in Milton Abbas, Dorset (1773–9), see Arthur Oswald, 'Market Town into Model Village', *C.L.*, 29 Sept. 1966, and for Robert Adam's highly original designs for Lowther Village, one dated 1766, for Sir James Lowther see R. W. Brunskill, 'Lowther Village and Robert Adam', *Transactions of the Ancient Monuments Society*, N.S. XIV, 1967.

interior of the castle in the 1770s and 1780s provided the grand climax of the whole.

The Modern Taste found its first expression in the work of the craftsmen who supplied the furniture, furnishings, tableware, and ornamental treasures of town and country houses. Adolph Reichwein has described European porcelain as the *Urstoff* of the rococo.[1] The first English factories were growths rather than foundations, so that a precise date for their commencement cannot be given.[2] Ever since the Royal Saxon Porcelain Manufacture had been founded at Meissen by Augustus the Strong in 1710 as a result of the discovery of the composition of hard porcelain by Johann Friedrich Böttger, an alchemist in his service, others had tried in vain to emulate his success. Two major difficulties were finding a white clay like the Chinese *kaolin*, and a fusible rock which would serve as a substitute for *petuntse*. *Kaolin* is exceptionally plastic for a white clay, and when it is fused with *petuntse* at a high temperature in the kiln the resultant paste has the prized qualities of whiteness, translucency, and hardness. Local deposits varied so decisively in their chemical ingredients that the search for true or 'hard-paste' porcelain acted as a stimulus to the improvement of existing imitation substances which satisfied the taste for a lovely appearance, particularly in France. It is to this group of soft-paste manufactures that all the English factories belong, apart from a few experiments, until the discovery of true porcelain by William Cookworthy of Plymouth, who took out a patent for the manufacture of hard-paste in 1768.

The 1740s is the decade of experiment and *incunabula*, the 1750s

[1] *China und Europa im achzehnten Jahrhundert*, Berlin, 1923, II. 30.

[2] The early history of the English porcelain manufactures is bedevilled by the uncritical assumptions of early authorities, still too often repeated as fact. The publications of Bernard Rackham, W. B. Honey, Dr Bellamy Gardner, A. J. Toppin, and R. J. Charleston are a notable exception. Much solid evidence has been published in the *Transactions of the English Ceramic Circle* from 1933 onwards.

The best account of English porcelain in its European context is Friedrich H. Hoffmann, *Das Porzellan der europäischen Manufakturen im 18. Jahrhundert*, Berlin, Propyläenverlag, 1932. George Savage in *Porcelain through the Ages*, Penguin Books, Harmondsworth, 1954, has ably incorporated the main findings of recent research, but W. B. Honey, *English Pottery and Porcelain*, 1945, also written for the general reader, remains a classic for its aesthetic insight.

of achievement.[1] Thomas Briand, a chemist possibly associated with the foundation of Chelsea, showed specimens of porcelain to the Royal Society in 1742–3. The first record of Bow is a patent specifying 'unaker', a clay brought from America. It was taken out in 1744 by Thomas Frye, an Irish mezzotint engraver, and Edward Heylyn, formerly a copper merchant of Bristol. In 1750 two London merchants, Weatherby and Crowther, were sufficiently impressed to invest in Frye's project, and the factory of *New Canton* was established at Bow. A year earlier, in 1749, Chelsea had run the first newspaper advertisements of porcelain made in England, an example followed by Worcester in 1751. Among those active in the Chelsea factory's establishment were Charles Gouyn, a jeweller, and Nicholas Sprimont, a notable goldsmith, later sole manager. Sir Everard Fawkener, secretary to William Augustus, Duke of Cumberland, played a leading part in its promotion, writing in 1751 to Sir Charles Hanbury Williams, Ambassador to the Saxon Court at Dresden, to secure models.[2]

Chelsea advertised from 1749, *New Canton* or Bow was founded in 1750. Both manufactures had been in production for several years, Chelsea from 1745 at latest, Bow from 1746–7 and perhaps from 1744. What emerges clearly from the fragmentary evidence is the fluid nature of the association between chemists, tradesmen, artists, and gentry in the early experimental stages, and the mobility of the craftsmen. The decorator F. Duvivier in his long career worked for Derby, Worcester, and New Hall.[3] William Cookworthy, an apothecary of Plymouth, as early as 1745 discussed samples of unaker imported from Virginia as a substitute for *kaolin* by a mining prospector who had read the report on *petuntse*, *kaolin*, and *hua-shih* by Père d'Entrecolles

[1] For the earliest period see A. J. Toppin, 'Contributions to the History of Porcelain in London', *Transactions of the English Ceramic Circle*, I. 1933, 30–43; H. Tait, 'Some Consequences of the Bow Exhibition at the British Museum', *Apollo*, Feb., Apr., June, and Oct. 1960; and F. S. MacKenna, *Chelsea Porcelain*, 3 vols., Leigh-on-Sea, 1948–52, vol. I: *The Triangle and Raised Anchor Wares*.

[2] Cited in G. Savage, *Porcelain through the Ages*, Penguin Books, Harmondsworth, 1954, 225.

[3] W. H. Tapp, 'Fidellé Duvivier, ceramic artist', *Apollo*, Dec. 1940, Mar. 1941, and addendum, Apr. 1941.

published in Jean-Baptiste Du Halde's encyclopedia *General History of China* (Paris 1735; 1st English translation, 1736).[1] Cornish soapstone, identified with an amalgam of *hua-shih* and *petuntse* described by Père d'Entrecolles as a rare and expensive variety of porcelain in China, that is, soft-paste, was used at Lund's works at Bristol by 1750, when Dr. Richard Pococke noted some 'beautiful white sauceboats' sold for sixteen shillings a pair.[2] It is unlikely that fourteen years later Cookworthy would have been described as the 'First inventor of the Bristol China works' if he had not been in close touch with the Bristol management. In 1751 the Worcester Tonquin Manufacture was founded by fifteen gentlemen, including Dr. John Wall, 'to discover the real true and full art' of making porcelain.[3] In 1752 'the Worcester Porcelain Company' took over the assets of the Bristol works. After he had discovered *kaolin* and *petuntse* on Lord Camelford's estate in Cornwall and taken out his patent for hard-paste in 1768, Cookworthy started a manufacture at Coxside, Plymouth, later transferred to Bristol, where Richard Champion purchased his patent rights in 1773-4. This confusing mobility is inherent in the nature of an industrial revolution with its initial failures.

Chelsea, Bow, Derby, Bristol–Worcester, Longton Hall, and Liverpool were all in production by the end of the fifties. It was a remarkable achievement, an exciting chapter in the history of the Industrial Revolution in England, and, not least, shows the

[1] Cookworthy's letter is cited by G. Savage, op. cit. 216, who plausibly corrects the earlier interpretation of W. Chaffers that the speculator meant to undersell the Bow Porcelain Company. The 'Company' whose prices for china he proposed to cut by 30 per cent must have been the East India Company. The word 'china' in the letter is ambiguous, but is more likely to refer to the manufacture than *kaolin*. The importation of *kaolin* from China was so obvious a solution that the absence of any evidence that this was done in significant quantities points to a restrictive monopoly practice on the part of the East India Company, designed to protect the market for Chinese porcelain. However, Savage may be right in allowing for the possibility that Chelsea at first had some access to supplies (op. cit. 27).

[2] See H. R. Hicks, 'William Cookworthy and the Plymouth porcelain factory', *Conn.*, Sept. 1945, 30-3, and Bishop Richard Pococke, *The Travels through England of Dr. Richard Pococke, successively Bishop of Meath and of Ossory during 1750, 1751 and later years*, ed. James Joel Cartwright, 2 vols., Camden Society, 1888 and 1889. Lowdin was probably Benjamin Lund.

[3] See F. S. MacKenna, *Worcester Porcelain*, Leigh-on-Sea, 1950.

early stirring of Enlightenment ideas, for some of those who took part were genuinely interested in scientific experiment and shared Voltaire's enthusiasm for bringing about prosperity by providing local employment in manufactures.[1] Chelsea from the first was the most splendid, and the only one to have ducal relations with royalty. But the early link with the provinces should be noted. Both Heylyn and Cookworthy were active in the 1740s, and were citizens of Bristol, where a factory was in existence by 1749.

Because craftsmen and decorators were mobile, and there was no protection by monopoly, substance is the surest guide to identification where a mark is lacking. It is also a touchstone of aesthetic appreciation, for the beauty of the early English softpastes is remarkable, that of the Red Anchor period at Chelsea being described by the late W. B. Honey as 'of a quality which at its best is unsurpassed by any other', with a paste exceedingly smooth and soft to the touch and a slightly opaque glaze of a cool white tone.[2] To Bow belongs the credit of first using bone ash, the origin of the bone china of the nineteenth-century factories.[3] The established demand for Continental porcelain led to much imitation of specially imported rococo models, but also to a prodigious effort to emulate the quality of craftsmanship. By 1755 Chelsea had attained the highest standard for ornaments for *la garniture de cheminée*, an advertisement of that year specifying 'a set for a chimneypiece or a cabinet, consisting of 7 Jars and Beakers, *beautifully enamelled with flowers*, and the beakers filled with flowers *after nature*'.[4] A vase and cover encrusted with flowers [plate 44A] from Longton Hall, Staffordshire, *c.* 1755, shows that the other factories were not lagging behind. The Chelsea group of *The Music Lesson*, adapted from François

[1] For a strictly economic analysis of the rise of manufactures see J. Thomas, 'Economic Development of the North Staffordshire potteries since 1730', a thesis summarized in the *Bulletin of the Institute of Historical Research*, XII. Feb. 1936, 177–9.

[2] *English Pottery and Porcelain*, 2nd ed., 1945, 112.

[3] W. B. Honey, *Dictionary of European Ceramic Art*, London, Faber and Faber, 1952, 126.

[4] Chelsea *Sale Catalogue* of 1756, cited by R. J. Charleston, 'Covered Vases for the Drawing Room', *C.L.*, 11 June 1959, 1309.

Boucher's *L'Agréable Leçon* engraved by J. E. Nilson [plate 40A; *c.* 1765], splendidly challenges the French on their own ground.[1] The influence of Meissen was at first dominant in elaborate *tour de force* pieces, but a happier inspiration came from its great Modellmeister Johann Joachim Kaendler, because his free style of modelling encouraged fluency. The Chelsea *Aesop* in the Fitzwilliam Museum, Cambridge, has all the immediacy of a baroque sketch, expressed in the liquidity of porcelain instead of oil upon canvas.

Almost from the beginning the English porcelain manufactures began to develop certain original lines of their own. One of the first to emerge was the series of statuettes commemorating national figures, for which there were no Continental sources.[2] The main reliance was on the tradition of British Worthies in sculpture, e.g. the figures of Shakespeare taken from Scheemakers's monument in Westminster Abbey.[3] Theatre pieces are even more distinctive, for they reflect the advanced naturalism of the English stage after its revolution by Garrick as well as the informality of the conversation piece. Contemporary engravings were particularly suited to lively interpretation by those who had learned to render the vivacity of rococo models. Henry Woodward and Kitty Clive had scored a triumphant success as the Beau and Lucy in Garrick's farce *Lethe* at its first performance in 1740. They were painted in these roles by Francis Hayman and Charles Mosley respectively, and both pictures were engraved by James McArdell, the latter dated 1750. The figures made from these engravings at Bow or Chelsea became immensely popular. Accounts show that they were being enamelled in colours at Duesbury's establishment in 1757, and Horace Walpole possessed one of Mrs. Clive painted in water-colours by Thomas Worlidge.[4] Fortunately,

[1] Victoria and Albert Museum. See Joan Evans, *Style in Ornament*, Oxford, 1950, note on plate 18.

[2] For the range of figures outside the national repertory see H. Bellamy Gardner, 'Chelsea Figures from the Italian Comedy', *Apollo*, May 1939; and Arthur Lane, *English Porcelain Figures of the Eighteenth Century*, London, Faber, 1961.

[3] Cf. A. Lee, 'Ceramic Shakespeareana', *Antiques*, Apr. 1947.

[4] See B. Rackham, *Catalogue of the Schreiber Collection of English Porcelain, Enamels and Glass*, V. & A., London, 1930. *Lethe* was Garrick's first play, a rococo skit on

uncoloured specimens survive without the added charms of the colourist. In the fine example of *Woodward as the Beau* [plate 41; after 1750] at Melbourne, the alert and mobile expression of the actor and his momentary pose had been translated into porcelain with sensitivity for the plastic medium and a feeling for the third dimension. The size of the fop's showy hat has been exaggerated, and similar liberties have been taken with his coat. The silhouette is striking from almost every angle. The result is more lively, spontaneous, and decorative than the engraving.

On the Continent the most admired of all the English specialties were the Chelsea toys.[1] In 1754 the Chelsea factory advertised a sale devoted solely to 'All the entire stock of Porcelain Toys', and specified 'Snuff-boxes, Smelling Bottles, Etwees and Trinkets for Watches (mounted in Gold, and unmounted) in various beautiful Shapes, of an elegant Design, and curiously painted in Enamel'.[2] Sprimont the manager, by now probably the proprietor as well, was, we have seen, a goldsmith, and the link with jewellery and metalwork, which has been noted in occasional designs borrowed from goldsmiths' work, is strengthened by the description of the lots as 'suitable for Jewellers, Goldsmiths, Toy-shops, China-shops, Cutters and Workmen in those Branches of Business'.[3] The 'toys' were not playthings for children, but articles of luxury for adults, and ranged from needle-cases to cane-handles and tobacco-stoppers. The term also comprised very small articles in general, e.g. miniature flower-pieces and statuettes. An example in the British Museum shows a masked Cupid beating a drum with his back to a rose tree, surmounted by a stopper in the form of two doves; the motto is, *j'engage le cœur.* Sometimes there are amusing misspellings, one of the most memorable being *je vous coffre* for *je vous l'offre.* 'I lock you up' may well have confirmed the worst French suspicions about the gallantry of the

crossing the Styx, so that the figure should be read not merely as a satire on contemporary manners but a burlesque of the heroic.

[1] See G. F. Bryant, *Chelsea Porcelain Toys*, London, 1925.

[2] R. L. Hogson, *Catalogue of the Collection of English Porcelain in the Department of British and Medieval Antiquities and Ethnography of the British Museum*, London, 1905, 47.

[3] For the influence of silver on porcelain see Dr. Bellamy Gardner, 'Silvershape in Chelsea Porcelain', *Transactions of the English Ceramic Circle*, no. 6, 1939, 27–30.

British to the fair sex. In some of the pieces there is evidence that the modeller took direct inspiration from life. The truth in the observation of a young man pushing a wheelbarrow with a handle too high can be verified by looking at any child attempting to manage a lawn-mower today.[1]

Transfer-printing appears at the Battersea manufacture of painted enamels on copper at least as early as 1753. Its probable inventor was the Irish mezzotint engraver John Brooks, with whom S. F. Ravenet was associated at Battersea. It quickly became the principal means for the dissemination of rococo designs in the British Isles. The leading exponent was Robert Hancock (1729 or 1730–1817), who was trained as an engraver in Birmingham and came to London in the early fifties.[2] After practising in London he was employed at Worcester (c. 1757–74) and for a short time at Caughley (1775). It is likely that he sold engraved plates to all and sundry. His special gift may be defined as a sensitive faculty for adapting engraving techniques to the properties of glazed porcelain on a miniature scale. Indeed he might have been the Bewick of porcelain if his flair for working in small had been supported by comparable powers of observation. Instead he worked with art, not nature, before him, taking designs from Ravenet, Boitard, and Gravelot in England, and from Watteau, Boucher, Lancret, C. N. Cochin fils, Jean Pillement, and Chardin in France.[3] After Gravelot went back to France, he continued to copy his designs. The conversation pieces and subject pictures of Amigoni and Hayman, the Vauxhall paintings of Hogarth, the figures of Gainsborough and Reynolds, and the bird and animal paintings of Barlow and Seymour were all grist to his mill. He was more than a mere copyist, inventing delicious

[1] See G. F. Bryant, *Chelsea Porcelain Toys*, London, 1925, 62, plate 10 (2), and 180, plate 56 (4).

[2] See Cyril Cook, *The Life and Work of Robert Hancock*, London, 1948, an authoritative monograph with many precise identifications of sources, and a key study of the influence of the French rococo in England.

[3] Cook, op. cit., *passim*.

For examples of other borrowings from rococo motives see B. Rackham, 'English Pottery—new quests in old fields', part V: 'The Early Porcelains, Chinoiserie and Rococo', *C.L.*, 22 Aug. 1942.

frames and translating, for example, the figures from Reynolds's *Garrick between Tragedy and Comedy* into an altogether different setting. His best work was done at Worcester during the Wall period, when the beauty of the silky porcelain, the precise printing of his delicately engraved designs, and his respect for the curved surface combined to achieve the summit of transfer printing in England. A die-hard of the rococo, he worked up to 1775 without succumbing to the Adam style.

The last of the innovations to be noted is in flower-painting. In general the sources were the same as on the Continent, and range from China and Japan to rococo engravings after Watteau and Boucher. But a distinctive category of 'Sir Hans Sloane's Plants', to quote a contemporary advertisement, has been traced to drawings of specimens in the Chelsea Physic Garden published in Philip Miller's *Figures of Plants*, 1755 [plate 40B].[1] These and related pieces painted in a free, bold manner, frequently including insects and other ecological details, translate the accurate naturalism of the botanical drawing or engraving into vigorous, telling decorations of the round shapes.

After the Revocation of the Edict of Nantes by Louis XIV in 1685 a large number of Huguenot craftsmen had settled in England, where they joined earlier refugees. Although heavily outnumbered by the native craftsmen, they were a powerful force, some one hundred and twenty French goldsmiths having been traced in London alone between 1685 and 1710.[2] 'Their intellectual vigour', writes Charles Oman, 'dominated English silver from 1700 to 1760.'[3] Like their Dutch predecessors, they adapted themselves to indigenous influences, so that the simplicity established by the Queen Anne style not merely survived but actually

[1] See Bellamy Gardner, 'Old Chelsea Plates copied from Philip Miller's Figures of Plants, 1755', in *C.L.*, 20 Nov. 1937, 516–17. Miller was gardener to the Worshipful Company of Apothecaries in charge of the Chelsea Physic Garden.

[2] See Joan Evans, 'Huguenot Goldsmiths in England and Ireland', 1936, reprinted from *Proceedings of the Huguenot Society*, vol. XV, no. 4; Andrew G. Grimwade, 'The Huguenot Goldsmiths', *C.L.*, 11 Apr. 1947; and J. F. Hayward, *Huguenot Silver in England*, London, 1959, with the review of the last by N. M. Penzer, *Apollo*, 7 Nov. 1959.

[3] *English Domestic Silver*, 1947 (1st ed., 1934), 88.

flourished in the reign of George I, thus becoming as much a symbol of Georgian good taste and sobriety in silver as the country rectory or the merchant's town house in architecture. From about 1735 there was a strong invasion by the rococo style, not merely in ornamental motives but shapes as well, including those of undecorated or lightly decorated coffee-urns, teapots, and other small vessels in which the attenuated serpentine or ogee outline appears. This adoption of the chaste undulating line in the silhouette, together with a tendency to elongation, transformed the severity of the Queen Anne style into a characteristically Georgian elegance. In pieces of display elaborately asymmetrical rococo ornament was applied during the same period to inherited baroque shapes.

The ornamental styles that succeed one another or are intermingled can be splendidly illustrated from the work of Paul de Lamerie, a Huguenot of the second generation in England.[1] Apprenticed to Pierre Platel the Elder, by the late thirties he had developed those powers of *tour de force* craftsmanship which have made his name so well known in England. In 1741 he executed the famous gilt helmet ewer in the Goldsmiths' Company, a display-piece which takes the visual climax away from the body to the uplifted head of the marine god whose figure forms the handle [plate 44B].[2] Lamerie stands here in the tradition of those Renaissance goldsmiths whose work has as good a claim to be discussed in the context of sculpture as that of ornament. The monumental boldness of the forms obscures the fact that the design is an assembly of rococo motives rendered three-dimensionally in high relief instead of being squeezed back into the surface. No less sculptural in its modelling is the Gilt Dish, also chased with the arms of the Company, with its sumptuous rim, on which putti with the attributes of Vulcan, Mercury, Hercules, and Minerva respectively are separated by panels of trellis-work, rococo scrollwork, flowers, and fruit surrounding

[1] See A. S. Phillips, *Paul de Lamerie*, 1935, and A. G. Grimwade, 'Paul de Lamerie' (as represented in the Farrer collection), *C.L.*, 20 June 1947.

[2] *Catalogue of the Historic Plate of the City of London*, Goldsmiths' Hall, London, 1951, no. 235.

figures of an eagle, a falcon, a lion, and a dolphin. Both works were commissioned by the company to replace plate melted down to raise money during the various emergencies from the Civil War onwards.[1] Fittingly, neither breaks with the monumental baroque tradition, which the modern French style here reinforces rather than dissolves.

By contrast, virtuosity of ornament was applied by Lamerie in the Ashburnham Cup at Clare College, Cambridge [plate 43; 1739], to a Georgian design classic in its symmetry and proportions.[2] In this as perhaps in no other work the two predilections of Lamerie's genius, for sculptural ornament and plain shapes, are perfectly reconciled. For while he clearly relished the opportunities provided by chinoiserie and other ornate styles, a very large number of the works that bear his hallmark are as chaste and plain as the Queen Anne style from which they ultimately derive. The playful naturalism that has been noted as a by-product of the rococo in English porcelain appears in one of his severer pieces, a soup-tureen of 1750 in the shape of a mother-turtle on her back with the baby-turtle (the lid) shambling on top.[3] A similar ambivalence between the chaste and the ornate is characteristic of his leading contemporaries, including Charles Kandler, whose tea kettle and stand of *c.* 1727-37 in the Victoria and Albert Museum illustrate the *ne plus ultra* of rococo extravagance in English metalwork.[4] During the whole of this period the standard of design and craftsmanship was just as high in the work of the leading goldsmiths of the native school, like George Wickes, and Thomas Heming, with the single exception of *bravura* sculptural showpieces, a category which for the most part they avoided. The highly accomplished engraving of coats of arms and their surrounds was the province of specially trained craftsmen who were

[1] Ibid. no. 236.

[2] *Catalogue: Treasures of Cambridge*, Goldsmiths' Hall, London, 1959, no. 217.

[3] C. J. Jackson, *An Illustrated History of English Plate: Ecclesiastical and Secular, in which the development of form and decoration in the Silver and Gold Work of the British Isles from the earliest known examples to the latest of the Georgian period is delineated and described*, London, 2 vols., 1911, II. 816, fig. 1055.

[4] Reproduced in Gerald Taylor, *Silver*, Penguin Books, Harmondsworth, 1956, plate 32.

apprenticed to goldsmiths and had the advantage of working in collaboration with them from the very beginning.

The most original adaptation of the rococo style in England was by the cabinet makers. In 1736 Gaetano Brunetti published *Sixty Different Sorts of Ornament*, in which shell-work twisted into intricately asymmetrical shapes was adapted in several instances to furniture design. In 1740 Batty Langley included six projects taken without acknowledgement by the engraver, his brother Thomas, from Nicolas Pineau in his *Treasury of Designs*.[1] These are eclipsed in importance by a group of publications by the carver and engraver Matthias Lock, *A New Drawing Book of Ornaments* (1740), *Six Sconces* (1744), *Six Tables* (1746), and *A New Book of Ornaments* (1752), the last in collaboration with H. Copland. Drawings from Chippendale's workshop, including designs for the *Director*, have been found among collections purchased from Lock's grandson. Other designs for Chippendale's *Director* have been assigned to Copland on the basis of a stylistic comparison with his published engravings.[2] These discoveries have led to the extreme claim that Lock and Copland were Chippendale's 'ghosts'.[3] While Lock was almost certainly employed by Chippendale and may reasonably be given the credit for taking the rococo lead, this is not in itself a valid reason for rejecting the possibility that Chippendale himself was an active and talented designer. After scrupulously investigating the evidence, the most recent authority has concluded that Chippendale 'emerges as a great and original designer instead of the unscrupulous exploiter of other men's ideas, which has been the part assigned to him by most modern authorities'.[4]

The publications of Lock and Copland announce the rise of the specialist designers for furniture, who now wrest the leadership

[1] Peter Ward-Jackson, *English Furniture Designs of the Eighteenth Century*, H.M.S.O., 1958, 35.

[2] See Fiske Kimball and Edna Donnell, 'The Creators of the Chippendale Style', *Metropolitan Museum Studies*, New York, vol. I, 1929, 115–54, and vol. II, 1930, 41–72, and Peter Ward-Jackson, op. cit. The following account is largely based on Ward-Jackson's judicial summing-up.

[3] Kimball and Donnell, op. cit.

[4] Ward-Jackson, op. cit. 44.

of taste from the architect in England as the *ornemanistes* had done in France. There can be little doubt that Lock was the key figure in the new movement, for his rococo publications precede those of Chippendale, who was only twenty-two when the first appeared. Thomas Chippendale (*c.* 1718–79) was by no means the leading cabinet-maker of his age, but he stands out as the most influential publisher before Hepplewhite and Sheraton.[1] The son of a village carpenter at Otley in Yorkshire, he established himself in London and by a combination of self-education, managerial ability, and a shrewd sense of publicity built up a business and fashionable connections remarkable for a man who with so few initial advantages competed against older and much wealthier rivals. His most original step as an entrepreneur was to raise the status of the cabinet-maker's publication from that of a purely tradesman's manual to the level of the architects' publications by addressing the gentry as well as the trade. On the title-page and in his preface and notes to the *Gentleman and Cabinet-Maker's Director* (1754) he borrowed the style and sometimes the language of the manifesto from the Burlingtonians, but in opposition to their creed. He boldly announced his plan to 'improve and refine the present taste', and anticipated the Adam brothers by appealing to the values of 'elegance', 'variety', and 'lightness'. The three standards he opposed to Vitruvius, Palladio, and Inigo Jones were 'the gothic, Chinese and the modern taste'. Anti-classicism, too, had the sanction of a venerable antiquity: 'the Chinese taste admits of the greatest variety, I think it the most useful of any other.' Gothic provided the essential roots in the national past. Like Walpole at Strawberry Hill, he upheld the Liberty of Taste: 'I frankly confess that in executing many of the drawings, my pencil has but faintly copied out those images that my fancy suggested.' Fancy not fidelity is his touchstone of excellence. Just as Campbell wrote the manifesto of the Palladian Revival and the Adam brothers of English neo-classicism, so Chippendale wrote the manifesto of the rococo in England. The trinity of

[1] For Chippendale see Oliver Brackett, *Thomas Chippendale*, London, 1924 (mainly for illustration); Ralph Edwards and Margaret Jourdain, *Georgian Cabinet-makers*, London, 1944; and Ward-Jackson, op. cit.

prefaces thus constitutes a programmatic summary of the three major seminal movements of taste in the century.

In 1732 Hogarth had depicted the harlot kicking over a small table of French design, and in 1738 the *London Magazine* had described the ridiculous imitation of the French as the epidemical distemper of the Kingdom.[1] In 1753 *The World* had sarcastically observed, 'everything is Chinese, or in the Chinese taste; or, as it is sometimes more modestly expressed, *partly after the Chinese manner*'.[2] In all these contexts and references there is a note of national hostility. A year later the same journal commented appreciatively on an improvement in architecture, 'not merely by the adoption of what we call Chinese, nor by the restoration of what we call Gothic; but by a happy mixture of both'.[3] The great merit of Chippendale's publication was not that it mixed the styles but that it provided for the first time a consistency of principles. This may be seen by contrasting it with Matthew Darly's *A New Book of Chinese, Gothic and Modern Chairs*, with plates dated 1750 and 1751, in which Gothic is practically a synonym for eccentricity. Chippendale also kept the rococo style within certain limits of decorum [plate 42B]. He never went as far as Thomas Johnson, who first published in 1755 and whose collection of designs (1758) dedicated to Lord Blakeney, Grand President of the Anti-Gallican Association, marks the *ne plus ultra* of the English rococo.[4] In the dedicatory plate Britannia sits precariously on the slippery slope of an asymmetrical frame. Flying beside her a winged cherub sets fire to a fragment of rocaille and a scroll inscribed 'French Paper Machée'. Johnson's bizarre designs are in fact rooted in the French style he attacked. But he had a flair for invention, combining surrealist effects with abstract rhythms.[5]

Because the designs published by Chippendale were available to all cabinet-makers, an attribution to his firm can only be justified on the basis of documentary evidence, such as receipts. The

[1] Cited by Ralph Fastnege, *English Furniture Styles from 1500 to 1830*, Penguin Books, Harmondsworth, 1955, 135.

[2] No. 12, Thursday, 22 Mar. 1753. [3] No. 59, Thursday, 14 Feb. 1754.

[4] See Helena Hayward, *Thomas Johnson and English Rococo*, London, Tiranti, 1964.

[5] Ibid. 7.

heyday of his prosperity, although not his influence, was in the age of Adam. More eminent firms in the rococo decades 1740–60 were those of Benjamin Goodison (flourished *c.* 1727–67), who enjoyed the patronage of George II, and William Hallett (1707–81), probably the most fashionable furniture-maker of the same monarch's reign.[1] Other important suppliers were William Bradshaw and George Smith Bradshaw (flourished *c.* 1736–50) and William Linnel (flourished 1720–63). Before the decisive association of Chippendale and Adam, the finest pieces of Georgian furniture were those made by the firm of William Vile and John Cobb (flourished *c.* 1750–78), which took the lead among Royal cabinet-makers in the reign of George III. The bookcase [plate 42A] supplied by this firm to Queen Charlotte in 1762 at a cost of £107.14s. od. has no peer in any work known to have been made by the firm of Chippendale before this date.[2] Its carved rococo ornamentation is geometrically disposed and symmetrically balanced, and confers an air of richness rather than gaiety on this magnificent piece of truly Burlingtonian dignity. It is far more typical of the taste of the age than the emancipated designs of Johnson. The rococo invaded the classical world of the English Palladians; it occupied many of its outposts and infiltrated some of its strongholds; but it never challenged the ascendancy of its grand manner.

[1] See R. Edwards and Margaret Jourdain, *Georgian Cabinet-Makers*, 1944. In this and other works of collaboration, Edwards has bridged the gap between pioneering and modern studies, still basically indebted to his fundamental research.

[2] See H. Clifford Smith, *Buckingham Palace*, 1931, 73–4, and R. Edwards and P. Macquoid, *Dictionary of English Furniture*, revised by R. Edwards, 1954, I. 86.

VI

HOGARTH, ROUBILIAC, AND THEIR CONTEMPORARIES

IN May 1738 the statue of Handel by Louis François Roubiliac was erected at a focal point in Vauxhall Gardens, where the proprietor Jonathan Tyers had started an ambitious scheme for decoration by the work of living artists.[1] It represented the composer in contemporary costume and the attitude of Apollo improvising on his lyre [plate 50A]. According to J. T. Smith Tyers had consulted the sculptor Henry Cheere:

'I conclude you will have Music', observed Cheere, 'therefore you cannot do better than to have the carving of an Apollo. What do you say to a figure of Handel?—'Good', replied Jonathan, 'but that will be too expensive, friend Cheere.'—'No,' answered the Sculptor; 'I have an uncommonly clever fellow working for me now, and introduced to me by Sir Edward Walpole; employ him, and he will produce you a fine statue.'[2]

The fine statue occasioned congratulatory verses. One exhortation read:

See *Orpheus*, rising from th' *Elysian* Seats!
Lost to th' admiring world three thousand years.

Another versifier described the reaction of a peasant, Colin, 'suppos'd to be gazing with stupid Wonder, on all the countless Beauties round him':

I spy a *Harper* playing
All in his proud Alcove.

[1] Katherine A. Esdaile, *The Life and Works of Louis François Roubiliac*, Oxford University Press, 1928, 36. See also Joseph Burke, 'Hogarth, Handel and Roubiliac: A Note on the Interrelationships of the Arts in England, *c.* 1730 to 1760' in *Eighteenth-century Studies*, Winter 1969, from which part of the following is taken.

[2] J. T. Smith, *Nollekens and his Times*, 1828, II. 94.

> I doff my Hat, desiring
> He'd tune up buxom Joan:—
> But what was I admiring?
> Odzooks! A Man of Stone.[1]

Apollo plucking his lyre is mistaken for a village harper who could be invited to strike up a lively ballad.

The withdrawn expression of the face is worthy of a great composer at the moment of inspiration; but the Apollo of heroic antiquity does not sit with his knees crossed, in nightcap and *négligé*, with one of his stockinged feet resting on a slipper that he has carelessly kicked off. An infant genius on the ground takes down the solemn notes. His expression, too, is absorbed and serious, but the asymmetrical S-curves of his silky hair, at once realistic and composed, and the dimpling *embonpoint* of his cherubic figure look forward to *L'Enfant à la cage* of Jean-Baptiste Pigalle in France a decade later. He is the spirit of the rococo listening to a strain of higher mood, and tamed for once into quiet by it.

The age looked to the monuments of Westminster Abbey and the paintings of St. Paul's, Greenwich, and the royal palaces for its highest standards in sculpture and painting, not to the decorations at Vauxhall Gardens executed by a coterie of *avant-garde* artists. In music religious oratorio, in literature the elevated verse of tragedy, epic, pastoral, and elegy were similarly placed on a pedestal above the realist and the rococo. There was no relaxation of the moral didacticism of the age of Queen Anne in the reign of the German-born George I and George II. But the vitality of art, music, and literature increasingly poured into new forms of comedy and sentiment in which the humane was frequently opposed to the narrowly moral. The grand and the familiar interact, as in Handel's music. The connections between all the arts and the growth of humanitarianism during this period are striking. Swift, who published his *Modest Proposal for preventing the Children of the Poor People from being a Burthen to their Parents* in 1729, was still alive when the Foundling Hospital admitted 30 children into

[1] The two congratulatory poems were published in *A Sketch of the Spring-Gardens, Vaux-Hall, in a letter to a Noble Lord* (*c.* 1750), 8–9, cited by Esdaile, op. cit. 37.

a house in Hatton Gardens on 25 March 1741.[1] A whole chapter in the history of the arts in Britain in the eighteenth century could be written round their association with new or enlarged hospitals, notably the Rotunda Hospital in Dublin, the city where *The Messiah* was first performed in 1742 in a series of concerts Handel gave for the Hospital and other charities, St. Bartholomew's Hospital with Hogarth's gift of staircase paintings, and the Foundling Hospital decorated gratis by leading artists to attract visitors.[2] Appeals were launched for Guy's Hospital in 1721–5, the Lock Hospital in 1733, and the Middlesex Hospital in 1755–75 with the object of erecting handsome buildings. During the whole of this period artists, writers, and composers were in the forefront of 'the party of humanity'. The thawing of the Augustan mask in portraiture corresponds to the change in outlook and was the achievement of a single generation, of which the leading figure was Hogarth.

William Hogarth was born in Bartholomew Close, London, on 10 November 1697, the son of a classical scholar who conducted a school in the Close and nursed hopes of fame and success by the publication of a Latin dictionary.[3] Idle at his lessons but active in drawing, he was taken early from school at his own request and apprenticed to the silver-plate engraver and dealer in plate and jewellery, Ellis Gamble, but not formally entered in the Registry of Apprentices of the Merchant Tailors Company for a term of seven years until 2 February 1713/14.[4] When his father

[1] R. H. Nichols and F. A. Wray, *The History of the Foundling Hospital*, Oxford University Press, 1935, 21.

[2] For Handel's *Messiah* and his gift see O. E. Deutsch, *Handel: a Documentary Biography*, London, 1955, 401, 523 and R. H. Nichols and F. A. Wray, *The History of the Foundling Hospital*, London, 1935, 206.

[3] For Hogarth see Frederick Antal, *Hogarth and his Place in European Art*, London, Routledge & Kegan Paul, 1962, and Ronald Paulson, *Hogarth's Graphic Works*, Yale University Press, 2 vols., 1965, with an important biographical and critical introduction incorporating much original research. Austin Dobson, *William Hogarth* (1907 ed.), the pioneer scholarly study, is still of value for its insight into Hogarth and his age.

Michael Kitson, 'Hogarth's Apology for Painters', *Wal. Soc.* XLI, 1968, is a key source for the study of Hogarth's ideas and his part in the history of the academic movement.

[4] The entry in the Registry of Apprentices of the Merchant Taylors' Company was first discovered by Col. William Le Hardy and published in 'William Hogarth—

died 'disappointed by great mens Promises' in the affair of the Dictionary in 1718, he was twenty-one.[1] The financial crisis was eventually solved by the family going into trade on their own account. Hogarth designed his shopcard as a tradesman–engraver, the first known dated copy of which is inscribed 'April ye 20, 1720'.[2] About 1725 he designed a shop-bill for his sisters' frock shop.

In the year of his independence and setting up in business he joined the St. Martin's Lane Academy founded in opposition to Thornhill's School at Covent Garden.[3] But Thornhill's paintings at St. Paul's and Greenwich Hospital had fired his lifelong ambition to become a history painter, and the first print he published 'on my own account', *Masquerades and Operas, Burlington Gate* (1724), was a well-aimed blow at Thornhill's opponents. Thereafter he was a staunch member of the Thornhill faction. On 23 March 1729, aged thirty-one, he was married privately at Old Paddington Church to Thornhill's daughter Jane, aged nineteen, without her father's knowledge. The King's Serjeant Painter, Member of Parliament for Melcombe Regis and a wealthy man who later retired to an estate in Dorset, was irate, and the couple had to live apart from him for an uncertain but probably brief period. After a reconciliation they went back to live with Sir James and Lady Thornhill in the Great Piazza, Covent Garden, until 1733, a year after the publication of the *Harlot's Progress*, the success of which may have encouraged Hogarth to move to a handsome house in Leicester Fields, where he set up under the sign of the Golden Head a gilded bust of his hero Van Dyck.

Thereafter his rise was rapid. In 1735 he promoted the Copyright Act, and by this and unheard-of devices, sharply criticized by Vertue, for advertising the sale of his work in the press, became the first English painter to achieve a substantial measure of

A New Biography', *The London and Middlesex Historian*, no. 2, Dec. 1965. See the article with other new findings by R. Paulson, 'New Light on Hogarth's Graphic Works', *Burl. Mag.*, May 1967.

[1] William Hogarth, *The Analysis of Beauty with the Rejected Passages from the Manuscript Drafts and Autobiographical Notes*, ed. Joseph Burke, Oxford, 1955, 205.
[2] Paulson, op. cit. I. 92. [3] British Museum Add. MS. 23082, 35 ff.

independence from patronage. In the same year he revived the
St. Martin's Lane Academy with gear taken over from Thorn-
hill, who had died intestate the previous year. He was elected a
Governor of St. Bartholomew's Hospital and in 1739 became
a Foundation Governor of the Foundling Hospital, where he
promoted from 1745 the presentation of works by living artists,
a landmark in the history of art in England.[1] Active in artists'
clubs and societies, with a Continental reputation, an outstanding
record of service to charity, a remarkable contribution to history
painting, a treatise on aesthetics to his credit, and an income ade-
quate to maintain a town house, a country box at Chiswick, and
a coach and six servants, he obtained in 1757 the highest recog-
nition open to the profession, the appointment of Serjeant
Painter to the King in succession to Thornhill's son. He was never
knighted. On 26 October 1764 he died suddenly at his house in
Leicester Fields.

In tracing the evolution of Hogarth's art there are two lines of
growth to be considered. The first begins with the boy who
looked at the paintings in St. Paul's and Greenwich and dreamed
of becoming a history painter. This line continued when he
identified himself as the legatee of Thornhill's artistic mission to
promote *istoria*, and hung up the bust of Van Dyck, the national
hero by adoption whose superiority to Thornhill he recognized,
outside his house. The second begins earlier, in infancy and child-
hood. According to his own account, 'shows of all sorts' gave
him uncommon pleasure when he was still an infant. Mimicry,
'common to all children, was remarkable in me'.[2] The two lines
of development intertwine. Hogarth could not have parodied
baroque art as effectively as he did if he had not genuinely
admired its greatest masters.

During the years of apprenticeship he evolved the mnemonic
system by which he trained himself to analyse objects lineally and

1 For the list of fifteen artists who had agreed to present their work and were in
consequence elected Governors on 31 Dec. 1746 see R. H. Nichols and F. A. Wray,
History of the Foundling Hospital, 1935, 251. Cf. also the observations in John Pye,
Patronage of British Art, 1845, 87–93.

2 *Analysis*, etc., ed. J. Burke, 204.

read the Language of them (and if possible find a grammar to it)'.[1] His reference is to nature, but his visual memory was exercised on art as well. Among the pictorial sources that Antal has identified by precise examples are Callot; the Bosch–Breughel tradition; the Dutch painters of actualities, especially Jan Steen; the pioneers of the French rococo, notably Coypel; Rembrandt, Raphael, and the Carracci; and in England Van Dyck, Thornhill, and the popular print.[2] In 1745 Hogarth painted as a manifesto his self-portrait with the serpentine line of beauty and the works of Milton, Shakespeare, and Swift.[3] To this trinity of heroes from the national literature must be added the dramatic authors ironically depicted as 'wastepaper for shops' in *Masquerades and Operas*: Ben Jonson, Dryden, Otway, and Congreve. With the exception of Milton and Swift, his access to these authors was directly visual, for he saw their plays acted on the stage and stocked his imagination with the groupings, attitudes, and gestures he there witnessed.

Once out of his apprenticeship he earned his living by designing heraldic ornaments, shopcards, and more congenially by illustrating books and plays, notably by the comic authors Samuel Butler, Swift, Fielding, Molière, and Cervantes. Painting he learned in his spare time, with very little profit from his training as an engraver, by his own account confined to copying and adaptation. In the St. Martin's Lane Academy he drew from the antique and the life under the joint managers John Vanderbank and Louis Chéron, both practitioners of the late baroque. In 1724 he transferred to the Academy of Sir James Thornhill in Covent Garden. He was thirty-one when he is first known to have signed and dated a picture, *A Scene from the Beggar's Opera* (1728). His breakthrough into the profession of painting came with the vogue for the conversation piece. For Vertue the rise of the

[1] Hogarth's mnemonic system and its source in the mnemonic systems of Classical Antiquity are discussed more fully in my introduction to *Hogarth: the Complete Engravings*, London, Thames and Hudson, 1968, edited in collaboration with Colin Caldwell.

[2] F. Antal, 'Hogarth and his Borrowings', *Art Bull.* XXIX, 1947.

[3] For Swift's admiration of Hogarth see Dobson, *Hogarth*, 1898 ed. 52, citing Swift's 'Legion Club', 1736.

conversation piece and the rise of Hogarth are part of the same story. Alone of the native practitioners he invariably introduced the note of rococo playfulness. A little dog brings his alert curiosity to the maritime tableau of the *Woodes Rogers Family* (1729); putti frolic while the parson solemnly reads the sacred text in *The Wedding of Stephen Beckingham and Mary Cox* (1729–30); and a naughty son has climbed on to a chair to kick down the valuable folios which his older brother rushes to protect in *The Cholmondeley Family* (1732).[1] The masterpiece of this period, *A Scene from the Conquest of Mexico* (1731–2), depicts a performance of Dryden's play by aristocratic children in the house of John Conduitt, Master of the Mint, before younger members of the royal family. The seated woman bending down to attract the notice of a child is reminiscent of Watteau, but the down-to-earth realism of her action is Hogarth's own observant touch.

The conversation pieces brought him the patronage of the gentry and even of the aristocracy—the latter sometimes an uneasy relationship. The turning-point in his career was the success of the *Harlot's Progress* prints in 1732. According to Vertue, the starting-point was an excursion into rococo naughtiness, a single picture of a whore *en déshabillé*. He was then urged to add a companion picture, 'other thougts encreased, and multiplyd by his fruitfull invention. till he made six. different subjects'.[2] Some remarkable parallels have been detected with *Lo specchio al fin de la putana* (c. 1655–8), a series of twelve engravings of the life and death of a Venetian courtesan.[3] The precedents range from Dutch serial narratives of the Prodigal Son to Italian broadsheets based on the *canti carnascialeschi*. But dominating all pictorial sources is the influence of English tragicomedy and the comedy of manners from Ben Jonson to Fielding. By constructing his narrative cycle in the strict mode and visual language of a sophisticated theatre Hogarth justified the claim of Reynolds

[1] For these and other paintings discussed see the catalogue and illustrations in R. B. Beckett, *Hogarth*, 1949.

[2] *Vertue*, III. 58.

[3] Hilde Kurz, in 'Italian Models of Hogarth's Picture Stories', *J.W.C.I.* XV, 1952, traces the roots of this Italian tradition and demonstrates similar correspondences between *La vita del lascivo* (c. 1660–75) and the *Rake's Progress*.

that his countryman 'had invented a new species of dramatick painting'.[1]

Once the sale of engravings after the paintings was protected by the Copyright Act of 1735, known to his contemporaries as 'Hogarth's Act', he could afford to take greater pains over the following series. The titles of his characters, Moll Hackabout (1732), Tom Rakewell (1735), Viscount Squanderfield and Counsellor Silvertongue (1745), Thomas Idle and Francis Goodchild (1747), to say nothing of Timothy Babyhouse, who is named but never appears in *Marriage-à-la-Mode* (1745), stood for types of the bawd, rake, spendthrift, seducer, delinquent, model hero and booby familiar to every contemporary theatregoer. The same is true of the episodes with their stock properties and accessories: the lover surprised in a bedroom, the intrigue at the levee, the confrontation in the street, the uproar in a tavern, the duel scene, the death-bed denouement. A plot is unfolded, and as Walpole pointed out, a sub-plot or intrigue is carried on through *Marriage-à-la-Mode*. Every action could be readily translated into stage directions. In the *Duel Scene* from the last series [plate 46A] the Watch break in through the door (backstage right); the lover escapes through the window (backstage left); the Countess (centre-stage left) kneels in classic or heroic profile while the Earl (centre-stage right) dies in an exquisite parody of the serpentine line of rococo grace.

Marriage-à-la-Mode concludes the moral series in a strictly dramatic mode.[2] In 1742 his friend Henry Fielding in the Preface to *Joseph Andrews* described Hogarth as a comic history painter, and himself as a writer of comic romances: 'Now, a comic romance is a comic epic poem in prose; differing from comedy, as the serious epic from tragedy; its action more extended and comprehensive, containing a much larger circle of incidents, and introducing a greater variety of characters.' Having mastered the dramatic mode of satire, Hogarth now turned to the epic,

[1] *Discourses*, ed. Wark, 254.

[2] Cf. F. Antal, 'The Moral Purpose of Hogarth's Art', *J.W.C.I.* XV, 1952, in which he stresses the bourgeois character of Hogarth's morality, and its parallels with Fielding.

just as Fielding had written comic plays before novels.[1] Above Thomas Idle's head in Plate I of *Industry and Idleness* (1747) hangs a copy of Daniel Defoe's *Moll Flanders*, a key source for the series, although certain episodes are still taken straight from the theatre.[2] *The Four Prints of an Election* (1755–8) is his masterpiece of comic history painting, a *tour de force* in mock-heroic baroque parody. It opens with a banqueting scene alluding to the *Last Supper*. *Canvassing for Votes* is an open street scene with a riot in the distance. *Polling for Votes* substitutes an elevated booth for the temple approached by steps in Venetian Bible paintings. *The Election: Chairing the Member* [plate 46B] is an elaborate parody of two types of baroque painting, the battle piece and the *sacra conversazione*. The goose that flaps its wings over the head of the first elected Member (only the shadow of the second can be seen) is wittily substituted for the eagle that flies over the head of Alexander the Great in Pietro da Cortona's *Battle of Arbela*, which Hogarth knew from the engraving by G. G. Rossi.[3] The group of the enthroned Member supported by chairmen and escorted by admirers parodies the enthroned Madonna attended by saints and angels playing music, the spiral composition being translated into a precarious zigzag in accordance with the doctrine propounded at such length in *The Analysis of Beauty* (1753), that the forms of comic art must be the reverse of those of the norm for beauty.

Hogarth made a striking advance as a painter by radically revising his style in the late thirties or early forties, probably under the stimulus of Roubiliac, whose model for the bust of Hogarth [plate 1] Vertue saw in the sculptor's studio in 1741.[4]

[1] See Ronald Paulson, 'The *Harlot's Progress* and the Tradition of History Painting', *Eighteenth Century Studies*, University of California Press, vol. I, no. I, Fall 1967, for a masterly study of Hogarth's parody of *istoria* and its revolutionary implications.

[2] Chapman, Marston, and Jonson's *Eastward Hoe!* had recently been republished in Dodsley's *Old Plays* (1744). See Paulson, op. cit. I. 194. The influence of Hogarth on both the stage and fiction is fully discussed in R. E. Moore, *Hogarth's Literary Relationships*, University of Minnesota Press, Minneapolis, 1948.

[3] John Ireland in *Hogarth Illustrated*, 1791, II. 383, states that Hogarth was parodying the eagle in Le Brun's *Battle of Granicus*, but this is clearly a confusion.

[4] *Vertue*, III. 105. Vertue lists it as a model in clay, so he may have seen it before it was fired.

He is known to have greatly admired Quentin De la Tour, and he visited France in 1743.[1] But the feeling for modelling now infuses itself so powerfully into his painting of plastic forms, and the schemata of his portrait heads correspond so closely with Roubiliac's, that his friendship with the sculptor must at least have predisposed him to the new influences from France, operating much more strongly on his awareness of three-dimensional form and its spatial ambience than anything he could have learned from Mercier and Gravelot. There is nothing in the conversation pieces, for all their delicious passages of sensitive brushwork, to prepare the spectator for the monumentality of his portrait of *Captain Coram* (1740), the composition of which is adapted from Drevet's engraving after Hyacinthe Rigaud's portrait of Samuel Bernard,[2] and the fluidity of *Mrs. Elizabeth Salter* (1744), which is as close to Roubiliac's schemata for the face as the self-portrait of 1745. During this period of advance he even essayed the conversation piece on a more monumental scale. *The Graham Children* [plate 47A; 1742] is a realist painting animated by rococo playfulness and liveliness of movement. The boy plays the bird-organ or *sérinette*, on the side of which is painted *Orpheus taming the Wild Beasts* in witty allusion to the role of the boy amusing his three sisters. The girl in the centre dances; the eldest sister teases the child by dangling cherries while restraining its grasping hand. A cat, its whole soul in its eyes, unsheathes its claws as it gazes with total concentration on the terrified goldfinch in a cage. The infant is in a state of over-stimulation induced by the simultaneous excitements of being wheeled in on a go-cart, the sound of music, the movement of dancing, dangled cherries, and a piece of sticky biscuit in its hand. Every formal device has been used to keep the eye in constant movement. The composition is balanced, but there is no central

[1] *Vertue*, III. 116. This is the more important of his two visits to France, for the second in 1748 was cut short by his arrest. Moreover, early in 1744 he brought over a French engraver from Paris to assist him (*Vertue*, III. 120). For his admiration of Quentin de La Tour see W. T. Whitley, *Artists and their Friends in England 1700–1799*, London, I. 31.

[2] For the correspondences with Rigaud's portrait see F. Antal, 'Hogarth and his Borrowings', *Art Bull.* XXIX, 1947.

focus. Let the eye rest on one face, and it is drawn to another. The painting is rich in rococo forms, the asymmetrical serpentine line of the boy's coat eloquently echoed by the girl's upheld apron. Especially French is the play of light on the soft but intricately broken surface of the dresses. But according to his theory of comic form as an inversion of the norm, he introduces surprising contrasts of straight lines and zigzags.

At the time of his death Hogarth had an extraordinarily varied record of original achievement behind him. In addition to his elevation of comic art, he had painted more history paintings on a monumental scale than Reynolds was ever to achieve. One of the earliest, *The Tempest* (*c.* 1734), is an illustration of Shakespeare in the great style of Bible painting, thus anticipating the Boydell Shakespeare Gallery by several decades.[1] Ferdinand and Miranda are shown as an Annunciation pair and Prospero as a Joseph figure. Some were presented as gifts, but for others he received substantial sums, including 500 guineas for the *Ascension Altarpiece* in St. Mary Redcliffe, Bristol.[2] He therefore played a notable part in keeping the category alive between the ages of Thornhill and West, although not so prolific in it as Hayman. As a painter he not only stands first amongst those pioneers who humanized the English portrait, but advanced from modelling with the brush to an almost impressionist freedom of technique, the late but undated *Shrimp Girl* being hailed as a forerunner of modern art by Meier-Graefe as early as 1904. The range of his satire is so wide that it is impossible to do justice to it in a general account, but mention may be made of his attack on social problems in *Beer Street* and *Gin Lane* (1751), his crusade against cruelty culminating in *The Four Stages of Cruelty* of the same year, his deep concern with the welfare of the young in the lower classes and his championship of Fielding's cause after the novelist's death in prints like *The Bench* (1758), which looks forward to Daumier in spirit if not in style. He closed his original *œuvre* as he had begun

[1] R. B. Beckett, op. cit. 74, dated the picture *c.* 1728, but stylistically the painting belongs to the cycle of history paintings commencing *c.* 1735.

[2] The total bill, including installations, came to about £800. See *The Altarpiece of St. Mary Redcliffe*, Bristol, City Art Gallery, 1963.

it, with a satire on connoisseurship: 'FINIS, or the Tail-Piece. The Bathos, or manner of sinking in Sublime Painting, inscribed to the Dealers in Dark Pictures.' Hogarth must have enjoyed his ideas as they crowded on his imagination in this mock-rococo counterpart to Dürer's *Melancholia* [plate 45A]. The composition draws on traditions of the funerary monument that had been revived by Roubiliac in his monument to *General Hargrave* in Westminster Abbey, erected in 1757 [plate 45B]. Specially noteworthy is the witty parody of baroque sublimity by association: the tumbling post of The World's Tavern has been substituted for the sculptor's crashing pyramid. Among the scattered emblems of mortality is a legal commission declaring Nature bankrupt. This was the crux of his message, for the party of humanity to which he belonged fought under the banner of nature as well as reason.

During the lifetime of Hogarth Vertue records the growing tendency of artists to unite in groups at coffee-houses and taverns.[1] Old Slaughter's Coffee House in St. Martin's Lane, which Vertue stated was 'a rendezvous of persons of all languages and Nations, Gentry artists and others', has been described as being to the mid-eighteenth century what the Café Royal was to the 1890s.[2] Almost its whole set of artists was employed on the decoration of Vauxhall Gardens, where Jonathan Tyers reopened the New Spring Gardens on 7 June 1732 with a new entertainment styled a *Ridotto al fresco*.[3] The same group also gained something like a coterie control of the St. Martin's Lane Academy after Hogarth's intervention in 1735. In its heyday it shared in the patronage of Frederick Prince of Wales and his circle, and its members included Hogarth, Gravelot, Roubiliac, Hayman, Moser, Yeo, and Wale,

[1] See *Vertue*, III. 91, for his reference to Slaughter's Coffee House.

[2] Mark Girouard in three articles with much new information on 'English Art and the Rococo', *C.L.*, 13 Jan., 27 Jan., and 3 Feb. 1966, devoted the first to Old Slaughter's Coffee House and especially its associations with the St. Martin's Lane Academy and the Vauxhall Gardens decorations.

[3] The best account of the works of art at Vauxhall is by Laurence Gowing, 'Hogarth, Hayman and the Vauxhall Decorations', *Burl. Mag.*, Jan. 1953, with many illustrations. See also J. G. Southwark, *Vauxhall Gardens*, Columbia University Press, New York, 1941, and Warwick Wroth, *London Pleasure Gardens of the Eighteenth Century*, London, 1896.

as well as the novelist Fielding and the actor Garrick. Gainsborough joined it in his early years in London. It became a major force in disseminating the rococo in England, the leading part here being played by Gravelot. It was active in presenting works to the Foundling Hospital, and its core led the exhibiting societies of artists from 1760. Those of its prominent members who survived were all elected Foundation Members of the Royal Academy.

In a list of the principal members of the St. Martin's Lane Academy in 1745 Vertue puts Francis Hayman (1708–76) first and Hubert-François Gravelot (1699–1773) second. The figure of Hayman, boon companion, affable, co-operative, in favour with Sir Robert Walpole when he was Prime Minister and active in clubs and societies, crops up again and again in the records and memoirs of the time.[1] Less enterprising than Hogarth, but also less of a controversialist, he was naturally chosen Chairman of the twenty-five artists set up to plan an Academy in 1755 and of later elective bodies, and held the Presidency of the Society of Artists from 1766 to 1768, when he seceded to the Royal Academy under Reynolds. The dominant force, however, was Gravelot, who arrived in England in 1732 and by 1739 had become a leading light at Old Slaughter's Coffee House, where he endeared himself to the anti-Burlingtonians by his lively opposition to Sir Andrew Fountaine and other connoisseurs.[2] A pupil of Boucher, who encouraged him to work on a miniature scale, he was a true *petit-maître* of the rococo, and nothing com-

[1] For Hayman see L. Gowing, op. cit.; A. Graham Reynolds, 'Painters of the British Stage I. Francis Hayman and John Zoffany', *New English Review Magazine*, Oct. 1948; M. A. Hammelmann's articles on eighteenth-century English book illustrators in *Book Collector*, 1952 and 1953, and 'The Art of Francis Hayman', *C.L.*, 14 Oct. 1954, W. Moelwyn Merchant, 'F. Hayman's Illustrations to Shakespeare', *Shakespeare Quarterly*, IX, Sept. 1958, S. A. Henry, 'A Further Note on The Engravings of The Oil Paintings of Francis Hayman in Vauxhall Gardens', *Burl. Mag.*, Dec. 1958, and especially G. L. Conran, *Paintings, Drawings and Prints by Francis Hayman R.A.*, catalogue of an exhibition at the Iveagh Bequest, Kenwood, L.C.C., 1960.

[2] For Gravelot see H. A. Hammelmann, 'A French Master of Eighteenth Century Illustration', *C.L.*, 3 Dec. 1959: Yves Bruand, 'Hubert Gravelot et l'Angleterre', *Gazette des Beaux Arts*, Jan. 1960; Vera Salomons, *Gravelot*, London, 1911; and Lady Dilke, *French Engravers and Draughtsmen of the Eighteenth Century*, London, 1902, 112–15, 118–20.

parable to his modish skill had been seen in the subscription Academies. His fine, sensitive line, cult of the silhouette, and observation not only of the texture of materials but the cut and hang of costume combined to set a standard of elegance far above that of his French predecessors like Mercier. He is iconographically important in that his engraved costume studies and inventive series depicting children's games (from about 1732) provided a repertory of images on which decorators of porcelain drew for several decades, and echoes of their stylish attitudes can be found in artists as diverse as Hogarth (notably the Rake in the *Levée* scene), Hayman, Highmore (in the Pamela series), Arthur Devis, and especially Gainsborough.[1] According to Vertue, it was believed that he had made a considerable fortune before he retired to France in 1746.[2] This is credible in view of his recorded activity in designing for goldsmiths, joiners, cabinet-makers, and other artists, in inventing the rococo ornaments for John Pine's engravings of *The Tapestry Hangings of the House of Lords* (1748), and as a leading book illustrator and a painter of conversation pieces. Gravelot cannot be claimed for English art, but as a teacher with his own drawing-school off the Strand and by virtue of his talents he made an impact on it out of all proportion to the length of his stay.

John Pye, echoing Edward Edwards, described Hayman as the most distinguished English historical painter of his day, a reputation presumably based on his scenes for Drury Lane Theatre, a number of ceiling paintings, his work at Vauxhall and the Foundling Hospital, and his activity as an illustrator to Congreve, Milton, Pope, Cervantes, and Shakespeare. In common with some earlier Dutch painters of *istoria*, he depicted the expressive features of face and body too large. Horace Walpole described his composition as 'easily distinguishable by the large noses and shambling legs of his figures'.[3] Between 1743 and 1744 no fewer than eighteen engravings after Hayman's paintings at Vauxhall were published, two of the designs for these having been furnished by Gravelot.[4] The project for decorating the Supper Boxes at

[1] Many borrowings from Gravelot are identified in Cyril Cook, *The Life and Work of Robert Hancock*, London, 1938.

[2] *Vertue*, III. 131. [3] *A. of P.* II. 325. [4] G. L. Conran, op. cit. 19–20.

the Gardens with more than fifty large paintings, the majority 8 feet across, was well under way by 1741. Hayman's first subjects were either recreational or taken from the stage, *Sliding on Ice* being a typical example of his eclectic style, combining as it does a classical frieze composition with gestures of baroque rhetoric and the Dutch humour of a kneeling figure exposing rents in the seat of his breeches. Before the death of Frederick Prince of Wales in 1751 a special pavilion in the Gardens was set aside in his honour. In this pride of place was given to four paintings of Shakespearean scenes by Hayman.[1] His greatest opportunity came in 1760, when he decorated the new music room with 'some of the glorious transactions of the late war', namely, the surrender of Montreal to Lord Amherst, Hawke's victory at Quiberon Bay, Lord Clive receiving the homage of the Nabob after Plassy, and Britannia distributing laurels to a group of leading generals headed by the Marquess of Granby, a cycle which preludes the achievements of the Anglo-American school of history painters later in the century.[2] Nevertheless, these scenes in contemporary costume were rendered in too realistic a style to be regarded unequivocally as in the great style of history painting.

'In consequence', wrote John Nichols, 'of the public attention bestowed upon the painting presented to the Foundling Hospital by Hogarth, the Academy in St. Martin's Lane began to form themselves into a more important body, and to teach the Arts under regular professors.'[3] It was more important because it was more representative than the Old Slaughter's Coffee House set. Ramsay, not a member of the coterie, was an early donor in a list which reads like a roll-call of illustrious artists through the generation of Reynolds to the generation of West. Joseph Highmore (1692–1782) presented *Hagar and Ishmael* in 1746. The broad handling recalls Amigoni, Hagar is modelled on the Virgins of

[1] Vertue in 1745 noted two or three large history paintings lately painted for Vauxhall Gardens and placed in the Hall Room, but does not specify their subject. See *Vertue*, III. 126.

[2] Cf. Charles Mitchell, 'The History-Picture in English Art', *Listener*, 25 May 1950, 918.

[3] *Anecdotes of William Hogarth*, 1833, 139, reprinted from *The Works of William Hogarth*, 1822.

Murillo, and the pointing hand of the angel reproduces the hand of God in Michelangelo's *Creation of Adam*. In short, it suffers from the same defect of eclecticism as the other history paintings that were presented. Older than Hogarth and Hayman, he was a member of Kneller's Academy as early as 1714, but emerges late on the scene because he lost so many years training as a clerk to an attorney, and did not mature until the mid-1730s.[1] According to Vertue, he was initially a realist, painting family pieces of citizens 'in the Very habit They appear in'.[2] If so late a date as 1740 can be accepted for *Mr. Oldham and his Friends*, it must have been a reversion to his earlier realism.[3] Generally by this date he depicted his sitters in attitudes which are both easy and elegantly stylized, and rendered their bodies and costume with a mannered and elongated silhouette which is the hall-mark of Gravelot's English followers. He was also highly expert in catching the bloom of velvet and the sheen of satin, a skill in which he was unrivalled before Cotes. Vertue attributed his remarkable progress to his observation of 'celebrated Artists, especially Vandyke'.[4]

Highmore has been compared with Sterne, but the novel he chose to illustrate in a bid to rival the success of Hogarth's narrative paintings was Samuel Richardson's *Pamela, or Virtue Rewarded* (1740). The series is now divided between the Tate Galley, the Fitzwilliam Museum, Cambridge, and the National Gallery of Victoria, the last having the most important single collection of

[1] *Vertue*, III. 29, reports 'came into the academy under Sir G. Kneller about ye 3d or fourth year after it was sett up' in 1711. The obituary in the *Gentleman's Magazine*, 1780, 176, implies that he entered the Academy while still a clerk, and 'drew 10 years'. His clerkship expired on 13 June 1714.

[2] *Vertue*, III, loc. cit.

[3] Cf. F. Antal, 'Mr. Oldham and His Guests', *Burl. Mag.* XCI, 1949. Highmore had been painting realist portraits from 1721, see J. W. Goodison, 'Two Portraits by Highmore', *Burl. Mag.*, Sept. 1938.

[4] *Vertue*, III, loc. cit. Another important source of his style was Rubens, whom he discussed in two articles in the *Gentleman's Magazine*, 'Remarks on some Passages in Mr. Webb's Enquiries into the Beauty of Painting', 1766, 533 ff. and 'Note to an Eminent Painter', 1778, 526 ff. His admiration of Rubens was stimulated by a visit to Düsseldorf and Antwerp in 1732, the year of Gravelot's arrival in England.

The influence of Gravelot is discussed by E. K. Waterhouse, 'English Painting and France in the Eighteenth Century', *J.W.C.I.* XV, 1952.

Highmore's paintings including portraits.[1] The explanatory text to the engravings by Benoist and Truchy (1745, a second set in 1762) was published in both French and English, as befitted a work clearly designed to appeal to the French market as well as the home one. Its narrative mode is unique in European painting of the period, combining as it does a witty interpretation of the serious masterpiece of a great psychological novelist with the intimate elegance of the conversation piece.

In the scene of *Lady Davers ill-treating Pamela* [plate 47B; 1741–5] a domestic outrage has disturbed the normal tranquillity of English country-house life. The proud Lady Davers, sister to Squire B., who first tries to seduce his servant Pamela and has now agreed to marry her, is about to attack the virtuous girl whose long-suffering patience is on the verge of being rewarded. Like a faithful satyr rescuing a wood nymph from assault by a rival in his proprietary territory, the housekeeper Mrs. Jewkes rushes in on hearing the cry of alarm. There is a kind of picture that appeals strongly to those interested in other people's houses and how they live in them, and this is an excellent example with its economical and therefore telling selection of typical and appropriate objects.[2] The arrangement calls to mind the tact of display in the conversation pieces of Arthur Devis, but the style of painting is very different. Pastel colours, muted by browns and greys broadly brushed in, are enlivened by white and pink impasto, and a brilliant note of colour is struck by the red orange almost in the centre of the table.

When Pamela's old father, poor but honest, appears on the scene, one is reminded of both Greuze and Hogarth, *le genre sérieux* and the comedy of manners. But Greuze was a later painter, and the affinity is adduced merely to suggest how well the *Pamela* series would survive the test of a French context,

[1] The Pamela group was acquired on the recommendation of Frank Rinder in 1921; the self-portrait and family portraits from his descendant Archdeacon Morgan Payler in 1947, and the portrait of Samuel Booth in 1959. See Ursula Hoff, *Catalogue of European Paintings before Eighteen Hundred*, National Gallery of Victoria, Melbourne, 1961, 66–71.

[2] See G. Bernard Hughes, 'Glass Pyramids on the Dessert Table', *C.L.*, 26 Mar. 1964, for a salver with 8 jelly glasses close to the sweetmeat stand in this painting.

the ideal foil to its Englishness. With Allan Ramsay (1713–84), a painter whose contacts with French art were more direct, the borderline is crossed between the Old Slaughter's Coffee House set and the purveyors of fashionable portraiture.[1] In a letter to a Scots countryman, dated 10 April 1740, Ramsay, who had settled in London for nearly a year after studying in Italy from 1736 to 1738, wrote, 'I have put all your Vanloos and Soldis and Ruscos to flight, and now play the first fiddle myself.'[2] Jean-Baptiste Van Loo had been in London since 1737, Andrea Soldi since about 1736, and Francesco Carlo Rusca since 1738; the last had been pro-mised opportunities to paint 'all the Royal Family' by George II.[3] The ambitious Scotsman did not mention his leading English rivals in portraiture, Hogarth, Hudson, Highmore, and Knapton. These were all masters whose true talents were for the informal portrait. When they attempted formal full-lengths, their pictures did not really hang compatibly alongside the noble images by Van Dyck inherited by their most aristocratic patrons. This was the vacuum that Ramsay, before Reynolds and Gainsborough, set out to fill.

In a letter of November 1736 to Mariette in Paris he declared that 'it is at the French Academy alone that Youth can profit in a study of the fine arts'.[4] In the event he modelled himself chiefly on Francesco Imperiali and Pompeo Batoni in Rome and Solimena in Naples. Shortly after his return he painted the full-length of *Thomas Henry, Viscount Deerhurst* (c. 1740), one of a large group of paintings which are more Italianate than French.[5] Here at last was a completely modern standing figure by a British painter which could hang admirably in an ancestral portrait gallery ranging from the reign of Queen Elizabeth to the age of Kneller.

[1] The standard authority is Alistair Smart, *The Life and Art of Allan Ramsay*, London, 1952, 45. See also Sir James Caw, 'Allan Ramsay, Portrait Painter', *Wal. Soc.* XXV, Oxford, 1947, E. K. Waterhouse, *British Painting*, 1953, and *Allan Ramsay: his Masters and Rivals*, an exhibition catalogue by Colin Thomson and Robin Hut-chinson, National Galleries of Scotland and The Arts Council Scottish Committee, 1963. [2] Cited in Smart, op. cit. 45.

[3] For the arrivals of these artists see *Vertue*, III. 82, 84, 85, and for George III's promise to Rusca, ibid. 76. Van Loo's English *œuvre* is discussed in E. K. Waterhouse, 'English Painting and France in the Eighteenth Century', *J.W.C.I.* XV, 1952.

[4] Cited by Alistair Smart, op. cit. 30. [5] Illustrated ibid., plate IV.

He quickly gained the prestige that such a talent conferred, and the practice that went with it. He became the favourite portrait painter of George III, and between 1760 and 1769 his studio was prodigiously busy in turning out official portraits of the King and Queen. In 1767 he succeeded Shackleton as Serjeant Painter.[1] By the time the star of Reynolds was in the ascendant, he was a wealthy man with large shareholdings in the East India Company, and could afford to play the part of a country gentleman with a record of literary authorship and somewhat eccentric scholarly interests.

Vertue's observations on Ramsay are confined to the period between his first visit to Italy in 1736–8 and his second of 1754–7. He particularly disliked the underpainting of the whole face in red, a method 'used in Italy by Cavaliere Luti and others, and so did Titian he says'.[2] The effect was censured as 'rather lick't than pencilld'. The break with the Kneller tradition upheld by Vertue is magnificently justified by Ramsay's full-length of *Archibald, 3rd Duke of Argyll* [plate 52; 1750] in the Glasgow Art Gallery, a painting not unworthy of comparison with Roubiliac's *Lord President Forbes* [plate 53]. The seated Duke in his flowing robes turns from his open book in a relaxed and lifelike attitude; the aloofness of grandeur is tempered by the keen gaze, which seems directed at an individual rather than a group audience. Ramsay was no admirer of *The Analysis of Beauty*, some of the theories of which he had debated with the author before its publication in 1753, but the composition is dominated by the serpentine line of grace derived from the same rococo source. It is generalized, like those of the contemporary Italian masters he admired, but the surface delicacy with which passages of minute observation are handled can only have been learned from the French. In such portraits Ramsay combined dignity with informality, and more than any other portraitist of the time made intimacy acceptable in apartments of state. 'The age of the peri-

[1] T. Borenius, 'The Serjeant Painters', *Burl. Mag.*, Apr. 1944. For the painting of the accessories by David Martin, George Roth, Philip Reinagle, and a dozen or more others in many of these official portraits and their replicas see Smart, op. cit. 121.

[2] *Vertue*, III. 96.

wig and the poker face', writes Waterhouse, 'disappears from portraiture, and character, rather than dignity, becomes what the intelligent sitter demanded from a portrait.'[1] Ramsay offered both character and dignity.

Before his second visit to Italy Ramsay had become confirmed in his initial liking for French art, expressing in particular an admiration for Quentin de La Tour. His *Portrait of his wife*, that is, the second wife he had just married, in the National Gallery of Scotland, was probably painted in Italy. At first sight this study of a sensitive and beautiful young woman surprised while arranging flowers, her head turned 'comme pour répondre à une question', would suggest that he had completely transferred his allegiance from the Italians of the *Settecento*.[2] There are few portraits in *le style pompadour* that can rival its intimate charm and the lyrical delight in the colours and texture of the plum-coloured embroidered dress, fichu of white lace, silky hair, freshly cut flowers, and blue and white porcelain vase. But the colours are muted, and the design itself might have been borrowed from a portrait by Poussin. By combining the classicist forms which give finality or permanence to an image with a momentary action, Ramsay observed the precept of his favourite author, 'ars est celare artem'.

On his return his handling became softer, his composition more classical. *Lady Mary Coke* (1762; in the collection of the Marquess of Bute) stands in frieze profile, *Mrs. Elizabeth Montagu* (c. 1760; private collection) is seated with her dress spread out to form a triangle.[3] *Jean Jacques Rousseau* (1766; National Gallery of Scotland) derives ultimately from Raphael's *Baldassare Castiglione*. That the first of these sitters turns her head and lightly holds a theorbo, the second idly clasps her wrist and leans against a table, and the face of the third is almost startling in its nervous intensity disguises the extent to which Ramsay had incorporated classical values into the most delicate phase of his painterly style.

[1] 'English Painting and France in the Eighteenth Century', *J.W.C.I.* XV, 1952, 123.

[2] For a sensitive French appreciation see Henry Marcel in A. Michael (ed.), *Histoire de l'Art*, VII (1925), pt. 2, 707.

[3] Reproduced in *Wal. Soc.* XXV, 1937, plate 29a.

Among the native painters of fashionable portraiture with whom Ramsay competed Thomas Hudson (1701-79), who employed the drapery painter Joseph Van Aken, probably had the most solid practice.[1] 'The country gentlemen', writes Walpole, 'were faithful to their compatriot, and were content with his honest similitudes, with their fair tied wigs, blue velvet coats, and white satin waistcoats, which he bestowed liberally on his customers, and which with complacency they beheld multiplied in Faber's mezzotints.'[2] He and his drapery painter must have taken especial pains over the portrait of *Handel* in the Staadts-bibliothek in Hamburg, signed and dated 1749, to which Walpole's description in general applies.[3] In full-lengths like *Sir John and Lady Pole* (1755) he introduced informal but decorative poses which clash with the Van Dyck tradition but must have looked very well in those Palladian interiors which were adorned with rococo carving and plasterwork.

George Knapton (1698-1778), also a pupil of Richardson, returned from several years in Italy in 1732. He became an active member of the Society of Dilettanti and its official painter in 1736.[4] His portraits of the members constitute a remarkable and unique attempt to create a new type of club portrait, more lively than the Kit-Cat series by its use of jocular themes, fancy dress, and classical allusions. In 1750 Vertue commented on his 'great improvement' in oil painting and his established position as a connoisseur and art adviser to Frederick Prince of Wales, on whose succession to the throne so many artists based their hope.[5] His most ambitious painting, *Augusta, Princess of Wales and her Eight Children* (1751) at Marlborough House, assembles motives from the conversation piece, children playing with a ship model

[1] For Joseph Van Aken and his son see J. Steegmann, 'A Drapery Painter of the Eighteenth Century', *Conn.*, June 1936. The Van Akens played an important part in the dissemination of the vogue for 'Van Dyck' costume, notably imitating the dress worn by Hélène Fourment in her portrait by Rubens.

[2] *A. of P.* II. 323-4.

[3] Reproduced in Max Osborn, *Die Kunst des Rokoko*, Berlin, 1929, plate 499. For the portrait of Sir John and Lady Pole see Waterhouse, *British Painting*, plate 113.

[4] See Lionel Cust and Sidney Colvin, *History of the Society of Dilettanti*, 1898, for Knapton's work for the Society. [5] *Vertue*, III. 154.

and dogs frisking, the adults shown in attitudes of ease and familiarity, in the wholly artificial context of a monumentally baroque *mise en scène*.[1] The enormous but somewhat incongruous picture marks the peak of his career, but thereafter he gradually faded from active competition. At Althorp, where he had to meet the challenge of Van Dyck, he had been much more successful in his portrait of the *Hon. John Spencer and his Son* (1745), a sporting scene in which the group, including a negro attendant, is reminiscent of the casual figures in a Wootton landscape, here isolated and enlarged to noble proportions.[2]

An important consequence of the new developments in portraiture was the stimulus they gave to the reproductive print, which in eighteenth-century England conferred the highest status on engravers, particularly those who worked after the Old Masters.[3] Nicholas Dorigny, who presented a set of his Raphael Cartoon engravings to George I, was knighted in 1720 as a reward for the successful completion of a task which had taken him and his two assistants Charles Dupuis and Claude Du Bosc nearly ten years.[4] The other great reproductive commission of the age, John Pine's engravings after the Spanish Armada Tapestries (1738) in the House of Lords, was protected in advance by special legislation in Parliament in 1735.[5] Reproductive prints extended the fame of the collections of royalty and noblemen and of national treasures, and provided the first access of artists to the art of the Old Masters as well as a detailed reminder to those who had travelled and studied the originals.[6] Their

[1] Reproduced in C. H. Collins Baker, *British Painting*, 1933, plate 57.

[2] Reproduced in Waterhouse, *British Painting*, plate 109.

[3] The central importance of the reproductive print has been stressed by both A. M. Hind, *A History of Engraving and Etching*, 3rd ed., 1923, and Basil Gray, *The English Print*, 1937, but its study has been neglected by scholars outside the field of portraiture. Only portraiture is adequately covered by F. O'Donohue and H. M. Hake, *Catalogue of Engraved British Portraits in the British Museum*, 6 vols., 1908–25.

[4] *Vertue*, I. 51, 56–7, 65, and III. 8. Sir Robert Strange similarly received a knighthood for engraving Benjamin West's *Apotheosis of Prince Alfred*, see Whitley, *Artists and their Friends in England*, I. 309. [5] Act 8 George III, C. 13, 1735.

[6] The series of articles by W. Martin, 'The Life of a Dutch Artist', *Burl. Mag.* XI, 1907, richly illustrates the way in which artists used reproductive prints to assist them in their original compositions in the studio.

execution required insight into the originals as well as outstanding technical proficiency. Line-engraving captured the *disegno* of the great Florentines and Raphael, but was inadequate for translating the glow and bustle of the Venetians and the chiaroscuro of the masters of the baroque. The spontaneity of the informal portrait, the survival of the baroque painterly values, and the liveliness of the rococo posed a similar problem. It is to the credit of British art during this period that the engravers who set out to master the difficulties pioneered striking advances in mezzotint which spread to the Continent, where *la manière noire* came to be regarded as a distinctively English excellence.

Vertue's record, particularly complete as regards his own profession of engraving, centres on the demand for portraits of British Worthies, i.e. those historical figures whose virtues, talents, heroic deeds, or public services set an example to posterity, and illustrious contemporaries. He classified the main processes as 'Burination' or line-engraving, 'stylograph' or etching, 'Rasuration' or 'scrape-art', that is, mezzotint, and 'scratch-art' or drypoint, the descent from the Latinized to the vulgar term indicating his order of estimation.[1] In 1722 he described the leading line-engravers as Nicholas Dorigny, John Sturt, Claude Du Bosc, Michael and Jan Van der Gucht, Simon Gribelin, Elisha Kirkall, George Bickham, and Nicholas Gabriel Dupuis, and characteristically provided a separate list for the lower category of mezzo-tinters, John Smith, George White, John Simon, John Faber Junior, and Peter Pelham, the last of whom settled in Boston some time before 1727.[2] White and Faber attached themselves to Kneller and his school, the first ably reproducing the loose brushwork and tonality of the master, the second excelling in glowing light and softness of texture. In 1728 Thomas Beard, who had learned mezzotint in London, returned to Dublin, where he was joined in 1740 by another Irish enthusiast for the medium who had worked in London, John Brooks.[3] Brooks founded the

[1] *Vertue*, III. 146–8, 159. [2] Ibid. 8.

[3] Malcolm C. Salaman, *The Old Engravers of England in their relation to Contemporary Life and Art*, 1906, 98. The chief source for the Anglo-Irish school of mezzotint is Walter G. Strickland, *A Dictionary of Irish Artists*, Dublin, 2 vols., 1913.

Anglo-Irish school by training a large number of pupils who specialized in mezzotint, among them James McArdell, Richard Houston, Charles Spooner, Michael Ford, and Richard Purnell. In 1746 he went back to London, taking McArdell and Houston with him.

The achievement of the Anglo-Irish school of mezzotinters may be gauged by comparing the finest engravings after Kneller by the older generation with those after Reynolds by the new masters after two decades of practice in reproducing the painters of the mid-century. Already in 1749 Vertue, for all his conservative prejudice, proudly observed that mezzotint was 'noted by all foreigners to the Honour of this nation' and commonly called by them 'the English manner of engraving'.[1] One of his notes in 1751 refers to the success of 'Mr. McArdell . . . in Mezzotint scraping' after coming from Ireland 'a few years ago'.[2] The velvety blackness of *la manière noire* and the new subtlety of tonal gradation made the alliance between the contemporary painter and engraver mutually advantageous, for what was lost in colour was gained in chiaroscuro. But the prestige of the line-engraver and the demand for his services in performing other tasks than the reproduction of portraits and genre survived the challenge of mezzotint. Between Sir Nicholas Dorigny and Sir Robert Strange, also knighted for his services in reproducing paintings in the royal collection, this time contemporary, the leading line-engravers were favoured for employment in *istoria* and book-illustration. Vertue's liberality in handing out the title of history painter to his contemporaries is in some cases almost exclusively justified by commissions from publishers, who chose both the painter for the design and the engraver for its execution. When West had the *Death of Wolfe* engraved, it was to William Woollett he went, not to one of the masters of the Anglo-Irish school, thus underlining its status as a history painting. In the interregnum between Dorigny and the apotheosis of line-engravers in all categories by the neo-classicists, both the older exponents of line-engraving and etching like Simon Gribelin (1661–1738) and younger men like Louis Philippe Boitard, who probably arrived from

[1] *Vertue*, III. 148. [2] Ibid. 159.

France in the first decade of the century, were in lesser or greater degrees affected by the rococo cult of the miniature scale and decorative prettiness. Boitard, who had keen powers of observation and down-to-earth realism, may stand for a group of illustrators whose work and historical importance cannot be evaluated until the research being undertaken in this neglected field, an underground channel of *istoria* as well as innovation, is completed.[1]

At the turn of the century sculpture in England was rightly criticized for its low level.[2] Its links with Continental art established a favourable climate of taste for the reception of those foreign migrants who between 1715 and 1730 both transformed the character of English sculpture and raised it to a standard of excellence far superior to painting in this period. The importance of sculpture for the development of painting is a truism for historians of the Italian Renaissance. It is not so familiar a theme in writings about English art of the eighteenth century. During the emergence from the shadow of Kneller young painters were confronted with sculptured models in portraiture which were technically far in advance of works by those whom Vertue listed as the foremost Old Masters in painting, and they reacted to this superiority.

Between *c.* 1716 and 1720 Denis Plumière, Peter Scheemakers, Laurent Delvaux, and John Michael Rysbrack arrived in London, so that a Flemish invasion in sculpture shortly follows and overlaps with the Venetian invasion in painting, but with more lasting consequences. Scheemakers and Delvaux worked at first for Plumière and thereafter for a short time for Francis Bird (1667–1731), the latter the author of 'many lofty tombs and magnificent monuments' in Westminster Abbey and other churches.[3]

[1] For Boitard see H. A. Hammelmann, 'Portrayer of 18th-century Cockneys', C.L., 24 Sept. 1959. Although he designed in a rococo style for the Battersea enamel factory, his real gift was for a robust realism.

[2] See the comment of Conrad von Uffenbach cited by Margaret Whinney, *Sculpture in Britain 1530 to 1830*, 1964, 41, the most authoritative study of the subject.

[3] *Gentleman's Magazine*, 1731, 83, cited by Rupert Gunnis, *Dictionary of British Sculptors 1660–1851*, 1953. The phrase is almost identical with one used in *Vertue*, III. 49.

Le Temple auguste de Westminster, to quote the encomium of a French admirer of the monuments in Westminster Abbey, was the main theatre of rivalry among sculptors before the ban on monuments in St. Paul's was lifted.[1] Bird had been a pupil of the Cosyns in Flanders before working in the studio of Le Gros in Rome, so that he may be regarded as a precursor of the Flemings with their French affinities.[2] He had also formed a large collection of models and casts, a practice followed by other sculptors before the Duke of Richmond's Gallery in Whitehall provided students of both sculpture and painting with a far superior school under regular management. The availability of the sculptors' collections as well as the casts in the subscription academies must be taken into account in tracing the influence of sculpture, both ancient and modern, on painting during this period.

Before his death in 1721 Denis Plumière (born 1688), an Antwerp sculptor, executed the model for the monument to *John Sheffield, Duke of Buckingham* (c. 1721-2) in Westminster Abbey, in which he was assisted by Delvaux and Scheemakers. It was the first display of baroque drama in the Abbey. The figure of Time carved by Laurent Delvaux (1696-1778) was particularly admired, a precedent for singling out for praise the excellence of one figure on a monument.[3] Delvaux's English *œuvre* is widely scattered in country houses and churches, but his alternation between the baroque and the classical can be studied in the Victoria and Albert Museum, which possesses a small *Vertumnus and Pomona*, freely adapted from the figures of Zethus and Circe in the Farnese Bull. He also executed a restrained copy of Bernini's *David* and a chaste variant on the *Crouching Venus* in the Vatican. Only after his return to Flanders did he cross the dividing line between the late baroque and the rococo in such masterpieces as the *Chaire de vérité* in Ghent Cathedral (1745).

[1] See the Appendix to *L'Art de former les jardins modernes*, Paris, 1771, a translation from Thomas Whateley, *Observations on Modern Gardening*, London, 1770, in which the anonymous translator makes a number of interesting observations on English commemorative sculpture.

[2] The best account of Bird is in Whinney, op. cit. 74-8.

[3] The standard monograph on Delvaux is G. L. Willame, *Delvaux*, Brussels, 1914, still valuable for the English period.

Peter Scheemakers (1691–1781), who left England with Delvaux for Rome in 1728, returned in 1730. It was his second visit to Rome, and one of its objects was to make and bring back a collection of clay models of antique sculpture, among which Vertue noted: 'The Faunus and Young Bacchus the Centaur with Cupid on his back the Venus crouching—the Venus and cockle shell the Gladiator—the Flora and the Ceres—the Hermaphrodite and a woman one groupe . . . the Laocoon and sons some Busts. The Sphinx and Lyons. an Egyptian statue one of the Fiamingo—as fine as the Antique.'[1] The honours of sculpture in Westminster Abbey were now divided with Rysbrack, no fewer than seven commissions for monuments falling to the two between 1730 and 1732. In the year of his return Scheemakers completed the monument to *Dr. Hugo Chamberlen*, previously begun in collaboration with Delvaux, who is recorded as making one of the figures, on stylistic grounds almost certainly Longevity.[2] The effigy is his own, and the hand resting on the book shows that he had studied the Vatican Nile, the ultimate source of this type of reclining figure in funerary monuments. His, too, is probably the fine attendant figure of Hygeia, reminiscent in its restrained handling of Duquesnoy's St. Susanna in Sta. Maria di Loreto in Rome.

In 1740 he scored an outstanding success with his monument to Shakespeare, designed by William Kent on the model of the Craggs monument. According to Vertue, 'Shakespear. the publick favourite of all english playwrites—tossed the Sculptor above on the summit of the wheel.'[3] The image, from which not even Gainsborough could escape, stamped itself on the imagination of the age. Thereafter he was busier than ever with commissions for sepulchral monuments, memorial figures, chimney-pieces, and busts. His finest work is the monument to the *First Earl of Shelburne* (1754) in the church at High Wycombe, Buckinghamshire.[4] Against a Kentian backdrop of columns, pediment, and a pyramidal centre-piece, the Earl and Countess recline on the sarcophagus like Romans at a ceremonial banquet, while the

[1] *Vertue*, III. 44–5. [2] Whinney, op. cit. 93. [3] *Vertue*, III. 116.
[4] Reproduced in Whinney, op. cit., plate 96b.

mourners of the family are grouped in nobly graceful attitudes on either side. It is the most classical of all his compositions. Scheemakers, like his Flemish compatriots in England, like Duquesnoy nicknamed *Il fiammingo* in Rome, had an access to classical principles denied to the stricter followers of Bernini, and under the Burlingtonian Rule of Taste achieved a truly monumental expression of its ideal of *gravitas*.

The favourite sculptor of the Burlington circle was not Scheemakers but the more talented John Michael Rysbrack (1694–1770), who was trained under Michael Van der Voort in Antwerp and worked in Paris before coming to England at the age of twenty-six in 1720, when Vertue immediately recognized him as 'a great Master'.[1] He worked first in association with James Gibbs, but by 1730 had replaced the Italian Guelfi in the esteem of the Earl of Burlington, who later chose him for the key statues of Palladio and Inigo Jones at Chiswick House. Thereafter commissions poured in as fast as he could handle them; for the Abbey (fifteen before Scheemakers's success with Shakespeare in 1740, thereafter only two), churches and private chapels, royalty (from the thirties), the Universities, public buildings, and town and country houses. Horace Walpole summed up the verdict of the age: 'the greatest master the islands have seen since Le Sœur'.[2] He could have said as justly, since Torrigiani.

Rysbrack skilfully served the two tastes of the age for the classical and the baroque. Somewhat surprisingly, Burlington at first preferred his work in the latter style, for the heroes of classicism commemorated at Chiswick would not be out of place as prophets on Bernini's colonnade in front of St. Peter's if the costume were changed. Similarly the bust of *Rubens* (1746) at Hagley Hall, Worcestershire, with its swagger mustachio and air of nonchalant distinction, reflects the ethos of the court of Charles I as eloquently as Franz Hals had captured the robustious conviviality of the Dutch bourgeois militia.[3] This was possibly the

[1] *Vertue*, I. 76. He was christened John Michael, but signed his work with the second name. The standard life by M. I. Webb, *Michael Rysbrack*, 1954, introduced a new standard of scholarship into the study of English sculpture.

[2] *A. of P.* III. 33. [3] Reproduced in M. I. Webb, *Michael Rysbrack*, fig. 45.

reason for the stylistic choice, for all these statues are in period costume, not in classical drapery, thus proclaiming the link with the Renaissance and the age of Van Dyck.

Kent furnished the designs for the monument to *Sir Isaac Newton* (1731) and its companion to the *1st Earl of Stanhope* (1733) in Westminster Abbey, and for the great *Marlborough Monument* [plate 48; 1732] at Blenheim. In this masterpiece of the retrospective baroque of the 1730s the Duke stands in an attitude of imperial authority, one hand grasping a baton; the seated Duchess, protecting the youngest boy who has run naked to point to the god-like vision, looks upwards in awe like Niobe; only the eldest son, gazing outwards, is proudly detached, like a Gonzaga princeling by Mantegna. Fame and History, their wings still agitated from flight, guard the sarcophagus, under which the writhing monster Envy is pinned. Marble replicas of the Duke's medals are suspended from a lion's mask inside the pilaster of the framing arch; trophies hang in spacious panels the full height of the wall; and the classical pyramid shoots up through the cornice to the armorial shield flanked by eagle's wings. Richly coloured marbles, mottled pink, grey, brown, and dark grey veined with pink, contrast with the gleam of snowy white, and add by contrast a note of sombreness to splendour. The monument cost £2,200, but the Dowager Duchess Sarah for once did not grudge the expense for 'everything that could do the Duke of Marlborough Honour and Justice'.[1]

His classical style appears early in his large relief of *A Roman Marriage* (1723) over a fireplace in one of Kent's rooms at Kensington Palace, based on an engraving by Santi Bartoli in Bellori's *Admiranda Romanorum Antiquitatum*, a practice of translation he was to follow throughout his career, notably at Houghton.[2] As has been pointed out by Margaret Whinney, there is always a greater or lesser degree of baroque interpretation in these imitations. He had a deeper instinct of sympathy with the Roman

[1] Letter to Sir Philip Yorke, May 1732, cited by David Green, *Blenheim Palace*, 1951.

[2] For the Bellori identification see Whinney, *Sculpture in Britain*, 84. For another borrowing from Bellori, this time his *Veteres Arcus Augustorum*, 1690, see Webb, op. cit. 128.

portrait bust, two of the finest examples being *Daniel Finch, 2nd Earl of Nottingham* (1723) at Ayston Hall, Rutland, and *Alexander Pope* (1730) in the Athenaeum Club, London. The first has been described as 'probably unique in the Europe of its day'.[1] It is a classical revision of a baroque model with deep undercutting of the drapery and the arms cut short to form a concave sweep to the bust, and the head is turned as if caught in a moment of observation. Pope is less heroicized, but just as forceful: 'there is no sense of the crippled body, but only of the fine mind.'[2]

In a letter of 11 December 1759 to Sir Edward Littleton Rysbrack asked how he should dress a bust of Pope because 'he is not in that Antient Dress which the others are, neither has he that character in his Face, Tho' as Great a Man'.[3] The other busts he referred to were of Locke, Milton, Shakespeare, Bacon, and Raleigh. This concern shows the distinction he drew between his commemoration of the national heroes of the past depicted in classical garb and style and his more familiar style for contemporaries. Between 1731 and 1735 he executed the bronze equestrian statue of *William III* at Bristol for which he drew on Girardon's equestrian statue of Louis XIV (of which he possessed a plaster model), Donatello's *Gattamelata*, and the Marcus Aurelius on the Capitol.[4] While stylizing the horse's mane to match the flowing drapery of the rider's cloak with a baroque eye for rhythmic pattern, he preferred from his sources the shorter horse of the Marcus Aurelius in order to make the humanity of his hero more accessible. It was a worthy tribute to a king who was both a military leader and a champion of constitutional liberties. For his bust of *Sir Hans Sloane* (c. 1737) in the British Museum he completely discarded his Roman manner for a rococo realism which puts him in the forefront of those who pioneered the more intimate style in portraiture.

By the mid-century his range was fully extended, for while he had mastered the new graces he did not discard the heroic types

[1] Whinney, op. cit. 85. [2] Ibid. 87. [3] Webb, op. cit. 204.
[4] The plaster model of Girardon's statue was Lot 59 in Rysbrack's Sale Catalogue for 18 Apr. 1767 (copy in the possession of Messrs. Colnaghi, London). See Webb, op. cit. 141 and 186.

and manner of his early period. In 1747 he signed the contract to execute a marble *Hercules* for Henry Hoare at Stourhead, an ingenious variation on the theme of the Farnese Hercules. The legs are shown crossed on an Apollonian model; according to Vertue and Walpole, the arms were executed from Broughton the boxer, the breast from another pugilist, and the legs from John Ellis, Master Keeper of the Lions in the Tower of London.[1] The choice of particular excellencies from living persons has classical authority, but the outcome of so authentic an assembly of muscular models is curiously elegant. Elegant, too, fitly describes the statue of *Charles Seymour, 6th Duke of Somerset* erected in the Senate House in Cambridge in 1756, in which 'something of an air of fancy dress' gives an almost festive appearance to the proud Chancellor in his incongruous Praxitelean pose.[2] But he never lost touch with decorum. His putti, almost invariably excellent, are never rococo *gamins*. The pair on the monument to the *Hon. Harriet Bouverie* (1757) at All Saints, Coleshill, Berkshire, seem genuinely sad and reveal his respect for the age of innocence. Even at this late date he could revert to his 'baroque prophet' style, most notably in the terracotta model of John Locke in the Victoria and Albert Museum, which he prepared for the marble statue at Christ Church, Oxford, erected in 1758. There is thus ample ground for debate on the essential nature of Rysbrack's talent and temperament, one authority stressing the classical element, another the baroque. Following the masterly pioneer study of Mary Webb, who leaned to his classical side, he may be described as a late Roman born again in the eighteenth century, a title which he himself would surely not have disclaimed.

The greatest of the migrant sculptors was the least classical. Louis François Roubiliac (*c.* 1704/5–1762) was the son of a Huguenot merchant at Lyons who sent him to Dresden to serve his apprenticeship under Balthasar Permoser, Court sculptor to

[1] See *A. of P.* III. 36 and *Vertue*, III. 121–2, and for the cross-legged Apollo, S. Reinach, *Répertoire de la statuaire grecque et romaine*, I. 240. Vertue gives the fullest account of the seven principal naked models he used.

[2] Webb, op. cit. 169 and fig. 80.

the Elector of Saxony and one of the leading transalpine pupils of Bernini.[1] He next joined another Lyonese, Nicolas Coustou (1658–1733), presumably as his assistant, in Paris, where he gained the second *Grand Prix* of the French Academy for sculpture in 1730 with a group representing *Daniel saving Susannah when she was condemned to death*, the earliest evidence of his attraction to pathos, the leitmotiv of his art. Both at the Zwinger and at Versailles the gifted youth witnessed the first stages of the transformation of the baroque into the rococo. The first firm date showing that he had joined the Huguenot colony in London is 11 April 1735, when he took out a licence to marry Catherine Helot. He was employed at first, like most of the other migrants, in working for an established English master, probably either Benjamin or Thomas Carter and certainly Henry Cheere, before receiving the commission for the statue of Handel in Vauxhall which brought him fame in 1738 [plate 50A]. In 1745 he became teacher of statuary at the St. Martin's Lane Academy.[2] His second signed success was the monument to *John, 2nd Duke of Argyll* [plate 49] in Westminster Abbey, for which he signed the contract with the Duchess of Argyll on 25 May 1748. A terracotta model in the Victoria and Albert Museum, signed and dated 1745, and two drawings by his senior rival Rysbrack, show that he received the commission against the latter's competition.[3] The great Duke, born, according to Pope, 'to shake alike the senate and the field', reclines in meditation on the lofty sarcophagus beside the figure of Fame, surprised in the action of writing 'John Duke of Argyll and Gr—'.[4] The base is flanked by two

[1] For Roubiliac see Katherine A. Esdaile, *The Life and Work of Louis François Roubiliac*, Oxford, 1928, a richly illustrated and documented study, and Whinney, op. cit., chapter 12.

[2] *Vertue*, III. 127. [3] Esdaile, op. cit. 62.

[4] That is, Duke of Greenwich, an additional honour bestowed in 1718 for his part in suppressing the 1715 rebellion. Pevsner, *London*, I (B.E. 12), 386, has detected the source of the device of a writing Fame in Fischer von Erlach's Mitrovitz monument at Prague, illustrated in his *Historische Architektur*, an English edition of which had appeared in 1730. For other French sources, including Jean Baptist Tuby's tomb of Turenne, designed by Le Brun in the Invalides, and Tuby's Colbert monument in Saint-Eustache, Paris, see Whinney, op. cit. 106, and M. I. Webb, 'The French Antecedents of L. F. Roubiliac', *Gazette des Beaux Arts*, XLIX (1957).

figures, brought close to the ground in defiance of precedent. Eloquence, like a proscenium figure in Venetian painting, advances into the spectator's space; on the other side Pallas Athena gazes upwards at the hero. The four figures flow asymmetrically within and outside the triangle of the monument with true rococo audacity. Eloquence was the first figure in the Abbey to startle the onlooker by a direct contact, a daring innovation at the time and an immediate success. Vertue praised 'the great beautyes in the attitude', and among those who later went on record in singling it out for tribute among the sculptures of the Abbey were Walpole, Bacon, Chantrey, and Canova.[1]

The victor of Vauxhall Gardens had now won the laurels of the national Pantheon, and was henceforth the favourite sculptor of the age for funerary monuments. In 1749 he received the commission for the monument to the *2nd Duke of Montagu* (completed 1752), followed by that of his *Duchess* (completed 1753) at Warkton, Northamptonshire. For the first he chose the pathetic theme of a broken domestic relationship which he was to make peculiarly his own, the second is the most rococo in design of all his funerary monuments, almost licentious with its interplay of movement disturbing the decorum of a church. These shock tactics, like the proscenium device he now seldom omits, were all designed to affect the emotions. His *tour de force* of illusionism is the *Shannon Monument* (after 1755) at Walton-on-Thames. The background is a tent which might well be put up for a prize in *trompe-l'œil* virtuosity, for its actual projection is about two inches. By using dark greenish marble for the side in shadow he has tricked the eye almost as cleverly as Tiepolo in his roughly contemporary frescoes in the Palazzo Labia. Richard Boyle, Viscount Shannon, who had begun his military career as a volunteer at the Battle of the Boyne and ended it as Field Marshal, leans thoughtfully on one of the piles of trophies by which he is surrounded. The chords of military glory sounded by the emblems of conquest, flags, and cannon, are softened by

[1] *Vertue*, III. 149; Walpole, *A. of P.* III. 38: John Bacon as reported by J. T. Smith, *Nollekens and his Times*, 1828, II. 164; Canova cited by Alan Cunningham, *Lives of the most eminent British Painters, Sculptors and Architects*, 1830, III. 46.

an accompaniment of domestic and tender grief. At the foot of
the monument sits Shannon's daughter, the Countess of Middle-
sex, her feet in high-heeled shoes, her lovely right arm negligently
embracing an urn as she gazes towards but not directly into the
face of her father, a device for suggesting the barrier of death
that he had first used in the Owen monument at Condover
(1746).[1]

Roubiliac, who had now mourned the loss of two wives,
played his most convincing variation on the theme of grief at
separation by death in the monument to *Lady Elizabeth Night-
ingale* [plate 51; 1761) in Westminster Abbey. Wesley, who had
little to learn about establishing a personal relationship with his
audience and was an even greater master of pathos, thought it
the one tomb in the Abbey that showed 'common sense'.[2] The
bereaved husband, Mr. Joseph Gascoigne Nightingale, supports
the realistically agonized wife with one arm and attempts to ward
off the attack of Death with the other. A macabre illusionism
involves the spectator with the awful happening. The iron doors
of the vault are real, and open into the Abbey; out of its shadowy
concealment creeps Death. His nearness, skeleton, and 'animated
malignity expressed without the aid of features' come as a sur-
prise to those who approach the monument.[3]

For the period between the Glorious Revolution and the middle
of the century Roubiliac constructed by his busts a representative
national portrait gallery of the illustrious in war, statesmanship,
law, scholarship, literature, art, and music.[4] Of special interest
are those portraits taken *ad vivum* from friends and men of genius,
apparently without thought of immediate recompense, thus
anticipating the literary portraits of Reynolds. The bust of
Hogarth *en négligé* [plate 1] may be grouped with those of himself
and the antiquary Dr. Martin Folkes as images of a circle of
friends sharing the same forthright and humane values. The
terracotta model on which his four signed busts of Pope are

[1] Unless otherwise stated, these and other works referred to are illustrated in
Esdaile, op. cit.

[2] *Journal*, 16 Mar. 1764.

[3] *Gentleman's Magazine*, LXXXVIII. 300, cited by Esdaile, op. cit. 157, 158.

[4] See Esdaile, op. cit. 196–7, for the historical range of his portraits.

based was made *c.* 1738 when the poet was fifty. It is his master-piece of pathos in portraiture, combining a visionary expression with the lines of physical suffering.

His rococo manner was carried to its extreme limits in the leaden statue of *Sir John Cass* (1751) in the Cass Institute, a textbook example of the style with its serpentine lines, transience of action, and glorification of the complexities of lace, fur, and fabric. Arrested movement is the keynote of *Lord President Duncan Forbes* [plate 53; Advocates Library, Edinburgh] erected in the Outer Parliament House, Edinburgh, on 21 May 1752. 'The great lawyer–statesman with his alert and delicate face sits in the act of laying down some point of law.'[1] No photograph can do justice to the original. The formalized curls of the judge's tied wig, the softly intricate folds of lawn and silk, the thin breeched leg with its projecting leather shoe, all these *minutiae* of observation are subordinated to a dramatic concept unsurpassed for acuteness and nervous vitality. 'That old woman who talked to me about humanity' was the Duke of Cumberland's outburst of contempt after the battle of Culloden.[1] The description fits the statue, but the old woman is now seen as a hero. Unfortunately, the Puritanical prejudice of the English against the rococo has delayed its recognition as one of the greatest masterpieces of the century, the supreme image of the humanity it commemorates.

Roubiliac did not visit Italy until 1752, and then only briefly. He had already learned all that he needed from Bernini indirectly, and it is difficult to detect any innovations in his style after his return, the almost neo-classical economy of the Nightingale monument excepted. The last of his major commissions, like the first, depicts *Handel* (1761) in the moment of composition [plate 50B]. There is no possibility of mistaking the air that is being played by the angel in the Abbey monument, for the composer is shown taking down the notes of 'I know that my Redeemer liveth'. For Vauxhall Gardens he had chosen to stress the intimacy, almost the privacy, of Handel's muse. His final tribute to the national hero who had composed the *Messiah* is, for all its realism and spontaneity, unmistakably in the grand manner. Between these

[1] Esdaile, op. cit. 96.

two polarities lies the essence of the mid-century as an inter-regnum between the Rule of Taste and neo-classicism.

The ascendancy of the Flemings and Roubiliac did not close the avenues of employment for others, for their combined energy was altogether insufficient to supply the prodigious demand for monumental sculpture during this period. The only sculptor whose talents seem to have been neglected is Giovanni Baptista Guelfi (in England 1714–34), who arrived earlier on the scene than the Flemings in the train of the Earl of Burlington.[1] His most important commission was the monument to the Secretary of State *James Craggs* [plate 28A] erected in 1727 in Westminster Abbey. Its sources in antique sculpture have already been noted in the discussion of Hudson's portrait of *Theodore Jacobsen* [plate 28B]. It is to the credit of Gainsborough, who used the Craggs pose for his Jubilee portrait of Garrick, that he was one of the few artists to restore it to its elegiac context, for the actor is shown embracing a pedestal supporting the bust of Shakespeare. There-after Guelfi found employment in both London and York and its vicinity, the latter region suggesting the possibility that Burlington found it convenient to pass him on to his North of England friends.

Andries Carpentière (*c.* 1677–1737), who may have been French but was probably a Fleming, worked first for John Nost and on his own account from *c.* 1720.[2] His statuary's yard at Hyde Park specialized in lead statues of high quality to supply the market for garden statuary. His summary dismissal by Walpole is unfair, for he studied antique models carefully and at his best was a fine craftsman. The vicinity of Hyde Park Corner was one of the sights of mid-Georgian London for its statuary's yards, including those of the brothers Benjamin (died 1760) and Thomas Carter

[1] For Guelfi see Mary Webb, 'Guelfi: an Italian Sculptor in England', *Burl. Mag.*, May 1955, and Rupert Gunnis, *Dictionary of British Sculptors 1660–1851*, 1953. The tomb of T. Watson Wentworth (*d.* 1723) in York Minster is signed 'Guelfi Romanus' in allusion to his training under Cavaliere Rusconi in Rome as well as his admiration of antiquity, although he came from Bologna.

A. P. Stanley, *Memorials of Westminster Abbey*, 1868, contains the finest aesthetic criticism of the sculptures in the Abbey that has yet been written. His description of the Craggs monument as 'the earliest example of a complete dissociation of the grave and tomb' presumably refers only to the Abbey monuments.

[2] Whinney, op. cit. 126.

(died 1795).[1] The researches of Katherine Esdaile first restored the reputation of the Carters, whom Walpole passed over in silence.[2] The career of Sir Henry Cheere, Bart. (1703–81), is interesting for the light it throws on the huge fortunes that could be made out of sculpture in the eighteenth century and thereafter up to the time of Chantrey. With the exception of the fortune left by the genial miser Nollekens, the largest were accumulated by those who established a manufacture for supplying country houses with chimney-pieces and gardens with statues. The nine monuments claimed by Henry Cheere to be wholly his own in Westminster Abbey reveal that he had a genuine talent, especially for mourning putti 'washed and told to look sad and pretending to cry'.[3] After an apprenticeship to the English mason–sculptor, Robert Hartshorne, he went into partnership with Henry Scheemakers, the brother of Peter, and subsequently acquired adjacent premises in St. Margaret's Lane, Westminster, from 1729 to 1733. Later he moved near by to Old Palace Yard, Westminster, where Peter Scheemakers had his workshop until 1741, and finally to Hyde Park Corner, close to his brother John. In his later life he was much occupied in real-estate speculation and civic leadership, for which he was first knighted and then created a baronet.

He numbered among his pupils the not undistinguished Richard Hayward (1728–1800) and a sculptor who became a leading architect, Sir Robert Taylor. He employed Roubiliac, 'an uncommonly clever fellow', after his arrival in England. The hostility of Hogarth, who wrote contemptuously of the leaden imitations of the Farnese *Hercules* 'near Hyde Park', and the silence or at best summary treatment of Walpole can be plausibly explained by their knowledge that the Carters and Cheeres lowered their standards to supply popular demand, and sometimes

[1] Plate I in Hogarth's *Analysis of Beauty* (1753) gives a good general idea of the appearance of these yards, which extended from Hyde Park Corner as far east as Shepherd's Market.

[2] For further research see Rupert Gunnis, 'The Carters, Georgian Sculptors', *Arch. Rev.* CXXIII, 1958, 334, supplementing the articles in his *Dictionary*.

[3] See M. I. Webb, 'Henry Cheere, Sculptor and Businessman, and John Cheere', *Burl. Mag.*, July and Aug. 1958. For further details of their careers see Gunnis, *Dictionary*.

employed assistants with superior ability for important com-
missions.[1] Like the average portraitist who employed drapery
painters, they have suffered from the suspicion that such practices
arouse. In the present uncertain state of knowledge it is safer to
conclude that the Carters and Cheeres were highly trained men
of considerable ability, whose original contribution to Georgian
sculpture has yet to be made clear.

[1] For Hogarth's contemptuous reference see *The Analysis of Beauty and Auto-
biographical Drafts*, ed. J. Burke, 34.

PART THREE

THE AGE OF REYNOLDS

THE ELEVATION OF PORTRAIT
AND LANDSCAPE
REYNOLDS, GAINSBOROUGH
AND WILSON

GEORGE II died suddenly on 25 October 1760. His grandson came to the throne at the age of twenty-two 'amid an enthusiasm such as England had hardly seen since Charles II restored the monarchy'.[1] Not since Charles I had a new king raised such expectations as a patron of the arts. His father Frederick Prince of Wales had taken special pains over his artistic education. As a child he had shared in the drawing lessons given to his older sisters by Joseph Goupy.[2] Thereafter he was 'carefully instructed in the principles of architectural design by Chambers, of delineation by Moser, and of perspective by Kirby'.[3] Goupy as art adviser to his father had bought for him abroad. Chambers was appointed architectural tutor almost immediately after his return from Italy in 1755. Both George Michael Moser (1704–83), a chaser from Geneva, and Joshua Kirby (1716–74) were eminent in the profession, the first as Manager (from 1745) of the St. Martin's Lane Academy, the second as an authority on perspective. Already as Prince of Wales the pupil was credited with one of the designs in Kirby's *Perspective of Architecture* (1761), and after his accession rumour attributed to him two landscapes exhibited at the Society of Artists.[4]

Et spes et ratio studiorum in Caesare tantum was the hopeful motto from Juvenal inscribed on the second state of his Serjeant

[1] W. E. H. Lecky, *A History of England in the Eighteenth Century*, 1921 ed. III. 169.
[2] Goupy was already teaching the royal princesses in 1743, see *Vertue*, III. 116.
[3] John Galt, *Life, Studies and Works of Benjamin West*, 1820, II. 33.
[4] W. T. Whitley, *Artists and their Friends in England 1700–1799*, 1928, I. 170–1.

Painter's frontispiece to the Catalogue of the Society of Artists exhibition at Spring Gardens in the first year of his reign. Britannia in the guise of Grammatica transmits with her watering-can the flow from a fountain surmounted by the King's bust on to three potted green trees labelled Painting, Sculpture, and Architecture.[1] In the event George fulfilled creditably the promise of his youth, and justified the hopes that his education in the arts had aroused. Within a decade of his accession he had founded the Royal Academy. He made splendid additions to the royal collection. Last but not least, he bought the works of living English artists on an unprecedented scale, acquiring either by purchase or commission paintings by Zuccarelli, Ramsay, Reynolds, Gainsborough, Zoffany, West, Beechey, Hoppner, Opie, and Laurence. He enabled Benjamin West as Court Painter to devote himself to history painting.

The monarch's artistic patronage was strongly influenced by personal loyalties. 'Mr. Ramsay is My Painter, My Lord', a remark first quoted against him in 1769, was not intended to depreciate Reynolds, whose portrait of Bute he had just requested from its owner.[2] Similarly, he had committed himself to West as a history painter before Reynolds had made any serious attempt to shine in the category. Once having started to buy landscapes by Zuccarelli, he kept on to the detriment of Gainsborough and Wilson. But he admired Gainsborough, asked him to bring *The Woodman* to Buckingham House, and described it as 'a masterpiece of the pencil' [plate 63B].[3] There is no reason to doubt the report that only the calamity of a mental breakdown prevented him from buying it.

At the time of his accession three artists who together inaugurate what has been entitled the Classical Age of Painting in Britain had reached maturity: in order of birth, Wilson, Reynolds, and Gainsborough. It was the joint achievement of these painters to elevate both portraiture and landscape by assimilating the great

[1] For the iconographical associations see E. Wind, 'Grammatica from Martianus Capella to Hogarth', *J.W.C.I.* II, 1938–9, 82–4.

[2] *The Middlesex Journal*, 1769, cited by W. T. Whitley, op. cit. I. 252.

[3] W. T. Whitley, *Thomas Gainsborough*, 1925, 296.

style of the Old Masters to the native tradition. The older genera-
tion of Hogarth had humanized the English portrait and intro-
duced a new vitality into landscape by its cult of *plein-air* natural-
ism. The three younger men built on these foundations by a
pursuit of elevation which led two of them to study antiquity
and the Old Masters in Rome with a discernment unmatched by
their seniors and contemporaries. Reynolds returned from his
Grand Tour towards the end of 1752, Wilson probably in 1757.
Certainly after his move to Bath in 1759, and probably before,
Gainsborough discovered his artistic hero in Van Dyck, his
substitute for the Grand Tour and central intermediary with the
Old Master tradition. He divides the honours of the elevation of
English portraiture with Reynolds, those of English landscape
with Wilson. When the Royal Academy was founded in 1768
the three stood head and shoulders over both the older men and
their contemporaries who were appointed Foundation Members,
for Allan Ramsay by this date was producing little besides copies
of his royal portraits and neither joined nor exhibited. The
situation was very different at the time of their deaths, when they
were surrounded by a galaxy of talent. Both by virtue of their
artistic stature and because they act as a bridge between two
generations, their art justifies a separate discussion.

On 16 October 1752 Joshua Reynolds (1723–92) arrived in
London on his return from Italy, although he did not settle there
until early in 1753.[1] The third son and seventh child of the Revd.
Samuel Reynolds, Master of the Plympton Grammar School and
sometime Fellow of Balliol, he was to move all his life with ease
and distinction in literary and learned circles. A vocation for art
was confirmed by his reading as a boy Richardson's *Essay on the
Theory of Painting* (1715), and by his life's work he may be said
to have carried out the Richardsonian programme for restoring
portraiture to the dignity of high art.[2] At the age of seventeen he
was apprenticed to Richardson's son-in-law Hudson in London.
After returning to Exeter in the early summer of 1743 he stayed
in London from the latter part of 1744 to nearly the end of 1746,

[1] C. R. Leslie and Tom Taylor, *Life and Times of Sir Joshua Reynolds*, 1865, I. 87, 90.
[2] Edmond Malone, *The Works of Sir Joshua Reynolds, Knight*, 1809, I. viii.

'the crucial years of his whole life', for he was now free to turn an independent eye on Old Masters in auctions and contemporary British paintings in the Foundling Hospital, and probably to work in the St. Martin's Lane Academy, thus forming the two major allegiances of his artistic career.[1]

On 11 May 1749 he sailed from Plymouth as the guest of the Hon. Augustus Keppel, the Commodore of a small squadron dispatched to Algiers. He read on the voyage out, and continued to read during his years in Italy, his notebooks indicating some of the authors, Vergil, Pliny's *Letters* (in Melmoth's translation), Shaftesbury, and Vasari.[2] He arrived in Italy with a single aim, to learn from the past. The only record of a diversion to the contemporary is a small number of caricature paintings in the manner of his fellow Devonian Thomas Patch [plate 94B]. His notebooks and sketches show that he believed he could learn more by making rapid drawings and sketches from many Old Masters than laboriously finished copies of a few. A day or two's work sufficed for copies of a Rubens or a Rembrandt; Raphael he reserved for more frequent study, just as during his three weeks in Venice he devoted much of his time to making abbreviated sketches of the great compositions of Titian.[3] A considerable proportion of his drawings was taken from classical sculpture, the source of many of his portrait poses.

After his return his triumph was rapid. The old Duke of Devonshire and the young Duke of Beaufort were among his first sitters.[4] His striking modes for fashionable women and children were no less successful, and by 1760 he was able to purchase the forty-seven-year lease of a house in Leicester Fields, where for four years the King's Serjeant Painter, William Hogarth,

[1] E. K. Waterhouse, *Reynolds*, 1941, 5.

[2] For his reading before and during the voyage see chapter 1, 'Education', in F. W. Hilles, *The Literary Career of Sir Joshua Reynolds*, New York and Cambridge, 1936, and id., *Letters of Sir Joshua Reynolds*, 1929, 5.

[3] Waterhouse, op. cit. 7–8. The chief sources for his studies in Italy are *Sir Joshua Reynolds and his Works. Gleanings from his Diary, Unpublished Manuscripts and other Sources*, 1856, and *Sir Joshua Reynolds: Notes and Observations on Pictures*, 1859, both by William Cotton. Both the Ashmolean and Professor F. W. Hilles have Italian sketchbooks by Reynolds, the first particularly rich in drawings from antique marbles.

[4] Leslie and Taylor, op. cit. I. 104, and Waterhouse, op. cit. 38.

living on the opposite side, must have seen the carriages of society draw up at the door of the younger man. After his election as Foundation President of the Royal Academy in 1768 until his death on 23 February 1792 his life is too closely intertwined with the artistic, literary, and social history of his time for a summary here to be adequate.

In tracing the evolution of his style the first object of consideration must be the contemporary foundations upon which it was based. His Richardsonian master was already taking hints from the rococo during his training. He observed the *ad vivum* spontaneity of Hogarth as well as the use of poses borrowed by painters from sculpture. Before he left for Italy he had also made his first steps in the imitation of Van Dyck, signposted by an existing trend, and had essayed fashionable conversations, perhaps the most interesting being the large *Thomas and Martha Neate and their tutor Mr. Needham* (1748), in which he characteristically refined and disguised the category by using the pastoral convention of Lely.[1] It has already been noted that in Italy he tried his hand at the latest mode of caricature, anticipating the overloading or fantastic distortion of George Townshend. Throughout his life there is the same prompt and instinctive response to what his English contemporaries were doing, together with an urge to excel by striking out on a path of his own.

'In painting portraits', wrote Edmund Burke in his obituary of Reynolds, 'he appeared not to be raised upon that platform, but to descend to it from a higher sphere.'[2] This sums up in a nutshell the effect of his studies in Italy. The higher sphere from which he descended was the ideal world of antiquity and the Renaissance, the platform upon which he took his stand the portraiture of society. In Italy he discovered that Raphael was not a painterly artist in the sense of the Venetians, and that he never acquired 'that nicety of taste in colours, that breadth of light and shadow, that art and management of uniting light to light, and shadow to shadow, so as to make the object rise out of the ground with that

[1] Unless otherwise stated, works by Reynolds mentioned in this chapter are reproduced in Waterhouse, op. cit.
[2] The obituary is given in full in Leslie and Taylor, op. cit. II. 629-30.

plenitude of effect so much admired in the works of Correggio'.[1]
These are all qualities which might have been enumerated by a
Rubéniste arguing with a *Poussiniste*. Unlike the neo-classicists
later, he did not change from a painterly to a linear style, but
used his own abstract method to study some of the painterly
masters admired by Van Dyck, still the artistic hero of the English
aristocracy:

> When I was at Venice, the method I took to avail myself of their
> principles [those of Titian, Paul Veronese, Tintoretto, and their follower
> Rubens] was this. When I observed an extraordinary effect of light
> and shade in any picture, I took a leaf of my pocket-book, and darkened
> every part of it in the same gradation of light and shade as the picture,
> leaving the white paper untouched to represent the light, and this
> without any attention to the subject or to the drawing of the figures.[2]

'From 1754 to 1756 his best portraits', writes Waterhouse, 'are
in a Venetian mode', not a Raphaelite one.[3]

Reynolds did not question the superiority of Raphael. His
analytical mind solved the dilemma by distinguishing between
the great and the ornamental styles. For himself he chose a com-
posite style. He was aware of the difficulty. The great style could
not 'happily be blended with the ornamental', nor the dignity of
Raphael with 'the glow and bustle of a Paulo, or Tintoret'. To
justify his own course of associating the ornamental with the
great, he drew a distinction between heightening the elegant
and degrading the sublime: 'it happens in a few instances that
the lower may be improved by borrowing from the grand'.
When the union is accomplished in a high degree, portraiture
'becomes in some sort a rival to that style which we have fixed
as the highest'.[4] The only difference between this analysis and
the eulogy of Burke is that he saw himself more modestly as
being raised from the platform of portraiture.

[1] Sir Joshua Reynolds, *Discourses on Art*, ed. Robert Wark, Huntington Library,
San Marino, Calif., 1959, 81.

[2] Reynolds's Notes on C. A. Dufresnoy's *Art of Painting*, published in E. Malone,
Works, III. 147–8.

[3] *Reynolds*, 10.

[4] For this and the immediately preceding quotations see *Discourses*, ed. Wark,
63, 64, 72, 89.

In the following account the art of Reynolds will be discussed typologically, for the evolution of his style has been subjected to a masterly analysis by Waterhouse. Following the method but not the strict classifications of Edgar Wind, the main groupings of his portraiture are: naval and military heroes; civil worthies; the 'quality' in both its public and private aspects; actors and actresses; and children in fanciful roles.[1] To a class apart belong his portraits of those men of genius with whom he was personally intimate, and of whose characters he made written assessments. If fancy pictures and history paintings are added to the list, and the short excursion into caricature included, the range of his art is adequately covered.

By the circumstances of his Devonian connection he had life-long contacts with naval men, whose portraits commence and continue the long line of heroicized likenesses. The two devices that he used most frequently for elevation were the attitude borrowed from antiquity or the Old Masters, and the emotive background. Both appear in his full-length of *Captain the Hon. Augustus Keppel* (1753-4) at Greenwich, 'the portrait which tended most to establish his reputation' after his return from Italy.[2] Following the example of Allan Ramsay's *Macleod of Macleod*, the pose is adapted from the *Apollo Belvedere*; the storm-tossed sea alludes to the hero's recent shipwreck.[3] *Captain Robert Orme* (1756) in the National Gallery and *Captain Winter* (1759) in the Southampton Art Gallery combine three motives taken from Van Dyck's portrait of *Charles I* in the Louvre: the profile stance with head turned to the spectator; the horse with head bent down to an upraised leg; and the arm laid on the withers with its hand

[1] My minor changes have been made solely for brevity. No summary can do justice to the importance of Wind's long article on 'Humanitätsidee und heroisiertes Porträt in der englischen Kultur des 18. Jahrhundert' in *Vorträge der Bibliothek Warburg*, 1930-1, 157-229. Quite apart from the richness of its iconographical discoveries and the study of ideas, it placed the formal analysis of eighteenth-century English painting on an altogether new footing. Only Dagobert Frey has attempted a comparable formal analysis in *Englisches Wesen in der bildenden Kunst*, Stuttgart, 1942, and of the two Wind's is superior.

See also Charles Mitchell, 'Three Phases of Reynolds' Method', *Burl. Mag.*, Feb. 1942.　　　　　　　　　　　　　　　　　[2] Leslie and Taylor, op. cit. 104.

[3] Waterhouse, *Painting in Britain 1530-1790*, 166-7.

fingering the reins. The pose of *George Augustus Eliott, Lord Heathfield* (R.A. 1788) in the National Gallery is adapted from Van Dyck's *Iconography*. The background, like that of the Keppel portrait, may be similarly linked with Van Dyck's *Robert, 2nd Earl of Warwick* in the Metropolitan Museum, New York.[1] But the drama at this late date is more Rubenesque, while Reynolds has used a number of devices to introduce an illusion of intimacy, of being on the spot. The noble pose has been modified to look almost informal, and the figure stands right up to the frame of the picture, through which are glimpsed the emblems of key, sword, and cannon, and the smoke occupying the interval between the hero of Gibraltar and the looming clouds behind.

Reynolds never chooses for portraits showing the scene of action a pose which cannot be observed in daily life as well as on the battlefield. *Colonel Banastre Tarleton* [plate 55; R.A. 1782] does not brandish his sword, but adjusts his accoutrements. Like the gesture of Lord Heathfield with the key of Gibraltar, the action is a familiar one. Beneath the plumed helmet his head with its darting glance is surrounded by brilliantly lit clouds of smoke; swirling flags, a cannon pointing out of the picture, and the heads of two terrified horses, their eyeballs rolling in excitement as a single groom forces them back, complete the imagery of baroque heroicization. But frightened horses and restraining grooms were also seen in the streets of London. In appealing so strongly to recognition of the familiar in the most elevated contexts and grandiose compositions, Reynolds constructed a bridge between the everyday experience of his age and his own conception of high art.

Only on rare occasions did the painter find comparable opportunities to heroicize civil worthies, those who merited honour by their public role and services. Perhaps political caution held him back from the glorification of the party in power by a specific reference to a historic event. His bishops, judges, and Lord Mayors wear their ceremonial robes not on the public stage of cathedral, bench, or council chamber, but in the privacy of the study. The opportunities he chiefly exploited were ones where he could

[1] Whinney and Millar, O.H.E.A. VIII. 71.

introduce a note of romantic wonder by exotic association. In the portrait of *Lord Richard Cavendish* (R.A. 1781) the traveller was depicted against a sea-and-cloud-scape; for the engraving he converted the middle ground into an Egyptian desert with a mysterious Sphinx silhouetted against the breakers of a stormy ocean.[1] This truly Shakespearean licence enlarged the scope of association with his subject's travels. Once again he observed his precept not to trespass on the sublime; for the expository pose conjures up a talk to a meeting of virtuosi after the hero's return, rather than a perilous predicament in the desert or on the ocean.

The *Apollo Belvedere* pose, which he first used for a naval hero, was twice invoked to support a portrait from civil life. *Frederick, 5th Earl of Carlisle in Garter Robes* (1769; Castle Howard) is the young and gracious oligarch who has thoughtfully assumed the mantle of his station in life against a background of Venetian splendour, relieved by the rococo humour of a pet dog barking in anticipation of a walk. Typically, the familiar is introduced. *Omai* [Frontispiece; R.A. 1776] complements the handsome, highly educated, and gifted aristocrat who was the cynosure of London *salons* as an alternative showpiece of the fashionable world for different reasons. He is the noble savage whose example instructed society in natural virtue.[2] His spurious Tahitian garb evokes the Rajah and the Roman Senator. By altering the arms of the classical statue Reynolds has translated combative action into a gesture of proud indication as the young prince pauses during a stroll on his native island. For a memorable moment the classical and romantic tendencies of the eighteenth century are fused in perfect reconciliation, so that the picture becomes a kind of summation.

The leaders of the nation in war and peace were either members of the landowning class entitled to bear arms, or aspirants to it. By far the largest number of portraits by Reynolds depict members of this class which moved in the two related worlds of London

[1] See Wind, op. cit., fig. 58 and Waterhouse, *Reynolds*, plate 225. There is a dark boulder with a sphinx-like shape in the painting, but I have only seen a photograph.

[2] For the tragic life and romantic image of Omai see Chauncey Brewster Tinker, *Nature's Simple Plan*, Princeton, N.J., 1922, a classic study of the ideal of the noble savage in the eighteenth century.

society and the country house. The grandest ones were destined for rooms of state, the splendour of which he kept in mind in planning his composition. *Charles Coote, Earl of Bellamont K.B.* [plate 54; R.A. 1774] in the National Gallery of Ireland magnificently displays his enormous plumed headgear and the robes of his Order against a background of baroque drapery, emblems, and architecture. The pose is a variant of the familiar propped-up one of the Craggs monument, the support of a ceremonial sword being ingeniously substituted for that of the pedestal. The upward gaze of the eyes misses the effect of heroicization, so that the earl looks as if he were negligently performing a feat of precarious balance. This criticism apart, the painting shows how admirably Reynolds had learned one of the main lessons to be gained by study in Italy, that the Old Masters designed for an architectural setting, and illustrates the extreme limits of his ornamental style in portraiture.

Reynolds frequently elevated his portraits of fashionable women by association with *istoria*, but his models were seldom taken out of the real world unless the ideal context could be supported by youth or beauty. *Lady Sarah Bunbury* (1765) in the Art Institute, Chicago, sacrifices to the Graces in a pose adapted from a classical relief,[1] and *Lady Elizabeth Delmé and her two children* (1777) in the National Gallery of Art, Washington, is similarly a variation on the Old Master theme of the Virgin with Child and the Infant St. John. Even the trees grow into a natural baldachin over the family group. His most ambitious translation of a subject picture into a portrait was *The daughters of Sir William Montgomery as 'The Graces adorning a Term of Hymen'* (R.A. 1774; National Gallery, London), which he hoped would be 'the best picture I ever painted'.[2] He exhibited the picture at the Academy in 1774

[1] Sources of the pose in a classical cult-figure and J. Vien's *La Jeune Grecque* are illustrated in Joseph Burke, 'Romney's *Leigh Family* (1768): a link between the conversation piece and the neo-classical portrait group', *Annual Bulletin of the National Gallery of Victoria*, II, 1960, figs. 12–14.

[2] This picture is the subject of an important article by E. H. Gombrich, 'Reynolds' Theory and Practice of Imitation: Three Ladies adorning a Term of Hymen', *Burl. Mag.*, 1942, reprinted in *Norm and Form: Studies in the art of the Renaissance*, 1966. There is a considerable contemporary literature on this famous painting. See

under the title of 'Three Ladies decorating a term of Hymen'. It was a *tableau vivant*, a kind of Miltonian bridal masque with Hymen substituted for Comus as befitted the allusions, for it was commissioned to celebrate three beautiful sisters, one just married, the second about to be married, and the third married a year later.

Gombrich has identified the subject as a rite of worship to the God of Wedlock, and noted that, of the two ministrants to the conjugal sacrifice, the youngest sister who was already married has passed the image of Hymen, while the eldest of the three, who was not yet betrothed, is shown as still engaged in collecting flowers for the rite.[1] By the time Reynolds began the picture the central sister had become the wife of the Rt. Hon. Luke Gardiner, M.P., who commissioned the picture, and therefore joins in the act of decoration. Two of the poses are taken from Maenads surrounding a term of Bacchus in a famous *Bacchanal* by Poussin. The role of the three sisters as the three Graces was supported by Rubens's no less famous *Nature attired by the Three Graces*, in which the genius of fertility being attired is a term of the Diana of Ephesus. These and other learned emblematic allusions may only have been grasped by a private circle. But the 'three Irish Graces' were the talk of London society, and the meaning of the casting must have been widely recognized. According to Hazlitt, Charles Lamb defended the poetry of Pope by quoting from his compliments. The compliments of Reynolds were no less subtle, and no less memorable.

'Is not there humour and satire', wrote Walpole, 'in Sir Joshua's reducing Holbein's swaggering and colossal haughtiness of Henry VIII to the boyish jollity of Master Crewe?'[2] Wind has identified a whole group of serious portraits of children whose bearing and expression are prophetic of later life.[3] Others were straightforward fancy pictures and exhibited as such, although the

Martin Davies, *National Gallery Catalogues: the British School*, 1946, 113–14. For Reynolds's correspondence with the Rt. Hon. Luke Gardiner, who commissioned the painting shortly before his marriage to Sir William Montgomery's eldest daughter, see F. W. Hilles, *Letters of Sir Joshua Reynolds*, 35–6.

[1] *Norm and Form*, 130.

[2] *A. of P.* I. xvii note 2. This long note is central to any discussion of Reynolds's borrowed attitudes. [3] *Op. cit.* 187 ff.

portrait likenesses were unmistakable. The observation of Walpole introduces a second type of allusion to a dominant trait by the use of borrowed attitudes as a species of wit. Reynolds, Walpole wrote, 'has been accused of plagiarism, for having borrowed attitudes from ancient masters'. This was not plagiarism, he continued, 'but quotation; and a quotation from a great author, with a novel application of the sense, has always been allowed to be an instance of parts and taste; and may have more merit than the original.'[1] The distinction between the two modes of quotation, one serious, the other playful, is maintained in his portraits of actors and actresses. In the second mode wit can be used to make a serious point. *Garrick between Comedy and Tragedy* [plate 56A; 1760], with the figure of comedy in the manner of Correggio and tragedy taken from Guido Reni, poses the classic dilemma of Hercules between Vice and Virtue.[2] The actor humorously excuses himself to tragedy pointing to the heavens while allowing himself to be led on the downward path by comedy. 'When this passion [for fame] is carried to excess', Reynolds wrote in his character sketch of Garrick, 'it becomes a vice.'[3] In his farewell performance Garrick chose a comic role, after having first decided on a tragic one.[4] Reynolds's picture may be read as both a prophetic verdict on the man and a symbolic judgement on his age, the genius of which was for wit elevated to the level of poetry.

Mrs. Abington [plate 56C; R.A. 1771] in the collection of Lord Hillingdon holds her thumb to her lips as Miss Prue in 'Love for Love'; here no attempt has been made to elevate the comic actress by classical association. His highest powers of inventive allusion were called forth by the portrait of *Sarah Siddons as the Tragic Muse* [plate 57; 1784] in the Henry Huntington Art Gallery. The accounts of the origin of the striking pose are contradictory, Mrs. Siddons being responsible for at least two. Sir Joshua, she

[1] *A. of P.* I. xvii note 2.

[2] Waterhouse, op. cit. 168. Cf. F. Saxl and R. Wittkower, *British Art and the Mediterranean*, 1948, 64 and 65.

[3] *Portraits of Sir Joshua Reynolds*, ed. F. W. Hilles, 1952, 87.

[4] Don Felix in Mrs. Centlivre's *The Wonder*, generally considered his greatest comic part, in preference to Richard III. See Joseph Knight, *David Garrick*, 1894, 276–80.

related in later life, took her by the hand and led her up to his platform: 'Ascend your undisputed throne; bestow on me some idea of the Tragic Muse.'[1] Before time had gilded her memory, the actress confided to a friend that 'Sir Joshua had begun the head and figure in a different view; but while he was occupied in the preparation of some colour she changed her position to look at a picture hanging on the wall of the room . . . When he again looked at her, and saw the action she had assumed, he requested her not to move; and thus arose the beautiful and expressive pose we now see in the picture.'[2] This surely comes closer to the truth, for the arm flung over the support of the throne is so typical of grand actresses taking their splendid ease that there is no need to look elsewhere for an alternative explanation.

The composition makes elaborate use of motives supplied by Michelangelo's prophets in the Sistine Ceiling. Like Isaiah, Mrs. Siddons sits half-turned on her throne, her left arm resting on her elbow; she is flanked by two emblematic figures, the Aristotelean genii of Pity and Terror, holding dagger and cup of poison respectively as symbols of Open and Secret Murder, and the first of these is faithfully copied from the left of the two figures behind Jeremiah.[3] Even the outflung right arm is reminiscent of Daniel, whose image may have predisposed Reynolds to his observant choice. It is his most ambitious essay in sublime association, and yet every heroic borrowing is justified by its context.[4]

The small group of portraits of men of genius with whom he was intimate is unique in the history of European portraiture in that they correspond to the judgements he passed in writing his character sketches.[5] *Oliver Goldsmith* (R.A. 1770) at Woburn

[1] Cited in Leslie and Taylor, op. cit. II. 422. [2] Ibid. 422.

[3] Wind, op. cit. 184. The Sistine Chapel borrowings were discussed by contemporaries, as no doubt Reynolds intended, and Pity and Terror variously interpreted as Pity and Remorse, or Crime and Remorse. See Leslie and Taylor, op. cit. II. 422, note 1.

[4] Derek Hudson, whose *Sir Joshua Reynolds: A Personal Study*, 1958, contains important new material, has added to the list of detected borrowings in Reynolds's art, notably in chapter XII, 'The Silver Spectacles'.

[5] F. W. Hilles has published the character sketches of Goldsmith, Johnson, and Garrick and the two dialogues on Johnson against Garrick, and Johnson defending Garrick in *Portraits by Sir Joshua Reynolds*, 1952.

Abbey, who appeared as a clown to others besides Boswell, is depicted as the poetic visionary. Reynolds's written sketch shows that he was indignantly aware of the unjust charge that some of the finest lines in his verse were supplied by Dr. Johnson.[1] Similarly, the portrait of *Dr. Johnson* (R.A. 1770), of which a replica is in the National Gallery, London, rejects Boswell's undoubtedly faithful image of the pugnacious controversialist for that deeper side of the literary hero which was revealed posthumously by the publication of the prayers that he composed [plate 56B]. Among his intimates only Edmund Burke, of whom he left no pen portrait, eluded his psychological probing in the three portraits that he painted.

The history paintings of Reynolds have not yet been the subject of the special study they deserve. They were nearly all painted late in his career, after the second visit to Flanders and Holland between 24 July and 16 September 1781, when he came more deeply under the spell of Rubens.[2] They also suggest the influence of Fuseli, but not his neo-classical manner. In fact Reynolds painted remarkably few pictures in the linear bas-relief style, perhaps the closest approximation to *avant-garde* neo-classicism being the portrait of the *Hon. Mrs. Edward Bouverie and her son Edward* (R.A. 1770) in the collection of the Earl of Radnor at Longford Castle.[3] The renewed contact with Rubens confirmed his allegiance to the ornamental style and liberated his brush, so that from a purely painterly point of view the last decade of his life is one of the richest.

Edmund Burke did not apply his analytical gifts to an obituary of Gainsborough, but when he stated that the portraits of Reynolds 'remind the spectator of the invention of history, and the amenity of landscape', he hit upon two phrases which serve conveniently to distinguish between the two, for it was Reynolds who pre-

[1] Hilles, op. cit. 41 and 50 n. 1.

[2] The diary of this excursion is published in Leslie and Taylor, op. cit. II. 329–34, and Reynolds's full and detailed observations of the works he studied in 'A Journey to Flanders and Holland', in Malone, *Works*, II. 247–427.

[3] At the same Royal Academy in 1770 Reynolds exhibited another of his most neo-classical portraits, Thomas, Viscount Sydney, and Colonel John Dyke Acland as *The Archers*, in a pose reminiscent of Pallaiuolo.

eminently wedded portraiture to history, while Gainsborough did so to landscape. The comparison between the two artists was a favourite topic during their lifetime. Reynolds gave his own opinion of his rival when he said that Gainsborough 'did not look at nature with a poet's eye' but 'saw her with the eye of a painter'.[1] By the poet's eye Reynolds meant the visual imagination of the learned painter of *istoria*. His formulation fits in with Wind's distinction between idealism and empiricism, and that of Waterhouse between sense and sensibility.

Thomas Gainsborough was born on 14 May 1727, like Reynolds the seventh child in a large family.[2] His father, a cloth merchant of Sudbury in Suffolk, was sufficiently impressed by his boyhood paintings to send him to London 'in his thirteenth year', i.e. 1740. Whether he was actually apprenticed to Hayman or worked as an assistant to Gravelot is unknown. Many of his early figures recall the loose and shambling ones of Hayman, and the influence of Gravelot is unmistakable. Both were working at the time on the project for decorating Vauxhall Gardens. Later accounts of his formal relationship to each are tangled, but if he was bound to or employed by one he would certainly have got to know the other. He is reported to have copied and restored Dutch landscapes for dealers, and he drew the rococo decorations for Birch's 1743 edition of Houbraken's heads. At the age of nineteen he married Margaret Burr, a natural daughter of the Duke of Beaufort. She brought him an income of £200 a year.

No painter of the century before Turner was more precocious. In a letter written in the last year of his life he stated that the picture known as *Gainsborough's Forest* in the National Gallery was painted in Sudbury in 1748, but begun before he left for London as a schoolboy.[3] Careful examination has shown no traces of painting as early as 1740. On the contrary, it looks as if

[1] Discourses, ed. *Wark*, 253.

[2] The standard authority for the life is W. T. Whitley, *Thomas Gainsborough*, 1915, supplemented by the researches of E. K. Waterhouse, Mary Woodall, Oliver Millar, and especially John Hayes, whose articles on Gainsborough and his circle have appeared in the *Conn.* and other periodicals. E. K. Waterhouse, *Gainsborough*, 1958, contains an authoritative catalogue, bibliography, and some 300 illustrations.

[3] 11 Mar. 1788. The letter is cited in full in Whitley, *Gainsborough*, 298–9.

the whole picture was done in 1748. It is a version of Ruisdael's *Forest* in the Louvre, which he must have known from an engraving or a copy. Gainsborough's factual statements are remarkable for their accuracy. He probably did start an imitation of this picture as a boy, but the canvas on which he began has not survived.

At the age of twenty-one he was so much admired as a landscape painter that he received a high professional honour. He was one of the artists chosen to present a picture of a London hospital for the series decorating the Court Room of the Foundling Hospital. His subject was *The Charterhouse* (1748), and he handled it more brilliantly than any of his seniors in the series, Samuel Wale, Edward Haytley, and Richard Wilson, did its companions, although the first had the chance to shine in three and the others in two. There can be little doubt that he learned the secrets of Dutch painting by copying and restoring originals. The list of Dutch painters with whom writers on Gainsborough have detected resemblances includes Ruisdael, Hobbema, Du Jardin, Van der Heyden, Berchem, Cuyp, Paul Potter, and Teniers.[1] In the majority of cases the references are to some correspondence of handling or technical effect, not merely composition, although the compositional resemblances are numerous. Composition can be learned from engravings, but technical procedures only from paintings or a master. Neither Hayman nor Gravelot could have given him the clues he so ably followed.

All Gainsborough's landscapes, including the earliest that are known, show that he owed as much to the observation of nature as he did to the imitation of art. From Hayman the scene-painter and Gravelot the rococo decorator he learned how to approach pictorial composition on altogether different principles from those of the Dutch. There is a doll-like quality in some of his small full-length portraits, aptly described by Waterhouse as a 'bottle-like appearance', which recalls the practice of Gravelot in using dressed-up dolls for his drawing lessons.[2] During this

[1] Cf. John Hayes, 'The Gainsborough Drawings from Barton Grange', *Conn.*, Feb. 1966, 86–93.

[2] *Gainsborough*, 1958, 14.

formative period he also modelled figures of 'cows, horses and dogs'.[1] Stage scenery, artificial lighting, models, and mock-ups were henceforth a recurrent source of pictorial inspiration, so that at the outset of his career the ground was prepared for his development on two lines, the first realist and the second decorative. Both may be illustrated by comparing *Mr. and Mrs. Robert Andrews* [plate 62A; c. 1749] in the National Gallery with *Heneage Lloyd and his Sister* (c. 1750) in the Fitzwilliam Museum, Cambridge.[2] The former couple are shown 'in a pretty landskip of their own possessions'; directly observed corn stooks and parsley replace the more conventional foreground weeds of Wynants, and the Suffolk landscape rolls back in dappled sunlight and shadow of cloud. There is a touch of artifice about the figures, but the open-air vision of the countryside looks forward to Constable. In the second picture the brother and sister face the spectator with wide-eyed artlessness from a limpid background of stage scenery. The girl especially is like a doll who has shyly come to life in some charming rural and rococo version of the legend of Pygmalion.

Portraits which combined the charms of the conversation piece with those of landscape made a strong appeal to the country gentry. Gainsborough's attack on high society was a flank one. He worked first in Sudbury, then Ipswich (from c. 1750), moved to Bath in 1759, and did not finally settle in London until 1774. Thus, of his life of sixty-one years only fourteen were spent in London, apart from his student years. There is some evidence that while based on Ipswich he travelled round to paint portraits, so that he may have seen paintings by Van Dyck before his move to Bath made accessible the masterpieces at Wilton and other great houses. At Bath in 1760 he painted the portrait of one of his Suffolk friends, *Mrs. Philip Thicknesse*, who crosses her legs above the knee, a masculine freedom unrecorded in the female portraits of Rubens and Van Dyck. 'I should be very sorry', wrote Mrs.

[1] Mary Woodall, 'Gainsborough's use of models', *Antiques*, Oct. 1956, an important article which is documented and illustrated.

[2] All works discussed are illustrated, unless otherwise stated, in Waterhouse, *Gainsborough*, 1958.

Delaney after seeing the picture, 'to have anyone I loved set forth in such a manner.'[1] An air of high breeding redeems the suggestion of wantonness in the bold asymmetrical pose. The stylish elongation of the figure and the sensitive treatment of the dress, at once crinkling and drawn out in flowing lines, have their parallels in Gravelot. But the new note of authority in fashionable portraiture stems from only one source, Van Dyck.

Once he had found his model for elevated portraiture in Van Dyck, Gainsborough began to borrow attitudes as skilfully as Reynolds, but without any allusion to *istoria*. The equestrian portrait of *Lt.-Gen. Philip Honywood* (1765: John and Mable Ringling Museum, Sarasota), based on Van Dyck's *Charles I* in the National Gallery, is typical of his procedure. The blunt general has been substituted for the superb monarch, the horse is smaller, the mood quieter, and the scheme of light and dark reversed like a negative. Because the transformation is so radical, one can forget the source. In a more famous but exceptional painting recognition was essential, for it was a challenge to Reynolds's own evocation of Van Dyck, the *Brown Boy, or Thomas Lister, 1st Lord Ribblesdale* (1764), in which the boy of twelve was depicted in Van Dyck dress. The attitude of the *Blue Boy* [plate 58; R.A. 1770] was taken with only the alteration of a hand from the older boy in Van Dyck's *George Villiers, 2nd Duke of Buckingham and his brother Francis* at Windsor. It was exhibited under the title of 'a young gentleman', for its subject Jonathan Buttall had reached adolescence.[2] It can thus be read in two ways, as a rival

[1] The *Autobiography and Correspondence of Mary Granville, Mrs. Delaney*, ed. by the Rt. Hon. Lady Llanover, 1861. The letter is dated from Bath, 23 Oct. 1760.

[2] It was the practice of the Royal Academy until 1798 to catalogue portraits other than those of the royal family anonymously under such general titles as *A Nobleman, A Lady of Title, A Gentleman, An Artist*. This safeguarding of the sitter from publicity was defeated by newspapers publishing on the opening of the Academy a list of names with the catalogue numbers.

A letter of 1770 from Mary Moser to Fuseli in Rome, 'Gainsborough is beyond himself in a portrait of a gentleman in a Vandyke habit', and the catalogue entry no. 85, 'Portrait of a Young Gentleman' by Gainsborough, are in conjunction conclusive evidence of the identification, confirmed by the researches of W. T. Whitley in *Gainsborough*, chapter XX, 'The Blue Boy'.

The misnomer 'Blue Boy' has acted as a barrier to the understanding of Gains-

to two famous portraits of boyhood and a haunting study of adolescence.

Among the Van Dyck poses that appealed to him four were favoured for decoratively filling tall frames: first, the standing male figure with one arm resting backhanded on the hip, the other hanging loosely alongside the body, as in the *Blue Boy*; secondly, the male figure with a more marked transference of the weight to one side, so that straight and bent leg are contrasted, as in *John, 10th Viscount Kilmorey*; thirdly, the standing female figure with one arm hanging down, its hand fingering or lifting the dress, the other bent inwards and held freely across the body, as in *Lady Sheffield* (1785) at Waddesdon Manor; and fourthly, the full-size female figure with both arms folded or linked together to form a frame for the torso, as in the seated *Mrs. Robinson as Perdita* (1781/2) in the Wallace Collection. Common to all four poses is the long-drawn figure shown in *contrapposto*, the head facing the spectator across a body turned to one side. All through his life he played variations on these attitudes, which involved his sensibility in the grace of bodies and the felicitous pattern and folds of costume and drapery.

Viscount Kilmorey [plate 59; *c.* 1768] in the Tate Gallery is an outstanding study of character as well as a superb example of his sense of pattern. The powerful frame of the nobleman supports the boldly defined surfaces of blue coat, breeches, and ample red waistcoat, the last trimmed with a zigzagging gold border echoed in the hat tucked under his arm. The eyes penetrate the spectator instead of merely looking at him, and give the impression of an alert curiosity. Such portraits redeem him from the charge that he was indifferent to personality, and merely regarded his sitters as models. His response to the humanity of his sitters was not confined to the rich individualism of age, as may be seen from the portraits of his daughters and such likenesses as *Mr. and*

borough's intention in painting a young bourgeois as a gentleman in blue in rivalry to the celebration of young aristocrats by both Reynolds and Van Dyck.

For his awareness of Van Dyck's archetypal models of aristocracy see J. B. Muswick, 'Lord John and Lord Bernard Stuart by Thomas Gainsborough after Van Dyck', *St. Louis Museum Bulletin*, 1943, 7–10.

Mrs. William Hallett, or *The Morning Walk* (1785) in the National Gallery, London, at once 'an incomparable picture of young love' and a classic image of the aristocratic ethos of the eighteenth century.[1] Among those into whose characters he showed a consistently penetrating insight were those beautiful women whom a scandal-loving age described as 'demi-reps'. The character of *Mrs. Elliott* (R.A. 1778) in the Metropolitan Museum, New York, has something of the pathos of Sophia in *The Vicar of Wakefield*, for she had qualities of heart as well as folly that together engage the sympathies [plate 63A]. The pose, related to the third of his favourite Van Dyck attitudes, shows the actress advancing across the canvas with classic dignity. But the majestic step of a great lady has been amusingly translated into a lightly tripping gait on high-heeled shoes, and the face is a masterly compound of impulsive warmth, vivacity, vanity, and foolishness, corresponding with what is known of the famous mistress in real life.

Van Dyck was not the only painter from whom Gainsborough borrowed. The composition of *James Quinn* (1763) in the National Gallery of Ireland was cleverly adapted from Hogarth's print of *Simon Lord Lovat* (1746). The chair is at the same angle, the legs are identically placed but seen more from one side, one hand is an almost literal transcript, the other only modified to clasp a book, and the actor is shown in an old-fashioned suit of clothes which, like his wig, coincides with the dress of the Jacobite rebel. Even the pattern made by the buttons and frogs continuing the line of the slits has been reproduced. By shifting the weight to one side and turning the head Gainsborough has disguised the source from the casual observer. In other portraits, like the superb *Viscountess Molyneux* (1769) in the collection of the Earl of Sefton, one sees him taking hints from the elevated style of Reynolds.

The excellence to be observed in Gainsborough's fancy pictures was, Reynolds tells us, 'his own, the result of his particular observation and taste'.[2] In 1738 Vertue had used the term 'fancy' as a

[1] Waterhouse, *Painting in Britain*, 188.

[2] *Discourses*, ed. Wark, 254. See E. K. Waterhouse, 'Gainsborough's Fancy Pictures', *Burl. Mag.*, June 1946.

synonym for a pleasant conceit introduced into conversation pieces.[1] By the time Reynolds used the word it had acquired associations with Arcadian pastoral and sentimental genre. It was a handy term to distinguish between a genre picture refined by invention and sensibility and a precise mode of association; indeed the shift from the allegorical to the fancy picture is characteristic of the change of taste between the seventeenth and the eighteenth centuries. When Reynolds paid his tribute to the fancy pictures of Gainsborough, he specified 'the mean and vulgar form of a woodcutter, beside a child of an interesting character', the latter being his own favourite model for excursions into the category. He stated that Gainsborough did not attempt to raise his woodcutter, i.e. disguise the lowliness of his subject, and did not lose any of the natural grace and elegance of the child, 'such a grace, and such an elegance, as are more frequently found in cottages than in courts'.[2] He bought the *Girl with Pigs*, one of his rival's first fancy pictures, when it was exhibited in 1782.[3] His choice may well have been influenced by the fact that the girl is shown in a classical attitude of sad meditation revived in mourning figures on eighteenth-century funerary monuments.

The intermediary between Gainsborough's fancy pictures and the Old Master tradition was Murillo. He admired and copied Murillo or works after Murillo, and in 1787 bought a *St. John in the Wilderness*, now ascribed to a follower, for five hundred guineas from Desenfans.[4] In turning to the Spanish master he was following a trend in the romantic taste of his time. The Revd. Matthew Pilkington, who dedicated *A Gentleman's and Connoisseur's Dictionary of Painters* (1770) to the President and Council of the Royal Academy, listed Murillo's principal works

[1] *Vertue*, III. 82: 'several peices of some figures of conversation . . . conceited plaisant Fancies and habits. mixt modes really well done'.

[2] *Discourses*, ed. Wark, 254.

[3] W. T. Whitley, in 'An Eighteenth-Century Art Chronicler: Sir Henry Bate Dudley, Bart.', *Wal. Soc.* XII, 1925, 44–5, gives the full story of the purchase.

[4] W. T. Whitley, *Gainsborough*, 275 with the *St. John* illustrated facing p. 328. Cf. Tancred Borenius, 'Gainsborough's Collection of Pictures', *Burl. Mag.*, May 1944, 106–10.

as 'History, Landscape and Beggar-Boys', and described the last of these subjects as appealing particularly to English collectors:

But notwithstanding his genius, taste, and abilities, qualified him to execute subjects of history with general applause; yet his favourite subjects were beggar-boys, as large as life, in different attitudes and amusements; which he usually designed after nature, and gave them a strong good expression. His original pictures of those subjects, have true merit, and are much esteemed, many of them being admitted into the most capital collections of the English nobility; but of those, there are abundance of copies, which, to the dishonour of the artist, are sold as originals to injudicious purchasers.[1]

The late Chauncey Brewster Tinker noted a number of parallels between the fancy pictures of Gainsborough and early romantic poets like Thomson, Gray, Burns, and the young Wordsworth.[2] *The Cottage Girl with Dog and Pitcher* [plate 60; 1785] has something in common with Greuze. Unlike *La Cruche cassée*, it would make an almost perfect frontispiece to the *Lyrical Ballads* (1788):

> The floating clouds their state shall lend
> To her . . .
> She died, and left to me
> This heath, this calm and quiet scene.[3]

There is one difference to be noted. Gainsborough's image evokes the Christ Child as the Good Shepherd. Similarly, *The Woodman* [plate 63B; the original painted in 1787], which Gainsborough mentioned in his death-bed letter to Reynolds, 'My Woodman you never saw', recalled the saint or hermit in a wilderness while depicting old age at the mercy of wild nature.[4] Visionary devotion has been translated into the tramp's fear before

[1] *Dictionary*, article on Murillo, 410–11.

[2] *Painter and Poet*, Cambridge, Mass., 1938. Tinker's thesis has been brilliantly developed by Kenneth Clark, 'English Romantic Poets and Landscape Painting', *Memoirs and Proceedings of the Manchester Philosophical Society*, LXXXV, also privately printed at the Curwen Press, Jan. 1945.

[3] 'The Education of Nature', cited from the fourth and last stanzas.

[4] The painting was destroyed in the fire at Exton Park, Oakham, 23 May 1810, and is only known from the engraving by Simon. The history of the picture, together with the death-bed letter, is given in full in W. T. Whitley, *Gainsborough*, 235, 285, 296, 322–32, 371.

the lightning; his hands are clasped not in prayer but on his stick; in place of St. Jerome's placid lion, a Snyders-like dog shrinks back with snarling defiance. The evocation of religious art is probably unconscious and due simply to Gainsborough's study of religious paintings by Murillo and similar masters.

Among the elegies published after Gainsborough's death, one in *The World* singles out his landscapes in verses which draw on Milton's *Lycidas* and Gray's *Elegy*.[1] The affinity with Gray has been precisely described by Lord Clark:

The picture of rustic life in Gray's *Elegy* . . . is the result of sincere contemplation by a mind so elegant and discriminating that natural roughnesses are hardly perceived. Exactly the same is true of Gainsborough . . . For him the village children who run to lisp their sire's return, or climb his knees the envied kiss to share arranged themselves in groups as elegant as Gray's diction; and when he sat down to draw cows, his pencil instinctively traced a visual equivalent to 'the lowing herd winds slowly o'er the lea' . . . To read the *Elegy* in front of the canvases of Gainsborough heightens our pleasure in both . . .[2]

Like Gray, Gainsborough brought to the observation of rustics the sensibilities of the Man of Feeling, so that Constable could refer justly to 'the canvasses of this most benevolent and kind-hearted man'.[3] *The Cottage Door* [plate 61; R.A. 1780] in the Huntington Art Gallery illustrates the various strands that united to form his final style. The foreground plants recall Wynants; Salvator Rosa would not have rejected the setting for a bivouac of bandits; a Herculean tree-trunk is painted with the bravura of Rubens; and the light of the setting sun comes in as tenderly as with Claude. The 'grace and elegance more frequently found in cottages than courts' are typified by the peasant woman, who might have been posed for by Mrs. Sheridan.

A good deal of evidence survives about Gainsborough's use of artificial models, lighting, and experiments with materials, because

[1] 'Elegy on the Death of Mr. Gainsborough', cited in Whitley, *Gainsborough*, 313–14.

[2] *English Romantic Poets and Landscape Painting*, privately printed at the Curwen Press, 1945, 3.

[3] Fourth Lecture on the History of Landscape Painting at the Royal Institution of Great Britain, 1836, in C. R. Leslie, *Memoirs of the Life of John Constable, Esq., R.A.*, 2nd ed., 1845, 354.

these captured the imagination of contemporary painters. In the two best accounts by Reynolds and Edward Edwards, the list of materials used for scenic models comprises pieces of looking-glass, broken stones, cork, coal, sand, clay, mosses, lichen, dried weeds, and that most rococo of green vegetables, broccoli.[1] In drawing he variously used a small piece of sponge tied to a bit of stick, a small lump of whiting held up by a pair of tongs, black lead, black and white chalks, indian inks, and slight touches of oil colour. He experimented with unorthodox papers.[2] As regards lighting, he alternated between working in a darkened room, by candlelight, and in sunlight. After painting in a darkened room he would let in more sunlight to test the effect.[3] The Victoria and Albert Museum has the remarkable set of painted transparencies made for his Eidophusikon, a box lit by candles. One of these corresponds in reverse with the *View at the Mouth of the Thames* [plate 62B; c. 1783] in the National Gallery of Victoria.[4] A study of the oil painting shows what he gained by these researches, a mastery of the steady but harmonious diffusion of light which is one of the hardest tasks for the painter of open-air scenes to achieve. The painter's artifice was always controlled by the observant eye trained on nature. 'All those odd scratches and marks, which, on a close examination, are so observable in Gainsborough's pictures', Reynolds noted, 'and which even to experienced painters appear rather the effect of accident than design; this chaos, this uncouth and shapeless appearance, by a kind of magick, at a certain distance assumes form.'[5] This distant form is that of nature, whereas the tapestry-like sensuousness of texture noted by a contemporary in rococo paintings like *The Mall* (1783) was the abstract language of his

[1] Edward Edwards, *Anecdotes of Painters who have resided or been born in England*, 1808, 139, and Reynolds, *Discourses*, ed. Wark, 205. For his 'distant woods of broccoli' see the letter of an 'Amateur of Painting' cited in Whitley, *Gainsborough*, 369.

[2] On 26 Nov. 1767 he wrote to James Dodsley the publisher about a paper without cross-wire impressions on which Anstey's *New Bath Guide* had been printed, because he had set his heart on it for drawing landscapes. See Whitley, op. cit. 59.

[3] Cf. the statement of Ozias Humphrey, 'he let in (of necessity) more light for the finishing of them', cited by Whitley, op. cit. 392.

[4] Ursula Hoff, *Catalogue of European Paintings before Eighteen Hundred*, National Gallery of Victoria, Melbourne, 1961, 58. [5] *Discourses*, ed. Wark, 257–8.

sensibility.[1] It is not surprising that Gainsborough, who set out for the Lake District in 1783, became a hero of the theorists of the picturesque, of which he was the leading English pioneer, and was no less strongly admired by Constable, the apostle of truth to nature.

The third of the trinity who led the Classical Age of British Painting was Richard Wilson (1713/4–82).[2] The third son of the rector of Penygoes in Montgomeryshire, he was connected by birth with several notable landowning families and under his father received an excellent classical education. In 1729 he was sent to London 'to indulge his prevailing love for the arts of design', a euphemism for six years' training under the obscure portrait painter and copyist Thomas Wright, possibly a pupil of Thomas Hudson.[3] When his training was over he was helped by his family connections to get portrait commissions, including one from the royal family. In the autumn of 1750 he went to Venice, and about a year later to Rome, his headquarters until his departure for England in 1756 or 1757. On his return he 'soon attained the highest reputation' and 'gained great celebrity as a landscape painter', maintaining a fine apartment in the Great Piazza, Covent Garden, with two studios, the second for his pupils, and a large showroom.[4] In 1768 he became a Foundation Member of the Royal Academy. Thereafter his fortunes declined.[5] A desire to

[1] The reviewer of the Academy Exhibition of 1779 in the *St. James's Chronicle* used the term 'embroidery' for his landscapes. See Whitley, op. cit. 158.

[2] W. G. Constable, *Richard Wilson*, 1953, contains the authoritative life, illustrated catalogue, and a select bibliography listing the important articles of Brinsley Ford. See also *Richard Wilson and his Circle : a Catalogue of an Exhibition of Pictures organised by the City Museum and Art Gallery, Birmingham*, Tate Gallery, London, 1949, with an introduction by Mary Woodall (a reprint of the Birmingham Catalogue).

[3] 'An Account of Richard Wilson Esq. Landscape Painter', *European Magazine and London Review*, XVII, June 1790, 403 ff. The author has been identified by Douglas Cooper, 'The Iconography of Richard Wilson', *Burl. Mag.*, Apr. 1948, as William Hodges, who was Wilson's pupil. This article includes other valuable findings about Wilson's life.

[4] Constable, *Wilson*, 39. The apartment and his teaching are described in 'The Memoirs of Thomas Jones', ed. by A. P. Oppé, *Wal. Soc.* XXXII, 1951, 9–10.

[5] On 25 Nov. 1772 he was discharged from a hospital, see the *Memorandum Book of Richard Wilson, R.A. 1771–5*, V. & A., P.D. 29a, cited by Constable, op. cit. 51. His change to cheaper lodgings may be linked with ill health.

relieve him possibly lies behind his appointment as Librarian to The Royal Academy in 1776 in succession to Hayman. In 1781 the Council resolved that the Librarian 'on account of his state of health be indulged with a Deputy', and he died the following year in Denbighshire.[1]

The neglect of Wilson was a favourite topic of writers on art after his death. But was he neglected? The record of the landscapes that he sold reveals a considerable and sustained demand for his art. He is known to have been generous and to have lent money, to have suffered sporadically from ill health, and to have been too proud and sensitive to act the courtier: 'He had a deep feeling of the importance of his art and of his own importance as a professor of it. Humour him but upon this point and he would be most agreeable.'[2] There is some evidence that his sales fell off from about the mid-seventies. He devoted an inordinate proportion of his time to painting to please himself and not his patrons, who wanted pictures of their country houses. The shift of taste towards the picturesque lessened the demand for those of his classical landscapes which were the outcome of years of study and revision.[3] But he could always fall back on painting country seats, and a good deal of money must have passed through his hands. If he was unbusinesslike as well as generous and in his later years ailing, then the romantic notion of a neglected genius should be modified.

Before he left for Italy in 1750 he painted portraits which modernized the Kneller–Dahl tradition, attempted conversation

[1] A son, John Wilson, emerged to claim (and receive) assistance from the Council of the Royal Academy after the painter's death, see W. T. Whitley, *Artists and their Friends in England*, I. 386, and Constable, op. cit. 61. If Wilson ever married, he kept it very close.

[2] Sir William Beechey orally to Mr. Harvey of Catton, cited without a reference by Whitley, op. cit. I. 381. The late W. T. Whitley worked with scrupulous accuracy from periodical, newspaper, manuscript, and other contemporary records, but was suspicious that other writers would cite his references without acknowledgement. He used various devices to ensure acknowledgement, e.g. by omitting page references, giving the month but not the day of a newspaper, etc. In all cases the source can be tracked down from the clue given in the text.

[3] 'The apostles of the picturesque', writes W. G. Constable, op. cit. 58, 'never mention Wilson.'

pieces and sentimental fancy pictures, and made a reputation amongst artists for topographical landscape.[1] *Captain Michael Everitt* (*c.* 1747) in the National Gallery of Victoria, Melbourne, was painted after his association with Hogarth's project to decorate the Foundling Hospital. He would certainly have seen the latter's portrait of Captain Coram and possibly his manifesto self-portrait of 1745. The composition of *Captain Everitt* is dominated by the S-curve of the coat, identical with Hogarth's line of beauty and matching Captain Coram's. The forms are volumetrically presented, and colour and reflected light are broadly handled. This and other early portraits showed great promise. A pointer to the direction his style might have taken if he had stuck to the category is the lovely drawing later given the name of Thomas Jenkins and probably done in Rome, which combines chalk *sfumato* with both clear and tremulously broken lines.

The landscapes known to have been painted in England prior to his departure are in the topographical tradition to which the Thames Estuary School had recently imparted a new vitality. *Westminster Bridge* (1745) in the Philadelphia Museum of Art deserves a creditable place among those Thames scenes which show that direct and independent observation of light and atmosphere was firmly entrenched before the arrival of Canaletto in the following year exposed the native practitioners to the seductions of his Venetian style. In 1746 he painted the *Foundling Hospital* and *St. George's Hospital* for the Court Room series of eight London hospitals, all identical in size and in circular frames of oak foliage in plaster work.[2] The series hung between the large history paintings of Bible stories and was clearly a bid to secure recognition for the naturalistic English school.

Early writers have made much of the encouragement that Wilson is said to have received in Venice from Zuccarelli, to whom he presented one of his landscapes in 1751, and Vernet,

[1] *The Sleepy Eye that spoke the Melting Soul*, known only from the mezzotint by J. Faber jun., is a fancy picture somewhat in the manner of Highmore.

[2] Nichols and Wray, *The History of the Foundling Hospital*, 1935, 251, 261–2. The idea seems to have originated in some circular landscapes presented by Francis Harding, an imitator of Canaletto and Pannini, in 1745, see *Vertue*, III. 127. These are missing, and were never part of the series, cf. W. T. Whitley, op. cit. 163–4.

who in Rome 'advised him to the pursuit of landscape'.[1] There is no reason to doubt the evidence, but they were probably speaking to the converted, for he was prodigiously active in painting landscapes in Italy from the beginning, although he kept on with portraiture either to supplement his income or as a kind of insurance. Wilson entered the realm of ideal landscape by way of the Venetian painters of *vedute* and *capricci*, a fortunate transition because his palette and technique were enriched without too abrupt a break with the spontaneity of his earlier work. In spite of superficial resemblances there is a fundamental difference between the approaches of Zuccarelli and Wilson, and a more congenial painter must have been Marco Ricci, a favourite of Consul Smith, from whom borrowings have been detected.[2] In his first years at Rome Wilson was at his most receptive. A carry-over from Venice shows that the habit of harking back to scenes and artists that had impressed him in the past was beginning to form. He painted a *Landscape with Banditti: Murder* (1752) in the romantic vein of Salvator Rosa modified by the influence of Ricci, while two Roman history paintings in a landscape setting are indebted to Nicolas Poussin.[3] In other works of his Italian years he adapted poses from Pompeo Batoni and classical marbles, and enveloped his figures with an atmospheric haze reminiscent of Correggio's nudes *nel bosco*. *A Lake and Villa* (1752) depicting the Villa Medici in imaginary surroundings is one of a group of paintings announcing a lifelong devotion to Claude.[4]

[1] E. K. Waterhouse in *Burl. Mag.*, Aug. 1949, 230, quotes from a note by Sir Richard Colt Hoare recording the gift of *A River and Farmhouse*, now in the Victoria and Albert Museum, to Zuccarelli, from whose estate he bought the picture. Edward Edwards, *Anecdotes of Painters*, 1808, mentions a 'small landscape' painted at Venice and seen by Zuccarelli, who advised him to pursue landscape painting. Cf. the important article by M. Levey, 'Wilson and Zucarelli at Venice', *Burl. Mag.*, Apr. 1959, 139–43.

The authorities for the encouragement by Vernet are Wilson's pupils Hodges and Farington, cited by Constable, op. cit. 28.

[2] Brinsley Ford, in 'Richard Wilson in Rome, I. The Wicklow Wilsons', *Burl. Mag.*, May 1951, 162 n., has noted motives taken from a Marco Ricci in the collection of Consul Smith, later acquired by George III.

[3] Constable, op. cit. 80, and Brinsley Ford, op. cit. 165.

[4] Brinsley Ford, 'Richard Wilson in Rome, II. Paintings from Various Sources', *Burl. Mag.*, Nov. 1952.

'Wilson at his best', writes Lord Clark, 'understood the two chief lessons of Claude, that the centre of a landscape is an area of light and that everything must be subordinated to a single mood.'[1] W. G. Constable has listed the main compositional correspondences with the seventeenth-century master: the parallel recession of frontal planes; the trees in silhouette-like side-wings, not flat, as Roger Fry complained, but in mass, one side weightier than the other; the combination of architectural forms with trees, and the isolation of a building between the further mass and the edge of the picture; and the hazy atmosphere through which shines the nostalgic light of the afternoon sun, more muted in Wilson than in Claude.[2] What Wilson brought of his own to these Claudian prescriptions was a keen eye for topographical character, so that even the ideal looks particular, the glow that he admired in his favourite Dutch masters, and an imagination steeped in those aspects of classical history and literature which appealed either to his love of the sublime or his taste for the civilized. In the words of Beechey:

I was for a long-time on the most intimate terms with Wilson and I once asked him whom he considered the best landscape painter. 'Why Sir,' said he, 'Claude for air and Gaspar for composition and sentiment; you may walk in Claude's pictures and count the miles. But there are two painters whose merit the world does not yet know, who will not fail hereafter to be highly valued, Cuyp and Mompers.'[3]

It is not known which of the three Momperses working in Rome in the seventeenth century he meant, and the conjunction with Cuyp is the only precise clue to his meaning.[4] One difference between his emulation of Claude and that by Turner later reveals the distinctive nature of his approach. He seldom took the baroque licence of making his forms, especially trees, look fantastically large, a licence which Turner carried to the extreme of bravura.

[1] *Landscape into Art*, 1949, 70.

[2] *Wilson*, 81. Constable's reservation about Fry's criticism in *British Painting*, 1934, 46, can be strengthened. Wilson distinguished between trees, and the silhouette forms described by Fry are frequently pines.

[3] Cited by Whitley, *Artists and their Friends*, I. 380.

[4] Constable, op. cit. 84.

I

In his paintings of Roman antiquity Wilson created a Horatian landscape to take its place beside Claude's Vergilian one.

The crucial episode of Wilson's career was the bid for fame he made three years after his return at the first exhibition of the Society of Artists in 1760. *The Destruction of the Daughters of Niobe* [plate 64B], illustrating the version of the story in Ovid's *Metamorphoses*, may not have been painted under the influence of Edmund Burke's *Philosophical Enquiry into the Sublime and Beautiful* (1757), but the coincidence is too remarkable to be passed by. Burke's theory of the sublime is based on the principles of infinity, vastness, power, magnificence, and obscurity. It was on this high ground that Wilson made the most sustained and concentrated effort of his lifetime. Three of the versions have been at some time or other claimed for his years in Italy, before Burke's essay appeared, and there is other evidence that during the same period he was nursing ambitions to excel in heroic *terribilità* and pathos, completely outside Claude's emotional range and different in intention from the romantic wildness of Salvator Rosa's bandit paintings.

The effort was not without recompense, for he found buyers for most of the versions, among them the Duke of Cumberland.[1] But the bid for fame was less successful. Somewhat surprisingly in the context of a posthumous tribute, Reynolds made particularly damning criticisms of the version exhibited in 1760. 'A little Apollo, who appears in the sky, with his bent bow' kneels on clouds which do not have 'the appearance of being able to support him'. Moreover, these clouds have neither the substance nor the form fit for the receptacle of a human figure and lack 'that romantick character which is appropriate to such a subject'.[2] The destroyed National Gallery version might almost have been painted to meet Reynolds's objections, and raises the

[1] The history of the versions is given in Constable, op. cit. 160–3, and in his article 'Richard Wilson: a second Addendum', *Burl. Mag.*, Apr. 1962. The best-known, in the National Gallery, London, was destroyed by enemy action in 1944.

The Mellon version reproduced here was the one bought by the Duke of Cumberland. See Basil Taylor, *Painting in England 1700–1850 from the collection of Mr. and Mrs. Paul Mellon*, Winter Exhibition 1964–5, Royal Academy of Arts, no. 301, 84–5.

[2] *Discourses*, ed. Wark, 255–6.

possibility that the President was defending publicly a position that he had taken privately nearly thirty years earlier. Reynolds disliked controversy, and rarely committed himself to a hostile stand unless he suspected a real threat to the orthodoxy of which he was champion, e.g. his initial objections to West's *Death of Wolfe* and Gilpin's theory of the picturesque. Whether or not his ridicule of the *Niobe* was a late verdict or a confirmation of an earlier one, it must have been based on strong feeling to warrant its discordant inclusion among only three substantial references he made to deceased contemporaries in his *Discourses*, the other two being the tributes to Hogarth and Gainsborough. In any case it was the dramatic vein of Wilson, not the Claudian one, to which he objected.[1] The adverse judgement is wholly consistent with Reynolds's immediate reactions against any attempt to trespass on the sacred ground of *istoria* without the authority of a precedent in antiquity or an approved Old Master, in the case of landscape Poussin.

Today the beautiful painting in the Mellon Collection stands out as one of the masterpieces of the century in which a classical theme is treated romantically. Nevertheless, it cannot be rated as highly as the destroyed National Gallery version, where the revisions were all on the side of classicism. The Niobid figures were rearranged logically as they would appear on one side of a Greek pediment, and the foliage was reduced to allow for a balance between the masses of cloud and mountain.[2] The correspondence with Burke's theory of the sublime was stricter. It was the grandest and most elevated of all Wilson's landscapes, and constitutes his chief claim to have raised the category to the level of *istoria*. His other attempts to scale the sublime were less disciplined and indeed verge on the rhetorical. *Ceyx and Alcyone* (c. 1768) is a shipwreck scene and like the earlier paintings of Vernet and the later ones of De Loutherbourg illustrates a stage

[1] The strictures of Reynolds apply better to the Mellon and the Ellesmere versions, the former of which was engraved by William Woollett in 1761, than to the destroyed National Gallery one, which on other grounds as well I am inclined to place as the last and finest of the group.

[2] For Wilson's drawings from the Niobid group see Brinsley Ford, *The Drawings of Richard Wilson*, 1951, 27 ff.

in the elevation of the shipwreck to a romantic symbol of man at the mercy of the violence of nature. *The Murder* (1752) in the National Gallery of Wales is closer to Salvator Rosa than Vernet, and could pass muster as a scene of Gothick romance [plate 64A].[1]

It was as the English Claude, not as the painter of heroic disaster in a mountainous landscape, that he became famous, and the incomparable collections of Brinsley Ford and at Holkham show how poetically he could render the ambience of light and atmospheric haze he so much admired in the master. The *Temple of Minerva Medici*, Rome (after 1754), in the Brinsley Ford Collection heralds both the austerity of his later classic compositions and the 'glow of light learned from the Dutch as well as from Claude' [plate 65].[2] The lessons learned in Italy were no less happily applied to topographical scenes. Sometimes Claudian principles are adjusted to the wide panoramic sweep of the Siberechts–Tillemans tradition, as in *Croome Court, Worcestershire* (1758) in the collection of the Earl of Coventry, with its addition of side-wing trees. In *Pembroke Castle and Town* in the National Museum of Wales, Cardiff [plate 66A; 1774] a slice of foreground slides diagonally out of the picture frame, like the river itself. This tilting of the river became an almost obsessive device emphasizing the planar surface of the canvas.

Of especial interest are those topographical landscapes in which he dispensed altogether with devices borrowed from the Claudian formula. The engraving published by William Byrne of the *Cataract of Niagara* in the Wolverhampton Art Gallery bears the inscription 'Richard Wilson pinx[t] From a Drawing taken on the spot by L[t] Pierie of the Rl. Artillery 1768'.[3] Naval and military draughtsmen who had been trained scientifically were averse to invented ornaments of scenery, so that a landscape

[1] Constable, op. cit. 54, cites a statement by William Paulet Carey, *Letter to I. . . A. . . Esq., a Connoisseur in London*, Manchester, 1809, that Wilson 'consulted the broken surface and rich hues of a large decayed cheese, for ideas of form and colour' in painting the comparable *Meleager and Atalanta*, finished before 1771.

[2] Peter and Linda Murray, *A Dictionary of Art and Artists*, Penguin Books, Harmondsworth, 1960, article on Wilson.

[3] Constable, op. cit., plates 126a and 126b.

painting faithful to the source had to be ennobled by other means, here the bold massing of cloud, waterfall, and geological environment. *The Great Bridge over the Taaf, Wales*, known only from the engraving by P. C. Canot (1775), relies wholly on the outline of a massive cliff and the echoing curves of bridge and hills for its striking but unconventional pattern.

The final stage of emancipation from the pictorial conventions of the masters whom he had taken as models may be illustrated by comparing *Snowdon from Llyn Nantlle*, in the Walker Art Gallery, Liverpool, of which versions probably go back to 1766, with the undated but late *Cader Idris* [plate 66B; possibly *c*. 1774] in the National Gallery in London. The first is one of the most abstract of his classical compositions, a skeletal scheme of divided areas in which the colours are broadly applied with such mastery of tonality that the illusion of depth is almost stereoscopic in its intensity. The foreground is beautifully related to the lake and mountain, but artificial. Martin Davies, who made an investigating pilgrimage to the spot, has identified the later mountain scene as a view of the Llyn-y-Cau lake from the slopes of a secondary summit of Cader Idris, Mynydd Moch, and noted that 'the topography is summary and the foreground invented'.[1] The foreground is invented, but not from the repertory of stock devices, for it consists of irregularly strewn boulders on a plateau and is bare of trees. On this viewpoint of romantic wonder Wilson has stopped short of dehumanizing the landscape, like Caspar David Friedrich later, as a symbol of nature's separateness from man. He has introduced the Gray-like images of a solitary artist, a cow, and a herdsman sounding his horn. The mood of contemplation is altogether different from the drama of his essays in the sublime, or the violence of the mountain scene described by Collins:

> Or, if chill blustering winds, or driving rain,
> Prevent my willing feet, be mine the hut
> That, from the mountain's side
> Views wilds, and swelling floods.[2]

[1] National Gallery Catalogue, *The British School*, 1946, 180.
[2] *Ode to Evening*, 1746, lines 33–6.

It is equally distinct from the wildness of Salvator Rosa and *il riposo di Claudio*. Wilson may have sometimes made his English rivers look like the Arno, just as his Welsh lakes can conjure up Lake Nemi. Even here his choice of the mountain scene may have been influenced by a recollection of the crater of Vesuvius. The two real landscapes of Italy and Britain were as intertwined in his imagination as were the painted ones of Claude and the Dutch school. Before nature he freed himself from dependence on his masters, and came closer to the threshold of true romanticism than either Reynolds or Gainsborough.

VIII

THE ROYAL ACADEMY
AND THE
GREAT STYLE

THE idea of a Royal Academy had lain dormant since the failure of Kneller and Thornhill to unite the artists behind their Academies. Hogarth was strongly opposed to its revival. It is therefore not surprising that the initiative should come from outside the body of artists. In 1748 a member of the Society of Dilettanti, Robert Dingley, secured a promise of support from its members for a proposal for a Public Academy, i.e. one that would become Royal in due course.[1] In the following year John Gwynn the architect published *An Essay on Design, including proposals for erecting a Public Academy to be supported by Voluntary Subscription (until a Royal Foundation can be obtained)*, and urged in addition the establishment of Chairs of Fine Arts, including Architecture, at the Universities of Oxford and Cambridge. Also in 1749 a 'Grand Clubb' met at the Bedford Head, Covent Garden, to raise subscriptions for an Academy in London. Its membership of 'persons of quality, nobles and gentlemen' suggests that this was the outcome of the promise given by the Society of Dilettanti. The meeting was inconclusive.[2]

In 1752 an Academy, described as 'an asylum of artistic scamps', was founded in Rome by sixteen British artists under the Directorship of the history painter John Parker, who had contacts with the Society of Dilettanti.[3] With the idea so much alive it was difficult for the St. Martin's Lane Academy to remain inactive. A meeting was called at the Turk's Head Tavern, Green Street,

[1] W. T. Whitley, *Artists and their Friends in England*, I. 157. [2] Loc. cit.
[3] John Fleming, 'Some Roman Cicerones and Artist Dealers', in *The Conn. Year Book*, 1957, 24–7, and E. K. Waterhouse, 'The British Contribution to the Neo-Classical style in Painting', *Proceedings of the British Academy*, XL, 1954, 66.

Soho, on 13 November 1753, to elect twenty-four artists to go into the matter and make recommendations.[1] Paul Sandby in his polemical prints identifies Hogarth as the leader of the opposition both then and later.[2]

In 1755 the sculptor Sir Henry Cheere presented a plan for an Academy to the Society for the Encouragement of Arts, Manufactures, and Commerce, founded the year before.[3] This was eclipsed by *The Plan of an Academy*, including the abstract of a Royal Charter, also published in 1755 by a committee of the twenty-four artists under the Chairmanship of Francis Hayman.[4] Hogarth was believed to be preparing a vigorous pamphlet denouncing the scheme.[5] In 1757 he became Serjeant Painter to the King. Possibly as a bid for his support, Hayman presented a modified scheme at the anniversary dinner of artists (5 November 1759) held in the Court Room of the Foundling Hospital, originally the artistic stronghold of the Hogarth party as much as Burlington House had been that of the Palladians.[6] This was for 'a public receptacle to contain the works of artists for the general advantage and glory of the Nation and satisfaction of foreigners'.[7] This selective meeting was followed by 'The General Meeting of the Artists and of the Committee for Manageing the Public Exhibition, 1760', at the Turk's Head, Gerrard Street, Soho, on 12 November.[8] A committee was chosen by ballot to organize

[1] Whitley, op. cit. I. 157-8.

[2] F. G. Stephens and E. Hawkins, *Catalogue of Prints and Drawings in the British Museum*, Division I, vol. III, part iii, 1877, under the years 1753-5.

The authorities cited below have been valuably supplemented by the researches of Michael Kitson, published in the Introduction to 'Hogarth's *Apology for Painters*' in *Wal. Soc.* XLI, 1968.

[3] Derek Hudson and Kenneth W. Luckhurst, *The Royal Society of Arts 1754–1954*, 1954, 40.

[4] John Pye, *Patronage of British Art*, 1845, 77, also citing Nesbitt's *Essay on the Necessity of a Royal Academy of Arts*, 1755.

[5] See Michael Kitson, 'Hogarth's *Apology for Painters*', *Wal. Soc.* XLI, 1968, 58.

[6] Sidney C. Hutchinson, *The History of the Royal Academy 1768–1968*, 1968, 35.

[7] The *Royal Magazine*, cited by Whitley, op. cit. I. 165.

In the archives of the Foundling Hospital is a paper headed 'Dilettante, Virtuosi, Feast', giving the names of 157 artists and men famous in other walks of life present at the dinner.

[8] 'Papers of The Society of Artists of Great Britain', *Wal. Soc.* VI, 1918, 116.

a public exhibition, the profits to be set aside for the support of artists. Its membership, headed by Reynolds, included the future President, Secretary, Keeper, Treasurer, and Librarian of the Royal Academy, as well as its first Professors of Architecture and Perspective, a striking proof of the professional autonomy of the English institution.

The first public exhibition of contemporary British art open to all 'the Present Artists', as distinct from the Hogarth–Hayman coterie control at Vauxhall Gardens and initially at the Foundling Hospital, was held in the Strand Great Room of the Society of Arts from 21 April to 8 May 1760.[1] Its success was beyond expectation. Free admission attracted uncontrollable crowds; 6,582 sixpenny catalogues were sold.[2] In 1761 the exhibition, now described as 'The Society of Artists of Great Britain', was transferred to the Great Room of Cock the auctioneer in Spring Gardens, because the Society of Arts felt unable to accede to a request that the purchase of catalogues should be a compulsory charge for admission. More than 13,000 copies of the new catalogue, with a frontispiece and tailpiece by Hogarth and an allegorical illustration by Samuel Wale on the first page, were sold for a shilling apiece.[3]

In the same year sixty-five artists, who objected to the decision to use profits from both the 1760 and 1761 exhibitions for 'the advancements of the Arts', i.e. the setting-up of a Public Academy, held a rival exhibition at the Society of Arts.[4] In 1762 this second exhibiting body formed itself into 'A Free Society of Artists', associated for 'Relief of the Distressed and Decayed Brethren, their Widows and Children'.[5] There were now three societies promoting the arts, henceforth referred to by the short titles most frequently used: the Society of Arts (1754), the Society of Artists (first exhibition 1760, adoption of title 1761), and the Free

[1] Pye, *Patronage of British Art*, 92.

[2] 'Account of the Receipt and the Disbursements at the Publick Exhibition April 21st 1760' published in *Wal. Soc.* VI. 119, and for the crowds, ibid. 122.

[3] Pye, op. cit., Chronological Table opposite p. 285.

[4] Pye, loc. cit., and Sidney C. Hutchison, 'The Royal Academy Schools, 1768–1830', *Wal. Soc.* XXXVIII, 1962, 125.

[5] Pye, op. cit. 108.

Society (first exhibition 1761, adoption of title 1762). The promotion of art by premiums and prizes and the exhibition of competitor's work was of course only a part of the activities of the first, which was never an artists' society but typical of the Enlightenment in the width of its aims and the linking of Arts, Manufactures, and Commerce. But by 1847, when it became the Royal Society of Arts, its art awards had totalled about 3,000.[1] After its incorporation by Royal Charter on 26 January 1765, the Society af Artists of Great Britain was often referred to as the Incorporated Society. Another mode of distinction between the Society of Artists of Great Britain and the Free Society of Artists was to specify the place of exhibition, e.g. 'the artists exhibiting in Spring Gardens', for the former.[2]

After 1765 the hopes for a Royal Academy centred on the Society of Artists with its prestige membership. In 1767 George Michael Moser, who as a former drawing master enjoyed the confidence of the King, informed the St. Martin's Lane Academy that George III intended to found an Academy. On the strength of an assurance of certain privileges for its members, it was agreed to remove the stock of casts, anatomical models, and other studio properties to premises in Pall Mall.[3] In 1768 there was a decisive split. Accusations of dictatorial conduct were made against the management by the members, swollen to the inordinate number of more than 200 by 1766.[4] Sixteen of the twenty-four Directors were expelled; the remaining eight, including Moser, Chambers, and West, possibly retained because of their high standing with the King, promptly resigned. At the election on 18 October 1768, the Society was left stranded with Joshua Kirby, the only surviving 'King's man', as President.[5]

At this crisis appeared a strategist of genius who took charge of the situation and moved with astonishing speed. In late November William Chambers was received by the King. A few days

[1] D. Hudson and K. Luckhurst, *The Royal Society of Arts*, 43.

[2] Algernon Graves, *The Society of Artists of Great Britain (1760–91): The Free Society of Artists (1761–1783)*, 1907, invaluably supplements Pye's account by listing the contributors and the titles of their works.

[3] Whitley, I. 234. [4] The names are listed in Pye, op. cit. 118–20.

[5] Whitley, I. 224.

later, on 28 November, he brought a deputation consisting of himself, Moser, Francis Cotes, and Benjamin West, all *personae gratissimae*. The deputation presented a Memorial signed by twenty-two leading artists, including the expelled President of the Society of Artists, Francis Hayman.[1] Chambers's next and most remarkable feat was to draft, apparently in a matter of days, the Instrument establishing 'The Royal Academy of Arts in London', which George III signed on 10 December 1768.[2] Even before that date he found time to secure and play his trump card. The supreme obstacle in the past had been the reluctance of the leading artists to unite under any of the King's Serjeant Painters or Principal Painters, notably Kneller, Thornhill, Hogarth, and Allan Ramsay. Throughout the rows and the early negotiations Reynolds had preserved an Olympian detachment. He now agreed to be President. He was neither Serjeant Painter like 'Athenian' Stuart nor Principal Portrait Painter like Ramsay, but his standing among the body of artists was far higher than that of either. The first General Assembly of the Royal Academy met on 2 January 1769, when he delivered his first Discourse. The twenty-eight Academicians already nominated by the King for the forty vacancies unanimously passed a resolution thanking 'Mr. Chambers for his active and able conduct in planning and forming the Royal Academy'.[3]

The complex origins of the Royal Academy in London explain most of the features that distinguish it from its Continental predecessors. It grew out of a society founded to promote exhibitions, its directors elected by a general assembly of artists. With one or two minor exceptions, these directors were the very men whom the King appointed to the exclusive self-perpetuating body of forty and who became the leading office-bearers. The price paid for autonomy was the relinquishment of any hope of becoming an official machine for the control of state patronage. No Parliament could have surrendered such powers

[1] The Memorial is published in full in Sidney C. Hutchison, 'The Royal Academy Schools, 1768–1830', *Wal. Soc.* XXXVIII, 1962.

[2] The Instrument is published in full in J. E. Hodgson and F. A. Eaton, *The Royal Academy and its Members 1768–1830*, 1905. Appendix I. [3] Ibid. 28.

to a body it did not appoint. In these circumstances the Academy dedicated itself to a single dominant aim, to which all others, including exhibitions and artists' welfare, were subordinated: the training of a national school of history painters.

When George III later referred, as he often did, to 'my Academy' he was not speaking in an autocratic sense. In the vital matter of elections he had no say whatever. When in 1797 Sawrey Gilpin was preferred to the royal favourite, Beechey, the King could only state sarcastically that the latter was not elected 'because He is the best painter'.[1] His initiative was limited to appointing the Treasurer, but his choice was confined to Academicians. The Presidency was specifically exempted from the list of offices subject to his approval or tenable during His Majesty's pleasure. As 'patron, protector and supporter' he undertook to make good any deficiencies in its quarterly budgets from his Privy Purse. If these had been permanent, his power might have been very real. But after the first eleven years, when the deficiencies defrayed by him amounted to the generous sum of £5,116, the Academy was self-supporting, the buildings provided by the State excepted.[2]

In the Memorial drafted by Chambers the two principal objects were defined as 'a well regulated School or Academy of Design' and 'an Annual Exhibition', in that order.[3] The first exhibition promptly held in Old Lambe's Auction Room in Pall Mall on 26 April 1769 was a very small and select showing, only 136 works, and out of 50 professional artists whose work was selected 30 were Academicians.[4] Ten years later the number of exhibitors had grown to the total of 204, of whom only 20 were Royal Academicians. Not the King, not the State, but the Annual Exhibition became the main source of finance, and for this reason the door into it had to be opened wide to the body of artists.

When Pevsner described the 'glamour' brought about by a private body without any official interference from court or

[1] *The Farington Diary*, ed. James Gregg, 1922, I. 213.

[2] Hodgson and Eaton, op. cit. 29.

[3] S. C. Hutchison, *The History of the Royal Academy*, 1968, 43–4, where the Memorial is printed in full.

[4] E. K. Waterhouse, 'The First Royal Academy Exhibition, 1769', *Listener*, 1 June 1950, 944–6.

nobility as 'the most remarkable English contribution to the history of art academies', he identified its most lasting achievement.[1] Its most significant, however, was the success of the Royal Academy Schools in promoting history painting during the first fifty years of its history. Chambers's rules for the conduct of a 'School of Design' were ready for submission and approval at the first General Assembly held on 2 January 1769.[2] They were modelled on Colbert's revised rules of 1663, the principal difference being that entry was not through the studio of an Academician, but by interview and examination. Instruction was to be given in turn by nine Visitors, chosen from the Members. The key figure in charge of students was the Keeper, a post for which Moser was the natural choice as Manager and Treasurer of the St. Martin's Lane Academy, already dedicated to the training of history painters. In his obituary notice of 1783 Reynolds described Moser as 'in every sense the father of the present race of artists'.[3] Next in importance came the Librarian, whose guidance and criticism were so vital to students engaged in rendering subjects from the Bible, classical mythology, history, and heroic literature.

The professors were expected to provide a background of theory for the future history painters. Their sole duty laid down in the Instrument was to deliver annually six lectures for an honorarium of thirty pounds. Because the text had to be submitted to the Council, and the audience included distinguished visitors, they were carefully composed, generally with an eye to publication. Barry, Fuseli, Opie, Flaxman, Westmacott, and Soane took particular pains, although the lectures of the last were not published until 1929. The outstanding figure was Fuseli, the leading theoretical exponent of neo-classicism in England, but the credit of being the first to begin with a historical survey belongs to Barry, whose opening lecture in 1784 was on 'the History and Progress of Art', an example followed by Fuseli, West, Flaxman, and Soane. This group, all of whom had made the Grand Tour and were

[1] *Academies of Art Past and Present*, 1940, 186-7.

[2] The details for the conduct of the Schools are given by Sidney C. Hutchison in *Wal. Soc.* XXXVIII, 1962, 128-9. For Colbert's revised constitution of 1663 see Pevsner, *Academies of Art*, 89-92.

[3] Hodgson and Eaton, op. cit. 51.

familiar with the ideas of Winckelmann, pioneered art history as an academic subject in England.[1] John Constable, who had not made the Grand Tour but as a student and Member attended Academy lectures, showed a creditable grasp of art history in his lectures on landscape painting delivered at the Hampstead Assembly Rooms, the Royal Institution of Great Britain, and at Worcester between 1833 and 1836.

In addition to the artist Professors of Painting, Architecture, Perspective, and Sculpture (the last added in 1810), William Hunter, the distinguished brother of the famous John, was appointed Professor of Anatomy in 1768, and two years later Samuel Johnson and Oliver Goldsmith, Professors of Ancient Literature and Ancient History respectively, the latter post being held by Edward Gibbon from 1787 to 1794. The last two offices were honorary, but the holders must surely have been consulted on the formation of the Library, which with its rich collection of illustrated works may well have meant more to students like Blake than the teachers.

Primus inter pares in this society of humanists stood Reynolds, who as President preferred the gown of the scholar to the toga of the committee-man. His deepest convictions were involved in the theory and history of art, and he quickly revealed himself as the Professor *par excellence* if not by title. The *Discourses* delivered *ex cathedra* to the General Assembly from 2 January 1769 to his last appearance at the distribution of prizes on 10 December 1790 embodied a doctrine and outlined a programme which rank as the classic statement of academic ideals in Europe after three centuries of debate. Their conciliar formulation and openness to new ideas mark a watershed in the history of academic art theory.

Before the death of George III the Royal Academy Schools had admitted among their students Rowlandson, Hoppner, Blake, Lawrence, Turner, Haydon, Constable, Wilkie, Etty, and Landseer in painting; Gandon, Smirke, and Soane in architecture; and

[1] See *Lectures on Painting by the Royal Academicians: Barry, Opie and Fuseli*, ed. Ralph N. Wornum, 1848. The lectures of West and Constable are abstracted in their respective lives by John Galt and C. R. Leslie.

Bacon, Banks, and Flaxman in sculpture.[1] All were firmly grounded in the great style, even Rowlandson making his début with a Bible picture. Among the painters the imaginations of Blake and Turner in particular were haunted all their lives by themes from *istoria*. The architects and sculptors similarly sought to distinguish themselves in elevated commissions for State and Church.

The revival of history painting dates from the outbreak of patriotic fervour which followed the accession of George III in 1760. It was distinguished from the last flowering under Thornhill by the vital legacy inherited from Hogarth and Hayman at Vauxhall and the Foundling Hospital, namely, the widening of the scope of *istoria* to include themes from Shakespeare and national history. Already before the death of George II the Society of Arts had announced its intention of awarding a premium of a hundred guineas for 'the best historical picture painted in oil colours, the figures to be as large as life, and the subject to be taken from the English history'. The award went to Robert Edge Pine for *The Surrender of Calais to Edward III*, and the second premium to the Chevalier Andrea Casali for *The Story of Gunhilda*.[2] Almost all types of artists attempted to shine in the category as soon as the exhibiting societies gave them an opportunity to do so. In 1761 Charles Grignion published an engraving after a design of Hayman depicting *Caractacus before the Emperor Claudius*, a theme combining the attractions of the most remote national past with those of Roman antiquity. In the same year Alexander Cozens exhibited *An historical landscape representing the retirement of Timoleon* and Francis Towne *A large landscape, with a scene in Shakespeare's Cymbeline* at the Free Society.[3] In 1769 Sawrey Gilpin showed *Darius obtaining the Persian empire by the neighing of his horse*, a sketch, at the Society of Artists. Figure painters, especially those who either taught or had been trained in the St. Martin's Lane Academy, naturally outnumbered

[1] The full list of students and dates of enrolment up to 1830 are given by Sidney C. Hutchison in *Wal. Soc.* XXXVIII, 1962.

[2] Edward Edwards, *Anecdotes of Painters*, 171, 23.

[3] Towne's *Macbeth and the Witches*, in the collection of T. S. R. Boase is illustrated and discussed in W. Moelwyn Merchant, *Shakespeare and the Artist*, 1959, 86–7 and plate 36a.

the engravers, landscape painters, water-colour artists, and animal painters who showed heroic themes at the Society of Artists and Free Society. The Bible and classical mythology remained stock sources, but national history and subjects from classical history bearing on national aspirations became immensely popular. In national literature the writers most frequently illustrated were Shakespeare, Milton, and Spenser; in Continental literature Cervantes was an early favourite, Dante a later one. There is a marked tendency to pathos, the theme of the dying hero being taken up by artist after artist, sculptors as well as painters.

The stage was almost ideally set for the Anglo-Romans, a group of British neo-classical artists who resided in Rome or during their stay came under the influence of the new archaeological discoveries.[1] Nathaniel Dance was the first to send a picture for exhibition while still in Rome. Its exceptionally long title in the Society of Artists catalogue for 1761 appealed to the values of liberty, morality, and patriotism, heightened by pathos: '"An Historical Picture"; the death of Virginia by the hand of her father, to prevent her falling prey to the lust of Appius, one of the Roman patricians and chief of the decemvirs, which occasioned the dissolution of the Decemvirate, and produced the second revolution, whereby the citizens of Rome received their liberty.' A year later Gavin Hamilton followed suit sending *Andromache weeping over the body of Hector*. In 1766 the Free Society scored a signal success over its rival by securing entries from Anton Raphael Mengs, 'Principal Painter to the King of Spain', and the already celebrated female prodigy Angelica Kauffmann. Meanwhile the American Benjamin West, on whom the leadership of the movement in England devolved, had arrived in person in

[1] The term has been widely accepted since the appearance of Hugh Honour's articles, 'Antonio Canova and the Anglo-Romans', in *Conn.*, May, June, and Dec. 1959. Since 1950 there has been a marked increase in the number of periodical articles embodying research into this seminal group, notably by E. K. Waterhouse, Margaret Whinney, David Irwin, F. J. B. Watson, A. M. Clark, Basil Skinner, Brinsley Ford, John Fleming, Robert Rosenblum, and Dora Wiebenson. An important group of articles was published in the special neo-classical number of *Apollo*, Nov. 1963.

It should be borne in mind that most of the key figures were not English, but Scottish or American, thus justifying Robert Rosenblum's avoidance of the term in *Transformations in Late Eighteenth Century Art*, Princeton University Press, N.J., 1967.

1763 and a year later exhibited at the Society of Artists *Angelica and Medoro, an historical picture*, and its companion *Cymon and Iphigenia*.

The origins of the neo-classical contour style in painting have been ascribed to the influence of the Greek vase.[1] More probably it was an autonomous growth fostered or favoured by the study of ancient art not in originals but in engravings from Montfaucon onwards, for the emergence of the style can be noted before the vase publications that undoubtedly shaped its evolution. The rise of archaeology and the immense accession of new materials created a fresh wave of enthusiasm for classical studies, which now had the excitement of novelty as the results of the excavations in Asia Minor became known. In 1758, the year in which John Parker showed Lord Charlemont a series of paintings which illustrated a predominantly Greek neo-classical programme, Gavin Hamilton (1723–98) painted on commission the great manifesto picture of English neo-classicism, *Dawkins and Wood discovering the Ruins of Palmyra*, engraved by John Hall in 1773 [plate 68A].[2] It commemorates the climactic moment of an archaeological expedition. The discoverers are dressed in togas and nobly gesticulate in strict frieze profile against a Rubenesque background of turbaned Arab horsemen, a camel-rider, and an exotic palm. The Arabs on their mounts in the wings invade the picture space in depth, as in a baroque painting, but the central rider is posed like the archaeologists in classic profile, although his head is turned frontally to look down upon the leaders. The forms are noble, large, and simplified; each figure is clearly isolated in silhouette where it is visible; and the style is harmoniously linear throughout. The plane of the frieze is dominant. The vacant or relieving intervals of space are clearly shaped. The two remotenesses of time (antiquity) and place (Asia Minor) are united. The heroes are shown as Romans with a retinue of Arabs and a Negro page. Just as Reynolds's *Omai* [Frontispiece] wears robe and turban, so Wood and Dawkins wear toga and Arab boots.

[1] Walter Friedlander, 'Notes on the Art of William Blake: A Romantic Mystic Completely Exhibited', *Art News*, 18 Feb. 1939, 9.

[2] E. K. Waterhouse, 'The British Contribution to Neo-Classical Style in Painting', *Proceedings of the British Academy*, XL, 1954, 67–8.

As early as 1760 James Grant of Grant, later 8th Baronet, had commissioned Hamilton to paint a large history piece from the *Iliad*, *Achilles lamenting over the death of Patroclus* (Society of Artists, 1765).[1] The great cycle of *Iliad* paintings was engraved by Domenico Cunego between 1764 and 1775.[2] The paintings figure in the correspondence of Mariette and Winckelmann, who found in the *Andromache* 'that calm which the Ancients sought', and in contemporary anecdotes about Canova.[3] Waterhouse has established the priority of Hamilton over Mengs, whose conversion to neo-classicism by Winckelmann did not bear fruit before the *Parnassus* (1761) in the Villa Albani and was in any case short-lived.

A French historian has paid a generous tribute to the pioneer achievement of the Anglo-Romans:

The choice of subjects, by itself, proves that Hamilton and West are the precursors and initiators . . . But it is by the general conceptions of the works, by the disposition of the figures *en bas relief*, by the calm and clear ordonnance of the groups and cortèges, by the grave rhythm of movements and of draperies, the effort towards the exact reproduction of the furniture and costume of the Greeks and Romans, by the evocation of the forms of antique sculpture, by the laconic energy of expression, of which Poussin had found the secret, that the English school affirms, at this moment, its superiority.[4]

The opinion of Locquin has been supported by recent writers, and it has been noted that Hamilton was Canova's mentor at the

[1] See Basil Skinner, 'A Note on Four British Artists in Rome', *Burl. Mag.*, July 1957, and David Irwin, 'Gavin Hamilton: Archaeologist, Painter and Dealer', *Art Bulletin*, June 1962, for documentation of Hamilton's paintings and their dates, and especially the account of Hamilton by the latter in *English Neoclassical Art*, 1966.

[2] For the Cunego engravings and Hamilton's indebtedness to Poussin see Dora Wiebenson, 'Subjects from Homer's Iliad in Neoclassical Art', *Art Bulletin*, Mar. 1964.

[3] See Waterhouse, op. cit. 69, citing Carl Justi, *Winckelmann und seine Zeitgenossen*, Leipzig, 1898, II. 312, and for Canova's admiration Hugh Honour in *Conn.*, June 1959, citing Quatremère de Quincy, *Canova et ses ouvrages*, Paris, 1834, and Antonio D'Este, *Memorie di Antonio Canova*, Florence, 1864.

[4] Jean Locquin, 'La part de l'influence anglaise dans l'orientation néo-classique de la peinture française entre 1750 et 1780', *Actes du Congrès d'histoire de l'art*, 1921, II. 391–402. The translation is by Fiske Kimball, 'Benjamin West, 1738–1820', *Pennsylvania Museum of Art Bulletin*, 1938, 10.

decisive moment of his turn to Greece.[1] He also helped to form the Anglo-American School of History Painters founded by Benjamin West. His style is therefore of some importance. What chiefly distinguishes it from the classicism of Poussin is the inflation of the figures, carried later to inordinate, ultra-Michelangelesque lengths by the megalomaniac Barry. There was also the novelty of his attempt, however inept in modern eyes, to differentiate between the furniture and costume of the Greeks and Romans in the light of the new archaeological evidence.

Benjamin West (1738–1820), the second in importance of the group, arrived in Rome on 10 July 1760.[2] The handsome Pennsylvanian, brought up 'among the wigwams of the Indians', was made much of by the blind Cardinal Albani, even after he discovered that his skin was white. West's startled exclamation before the *Apollo Belvedere*, 'My God, how like it is to a young Mohawk warrior!', at first displeased the Italians, until he defended it by describing the character and activities of young Mohawks, their dexterity with bow and arrow, elasticity of limb, and expanded chests, whereupon it was allowed that 'a better criticism had rarely been passed on the merits of the statue'.[3] With his exotic background he was cut out to become a neo-classical hero, bringing the insights of the New World with its noble savages to the study of the Ancients.

In England he was fussed over by liberal Bishops who admired his Quaker simplicity.[4] In 1767 came the momentous introduction to George III by Archbishop Drummond of York, when the

[1] See Waterhouse, op. cit. 71, for a comparison between Hamilton and David, and Robert Rosenblum, 'Gavin Hamilton's *Brutus* and its Aftermath', *Burl. Mag.*, Jan. 1961. For Canova and Hamilton see Hugh Honour in *Conn.*, June 1959.

The more general relationships between the Anglo-Romans and the French are ably discussed in David Irwin, *English Neoclassical Art: Studies in Inspiration and Taste*, 1966, part VII, 'The Contemporary Scene'.

[2] Grose Evans, *Benjamin West and the Taste of his Times*, Carbondale, S. Illinois, 1959, is the best source of illustration, and has a good bibliography. Lewis Einstein, *Divided Loyalties*, London, 1933, gives an excellent account of his life.

[3] John Galt, *Life, Studies and Works of Benjamin West*, 2 vols., London 1820, I. 103–4.

[4] West undoubtedly came from a Quaker background, but for his parents' lack of standing in the Pennsylvanian community see Henry Hart, 'Benjamin West's Family', *Pennsylvania Magazine*, XXXIII. 2–3

King on the spot suggested the subject of 'the final departure of Regulus for Rome' and commissioned him to paint it [plate 68B; R.A. 1769].[1] Its success prompted further commissions, culminating in the project to decorate 'His Majesty's Chapel at Windsor' with a vast cycle illustrating the Progress of Revelation. The King originally intended to build a 'New Chapel' in Horn's Court of Windsor Castle, some ninety feet long by fifty wide, as a suitable receptacle, but subsequently preferred a scheme for a structural remodelling of St. George's Chapel by Wyatt.[2] In the event West's vision of conferring Vatican splendours on Windsor Castle was never realized by reason of the King's ill health and the hostility of the architect. The first specimen was exhibited at the R.A. in 1781. Thereafter the public was reminded of the progress of the cycle by sketches and oil paintings shown almost every year. From 1780 West was paid a yearly salary of £1,000 for this commission alone, although he executed paintings for the Audience Chamber, the Queen's Boudoir, etc., at Windsor as well.[3] St. Paul's Cathedral heads the long list of cathedrals and churches for which he simultaneously took commissions. The range of other institutions which received his history paintings extended from a Hospital and University in England to a Hospital and Academy in Philadelphia. The first of the series painted for William Beckford at Fonthill Abbey was exhibited in 1778. Although the culmination of these projects and the singular fatality that overtook most of them belong to a later period, his leadership of the revival of history painting is undisputed, and helped to secure his election as President of the Royal Academy after Reynolds's death in 1792.

The first neo-classical paintings exhibited by West were Poussin miniatures, in which the figures were reduced to the scale of a conversation piece.[4] This cabinet-size version of the

[1] In the West correspondence in the Pennsylvania Historical Society there is a draft of a letter by West to George III giving this date.

[2] W. H. St. John Hope, *Architectural History of Windsor Castle*, 1913, and for Wyatt's opposition to West, Farington, *Diary*, II. 243.

[3] West's payments, however, averaged £1,500 per annum from 1780 till 1801, see Pye, *Patronage of British Art*, 230.

[4] Cf. Horace Walpole, letter to Sir Horace Mann, 6 May 1770: 'One West, who

great style pleased the monarch, who found in West and Zuccarelli his favourite painters for epic and pastoral. In the *Regulus* West alluded gracefully by his borrowings to masterpieces in English collections, the Bridgwater Poussins and the Hampton Court cartoons by Raphael, a source on which he drew also for *Penn's Treaty with the Indians* (R.A. 1772), in which the general grouping and kneeling figure were adapted from *Feed my Sheep*.

Towards the close of West's life the American poet Joel Barlow wrote to a friend that his famous countryman had promised 'to give me an account about himself and the revolution that has been brought about in the whole of the art within the last thirty years by his having broke thro' the ancient shackles and modernised the art'.[1] Neo-classical artists were prone to proclaim themselves revolutionaries, witness the Preface to the *Works* of Robert and James Adam. The revolutionary claim of West, which has the authoritative endorsement of Reynolds, was based on a single picture, *The Death of Wolfe* [plate 70A] exhibited at the Royal Academy in 1771.[2] After the hero's death on the Plains of Abraham on 13 September 1759 had been reported in England, artists vied with one another in commemorating the event. At the very first exhibition of the Society of Artists in 1760 the sculptor Agostino Carlini submitted *A Design for General Wolfe's Monument, near Buckingham Gate*. George Romney, who like so many others at the time was attracted to death scenes, entered his *Death of Wolfe* in 1763 for the premium of one hundred guineas awarded by the Society of Arts for British history painting. Edward Edwards later dismissed it as 'a coat and waistcoat' piece.[3]

paints history in the taste of Poussin, gets three hundred pounds for a piece not too large to hang over a chimney.'

[1] Quoted by Yvon Bizardel, *American Painters in Paris*, New York, 1960, 77.

[2] There is an extensive literature on this famous painting. The major study is E. Wind, 'The Revolution of History Painting', in *J.W.C.I.* II, 1938–9, and its follow-up by Charles Mitchell, 'Benjamin West's Death of Wolfe and the popular history piece', ibid., Jan.–June 1944. See also Fiske Kimball, 'Benjamin West au Salon de 1802', *Gazette des Beaux-Arts*, 6th Ser. VII. 1932, 403–10.

[3] *Anecdotes of Painters*, 277. According to William Hayley's *Life of George Romney Esq.*, 1809, the picture was sent to India, but Edwards's description of its realism is confirmed by Richard Cumberland, 'Memoirs of Mr. George Romney', *European Magazine*, June 1803.

In 1764 Edward Penny followed suit with his version in contemporary costume at the Society of Artists. A reviewer in the *Gentleman's Magazine* for May 1764 described it as the best of the 'conversations'.[1]

A coat-and-waistcoat piece, a conversation—these terms have connotations of style as well as contemporary realism. If Wolfe had been shown in the nude with allegorical figures in classical garb, then the great style would have been *de rigueur*. If a battle was depicted as a documentary, as was the norm, then the style must be realist too. West's picture was unmistakably in the great style hitherto reserved for *istoria*, that is, an ideal world. The main source in Bible painting was the Mourning of Christ, the closest parallel being with Van Dyck's *Deposition* in Munich, available to him in engravings.[2] The Red Indian 'philosophically watching how an Englishman dies' is modelled on a familiar type of seated figure of Mourning on funerary monuments.[3] But the same attitude, the face resting on the right hand, also appears in *Et in Arcadia Ego* paintings. This figure alone is detached from the Christian mourners, who thereby number twelve. But Necha, Chief of the Cherokees, is not an Arcadian shepherd contemplating the inscription of a sarcophagus from a vanished culture. Instead he is the child of nature, brooding on the death of a modern hero in a struggle between two rival powers for the possession of his ancient land.[4]

The success was without precedent. Crowds came to the Academy to see a single picture. Garrick re-enacted the scene on the floor immediately in front of it, characteristically to improve

[1] Penny's painting is reproduced in Mitchell, op. cit., plate 53a. Its contemporary description as a conversation supports the argument of E. Wind, 'Penny, West and the Death of Wolfe', in *J.W.C.I.* X, 1947, that it was not a true precursor of West's heroic painting in the great style.

[2] See Mitchell, op. cit. plate 54c.

[3] e.g. Roubiliac's Owen Monument in Andover Church, near Shrewsbury, 1746, illustrated in K. Esdaile, *Roubiliac*, plate XV.

[4] One of West's mistakes was to show the Chief without his moccasins, for the Cherokees never fought barefoot. See the article on the *Death of Wolfe* and its versions in the *William L. Clement's Library Bulletin*, Ann Arbor, Mich., no. 17, 1828, and J. C. Webster, 'The Pictures of the Death of Major-General James Wolfe', *Journal of the Society of Army Historical Research*, VI, 1927.

on West by choosing the moment of rapture when the dying general heard the cry 'They run, they run!'[1] By 1790 Boydel was able to announce that the profits from the print had reached £15,000. When in 1799 David stated that the picture of the Deaths of General Wolfe and Lord Chatham by West and Copley had earned immense sums, he paid tribute to the American painters for opening up a new era of exhibitions, in which artists would be given the means of independent existence and self-support, and the enjoyment of the noble independence proper to genius.[2]

Among those who noted the acclaim given to a work which challenged the central academic doctrine that the ideal style must never be contaminated by contemporary realism was the classically educated Irishman James Barry (1741–1806), whose studies in Italy 1766–71 had been generously subsidized by his patron Edmund Burke.[3] Barry was the first of the Anglo-Romans in whom megalomaniac and eccentric tendencies unmistakably appear. Gavin Hamilton's paintings at first gave him infinite satisfaction, but he quickly discovered that all the Anglo-Romans were out of step except himself. Elected R.A. in 1773 and Professor of Painting in 1782, he was expelled in 1799 for outrageous attacks on his fellow Members in general and his former benefactor Reynolds in particular. In a late portrait as his own monument to posterity he showed himself against a statue of Hercules crushing the snake of Envy, together with accessories that identified him as Timanthes, the Longinus of ancient painting.[4] At the R.A. exhibition of 1771 he was mortified to find that West's *Death of*

[1] W. T. Whitley, I. 282. For the influence of Le Brun's *Passions* on West and his contemporaries see C. Mitchell, loc. cit., and F. Cummings, 'Charles Bell and the Anatomy of Expression', *Art Bull.*, June 1964.

[2] See Elizabeth G. Holt, *From the Classicists to the Impressionists: A Documentary History*, New York, 1966, 5. David mistakenly attributed the Chatham to West.

[3] The best account is the chapter 'James Barry and *True Taste*' in David Irwin, *English Neoclassical Art*, 1957, with full bibliographical references. See also R. R. Wark, 'James Barry', Ph.D. Thesis, Harvard, 1952.

[4] The description of Timanthes as the Longinus of painting in George Turnbull's *Treastise on Ancient Painting*, 1740, is the key to the picture. For the other classical allusions see R. Wark, 'The Iconography and Date of James Barry's Self-Portrait in Dublin', *Burl. Mag.*, Aug. 1954.

Wolfe distracted attention from his own *Temptation of Adam*, in which both Adam and Eve are shown in Herculean proportions.[1]

By the autumn of 1773 he was in collaboration with Reynolds over a project to complete Thornhill's decoration of St. Paul's with paintings presented by a largely Anglo-Roman team which was to include West, Nathaniel Dance, Angelica Kauffmann, and Cipriani, and a petition was presented to the King.[2] 'While I live and have the power,' wrote the Bishop of London, Dr. Terrick, on receiving the application of the Dean and Chapter of St. Paul's, 'I will never suffer the doors of the Metropolitan Church to be opened for the introduction of Popery.'[3] In 1774 the Society of Arts, prosecuting its policy of promoting history painting, supported a proposal that the disappointed artists should be joined by Romney, Wright, Mortimer, and Edward Penny, in order to provide a cycle of pictures for the Great Hall in their new building by Adam in the Adelphi.[4] The scheme fell through, whereupon Barry undertook to decorate the room single-handed and without payment. His terms were the right to appropriate the profits from public exhibition of the work when completed, which he did in 1783 and 1784. Barry later made much of his poverty, with some justification but also some exaggeration, for the proceeds, together with the sale of prints and an *ex gratia* payment voted by the Society, brought him a frugal independence which enabled him to paint *istoria* for the rest of his life in cantankerous isolation.

The Progress of Human Culture (1777–83) is an Enlightenment counterpart to West's orthodox *Progress of Revelation*, begun slightly later. Its ameliorist programme was designed to 'illustrate one great maxim or moral truth, viz., the obtaining of happiness as well individual or public, depends upon cultivating the human

[1] He later tried to eclipse West by painting the death of Wolfe in 1776. See David Irwin, *English Neo-Classical Painting*, plate 145, and his article 'James Barry and the Death of Wolfe', *Art Bull.* XLI, 1959, 330–2. [2] W. T. Whitley, I. 293.

[3] Cited by Lady Victoria Manners, 'Fresh Light on Nathaniel Dance, R.A.', *Conn.*, Jan. 1923, 24. Cf. *The Works of James Barry . . . containing his correspondence . . . his lectures . . .*, ed. E. Fryer, 2 vols., 1809, I. 408.

[4] Edward Edwards, *Anecdotes of Painters*, 299, and Hudson and Luckhurst, *The Royal Society of Arts*, 22.

faculties'.[1] The story of Human Culture opens with an attack on the notion of the noble savage, namely, *Orpheus reclaiming Mankind from a Savage State*, followed by *The Grecian Harvest Home*, or *Thanksgiving to Ceres and Bacchus*, a celebration of agriculture and the useful arts. The cycle of antiquity concludes with *The Victors of Olympus*, the modern opens with *Navigation, or the Triumph of the Thames* [plate 69B], that is, the expansion and sharing of benefits under the new Olympians, the British. Among the Tritons and Nereids swim Sebastian Cabot, Raleigh, Drake, 'the late Captain Cook of amiable memory', and Barry's friend the musical historian Dr. Charles Burney. 'It irks one', wrote an indignant dowager, 'to see my good friend Dr. Burney paddling in a horse-pond with a bevy of naked wenches.'[2] In the background rises an enormous Pharos supported by a giant, his hands alone larger than the ship below, an early example of the megalomaniac visionary architecture so characteristic of neo-classicism, especially in France. The second picture of the modern cycle is *The Distribution of Premiums by the Society of Arts*, illustrating the new School of Athens, a concourse of contemporary British patrons discovering or rewarding talent with the grave approval of Dr. Johnson. For the final picture he turned for his thematic model from Raphael's *Stanza della segnatura* to Michelangelo's *Last Judgement*. *Elysium and Tartarus, or the State of Final Retribution* assembles in a vast iconography philosophers, mathematicians, and scientists from Thales and Archimedes to Locke and Harvey; lawgivers from Moses to William Penn; theologians from Origen to Bishop Butler; poets from Homer to Oliver Goldsmith; artists from Apelles to Romney; and patrons of art from the monk Cassiodorus to the noble Earl of Arundel. Brutus leans on Sir Thomas More, and Alfred the Great on William Penn showing his code to Lycurgus.

One of the best of Horace Walpole's many excellent remarks about Barry was that 'if the House of Commons thought fit to

[1] *Account of a Series of Pictures in the Great Room of the Society of Arts*, 1783, reprinted in Barry, *Works*, II. 301 ff.

[2] Cited by T. Bodkin, 'James Barry', *Journal of the Royal Society of Arts*, 13 Dec. 1940, 44.

vote that Mr. Barry shall decorate Westminster Hall with giants, he should be the last to oppose the motion'.[1] Barry would have handled a Gigantomachy in the Mother of Parliaments splendidly. The Adelphi cycle is another matter. He lacked the artistic sensibility to sustain his soaring ambition over so vast a range, like Haydon later, but less disastrously. He lacked too the mystic fervour of Blake, whose own epic fragments and visions of the course of human destiny the series resembles both in scope and selection. It is difficult to detect in his lengthy explanation an underlying metaphysical system which unifies the whole, despite Dr. Johnson's statement about 'a grasp of mind . . . which you will find nowhere else'.[2] Nevertheless, there is something in Barry's failure which is more interesting than many successes. It is as if he had wanted to create a Sistine Chapel of the Enlightenment, and indeed few of the Enlightenment attitudes are missing: the missionary cult of genius, the glorification of the human faculties, the ameliorist confidence, the encyclopedic approach to both history and knowledge, the patriotic pride alongside the assertion of the brotherhood of nations. Even the wilful egocentricity, the partisanship, and the extravagant eulogy of friends can be matched in the circle of Diderot.

The showing of the completed work in 1782 was not the first one-man exhibition to attract large crowds. In 1781 the American John Singleton Copley (1738–1815) hired the Great Room in Spring Gardens from Christie the auctioneer to display *The Death of Chatham*. Twenty thousand paid for admission and 2,500 subscribed for the large engraving by Bartolozzi. The *Morning Post* noted two or three years later a return of £5,000; the final profits are unknown.[3] The advent of the one-man exhibition seemed to the history painters like the dawn of a new era, for the admission charge was merely the beginning of the rewards. The main profit came from the sale of engravings. Copley's example, if not his success, was emulated by artist after artist and, as is well known, suggested to David the idea of showing the *Battle*

[1] Edward Edwards, *Anecdotes of Painters*, 314.
[2] Boswell, *Life of Johnson*, ed. Birkbeck Hill and L. F. Powell, Oxford, IV, 1934, 224.
[3] W. T. Whitley, I. 356–7.

of the Sabine Women at the National Palace of Science and Art in 1800.[1]

The Death of Chatham was a vast narrative group-portrait, heralding a type which was to flourish in the First Empire.[2] Copley followed its success with *The Death of Major Pierson* (1783), fighting against the French at St. Helier, Jersey, possibly the most influential picture he ever painted, for echoes of it were to reverberate in illustrations of books for schoolboys over the next 150 years.[3] The artist's greatest labours were expended on *The Defeat of the Floating Batteries at Gibraltar* [plate 70B], commissioned by the Corporation of the City of London, on which he worked from 1786 to 1791.[4] The King, now ardently interested in Copley's work, requested him to go to Germany in 1787 to take the portraits of four Hanoverians who were present at the siege. On the painting's completion he granted the artist permission to place a tent for its exhibition in Green Park.[5] Again the crowds were immense. By 1799, when Copley held a retrospective exhibition of the *Death of Chatham* and *Charles I demanding the surrender of the five impeached MPs* (first exhibited in 1785), together with his new *Admiral Duncan's Victory at Camperdown*, his fame was such that 60,000 paid to enter the tent in Lord Sheffield's garden in Albemarle Street.[6]

The naval battle as a scene of carnage had been painted by others, including West, in *The Battle of La Hogue* (1780), but the historical painting with a loaded political message was a novelty at the time. The subject of Charles I disastrously demanding the impeachment of the representatives of the people was exhibited after George III had been forced to yield to the American colonists. It is known that the idea emanated from the circle of Edmund

[1] E. G. Holt, *From the Classicists to the Impressionists*, New York, 1966, 4.

[2] E. H. Gombrich in *The Story of Art*, Phaidon Press, 1950, 363–4, singles out Copley as an example of the originality of the Americans working in England.

[3] Tate Gallery. Because it was painted for the Boydell Gallery, it was well known by reproduction.

[4] See J. L. Howego, 'Copley and the Corporation of the City of London', *The Guildhall Miscellany*, no. 9, July 1958. [5] W. T. Whitley, II. 138.

[6] Ibid. 140. For this account of Copley I have also drawn on Barbara N. Parker and Anne B. Wheeler, *J. S. Copley*, 1938, and J. T. Flexner, *J. S. Copley*, Cambridge, Mass., 1948. See also E. P. Richardson, *Painting in America*, New York, 1956.

Burke.[1] In a sense the message was a reconciling one. The quarrel could be made up now that George had followed a wiser course than his absolutist predecessor.

The third of the trinity that heads the Anglo-American school of history painters was John Trumbull (1756–1843), who on his return to America in 1816 took his epic cycle of the American Revolution with him.[2] West had himself wanted to undertake the task, writing to C. W. Peale that he was planning 'a set of pictures containing the great events which have effected the Revolution of America'.[3] He gave way, either from generosity or prudence as the King's favourite, to the younger man, who had the advantage of having fought in the war that he illustrated.

The series is the first set of Revolutionary paintings in Europe. It is balanced in two groups, four battles and four ceremonial, the second group consisting of the *Declaration of Independence*, two surrenders, and the *Resignation of Washington*, the only one of the series to be executed in America. *The Death of General Warren at the Battle of Bunker's Hill, Charleston, Mass., 17 June 1775* [plate 71A] was painted in West's studio and finished by March 1786.[4] The composition with its great diagonal sweep, slice of sloping land, and climactic flags—not unlike Géricault's *Raft of the Medusa*— is strongly baroque, corresponding to West's practice in preferring this style for violent action. With the possible exception of the officer on the right, the facial expressions could almost have been painted on the spot. This is the realism of Copley, not of West. Trumbull was a born story-teller, but he does not enter into the depths of the human predicament like his Romantic successors in France. The engraving after the picture by Johann Gotthard von Miller was published in 1788, but Trumbull's hopes of a large French market for the sale of engravings were dashed by the Napoleonic Wars. Yale College accepted the cycle as a gift from

[1] E. H. Gombrich, *The Story of Art*, 363.

[2] Trumbull is the best served of the three by scholarship in the magisterially edited *The Autobiography of Colonel John Trumbull, Patriot-Artist, 1756–1843*, New Haven, Conn., 1953, and *The Works of Colonel John Trumbull, Artist of the American Revolution*, New Haven, Conn., 1950, both by Theodore Sizer.

[3] Cited by Yvon Bizardel, *American Painters in Paris*, New York, 1960.

[4] See Sizer, *Works*, 72 and plate 30.

the artist in exchange for an annuity in 1831 and erected a handsome neo-classical gallery, the earliest art museum connected with an institution of higher learning in America.[1] The studies of Sizer have done full justice to a work which commemorates the birth of a nation in a style consciously based on Old Master traditions.

'There is a large field for the exercise of your art', wrote Dr. Sleigh from Cork on 31 December 1763 to James Barry in Rome, 'in the description of our three great English poets, Spenser, Shakespeare and Milton, not to mention the number of excellent subjects in the Scriptures.'[2] In his recommendation the writer puts the heroes of national literature first, the Bible second. Fuseli noted the English pride in the great writers of the country: 'The Englishman eats roast beef and plum pudding, drinks port and claret; therefore, if you will be read by him, you must open the portals of Hell with the hand of Milton, convulse his ear or his sides with Shakespeare's buskin or sock, raise him above the stars with Dryden's Cecilia or sink him to the grave with the melancholy of Gray.'[3] If Ossian is added, the list covers adequately the generic range of literary subjects that can be reconstructed from the titles of pictures exhibited at the Royal Academy and the rival societies, comic authors excepted.

The first bookseller to combine a publishing venture with an Exhibition Gallery of Painting was Thomas Macklin (d. 1800), who opened his Poets Gallery in Pall Mall in 1787/8. Boydell's Shakespeare Gallery followed in 1789, and Robert Bowyer's Historic Gallery, according to Whitley, in 1793.[4] In each case the exhibition in the Gallery, for which admission was charged, was designed to secure subscriptions for the illustrated book, or

[1] Sizer, Preface to Trumbull's *Autobiography*, xvii and 378. It is reproduced in *Works*, ix.

[2] *The Works of James Barry*, I. 4.

[3] Letter to Dälliker, Nov. 1765, in Eudo C. Mason, *The Mind of Henry Fuseli*, 1951, 110–11.

[4] For the Shakespeare Gallery see 'Illustrations of Shakespeare's Plays in the 17th and 18th Centuries', *J.W.C.I.* X, 1948, and for the Poets Gallery and Historic Gallery, 'Macklin and Bowyer', *J.W.C.I.* XXVI, 1963, both by T. S. R. Boase. The date of the third Gallery is given in Whitley, II. 179.

purchase of the engravings separately, so that the word 'Gallery' was used to embrace both the exhibition and the publication. In 1790 Macklin added scriptural subjects to his exhibition, and a Bible Gallery eventually took its place alongside the Poets' one. By far the most ambitious of the four undertakings was Alderman John Boydell's Shakespeare Gallery; the first unbound parts of the *Dramatic Works* were published on 1 January 1791.

On 4 November 1787 nine gentlemen, corresponding to the number of the Muses, had met at a private dinner at Westend, the Hampstead home of Boydell's nephew Josiah, a former pupil of West.[1] The party consisted of three artists, West, Romney, and Paul Sandby; three men of letters, William Hayley, John Hoole the translator of Ariosto, and Daniel Braithwaite; and three publishers, the Boydells, and the King's Printer George Nicol. A long and shadowy succession of Shakespearian images had dawned on the fancy of Fuseli as he lay on his back marvelling in the Sistine Chapel.[2] Northcote had scored a triumph by exhibiting his *Murder of the Princes in the Tower* at Boydell's house in Cheapside.[3] As early as the Stratford-on-Avon Shakespeare Jubilee of 1769 George Nicol had broached a scheme for illustrating Shakespeare to Garrick.[4] Romney was currently working on Shakespearian themes, and Hayley was adding fuel to the flames of his Shakespearian passion. There is something a little ingenuous, therefore, in Josiah Boydell's statement that the meeting which launched the idea of a Shakespeare Gallery was 'entirely accidental'.

The Gallery was open by June 1789 with thirty-four paintings. At the Annual Dinner of the Royal Academy that year, the Prince of Wales proposed a toast, drafted by Edmund Burke on the spot, to 'an English tradesman who patronises the art better

[1] See John Boydell's Preface to *A Collection of Prints . . . illustrating the Dramatic Works of Shakespeare*, published by John and Josiah Boydell at the Shakespeare Gallery, Pall Mall, 1803, vol. I, and the discussion in Arthur B. Chamberlain, *George Romney*, 1910, 140–2.

[2] Alan Cunningham, *Lives*, 2nd ed., 1830, II. 291.

[3] Stephen Gwynn, *Memorials of an Eighteenth Century Painter (James Northcote)*, 1898, 205.

[4] Preface to *The Dramatic Works of Shakespeare*, vol. I, 1803.

than the Grand Monarque, Alderman Boydell, the Commercial Maecenas'.[1] The story of the Gallery belongs as much to the next volume as this, but note may be taken of some of the 'grand manner' pictures executed before 1800. The dominant trend was romantic and sympathetic to the baroque, especially in Reynolds, West, and Romney. Romney's *The Tempest* [plate 69A] was begun in 1787 and finished in April 1790.[2] He prepared himself by studying the Raphael cartoons at Hampton Court, but Mannerist and Baroque influences are just as marked. That Romney now chose a shipwreck scene instead of a dying hero fits in with a current emphasis on the violence of nature. The picture was greatly admired, as was Benjamin West's *Lear in the Storm*, also promoting Shakespeare as a romantic symbol by its horrific associations with elemental violence and insanity. Reynolds, whose *Death of Beaufort* was a more conventional death-scene, himself tried his hand at storm and the supernatural, showing at the R.A. in 1789 the largest of all the pictures commissioned by Boydell, *Macbeth visiting the Witches*, described by Hazlitt as 'an inventory of dreadful objects'.[3] In such company Gavin Hamilton's Poussinesque *Coriolanus and Volumnia* must have looked frigid and dated.

Macklin's Bible Gallery, the first volume of which was dedicated to the King in 1791 and the last published in 1800, the year of his death, favoured 'the scenically picturesque'.[4] De Loutherbourg contributed no fewer than twenty-two of the seventy-one paintings that were engraved. He was happier with contemporary historical subjects, especially scenes of violence at sea, his masterpiece in this category being *Lord Howe's Victory on the First of June, 1794*, signed and dated 1795 [plate 71B], in which baroque bravura was supported by realistic virtuosity, the individual expressions of the drowning and the fine detail of the rigging being particularly admired. The moment chosen was when the

[1] Whitley, II. 112, and W. Moelwyn Mechant, *Shakespeare and the Artist*, 69.

[2] A. B. Chamberlain, *Romney*, 143, 151, 157.

[3] For contemporary and later criticisms of the picture see Boase's article in *J.W.C.I.* X, 1948, and C. R. Leslie and Tom Taylor, *Life and Times of Sir Joshua Reynolds*, II. 502.

[4] Boase, 'Macklin and Bowyer', *J.W.C.I.* XXVI, 1963, 166–8.

flag-ship, the *Queen Charlotte*, lost her fore-topmast, thus enabling the French to escape.[1] The swelling of the romantic note in the scenic picturesque, so congenial to the young Turner, can be matched in the more orthodox figure paintings of Bowyer's Historic Gallery, in which the paintings were commissioned to illustrate Hume's *History of England*, for which he issued the prospectus in 1792.[2]

In December 1794 the students of the Royal Academy subscribed 'a shilling each to pay for advertisements of thanks to Messrs. Boydell and Macklin for the privilege of going into their picture galleries without expence'.[3] The well-meant gesture was made in time of trouble for the publishers. The expansion of the British print industry, for such it was, depended on export sales, now stopped by the Napoleonic Wars. In a letter read to the House of Commons to support the lottery of works from his Gallery in 1804, Boydel stated: 'I have laid out with my brethren, in promoting the commerce of the fine arts in this country, above £350,000.'[4] Not all of this vast sum was expended on history painting. but the Revival never recovered from the collapse of the print market, its main economic foundation.[5]

Those artists who organized their own exhibitions or galleries also suffered from the depression. The example of Copley's first Pavilion in 1781 was followed by Barry's public exhibition of his completed cycle at the Society of Arts in 1783 and 1784, and Wright of Derby's one-man show of twenty-five pictures, including *A View of Gibraltar during the destruction of the Spanish Floating Batteries*, at Robins's Rooms, Covent Garden, in 1785. William Hodges's Gallery in Bond Street opened in the 1790s to show *The Effects of Peace* and *The Effects of War*, typical Enlightenment propaganda pieces, and Fuseli's Milton Gallery at the old Academy

[1] E. H. H. Archibald, *Sea Fights: Oil Paintings in the National Maritime Museum*, H.M.S.O., 1957, plate XVIII and notes.

[2] For the influence of De Loutherbourg on Turner see C. H. S. John, *Bartalozzi, Zoffany and Kauffman, with other Foreign Members of the Royal Academy, 1768–1792*, 1924, 124.

[3] T. S. R. Boase, op. cit. 148, note 2. [4] *The Annual Register*, XLVI. 366.

[5] The fullest source for the economy of the boom and its collapse is still John Pye, *Patronage of British Art*, 245–53.

Rooms in Pall Mall in 1799.[1] Benjamin West's Gallery in Newman Street, the Morland Gallery run by a dealer, and the Trumbull Gallery at Yale College belong to a separate category, for no admission was charged. None of the other exhibitions enjoyed Copley's success, based on the sale of prints, but the hopes raised by it and the earlier profits from West's *Death of Wolfe* died hard. Blake's projected Dante Gallery, the idea of which kept him so happy in his last years, might well have succeeded if the artist had lived to make engravings of his water-colours as he intended, for he would have been content with modest sales to his small but growing circle of admirers from his own home. David, who was more ambitious, did not fully realize that the success of his own Pavilion depended on capital and promotion provided by a printselling industry. Nevertheless, his enthusiastic championship of the British innovation had important consequences for French art. So, too, did the single-handed undertakings to interpret a great author like Fuseli's Milton and Blake's Dante, for Daumier's *Don Quixote* paintings are a late flowering of the same tree of literary illustration that produced Delacroix's Shakespeare lithographs. Appropriately, it was a Frenchman who spectacularly revived the idea of a Gallery in the two senses of exhibition and publication in England in the nineteenth century, for the Doré Gallery, which opened in Bond Street in 1867 and added a new Victorian hero of literature, Tennyson, to form a trinity with the Bible and Milton, lasted right into the twentieth century.[2] By showing that the future of *istoria* lay not on the walls of churches and palaces but in the pages of the printed book Boydell, Bowyer, and Macklin promoted its survival but at the same time contributed to its divorce from architecture and consequent decline.

[1] I have excluded from this select list minor one-man shows like George Carter's *Siege of Gibraltar* and 34 other history paintings, Pall Mall, 1785, said to have realized a fortune, and the Panoramic Exhibitions discussed later.

For Wright's 1785 exhibition see Benedict Nicolson, *Joseph Wright of Derby*, 1968, I. 15–16, 278; for Hodges's one, Edwards, *Anecdotes of Painters*, 241–51; and for Fuseli's ill-fated venture, *English Neoclassical Art*, 131–4, and 'Fuseli's *Milton Gallery*: Unpublished Letters', *Burl. Mag.*, CI, 1959, 436–40, both by David Irwin. The Milton Gallery is fully discussed in its European context in Gert Schiff, *Johann Heinrich Füsslis Milton-Galerie*, Zürich, 1963.

[2] Millicent Rose, *Gustav Doré*, London, 1946, 37.

In this account of the Revival of History Painting the emphasis
has been on the great style, not its rivals. Anchored by neo-
classicism to antiquity, the movement was continually being
dragged away in different directions. The Terrible Sublime was
one pull, all the stronger for being sanctioned by antiquity, now
undergoing a romantic revision. Among its protagonists was
John Hamilton Mortimer (1741–79), whose contemporary repu-
tation for 'horrible imaginings' seemed until recently inexplicable
by his known achievement.[1] A neo-classical Caravaggio, who
destroyed himself by wild and drunken conduct, he was held in
extraordinary esteem by artists, partly on account of drawings
that were handed round. His grandiose history paintings were
exhibited mainly at the Society of Artists, of which he became
President in 1774; many are today only known from reproductive
prints, like *An Incantation*, a mezzotint dated 20 July 1773 by John
Dixon after the painting that was shown at the Society of Artists
in 1770 and praised by Horace Walpole as 'very fine'. His best-
known works suggest an Anglo-Roman with a taste for the
figurative work of Salvator Rosa, although he is not known
to have studied outside England. *Monsters Fighting* in the Museum
of Art, Rhode Island School of Design [plate 72A; *c.* 1775–9],
probably illustrates what was most admired. Because his drawings
were so greatly admired, some were engraved, like *The Captive,*
from Sterne's *Sentimental Journey*, an etching by Robert Blyth
published on 1 November 1781 [plate 73A]. *Man attacking a
Monster* in the Mellon Collection [plate 72B], with its classically
posed hero against a romantic background, is very much in the
manner of Mortimer, and may well be by him. If research could
establish his *œuvre* more fully, his name might well be added to

[1] The phrase 'horrible imaginings' is from Edwards, *Anecdotes of Painters*, 63.
Anecdotes of his wildness were collected by Allan Cunningham for the sketch in
his *Lives*, ed. cit. V. 186–203. There is a rare copy of a contemporary catalogue of
works by Mortimer in the Library of the Royal Academy.

The best source for both fact and illustration is the Benedict Nicolson *John Hamilton
Mortimer 1740–1779: Paintings, Drawings and Prints*, a catalogue of the exhibition
arranged by the Paul Mellon Foundation at the Towner Art Gallery, Eastbourne,
and the Iveagh Bequest, Kenwood, 1968, where the works discussed are fully
catalogued.

the list of neo-classical artists whose merits have been neglected.[1] Behind Mortimer lies the even more shadowy figure of Giles Hussey (1710–88), who has claims to be considered the earliest neo-classical painter in England, for his simplified contour style was arrived at, apparently from a study of engravings, antique gems, and intaglios, well before the impact of the archaeological discoveries.[2] From an opposite side came the pull of the decorative painters, Angelica Kauffmann (1741–1807), Giovanni Battista Cipriani (1727–85/90), Biagio Rebecca (1735–1808), and Antonio Zucchi (1726–95). What has been well described as the rococo elegance of their style, modishly adapted to the archaeological taste, charmed the age, but its ornate prettiness and sentimentality are somewhat disturbing to the modern eye, unless seen in the context of Adam interiors, which provide the architectural structure to reduce the richly coloured inset paintings to a pleasing foil.[3]

The restoration of the great style in sculpture was a prime object of the Academy. Reynolds devoted an entire Discourse, the tenth, to this theme at the distribution of prizes on 11 December 1780. There was, he declared, only one manner or style in which the sculptor could properly work, the highest or the grand style. The ornamental was ruled out. Costume must never be contemporary, architectural backgrounds in perspective were to be avoided, picturesque contrasts had no place, and the utmost degree of formality required a symmetrical balancing of parts. 'A child', he specified, 'is not a proper balance to a full-grown figure, nor is a figure sitting or stooping a companion to an

[1] This was written before the publication by Nicolson cited in the preceding note and the reference in Robert Rosenblum, *Transformations*, 1967, 11. It is to be hoped that Nicolson's pioneer study will lead to a full-scale monograph.

[2] For Hussey see the long memoir in John Hutchins, *The History and Antiquities of the County of Dorset*, 5 vols., 2nd ed. by Richard Gough and John Bowyer Nichols, vol. IV, 1825, 154–60. This gives the fullest available account of his famous musical scale, cf. the references in *Vertue*, III. 82–3, 108, 137–8. See also J. J. Foster, 'Giles Hussey, a Dorset Artist', *Conn.*, Mar. 1923, 134–9, and Whitley, I. 125–9.

[3] For their decorative work in country houses see David Irwin, *English Neoclassical Art*, giving the main bibliographical references.

See also The Exhibition Catalogue, *Angelica Kauffmann*, Kenwood House, 1955, and Lady Victoria Manners and G. C. Williamson, *Angelica Kauffmann*, 1924.

upright figure.'[1] The target of these strictures, supported by a censure of Bernini, is clear: the funerary monuments of Roubiliac in Westminster Abbey.

The war that he declared ranged over a wide terrain, but its main battlefield was the Abbey. The baroque tradition was so strongly established in English sculpture that the struggle could only be won when the Academy had trained its own sculptors, a task which it accepted seriously. Only three sculptors, apart from medallists, were elected Foundation Members, Agostino Carlini, William Tyler (elected as an architect), and Joseph Wilton, and none came anywhere near Reynolds's requirements. Carlini (d. 1790) was a native of Genoa, but a note by Walpole against his name in an Academy catalogue, 'Sings French songs', suggests a French background as well.[2] His bust of *George III* (1773) at Burlington House is a strongly baroque rendering of the monarch's more prominent features. Even more of a baroque *tour de force* is the standing figure of *Dr. Joshua Ward* (*c.* 1760) at the Royal Society of Arts. The medical practitioner who promoted Ward's Drops and Friar's Balsam strikes an authoritative pose which might have been designed to illustrate Hogarth's curve of self-importance.[3] The oily stiffness of the wig, crinkliness of cloth, and crispness of lace could not be more contrary to Reynolds's precepts.[4] Although employed by Chambers at Somerset House and Gandon at the Dublin Custom House, Carlini received no major commissions for the Abbey, but executed two outstanding monuments in his academic neo-baroque style elsewhere, to *The Countess of Shelburne* (1771) at High Wycombe, Bucks., and to *The Earl and Countess of Dorchester* (1775) at Milton Abbey, Dorset.

[1] *Discourses*, ed. Wark, 176. For the following account I am heavily indebted to Margaret Whinney, *Sculpture in Britain 1530 to 1830*, 1964, and to personal advice from the author.

[2] Algernon Graves, *The Royal Academy of Arts*, 8 vols., London, 1905/6, under Carlini for the year 1770.

[3] Cf. the observation in the article on Carlini in Samuel Redgrave, *A Dictionary of Artists of the English School*, 2nd revised ed., 1878: 'Dr. Ward, strutting in dignity and drapery'.

[4] See Whinney, op. cit., plate 114b.

William Tyler (d. 1801), who did get Abbey commissions, did nothing there to exorcize the spirit of Roubiliac, which he well understood. Indeed one of his monuments, *Dr. Martin Folkes of Hillingdon* (erected 1788), is not unworthy of Roubiliac in its ingenuous exploitation of the increasingly common Abbey situation of a high wall with a narrow-aisle viewpoint, a choice imposed by overcrowding. The scholar looks directly down so that his contemplative gaze meets that of the spectator looking up, thus creating a shock of intimacy.[1] The long life of Joseph Wilton (1722–1803) spans the interval between the Flemish invasion and the rise of neo-classicism, for he was apprenticed to Laurent Delvaux at the height of his rococo phase at Nivelles and next sent to the French Academy in 1744 to study under Jean-Baptiste Pigalle.[2] A prize winner both in France and Italy, where he stayed about seven years, he returned to England in 1755 with Chambers and Cipriani, with the latter of whom he was appointed in 1758 Joint Manager of the Duke of Richmond's Gallery of Casts in Whitehall, an important training ground for neo-classicists. During his long studies he had qualified himself to become the heir of Roubiliac and Rysbrack. Of the two, he comes closer to Rysbrack in his awareness of Roman models. His bust of *Philip 4th Earl of Chesterfield* (signed and dated 1757) in the British Museum shows the apostle of French manners as an elder Cato. By the time the Academy was founded, he had proved himself the first native-born sculptor whose busts could challenge those of the Anglo-Flemings, especially fine being the noble, almost poetic *General Wolfe* (c. 1760) at Dalmeny, a masterpiece of the classically refined rococo, and *Oliver Cromwell* (either 1761 or 1766) in the Victoria and Albert Museum, an arresting image in the Bernini–Roubiliac tradition. In 1761 Wilton and Roubiliac exhibited plaster casts of busts of each other at the Society of Artists.[3] The notion of authorized succession could hardly have been indicated more gracefully.

[1] Illustrated in Whinney, op. cit., plate 115a.

[2] See ibid. 137–41, for his life and illustrations of the works discussed below.

[3] See St. John Gore, *Treasures of the Royal Academy*, Royal Academy of Arts in London, 1963, no. 143, and K. A. Esdaile, *Roubiliac*, 177.

Wilton was less happy in the sequence of eight funerary monuments that he executed at Westminster Abbey between 1757 and 1792. His first major monument was to Rear-Admiral Holmes [plate 76A; after 1761]. The Admiral gallantly poses in Roman armour against the stage properties of a metallic canon, a minutely creased flag, and a singularly fibrous coil of rope. The attitude of the hero hesitates between the quarter-deck and the lounge. The head, as nearly always in Wilton, gives an admirable illusion of *ad vivum* spontaneity. In short, he has juxtaposed the two worlds of the eighteenth century and anti-quity, and it was this juxtaposition rather than the reconstruction of a wholly Roman image that was his aim. Thereafter he made various attempts to elevate his figure compositions by classical and Old Master borrowings. His *Monument to General Wolfe* (1772) in Westminster Abbey is a compound of Penny's realism and the great style. The figure of the hero has been likened to the dying Meleager, but the realistic touches, including a formidable display of muscular toes, conflict with the ideal character, just as do the two mourning soldiers in their regimentals, who appear to be attending a patient. In the *Monument to Dr. Stephen Hales* (erected 1762) the draped female figures of Religion and Botany flanking the portrait medallion are posed in attitudes reminiscent of a Donatellesque Annunciation, the major difference being the right arm of Botany, which supports the medallion instead of saluting the Madonna.

By the time Wilton was appointed Keeper of the Academy in 1790 he was sixty-eight and had virtually resigned from the creative struggle, his claim to fame resting mainly on the fine portrait busts he had executed, many before the Academy was founded. Joseph Nollekens (1737–1832) was the last major pupil of the Anglo-Flemings.[1] After an apprenticeship to Peter Scheemakers he went to Italy in 1760, having already been awarded two premiums by the Society of Arts, one for a model in clay of *Jephtha's Rash Vow*. Two years later he sent from Rome a

[1] In addition to Whinney and the article in Rupert Gunnis, *Dictionary of British Sculptors 1660–1851*, both citing primary sources, see R. Baum, 'Joseph Nollekens: A Neo-Classical Eccentric', *Art. Bull.* XVI, 1934.

marble relief of *Timocles conducted before Alexander* which gained a prize of fifty guineas. In Rome he made a closer technical study of ancient marbles than any of his predecessors from England, but he was not interested in the world of ideas. He seems to have ignored Winckelmann, and although well known to the Anglo-Romans was never a member of their set. Instead he frequented the studio of Cavaceppi, whose activities as a restorer and forger provided him with a fund of anecdote, and the company of the dealer Jenkins. Whether or not he himself made fakes of ancient marbles, he acquired the skill to do so. There is an attractive side to Nollekens's imitations which may be compared with the musician's variations on a borrowed theme. Looked at in this light, both the charming *Cupid asleep on a Dolphin* (*c.* 1766; Burghley House), from a Renaissance original in Cavaceppi's collection, and the *Castor and Pollux* made for Thomas Anson in 1768, in the Victoria and Albert Museum, justify a reputation for classical statuary of which he was inordinately proud.[1] On his return in 1770 he continued to experiment with free versions of the antique, examples of which can be seen at Wentworth Woodhouse and the Usher Art Gallery, Lincoln, notably *Venus chiding Cupid* (1778) and a *Seated Mercury* (1783) in the latter collection. Flaxman particularly admired such works, which were highly prized in an age which admired virtuosity in interpretation.

His remarkable gifts for portraiture, the staple of his practice, were also revealed in his Roman period. The four cornerstones of his appeal were the same as those of Reynolds, with whom he has been aptly compared: likeness, character, social tact in casting, and ennoblement. Only intellectual subtlety is lacking to raise him to the same level. His bust of *David Garrick* (Althorp, Northants.), for which he made the model in April 1764, shows the actor, whom he had no opportunity to study on the stage, as an ideal type of the Enlightenment, a not inappropriate casting in view of his triumphal procession among the *philosophes*. Equally fine is the bust of *Lawrence Sterne* (1766) in the National Portrait Gallery, a penetratingly nervous study close to the

[1] Cf. Seymour Howard, 'Boy on a Dolphin: Nollekens and Cavaceppi', *Art Bull.*, June 1964, 177–89.

psychology of the sitter. On his return he broke with the tradition of commemorating British worthies, the first sculptor to do so, perhaps because he needed the stimulus of a living model. His portrait gallery of English oligarchs is incomparable. The range of interpretation extends from the mobile intelligence of the *Earl of Mansfield* (1779; Kenwood) and the magisterial authority of the *5th Duke of Bedford* (1802; Shugborough Hall) to the side-whiskered distinction of the *Marquess of Hastings* (1803; Holkham) and the lofty calm of the *6th Duke of Devonshire* (1812; Windsor Castle). He catches the class and type of the older men, as Romney does the patrician ease and good looks of the younger ones. It is difficult to resist the conclusion that the spectacle of distinguished oligarchy had for Nollekens an aesthetic appeal, as it did for Romney; and it is worth noting that both brought the detachment of the antisocial to their task. By contrast, the commoner *Samuel Whitbread* (1814; Drury Lane) appears as a plain unvarnished man of sense, the 'good man' of the eighteenth century. His gift for casting can be further illustrated by comparing two busts of famous statesmen, from the replicas of which he is reputed to have made a small fortune. *William Pitt* [plate 76B; 1807] at Windsor Castle carries his lean head superciliously high, a superb patrician image of Georgian leadership in its imperial phase, whereas *Charles James Fox* [plate 76C; 1792] at Holkham Hall, whose corpulent body was a baroque mansion in its own right, is shown with pendulous folds of flesh, as much *un honnête homme* as Whitbread, but endowed with reserves of power as well as of humanity.[1]

Nollekens was weak in the invention required for high art. Despite a large practice in funerary monuments, he created few outstanding pieces. His elegant mourning ladies deserve the seductive setting of the garden rather than the sombre pedestal of the sarcophagus, and his putti run to fat and frivolity. A happy idea, however, enabled him to achieve one of the finest monuments of the century. At Great Offley, Hertfordshire, he showed *Sir Thomas and Lady Salusbury* (1777) as a Roman marriage pair

[1] The busts of Pitt and Fox are compared in Whinney, op. cit. 163. Unless otherwise stated, the portraits discussed are illustrated in the same source.

with just the right touch of tenderness to offset their patrician status. So the Earl and Countess of Burlington might have wished to be commemorated, for Nollekens has here used his Roman studies, possibly with the relief of Marcus Aurelius from the Temple of Jupiter in mind, in an Augustan mode which the Palladians would have surely approved. The monument expresses the high-minded ethos of Georgian oligarchy in a scene of the affections, its retrospective solemnity complementing the elegance of Gainsborough's *Morning Walk*, where married life is shown just beginning. By contrast, he was less happy when he reverted to the baroque grand manner in the monument to three naval heroes, *The Captains William Bayne, William Blair and Lord Robert Manners* in Westminster Abbey, a task for which he was nominated by the Royal Academy in 1782. Here Britannia looks like a female sentry attended by a lugubrious lion.

As Margaret Whinney has pointed out, his biographer J. T. Smith has left a somewhat one-sided picture of Nollekens, whose noble will distributing his fortune of over £200,000 almost entirely to individuals is one of the most moving documents ever drafted by a Man of Feeling.[1] The miserly eccentric humorously presented a crusty, down-to-earth image of himself to the outside world, but behind this must have lain both imagination and sensibility. A character who admired character in others, he was ideally suited to be the portraitist of the political leaders and great landowners of his age, and the Nollekens Gallery has recorded with complete authenticity both the individualism of his sitters and their continued self-identification as a class with senatorial Rome.

The first sculptor of eminence to be trained at the Academy Schools was John Bacon (1740–99), who enrolled on 24 June

[1] The long will is published in full in J. T. Smith, *Nollekens and his Times*, 2 vols., 1828, II. 17–34. This minor classic of biography by a former pupil and friend has been harshly criticized, some writers attributing to its author spitefulness and resentment at receiving only £100 as an executor. Smith undoubtedly depicts Nollekens as a lifelong miser surrounded in his dotage by parasites, and completely fails to grasp the nobility of the will. At the same time he depicts the eccentricity and humour of Nollekens with such relish that the affections of the reader are engaged on almost every page.

1769, the year of the opening.[1] He was twenty-nine at the time and had been trained in a style repugnant to its Professors, namely the rococo. The son of a Nonconformist clothworker at Spital-fields, he was apprenticed to Nicholas Crisp, jeweller and watch-maker, who was Liveryman of the Haberdashers Company and a Foundation Member of the Society of the Arts.[2] Crisp owned a china manufactory at Vauxhall, but failed in business a year before Bacon received his freedom on 4 July 1764. According to Cunningham, Crisp taught him 'the art of modelling the deer and holly-tree, the bird and bush, the shepherd and shepherdess, and birds of all shapes and beasts of every kind'.[3] Thereafter he worked for Duesbury and Josiah Wedgwood, his introduction to neo-classicism. In 1769 he commenced his association with Coade's Lithodipyra Terra-Cotta or Artificial Stone Manufactory at Lambeth, a firm which prospered and from c. 1774, when it was fully established as a major industry, turned out in remarkably permanent material river-gods, sphinxes, allegorical figures, urns, antelopes, and lions for noblemen's parks and citizens' gardens throughout the British Isles, as well as most of the archi-tectural ornaments in the West End of London. Bacon's family later made the unlikely claim that he invented the Coade process.[4]

In the Academy Schools he proved himself a model student in following the path of *istoria*. In the year of his admission he submitted a trial specimen, probably on the theme of *Abraham sacrificing Isaac*, and was awarded the first Gold Medal in sculpture for a gesso-relief of *Aeneas escaping from Troy*. Also in 1769 he exhibited a model of Bacchants, and in the following year a bas-relief of the *Good Samaritan*, whereupon he was elected A.R.A. He was clearly the star pupil of the opening year. In 1771 a life-

[1] The chief source for Bacon is the unpretentious but scholarly monograph by Anne Cox-Johnson, *John Bacon R.A. 1740–1799*, St. Marylebone Society Publications no. 4, 1961.

[2] For his Nonconformist upbringing and devotion to Methodism see the Revd. R. Cecil, *Memoirs of John Bacon Esquire, R.A.*, 1801.

[3] *Lives*, ed. cit. III. 201.

[4] For this factory see K. A. Esdaile, 'Coade Stone', *Architectural and Building News*, 19 and 26 Jan. 1940, S. B. Hamilton, 'Coade Stone', *Arch. Rev.* CXVI, 1954, 295–301 ill., and *Survey of London*, XXIII. 58–61. See also John Summerson, *Georgian London*, 1945, 115, for the statement about London.

size *Mars* prompted West to utter one of his oracular encomiums, and so impressed Dr. Markham, later Archbishop of York, that he secured sittings from George III, a turning-point in his career.[1] In 1778 he was elected R.A. and was given the most important sculptural commission of the second half of the century, the monument to William Pitt, Earl of Chatham, in Westminster Abbey.

In the first commissions that brought him fame Bacon did not break with the Roubiliac tradition. The bust of *George III* (1773; Royal Society) is more rococo than Roman, and the *Monument to Thomas Guy* (1779; Guy's Hospital) breaks every one of the rules later formulated by Reynolds [plate 74]. A sitting figure is companion to a standing one. The costume of the philanthropist is contemporary. There is a view of the Hospital in oblique perspective. Guy relieves Sickness with the compassionate concern of Howard visiting the prisoners in Wheatley's painting. Intimacy with the spectator is established by the proscenium device whereby Sickness hangs his leg outside the frame of the monument. An even more serious transgression, the great style of *istoria* is introduced into a realistic contemporary scene as unmistakably as in West's *Death of Wolfe* exhibited in the same year, for Guy and the sick old man are shown in the attitudes of Christ raising Lazarus.

The Monument to the Earl of Chatham [plate 75; 1779–83] was begun before Reynolds had launched his attack on the principles of Roubiliac. The statesman appears in his robes as if he were dramatically addressing the House of Lords. In Macaulay's words, 'his effigy, graven by a cunning hand, seems still, with eager face and outstretched hand, to bid England be of good cheer, and to hurl defiance at their foes.'[2] If the figure is compared with that of Eloquence in the Argyll monument, it will be seen that neither is speaking but commanding attention by a gesture of the right hand. By the device of two zones, Chatham in contemporary

[1] Anne Cox-Johnson, op. cit. 11. The illustrations in this and Whinney, op. cit., embrace most of the works discussed.

[2] Cited by Dean Stanley, *Historic Memorials of Westminster Abbey*, 1868, 260. Stanley's brilliant work is the only literary classic to be inspired by British sculpture.

costume is separated from the allegorical group below. The composition is symmetrically balanced. Prudence and Fortitude recline above Britannia, Earth and Ocean flank her below. Each of the six figures is clearly distinguished, overlapping has been avoided, and nothing is allowed to confuse or obliterate the architectural forms of the monument. But Bacon has also used devices of baroque coalescence and introduced a strong chiaroscuro while every form leads up to the climactic figure.

The baroque element is more restrained than in Reynolds's *Infant Hercules strangling the Serpent* [plate 67; R.A. 1788] or West's altarpiece of *Moses and the Brazen Serpent* (begun 1786) at Greenwich. Nevertheless, it belongs to the same category of grand-manner works by Royal Academicians. Although Bacon had clearly separated the hero in contemporary costume from the allegorical group below, it approximates so closely to Reynolds's exposition of the great style in history painting that it may be said to realize for the first time the President's ideals of sculpture in the national Pantheon. But the injunction to prefer classical drapery for sculpture had to be observed after he was chosen by the Academy on 6 April 1784 to execute the monument to Admiral Lord Rodney to be erected in Spanish Town, Jamaica. His original model, made after Carlini, Nollekens, Tyler, and Wilton had also been invited to compete, showed the naval hero in eighteenth-century dress. It was in classical garb that he eventually appeared, for the Academicians felt that this was more dignified.

In 1790 the overcrowding at the Abbey was such that the Dean and Chapter of St. Paul's reluctantly agreed to allow monuments in Wren's interior, and gratefully accepted the offer of the President and Council of the Academy to advise on the siting in the aisles. Bacon received the two commissions that inaugurated the alternative Pantheon, appropriately associating John Howard the prison reformer and Dr. Johnson, the man of letters who had given a lifelong service to Christianity. The statues were unveiled in February and March 1796 respectively. For Howard he had prepared a model showing the philanthropist relieving a prisoner, a theme strikingly close to the Guy monu-

ment. The design was warmly approved, but the Academy objected that a two-figure group would spoil the general effect of the Abbey, since a single figure had been chosen for Johnson.[1] The episode is important because it marks the introduction of a system for the mismanagement of patronage which has lasted to the present day, namely, the triangle of a client's committee, expert advisers, and the artist who has his say but is overruled. Bacon, who had received the Howard commission before Reynolds, insisting on a toga, negotiated the one to commemorate Johnson, was naturally dissatisfied.

Howard in a chiton takes a step forward with scroll in one hand and key in the other. The forward foot tramples on chains. Key, scroll, and chains are emblems of St. Peter, for whom the statue, despite an improbable hairstyle, has been sometimes mistaken by Continental visitors.[2] Even the small bas-reliefs on the base can be read as acts of Biblical mercy instead of social reform. The brooding head of Dr. Johnson is thrust on a massive and muscular body posed like an orator. The introspective struggle of the moralist contrasts with the active benevolence of the philanthropist. Bacon was highly pleased with the observation of John Francis Rigaud, that while Howard was not as grand as Johnson, the one figure seemed going about what the other was projecting.[3] A later and less sympathetic critic stated that Johnson reminded him of 'a retired gladiator, meditating upon a wasted life'.[4] However this may be, a notable victory had been won by the opponents of the Roubiliac tradition. Thereafter St. Paul's became the principal theatre for the display of neo-classical sculpture in England.

When George III learned during his sittings that Bacon had never left the country, he exclaimed, 'I am glad of it—you will be the greater credit to it.'[5] But the future of sculpture after his death lay more firmly than ever in the hands of those who had

[1] Anne Cox-Johnson, op. cit. 35–8, an account based on archival sources.
[2] Cf. Cunningham Lives, ed. cit. III. 238: 'the mistake of a distinguished foreigner who paid his respects to them [Howard and Johnson] as St. Peter and St. Paul'.
[3] Anne Cox-Johnson, op. cit. 38.
[4] John Bailey in Johnson and his Circle, cited by Anne Cox-Johnson, op. cit. 42, note 6.
[5] Anne Cox-Johnson, op. cit. 12.

made the Grand Tour to Rome, for it was the policy of the Academy to encourage travel and in this respect Bacon's education was incomplete. In 1772 Thomas Banks (1735–1805) went to Rome on a scholarship from the Royal Academy schools, and stayed seven years.[1] Although he only briefly entered the nineteenth century, he exerted his main influence in it and has therefore been rightly discussed in its context. But one work at least shows that he had his roots in the age of Edmund Burke and the cult of the Sublime. In 1786, when he had returned and had portrait busts of Benjamin West (1780) and Sir Joshua Reynolds (1785) as well as a monument in Westminster Abbey to his credit, he was elected R.A. and presented as his Diploma work *The Falling Titan* [plate 73B]. His daughter later stated that it derived from drawings which he and Fuseli had made together in Italy.[2] The hurtling rock and its giant victim have been cast by Jupiter on a primitive world of satyrs and goats, rendered by diminutive figures. Once this tiny scale has been noted, the megalomaniac nature of his conception becomes as clear as in any fantasy by Boullée or Goya. This is the key to its revolutionary character, for although he would have been justified by classical texts not even the Mannerist Giulio Romano would have juxtaposed the megalomaniac and microscopic in so startling a manner. Banks did not persevere in the Terrible Sublime, but he lodged in the Royal Academy a romantic image beside which the heroics of the Shakespeare Gallery look almost insipid. Thereafter he proved a model Academician, closer to his junior Flaxman than to Fuseli, in his zeal to preserve the Apollonian as opposed to the Dionysian interpretation of antiquity.[3]

In submitting so irrational a work Banks did not attempt, like Reynolds, to reconcile the conflict between the classical and anti-classical tendencies of the age, but allied himself with Fuseli, Mortimer, Sawrey Gilpin, Reinagle, and other proto-romantics who cultivated horror. There is little evidence to suggest that his

[1] The chief authority is C. F. Bell, *Annals of Thomas Banks, Sculptor, Royal Academician*, Cambridge University Press, 1938, both richly documented and well illustrated.

[2] Bell, op. cit. 68.

[3] For Banks as neo-classicist see Whinney, op. cit., and Boase, O.H.E.A. X. 129–30.

academic colleagues were seriously disturbed, but then the Gigantomachy was a licensed field, just as the *terribilità* of Shakespeare was for Reynolds and Romney. Nevertheless, its megalomania is a far cry from the Rule of Taste as understood by the age of Burlington. Both the Revival of History Painting and the restoration of the great style in sculpture were more open-ended than they appear at a first general inspection, or from reading the programme of the Academy as formulated by Reynolds in his *Discourses*.

THE ERA OF EXHIBITIONS
AND THE
ELEVATION OF GENRE

THREE years after the foundation of the Royal Academy Robert Strange published an attack on its policy in which he coined a memorable phrase, 'the era of exhibitions'.[1] The movement to found a Public Academy, he declared, originated in the desire of artists to appeal direct to the public and thus escape from the constraints of connoisseurs and picture dealers. He identified the new era with liberty, 'ever considered the friend and parent of the fine arts'. By 1787 a press notice could refer to the 'picture mania' then raging: 'no less than six places are now open for the exhibition of ancient and modern paintings.'[2] When Prince Hoare, Secretary for Foreign Correspondence to the Royal Academy, published in 1805 his *Academic Annals for 1804–5* he included a list of those art galleries in London which had been founded by printsellers to show modern British history paintings. In addition to the exhibiting societies and the printsellers' galleries there was the unprecedented activity of artists in holding one-man shows and setting up their own galleries, already noted in the account of the revival of history painting.[3]

The battle of the exhibitions which caused the Royal Academy to make its momentous change of policy and open its doors to the 'inferior practitioners' still left it the first choice for showing history paintings and fashionable portraits. Artists who joined

[1] *The Conduct of the Royal Academicians while Members of the Incorporated Society of Artists*, 1771, 5.

[2] *The Public Advertiser* in the spring of 1787, cited by Whitley, II. 71.

[3] To the list may be added the Adam Gallery in Lower Grosvenor Street, where Robert exhibited the marbles and plaster casts he had brought from Italy. See John Fleming, *Robert Adam and his Circle*, 250–1.

in group exhibitions elsewhere did so either by the invitation of publishers or because they believed in an alternative to the Academy. The Independent Societies performed a valuable function in supporting heterodoxy precisely because they were not rival Academies committed to the cause of ideal art. In the end the open-door policy of the Royal Academy destroyed them. Before this happened, however, they had both widened the market and diversified its supply by simultaneously appealing to the middle classes and those luxurious tastes among the aristocracy which required satisfaction by ingenious or expensive novelties. In the former category came the engravers and the water-colour painters, for whom the additional support of the middle classes was decisive; in the latter may be mentioned the miniature painters, who now advanced on earlier techniques, the modellers in wax, the makers of silhouettes, and at the tail-end those artists, generally female, who specialized in hair-pictures.[1] The silhouette was a cheap form of art and became immensely popular, but from the first it was taken up in aristocratic circles.[2] Finally, the Independent Societies were a court of appeal and a rallying ground for dissenters, attracting artists of the stature of Gainsborough, Romney, and Wright. It is noteworthy that when Gainsborough decided to support the moribund Free Society at its last exhibition in 1783, he did not send portraits but two landscapes, showing by this choice his understanding of its true function as a *salon* of the undervalued if not rejected.

The Society of Artists dragged on until 1791, when Morland exhibited with it, but it had ceased to be prosperous as early as 1776, when it was forced to sell its premises in the Strand, 'the best Gallery in the Kingdom'. Its last exhibition of any consequence was in 1783.[3] Three years later, in 1786, an unsuccessful

[1] Among the modellers in wax the most distinguished were James Tassie (1739–99) and his nephew William, who evolved a secret formula for paste used in gem-stone reproductions and portrait medallions. See Basil C. Skinner, 'Master of the Paste Portrait', *C.L.*, 21 July 1960.

[2] Among the factors promoting the cult of the contour in portraiture must be included the silhouette, which reaches its peak in the neo-classical period. See E. Nevill Jackson, *The History of Silhouettes*, 1911.

[3] Although Algernon Graves in *The Society of Artists and Free Society*, 1917, dates

attempt was made to combine the two Societies. Their major achievement was confined to the first six or seven years of the history of the Royal Academy, on which their competition forced the adoption of a liberal policy.

In fashionable portraiture the leading practitioner in the elevated style after Reynolds and Gainsborough, George Romney (1734–1802), never exhibited at the Royal Academy, being dissuaded from becoming a member and consequently involved in its disputes by his friend the poet William Hayley on the ground of his nervous disposition.[1] The main periods of his style can be related to his moves of residence, each coinciding with a change in the nature of his practice: the provincial (up to 1762); Gray's Inn (1764–7), predominantly legal and bourgeois; Great Newport Street (1767–75), mixed bourgeois and aristocratic; and Cavendish Square (1775–98), when he returned from Italy to become the favourite of high society. The last may be subdivided by his illness of 1788. With the final collapse of his health in 1799 he returned to Westmorland.

A turning-point in his career was the portrait of *The Leigh Family* [plate 81A; Free Society, 1768], representing Mr. Jarret Leigh, a Proctor in Doctor's Commons. It is a large-scale conversation, in the handsome realistic style that appealed to his prosperous bourgeois patrons. But the student of the antique in the Duke of Richmond's Gallery has taken the pose for the central daughter from a well-known votive image in classical sculpture, already used by Reynolds and Vien in France, and here shown in strict relief profile.[2] Garrick visited the artist's

the demise of the latter to 1783, it had become moribund when it lost Christie's Room in 1774. See Edward Edwards, *Anecdotes of Painters*, xxix.

[1] For Romney see Arthur B. Chamberlain, *George Romney*, 1910, still the best-documented study, John Hayes, 'Romney at Kenwood', *Burl. Mag.*, Aug. 1961, Denys Sutton, 'Romney: precursor of the Romantics', *C.L.*, 22 June 1961, Hermann W. Williams, 'Romney's Palette' in *Technical Studies, Fogg Art Museum*, 1937, v–vi, and the important article by Anne Crookshank, 'The Drawings of George Romney', *Burl. Mag.*, Feb. 1957. There has been no catalogue since Humphrey Ward and W. Roberts, *Romney*, 2 vols., 1904.

[2] See Joseph Burke, 'Romney's *Leigh Family*, 1768: a Link between the Conversation Piece and the Neo-Classical Portrait Group', *Annual Bulletin of the National Gallery of Victoria*, II, 1960, 5–14.

studio and ridiculed the rest of the picture: 'Upon my word, Sir, said he, this is a very regular well-ordered family, and that is a very bright well-rubbed mahogany table, at which the motherly good lady is sitting, and this worthy gentleman in the scarlet waistcoat is doubtless a very excellent Subject—to the State I mean, (if all these are his children)—but not for your art, Mr. Romney.'[1] Garrick had previously put himself in the attitude of the Proctor, as he later assumed that of the dying General Wolfe, but Romney took his criticism more seriously than Benjamin West. His style became more refined, and while he did not discard familiar realism he made increasing use of the borrowed attitude, the grace within the reach of art. In the most famous of his group portraits, the dancing *Leveson-Gower Children* (1776–7), the conversation piece proper has been transformed into a neo-classical fancy picture in which every pose adapted from Poussin's *Adoration of the Golden Calf* has been given a vase-like elegance. The *Beaumont Family* (1776–8) is more orthodox, but even here the two-dimensional linearism, which has been noted as a feature of his neo-classical style, gives the informal gathering the dignity of a classical group.[2]

Sentiment rather than the heroic was his forte. There was something reminiscent of Henry Mackenzie's *The Man of Feeling* (1771) in his attitude to his sitters; the society portrait in his hands became a vehicle for refined sensibility, contrasting with the more robust humanity of Gainsborough and Reynolds, the child and the fancy portraits of the latter excepted. A neurotic, he kept himself on the whole aloof from the social world of his sitters, and much of the glamour of his art derives from this detachment, for it enabled him largely to ignore individual character and concentrate on those generalized charms of youth, health, and

[1] Richard Cumberland, *Memoirs of his Own Life*, 2 vols., 1806–7, quoted by John Romney, *Memoirs of the Life and Works of George Romney*, 1830, 56, and more fully by A. B. Chamberlain, op. cit. 53, with Garrick's equally stringent comment on the portrait Romney was painting of Cumberland, later engraved in stipple by William Evans as a frontispiece for the *Memoirs*.

[2] Cf. A. C. Sewter, 'Romney's Sketches for the Beaumont Family', *Burl. Mag.*, July 1941, 12–17, which draws attention to the two-dimensional linearism of the composition, a feature of his neo-classical style.

a place in the sun with which he was psychologically involved.[1]
This is particularly notable in his portraits of schoolboys and
adolescents. During the Headmastership (1754–65) of Dr. Barnard
at Eton, the practice had been introduced of asking the more
distinguished pupils to present a portrait instead of a leaving fee.[2]
Those by Romney, e.g. *Charles Grey, later second Earl Grey*,
painted in 1784, are outstanding, and he made the category
peculiarly his own, painting full-lengths of sitters of the same age
for private houses and stamping an image on aristocratic adoles-
cence as memorably as did Van Dyck and Gainsborough before
him. His eye for the grace of a casual pose was even keener.
The *Young William Pitt* (possibly a mistake for the Duke of
Hamilton) in the collection of the Earl of Crawford and Balcarres
[plate 78B] and *Sir Henry Paulet St. John Mildmay* (1783–5; Lord
Mildmay of Flete, London), the latter wearing the gown of a
fellow-commoner of St. John's College, Cambridge, capture the
high-born charm and freshness of the good-looking youths with
such unstinted admiration that to search for deeper responses
seems pointless.

By 1782, when he fell under the spell of Emma Hart, later Lady
Hamilton, he had very nearly evolved the sketch-like portrait,
in which everything was sacrificed to an effect of the utmost
simplicity. The Emma Hart series invites comparison with
Reynolds's portraits of actresses and courtesans in classical roles.
The endless impersonations that Romney suggested to his sitter,
Circe, a Bacchante, Cassandra, Calypso, Euphrosyne, Alope
exposed with her child, the Pythian Priestess, Miranda, Joan of
Arc, St. Cecilia, and Mary Magdalen, were an expression of his
own obsession rather than considered verdicts on her character
and circumstance. Like Reynolds, he painted most of the men of
letters with whom he was intimate, but psychological under-
standing was largely confined to those with nervous traits like

[1] Cf. John Hayes, 'Romney at Kenwood', *Burl. Mag.*, 1961, 370: 'It was the very
surface qualities of his sitters, the good looks and charm and social manner, that he
most admired and envied.'

[2] *Exhibition of the Eton Leaving Portraits*, The Tate Gallery, 1951, introduction by
Geoffrey Agnew. See also Sir Lionel Cust, *Eton Leaving Portraits*, 1910. The first by
Allan Ramsay may be dated 1756–7.

his own, e.g. the moving portrait of *William Cowper* (possibly 1792) in the National Portrait Gallery.

The sentiment of Romney was closer to the sensibility of Gainsborough than the sense of Reynolds. Once he had evolved his distinctive style by a compound of neo-classical line with painterly, almost monochrome chiaroscuro relieved by bright colours, he not infrequently displayed the facility that marks the fashionable formulator. His eye for simple, flowing shapes was well suited by the trend of fashion; he ably exploited the decorative possibilities of the ladies' large hats, and he handled the full-length white muslin dress set off by a coloured sash with unrivalled refinement. Chamberlain, still the best authority on Romney, singled out as 'the very finest full-length portrait he ever accomplished' the portrait of *Mrs. Lee Acton* [plate 77; 1791].[1] When Chauncey Brewster Tinker collected his literary parallels for eighteenth-century English painters, he produced an apt quotation from Collins's *Ode to Simplicity* (1746) for the *Leveson-Gower Children*.[2] But the sentiment of Romney really looks forward to the nineteenth century. Mrs. Lee Acton could almost pass muster as the frontispiece to *The Woman in White* (1860), written by Wilkie Collins at a much later date. The young lady with the far-away gaze that borders on the apprehensive, her fingers nervously clasped, strays through a formless landscape menaced by storm-clouds. Visual refinement, nervous sensibility, and a pathetic cast of imagination are here in perfect alliance, and it is for the revelation of these qualities that Romney at his best deserves to be admired.

After Romney the elevated style associated with *istoria* was carried on by younger fashionable portrait painters right through to the Waterloo Chamber splendours of Lawrence. Two other modes of association made a rival appeal to society, the first with luxury and the second with genre, the rise and proliferation of which are the outstanding phenomenon of the era of exhibitions. The central figure in the former is Zoffany, who painted sitters in minute detail with their costly possessions and articles of conspicuous consumption as distinct from splendidly generalized

[1] Chamberlain, op. cit. 321. [2] *Painter and Poet*, 1938, 19.

settings of house and park. The genre portrait, so notably developed by artists like Francis Wheatley and Henry Walton, was more widely diffused and never became the prerogative of specialists. Add to this the infusion of ideas and styles from a wide range of subject pictures, together with the important innovations of the realists, and it will be understood why portraiture during this period becomes more diversified than at any previous period of its history in England.

Of those who made their reputation mainly in the elevated style, John Hoppner (c. 1758–1810) and Sir William Beechey (1753–1839) both cross over into the next century, to which the latter really belongs. The most important of the many portraits painted by Beechey before 1800 was the huge *George III and the Prince of Wales reviewing the Tenth Dragoons* [plate 83B; R.A., 1798] in the Royal Collection. The theatrical chiaroscuro and heroic grouping do not necessarily discredit the story that the idea originated in a sketch taken four years earlier in a morning walk through Kensington Gardens, for Beechey had a sober respect for visual truth.[1] The romantically biased narrative force of Copley's and Trumbull's history paintings has here been poured into a portrait group which invests a review in a public park with the drama of a battle scene. Not surprisingly, the picture brought him a knighthood and election to the R.A.

Hoppner, whose family later promoted the rumour that he was a natural son of George III, entered the R.A. Schools on 6 March 1775 and won two prizes, the second for a scene from *King Lear* in 1782.[2] A somewhat slapdash virtuosity and a touch of bravura made him a natural choice as Portrait Painter to the Prince of Wales in 1789. *Princess Mary* (1785) at Windsor Castle shows how ably he could follow Reynolds, at the cost that is involved in popularization. At his best, e.g. the *Daughters of Sir Thomas Frankland* (R.A. 1795), he could not merely create a striking image, but compose brilliantly. Unfortunately his compositional gifts were not supported by a sensibility comparable to Romney's.

[1] W. Roberts, *Sir William Beechey, R.A.*, 1907, 57–60.
[2] For Hoppner see W. McKay and W. Roberts, *John Hoppner*, 1909, with supplementary volume.

The strongest criticism of the elevated style came from an American painter who has been credited with importing into his native country 'the crafty, romantic artificiality of the English tradition at its poetic best'.[1] It was as an exponent of this tradition that Gilbert Stuart portrayed the social leaders of Washington, Boston, and New York after his return in 1792/3; his equestrian portrait of *George Washington at Dorchester Heights* (1806) is unequivocally in the grand style. Nevertheless, he poured scorn on the doctrines of Reynolds, whom he described as doing 'incalculable harm' by many of his remarks, and ran down Academies as proliferating mediocrity. He described himself as a face-painter who dressed hair; brushed hats and coats; adjusted cravats; and made coats, waistcoats, breeches, and shoes.[2] 'No man', he asserted, 'ever painted history if he could obtain employment in portraits.'[3] He preached a doctrine of naturalism: 'You may elevate your mind as much as you can, but, while you have nature before you as a model, paint what you see, and look with your own eyes.'[4] Stuart had a marvellous eye, and his down-to-earth sarcasms disguise a poetic response to distinction and elegance. That the attack should come from an American colonist draws attention to the fact that there was no leading English spokesman of the native as opposed to the genteel tradition, a striking consequence of the influence of the Academy with its Old Master standards.

The kinds of naturalism that found favour with society were far removed from bourgeois realism. No doubt the influence of France and Italy was chiefly responsible for the break, but it is notable how many of the more straightforward portrait painters in fashion also practised as miniaturists or in crayons. Francis Cotes (1726–70), a Foundation Member of the Royal Academy,

[1] Alan Burroughs, *Limners and Likenesses: Three Centuries of American Painting*, Cambridge, Mass., 1936, 104. For Stuart see Laurence Park, *Gilbert Stuart*, New York, 2 vols., 1926 (with catalogue), and W. T. Whitley, *Gilbert Stuart*, Cambridge, Mass., 1932. More recent research is widely scattered in articles and general monographs, notably by Edgar P. Richardson and J. T. Flexner.

[2] William Dunlap, *History of the Rise and Progress of the Arts of Design in the United States*, New York, 1934, I. 189.

[3] Ibid. 185. [4] Ibid. 217.

who occupied the house in Cavendish Square later acquired by Romney, studied crayons under Knapton. According to Edward Edwards, he employed the same drapery painter as Reynolds, Peter Toms, but his personal style, with its clear colours and linear precision, is easily recognized.[1] His portrait of *Benjamin Vaughan* (1768) in the Museum of Fine Arts, Boston, would hang creditably in any exhibition of master portraits of the eighteenth century. A comprehensive exhibition of his work might well upgrade his reputation. Nathaniel Hone (1718–84), also of the older generation, began as a miniaturist. John Russell (1745–1806) was appointed 'Crayon Painter to the Prince of Wales' in 1785, Ozias Humphrey (1742–1810) 'Portrait Painter in crayons to his His Majesty' shortly after his election as R.A. in 1791. Daniel Gardner (c. 1750–1805), an exceptionally rich colourist, did not take up oils until after he had established himself in crayons.[2] If to this list are added those who did not practise seriously in the sister media but were influenced by those who did, Robert Edge Pine (c. 1730–88), Mason Chamberlin (d. 1787), Tilly Kettle (1735–86), and Lemuel Francis Abbott (c. 1760–1803), the student is confronted with a galaxy of talent, any member of which would have stood out in the Age of Kneller. Pine ended up in America; Tilly Kettle was the first professional artist to go to India, where he painted Rajahs and Nabobs from 1769 to 1776.[3] Abbott specialized in portraits of naval officers.[4] From Clive to Cook, from Washington to Nelson, the heroes of the age of imperial expansion and the birth of the United States of America were

[1] *Anecdotes of Painters*, 54, article on Toms.

[2] See *John Russell*, 1894, *Ozias Humphrey*, 1918, *Daniel Gardner*, 1921, three well-documented studies all by G. C. Williamson, and R. M. See, *English Pastels 1750–1830*, 1911.

[3] For Kettle see the documented and illustrated study by James D. Milner in *Wal. Soc.* XV, 1927. The Georgian artist in India has been the subject of several specialized articles since Sir William Foster published 'British Artists in India, 1760–1820', *Wal. Soc.* XIX, 1931, notably by Mildred Archer and Thomas Sutton, whose *The Daniells: Artists and Travellers*, 1954, has references to Zoffany and Hodges. The leading authority on British art in India is Mildred Archer, whose research has con-centrated on architecture.

[4] For Abbot see A. C. Sewter, 'Some New Facts about Lemuel Francis Abbott', *Conn.*, Feb.–June 1955, 178.

worthily portrayed by a small army of accomplished painters who flourished in the shadow of Gainsborough, Reynolds, and Romney.

The record of the aristocracy, gentry, and merchant classes was immensely extended by the vogue for miniatures.[1] Miniaturists had always been associated with aristocratic luxury, but the demand from other classes was greatly increased by the expansion of empire. The Man and indeed the Woman of Feeling were not completely equipped without this portable memento of a beloved person, introduced with telling effect in novels and plays. Even a Grand Tourist like Sir Sampson Gideon had himself portrayed showing a miniature of his fiancée to his friend.[2] The Royal Academy, in its original exclusion of the inferior practitioners, like engravers, from membership, made an exception in the case of the miniaturists, who were admitted as painters in oils, which most of them could claim to be, and whose most ambitious work attempted to emulate that of the fashionable portrait painters on the scale of life. Their interests were represented from the very beginning, for Jeremiah Meyer, who held the appointments of miniature painter to Queen Charlotte and painter in enamels to George III, was one of the 'King's friends' to be appointed a Foundation Member. Outstanding advances in technique opportunely coincided with the fashionable vogue promoted by almost all members of the Royal Family, the Prince Regent and his brothers included, to raise the British miniature to the second peak in its history.

[1] British Portrait Miniatures, 1963, and British Portrait Miniatures: An Exhibition arranged for the period of the Edinburgh International Festival, The Arts Council of Great Britain, 1963, both by the leading authority, Daphne Foskett, contain bibliographies listing the major publications of B. S. Long, G. C. Williamson, and Graham Reynolds; to which may be added Carl Winter, The British School of Miniature Portrait Painters, Henrietta Herz Trust Lecture, Proceedings of the British Academy, XXXIV, Cambridge, 1948, and Jonathan Mayne, 'Portrait Miniatures', in The Late Georgian Period, The Connoisseur Period Guides, ed. R. Edwards and L. G. Ramsay, 1956.

[2] Reproduced and discussed in Harley Preston, 'Two Portraits by Pompeo Batoni', Annual Bulletin of the National Gallery of Victoria, VI, Melbourne 1964, 11–19, and in Studies in the Eighteenth Century: Papers presented at the David Nichol Smith Memorial Seminar Canberra 1966, ed. R. F. Brissenden, Canberra, 1968, plate XII and p. 63. The unidentified friend has been misleadingly described as his tutor.

The method of painting miniatures on ivory or bone, discovered by Rosalba Carriera, was first used in England by Bernard Lens (1682–1740).[1] Gouache was the principal medium until later in the century. Richard Cosway and others revolutionized the technique by painting in water-colour on prepared formats cut from thin sheets of ivory. Miniaturists must therefore be taken into account in tracing the origins of the English water-colour school.[2] It is significant that while they responded to the styles of almost all the leading portrait painters, Gainsborough was a pervasive influence from outside their own tradition.

Both continuity with the English tradition and a renewed stimulus from the Continent are exemplified in the career of Jeremiah Meyer (1735–89). A native of Tübingen brought to London at the age of fourteen, he studied at the St. Martin's Lane Academy and under Christian Friedrich Zincke (1683/4–1767), who also came to England from the Continent, having been trained as a goldsmith in Dresden. Some time after his arrival in 1706 Zincke studied miniature painting under Charles Boit (1662–1727), a Swede who had likewise been apprenticed to a goldsmiths' guild. Boit is the miniature mirror of his fellow Swede Michael Dahl, Zincke of Hudson. Meyer was not the greatest miniaturist of his day, but far more emancipated from oil-painting conventions than his predecessors. His silhouettes respect the oval in which they are placed; the plain background is delicately clouded; the eyes are extraordinarily lustrous and clear; and an exquisite contrast between opaque and translucent colour enhances an image in which delicate line is combined with sensitive modelling and sometimes *sfumato*.

Miniatures of this water-colour type appealed to two tastes, the first for a vivid likeness which called the absent friend or a vanished state of youth to mind with a strong sense of immediacy, and the second for the rare and costly showpiece which could be handed round a circle of admirers. The brilliant school that now

[1] Daphne Foskett, *British Portrait Miniatures: An Exhibition*, etc., 1963, Foreword, iii.

[2] For the importance of the miniature in the evolution of the English water-colour see Richard and Samuel Redgrave, *A Century of British Painters*, ed. Ruthven Todd, London, 1947 (1st ed., 1866), chapter XII, and H. M. Cundall, *A History of British Water Colour Painting*, 1908, chapter I.

came to the fore were nearly all prize-winners of the Society of
Arts, whose founder and registrar, the drawing master, William
Shipley, introduced a policy of encouraging the medium, al-
though he did not teach in it. Richard Cosway and his friend
John Smart were both pupils at his drawing school. Another
preparatory training ground was the Duke of Richmond's
sculpture gallery under Cipriani and Wilton, attended by Ozias
Humphrey and Richard Crosse, another Shipley pupil. Cosway
was a pupil with Engleheart in the first year, 1769, of the Royal
Academy schools, and after he left Shipley's School became a
drawing master at Parr's Academy. All these centres were exposed
to neo-classical influences, and the early cult of line drawing
underlies the painterly style of the group.

In Nollekens's memorable phrase Richard Cosway (1742?–1821)
'rose, from one of the dirtiest boys, to one of the smartest of men',
caricatured as 'the Macaroni Miniature-Painter'.[1] Charles Townley
the collector gave away his bride Maria Hatfield, also a practitioner,
and the Prince Regent took up with enthusiasm an artist notable
for his virtuosity, dandyism, and reckless extravagance. Never-
theless, his early successes—A.R.A. in 1770, R.A. in 1771—were
firmly founded on hard work and outstanding ability, not his
social connections. Cosway did more than any other member of
the school to elevate the medium, introducing subjects from
classical mythology in a style adroitly combining the opulence of
the baroque with the delicate prettiness of Angelica Kauffmann.
By contrast, John Smart (1742/3–1811) preserved the original
integrity of the medium, so that today his reputation stands as
high as if not higher than that of his fellow pupil.

Master Impey [plate 79C; inscribed and dated 1785] in the
collection of Mrs. K. Gifford-Scott is a water-colour drawing on
paper and shows Smart at his best.[2] Like Richard Crosse's equally
superb *James Crosse* [plate 79B; in the collection of Lt.-Col.
Reeder Cross-Upcott], it demonstrates what had been gained
by the revolution in technique. Crosse, here influenced by

<hr>

[1] *Nollekens and his Times*, 1828, II. 392–3.
[2] Cf. the discerning appreciation in Daphne Foskett, *John Smart: the Man and his
Miniatures*, 1964.

Gainsborough, has something of the softness of Smart's drawing, but already the eyes and hair are more sharply distinguished from the delicate modelling of the face. In Richard Cosway's *The Ladies Georgiana and Henrietta Cavendish* [plate 79D; signed and dated on the back 1789] in the collection of Earl Spencer the distinction is positively emphatic. Such intense luminosity is impossible on canvas or paper, and was used both for pattern making and to focus attention on the gaze of the eyes, a prized device in a keepsake. In George Engleheart's *Mrs. Gillespie* [plate 79A] in the Victoria and Albert Museum the contrast between strong and delicate touches for decorative purposes is carried even further.[1]

Accompanying the popularity of the miniature was a revival of the portrait in crayon or pastel, also linked with a strong and continuous English tradition. In 1753 the Swiss Jean-Étienne Liotard (1702–89) arrived in London, where he practised until 1755 and later from 1772 to 1774 and influenced Francis Cotes, who taught John Russell.[2] His heightened colour rather than the fastidious realism of his minute detail impressed the native practitioners. Ozias Humphrey practised mainly in crayon from about 1791, and Daniel Gardner, the most talented in the medium, created unsurpassed effects of brilliance and textural richness.[3] With this group considered not as oil painters but as masters of crayon may be associated John Downman (*c.* 1750–1824), who became one of the favourite portraitists of Regency society. He sketched in coloured chalks, but he made his fashionable reputation with tinted water-colours, in a substantial number of cases putting colour in at the back to show through the thin transparent paper he used for this purpose.[4] The drawing was done with a very fine point, and has much in common with miniatures of the period, like his small-scale oil portraits on copper.

Downman worthily concludes the list of Little Masters of the late Georgian period. Like Cosway, he cultivated a decorative

[1] For illustrations of his other works see G. C. Williamson's *George Engleheart*, 1902, privately printed.

[2] Waterhouse, *British Painting*, 244–5. [3] See p. 280, n. 2 above.

[4] C. G. Williamson, *John Downman*, 1907, is still the fullest source for illustration, in spite of many omissions.

vein which may be compared stylistically with Cipriani, Barto-
lozzi, and Angelica Kauffmann. He studied with West after
leaving the Royal Academy Schools, and the best of his drawings,
like those of his master, represent a decorative phase of neo-
classicism with their fine-point elegance of contour. That he had
ambitions to associate his art with history painting is indicated
by *The Return of Orestes* [plate 81B; R.A. 1782] in the collection
of Ralph Dutton, recording a performance of Voltaire's *Oreste*
at Drury Lane on 15 October 1774.[1] The group reads from
left to right: John Palmer (Aegisthus); J. Aicken (Parmenes) in
helmet; William Smith (Orestes) with outstretched hands; Mrs.
Yates (Electra) holding urn; and Mrs. Baddeley (Iphisa) with
clasped hands, the others being minor members of the cast. The
style of the theatrical conversation has been discarded for that of
the neo-classical history painting introduced by Gavin Hamilton
and West, thus linking it with a number of tragic scenes in
Boydell's Shakespeare Gallery. During his visit to Italy (1773–5),
in the course of which he accompanied Wright of Derby part of
the time, he made a number of landscape drawings, especially
around Albano again suggesting that he was ambitious to shine
in other walks than portraiture.[2] But society demanded otherwise,
and a water-colour on paper of *Edward, Duke of Kent* (1785;
$7\frac{1}{4} \times 5\frac{7}{8}$ in.), the father of Queen Victoria, at Windsor Castle, with
the ribbon and star of the Order of St. Patrick founded in 1783
prominently displayed, established him in royal favour as well.[3]
It has been justly observed that he excelled with children and
young and lovely people of fashion, achieving 'a faint fragrance
of character exactly suited to his almost evanescent medium'.[4]

The term *genre* was used by contemporary writers in the
French sense of a category of subject picture, its precise appli-
cation being determined by a qualifying adjective or noun, as

[1] The iconography and history of the painting are given in *C.L.*, 25 Nov. 1965,
1401.

[2] For his association with Wright see Benedict Nicolson, *Joseph Wright of Derby*,
1968, I. 6–7.

[3] Reproduced in the Commemorative Catalogue of the *Exhibition of British Art*,
Royal Academy of Arts, Oxford University Press, 1935, plate CLIII, catalogue no. 655.

[4] Waterhouse, *British Painting*, 232.

le genre historique, le genre du paysage, le genre pittoresque, etc.[1] The
case for the categorical depreciation of genre in its lowest sense
of realistic scenes of everyday humble life was forcibly put by
Reynolds in the Third Discourse (1770).[2] During the era of
exhibitions two phenomena of outstanding importance for the
future of genre may be noted. First, genre began to rival portraiture
in popularity, as may be shown by the demand for prints after
genre paintings. Secondly, the leading practitioners elevated
genre by both style and association. In England the elevation
of genre lacked a champion as eloquent as Diderot, who in his
reviews of the Paris *salons* campaigned vigorously on behalf of
Greuze and *le genre du tableau*, and justified *le genre sérieux* on
the high ground of *la peinture morale*.[3] Nevertheless, the founda-
tions were firmly laid for the apotheosis of genre in the age of
Wilkie, when Géricault and Delacroix on their visits to London
could single out the modern English school of genre painters
for particular praise.

The hydra-headed growth of genre in this period defies cate-
gorization by subject, the method followed by most contemporary
writers on art, to the annoyance of painters like Stubbs and Wright
of Derby.[4] Broadly speaking, the attempts at elevation may be
grouped under two main headings, heroic genre and the genre of
sentiment. The painters of heroic genre sought to invest scenes
from everyday life with something of the dignity and consequence
hitherto reserved for subjects from the Bible and antiquity.
Sentimental genre is closer to *le genre sérieux* of Diderot, and not
infrequently has a moral or humanitarian message. In many cases,
however, it was simply a refined depiction of everyday life, not
uninfluenced by the pathos of Gainsborough's cottage scenes.
In the case of rustic life it is difficult at times to distinguish between
genre and the picturesque landscape with figures. Where Claude

[1] See E. K. Waterhouse, 'English Painting and France in the Eighteenth Century',
J.W.C.I., 1952, and compare the accounts of genre in R. and S. Redgrave, *A Century
of British Painting*, ch. XXI, and Ernest Chesneau, *The English School of Painting*, 1st
English ed., London, 1884, ch. I., still a valuable discussion.

[2] *Discourses*, ed. Wark, 51. [3] Waterhouse, op. cit. 135.

[4] Cf. Robert Rosenblum, *Transformations in Late Eighteenth Century Art*, Princeton,
N.J., 1967, viii.

had elevated the Roman campagna by introducing the Flight into Egypt, Bewick inserts the tragedy of rustic suicide into a delicious sylvan scene [Figure].

Joseph Wright of Derby (1734–97) virtually created a new mode of heroic genre linked with science and industry. The son of 'Equity' Wright, a distinguished attorney and later Town Clerk of Derby, he was favourably placed to absorb the influence of the Provincial Enlightenment, in contrast to Reynolds, whose west-country world of landed gentry and classical scholars differed little from the social circles in which he moved in London.[1] Wright studied from 1751 to 1753 under the same master, Thomas Hudson, as Reynolds, but he made his tour to Italy (1773–5) at a much later age, thirty-nine as against twenty-six. Apart from two frustrating years in Bath (1775–7) trying to capture the position vacated by Gainsborough, he resided at Derby and only visited London, where he exhibited regularly.[2]

The neglect of Wright is the most serious charge that can be levelled against the Academy under the Presidency of Reynolds. He was elected A.R.A. in 1781, disgracefully late in view of the pictures shown at the Society of Artists from 1765, and elected R.A. in 1784, an honour which he declined. In one respect he was more genuinely devoted to the original ideals of the Renaissance than any of his contemporaries except Stubbs. He combined the pursuit of high art with those scientific studies which the post-Renaissance academies had allowed to lapse by substituting doctrine for experiment. There can be little doubt that the reason for his neglect was not lack of recognition of his talent, but the categories in which he chose to employ it. That he himself thought so is suggested by his statement that those who 'propagate

[1] An excellent general account of Wright's industrial background is in Francis Klingender, *Art and the Industrial Revolution*, 1947. See also Joseph Burke, 'The Iconography of the Enlightenment in English Art', *Proceedings of the Australian Academy of the Humanities*, I, 1970, 47–65.

[2] The remarkable revival of Wright studies has been pioneered notably by Ruthven Todd in England and Charles E. Buckley and Robert Rosenblum in the U.S.A. The extensive bibliography is given in the monumental and definitive study by Benedict Nicolson, *Joseph Wright of Derby: Painter of Light*, the Paul Mellon Foundation for British Art, 2 vols., 1968, the finest study of an eighteenth-century English painter that has yet been written.

a report that I paint fire-pieces admirably' were his enemies.[1]
In 1772 Northcote wrote enthusiastically home about 'the most
famous painter now living for candlelight', one who was 'in
this way the greatest in the world' [plate 88A].[2] Fuseli praised
him in an account which might almost have been used for his
rejection from the Academy in competition with a history
painter.[3] It was difficult, he stated, to assign its class to his subjects,
and tell whether it belonged to landscape or history. In the
latter he generally failed, because he was totally ignorant of 'heroic
or poetic form'. Fuseli's proposal for classification, not at all a
bad one, was to specify excellence in 'contemplative subjects'
and landscapes connected with 'a phenomenon, moonlight, fire,
storm' or with 'a sentiment, solitude, tranquility, melancholy',
in short, a list of romantic attributes. He placed immediately
after his contemplative subjects, perhaps as a gloss, 'night-pieces
in the manner of Schalken, although on the scale of Gherardo
dalle Notte'. Schalken and the Utrecht Caravaggesques, especially
Honthorst, who worked in England, were not acceptable models
by the highest standards of the Academy any more than the
picturesque of Vernet which underlies the observation in his
phenomenal landscapes.[4] Even when he came under the spell of
the Anglo-Romans, he did not abandon his realism. As much
a prodigy as Copley, whose *Boy with a Squirrel* was mistaken for
a work by the young Wright, he did not emulate the colonial by
adapting his style to the fashionable taste of the metropolis.

Wright's bid for fame was made with three paintings that
illustrate the scientific and artistic studies of his circle in Derby:
Three Persons viewing the Gladiator by Candlelight, Society of
Artists 1765, *A Philosopher giving a Lecture on the Orrery* [plate

[1] Letter of Feb. 1776, cited by C. Reginald Grundy, 'Wright of Derby', *Conn.*,
Dec. 1930, 345–54.

[2] Whitley, II. 288 and 291.

[3] Article on Wright in Revd. M. Pilkington, *A Dictionary of Painters*, revised and
enlarged by H. Fuseli, 1810, 628.

[4] For Wright's sources see Benedict Nicolson, 'Joseph Wright's Early Subject
Pictures', *Burl. Mag.*, Mar. 1954, Robert Rosenblum, 'Some Sources of two paintings
by Joseph Wright of Derby', *J.W.C.I.* XXV, June 1962, and Charles Buckley,
'Joseph Wright of Derby', *Magazine of Art*, Apr. 1952, 160–7.

88B], Society of Artists 1766, and *An Experiment on a Bird in the
Air Pump* [plate 89A], Society of Artists, 1768. *An Academy by
Lamplight* [plate 87], *c.* 1768–9, in the Mellon Collection, catches
the high seriousness of an academy of the Provincial Enlighten-
ment in England, although neither the location nor the young
students have been identified.[1] The Forge paintings commence
with *The Blacksmith's Shop* and *An Iron Forge*. Significantly, he
chose to exhibit them at the Society of Artists in 1771 and 1772
respectively, instead of submitting them to the Royal Academy,
a preference which shows how important the Independent
Societies then were as an exhibition ground for innovators. The
Forge paintings are grander in composition and more dramatic
in chiaroscuro than the history paintings, a daring reversal of
orthodox practice by which he proclaimed the heroic importance
of his industrial themes. Of the two the earlier picture, engraved
by R. Earlom in 1771, is deliberately elevated by associations with
istoria. Klingender has pointed out that the setting is a classical
ruin with a sculptured angel flanking the arch that leads into a
thatched shelter, the whole of a kind chosen by Italian painters of
the sixteenth century for Nativity scenes.[2] The dominant figure
wields his hammer in a pose reminiscent of Hercules with his
club. The smith with his back to the spectator could be converted
into a warrior by substituting a sword in his right hand. The
old smith seated at the right corresponds with Vulcan figures
in paintings by both Matthieu and Louis Le Nain.[3]

In *An Iron Forge* [plate 89B; 1772] the shed looks exactly as if
it had been painted from one of the water-driven forges of the
period. The central light falls on a smith with his arms folded,
looking towards the mother and children. The seated old man
shields his eyes from the light with his hands, while a child hugs
his knees. A dog with a face curiously like St. Jerome's lion
looks mysteriously from the shadows behind the family group,
his one concession to the iconography of *istoria*. It is as if he

[1] All the paintings by Wright mentioned hereafter are illustrated and fully dis-
cussed in Nicolson, *Joseph Wright of Derby*.

[2] *Art and the Industrial Revolution*, 50.

[3] Ibid. 51. The heroic attitudes are emphasized by comparison with the painting
attributed to Jan Molenaer, reproduced by Nicolson, *Wright of Derby*, I. fig. 60.

wished to demonstrate that elevation did not depend on association, and that manual labour and the domestic affections could be represented as solemnly as a religious theme from the Bible.

During his stay in Italy, where he found that the Old Masters, especially Correggio, did not always satisfy the expectations aroused by engravings, he collected material for classical landscapes, but it was scientific and phenomenological studies that occupied him chiefly as a painter—the Mediterranean grotto with its geological curiosities, firework displays, and Vesuvius, already becoming a favourite subject with romantically inclined artists. These scientific interests, including geology, had all been developed before he left for Italy.

Wright was a keen student of romantic literature, his range extending from the fable and morality, e.g. the *Old Man and Death* (Society of Artists, 1774), to Gothic horror, *Miravan breaking open the Tomb of his Ancestors* (Society of Artists, 1772), and exotic pathos, like the highly romantic *Indian Widow* (1785) which through the engraving by J. R. Smith of 1789 influenced *Les Natchez* by Delacroix [plate 118A].[1] His 'classical' histories are so eccentric in their choice of subject-matter that they may well have failed to be regarded as such by the Academy. *The Hermit studying Anatomy* (c. 1771–3) was probably inspired by a painting in an English collection by Salvator Rosa, *Democritus studying Anatomy*, but the benighted wayfarers who discover him are dressed like gentlemen from the court of Naples in contemporary paintings of Shakespeare's *Tempest*. He also depicted a recherché theme in *The Corinthian Maid* (1783–4), a subject suggested by Wedgwood, then seeking a classical authority for his own industrial researches, in 1778.[2] The story of Dibutades, more correctly Butades, the Corinthian potter who discovered a ceramic process for rendering the figure, is a companion to the legend of Callimachus, the inventor of the Corinthian capital,

[1] Cf. Charles Buckley, 'An Eighteenth Century British Painting', *Wadsworth Athenaeum Bulletin*, Hertford, Conn., Apr. 1953, in which his *Old Man and Death* is related to Gothic horror sources.

[2] See Robert Rosenblum, 'The Origins of Painting: a problem in the iconography of romantic classicism', *Art Bull.*, Dec. 1957; Klingender, op. cit. 43; and especially Nicolson, *Wright of Derby*, I. 64–5.

the illustration of which in the 1707 edition of John Evelyn's *Parallel of the Ancient Architecture with the Modern* may well have provided hints for his rendering.

After his return from Italy Wright commanded from his base in Derby a considerable regional practice as a portraitist, becoming a favourite with the great industrial pioneers and their families, the Arkwrights, Wedgwoods, Samuel Oldknow, and Jedediah Strutt. In 1785 he joined the numerous company of those who held one-man shows in London, exhibiting twenty-five pictures in Mr. Robbins's Rooms at Covent Garden, where the principal draw was *The Siege of Gibraltar*, sold for over four hundred pounds.[1] On the whole he had little difficulty in selling his subject pictures, Catherine II of Russia securing, among other pictures, one of the finest of the Forge paintings.

Benedict Nicolson in an illuminating passage has shown how artificial light, which he rendered with a dream-like intensity, stimulated his imaginative responses:

But it was in the realm of artificial light and moonlight, in the glare of the blacksmith's shop, in cotton mills humming by night along the Derwent valley . . . in the twists that shadows make as the flare of a candle plays over a face, in a cottage or town reduced by a conflagration to the shell of itself, in the moon reflected in the surface of water, in the phenomenon of Vesuvius erupting and fireworks disgorging pellets from the Castel Sant' Angelo—in all those freaks of illumination which were calculated to appeal to a provincial artist witnessing around him the hard birth of industry—that Wright struck out a line of his own, and soon proved himself without a rival.[2]

The candle-light painter by no means confined himself to nocturnal subjects. The portrait of the *Reverend and Mrs. Thomas Gisborne* (1786) in the Mellon Collection, showing the amateur seated with his crayon-holder and portfolio on a mossy bank, his wife holding the indispensable umbrella, is a manifesto of the picturesque, to which he made a characteristically phenomenological contribution, notably with the late *Landscape with a Rainbow* in the Derby Art Museum, c. 1794–5 [plate 93A]. Unfortunately

[1] Edward Edwards, *Anecdotes of Painters*, 1808, 234.
[2] Introduction to *Joseph Wright of Derby: an Exhibition*, The Arts Council, 1958, 6.

the grotto paintings are widely scattered. For all their realism these are, in Fuseli's phrase, contemplative subjects, heightened by sentiments of tranquillity, solitude, and melancholy, just as his literary paintings are deepened by a disguised but equally romantic allegory.

George Stubbs (1724–1806) was ten years older than Wright, with whom he and Bewick share the leading artistic honours of the Provincial Enlightenment.[1] His father, a Liverpool currier, arranged for him to study under the obscure Hamlet Winstanley, a pupil of Kneller then copying the Earl of Derby's pictures at Knowsley Hall. Like Romney, he relied more on his own efforts than the teaching of his master, with whom he stayed a very short time. The origins of his interest in science are obscure. After moving to York about 1745 he lectured on human and animal anatomy to the students of York Hospital in collaboration with the surgeon Charles Atkinson. His earliest known works are some illustrations to Dr. John Burton's *Essay towards a Complete New System of Midwifery* (1751).

In 1754 he went to Rome, an experience which according to Ozias Humphrey led him to proclaim the superiority of nature to art. He returned to his native Liverpool, but *c.* 1756–60 retired to a lonely farmhouse near Horkstow in Lincolnshire, where he set up elaborate mechanical equipment for suspending the carcasses of horses. Unable to find a celebrated engraver to reproduce his drawings, he set about the task himself. *The Anatomy of the Horse* was published in 1766 and brought him the unreserved

[1] Like Wright, Stubbs has been the subject of much recent attention from scholars, first and foremost being Basil Taylor, so that the bibliographical references in Walter Shaw Sparrow, *George Stubbs and Ben Marshall*, 1929, are only valuable for early sources. See especially 'George Stubbs 1724-1806' in *The Harp of Aeolus*, 1946, and 'George Stubbs' in *Signature*, Jan. 1940, both by Geoffrey Grigson; *George Stubbs 1724-1806: Catalogue of an Exhibition at the Whitechapel Art Gallery*, 1957, and the entries under Stubbs in *Painting in England 1700–1850: Collection of Mr. and Mrs. Paul Mellon*, Virginia Museum of Fine Arts, 2 vols., 1963, both by Basil Taylor, who has also written the introduction to *George Stubbs: Rediscovered Anatomical Drawings from the Free Public Library, Worcester, Mass.*, The Arts Council of Great Britain, 1958. See also Basil Taylor, *Stubbs*, London, 1971, and 'Josiah Wedgwood and George Stubbs', *Proceedings of the Wedgwood Society*, no. 4, 1961, 209-27, and 'The Prints of George Stubbs', *Exhibition Catalogue*, 1969, Paul Mellon Foundation for British Art.

tribute of Petrus Camper: 'How is it possible that a single man can execute such a plan with so much accuracy and industry?'[1] The work is in the tradition of Carlo Ruini's treatise (1598) but its scheme is also indebted to Bernhard Siegfried Albinus's *Tabulae Sceleti et Musculorum Corporis Humanae* (the edition of 1747) with its plates by Jan Wandelaar of skeletons and figures half-dissected or *écorchés* attitudinizing in landscapes.[2] Stubbs preserved the animation but discarded the landscape *mise en scène* [plate 86A]. From 1795 until his death he worked on the *Comparative Anatomical Exposition of the Human Body with that of a Tiger and a Common Fowl*, published posthumously in 1817.

Stubbs quickly became famous as a horse painter. According to the article in Thieme-Becker, he was called the Reynolds of the horse after 1766, and this is far more likely than the label that has since become popular, the Leonardo of the horse, for it was the oil paintings elevated by classical borrowings that appealed to his patrons in the golden age of horse-racing as an almost private diversion of landowners.[3] The stigma of being an animal painter, however, was as disadvantageous to his academic recognition as that of being a candle-light painter was to Wright. He was late in his election as A.R.A. in 1780, and although elected R.A. in 1781, he declined to submit a diploma work and his position was declared vacant in 1783. Like Wright, too, he was happier with the Society of Artists, of which he became President in 1773.

The foremost aim of Stubbs was to raise animal painting to the dignity of *istoria*. The heroic theme of the animal combat between

[1] For this and other tributes by Petrus Camper see Basil Taylor's introduction to *George Stubbs: Rediscovered Anatomical Drawings*, 9, and Geoffrey Grigson in *The Harp of Aeolus*.

[2] There is, as John Hayes has pointed out, a whole European tradition of this kind of comparative drawing, going back to Leonardo da Vinci. See the reference to Thomas Rowlandson's *Comparative Anatomy: Resemblances between the Countenances of Man and Beasts*, 1821 in J. Hayes, *A Catalogue of the Watercolour Drawings by Thomas Rowlandson in the London Museum*, London Museum Catalogue no. 9, H.M.S.O., 1960, 7.

[3] Another variant is 'The Poussin of the Horse', see Basil Taylor, *George Stubbs: Catalogue of an Exhibition at the Whitechapel Art Gallery*, 1957, introduction. Stubbs can only have seen the Leonardo drawings at Windsor Castle late in the 1790s, see B. Taylor, *Rediscovered Anatomical Drawings*, 11.

a lion and a bull or horse had been a favourite of late antiquity.
Two masterpieces in particular had been singled out for praise
by the Richardsons in their guide for Grand Tourists: 'A Lyon
tearing a Horse, Marble, and finer than that famous one in the
Capitol.'[1] The work they preferred was in the Pitti Palace, but
it was the Capitoline sculpture that was chiefly admired.[2] Today it
has been removed to the garden and is seldom seen by visitors,
but in the eighteenth century it was a celebrated showpiece, much
copied. A copy of another late antique version, as has been noted,
was given the place of honour in the Rousham gardens.

The animal combat paintings of Stubbs have an assured place
in the history of European romanticism, for they were admired
by both Géricault and Delacroix and copied by the former.[3]
Despite Stubbs's statement that 'Nature is superior to art' and the
story that he witnessed from the walls of Ceuta in Morocco a
lion stalk, seize, and devour a white Barbary horse, it was the
classical models on which he based the renderings executed *c.*
1760 to 1765, that is, overlapping with his anatomical labours at
Horkstow.[4] The most romantic version is at Yale; the most
severely neo-classical in the National Gallery of Victoria [plate
85B]. That he should have preferred a bas-relief composition to
a free-standing one suggests that despite the brevity of his stay in
Rome he had come under the influence of the Anglo-Romans.
A similar alternation between the two modes, one in classical
frieze profile, the other freer and more baroque, and the setting
in a lonely landscape are to be noted in Géricault and Delacroix.

To the same decade of the sixties belong the series of frieze
paintings depicting mares and foals, described as his most original

[1] *An Account of Some of the Statues, Bas-reliefs, Drawings and Pictures in Italy, etc.*
by Mr. Richardson [senior and junior], London, 1722, 59.

[2] Reproduced in H. Stuart Jones, *A Catalogue of the Ancient Sculpture preserved
in the Municipal Collection of Rome: The Sculpture of the Palazzo dei Conservatori*,
Oxford, 1926, plate 96.

[3] Neville Wallis, 'Géricault—the Great Unknown', *Conn.*, Jan. 1965, illustrates
one of the copies, a tiger lying on the edge of a stream, after Stubbs. Géricault also
copied a lion attacking a horse, probably from the print published in 1788.

[4] The romantic Ceuta story was first published posthumously in the *Sporting
Magazine* for May 1808, see W. S. Sparrow, op. cit. See Basil Taylor, 'George Stubbs:
the *Lion and Horse* Theme', *Burl. Mag.*, Feb. 1965, for a full discussion of the variations.

contribution to European painting.[1] The mystery of breeding invests these solemn paintings with a much deeper meaning than the mere portrayal of equine elegance and grace of movement. At Wentworth Woodhouse a whole room, the Whistlejacket Room named after the champion, was given over to the celebration of the horse, like a chapel to a religious cycle.[2] No doubt the series also appealed to the owner's more practical interest in breeding as science. The masterpiece of the series is *Mares and Foals* [plate 85A; Earl Fitzwilliam, formerly at Wentworth Woodhouse, now at Milton], in which the painter invites us to enter an ideal world of harmony and beauty by composing the group on the principle of a Greek frieze. For the scientifically minded agriculturalists of the day breeding was a symbol of improvement and the pursuit of excellence, and by stamping on his celebration so classic a character Stubbs associated the cult of the horse with both the ideals and the taste of his patron. More directly related to the scientific concerns of his circle, which included John Hunter and Sir Joseph Banks, is the group of wild animals from distant parts of the globe, admired by both scientists and spokesmen. 'His Tiger', wrote Fuseli, 'for grandeur has never been surpassed.'[3] The masterpiece is the *Zebra* (*c.* 1760–3) in the Mellon Collection, which achieves a Blakeian intensity of vision. While not 'burning in the forests of the night', the animal glows against the dark tropical vegetation, and the 'facsimilist's precision' denounced by Fuseli as a vice of Stubbs also anticipates the poet-painter who valued determinate outlines. Quite what Stubbs had as his practical goal in this decade of prodigious effort is unknown, but *A Cheetah with Two Indians* (*c.* 1765) in the Manchester Art Galleries suggests that he had in mind creating a market for what he most wanted to do. The painting commemorates

[1] By Basil Taylor in the introduction to the Whitechapel Art Gallery Exhibition, 1957.

[2] *A Catalogue of Paintings by George Stubbs, A.R.A. from Wentworth Woodhouse,* Messrs. Ellis and Smith, with an appreciation by Sir Alfred Munnings, 1946, and E. K. Waterhouse, 'Lord Fitzwilliam's Sporting Pictures by Stubbs', *Burl. Mag.,* Aug. 1946, 199. See also Sir George Clutton, 'The Cheetah and the Stag', *Burl. Mag.,* Aug. 1970, 536.

[3] In his additions to the Revd. M. Pilkington's *Dictionary of Painting,* 1810 ed. 19.

two cheetahs which were sent to London by Lord Pigot, the Governor of Madras, and became notorious for being too stage-struck to chase a stag in Windsor Great Park before a large and fashionable audience.

A number of animal history paintings were listed in the auction of works unsold in his lifetime: the *Rape of Deianira*, the *Choice of Hercules, Hercules capturing the Cretan Bull*, and the *Infant Saviour treading on a Serpent*. Reynolds singled out for praise the *Fall of Phaeton*, an infelicitous choice. It was the fate of Stubbs, in Henry Angelo's jaunty phrase, to become 'the pet of those lordlings who prefer a racer to Raphael and a stud to the studio of Michelangelo'.[1] A grand neo-baroque equestrian portrait of *Baron de Robeck* (1791) in the collection of Brigadier the Baron de Robeck is exceptional; the demand of society was for his horse portraits and conversation pieces, of which he was a master. His range extended from the Tillemans–Wootton tradition of sporting groups with small figures to the larger scale and richly detailed mode in which Zoffany also worked. *The Melbourne and Milbanke Families* (before 1770) in the collection of the Hon. Lady Normand combines what has been described as a Chinese sense of interval with a masterly spacing and arrangement of the silhouette elements. The *Prince of Wales' Phaeton and State Coachmen* [plate 83A; 1793] differs from this gracious and poetic composition by an almost geometric resolution of the forms subtly breaking the frieze alignment, a formula he adopted in *Two Corporals, a Private and a Trumpeter* (1793), also in the Royal Collection.[2] Both are related to the current vogue for costume and military uniform pictures. His group portraits taken as a whole depict the Arcadia of English aristocratic life in the country without temple and urn, while stressing the favourite out-of-door recreations of riding, hunting, fishing, shooting, and horse-racing.

In 1794 Anthony Pasquin wrote that 'Mr. Gilpin is inferior to Mr. Stubbs in anatomical knowledge, but is superior in grace

[1] *The Reminiscences of Henry Angelo*, with an introduction by Lord Howard de Walden and notes and memoir by H. Lavers Smith, 2 vols., 1904.

[2] Cf. the analysis of Stubbs's composition in Geoffrey Grigson, op. cit., and Basil Taylor, *Animal Painting in England*, Penguin Books, Harmondsworth, 1955 and the introduction to the Whitechapel Art Gallery Exhibition, 1957.

and genius'. The grace was picturesque, the genius more overtly romantic. Sawrey Gilpin (1733–1807) was a younger brother of the picturesque theorist William Gilpin.[1] Much of his work can be traced back to the example of Stubbs. Thus *Mares and Foals in Windsor Great Park*, painted in collaboration with Paul Sandby, in the Royal Collection, develops a favourite theme of Stubbs, whom he also followed in animal history, e.g. *The Election of Darius* (York Art Gallery) with a grandiose architectural background. But his most original and important paintings have no precedent in the work of the older artist. Between 1768 and 1772 he showed at the Society of Artists three paintings illustrating Swift's *Gulliver's Travels*, each depicting an episode from the hero's sojourn among the Houyhnhnms. It is the first romantic, i.e. wholly serious interpretation, of the great satirist, and in this respect may be compared with Daumier's later and profoundly moving renderings of Cervantes's *Don Quixote*. The noble horse had been invented by Swift to support his indictment of man's depravity, but is here celebrated without a satirical sting.

The theme of the frightened horse (or horses) has been described as 'the principal contribution made by English animal painters to the Romantic movement'.[2] Because Sawrey Gilpin had to wait until he was sixty-four for his election as R.A., his Diploma painting of *Horses in a Thunderstorm* [plate 84B; 1797] was executed at the height of his powers. It marks the peak of early romanticism in its picturesque phase. In the same year George Garrard the animal sculptor (1760–1826) exhibited at the Academy *Duncan's Maddened Horses* [plate 84A]. Géricault and Delacroix visited the Academy much later, but it would have been surprising if they had missed Gilpin's painting among the Diploma pictures, and it has been suggested that a plaster cast of Garrard's relief, or its companion of bulls fighting, could have also been seen by them in London.[3] However this may be, the cult of what Payne Knight

[1] For Sawrey Gilpin see Waterhouse, *Painting in Britain*, 220; Basil Taylor, *Animal Painting in Britain*, under index; and A. C. Sewter, 'Four English Illustrative Painters', *Burl. Mag.*, Mar. 1939.

[2] *Catalogue of the Exhibition of Royal Academy Diploma Pictures*, The Arts Council of Great Britain, 1961.

[3] M. Whinney, *Sculpture in Britain*, 173–4.

in a letter of 1777 to Romney called 'the sublime and savage horse' had given rise to both neo-classical and picturesque versions before it was taken up by the French romantics with renewed enthusiasm after their visit to England.[1]

Elevation of animal genre by *terribilità* is represented by another Diploma painting, *Hyena disputing with a Vulture* [plate 86B; 1801] by Philip Reinagle (1749–1833). 'The awesome savagery of the contestants', writes Denys Sutton, 'make this a splendid illustration of what was meant by the sublime in the early years of the Romantic era.'[2] A vulture, a hyena, a hare, and an Andean condor are assembled together according to the principles of typical habitat introduced by Hodges, although their conjunction at one moment of time is highly improbable.[3] Like the other animal painters, Reinagle had to wait a long time for election as R.A. (1812). In 1811, when he just missed, Turner observed that he was 'not fixed in any one point in art'.[4] But his choice for the Diploma painting on his election as A.R.A. clearly shows what he regarded as the highest ground for his admission.

Violence and *terribilità* were out of place in the genre of sentiment, appealing to 'those domestic and familiar incidents from home life and the affections which in France have obtained the name of *Tableaux de genre*'.[5] In this second mode of elevation there was a shift of emphasis from the ragged poverty of rural life to its neat simplicity—the world of Goldsmith's *Vicar of Wakefield* rather than Murillo's beggar-boys. A leading advocate of sentimental genre was Richard Payne Knight, who made the highest claims on behalf of works which evoked 'those tender feelings which we call pathetic'.[6] He owned Richard Westall's *Storm in a Harvest*, which he considered one of the three 'most interesting and affecting pictures that the art has produced'.[7]

1 For Romney's letter see *Conn.*, CXXXV, 1955, 10.

2 'The Reinagles Reconsidered', *C.L.*, 1 Dec. 1955.

3 It therefore falls into a category promoted by Humboldt for its scientific value. See Bernard Smith, *European Vision and the South Pacific*, Oxford, 1960, 4–5.

4 Cited by D. Sutton, op. cit. 1264.

5 R. and S. Redgrave, *A Century of British Painters*, ed. cit. 288.

6 Christopher Hussey, *The Picturesque*, 1966 (1st ed., 1927), 79.

7 Ibid. 267.

It would be difficult to match even in Gainsborough such an idealization of labourers; the young man with a scythe has a face as delicate as the young Mrs. Sheridan in Gainsborough's portrait of the famous beauty. Each of the group of harvesters could be credited with the most affecting emotions and language of Wordsworth's rustics. Westall was not unjustly criticized for introducing 'somewhat of the air of persons in a higher rank in life'.[1] Even when credulity is not strained, as in Henry Walton's *The Silver Age* [plate 90B mid-1770s] in the Mellon Collection, the image is far removed from rustic wretchedness. Here the beautiful girl resting by the wayside with a basket of eggs lacks the obvious pathos of Millais's *Blind Girl*, but arouses sympathy by her solitude and air of earnest reverie.

Whether the subject inculcates a moral lesson or promotes a virtue like charity, pathos is the prevailing sentiment. Morland's *Letitia* or *Seduction* series, painted after his marriage in 1786 and published in coloured mezzotint by J. R. Smith in 1811, tells a story of folly ending in forgiveness, not punishment.[2] Some of his most popular works show the high society of the cottage, and his paintings in this class are executed in the same refined style as *A Visit to the Boarding School*, which appeals to maternal sympathies and hangs appropriately in the Wallace Collection beside the work of Boilly.

Francis Wheatley produced one of the best sellers of the age in the *Cries of London*, which takes up the theme of Marcellus Laroon's *The Cryes of the City of London*, engraved by P. Tempest and published in 1688.[3] Sets have been reproduced and sold steadily from 1792 to at least 1939, their survival in popularity being as much due to sentiment as to the picturesque record of itinerant street vendors and their costumes. Both Wheatley and Walton depicted scenes of street charity, sometimes taken from topics of the day. Thus Walton painted *Esack Basha, a Turkish*

[1] Cited from an early but unidentified press or periodical cutting, the Witt collection of photographs, Courtauld Institute, Westall Box I.

[2] For the *Laetitia* series see G. C. Williamson, *George Morland*, 1907, 34–5, 122–3.

[3] For Wheatley's *Cries of London* see Francis Harvey, 'Stipple Engravings as Practised in England, 1760–1810', *Print Collectors Quarterly*, XVII, 1930. See also M. Webster, *Francis Wheatley*, 1970.

Refugee, engraved by J. R. Smith, 1777, showing a pathetic but noble figure patiently awaiting alms in his Oriental robes.[1] In Wheatley's *Mr. Howard offering Relief to Prisoners* [plate 92B; 1787] the sombre prison is occupied by a cast out of Greuze, but the face of the philanthropist is so lifelike, its expression, at once indignant and compassionate, so convincing, that theatricality is redeemed and the picture becomes a moving document of the humanitarianism of the age. Five years earlier, in 1782, Edward Penny, R.A. (1714–91), the Academy's first Professor of Painting, who had a penchant for scenes of charity, e.g. *The Marquis of Granby relieving a Sick Soldier*, caused a stir by exhibiting *Widow Costard's cow and goods, distrained for taxes, redeemed by the generosity of Johnny Pearmain*.

In the heyday of the genre portrait almost every mode of contemporary genre is assimilated. *Lord Aldborough on Pomposo* [plate 92A] (*c.* 1781; Waddesdon Manor) by Francis Wheatley is based on the tradition of the conversation piece, although the party in the park is now a very large one.[2] The second Earl of Aldborough is shown on his country estate, Belan Park, County Kildare, with his family and close friends. But the occasion is a review of the Irish Volunteer Troops founded during the War of the American Revolution to protect Ireland from French invasion. The correspondences with the military-parade picture then in vogue, particularly with prints representing exercises set in Hyde Park where the fashionable audience occupy the foreground, are striking. At the intimate and wholly private end of the scale the distinction between portraiture and subject picture can be so blurred that, in Fuseli's phrase, one is at a loss to assign the subject to its class. Henry Walton's *Three Young Men with a Boat on the Waveney* [plate 91] (*c.* 1780; formerly collection of Sir Osbert Sitwell) depicts William Crowfoot of Beccles and Randall and Thomas Burroughs of Long Stratton, who each contributed £10 to Walton's price and then drew lots for it. The

[1] See George Kidston, 'The Unfortunate Turk', *C.L.*, 21 June 1946, 1136–7.

[2] For Francis Wheatley see Ross Watson, 'Francis Wheatley in Ireland', *Irish Georgian Society*, Apr.–June 1966, and for Walton, J. Cornforth, 'A Painter of Norfolk Gentry', *C.L.*, 14 Nov. 1963.

picture would make a delightful addition to an ancestral portrait gallery, if only those portrayed belonged to the same family. Like the fancy portraits of Reynolds and Gainsborough, it directs the attention to the subject before arousing curiosity about the sitters.

John Opie (1761–1807), the outstanding figure after Wright in advancing the dignity of genre, combined in his realistic depictions of everyday life something of both the sentimental and the heroic modes.[1] Precociously gifted, he was launched in London as an untaught Rembrandt, 'the Cornish Wonder', by his teacher and champion, Dr. John Wolcot, who published art criticism under the name of Peter Pindar. Opie wrote that he wanted philosophical dignity in old persons, not the 'old fools' of Rubens, and figures that looked sensible and earnest, such as he found in Rembrandt.[2] Surprisingly, Wolcot described his taste as one for rough cider rather than burgundy and champagne, and added more reasonably that he despised elegance as affectation. The alert Fuseli was nearer the mark when he noted the heroic scale on which he worked. 'Not made to dandle a kid, he painted in large historic proportions, misses eloping, beggars, fortune-tellers, cottage visits and what commonly recommends itself to the cabinet or parlour by smallness of size and elaborate finish.'[3] Reynolds praised his work extravagantly to Northcote because he could recognize a likeness to Caravaggio, 'but finer', that is, a likeness to an accredited Old Master, not a Dutch genre painter.[4] Because Opie quickly established himself as a history painter, he had a highly successful career in the Academy, A.R.A. in 1786 at the age of twenty-five, R.A. next year in 1787, and Professor of Painting when Fuseli resigned in 1805. By alternating success-fully between history and genre, he probably did more than any

[1] For Opie see Ada Earland, *John Opie and his Circle*, 1911, mainly biographical, and J. W. S. Armstrong, 'The Early Works of John Opie, R.A.', *Conn.*, Oct. 1934, 245–51.

[2] Letter to the Revd. John Opie, cited by John Jope Rogers, *Opie and his Works*, 1878.

[3] In Pilkington's *Dictionary*, 1810 ed., 362.

[4] Cf. Horace Walpole, letter to the Revd. William Mason, 14 Feb. 1782: 'a new genius, one Opy, a Cornish lad of nineteen, who has taught himself to colour in a strong, bold, masterly style, by studying nature, and painting from beggars and poor children.'

other artist before Wilkie to secure academic recognition for the former category.

The old *Mrs. Delaney* (1782) in the National Portrait Gallery and the boy portrait of *Thomas Abraham of Gurrington* [plate 90A; 1784] in the Mellon Collection signalize the precocity of his development. In the year that he painted the latter he showed at the Academy *The Schoolmistress*, essentially in the same style.[1] He had been taken up in blue-stocking circles, and the group conveys something of the humane ideals of Hannah More's Sunday Schools, although the well-dressed boys clearly come from a different class. Unlike Morland in his *Visit to a Boarding School*, he has turned away from French sentimental models.

The influence of genre on portrait painting greatly widened the range of borrowings from subject pictures taken from everyday life. Both the Scotsman Henry Raeburn and the American John Singleton Copley painted portraits of gentlemen skating on ice; the former's *Reverend Robert Walker D.D. on Duddingston Loch* (*c.* 1784) in the National Gallery of Scotland cuts as elegantly neo-classical a figure as any on a Wedgwood plaque. The conversation piece, with its original roots in genre, was especially open to new ideas from everyday subject pictures. The consequent enlargement of its scope can be demonstrated by a brief retrospective glance at its development since the age of Hogarth. A single family of artists spans the interval, its most distinguished members being Arthur Devis (1711–87) and his son Arthur William Devis (1762–1822). The first was the most striking figure in the category in the central decades of the century, an example of a minor artist cultivating a special talent so exquisitely that for some he is the prince of the conversation piece.[2] *John Orde and his Family* [plate 80A; *c.* 1750–5] in the Mellon Collection typifies his gifts. The mid-eighteenth century was the golden age of the doll's house as a work of art. In England this characteristically rococo cult takes the unusual form of perfectionist

[1] Reproduced in Waterhouse, *British Painting*, plate 164b.

[2] For Devis see 'Biographical Notes on the Devis Family of Painters', *Wal. Soc.* XXV, 1937, and *The Devis Family of Painters*, Leigh-on-Sea, 1950, both by Sidney H. Pavière, and the sensitive appreciation in Sacheverell Sitwell, *Conversation Pieces*, 1936, ch. IV, 'Arthur Devis'.

craftsmanship directed to effects of classical simplicity, in which minute finish is subordinated to clarity, proportion, and arrangement. The use of miniature models was not uncommon at the time, witness Gravelot's dolls and Gainsborough's artificial landscapes set up on tables. Whether Devis used such models or not, it was essentially a doll's-house world that his imagination occupied. His interiors have the rectilinear neatness and dovetailing precision of the model cabinet-maker's masterwork; his landscapes could be cut out for a toy theatre; and his silhouette figures positively invite the scissors. In the deftly articulated space the sitters take up their allotted positions. But the tact in disposing forms in relation to voids, the silhouette frailty of the figures, and the modulated infusion of softly glowing warmth into predominantly cool colours are never mechanical. Devis delighted in the immediacy of his proprietary settings; his observant eye was constantly turned on nature, to which he had a genuinely poetic response; his fresh greens and limpid atmosphere are truly stated. He deserves the tribute of being placed amongst those artists who have created a private world out of reality so compulsively that the spectator enters it on the artist's own terms.

The son went to India in his twentieth year after studying at the Academy and stayed until 1795, exhibiting on his return genre pictures from a series 'illustrative of the arts, manufactures, and agriculture of Bengal'.[1] His project, announced in 1792, to have these engraved and published came to nothing, and was probably another casualty of the collapsed print market. His portraits are academically sophisticated and show little if anything of his father's influence. The break between the first and the second generation is equally marked in the neo-classical conversation pieces of the Anglo-Romans, Gavin Hamilton and Nathaniel Dance (1735–1811), both of whom favoured a larger scale for their Grand Tourist groups and introduced or selected accessories to make a commemorative point. Thus Dance's *Hugh, Duke of Northumberland and his Tutor* (1763) commemorates a

[1] Sir William Foster, 'British Artists in India', *Wal. Soc.* XIX, 1931, 26. For the subsequent history of the scheme and the paintings for it that survive see S. H. Pavière, 'Biographical Notes', op. cit. 141–2.

patron–tutor relationship and shows as objects of study urn and bas-relief against the background of the Colosseum, in a style close to Pompeo Batoni.[1]

The central figure among the conversation painters of the second half of the century was Johann Zoffany (1734/5–1810), who after training in Ratisbon under Martin Speer, a pupil of Solimena, assisted J. Zick on the decorations of the Kurfürst Residenz at Trier and worked in Rome, partly as a copyist of Old Masters.[2] Shortly after his arrival in England about 1761 he was employed as a painter of accessories by Benjamin Wilson (1721–88), the friend of Hogarth and a painter of theatrical subjects. This was a turning-point in his career, for while Zoffany did not invent the theatrical conversation he became its most adept exponent. In 1762 he exhibited Garrick in *The Farmer's Return* at the Society of Artists, choosing the same scene as Hogarth's print. Perhaps it was a bid for the actor's favour, for while he faithfully preserved the idiom of the English mode he displayed an extraordinary skill for minutely particularizing objects as well as individual likeness, thus strengthening the documentary value of the category.

Zoffany further enlarged the scope of the conversation piece by reviving the Teniers tradition of recording collections. In 1772 he returned to Italy, armed with a commission from Queen Charlotte to make a sketch of the Uffizi Gallery.[3] The commission grew into a major undertaking on which he worked for

[1] Reproduced in Waterhouse, *Painting in Britain*, 164A. For the influence of Batoni see the article by William Weddell in the *Leeds Art Calendar*, 1961, nos. 46–7. There are notices of Dance in the *Art Quarterly*, Spring 1961, and by Basil Skinner in the *Burl. Mag.*, July 1957.

[2] Lady Victoria Manners and G. C. Williamson, *John Zoffany: his Life and Works*, 1920, gives the fullest biographical account, valuably supplemented by C. H. S. John in *Bartolozzi, Zoffany and Kauffmann*, 1924, and Sacheverell Sitwell, 'John Zoffany', *Conversation Pieces*, 1956.

For foreign artists working in England see L. Binyon, *Catalogue of Drawings by British Artists and Artists of Foreign Origin working in Great Britain, preserved in the British Museum*, 4 vols., 1898–1907, and John Harris, Geoffrey de Bellaigue, Oliver Millar, *Buckingham Palace*, 1968.

[3] Oliver Millar, *Zoffany and his Tribuna*, 1967, a learned monograph devoted to the picture and its history.

many years. To the surprise and at first annoyance of the King and Queen, he provided in addition a *conversazione* of Grand Tourists presided over by Sir Horace Mann. *The Tribuna of the Uffizi* [plate 82A] was exhibited at the Academy in 1780; ten years later he showed Charles Townley and his friends in *The Townley Collection*, in which an Alaskan dog named Kamchatka lies amongst ancient marbles. His gift for itemizing likenesses as well as objects was most ambitiously displayed in an earlier work which crosses the dividing line between a conversation and an assembly painting, *The Royal Academicians in the Life Class* (1772), a type taken up by Copley and others and culminating in the Napoleonic concourses of David.

Because the conversation piece was now publicly exhibited, it became a prominent medium for advertising claims to social esteem. Once again the gifts of Zoffany were well suited to documenting the social standing, wealth, achievement, and domestic virtues of his sitters. There is a tradition that Handel's *Water Music* (1715) was originally performed for the royal family by the forebears of William Sharp, surgeon to George III. *A Music Party on the Thames* [plate 82B; R.A. 1781] shows his family on a pleasure barge at Fulham, the church of which appears in the background alongside the balconied cottage he kept for recreation.[1] William Sharp holds the tiller; in the centre Granville Sharp, the abolitionist, looks towards Archdeacon Sharp. It is the grandest of Zoffany's decorative conversations, in baroque-rococo contrivance only eclipsed by Copley's *Children of George III* (1785). The boldness of departure from the traditional conversation may be illustrated by comparing it with those portraits, like *Sir Laurence Dundas with his grandson Laurence* (*c.* 1769) in the collection of the Marquess of Zetland, in which the scene of domestic privacy and affection is almost photographically taken from real life. Consummate skill and a jewel-like richness of colour, however, make it as much a display piece as any miniature of the period.

[1] For accounts of this picture see *British Life: A Catalogue of an Exhibition*, The Arts Council of Great Britain, 1953, 10, and the full note by Michael Sevier to Sitwell, *Conversation Pieces*, 94.

Another type of commemorative painting records a topical rather than a typical episode, a heroic event which can only happen once: the *Death of Captain Cook*, painted between 1789 and 1797, the *Plundering of the King's Cellar at Paris* (R.A. 1795), and the most ambitious of his Indian paintings, the *ne plus ultra* of his cumulative manner, the prodigious *Embassy to Calcutta from the Vizier of Oude* (R.A. 1796). The first item of the long explanatory key reads: 'No. 1. A Male Baggage eliphant, irritated by his Driver, who is taken from his Seat and destroy'd; and by the Violence of the Eliphant's Action, are seen the Women and Children falling from his Back, this was the moment when Mr. Zoffany took his Design for the Picture'—a record of exotic *mirabilia* reminiscent of Copley's *Brook Watson and the Shark*.[1]

Zoffany had few rivals and no equals in his documentary conversation pieces of society, but in one branch, the theatrical conversation, he gave the impetus to something like a school. His *Love in a Village* [plate 80B; 1767] in the Detroit Institute of Arts sums up the merits that made the category so popular.[2] The scene is taken from the episode in Bickerstaff's play where Hawthorn expounds his philosophy of life to Justice Woodcock: 'Right, neighbour Woodcock—health, good humour and competence is my motto—and if my executors have a mind, they are welcome to make it my epitaph.' Hodge clasps his hat and straddles his feet with an inelegance which distinguishes him as much as his clothes from his social superiors, just as Hawthorn's exuberance would in its turn be out of place in a London levee. Zoffany did not wholly succeed in reconciling inventory and instantaneity, and never takes us as close to the spontaneity of great acting as Reynolds. But as a vivid record of the contemporary stage his work and that of his followers is unsurpassed.

Among the many artists who painted theatrical conversations, like James Roberts, Benjamin Vandergucht (1753–94), whose *Moody and Parsons in 'The Register Office'* (R.A. 1773; Garrick

[1] The key is taken from the print published by R. Earlom, 12 July 1800. See also Sir William Foster, op. cit. 83.

[2] *English Conversation Pieces of the Eighteenth Century: an Exhibition*, The Detroit Institute of Arts, 1948, cat. no. 29.

Club) is one of the outstanding comic masterpieces of the century, Thomas Hickey, J. H. Mortimer, de Loutherbourg, and those painters for the Shakespeare Gallery who observed the conventions of the stage rather than *istoria*, Benjamin Wilson, the intermediary between Hogarth and Zoffany, may well emerge as a more original figure than has recently been suggested.[1] In *Garrick as Hamlet*, engraved by James McArdell in 1754, and *Garrick and Mrs. Bellamy as Romeo and Juliet*, engraved by Ravenet in 1765, he introduced a Gothic horror style for tragic scenes which even Zoffany followed in *Garrick and Mrs. Pritchard in Macbeth*.[2] In the first of these pictures Garrick starts back from the ghost of his father in what looks more like the forecourt of Strawberry Hill than the ramparts of Elsinore. Of the followers of Zoffany, Samuel de Wilde (1748–1832) notably transmitted the tradition to George Clint (1770–1854) in the nineteenth century. De Wilde's *Bannister and Suett in Sylvester Daggerwood* recalls Devis in the masterly placement of the figures. De Wilde, again like Devis, was fascinated by the single-silhouette figure, which he exploited in a series of actors in famous roles, without ever straying outside the strict limits of the conversation-piece style, in contrast to Lawrence's grand images of *Kemble as Coriolanus* (R.A. 1798) and *Kemble as Hamlet* (1801), landmarks in the history of English romanticism.[3]

The painters of fashionable portraiture and genre were well served by contemporary engravers at a time when the British mezzotinters had brought *la manière noire* to its highest pitch of excellence. Heresy though it may sound, there is a case for preferring on aesthetic grounds John Raphael Smith's engraving

[1] An article by E. I. Musgrave, 'A Native Painter: Benjamin Wilson', *Leeds Art Calendar*, Autumn, 1947, does justice to his scientific activities and contacts with Enlightenment circles. See also G. L. E. Turner, 'A Portrait of James Short F.R.S.', *Notes and Records of the Royal Society of London*, Sept. 1967.

[2] Reproduced in W. Moelwyn Merchant, *Shakespeare and the Artist*, 1959, plates 12*a* and *b* and 13*a*.

[3] For the theatrical conversation see C. K. Adams, *A Catalogue of the Pictures in the Garrick Club*, 1936. In Malcolm C. Salaman, *The Old Engravers of England in their relation to Contemporary Life and Art 1540–1800*, 1966, there are numerous references to theatrical subjects which are still valuable. For Lawrence and Kemble see O.H.E.A. X. 12.

of *Mrs. Carwardine and Child* [plate 78A], one of the first pictures painted by Romney after his return from Italy in 1775, to the original, a masterly adaptation to domestic portraiture of Raphael's *Madonna della Sedia*, which Romney had admired in the Pitti Palace. Wright in particular was superbly interpreted by William Pether, Valentine Green, and Richard Earlom in what as a group may be considered the greatest mezzotints of the century. In contrast to heroic genre, the genre of sentiment lent itself to the colour print, the history of which may be briefly taken up at this point. The Frankfurt artist Jacob Christoph Le Blon (b. 1667), who became interested in the colour-light theories propounded by Newton in his *Optics* (1702, Latin text 1704) while working in Holland, published his *Coloritto* between 1723 and 1726; his experiments and those of his contemporary Elisha Kirkall in multi-block colour printing and multi-colour printing off a single intaglio plate were followed by John Baptist Jackson (*c.* 1701–*c.* 1770), whose *Essay on the Invention of Engraving and Printing in Chiaroscuro* (1754) contains a reference to his imitation of painting in 'water-colours', i.e. body colours.[1] In the same year Jackson, who had specialized in black-and-white engravings after the great Venetians, a key task because the lack of colour had to be compensated by richness of texture, opened his factory in Battersea for the manufacture of coloured wallpapers, the 'Jackson's papers' with which Walpole delightedly hung a room at Strawberry Hill. The idea of a Newtonian solution to the problem of colour reproduction haunted the commercially ambitious, like the glass-painter Francis Eginton of Birmingham, who entered into a partnership with Matthew Boulton in 1777–80 to exploit a process of 'mechanical painting' with oil and water-colours, and the promoters of the much-publicized Polygraphic Society in the late 1780s.[2] Meanwhile in France J. C. François, Gilles Demarteau,

[1] See Jacob Kainen, *John Baptist Jackson, 18th Century Master of the Colour Woodcut*, Washington, 1962, and Adolph S. Cavallo, 'John Baptist Jackson in Scotland', *Art Bull.*, June 1964, 233–7. In addition to Hans W. Singer, *J. C. Le Blon*, Vien, 1901 (English translation, 1903), I have found useful G. Wildenstein, 'Jacob Christoffel Le Blon ou le secret de peindre en gravant', *Gaz. des Beaux-Arts*, 1923, and a notice on 'Le Blond & Co. Printers' in *Antiques*, June 1937.

[2] For Eginton see Christopher Woodforde, *English Stained and Painted Glass*,

and others had made great advances, 'dans le genre qui imite le crayon', both red and black. Crayon engraving led to a revival and decisive improvement of stipple engraving, which became a rival to mezzotint, especially in England.[1] Apparently around 1760 William Wynne Ryland learned the secrets of both techniques in Paris, but instead of printing colours from several plates used the simpler method of applying all his colours 'à la poupée', that is, with rag dollies, to a single plate. After his bankruptcy in 1771 he petitioned Angelica Kauffmann for permission to print her designs in coloured stipple, and his success led to widespread imitation. Before he was executed for forging banknotes Ryland taught the method to Bartolozzi, who founded the English school of stipple engraving. His monochrome stipples were generally superior to the coloured ones. In 1774–5 Paul Sandby similarly introduced the aquatint process in England, following the successful experiments of Jean-Baptiste Le Prince, the Abbé de St. Non, and Per Gustav Flodny over three decades.[2] Stipple, mezzotint, and aquatint provided a far superior tonal background to colour printing than did line engraving. As regards the reproductive similitude that was the principal aim of the pioneer experimentalists, the technical difficulties proved insuperable, with the exception of aquatint, which did correspond approximately to tinted drawings. Two courses remained open. The first was to colour wholly or at least in the final stages by hand, thus providing employment for a small army of specialists, including young artists struggling to make their way. The second was to sacrifice similitude to prettiness of effect. In stipple or mezzotint the results of this second course were so appealing that according to one

Oxford, 1954. The main protagonists of colour-process experiments are noted in Whitley, II. and S. T. Prideaux, *Aquatint Engraving*, 1909. See also J. Frankau, *Eighteenth Century Colour Prints*, 1900, and for the background of scientific ideas, R. C. Teevan and R. C. Birney, *Colour Vision*, New Jersey, 1961.

[1] See Francis Harvey, 'Stipple Engraving in England', *Print Collectors Quarterly*, Jan. 1930, 59–71.

[2] A. M. Hind, 'Notes on the History of soft-ground Etching and Aquatint', *Print Collectors Quarterly*, Dec. 1921, 377–405, where isolated earlier examples are noted. J. R. Abbey, *Scenery of Great Britain and Ireland in Aquatint and Lithography 1770–1860*, London, privately printed, 1952, is a monumental study and catalogue which reveals the impact of the media on picturesque topography.

authority the colour prints created 'the sentimental mood for the storied picture'.[1]

The expansion of the colour print in the closing decades of the century created a booming industry until the war with France brought about a collapse, in which stipple engraving was a principal casualty. Aquatint continued to flourish well into the nineteenth century, although after 1840 it steadily lost ground to lithography, introduced into England by Philipp André and pioneered by Benjamin West in 1798.[2] In addition to the genre of sentiment, decorative allegories and mythologies, literary illustrations, the fancy picture, and a type of portrait allied to it, e.g. the buxom beauties painted by the Reverend Matthew William Peters (1742–1814), the colour print satisfied the popular demand for military costume pictures, sporting genre, cottage genre, the genre of spectacle, e.g. military parades, fairs, fashionable promenades, and balloon ascents, and picturesque topography. Thomas Stothard (1755–1834), who practised successfully in almost all these categories before the close of the century, typifies a trend of the reproductive engraver to compete with his sources by furnishing similar designs, a trend which can be traced back to the first engravers after painters as different as Morland and Angelica Kauffmann once they had discovered how easy it was to construct pictures in the new and prettily artificial artistic language.

There remains one category of genre in the sense of scenes from everyday life which by its nature was immune from elevation, namely, caricature.[3] In 1742 Fielding had defined its

[1] M. C. Salaman, *Old English Colour Prints*, Studio, Special Number, Winter 1909–10.

[2] See K. K. Andrews, '*Incunables* in the print collection of the Liverpool Public Libraries', *The Liverpool Bulletin*, vol. VI, nos. 1 and 2, Oct. 1956, 67, for a full discussion of West's *Angel*, described at the time as a Polyautograph. It was published in André's *Specimens of Polyautography* in 1803. For André see Felix H. Mann, *Artists' Lithographs*, New York, 1970, 15–16.

[3] The fullest record is the *Catalogue of Prints and Drawings in the British Museum. Division I. Political and Personal Satires*, vols. II to IV, 1873–83, by E. Hawkins and F. G. Stephens, later continued by D. M. George, vols. V–VII (not illustrated). The best accounts are *English Political Caricature: a Study of Opinion and Propaganda*, vol. I to 1792, vol. II 1793–1832, Oxford, 1959, and *Hogarth to Cruikshank: Social Change in Graphic Satire*, both by Dorothy M. George. An excellent source of

aim as the depiction of 'monsters, not men', and correctly identified
exaggeration or distortion of form or feature as the essential
element.[1] Twenty-five etchings of caricature portraits after
Ghezzi, published by Arthur Pond between 1736 and 1747, may
be taken as the English point of departure.[2] Basically, the carica-
ture conversation pieces of Grand Tourists painted by Reynolds
and Thomas Patch [plates 94A and B] in Italy from the 1750s
exaggerate the features of the originals without going beyond the
limits of possibility, e.g. a nose as grotesquely enlarged could
possibly be found in a *Lusus naturae*. Walpole noted the appearance
of 'a new species' of graphic satire in the 'caricaturas on cards'
invented by the amateur George Townshend, later Marquis, and
published in joint enterprise with the engraver Matthew Darly
in 1756.[3] A 'card' on *Fox and Newcastle* [plate 95A; 1761] illustrates
the momentous association of distortion with fantasy in a political
cartoon. What Walpole described as Townshend's 'talent for
buffoonery' was accompanied by a characteristically amateur gift
for 'drawing that was incorrect and expressive, an art superbly
practised by Max Beerbohm'.[4] His example was followed by a
host of political and social caricaturists, so effectively that by the
1780s political caricature was regarded on the Continent as a
peculiarly English excellence. The ridicule of fashion encouraged
the caricaturist to go to extreme lengths. In *La Françoise à
Londres*, engraved in 1771 after a drawing by S. H. Grimm, the
head-dress almost dwarfs the mountain in the picture behind it.[5]

illustration, with many contemporary references, is George Paston, *Social Caricature
in the Eighteenth Century*, 1905. *Hogarth and English Caricature*, edited by F. D. Kling-
ender, London and New York, 1944, is a finely selected picture book with a short but
stimulating text.

[1] In the Preface to *Joseph Andrews*. Cf. the observations in E. Kris and E. H. Gom-
brich, 'The Principles of Caricature', *British Journal of Medical Psychology*, XVII,
1938, 319–42.

[2] See H. M. Hake, 'Pond and Knapton's Imitations of Drawings', *Print Collectors
Quarterly*, IX, 1922, 325 ff.

[3] *Memoirs of the Reign of King George the Second*, ed. Lord Holland, 1846, II. 228;
Memoirs of the Reign of George III, I. 24. For Townshend see also R. W. Ketton-
Cramer, 'An Early Political Caricaturist', *C.L.*, 30 Jan. 1965, 214–16.

[4] Dorothy M. George, *English Political Caricature to 1792*, 112.

[5] Reproduced in George Paston, *Social Caricature*, plate CCIII.

In 1792 Richard Newton published a curiously Thurber-like coloured engraving, *Nymphs Bathing* [plate 95B], which might be subtitled *Les Fauves du Tamise*, with its witty allusions to the Rubenesque and *Les Baigneuses* of rococo artists.

James Gillray (1757–1815) stands at the head of those who cultivated the *outré* without losing touch with reality, and by his formal inventions in a strongly baroque language he established one of the main satirical traditions of the nineteenth century.[1] In contrast to the robustness of caricature, a delicate and decorative style was favoured for comic genre, where overloading was either absent or limited to accessories, as in the coloured mezzotint and stipple engravings published by the firm of Carrington Bowles. A number of able artists, like H. W. Bunbury (1750–1811), whom Horace Walpole called the second Hogarth, alternated between caricature, with its bias to the coarse, and comic genre, the satire of which was coated with the sugar of elegance.

Almost all the varieties of genre in the second half of the eighteenth century are reflected in the art of Thomas Rowlandson (1757–1827) who entered the Academy Schools in 1772 but absented himself for a study period of uncertain length in Paris.[2] He set his first course for an orthodox career in portraiture and history painting, exhibiting a drawing, *Dalilah payeth Samson a visit while in Prison at Gaza* in 1775, when the cult of Milton was in full swing. His *Imitations of Modern Drawings*, pastiches after Cipriani, Gainsborough, Barrett, Wheatley, and Mortimer, published in 1788 show how cleverly he had studied the elevated style of his contemporaries in figure drawing and landscape composition. He took up the recently fashionable promenade picture and gave it a new twist by the animation of his figures and inventiveness in handling large groups. *La Place des Victoires à Paris*, which created a stir in 1783, was followed by the triumph of *Vauxhall*

[1] O.H.E.A. X. 57–8.

[2] An excellent introduction to Rowlandson in *A Catalogue of the Watercolour Drawings by Thomas Rowlandson in the London Museum*, H.M.S.O., 1960, by John Hayes, with a select bibliography which includes the monographs by Joseph Grego, A. P. Oppé, and Bernard Falk and the valuable study of Edward C. J. Wolf, *Rowlandson and his Illustrations of Eighteenth-century Literature*, Copenhagen 1945. See also F. Gordon Roe, *Rowlandson : the Life and Art of a British Genius*, Leigh-on-Sea, 1947.

Gardens (1784), engraved by R. Pollard, the aquatint by F. Jukes, still one of his most sought-after works. From this it was a natural transition to military parade pictures, e.g. *An English Review* and *A French Review*, both published in 1786.

In deserting the high road of the Old Masters for the bypaths of comic genre and the picturesque, Rowlandson did not forget his learned training. Wilenski has identified groups borrowed from Rubens's *Kermesse*, and many other examples of witty adaptation could be given. In the Indian Summer of the mock epic he found an ideal task in illustrating the *Three Tours of Dr. Syntax* (1812–21) by William Combe in which he depicted his clergyman hero as the Don Quixote of the picturesque, armed with brushes, paintbox, and umbrella instead of lance, breastplate, and shield, and riding gallantly through the Lake District instead of the Sierra Morena.[1] The formal language of his genre sketches and caricatures is sometimes mannered, a kind of calligraphic shorthand, especially in the background, but the rich baroque exuberance of his fancy is in his best work supported by a masterly skill in drawing and a delicacy of perception which extends to colour and tone as well as line. Last but not least, he renewed the Hogarthian attack on the connoisseurs and their imported values, thereby striking a blow for contemporary English life and the English scene as subjects for art. By teaching his age to laugh at itself, he cleared the ground of a lot of rubbish which stood in the way of those who were trying to see nature without conjuring up ideas for its classical improvement. In so doing he became not the least powerful ally of those pioneers of heroic and sentimental genre who were emancipating art from the tyranny of a hierarchical scale of categories inherited from the past, although he chose to parody their elevated style.

[1] For Rowlandson in the context of mock-heroic epic see Joseph Burke, 'Hogarth, Handel and Roubiliac: A Note on the Interrelationship of the Arts in England, *c.* 1730–1760', *Eighteenth-century Studies*, vol. III, no. 2, Winter 1970, 159.

THE PIONEERS OF
NEO-CLASSICISM IN ARCHITECTURE
STUART, CHAMBERS, AND ADAM

WHEN Voltaire noted that the members of the English Parliament were fond of comparing themselves with the Old Romans he paid a tribute to Whig foreign policy: 'the greatest defect in the Government of the Romans raised them to be conquerors . . . the English are not fired with the splendid folly of making conquests, but would only prevent their neighbours from conquering.'[1] The setbacks that led to the Seven Years War declared in 1756 and the recall of Pitt summoned the nation once more to war with France, but this time the outcome was the expansion of an empire by conquest. Improvement and expansion are the two goals that unify the varied achievements of the second half of the century: the Age of Improvement and the Age of Expansion would be equally valid titles.

Neo-classicism is the new classicism that arose in an age of archaeological discovery and a more critical awareness of the processes of history, and its mature phase coincided with the rise of romanticism.[2] Some recent studies have stressed its revolutionary character, one going so far as to claim an overthrow of the classical system from within the classical camp.[3] Others have concentrated on the drive to imitate antiquity more correctly than in the past.[4] These two approaches appear contradictory,

[1] *Voltaire's England*, ed. Desmond Flower, 1950, 38–9.

[2] See chapter 25, 'Neo-classicism: Englishmen abroad', in Summerson, *Architecture in Britain*, for the nature and origins of the movement, and especially its historical view of antiquity.

[3] E. Kaufmann, *Architecture in The Age of Reason*, Cambridge, Mass., 1955, chapter VII.

[4] The authoritative study of English neo-classicism in relation to the antique is David Irwin, *English Neoclassical Art: Studies in Inspiration and Taste*, 1966. *Transformations in Late Eighteenth Century Art*, Princeton, N.J., 1967, by Robert Rosenblum,

but are reconcilable. The vast increases in materials for imitation made reappraisal inevitable and prompted a discriminating search for the purest models. At the same time their very diversity was a challenge to previous assumptions, and encouraged freedom in handling the classical forms.

A central clearing-house of neo-classicism was the French Academy in Rome, where the classicist propaganda of the Comte de Caylus bore fruit.[1] He had accumulated immense materials in Paris for the visual study of ancient art engravings, which favoured a linear mode of depiction. The Greek vases excavated on Italian soil and believed to be in part Etruscan were also published in engravings. Their figurative decoration was profusely illustrated and especially promoted the cult of an outline style, at a time when Winckelmann was proclaiming clarity of contour as an excellence of Greek sculpture. The fundamental problems of a revised notion of ancient art were posed by two sets of dis-coveries for which the learned world was unprepared. The first was the excavations at Herculaneum from 1711 and Pompeii from 1733, the full impact of which was delayed until the publica-tions of the *Accademia Ercolense* appeared from 1755. These proved Palladio to be altogether wrong in his theories about the nature of the ancient house, theories which had so profoundly influenced domestic architecture.[2] The exposure of Palladio's fallibility accom-panied and supported a widespread attack on rules.[3]

is a learned and highly original contribution to the debate on neo-classicism, which has been brilliantly surveyed as a European movement by Hugh Honour in *Neo-classicism*, Penguin Books, Harmondsworth, 1962.

An important study recently published is J. Mordaunt Crook, *The Greek Revival: Neo-classical Attitudes in British Architecture, 1760–1870*, 1972. See also *The Age of Neo-classicism*, The Arts Council of Great Britain, London, 1972.

[1] See chapter I, 'The Comte de Caylus and the Great Amateurs' and Appendix A, List of Works by the Comte de Caylus, in Lady Dilke, *French Engravers and Draughts-men of the XVIIIth Century*, 1902, and for the French Academy in Rome in this period, Jean Locquin, *La Peinture d'histoire en France de 1747 à 1785*, Paris, 1912.

[2] For Palladio's theory that private houses 'first gave rise to publick edifices' see the Preface to book I of the *Quattro libri*.

[3] For attacks on rules from opposite camps see Horace Walpole's strictures in F. W. Hilles and P. B. Daghlian, *Anecdotes of Painting*, volume V, New Haven, Conn., 1937, and William Gilpin, *Observations relative chiefly to Picturesque Beauty*, 2nd ed., 1788, I. 26–7.

The second discovery was, quite simply, Greek art. In July 1759 the *Gentleman's Magazine*, which made a special feature of up-to-date reports on art and archaeology overseas, declared that 'the Romans were only the petty imitators of the Greeks'. It went on to censure Palladio for introducing porticoes and ornaments not to be found in ancient models. In the same spirit of opposition to orthodoxy it stated that the 'Ancient Temples' were 'nothing compared with the spacious magnificence of Gothic cathedrals'. The realization that antiquity was separated not only from the Dark and Middle Ages but from the Renaissance and Palladio was followed by the realization that antiquity was separated *within itself*, thus giving rise to the debate between the devotees of Greek simplicity and the admirers of Roman grandeur.

The English took the lead in both areas of archaeological discovery after the excavations in the Kingdom of Naples, where Greek as well as Roman remains were uncovered. As early as 1744 the Society of Dilettanti were in possession of a fragment of the Parthenon frieze.[1] In 1748 James Stuart and Nicholas Revett issued their 'Proposals for publishing an Accurate Description of the Antiquities of Athens', the publication of which was later undertaken by Colonel George Gray, Secretary and Treasurer to the Society.[2] A group of Dilettanti in Rome agreed to finance the expedition, which arrived in Athens on 18 March 1751. In May Stuart and Revett were found at work by Robert Wood and James Dawkins, whose companion John Bouverie had died in Smyrna on 8 September 1750.[3] It must have been a remarkable confrontation between the pioneers of the two archaeological groups, one concentrating on Greece and the South Italian Greek colonies, the other on the Roman Empire and its Hellenistic inheritance.

The English were quicker to publish in the Roman field than in the Greek. *The Ruins of Palmyra, otherwise Tedmor, in the Desert*

[1] For this and other fragments taken before Lord Elgin's expedition see A. Michaelis, *Der Parthenon*, Leipzig, 1871, 249, 250, and Lionel Cust and Sidney Colvin, *History of the Society of Dilettanti*, 1898, 105.

[2] Colvin, *D.E.A.*, 581-2.

[3] Adolf Michaelis, *Ancient Marbles in Great Britain*, 1882, **115**.

(1753) by Robert Wood has the honour to be the first of the long line of English expeditionary publications.[1] A Frenchman, J. D. Le Roy, came out with *Les Ruines des plus beaux monuments de la Grèce* in 1758, well before Stuart and Revett published the first volume of *The Antiquities of Athens* (1762), which did not even include the Parthenon. The splendid vase publications of Sir William Hamilton, who was given special facilities for collecting and encouraging excavation by Charles of Bourbon, King of Naples, commence in 1766.[2] More decisive for the future of the Graecists in England, their ranks did not include any architects approaching the stature and energy of the Romanists William Chambers and Robert Adam.

It has been noted that artists who brought back new ideas from the Grand Tour quickly adapted themselves to the latest developments in the local situation. It is therefore to the changes that took place between the first wave of classicism in the century and the second that we must look for the national foundations of English neo-classical architecture. The Palladian tradition had been carried on by a younger generation who considerably modified it. Isaac Ware (d. 1766) had admitted the rococo style both in his theory and practice, with certain reservations. He advocated a discreet use of French ornaments with 'better figures' and their confinement to a classical frame.[3] At Clifton Hill House, Bristol (1746–50), 'the formal Palladian arrangement of the panels contrasts with the delicate and wayward freedom of the Rococo ornament within them'.[4] He counselled the architect to satisfy

[1] The account of the publications in Michaelis, op. cit., is supplemented by David Irwin, *English Neoclassical Art*, 1966, with an excellent bibliography, and for the wider background of Hellenism see M. L. Clarke, *Greek Studies in England 1700–1830*, Cambridge, 1945.

[2] Pierre François Hugues, called D'Hancarville, *Collection of Etruscan, Greek and Roman Antiquities, from the Cabinet of the Hon. W. Hamilton*, 4 vols., Naples, 1766–7. For the activities and influence of Hamilton see Brian Fothergill, *Sir William Hamilton, Envoy Extraordinary*, 1969.

[3] In his remarks on interior decoration in his *Complete Body of Architecture*, 1756, Ware even 'ventures to lead the student into all Fancy's wildness'. His part in the decline of Palladianism is ably assessed by John Fleming, 'Architecture and Interior Decoration' in *The Early Georgian Period 1714–1760*, The Connoisseur Period Guides, 1957, 27. [4] W. Ison, *The Georgian Buildings of Bristol*, 1952, 181.

the modern taste for fancy, variety, and elegance without violence to classical principles. At Wrotham Park, Middlesex [plate 96A; 1754], for Admiral Byng, he integrated the 1–3–1 formula of the villa façade with the great-house plan of Wanstead III and, by a bold compression of the wings, created the effect of 'a single continuous house', a landmark in the integration of villa and great-house ideas.[1] Thomas Hardwick in an often quoted passage in his memoir of Chambers (1825) stated that Paine and Taylor nearly divided the practice of the profession between them until Robert Adam entered the lists.[2] Both did much to establish a new *professional* conception of the architect. James Paine (c. 1716–89) began his official career as Clerk of the Works at Greenwich, apparently under the patronage of Richard Arundell, who as a former Surveyor-General had been so active in promoting the Burlington School. Thereafter he became President of the Society of Artists (1771–2) and High Sheriff of Surrey (1783), the former a position he did not owe to a patron. Sir Robert Taylor (1714–88), who succeeded Chambers as Architect of the King's Works in 1769, was the first leading architect to cultivate a banking and commercial connection, becoming Sheriff of London in 1782. His foresight in doing so helped him to amass a fortune of £180,000 the bulk of which he left to found the Taylorian Institute for the teaching of modern European languages at Oxford. Both were successful in obtaining commissions for civic as well as State public works.

Paine is of special interest as the major architect of country houses before Adam. The cause of Roman magnificence in Palladian mansions was splendidly upheld by his work for great landowners. At Kedleston (1757–61) for Lord Scarsdale he based his plan on one of the grandest of Palladio's country houses, the Villa Mocenigo with its four pavilions splayed out by wings from the central pile. On the garden front he projected a Pantheon-

[1] Summerson, 'The Classical Country House in 18th-Century England', *Journal of the Royal Society of Arts*, July 1959, 578. Summerson notes that a similar compression already appears in Harewood House (1759), without a true villa centre, ibid. 556.

[2] Prefixed to Joseph Gwilt's edition of Sir William Chambers, *The Decorative Part of Civil Architecture*, 1825.

like drawing-room, the greater part of its circle jutting out like a Temple of Vesta embedded in the block, an idea for which Adam substituted Constantine's Triumphal Arch.[1] Adam also revised his design for a basilican entrance hall, but the entrance or north front stands largely as Paine designed it, a handsome essay in orthodox neo-Palladianism. His Egyptian Hall at Worksop Manor, Nottinghamshire (1763–79; demolished *c.* 1840) for the Duke of Norfolk was 140 feet long and must have been equally impressive. Finally at Wardour Castle, Wiltshire [Plate 97; 1768–76], for another Roman Catholic grandee, Lord Arundell, he built one of the most spectacular of all entrance halls in the British Isles, introducing the beauties of the colonnaded circular temple inside the house and by this inversion, the high podium, and the sweep of the staircase he created an unrivalled effect of propylaean ascent.

Paine forged the central link between the country-house styles of the first and second halves of the century, a service performed for civic architecture by Sir Robert Taylor (1714–88). The son of a contractor and Master of the Mason's Company, he was apprenticed to Sir Henry Cheere and after a short visit to Rome made his mark as a sculptor before turning to architecture. His major work at the Bank of England (1766–83) was partly rebuilt by his successor as Surveyor to the Bank, John Soane. A notable innovation was the adaptation of the vaulted nave system of St. Martin-in-the-Fields to the three halls adjoining the Rotunda. More influential was the design of the Stone Buildings, Lincoln's Inn (1774–80), a commission won against the competition of Adam, Paine, and Brettingham, for here he returned to the precedents of Inigo Jones's Piazzas at Covent Garden and the Circus at Bath in avoiding a central pedimented emphasis. The palatial building thus avoided giving a place of honour to a particular tenant.[2] The idea of the corporate equality of residents in a grand unit was taken up by others, notably John Carr in

[1] His plan is reproduced in C. Hussey, *Mid-Georgian 1760–1800*, fig. 127.

[2] Reproduced in J. Lees-Milne, *The Age of Adam*, 1947, fig. 17. For Taylor's work at the Bank of England, now wholly replaced, see H. R. Steele and F. R. Yerbury, *The Old Bank of England*, 1930.

his majestic Crescent at Buxton (1779–84), and thus transmitted to Nash.

In his largest country house, Heveningham Hall, Suffolk [plate 96B; 1778–88], for Sir Gerard Vanneck, son of the Whig merchant banker, Taylor proclaimed civic grandeur in the countryside. As Hussey has pointed out, he handled the elevation with a continuity of plane akin to a street terrace in London or Bath, or his own Stone Buildings.[1] The centre-piece has almost a touch of the garden front at Versailles, but a closer and more immediate source is the Strand front of Somerset House. The proud assertion of *urbs romana in rure anglicana* is wholly appropriate to the self-confidence of a great banking family establishing its posterity on the land. For a civic grandee who wished to realize a very different ideal of recreation, Sir Charles Asgill, Lord Mayor of London, he had built not a country house but a Thames-side villa, Asgill House, Twickenham (1757–8).[2] The edges of this severely neo-classical composition of cubic, polygonal, and triangular shapes were left hard or unframed by quoins or pilasters. Ornament was eliminated or reduced to the barest accentuation, for example, the triangle of the pediment over the central first-floor window on the river front echoes the sloping sides of the roof. Asgill House is abstract in the two senses of shape and withdrawal, a much more private conception of the villa than Chiswick, which was both retreat and show-piece. It stands today as one of the most charming examples of a trend to abstraction which can be noted at Paine's Gosforth Hall, Northumberland (1755–64; gutted in 1914), and Axwell Park, Durham (1758), and in the very advanced compositions of William Thomas, architect to the Duke of Clarence, published as *Original Designs in Architecture* (1783).

Asgill House is a striking reminder that the stage was set for a sympathetic reception of the severer models of antiquity as these became better known. The first to make use of a Greek original in designing a building was James Stuart (1713–88),

[1] M.G. 167.

[2] Cf. Christopher Hussey, 'Asgill House', *C.L.*, 9 June 1944. There have been some alterations, but its original appearance is illustrated in Summerson, *Architecture in Britain*, plate 130.

who is said to have 'caught the idea' of architectural science from
his collaborator Nicholas Revett.[1] Within three years of his arrival
he chose the Theseion at Athens as the model for a prostyle
Doric temple (1758) at Hagley Park for Lord Lyttelton, 'the
earliest monument of the Greek Revival anywhere in the world'.[2]
In so doing he translated the noble temple below the Acropolis
into a summer-house on a hill. On another hill at Hagley stood
Sanderson Miller's Gothic Castle. But Stuart cannot be credited
with the identification of Doric with primitive simplicity, a
conception very different from 'the Simplicity of the Ancients'.
He was nicknamed Athenian for his taste, not his barbarity, and
he conceived his little building as a gazebo for an English peer,
not a hut for a Hottentot chief.[3] If he thought of his temple as
a rival to the sham castle, it was probably in terms of contrast. But
in the very year (1762) that Horace Walpole distinguished between
the taste essential for Greek and the passions wanted to feel Gothic,
Bishop Hurd asserted that 'Greek antiquity very much resembles
the Gothic', i.e. the barbarous, and in his comparison of the
Heroic and Gothic manners referred to 'the simple and uncon-
trolled barbarity of the Grecian'.[4] The Greek barbarian was Homer.
In 1768 Paestum was cited by Thomas Major as showing 'the
state of Grecian architecture in its infancy'.[5] The art of the Middle
Ages had originally been called Gothic or barbarous to oppose
it more sharply to the art of Antiquity. Now that Homer was
actually praised for being barbarous, the two cultures were no
longer thought of as incompatibles.

Previously employed by Lewis Goupy the fan-painter in

[1] The best accounts of Stuart are 'Stuart and Revett: Their literary and architectural
careers', *J.W.C.I.* II, 1938–9, and 'The Rise of Neo-classical Architecture in England',
M.A. Thesis, London University, both by Lesley Lawrence.

[2] N. Pevsner and S. Lang, 'Apollo or Baboon', *Arch. Rev.*, Dec. 1948.

[3] Cf. N. Pevsner and S. Lang, op. cit., for the primitivist associations of Doric.
The analogy of Greek and Hottentot was made by Lord Kames in his *Elements of
Criticism* (1762), thus anticipating the attack of Chambers.

[4] *A. of P.* I. 119, and Bishop Richard Hurd in *Letters on Chivalry and Romance*, 1762.

[5] See S. Lang, 'The Early Publication of the Temples at Paestum', *J.W.C.I.* XIII,
1950, citing *The Ruins of Paestum, otherwise Posidonia, in Magna Graecia*, London,
1768, by Thomas Major, whose career is discussed by H. A. Hammelmann, 'The
First Engraver at the R.A.', *C.L.*, 14 Sept. 1967.

London, and in Italy the friend of 'Old Nulty' the antiquarian, also a fan-painter, Stuart was not a romantic primitivist with a bias to the early Doric of Paestum.[1] His most important patron was a fellow Dilettante, Thomas Anson, who wished to make his seat at Shugborough, Staffordshire, a memorial to his younger brother the naval hero and circumnavigator of the globe.[2] On 15 June 1744 George Anson had returned to Spithead after his famous voyage lasting three years and nine months, and brought with him £500,000 of Spanish treasure, to be immediately promoted Rear-Admiral of the Blue by the Admiralty. About 1747 he contributed to Shugborough a Chinese House from drawings made in Canton by one of his officers, Sir Peircy Brett, the first known attempt at authenticity in the imitation of Chinese architecture in an English garden. On his death in 1762 he left his fortune to his sister, but Thomas was wealthy enough to build a London house, 15 St. James's Square, and employ Nollekens, Jenkins, and others in Rome to collect paintings, sculpture, and medals on his behalf.

The gardens at Shugborough are both the first and the finest example of neo-classical landscape design in England. The two collaborators—for Anson, who had himself travelled to visit classical sites in Asia Minor, must be given his share of the credit—broke with the pictorial tradition of framed views inspired by the landscapes of Claude and Poussin and scattered the monuments as they had seen them in open country. The rooms of state on the garden site looked straight out on to Stuart's ruins [plate 100C]. A painting of c. 1769 by the Danish scene-painter N. T. Dall shows a Triumphal Arch copied from Hadrian's Arch at Athens and a Lantern of Demosthenes, a title current for the Choragic Monument of Lysicrates, both in isolation from trees and shrubbery, which barely encroach on a Temple of the Winds, also taken from Athens [plate 100B]. The trophies of the naval hero adorn the

[1] For Nulty and Stuart see the 'Memoirs of Thomas Jones', *Wal. Soc.* XXXII, 1951, 72.

[2] See the article on Shugborough in C. Hussey, *M.G.* 79–85, on which this account is based, and *Shugborough*, National Trust Guide, 1966.

For Thomas Wright at Shugborough see Eileen Harris, 'The Architecture of Thomas Wright', *C.L.*, 1971, 546–50.

Arch, while the extent of his travels is indicated by the Chinese House and a tall Pagoda. Inside the house the grandeur of Rome was borrowed by Dall from Piranesi's *Della magnificenza* in huge monochrome ruin scenes adorning the Great Dining Room, adapted to match the glory of Greece from the *Antiquities of Athens*; dinners of state were served with an armorial set of 197 pieces presented to Admiral Anson by the merchants of Canton. While as much a monument to a single hero as Blenheim, Shugborough evokes a world of discovery rather than battle, and thus fittingly links Anson's name with the archaeological zeal of his age.

Most of Stuart's other patrons were also members of the Society of Dilettanti. For Earl Spencer he designed the splendid interiors on the first floor of Spencer House from 1760, the first grand scheme of Roman decoration revised by a Graecist, thus earning the tribute of Robert Adam that he introduced 'the true style of antique decoration' in England.[1] Montagu, afterwards Portman, House, Portman Square (*c.* 1775–82) for Mrs. Elizabeth Montagu, was admired by Horace Walpole as 'a noble simple edifice . . . grand, not tawdry, nor larded and embroidered and pomponned with shreds and remnants, and clinquant like all the Harlequinades of Adam, which never let the eye repose a monent'.[2] The 'Harlequinades of Adam' was Walpole's way of disparaging the rococo elements of his style. Stuart's one complete country house was Belvedere, near Erith, Kent, for Sir Sampson Gideon, later Lord Eardley, a notable Grand Tourist and Dilettante who was painted in Rome by Pompeo Batoni. Its style is Palladian, suitably chastened. Greenwich Hospital Chapel, which he rebuilt 1779–88 in collaboration with William Newton, is a landmark of the neo-Greek style, with features borrowed from the Erechtheum, the adjoining temple of Athena Polias, and the Lysicrates monument at Athens [plate 103A].[3]

[1] There is much useful information in an early description of the house by Earl Spencer in *C.L.*, 30 Oct. and 26 Nov. 1926. The most spectacular feature is the copy of the Aldobrandini Wedding in the Painted Room.

[2] Letter to the Revd. William Mason, 14 Feb. 1782.

[3] Leslie Lawrence, 'The Architects of the Chapel at Greenwich Hospital', *Art Bull.* XXIX, no. 4, 260–7, and F. Saxl and R. Wittkower, *British Art and the Mediterranean*, 1948, 79.

The favours of the Society of Dilettanti were shared with his co-expeditionist Nicholas Revett (1720–1804), who indulged his friends with scholarly trifles, the Doric portico (soon after 1766) at Standlynch, now Trafalgar House, Wiltshire, for Henry Dawkins, the Ionic portico to the west front of West Wycombe Park, Buckinghamshire (dedicated in 1771), for Sir Francis Dashwood, later Lord Le Despencer, and the Temple of Flora and the Island Temple for the same patron.[1] At Ayot St. Lawrence, Hertfordshire, for Sir Lionel Lyde he designed a remarkable church, consecrated on 28 July 1779, as an eye-catcher on a hill [plate 101B]. It is a genuine temple flanked by a colonnaded screen to look like a larger building. A touch of archaeological fanaticism was the unfinished fluting borrowed from the Temple of Apollo at Delos.

The works of Stuart and Revett were the 'proposals' for a Greek Revival rather than the Revival itself, which was delayed by the intransigent Romanism of Chambers and the more liberal Graeco-Romanism of Adam. By confining their services so largely to the Philhellenes of the Society of Dilettanti, and by a somewhat superior attitude as arbiters of taste rather than professional architects, they abandoned the leadership of neo-classicism to two strong individualists able and energetic enough to stamp the character of their own personal styles on the movement.

Sir William Chambers (1723–96), the son of a merchant of Scottish descent in Gothenburg, Sweden, began his career in the Swedish East India Company, studying modern languages, mathematics, and 'the free sciences', especially civil architecture, in the leisure of his long voyages as far as China.[2] Resigning in 1749, he studied architecture for about a year in Paris, notably under J. F. Blondel, whom he described as 'Mon Ancien Maître', before proceeding to Italy to five years (1750–5).[3] On his return

[1] Colvin, *D.E.A.* 494.

[2] A pioneer study by H. M. Martienssen, 'An Enquiry concerning the Architectural Theory and Practice of Sir William Chambers, R.A.', Ph.D. Thesis, London University, 1949, deserves honourable mention, but has been superseded by the magisterial work of John Harris, *Sir William Chambers*, 1970.

[3] Letter to Le Roy, about Nov. 1769, cited by Martienssen, op. cit., biographical summary.

Lord Bute appointed him architectural tutor to the Prince of Wales, the first step on the ladder of promotion by royal patronage. A year after George's succession to the throne he was appointed with Robert Adam one of the two Architects of the Works, in which he rose to be the first Surveyor-General and Comptroller on its reorganization in 1782. After his personal appointment by the King as Treasurer to the Royal Academy in 1768 there was never any doubt about his becoming the leading official architect in the country, a position confirmed by the honours he received from overseas, the Order of the Polar Star from the King of Sweden and election to the Swedish Academy of Sciences and the French Academy of Sciences.

All his life he kept in touch with French architects, corresponding with Le Roy and de Wailly and exchanging the latest information and books on architecture, but this French background of ideas was partially concealed by the image that he presented of himself as a Romanist. In February 1770 he wrote to Lord Charlemont describing the first volume of *Ionian Antiquities* (1769) as a 'cursed book', being composed on 'some of the worst architecture I ever saw'.[1] During Thomas Sandby's illness of 1768–70 he drafted substitute lectures on architecture in which he coined such memorable phrases as 'a Reverence for Attic Deformity', the 'Gouty Columns' of the Greeks, and 'a Hottentot and Baboon' for the *Apollo Belvedere* and *Laocoon*.[2] In the same polemical language, anticipating the intemperance of James Barry on the opposite side, he dismissed the Parthenon and the Theseion as beneath serious criticism and compared the Lysicrates Monument with 'the Taste of Borromini'. The lectures were never delivered, but some of the ammunition was published within two years of his death in the third edition of his *Civil Architecture* (1791), where he taunted Athens with its failure to defend her territories, let alone conquer a universe, and asserted that the Parthenon was not so considerable as St. Martin-in-the-Fields.[3]

[1] *Historical Manuscripts Commission, Charlemont MSS.*, I. 298.

[2] Extracts are cited in N. Pevsner and S. Lang, 'Apollo or Baboon', *Arch. Rev.*, Dec. 1948, and Lesley Lawrence, 'The Rise of Neo-classic Architecture in England', London University, M.A. Thesis, 1937, Appendix II.

[3] The title was altered to *A Treatise on the Decorative Part of Civil Architecture.*

There is much that is significant of the Enlightenment in the *Treatise*, originally published in 1759 as *A Treatise on Civil Architecture*, and some of its chapters, on 'The Origin and Progress of Building' and on the Orders, would not be out of place in the *Encyclopédie*. Artists, he claimed, benefited the nation by adding to the value of manufactures, extending commerce, and increasing profits.[1] Rome was the imperial model, practical as well as magnificent. The Italians and the French had each contributed improvements. The best was discovered by its merits. Writing to a former pupil in Rome on 5 August 1774, he advised him to observe well the works of Bernini, to use the materials of the Renaissance, and to search for more.[2] In 'materials' Chambers included the decorative part of architecture and those functional elements, arches, doors, windows, chimney-pieces, etc., which have an ornamental appeal.

It will be seen that, like Athenian Stuart and Robert Adam, he did not confine himself to strictly classical sources, but when he did he took pains to be correct. His remarks on proportion are so crucial that they deserve substantial quotation:

Perfect proportion, in architecture, if considered only with regard to the relations between the different objects in a composition; and, as it merely relates to the pleasure of the sight; seems to consist in this: that those parts which are either principal or essential, should be contrived to catch the eye successively, from the most considerable, to the least, according to their degrees of importance in the composition; and impress their images on the mind, before it is affected by any of the subservient members: yet, these should be so conditioned, as not to be entirely absorbed, but be capable of raising distinct ideas likewise . . .[3]

An empirical visual test is here substituted for the copybook application of mathematical ratios, long since eroded of their mystical significance.

'The pleasure of the sight'—this is the key to Chambers's compositional lucidity, whether in his elaborate or plain manner. His

[1] *A Treatise on the Decorative Part of Civil Architecture*, Preface, ii.
[2] To Edward Stevens. Cited by Martienssen, op. cit. 397.
[3] Chambers, op. cit. 46.

first designs in England were for Harewood House (*c.* 1755; unexe-
cuted), the triumphal arch and casino (before 1759) on one of the
classic sites of English Palladianism, the Earl of Pembroke's seat
at Wilton, the orangery, temple, and pagoda for the Princess
Dowager of Wales at Kew (1757–62), and some alterations at
Pembroke House, Whitehall (*c.* 1759). All his life he was in
demand for ornamental buildings, the Temple or Casino in the
grounds at Marino, near Dublin (1758–76), for Lord Charlemont,
being justly famous. It was originally designed for Edwin Lascelles,
later Lord Harewood, as one of the end pavilions of 'a consider-
able composition, made soon after my return from Italy'.[1] The
separation of the pediments from entrance and steps contradicts
traditional usage, but enabled him to place his formal emphasis
on massively framed rectangular shapes and the sarcophagus-like
block at the summit.

Duddingston House, near Edinburgh, for the Earl of Abercorn,
is even more severe [plate 98A; 1763–4].[2] By abolishing the base-
ment he was able to support the fluted columns on a stylobate of
three steps, the service wings being discreetly withdrawn so that
the main impact is made by the *corps de logis.* The staircase hall
[plate 98B] is a little masterpiece of symmetrical *ordonnance,* in
which everything is subordinated to the sweep of the staircase
and its beautiful return of lines. How delicate was his sense of
balance is shown by the disastrous discords introduced by C. R.
Cockerell's portico (1843) and the addition of a third storey (1913)
to Peper Harrow, Surrey (1763–75), for Lord Midleton, a cube
of five by seven bays.

Chambers's chief claim to fame is as the architect of Somerset
House (1776–86), where he abandoned his severe style for a
grandiose synthesis of Roman, Renaissance, Palladian, and French
'materials'. The expansion of empire had created an urgent need
for new government buildings when 'Mr. Burke and various

[1] Ibid. 136. Cf. the analysis in E. Kaufmann, 'Etienne-Louis Boullée', *Art Bull.,*
Sept. 1939: 'a prism with a temple front intersects another . . . the composition is
one of interpenetrating voids and masses.' The casino is authoritatively discussed by
John Harris, 'Sir William Chambers, Friend of Charlemont', *Quarterly Bulletin of the
Irish Georgian Society,* July–Sept. 1965, 83–7.

[2] See David Walker, 'Duddingston House, Edinburgh,' *C.L.,* 24 Sept. 1959.

other Men of Taste' suggested 'the propriety of making so vast and expensive a Design at once an object of national splendour as well as convenience'.[1] The Navy and Navy Pay Offices headed the long list of offices to be accommodated, but there was also felt a need to raise the level of England's learned and academic institutions to that attained by her imperial rival France. It was accordingly decided that the Royal Academy, the Royal Society, and the Society of Antiquaries should occupy a central Grand Pavilion, thus enabling Chambers to realize his theory of architecture as a discipline serving the progress of society.

The site was spacious, but its nature compelled Chambers to distinguish between three elements in his plan: the Strand front, the great court, and the spectacular river front. His principal difficulty was the narrowness, indeed obscurity of the Strand front. Here he chose the scheme of Inigo Jones's New Gallery, which had to be pulled down, but revised it on a more monumental scale, possibly taking hints from J. D. Antoine's Hôtel des Monnaies in Paris. The vaulted entrance to the court has precedents in Renaissance palaces in Rome, but scarcely prepares the visitor for the first of his surprises, the spaciousness of what is in fact one of the noblest squares in London.[2] His goal is not the modest buildings that confront him on the far side, but the terrace with its river prospect beyond, the success of which is proved by its appeal to many artists from Paul Sandby onwards. Chambers's second surprise is the Grand Pavilion backing on to the Strand entrance, the full impact of which is delayed until the return across the court [plate 99A]. Its central inspiration was Salomon de Brosse's Luxembourg Palace, which is almost identical in shape and ratio of windows. A massive rectangular block replaces de Brosse's cap-like dome, but something surprisingly like its delicate emphasis appears above the centre of the river front, which was designed as a spectacle to be seen across the river or

[1] *A Guide through the Royal Academy*, by Joseph Baretti, Secretary for Foreign Correspondence to the Royal Academy, *c.* 1781. See also the chapter on Somerset House in S. C. Hutchison, *The Homes of the Royal Academy*, Royal Academy of Arts, London, 1956.

[2] Baretti in his *Guide*, which was written with Chambers's approval, identifies the Farnese Palace among the sources.

from a boat on the Thames, then a main London thoroughfare. It was clearly a challenge to Adam's Adelphi Terrace, and oddly enough comes closer to the Roman imperial grandeur of the Palace of Diocletian at Spalato when viewed from the sea than its rival. The happiest of Chambers's original inventions was the vertical sequence of water-gate, terrace, and Palladian bridge in the river front [plate 99C]. The bridge was a true Palladian one with a pediment, and served both as caesura and link, while access through one of the water-gates must have provided visitors by boat with a thrill worthy of the entrance to one of Piranesi's *Carceri*.[1]

The iconographic programme of the sculptured adornment was the most ambitious of the century.[2] The sculptors employed by Chambers were G. B. Cipriani, who was the chief designer, Joseph Wilton, Agostino Carlini, Giuseppe Ceracchi, and John Bacon. On the Strand front colossal masks personify Ocean and the eight principal rivers of England for navigation and commerce: Thames, Humber, Mersey, Medway, Tweed, Tyne, Severn, and Dee.[3] On the summit of the attic four figures in senatorial robes wear the cap of liberty; their emblems are *fasces* in one hand and scales, mirror, sword, and bridle in the other for Justice, Prudence, Valour, and Moderation respectively. In the court Bacon's *George III* [plate 99B] in warlike Roman costume leans on a rudder with a lion couchant and the prow of a Roman trireme as his attributes; below him, a colossal reclining water-god with urn and cornucopia identifies Father Thames with Neptune. Arms, trophies, figures, and emblems from marine mythology are displayed round the court. The most important group is reserved for the return: the quarters of the Globe surmounting the

[1] Cf. E. Kauffmann, *Architecture in the Age of Reason*, 41. The east wing was added by R. Smirke, 1828–34, the west wing by J. Pennethorne, 1852–6.

[2] The principal source for the interpretation of the programme is Baretti's official *Guide*, cited above.

[3] Baretti's *Guide* gives many details that might escape the casual observer, e.g. the fish in the wave-like beard of Ocean and the crescent in his forehead to denote the influence of the Moon upon the waters. Humber is the most aggressive of the rivers, with his beard and hair seemingly disordered by tempests. Tweed is adorned with an ambiguous garland of roses and thistles. The majestic head of Thames is crowned with billing swans and garlands of fruits and flowers, possibly in allusion to Spenser's *Epithalamion*.

Grand Pavilion. Three bear tributary fruits and treasure; the fourth, America, is 'armed and breathing defiance'.[1] Somerset House was begun in the same year that the American colonies declared their independence, thus limiting British imperial ambition to three-quarters of the globe.

When Sir Joseph Banks and Sir Joshua Reynolds as Presidents of the Royal Society and Royal Academy respectively entered the vestibule of the Grand Pavilion and turned in opposite directions, the former under the head of Newton and the latter under the head of Michelangelo, the alliance between Science and Art was proudly proclaimed at the head of a group of State offices, including those that serviced a Navy engaged in the protection of commerce and the expansion of empire.[2]

It has been observed that the architecture of Chambers suffers from the slightest alteration. In the case of Somerset House it is the change of function that mars the effect he planned. If the central room of the river front, 57 by 37 feet, subsequently devoted to a museum open daily to the public and exhibiting 'models of typical ships and other objects illustrating the history, progress, and importance of the Navy', could be used again to house a collection, e.g. the relics of a national hero; if the terrace could be disencumbered of its accretions and opened to the public; if the suite of the Royal Academy, decorated by Angelica Kauffmann, West, Cipriani, Wilton, Nollekens, Carlini, and Locatelli, could be restored to something of its former splendour; and last but not least, if the court could again be levelled and handsomely flagged: then the whole would be seen as Edmund Burke and Chambers conceived it, an object of national splendour.[3]

Because he had visited China and published as his first book *Designs of Chinese Buildings, Furniture, Dresses, etc.* (1757) and in 1772 a *Dissertation on Oriental Gardening*, Chambers enjoyed a

[1] Raymond Needham and Alexander Webster, *Somerset House Past and Present*, 1905, 199.

[2] The Royal Academy was ready by 1 May 1780, the Royal Society by 30 Nov. 1780. See Needham and Webster, op. cit. 214–15.

[3] For the Naval Museum see Needham and Webster, op. cit. 241–4. The National Maritime Museum at Greenwich must therefore be added to the august list of national institutions for which provision was made at Somerset House.

reputation as a Chinese authority.[1] The Pagoda at Kew [plate 100A; 1763] is possibly as close to an original as many neo-classical imitations of antiquity, although the painted dragons with bells in their mouths have gone. Chambers has a place in picturesque theory, but was not a convinced Gothic Revivalist, his vast essay in the latter style, Milton Abbas, Dorset (1770–4), for Lord Milton being an uncongenial task.[2] What has been perceptively described as 'a well-concealed passion for the unacademic' found its outlet in his classical buildings, which are a watershed between the old and the new.[3]

Robert Adam (1728–92), the great rival of Chambers, was the second of the four sons of William Adam, Master Mason to the Boards of Ordnance in north Britain and the leading Scottish architect in the first half of the century.[4] After being head of his class at Edinburgh High School, where nothing but courses in Latin were given, he entered the University in 1743 at the age of fifteen, and appears to have joined his father's office sometime in 1746. According to John Clerk of Eldin, Robert's first ambition was to become a painter; he made pen-and-ink copies of engravings after Salvator Rosa, and at his death left a body of water-colours, still largely unpublished, which reveal him as an accomplished and original devotee of the picturesque.[5]

[1] Hugh Honour in *Chinoiserie: The Vision of Cathay*, 1961, 154–9, critically discusses the contribution of Chambers, whom he wittily describes as a cat amongst the ho-ho birds.

[2] See Arthur Oswald, 'Milton Abbey, Dorset', *C.L.*, 16 June, 23 June, 30 June, 21 July 1966. [3] Pevsner, B.E., *London*, I. 284.

[4] For Adam see A. T. Bolton, *Robert and James Adam*, 2 vols., 1922, the standard authority, and John Swarbrick, *Robert Adam and his Brothers: their Lives, Work and Influence on English Architecture, Decoration and Furniture*, 1915, valuable both for its documentation and illustrations of buildings later destroyed. J. Lees-Milne in *The Age of Adam*, 1947, ably discusses his work in relation to his predecessors and contemporaries. Cf. D. Stillman, *The Decorative Work of Robert Adam*, 1966.

For the formative years and sources see John Fleming, *Robert Adam and his Circle in Edinburgh. Cf. Rome*, 1962, which has not only set a new standard in Adam studies but is a classic account of the education of an artist.

For Adam as a decorator see the next chapter.

[5] The publication of these water-colours, mainly divided between the Soane Museum and the National Gallery of Scotland, awaits a scholar willing and able to tackle the formidable task of dating them and identifying their sources, for it is not

Because his father was Intendant-General at Inveraray, he was familiar with the designs for the new castle (1744–9) by Roger Morris. When it was completed by the 5th Duke after 1772, with Great Farm, bridges, and outlying buildings to match, Inveraray New Town anticipated the comprehensiveness of later schemes by Boullée and Ledoux in France and Pugin in England.[1] The foundation of the family's fortunes was his father's contracts for building forts in the Highlands, Robert working on the construction of Fort George after his father's death in 1748. So lucrative were the profits from this and related undertakings that when he set out for Italy on 3 October 1754 he had amassed the remarkable sum of £5,000, a provision for the undertaking to be envied by many a noble Grand Tourist.[2]

During his period of service with his father he met Paul Sandby, then working on the Survey of the Highlands, who probably encouraged his sketching activities, and when he made a journey to London in the winter of 1749–50, he filled the pages of his note-book with pen-and-ink drawings of Decorated and Perpendicular buildings and monuments.[3] In 1752 he worked with his elder brother John on the rococo decorations of Hopetoun House, West Lothian, rebuilt from 1723 for the Earl of Hopetoun, the most important of William's country houses, sounding 'more than a distant echo of the thunder that swells and rumbles in Vanbrugh's dramatic compositions!'[4] It is not surprising, therefore, that always easy to distinguish between pure invention and a topographical record. Selections have been published in A. T. Bolton, 'The Classical and Romantic Compositions of Robert Adam', *Arch. Rev.*, Jan. 1925, and A. P. Oppé, 'Robert Adam's Picturesque Compositions', *Burl. Mag.*, Mar. 1942, the first study to draw attention to their stylistic originality.

[1] The best account is Mary Cosh, 'Georgian Capital of Argyll: Inveraray, an early example of town planning', *C.L.*, 17 Aug. 1967.

Adam would only have known the work at Inveraray of Morris, his father William Adam, and eldest brother John, for Robert Mylne was not called in to make alterations at the Castle until 1772 and to design for the New Town and Estate some years later. See A. E. Richardson, *Robert Mylne: Architect and Engineer, 1733 to 1811*, 1955, for Mylne's own record, not always complete. The full story awaits the completion of the research being undertaken by the present Duke and Mary Cosh in the Inveraray archives.

[2] Fleming, *Robert Adam and his Circle*, 84. [3] Ibid. 85.

[4] Ibid. 47, and plates 38 and 39 for the rococo decorations.

'romantic' and 'picturesque' should be favourite terms of praise in
his letters home, or that the builder of forts and the admirer of
castles should show a special partiality for the Romanesque.[1]

On arrival in the classical Mecca he put aside the temptations
of the anti-classical and threw himself whole-heartedly into the
role of 'Bob the Roman'.[2] He used his wealth not merely to cut
a figure in society, although he certainly did this with an eye to
future clients, but to assemble a team of artist-tutors reinforced
by draughtsmen who collected materials, i.e. made drawings of
antiquities for future use as models. His first appointment was the
French prize-winner Charles-Louis Clérisseau (b. 1721), a former
pupil of J. F. Blondel in Paris and Gian Paolo Pannini in Rome,
his next the figure-painter Laurent Pecheux and an unnamed land-
scape painter. Among those who worked mainly on materials were
Laurent-Benoît Dewez, a pupil of Vanvitelli, and Agostino Brunias.

Clérisseau was the key figure in the group, the director of the
little academy-cum-drawing-office under a master who was also
its sole pupil. Because Clérisseau had quarrelled with the French
Academy he was highly regarded by Piranesi, who became almost
infatuated with his Scottish employer, depicting Adam's tomb
among the mausolea of the Appian Way and dedicating his own
archaeological publication on the *Campus Martius* (published
1762, but the dedicatory plate was executed in 1756) to the untried
architect as *architectus celeberrimus*. The protégé of Piranesi could
scarcely join the camp of the Graecists and Winckelmann, whom
he never mentions in his letters home, and it was accordingly to
the Roman ruins of the Emperor Diocletian at Spalato that he
finally made his way. Here he reconstructed in his imagination
the ceremonial and other social functions of a later imperial
palace, a highly congenial occupation for one who had already
indulged in *Capricci* and visionary neo-baroque fantasies for a
Palace in London and the rebuilding of Lisbon after the earthquake
on 1 November 1755 [plate 101A].

In London, where he returned early in January 1758, he bought
a house in Lower Grosvenor Street to display the paintings,

[1] Cf. his romantic description of Lyons, cited by Fleming, ibid. 116.
[2] Ibid. 175.

mantles, and plaster casts he had brought back, as well as a selection from what was now the finest collection of drawings and details of Roman architecture in the British Isles.[1] Within a few years the future roles of the brothers took shape. John, who had succeeded to his father's business, looked after a considerable estate from the seat at Blair Adam and kept a watchful eye on the family interests. William joined Robert in London to help with the financial and administrative side of the business. In 1760 James was sent to Italy to follow in his brother's footsteps. There he continued Clérisseau in employment and ran the Roman office with five draughtsmen, George Richardson, Domenico Cunego, Antonio Zucchi, Giuseppe Sacco, and Agostino Scara.[2] In Venice he supervised the engraving of the plates for his brother's *Ruins of the Palace of the Emperor Diocletian at Spalato in Dalmatia* (1764). He also worked seriously at his own studies, designing a new Houses of Parliament with a 'British Order' adorned with lion and unicorn, a notable addition to the invented orders that were so characteristic of both the rococo and the neo-classical periods.[3]

Of all the discoveries made by John Fleming in his Adam researches, none upsets previous notions about Robert more than that of an unfinished draft of an essay on painting written by James in Rome.[4] This shows conclusively that many of the ideas published in the Preface to the *Works of Architecture of Robert and James Adam* (1773) were originally formulated by the younger brother: the theory of movement in architecture, with its rise and fall, advance and recess, convexity and concavity; the comparison with landscape; and the praise of Vanbrugh. The architecture of Robert is further removed from Vanbrugh than that of Campbell; and his planar restraint similarly contrasts with the bold projections of the English baroque master. Such baroque features as rise and fall, advance and recess, do, however, appear in the projects of Robert and James in Rome. The praise of Vanbrugh was rightly retained, but in 1773 it had a different meaning.

[1] Fleming, *Robert Adam and his Circle*, 251 and fig. 13, illustrating one of the displays.
[2] Ibid. 280. [3] Ibid. 305–6 and plate 92.
[4] Dated 27 Nov. 1762, ibid. 303. Fleming draws attention (305, 307) to the influence of Lodoli and especially Lord Kames on James, whereas Robert was less inclined to theory and speculation (312).

It sanctioned a new conception of movement, not of mass and outline, but of the eye which, in Walpole's striking phrase, Adam never let 'repose a moment'.[1]

In the five years before James returned in the autumn of 1763, Robert had single-handed launched 'a kind of revolution in the whole system of this elegant and useful art'.[2] Thereafter the younger brother loyally played the part of chief assistant. The *Preface* they jointly published was much longer than Campbell's, but modelled on it. Like Campbell, the brothers enter the lists against the immediately preceding style, but now it is the turn of the Burlingtonians and especially Kent as an interior designer to be displaced. Different principles are stressed: novelty, variety, ingenuity, the picturesque, and elegance. Another difference is that they were not writing a manifesto before, but an apology after the event. Proudly they claim that they have improved 'the forms, convenience, arrangement, and relief of apartments' and brought about 'in the decoration of the inside, an almost total change'.[2] The Adam Revolution was essentially a revolution of the interior, to which the outside was related either as foil or announcement.

The first commissions were all for remodellings and additions: the interiors at Hatchlands, Surrey (1758–61), for Admiral Boscawen, where Robert reformed the neo-Palladian tradition of bold compartments and heavy frames; the portico, interiors, and stables at Shardeloes, Bucks. (1759–61), for William Drake; and the remodelling and interiors at Harewood House (1759–71) for Edwin Lascelles, later Lord Harewood. At Shardeloes his distinctive style of surface design already appears. Within Carr's compact Palladian frame at Harewood House he showed his gift for handling a group of rooms as parts of a symphonic whole, working out an ingenious system of pairs and contrasts.[3] Hall and saloon (now library) were one pair of related schemes,

[1] Letter to the Revd. William Mason, 14 Feb. 1782.

[2] The claim made by both brothers in the Preface to the *Works in Architecture of Robert and James Adam*, I, 1773.

[3] Hussey's article on Harewood House in *M.G.* 61–9 reproduces the plans and principal interiors.

music-room and dining-room another. But the hall also provided access to the contrasting music-room and original library. The climax was the great Gallery, with two approaches. The freedom to experience the same rooms in different groupings may be compared with the repetition of musical themes in different contexts. The discipline of the Palladian frame and the wealth of the owner combined to bring out his highest powers as a total designer, for even if he did not give working drawings to the firm of Chippendale there can be no doubt that he inspired the designs.

In 1761 Hugh Percy, first Duke of Northumberland, put the medieval and Jacobean building of Syon House, Middlesex, originally a convent, that he had inherited into the hands of Robert for thorough remodelling[1]. The outcome was the *tour de force* of his grand or monumental style, and would have been even more spectacular if he had been able to carry out his project for roofing the central court to create a vast Rotunda or Pantheon. Contrary to Burlingtonian usage, the basilican entrance hall was placed athwart the axis from entrance door to the proposed Rotunda [plate 103B]. The entry in the middle was well suited to its function as a sculpture gallery. When the hall and collection have been admired, the drive is to the splendid ante-room and then on through dining-room and drawing-room to the Long Gallery spanning the entire length of the river front. The revelation of his intricate surface style is postponed to this last room in the style of a columbarium.[2] In the further of the two closets that flank the Gallery is a playful rococo surprise, a circular Chinese room in which appropriately hangs a musical birdcage. The spatial sequence of state rooms is without peer in the British Isles, holding its own 'with the greatest palaces of the Continent'.[3]

In the last analysis the monumental and intricate styles of Adam cannot be separated.[4] At Kedleston (*c.* 1761–70) for Lord Scarsdale

[1] See 'Syon House, Middlesex' in C. Hussey, *M.G.* 86–98.

[2] 'The gallery is converting into a museum in the style of a columbarium, according to an idea that I proposed to my Lord Northumberland.' Horace Walpole to the Earl of Hertford, 27 Aug. 1764. [3] J. Lees-Milne, *The Age of Adam*, 107.

[4] Pevsner, *Outline of European Architecture*, 1945 ed. 194, writes that the Adam style 'is Rococo if anything . . . all the same, it is not wrong either to see in Robert Adam a representative of the Classical Revival.' Cf. Hugh Honour, 'Newby Hall,

he inherited the longitudinal alignment of the basilican great hall from Paine. Again he proceeded from the grand to the intimate, for the saloon is a miniature Pantheon with grisaille panels by Biagio Rebecca and paintings of Roman ruins by William Hamilton. But the eye is prepared for the change by the delicacy of the chimney-pieces and decorations in the Great Hall dominated by columns of green veined Derbyshire alabaster.[1] The sumptuous interiors at Osterley House, Middlesex (1761–80), for Robert Child similarly alternate between the impressive and the delicate. For all the consistency of his style he managed to stamp a different character on each of his commissions. At Kenwood (1767–9) for the Earl of Mansfield he inherited a Palladian scheme as at Harewood; again he reserved his grandest effects for a room at the side, the Library in the east wing [plate 105B].[2] This time it was not raised but level with the garden, a novelty by Burlingtonian standards. On the fire-place wall were originally inserted triple mirrors reflecting the light of the windows, a favourite rococo device. The colonnaded apse is Roman and monumental without being oppressive, and echoes the entrance. The responding patterns, carpet to ceiling, mirrors to windows, is never in Adam a replication, and again may be compared to a variation on a musical theme.

The shrine for the student of the 'form, convenience, arrangement and relief of apartments' in his domestic architecture is Home House, Portman Square (1775–7), for the Countess of Home, where as architect *ab initio* he had complete control of the plan.[3] The staircase-well [plate 104] invites comparison with Kent's solution of a similar problem at 44 Berkeley Square

Lincolnshire', *Conn.*, Dec. 1954, where it is aptly claimed that the Sculpture Gallery gives the key to the neo-classicism of Adam, as the Parnassus room in the Villa Albani does to that of Winckelmann and Mengs. A classicizing rococo is preferred for recreation and intimacy, monumental neo-classicism for state and ceremony.

[1] Hussey, op. cit. 70–8.

[2] See John Summerson, *Kenwood: a Short Account of its History and Architecture*, London County Council, 1962.

[3] An authoritative study of Home House is being prepared by Dr. Margaret Whinney in the light of John Harris's discovery of a unique copy of the original printed guide.

[plate 21]. The photograph here reproduced does not show a single doorway above the ground floor, but in fact there are enough on the landings to exhaust the ingenuity of an Agatha Christie in planning unobserved entrances and exits. Indeed the placing of the doorways in Home House for the contrasted purposes of access and escape, ceremony and service, would well repay a special study by the visitor. To return to the staircase, it is a demonstration-piece of what Adam understood by movement. He scrupulously avoided rise and fall, advance or recess, in massive Kentian or baroque terms. But the wall surface is a whole system of delicate modulations in depth and projection, which together with the variations of scale in ornament keeps the eye in continuous movement.

In designing his exteriors Adam either refined a traditional scheme or boldly introduced themes inspired by his Roman studies. The favourite neo-classical motive of the screen appears first in front of the Admiralty Court (1760) and was next taken up in splendid isolation at Syon Gate. At Osterley it takes the form of a wide and open portico based on the entrance to the Temple of the Sun at Palmyra. At Bowood he erected a Diocletian wing, somewhat resembling a screen in its flat lateral extension. The richest of all his buildings in Roman associations is Kedleston. A nineteenth-century guide lists the park lodge borrowed from the Porch of Octavia, the columns of the portico proportioned on those of the Parthenon, the arcade and corridors modelled on 'the great amphitheatres', and the 'idea' of the garden front taken from the Arch of Constantine [plate 102B].[1] The substitution of a triumphal arch for a temple-front portico in the centre of a palace front was not Adam's invention; he had already noted it in Rome, where Giuseppe Pannini was finishing Niccolo Salvi's Fontana Trevi (1732–62) during his stay. The striking inscription of the Roman imperial model and its enrichment by copies of the *Flora Farnese* and *Antique Bacchus* in the niches and the Medicean and Borghese vases on the steps that lead to the Pantheon saloon worthily place

[1] *Catalogue of the Pictures, Statues, etc. at Kedleston with some account of the Architecture*, Derby, W. Bemrose and Sons, 1861. I am indebted to Lord Scarsdale for showing me his copy.

it in the long line of Roman appropriations from Campbell, Burlington, and John Wood the Elder onwards. Imperial Osterley, Diocletian Bowood, and Constantinian Kedleston advertise the self-identification of their owners with the senators of Rome, but this time without strict reference to Palladio.

Apart from isolated commissions, like Pulteney Bridge, Bath (1769–74), and Mistley Church, Essex (1776; only the twin towers survive), the public architecture of Adam is concentrated in London and Edinburgh. In each city he was given an opportunity to plan a square. Charlotte Square, Edinburgh (designed 1791), belongs to the category of Palladian refinement.[1] The north side, completed after his death, is a particularly handsome example of his skill in grouping the traditional elements. Fitzroy Square, London (c. 1790–1835), on the other hand, was a bold and unprecedented attempt to introduce Roman novelties. In the elevation of the east side (1793–8) he used a triumphal arch motive three times, a possible influence on the flanking ones being Perrault's Louvre, where the central arch of the end pavilions is similarly lifted on a ground storey. The gigantic fenestration, which is even more striking, was taken from the crossing openings of Roman thermae.[2] The Royal Infirmary, Glasgow (1792–6; since rebuilt), has been attributed to his brother James, and is indeed closer to the monumental boldness of his Roman designs. Unfortunately, Edinburgh University (commenced 1789; completed 1815–34 by W. H. Playfair) came too late as a commission for Robert to do more than make a splendid beginning. 'The entrance, which has tremendous scale combined with a grand classic simplicity,' wrote the late Ian Lindsay, 'is the finest thing in Edinburgh.'[3]

There remains to be considered the influence that Adam exerted on style and taste through his organization of a team of decorators

[1] This and other works by Adam in Edinburgh are authoritatively discussed in A. J. Youngson, *The Making of Classical Edinburgh, 1750–1840*, Edinburgh, 1966.

[2] See Pevsner, B.E., *London except the Cities of London and Westminster*, 1952, 338. Only the east side strictly accords wth Adam's intention.

[3] *Georgian Edinburgh*, Edinburgh, 1948, 39. This is the pioneer study of Georgian Edinburgh and although superseded as a source of fact by the major work of Youngson is written with admirable clarity and aesthetic insight. The entrance as it stands is substantially modified.

and draughtsmen. 'Like a great conductor, he drilled and directed his orchestra throughout the architectural symphony.'[1] Just as the brothers recruited their principal draughtsmen from the original staffs in Rome, so they preferred to employ painters and decorators whom they had known in Rome or who had a Roman background. The principal task of the figurative and landscape painters was to fill the small roundels or panels inserted in the decorative scheme of ceiling or wall. In no case did Adam allocate a large or dominant area to a painter, thus giving the *coup de grâce* to monumental history painting in the grand manner of the Old Masters. The great machines of Benjamin West were paid for by the King, but were never incorporated with the wall designs of their buildings by the royal architects, who were unwilling to surrender their own decorative control.

The Adam style in the ornamental and useful arts is distinguished by the following features: a graceful balance of form and ornament in a geometric scheme; an emphasis on the rectilinear; a marked preference for the delicate and minute forms of classical ornament; the tapering of supports; a cult of the slender vertical as a foil to the square and the circle; and the offsetting of dark and rich colours by a background of pale ones. The favourite comparisons of those who disliked the style, like Walpole, were with lace, filigree, embroidery, confectionery, and 'toy-work', all images borrowed from the abuse of the rococo, some going back as far as Addison. The modern description of Adam as a rococo classicist can therefore be supported from the commentary of his contemporaries, but it must be borne in mind that he never admitted vegetative confusion. Nor does it do justice to that feeling for the monumental which seldom deserted him and which the firm of Chippendale so sympathetically interpreted at Harewood. Whether he designed or merely inspired the organ at Newby Hall, Yorkshire [*c.* 1775; plate 102A], it is a splendid example of the monumental Adamesque, a triumphal arch raised on a high base, its central opening rendered like an apse.[2] All

[1] J. Lees-Milne, *The Age of Adam*, 170.

[2] Ralph Edwards in the *Dictionary of English Furniture*, II. 384, states with characteristic caution that the design is 'probably' by Adam because the drawing for it

these features could be and were imitated: what is unique to the systems personally controlled by Adam is his colour sense, his chief claim to greatness as a designer for the interior.

The rivalry between Chambers and Adam did much to free English architecture from dependence on Palladianism. Each broke with the system of mathematical proportion and contributed to the purification of ornament. It was the great achievement of Adam to create a personal style with which his name will always be identified. His immense practice and indeed ascendancy in domestic architecture were due not merely to the appeal of this style but to his profound understanding of the personal and social life of his patrons. The analysis of Summerson can scarcely be bettered: 'The rooms in an Adam house are not a simple aggregate of well-proportioned and convenient boxes, but a harmony of spaces—a harmony in which many contrasts reside ... it is all devised for the conduct of an elaborate social parade, a parade which was felt to be the necessary accompaniment of active and responsible living.'[1] His further statement, however, that they were not built for domestic but for public life can perhaps be queried. They were surely built for both domestic and public life, although no doubt the latter was the prime consideration in an oligarchical society, to the ideals of which they give such consummate expression.

By contrast, the architecture of Chambers seems puzzling and incomplete. 'To understand thoroughly the art of living', wrote Robert and James Adam in their *Preface*, 'it is necessary, perhaps, to have passed some time amongst the French, and to have studied the customs of that social and conversible people.' Most of the lessons that Robert took from France about architecture for an aristocratic society could have been taken from the hotels that mushroomed in Paris during the period of emancipation that followed the death of Louis XIV. Chambers was much more alert to the *contemporary* developments of French neo-classicism.

cannot be found in the Soane Museum. But this is true of other pieces known to be by Adam, and at Newby he was working for one of his most devoted admirers, William Weddell the collector of ancient marbles.

[1] *Georgian London*, 1943, 125.

Somerset House, for all its orthodox and Palladian features, does not fit into the mainstream of English architecture. On the other hand, it gains merit from being considered in the wider context of European neo-classicism. Paradoxically, Adam had no pupils of note and fathered a whole army of imitators. Chambers did not stamp a style on anyone, but a special importance as an influence must be attached to an architect who numbered amongst his pupils James Gandon, Edward Stevens, John Yenn, Thomas Hardwick, Robert Brown, Willey Reveley, Thomas Whetton, and John Read, a remarkable society of individualists.[1]

[1] Colvin, *D.E.A.* 132.

THE INDUSTRIAL REVOLUTION AND THE PROVINCIAL ENLIGHTENMENT

XI

THE EXPANSION OF
NEO-CLASSICISM

IN the second half of the eighteenth century the Industrial
Revolution marshalled its forces for the greater strides of the
nineteenth century under the banner of science.[1] Its first leaders
were typically men of education, either gentlemen with capital
who were caught up by the enthusiasm for industrial enterprise,
or self-made men, like Josiah Wedgwood, whose self-education
cannot be separated from their commercial ambitions. The
Provincial Enlightenment was a distinctively English phenomenon,
for comparable conditions did not exist in the highly centralized
states of Catholic Europe, while republican Holland never
recovered its seventeenth-century pre-eminence in the alliance
between art, science, and manufactures.[2] The philosophical
societies that now mushroom in the provinces and constitute their
chief glory in the eyes of posterity disseminated the ideas of the
Enlightenment with an ameliorative optimism which spread to

[1] See chapter II, 'Under the Banner of Science', in F. D. Klingender, *Art and the Industrial Revolution*, London, 1947.

[2] For the parallels between Britain and Holland from 1600 to 1750 see A. G. H. Bachrach, 'Holland and Britain in the Age of Observation', in *The Orange and the Rose*, Exhibition Catalogue 1964, Victoria and Albert Museum.

The great pioneer study of the Enlightenment by Ernst Cassirer, *Die Philosophie der Aufklärung*, 1932, does full justice to the role of England in the first half of the eighteenth century, but recent studies have either concentrated on France, like Peter Gay's *The Party of Humanity*, New York, 1964, and later studies by the same author, or incorporated specialist research, e.g. *The Age of the Enlightenment: studies presented to Theodore Besterman*, ed. W. H. Barber *et al.*, Edinburgh, 1967. For the links with neo-classicism see Hugh Honour, *Neo-Classicism*, Penguin Books, Harmondsworth, 1968, and the two-volume collection of sources, *Neo-classicism and Romanticism 1750–1850*, ed. Lorenz Eitner, New Jersey, 1970, with a scholarly interpretative text. The provincial phase of the English Enlightenment has not yet been the subject of an adequate study, although there have been excellent monographs on some of its manifestations.

London rather than vice versa.[1] The idea for the Society for the
Encouragement of Arts, Manufactures, and Commerce, founded
in London in 1754, was conceived in Northampton.[2] The title
contrasts with that of Diderot's similarly ameliorative *L'Encyclo-
pédie, ou dictionnaire raisonné des sciences, des arts et des métiers*, the
prospectus of which he published in 1750, by putting art first.
The banner of art cannot henceforth be separated from that of
science, and it was under the former as much as the latter that
some of the new industries and trades captured European markets.[3]

'To Mr. Adam's taste in the Ornaments of his Buildings and
Furniture', wrote Sir John Soane, 'we stand indebted, in-as-much
as Manufacturers of every kind felt, as it were, the electric power
of this Revolution in Art.'[4] Among the thirty-odd volumes of
designs by Robert and James Adam in the Soane Museum three
are devoted to furniture, fittings, and other articles of domestic
use.[5] Nothing seems to have been overlooked, from carpets (44)
to commodes (18), stoves and grates (18) to sofas (17), cases
for organs (19) to clocks (10), brackets to brasswork. The Adam
style with its drawing-board precision of ornament and geometric
simplification of shape lent itself especially to reproduction by
mechanical processes in metal.[6] The main agency of dissemination
was not the Carron Ironworks in Stirlingshire, in which the
Adam family invested, but the Sheffield Plate industry based on
its two great centres in Sheffield, where the process was invented
about 1742 by Thomas Boulsover, and Birmingham, where
Matthew Boulton (1728–1809), the partner of James Watt and

[1] See Klingender, op. cit., 'New Life in the Provinces', 21–4.

[2] By the drawing master William Shipley. See D. Hudson and K. W. Luckhurst,
The Royal Society of Arts, 1954, 6.

[3] In addition to porcelain, Sheffield plate, and textiles, engravings became an
important article of trade as a result of technical improvements up to the Napoleonic
Wars, which caused a collapse of the print boom by closing the Continental market
for English prints.

[4] *Lectures on Architecture, 1809–36*, ed. A. T. Bolton, 1929. Cited by J. Lees-Milne,
The Age of Adam, 171. See the standard work, D. Stillman, *The Decorative Work
of Robert Adam*, 1966. [5] F. S. Robinson, *English Furniture*, 1905, 256.

[6] For the influence of Adam on ironwork see Raymond Lister, *Decorative Wrought
Ironwork in Great Britain*, London, 1957, 132–4, and John Harris, *English Decorative
Ironwork from Contemporary Source Books 1610–1836*, London, 1960.

the friend of Wedgwood, introduced it for the manufacture of buttons in 1762.[1] A founder with Dr. Erasmus Darwin and Dr. William Small of the most famous of the philosophical societies of the Provincial Enlightenment, the Lunar Society in Birmingham, Boulton left school at about fourteen.[2] Nevertheless, he made original contributions to technology, and the discussions at Soho House, the home he built near his Birmingham Manufactory in 1766, ranged over art and literature as well as science.

Boulton's passion for improvement led him perilously close to financial disaster. Indeed during this stage of the Industrial Revolution it is often impossible to distinguish between ameliorative enthusiasm and speculative ambition. Although he began in his father's footsteps as a buckle manufacturer, he quickly turned to other manufactures, following the precedent of the silk factory in Derbyshire by bringing in craftsmen from every branch of the trade. In 1773 he promoted the Act for assaying plate 'in the towns of Sheffield and Birmingham', a landmark in the history of English silver and a belated recognition of the high quality of provincial work. Between 1784 and 1788 he had established the Soho Mint, where the most famous of the Birmingham medallists received their early training. Among the architects and artists he employed to furnish designs for execution in ormolu, Derbyshire Fluorspar or 'Blue John', marble and other stones, silver, and Sheffield Plate were Robert Adam, John Flaxman, William Chambers, 'Athenian' Stuart, Francis Eginton, and George Wyon.

The urn-shape becomes the neo-classical leitmotive of articles for ornament and use, and was applied to coffee-pots, chocolate-pots, hot-water- and cream-jugs [plate 108B], tea-caddies, and sugar-bowls.[3] The Adam tapered leg was adapted to the single

[1] See W. K. V. Gale, *Boulton, Watt and the Soho Undertakings*, City of Birmingham Museum and Art Gallery, 1952, with bibliography, and F. Bradbury, *History of Sheffield Plate*, 1912, still valuable for its illustrations.

[2] See W. K. V. Gale, op. cit., and for a more fully documented study, H. W. Dickinson, *Matthew Boulton*, Cambridge, 1937.

[3] The Adam style in silver is well illustrated and described in Charles James Jackson, *An Illustrated History of English Plate*, I, 1911, and briefly analysed under types in Charles Oman, *English Domestic Silver*, 5th ed., 1962, and Gerald Taylor, *Silver*, Penguin Books, Harmondsworth, 1956.

candlestick, as was also the tall pillar of the Ionic or Corinthian order, which the Adam brothers had introduced into the design of chimney-pieces. The Greek vocabulary of refined ornament was borrowed for pierced-work in salt-cellars, epergnes, cake-baskets, and mustard-pots, from the early 1760s, and bright-cut decoration. Simplicity of design and, in the more elaborate examples, delicacy of decoration were specially favoured for Sheffield Plate, for the neo-classical style was ideally suited to fine manufactures, the processes of which encouraged a precise attention to outline and detail in the mind of a sensitive designer. Among the major craftsmen to imitate the Adam style in assayed silver was Paul Storr's master, Andrew Fogelberg. A pair of two-handled vases (1770–1) by this master was taken to Russia by Elizabeth Chudleigh and sold to Catherine II, who gave them to her favourite Potemkin. 'The design throughout', wrote the late Dr. Penzer, 'is Adam.'[1] The same may be said of much of the work produced by the firm of Rundell, Bridge, and Rundell, patronized by George III, the Prince of Wales, and the Duke of York. Early in the nineteenth century this firm of goldsmiths employed the astonishing number of a thousand hands.[2]

In 1769, seven years after Boulton had built his Soho Manu-factory two miles from his original premises, Josiah Wedgwood (1730–95) moved his own works for similar reasons some little way from Burslem in Staffordshire, and gave his new site the name of Etruria.[3] By his title he declared his enthusiasm for the new archaeological discoveries and his conviction that they pro-vided the best models for the manufacturer. Because the red-figure Greek vases recently excavated in such large quantities on south Italian soil and now illustrated in splendid publications were

[1] 'English Plate at the Hermitage: Part 2', *Conn.* CXLIII, 1959, 17.

[2] G. Taylor, *Silver*, 1956, 187, and Shirley Barry, 'The Lengthening Shadow of Rundells', *Conn.*, Feb. and Mar. 1966.

[3] For Wedgwood see W. Mankowitz, *Wedgwood*, 1953, with bibliography, and Eliza Meteyard, *The Life and Works of Josiah Wedgwood*, 2 vols., 1865, a mine of biographical information.

For later publications on Wedgwood see the bibliographical references in *The Age of Neo-Classicism*, The Arts Council of Great Britain, London, 1972; especially important are Alison Kelly, *Decorative Wedgwood in Architecture and Furniture*, 1965, and Carol Macht, *Classical Wedgwood Designs*, New York, 1957.

then called Etruscan, he promoted the Greek Taste in articles of use more powerfully than any other agency in the British Isles and perhaps overseas, at a time when the Chinese Taste was by no means abandoned by silversmiths and cabinet-makers. Wedgwood was a splendid example of the Provincial Enlightenment in industry, a self-made potter's son whose zest for self-improvement by scientific and artistic education was sustained throughout his strenuous life and complemented by his concern for the welfare of others.

A turning-point in his career was his meeting in 1762 with the Liverpool merchant Thomas Bentley, who joined him as a partner in 1768. A man of considerable classical attainments, Bentley opened up for him the world of fashion and polite learning. The classical self-education of Wedgwood was visual, not philological. It was also practical, for the illustrated books he bought or solicited on loan from his aristocratic acquaintance were used to provide models for decorating his wares. In addition to his own craftsmen he employed some of the most eminent neo-classical painters, sculptors, and modellers of the day—Stubbs, Bacon, and Flaxman—as well as Italian modellers who supplied copies and designs from Rome.

On 30 May 1779 Wedgwood wrote to Bentley a letter which reveals that the ideas of scientific and artistic improvement that governed his career were applied to the education of his family:

The two family pieces I have hinted at above I mean to contain the children only, and grouped perhaps in some such manner as this.

Sukey playing upon her harpsichord, with Kitty singing to her which she often does, and Salley and Mary Ann upon the carpet in some employment suitable to their ages. This to be one picture. The pendant to be Jack standing at a table making fixable air with the glass apparatus etc.; and his two brothers accompanying him. Tom jumping up and clapping his hands in joy and surprise at seeing the stream of bubbles rise up just as Jack has put a little chalk to the acid. Joss with the chemical dictionary before him in a thoughtfull mood; which actions will be exactly descriptive of their respective characters.

My first thought was to put these two pictures into Mr. Wright's

hands; but other ideas took place, and . . . I ultimately determined in favour of Mr. Stubbs.[1]

The ideas changed with the artist. Stubbs painted a single large conversation piece of the whole family (1780) with horses, four in all ridden by the older children, while two younger ones play with the infant in a go-cart and the head of the family and his wife sit beside a small table supporting one of the Wedgwood Vases. It is a document of social standing and success, differing only from its aristocratic counterparts in the sobriety of costume.[2]

In 1783 Wedgwood was made a Fellow of the Royal Society in recognition of his invention of a pyrometer. All his scientific research seems to have been concentrated within the field of his manufactures. From the very beginning of his business he originated and either conducted or supervised chemical experiments with bodies and glazes. His cream-coloured wares, made in the Burslem period, were followed from about 1767 by the Black Basalt ware or 'black porcelaine', a hard fine-grained stoneware which could be given a dull gloss by rubbing and was also suitable for lapidary polishing. About 1774–5 he invented another body, 'a fine white artificial *jasper*, proper for cameos, portraits and bas-reliefs'.[3] By 1775 he had made this stoneware in blue and sea green, and in 1777 he invented a 'jasper dip' to extend the colour range. The shapes of his tableware were thoroughly tested: the 'lids fit well, spouts do their work without spilling, bases give safety from overturning'.[4]

In 1790 he exhibited in his London showrooms a reproduction of the Portland vase after three years of trial and experiment, translating into black and white jasper ware a famous late antique amphora of dark-blue glass with an overlaying layer of opaque white glass cut away on the lapidary's wheel.[5] It was extravagantly

[1] Cited in F. D. Klingender, *Art and the Industrial Revolution*, 44–5. See B. Nicolson, *Wright of Derby*, 143–4. The source is the Barlaston MS. in the Wedgwood Museum.

[2] Cf. Sacheverell Sitwell, *Conversation Pieces*, London, 1936, 60, with illustration.

[3] Cited by Mankowitz, op. cit. 103.

[4] B. Rackham and Herbert Read, *English Pottery*, 1924, 120.

[5] See *Wedgwood Bicentenary Exhibition 1759–1959*, Victoria and Albert Museum Catalogue, 1959, 22; W. Mankowitz, *The Portland Vase and the Wedgwood Copies*,

admired as an artistic and technical showpiece of British progress in the ceramic industry. The neo-classical taste for plain and smooth surfaces, either polished or dull, as well as simplified outlines, was admirably provided for by his creamwares with marbled glaze [plate 108c] and the jaspers with a biscuit-like texture, a chaste substitute for the glitter of rococo porcelain. White jasper lent itself to bas-relief decoration, and in the hands of a modeller like Flaxman could be used to synthesize in a single work what the age most admired in Greek sculpture and the Greek vase. Such combinations appealed strongly to classical enthusiasts on the Continent as well as in the British Isles, and enabled even those with modest means to surround themselves with objects of use and ornament which were at once unmistakably modern and an evocation of the ancient world [plate 107].

In addition to exports, there were the factories which imitated both the style and the wares overseas, in France, Germany, Austria, the Low Countries, Scandinavia, and Russia. L. V. Gerverot, who had been employed by Wedgwood, became manager of the Fürstenburg manufacture at Brunswick from 1795 until 1814.[1] Francis Gardner, who founded a factory in Moscow in 1758, left too early to be directly influenced, but an English connection was established, and the Popoff factory from about 1806 was notable among the disseminators.[2]

The most distinctive contribution of Etruria to European neo-classicism was the Wedgwood–Bentley portrait gallery of ornamental statues, library busts, medallions, and cameos, for nowhere else were the ideals of the Enlightenment so comprehensively expressed through the commemoration of its heroes.[3]

1952, and Evelyn M. Vernon Montgomery, 'Josiah Wedgwood, James Tassie and the Portland Vase', *Magazine of Art*, Oct. 1930.

[1] George Savage, *Porcelain through the Ages*, Pelican Books, Harmondsworth, 1954, 162.

[2] See Alexandre Popoff, 'The Francis Gardner and other Russian porcelain factories', *Conn.*, Aug. 1935, and G. Bernard Hughes, 'An English Potter's Triumph in Imperial Russia', *C.L.*, 28 Feb. 1963, also *C.L.*, 22 June 1961.

[3] For the steady expansion of his portrait gallery see Wedgwood, *Catalogue: A Catalogue of Cameos, Intaglios, Medals, Busts, Small Statues, and Bas-reliefs; with a general Account of Vases and other Ornaments After the Antique, made by Wedgwood and Bentley . . .* , 1773, 1774, 1777, 1779, and 1787 (reprint 1873, ed. E. Meteyard).

The series opens with library busts and statuettes celebrating classical and modern authors, in that order, followed by Ancient, British, and European Worthies in the more general sense, the coverage of the jasper medallions being truly encyclopedic. The portrait gallery is now international, not national like Vertue's British Worthies. This immediately distinguishes it as a modern School of Athens from those galleries where antiquity conducts to a single country. The stress is now on the universality of genius and especially on the role of reason in promoting the progress of all mankind. Typical of the modern heroes of reason are Newton, Gibbon, and Voltaire, the last of whom attacked religious obscurantism from the standpoint of an enlightened Deist and promoted both agriculture and manufactures by farming, reclaiming waste land, planting, rearing poultry and breeding horses, and by establishing at Ferney a watch-making industry. The black basaltes figure shows Voltaire with the frank, alert look of the *honnête homme*, an interpretation which would have appealed to the actor in him; Rousseau alertly botanizes [plate 106B]. Among men of action Frederick the Great was not merely the ally of England; he had also been a patron of the *philosophes*, and as such was looked at with at least a degree of admiration by those theorists of the Enlightenment who preached monarchical ideals.

'The Greek Muses are daughters of Mnemosyne, or Memory, and not of Inspiration or Imagination.'[1] In those modern Ossianic epic fragments in which he created a private mythology to symbolize the course and conflicts of human destiny Blake joined forces with other early romantics like William Cowper in attacking the rationalist heroes of the Enlightenment. His gallery of great men is drawn from the same international sources as Wedgwood's, but white becomes black, and heroes figure as demons. Nevertheless, he too is a meliorist and encyclopedic in his range, and in these respects a child, albeit a rebellious one, of the Enlightenment.[2]

[1] W. Blake, *A Descriptive Catalogue of Pictures*, 1809, number II, reprinted in the Nonesuch edition of Blake's *Poetry and Prose*, ed. G. Keynes, 1956, 595.

[2] For Blake and the Enlightenment see David V. Erdman, *Blake: Prophet against Empire*, Princeton, N.J., 1953.

In 1845 John Pye noted that Wedgwood had 'adopted ancient forms of celebrated elegance and beauty . . . and thus created from our own earth articles of vast traffic'.[1] The Staffordshire potteries benefited generally from the expansion. Thus Leeds borrowed from Wedgwood the Queen's Ware, perfected by 1768, originating in an order he had received from Queen Charlotte, and earning his appointment as 'Potter to the Queen',[2] and with it successfully invaded the Continental market. Derby especially made an attempt to exploit the neo-classical style after William Duesbury purchased the Chelsea factory in London in 1770, an early example of a take-over from the provinces. One of its specialities was the production of biscuit figures, apparently a Duesbury innovation [plate 106A]. Among the modellers whom Duesbury employed were John Bacon, John Rossi, the Swiss Jean-Jacques Spängler, and Pierre Stephan, the last modelling groups from neo-classical paintings by Angelica Kauffmann.[3] The Derby biscuit figures and groups, whether classical or idealizing rustic genre, are one of the most charming by-products of English neo-classicism.

Porcelain manufactures continued to look to France for ideas and standards, although it is now Sèvres and not Meissen that inspired some of the finest works. The hexagonal and pear-shaped vases of Worcester, from about 1770, show that craftsmanship was creditably keeping up with the pace set by the French. Because designers, decorators, and craftsmen moved rapidly from one factory to another, and were recruited to cater for a variety of tastes, the range of styles throughout the factories was extraordinarily wide. Besides the large output of sophisticated productions in porcelain there was a marked revival of the vernacular traditions in Staffordshire, particularly after Thomas Whieldon (1719–95), with whom the young Wedgwood worked as partner from 1754 to 1759, had taken the lead from about 1750 in exploiting coloured lead-glazes for earthenware.

[1] *Patronage of British Art*, 62.

[2] Wedgwood's first order for the Queen was in 1765, but the distinctive creamware dates from 1768. See *Wedgwood Bicentenary Exhibition Catalogue*, 33.

[3] Cf. F. Brayshaw Gillespie, *Derby Porcelain*, London, Spring Books, 1965, and F. Hurlbutt, *Old Derby Porcelain and its Artist-Workmen*, London, 1925.

Whieldon, who rose by ability and integrity to be Sheriff of his county, produced fine wares combining fluency with richly streaked or mottled colouring, qualities highly prized for popular pieces, by obscure craftsmen whose figures, especially animals, deserve to be rated more highly for their primitive vitality than those better-known and more elaborate sale-room favourites, the Toby Jugs and *Moses and Aaron* group, now attributed to a French modeller, Jean Voyez, who worked for the Wood family in Staffordshire.[1]

Glass manufacturers shared in the search for technological improvement. The history of glass in this regard is longer than that of the other materials, except stoneware, for the lustrous English lead glass or 'flint glass' had been developed by George Ravenscroft in the 1670s.[2] After the Excise Act of 1745-6, when the metal lost in cutting was liable for duty, the industry was forced to rely for luxury glass more upon the resources of craftsmanship, fine cutting becoming a distinctively English (and Irish) excellence.[3] The decoration of glass, which had been greatly promoted by the taste for the rococo, was further enriched by air-twists and white twisted threads of enamel of the utmost refinement, also used for surface decoration, in the threads. Again the provinces come to the fore, William and Mary Beilby in Newcastle upon Tyne becoming noted for their interlacing and naturalistic enamel decorations [plate 108A]. Bristol took the lead in developing coloured glassware, dark blue and opaque white from the middle of the century; by the early nineteenth century the range included amethyst, purple, ruby, and green. The influence of neo-classicism is most marked where glass was associated with metalwork, e.g. in cruet-stands and epergnes. But as late as 1771 the six crystal chandeliers made at the Whitefriars Glass-houses, London, for William Parker, dealer in cut glass, Fleet

[1] W. B. Honey, *English Pottery and Porcelain*, 2nd ed., London, 1945, 98.

[2] E. Barrington Haynes, *Glass through the Ages*, Penguin Books, 1959, 158–60. There is an excellent survey of the main trends in glass design by R. J. Charleston in *The Late Georgian Period*, ed. R. Edwards and L. G. G. Ramsay, 1950.

[3] B. Rackham, *A Key to Pottery and Porcelain*, London and Glasgow, 1940, 164. See also the standard monographs by W. A. Thorpe, *English Glass*, 1935, and *A History of English and Irish Glass*, 1929.

Street, who supplied them to the shareholders of the New Assembly Rooms at Bath, are a masterly refinement of rococo traditions without any allegiance to the forms of antiquity.[1]

The export drive of the cabinet-makers was to the colonies, not the Continent. About 1760 the Lancaster firm of Robert and Richard Gillow leased land and built premises on the present site of Waring and Gillow in Oxford Street. One of the causes of growth of this and other firms of provincial origin is indicated by a contemporary phrase for the trade market, 'London and the plantations'.[2] Lancaster, for example, came to pride itself on its connections with Barbados, St. Domingo, St. Helena, the Cape of Good Hope, and New Britain, and its shops were named after particular places to which consignments were sent.[3] To meet the demand, the larger firms rationalized the division of labour and skills, on the lines widely advertised by the encyclopedias of Ephraim Chambers and Diderot. When Sophie von La Roche visited the London firm of George Seddon and Son in 1786, she noted that it occupied a house with six wings in Aldersgate Street and employed four hundred journeymen.[4]

The Adam drawing-office in Grosvenor Street exerted an influence on interior design and furnishings comparable to and even more comprehensive than that of Burlington House as a headquarters for the propagation of the Jones–Kent grammar of decoration. But much of what is loosely described as Adam was really an independent exploitation of identical sources. The first volume of J.-F. Neufforge's *Recueil élementaire d'architecture*, which increasingly promoted neo-classical designs up to the last supplement in 1777, appeared in 1757 before Robert Adam returned from Italy. Matthias Lock's *New Book of Pier Frames . . . etc.* (1769) and Matthew Darly's *The Ornamental Architect or Young Artist's Instructor* (1770), among the first English works to include neo-

[1] Illustrated in W. Ison, *The Georgian Buildings of Bath*, London, 1958, plate 11.

[2] Thomas Pennant, *Tour in Scotland*, 1772, cited in Ralph Edwards and Margaret Jourdain, *Georgian Cabinet-Makers*, London, 1944, 60.

[3] *Georgian Cabinet-Makers*, 60. See also the two articles on Lancaster by P. Fleetwood Hesketh in *C.L.*, 21 and 28 Oct. 1965.

[4] *Sophie in London* (1788), translated from the German by Clare Williams, 1933, 173-5, cited in *Georgian Cabinet-Makers*, 8.

classical designs for furniture, precede the publication of Adam.[1] Michelangelo Pergolesi, who came to England in the 1760s, probably at the Adams' invitation, published *Designs for Various Ornaments* in numbers between 1777 and 1801; in his prospectus he referred to his own practice as a designer and painter of interiors and ornaments 'in the Etruscan and Grotesque styles'.[2] Furniture and copy-books were imported from France, where the mania for antique shapes and decoration was as strong as in England. Rival architects entered the field, e.g. William Chambers designed the combined bureau, jewel-case, dressing-table, and organ made for Charles IV of Spain in 1793 by Seddon and Sons.[3]

The last phase of Chippendale was dominated by Adam [plate 105A].[4] A more popular course was taken by George Hepplewhite (d. 1786), whose modest firm was relatively unimportant but who provided in *The Cabinet Maker and Upholsterer's Guide* (1788; published posthumously by his widow Alice) a repertory of nearly 300 designs in which urns, medallions, paterae, swags, husks, oval-heart-, and shield-shaped backs were applied to middle-class furniture with conservatively bowed legs and wavy borders as well as to the ruler-and-compass frames favoured by the Adams.[5] Regard for conventional standards is

[1] The following account is heavily indebted to Peter Ward-Jackson, *English Furniture Designs of the Eighteenth Century*, H.M.S.O., 1958, an exemplary work of judicial scholarship admirably fair to the pioneer researches of the late Fiske Kimball.

In 'Les influences anglaises dans la formation du style Louis XVI', *Gazette des Beaux-Arts*, 5th Ser. V. 1931, 29–44 and 231–55, and 'The Moore Park Tapestry Suite of Furniture by Robert Adam', *Philadelphia Museum Bulletin*, Mar. 1941, Kimball put the extreme case for the priority of some English designs. This has been corrected in some points of substance by F. J. B. Watson, *Louis XVI Furniture*, 1961, and Ward-Jackson, op. cit., but the general argument is unshaken. Perhaps the final verdict is that of Eileen Harris in *The Furniture of Robert Adam*, 1963, 13, who points out that Anglomania in Paris was matched by Gallomania in London, so that it is really a question of interaction. The same authority, ibid. 10, has, however, demolished one of Kimball's special cases.

[2] Edwards, *Dictionary of English Furniture*, III. 18.

[3] Edwards and Jourdain, *Georgian Cabinet-Makers*, 56. Ingenuity of functional combination is characteristic of the neo-classical period.

[4] Roughly, 1770–9. See Edwards and Jourdain, op. cit. 43.

[5] For Hepplewhite see Ward-Jackson, op. cit., and the article in Percy Macquoid and Ralph Edwards, revised and enlarged by Ralph Edwards, *The Dictionary of English Furniture*, 1954, II. 259–60.

shown by the precise recommendation that chairs should be 20 inches wide in front, 17 inches in depth, 17 inches high in the seat frame, and the total height 3 feet 1 inch, average measurements for the time.[1] In the Hepplewhite plates the Georgian Rule of Taste survived the Piranesi perils to which it was exposed by the more eccentric designs that John Carter published in *The Builder's Magazine* from 1774.[2] Hepplewhite, like Chippendale, cannot be used as a term to describe the maker of furniture unless there is documentary evidence. This applies to the famous armchair with the three feathers in the back which he advertised as executed for the Prince of Wales, for the motive was widely copied.[3]

By contrast, Thomas Sheraton (1751–1806) is not known to have made any furniture from his own designs, although trained as a journeyman cabinet-maker in the provinces.[4] Very little is recorded about his early life; if his interest in the study of geometry and perspective was aroused before he came to London about 1790, he can be included with Stubbs, Wright, Wedgwood, and Bewick as a product of the Provincial Enlightenment. His principal ambitions were to pursue his scientific studies in the service of society, and further to benefit his fellow man by preaching and writing somewhat eccentric philosophical tracts. Active in Nonconformist circles, he also had close contacts with booksellers. Adam Black, later to purchase the copyright of the *Encyclopaedia Britannica* after Constable's failure, employed him to write articles and described his shabby house in London, where he sold books and stationery besides teaching 'Perspective, Architecture and Ornaments', as half shop, half dwelling-house.[5]

[1] Ralph Fastnedge, *English Furniture Styles from 1500 to 1830*, 1955, 195.

[2] Ward-Jackson, op. cit. 24–5.

[3] Edwards, *Dictionary*, II. 259–60. According to the same authority, exact correspondence between surviving pieces of furniture and a plate in his *Guide* is rare. His name has been given to a style because he so notably followed and promoted an existing trend to apply neo-classical motives to simpler furniture.

[4] Practically all that is at present known about his life derives from an obituary in the *Gentleman's Magazine*, Nov. 1806, and the *Memoirs* of Adam Black by Nicolson (1855), both cited in the *Dictionary of English Furniture*, III. 120. Because of his Nonconformist and publishing contacts, other contemporary references will probably come to light.

[5] *Dictionary*, III. 120 and fig. 2, for his Trade Card, and A. Heal, *The London Furniture Makers*, 1953, 167.

Sheraton shared the interest in gadgetry so characteristic of this age of mechanical improvement. Some of his contrivances were almost as ingenious as Stubbs's contraption for supporting the carcasses of horses, or Jefferson's furniture at Monticello. Linked with this love of gadgetry was his functional obsession with special-purpose furniture, singled out by Mario Praz as a feature of the neo-classical period.[1] His text, like that of the Adam brothers, is specially informative about function, and equally precise. Thus, he explains that he designed one kind of chair for eating, another for conversation, and a third for 'lolling after dinner'.[2] The breakdown was inherited, but no earlier commentary had dealt with such relish on functional sub-division, or discussed such a proliferation of models ingeniously designed for particular activities.

Sheraton's *Cabinet-Maker's and Upholsterer's Drawing Book* appeared in four parts between 1791 and 1794, and was followed by two further publications of note in the early nineteenth century. Some of his designs for library and dressing-tables are little masterpieces of taste and mechanism. He singled out specialists, e.g. John Lane, 44 St. Martin's-le-Grand, for knife-cases, and took pains over nomenclature, some of his notes having considerable etymological interest.[3] He also exercised his skill in contrivance on dual- and multi-purpose furniture, e.g. the Harlequin Pembroke Table or combined breakfast-table and lady's writing-desk, the kidney table adapted to various purposes, and the quartetto table for stacking.[4] His designs vary from hard-edge abstraction to the ornate, with an idiosyncratic partiality for elongated serpentine and bulbous shapes, some of his sofas having been aptly likened to bananas.[5]

[1] In *An Illustrated History of Interior Decoration from Pompeii to Art Nouveau*, London, 1964, Praz illustrates several instances of special- and combined-purpose furniture, not to be confused with using the same piece as a makeshift for other functions than its major one.

[2] *The Cabinet-Maker's and Upholsterer's Drawing Book*, 4 parts, 1791–4, under *chaise longue*.

[3] Lane's knife-cases were specially praised for being 'executed in the best taste, by one who makes it his main business', *Drawing Book*, part III, description of plate 39.

[4] Ward-Jackson, op. cit. 467–8. [5] Ibid. 29.

Among his contemporaries John Shearer deserves honourable mention for his version of the Lady's Writing Fire Screen published in 1788 in *The Cabinet-Makers' London Book of Prices*.[1] This opened out for the special purpose of writing letters by the fireside. An admirable example of the trend towards geometric abstraction is the severely rectilinear dressing-table at Nunnington Hall, Yorkshire [plate 109B; *c.* 1790] on legs with a hinged box lid or lifting top containing the mirror and toilet fittings. This neo-classical refinement of a traditional type which had proved its functional viability has a proportional rightness as satisfying as any Palladian architectural design.

Because it was the decorative part of civil architecture that had conquered fashion and had been stressed by Chambers and the Adam brothers in their publications, it was natural for other architects to follow suit by furnishing elaborate designs for interior decoration. One of the few leaders of the architectural profession not to publish was Robert Mylne (1734–1811), although he had made drawings in Italy in 1757 with a view to entering the archaeological field with a work on the Greek antiquities of Sicily.[2] His return a year later than Robert Adam coincided with the competition to design a bridge at Blackfriars (1760–9; demolished 1868), which he won against sixty-nine competitors with a design of elliptical arches. Thereafter he practised both as architect and as engineer, designing bridges, canals, and drainage systems. He evolved a distinctive type of town house with an arcade-like treatment of the ground floor (perhaps deriving from Covent Garden), a boldly asserted roof shape with flanking or centralized dormer windows, and a special emphasis on chimneys, thereby showing a regard for functional elements. The Wick on Richmond Hill (1775) for Lady St. Aubyn is a villa echoing this design. In 1800 he rebuilt the fine front of the Stationers' Hall, London, characteristically using a hard edge or very thin

[1] Reproduced in Fastnedge, op. cit., fig. 81.

[2] See A. E. Richardson, *Robert Mylne: Architect and Engineer 1733 to 1811*, 1955, which publishes extracts from his diary from 1762 to 1810, and drawings and photographs of many of his buildings. Apart from the diary extracts the biographical information is sketchy, and needs to be supplemented by the article in Colvin's *D.E.A.*, which correctly gives the New Style date for his birth, 4 Jan. 1733–4.

mouldings to define his boldest shapes. Mylne made sparing use of the order, and in this and other ways showed his sympathies with the functionalist and abstract trends.

James Wyatt (1746–1813) and Henry Holland (1745–1806) were the first of the younger architects to challenge the ascendancy of Adam in interior design. During his six years in Italy (1762–8), where he was for some time a pupil of Antonio Visentini in Venice, Wyatt had obtained facilities to make a special study of the *inside* of the dome of St. Peter's, where he performed Michelangelesque feats in making measured drawings from a ladder slung horizontally.[1] He leaped into fame with the Pantheon, Oxford Street (1770–2; burnt 1792), a hall for spectacles and entertainments which was structurally indebted to Hagia Sophia.[2] By shortening the pendentives and flattening the arches he gave prominence to the two-tier screens of colonnades which dominated the lower stage, a variation which is as typical of the new liberty of taste as Burlington's Assembly Rooms had been of classical orthodoxy. The colonnaded screen motive, which becomes almost an obsession with neo-classical architects, is reflected in his external treatment of his first major country house, Heaton Hall, Lancashire, for Sir Thomas Egerton, created Earl of Wilton [plates 111B, 111C; 1772].[3] Its application depended on the principal rooms being put on the ground floor, so that the order on its stylobate rises from the same baseline. The central block is two-storeyed, but the whole has the long horizontal alignment of Roman single-storey architecture, a noteworthy device in achieving this prized effect being the unorthodox

[1] In addition to the monographs by Anthony Dale, *James Wyatt*, 1936, and Reginald Turnor, *James Wyatt 1746–1813*, see the review of the latter in the *New Statesman and Nation*, 29 July 1950, and the observations in *Georgian London* and *Architecture in Britain*, all by Summerson, and O.H.E.A. X. 25–8, 67–8, 223–5.

[2] *Architecture in Britain*, 290, note 12. Gibbon's *Decline and Fall of the Roman Empire* (1776–88) with its splendid analytical description of Hagia Sophia (chapter XLIV) and its *aerial* cupola had not appeared, but plans were available and its construction was likely to attract those who had come under the influence of Lodoli's ideas in Venice.

[3] See the account of Heaton in Hussey, *M.G.* 18–20, with illustrations, and Summerson, 'The Classical Country House in 18th-Century England', *Journal of the Royal Society of Arts*, July 1959, 564–6.

placement of the Vanbrugh-like chimneys clustered in twin
towers above the colonnades, thus easing the drop in the skyline
between the central block and the side pavilions. In the interior
the Cupola Room painted by Biagio Rebecca and the grand
Staircase Hall are as elegantly classic as any design by Adam, but
notably more restrained in the use of intricate ornament.

The octagonal tower of the Radcliffe Observatory, Oxford
[plate 111A], which Wyatt completed 1773–94 after the death of
Henry Keene, is one of several variants executed in this period
on the theme of the Temple of the Winds at Athens and an
early example of the neo-classical 'temple in the skies', i.e. raised
at the summit of the building, here combined with a long hori-
zontal ground floor, screen-like in its thinness.[1] Unlike the sur-
prising example of the same temple on the top of Beckford's
Tower at Lansdown, near Bath (1825–6), which widely adver-
tised a new conception of the villa as a tower, it was symboli-
cally appropriate to the function of the building.[2] It also forecasts
his later picturesque style, for Fonthill Abbey similarly contrasts
massive height with a low body-line. In other designs he showed
a considerable regard for Palladian tradition, and this and his
avoidance of Adamesque intricacy made him a favourite with
Walpole and those of the aristocracy whose taste was for sim-
plicity. Oriel College Library and Common Room (1788–99) is a
perfect example of Palladian good manners allied to neo-classical
sobriety, an example of good sense at Oxford which Jane Austen
would surely have approved.[3] Wyatt's procession through the
great estates of England and Ireland left splendid memorials,
notably Castle Coole, Fermanagh, Ireland (1790–7), for the Earl
of Belmore, the finest of his interpretations of a Palladian
theme.[4] But much of his work and that of his gifted brother
Samuel (1737–1807), who in the garden front at Doddington
Hall, Cheshire (1776–98), for the Revd. Thomas Boughton, Bt.,

[1] Cf. Hugh Honour, 'Adaptations from Athens', *C.L.*, 22 May 1958.

[2] Reproduced in Ison, *The Georgian Buildings of Bath*, plate 109a.

[3] W. J. Arkell, *Oxford Stone*, 1947, 80–1.

[4] Perhaps because he took over a design by Francis Johnston. See *Irish Architectural Drawings*, R.I.B.A. *et al.*, 1965, a catalogue by Dr. Maurice Craig and the Knight of Glin, 11.

follows Adam's bow-fronted Mersham-le-Hatch, belongs to the next century.[1]

Henry Holland was also hailed by Walpole as a saviour or restorer of taste from the licence and excesses of Adam.[2] The son of a successful master-builder and speculator, he became in 1771 the partner and architectural assistant of Capability Brown, whose daughter Bridget he married.[3] A turning-point in his career was the commission to design Brooks's Club, opened in October 1778, for this gave him the entrée into the grandest Whig circles and ultimately secured him the patronage of the Prince of Wales. From the outside, there is little in the severely rectangular block with its monumentally applied Corinthian order to conflict with Burlingtonian expectations. The interior, however, is a triumph of neo-classical ingenuity in handling a complex of sharply defined and differentiated spatial enclosures. Among the effects he achieved were surprise and contrast, regulated by a superb sense of order and volumetric clarity. In the Great Subscription Room [plate 109A] the divisions are monumental, but relief has been squeezed back into the wall surface to preserve the purity of the space. The decorative system resembles a structural frame of almost tensile lightness, repeating and echoing the dominant forms of the rectangle and elliptical segment. Even the Venetian window, not shown in the illustration, is flatly inserted. When the fashion of dress changed to the linear silhouette style of the Regency, it must still have looked modern as a setting. The clarity of articulation is no less pronounced in the staircase hall, where open space itself is cut into geometric shapes by a series of separating enclosures.

When the Prince of Wales reached his majority on 12 August 1783 and was granted funds by Parliament for his own Establishment, his choice of architect for the rebuilding of Carlton House

[1] For Doddington Hall see Hussey, M.G. 160–4.

[2] See the eulogy of Carlton House concluding 'How sick one shall be after this chaste palace, of Mr. Adam's ginger-bread and sippets of embroidery!' Letter to the Countess of Ossory, 17 Sept. 1785.

[3] The standard authority is Dorothy Stroud, Henry Holland: his Life and Architecture, 1966, which is fully documented and incorporates much original research, particularly on Hans Town.

fell on Holland, who had prepared himself for so Francophil a patron by making 'a close study of French publications such as those of Peyre, Patte and Gondoin'.[1] The army he marshalled was even larger than the team recruited by the Adam firm from Rome.[2] The French draughtsman Jean-Pierre Trécourt was his chief personal assistant. In 1787 Guillaume Gaubert, the Clerk of the Works under Chambers, was replaced by Holland's assistant John Jagger and in about 1789 the young and gifted Charles Heathcote Tatham joined the office staff. Among the foreigners already in London he employed the Italian Dom Bartoli for scagliola work, the iron-founder and ormolu-worker Jean Dominique, and the wood-carver Jean Prusserot. The decorative painters Alexandre Louis Delabrière, Louis Belanger, J. Boileau, and T. H. Pernotin seem to have been personally recruited by Holland in Paris. A key part was played by the *marchand-mercier* Dominique Daguerre, who was chiefly responsible for furnishing from 1787 and imported work by Adam Weisweiler, Georges Jacob, and Claude-Charles Saunier. Holland cast his net wide, employing Biagio Rebecca, but the French component was naturally the strongest, although for statuaries and mason-contractors he relied largely on his established countrymen, notably Henry Wood the Elder, John Deval the Younger, Thomas Carter, John Wallis, and John Hickey, appointed sculptor to the Prince of Wales in 1786.[3]

The enlarged and altered Carlton House, Pall Mall (1783–5; demolished 1827–8), was the one building of the century to approximate to Shaftesbury's dream of a new royal palace, albeit transformed from a symbol of constitutional monarchy and national pride to the habitation of the First Gentleman of Europe. Its most acclaimed features were the colonnaded screen, the largest of the neo-classical versions in England [plate 111B], and its sumptuous interiors.[4] Unlike Rousseau's Ionic screen to the entrance

[1] Colvin, *D.E.A.* 291.

[2] For Holland's immense team of assistants and collaborators see Dorothy Stroud, op. cit., and Clifford Musgrave, *Regency Furniture 1800 to 1830*, 1961.

[3] The switch-over to the French was congenial to Holland, but the part played by the Francophil prince should not be underestimated.

[4] See J. Mordaunt Crook and M. H. Port, *The History of the King's Works*, VI, 1782–1851, 1972, 307 ff.

or courtyard front of the Hôtel de Salm, it fronted a yard running laterally to it, so that the Corinthian portico of the house served more efficiently as a *porte-cochère*. The interiors have a rose-coloured after-life in the coloured plates of Pyne's *Royal Residences*, where flamboyantly draped curtains, some of crimson damask with enormous gilt tassels, give a somewhat misleading impression, for they were introduced when the vulgarity of the Prince Regent finally triumphed over the taste of his architect.[1] A better guide to Holland's neo-classical intentions is the encomium of Horace Walpole: 'Every ornament is at a proper distance, and not one too large, but all delicate and new, with more freedom and variety than Greek ornaments; and, though probably borrowed from the Hôtel de Condé and other new palaces, not one that is not rather classic than French.'[2] Again and again in the contemporary debate on architecture it is the ornamental style which is singled out for praise or blame. Some of the furniture recalls types by Beneman and Weisweiler.[3] Possibly as a concession to his patron's partiality for the bizarre as a finishing touch to his dandyism, Mandarin terms, griffin-like dragons, aedicular canopies, and niches, all in a Chinese room, were allowed to diversify the otherwise tasteful scene.[4]

Carlton House was demolished in 1827–8, Brighton Pavilion, Holland's next commission for the Prince, was transformed by Nash from 1815, the East India House (1799–1800) was pulled down in 1861–2. Hans Town, dominated by his own house, Sloane Place, has been largely consumed by urban redevelopment. Few architects have suffered more from the destruction of their major works. As a country-house architect he is best known by his

[1] When the interiors were illustrated in W. H. Pyne, *History of the Royal Residences*, vol. III, 1819, the decorator Walsh Porter had refurbished the house and Nash had made substantial alterations, so that plates XXXI and XXXII in Sheraton's *Drawing Book*, 1793, representing the Chinese Drawing Room and the drawings of details in twos ketch-books by Holland's assistants, provide the best clue to the original appearance. See Stroud, op. cit. 66, 79–80.

[2] Letter to the Countess of Ossory, 17 Sept. 1785.

[3] Peter Ward-Jackson, *English Furniture Designs*, 27. Holland's style is here analysed in its neo-classical context.

[4] The two views of the Chinese Drawing Room in Sheraton's *Drawing Book* are discussed and reproduced in D. Stroud, op. cit. 80, plate 54.

additions and alterations to Woburn Abbey (1787–94) for the Duke of Bedford, and Althorp, Northamptonshire (1787–90), for Earl Spencer. Both promote the image of the country house as a palace rather than an enlarged villa. Dover House (1787) for the Duke of York, now the Scottish Office, is noteworthy for a screen wall taken from the rusticated wall of the Stoa in Stuart and Revett's *Antiquities of Athens* and its order from the Ionic columns of the Temple of Ilissus, most unclassically used to front a courtyard filled with a circular vestibule, one of his most ingenious and elegant designs.[1] On the south front of his finest surviving country house, Southill, Bedfordshire (1795–6), for Samuel Whitbread he exactly repeated the form of the colonnaded wings in his portico, again to emphasize a screening effect.[2]

In 1794 he sent his draughtsman Charles Heathcote Tatham to Italy for three years in order to collect materials, published in *Etchings of Ancient Ornamental Architecture drawn from the Originals in Rome and other Parts of Italy* (1799). In this and other ways Holland followed Adam in giving an architectural lead to the design of furniture and furnishings, at a time when the bronze and the sarcophagus were coming to rival the vase and the stucco bas-relief as antique sources for the useful arts.[3] This late stage of entry into archaeological publication was distinguished by its concentration on ornament, thus constituting an important link between the Adam Gallery in Grosvenor Street and the researches of Thomas Hope.[4] An earlier and more orthodox publication by a follower in the footsteps of Adam was the *Baths of the Romans Explained and Illustrated, with the Restorations of Palladio Corrected and Improved* (1772), dedicated by his fellow Scot Charles Cameron to

[1] Stroud, op. cit. 92–3.

[2] The house and its contents are illustrated and described in *Southill: a Regency House*, 1951, by A. E. Richardson and others, including F. J. B. Watson on the furniture.

[3] In the Preface to *Designs for Ornamental Plate*, 1806, Tatham explicitly championed the 'massive' against the 'light and insignificant'. For Tatham, who also bought specimens of classical ornament and contemporary neo-classical bronzes for Holland, see Colvin, *D.E.A.* 595–6, Ward-Jackson, *English Furniture Designs*, 64–5, Clifford Musgrave, *Regency Furniture*, 35–6, and O.H.E.A. X. 95.

[4] For Hope see O.H.E.A. X. 90–1, and David Watkin, *Thomas Hope and the Neo-classical Idea*, 1968.

the Earl of Bute, now a patron of lost causes rather than rising ones. The title advertised the fallibility of Palladio. The magnificent work attracted the favourable notice of the Empress Catherine II of Russia, who employed Cameron from 1779 at Tsarkoe Selo and appointed him architect of the Agate Pavilion (1782–5) and Cameron Gallery (1783–5). Under the stimulus of Russian imperial patronage he rose to heights which cannot, unfortunately, be discussed in a history of English art.[1]

In a class apart from the architect-decorators, Stuart, Chambers, Adam, Wyatt, and Holland, stand those who on the whole refrained from archaeological publication and were markedly more severe in their approach to design. The outstanding figure was George Dance the Younger (1741–1825).[2] After studying in Rome, Naples, Florence, and Parma for seven years and gaining some of the honours so liberally bestowed by the Italians on worthy foreigners, he returned to England in 1765. Three years later he succeeded his father as Clerk of the City Works. The church of All Hallows, London Wall (1765–7), is one of the first English buildings to break with tradition in accordance with the rationalist precepts of Laugier.[3] Soane as a young man was disturbed, then converted, by the omission of the full entablature between order and vaulting. The unusual structural shape of the Guildhall Common Council Chamber (1777; demolished 1906), with its umbrella-like dome, and the ceiling of Lord Lansdowne's

[1] Nevertheless, Cameron provides an interesting comparison with Adam and from a neo-classical point of view is more advanced. See Georges Loukomski, *Charles Cameron 1740–1812*, 1943, the best-documented and best-illustrated source; Maurice Craig, 'The Palace of Tsarke Tseloe', *C.L.*, 20 Jan. 1966, and Lord Oxmantown, 'The Building of St. Petersburg', *Quarterly Bulletin of the Irish Georgian Society*, Oct.–Dec. 1965. See also *Exhibition Catalogue: Charles Cameron*, London, 1967–8, ed. T. Talbot Rice and A. A. Tait.

[2] There is a considerable but scattered literature on Dance, from which may be singled out Helen Rosenau, 'George Dance the Younger', *R.I.B.A. Jnl.*, Aug.1947; Michael Hugo-Brant, 'George Dance the Younger as Town-Planner', *Society of Architectural Historians Jnl.*, nos. 14–17, 1955–8, 13 ff.; and Dorothy Stroud, 'The Novelty of the Guildhall Façade', *C.L.*, 2 Apr. 1964, 770–1. See also Summerson, 'John Wood and the English Town-Planning Tradition', in *Heavenly Mansions*, 1948, which covers the development from Bath to Dance in London and the Edinburgh New Town.

[3] Summerson, *Architecture in Britain*, 276.

Library (begun *c.* 1792) in his Berkeley Square mansion, with sources of light invisible from the body, also point the way to Soane, who became the supreme master of the mystery of ceilings.[1]

His civic appointment brought Dance his most famous commission, the rebuilding of Newgate Prison 1769–78 [plate 110c]. A tall Vanbrugh-like Gaoler's House and flanking entrances to the prison were squeezed between two massive wings. The wall surface was oppressively rusticated. Within the courts with their rows of windows turned inwards on to the convicts, so that they felt constantly overlooked, there was no escape from the relentlessly pursuing geometry of the prison-house with its monotonous repetitions. Outside, windows were confined to the grim entrances and the Gaoler's House. Understandably, Newgate Gaol has often been acclaimed as a masterpiece of *architecture parlante*.[2]

Sources have been adduced in Mannerism and Piranesi, but essentially it is a Palladian palace-front formula so handled that every normal expectation of size and shape is upset.[3] As *architecture parlante* it can be matched by James Gandon's Four Courts in Dublin (1786–1802), where the former pupil of Chambers raised a huge Temple of Justice on the roof, carefully concealing the conjunction from below. The temple in the skies has been noted as a favourite neo-classical theme, but its exploitation on so monumental a scale was unusual for the time, although much copied

[1] John Fleming and Hugh Honour in the *Penguin Dictionary of Architecture*, 1966, 66, aptly liken the Guildhall Dome to 'a parachute with fine lines radiating from the glazed opening in the centre'.

[2] See 'Newgate Gaol', *R.I.B.A. Jnl.*, 1959 (II), and 'Catalogue of Drawings of Newgate Gaol', *Society of Architectural Historians Jnl.*, 1959, 41–9, both by Sir John Summerson. The long account by Reginald Blomfield, 'The Architect of Newgate', in *Studies in Architecture*, 1905, has stood the test of time very well, for in it nearly all the original and disturbing features are analysed with exceptional insight.

[3] Even more eccentric and expressionist trends appear in the work of Joseph Michael Gandy (1771–1843), whose achievement belongs to the next century. See 'The Vision of J. M. Gandy', in *Heavenly Mansions*, 1949, and 'The Strange Case of Mr. Gandy', *Architecture and Building News*, Jan. 1936, both by John Summerson; and Dimitrios Tselos, 'Joseph Gandy: Prophet of Modern Architecture', *Magazine of Art*, XXXIV, 1941, 251–4.

later. The symbol was permanently visible, and expressed more powerfully than any allegorical figure the idea of the Law as shrine and sanctuary.

In 1779 Princess Dashkov invited Gandon to St. Petersburg, but he declined. 'It is amusing to speculate', writes Maurice Craig, 'what would have happened if the roles of Cameron and Gandon had been reversed: to visualize the Agate Pavilion or the Cameron Gallery rising by the banks of the Liffey, while the Custom House and Four Courts adorned those of the Neva.'[1] Gandon was lost to English architecture when he went to Dublin in 1781 to build the Custom House, but his work may well have influenced a young Irish architect, Francis Sandys, who was to build the most advanced neo-classical house in England, Ickworth, Suffolk (begun 1796), for Frederick Hervey, 4th Earl of Bristol and Bishop of Derry.[2] His eccentric patron, while an admirer of 'dear impeccable old Palladio's rule' of covering with stucco, had a marked taste for novelty.[3] He wanted a circular house in imitation of John Plaw's charming folly of Belle Isle (1774–5) on Lake Windermere in Westmorland. He had previously employed Sandys on his Irish mansion at Ballyscullion on the shores of Lough Beg (begun in 1787; demolished in an unfinished state in 1813), which was largely the prototype.

Ickworth is the neglected masterpiece of the century's architecture, so offensive to the Palladian-trained eye and the Rule of Taste that one critic after another has referred to its discords [plate 110B]. Its proper context, however, is French neo-classicism, which Sandys must have studied either on his way to or from Italy or in publication. The central feature is again a huge temple raised to be seen in isolation against the sky, this time a colonnaded Pantheon, its base-line level with the long roof-line of the wings

[1] M. Craig, *Dublin*, 1952, 238–9. For Gandon see also J. Gandon, jun., and T. J. Mulvany, *The Life of James Gandon*, Dublin, 1846 (ed. M. Craig), London, 1969, and Constantia Maxwell, 'James Gandon, Architect of Georgian Dublin', *C.L.*, 22 Oct. 1948.

[2] See T. G. F. Paterson, 'The Edifying Bishop', in the *Quarterly Bulletin of the Irish Georgian Society*, July–Dec. 1966, which supplements the account of the Earl and Ickworth given in C. Hussey, *M.G.*, 1956.

[3] The Bishop's letters about his house are quoted in Hussey, op. cit. 242 ff.

and pavilions. This isolation was not so marked at Ballyscullion, begun before the Four Courts temple was completed. Once again, the formula is basically Palladian, the shapes and sizes are not. The temple centre looks circular from outside, but is in fact oval, so that the main rooms of state are elliptical on the window side. Where Palladio had inscribed a circular hall inside a square block, Sandys defined a rectangular one within this oval by the use of columns skilfully concealing the curve on the entrance side. The centre of the hall was the site chosen for Flaxman's *Fury of Athamas* (1790–3), a *tour de force* in the horrific Sublime commissioned in Rome.[1] The spatial sequence and its surprises have to be experienced to be appreciated. The personal eccentricity of the Earl is beyond dispute but his taste in architecture was more advanced than eccentric, as befitted a patron who was delighted with Sandys's proposals and vaunted that he owned works by 'Cimabue, Giotto and Guido of Siena' and planned his collection, confiscated after the French occupation of Rome, to 'exhibit an historical progress of the art of Painting both in Germany and Italy, and that divided into its characteristical schools—Venice, Bologna, Florence etc.', an unusual programme for the time.[2]

Novel ideas were tried out more frequently in proprietary churches and chapels than in great houses.[3] The nave of the church rebuilt by Lord Le Despencer at West Wycombe, opened in 1763, and decorated by Giuseppe Borgnis, is orthodox enough, but the ball at the top of the tower for drinking in while observing the countryside realizes the completely spherical enclosure only projected by Boullée later. The chapel at Nuneham Courtenay (1764) by Athenian Stuart for Earl Harcourt 'looks rather like a Byzantine church clothed in Greek mouldings'.[4] A hexastyle Ionic portico was placed in front of the blind nave wall purely for visual effect, so that across the park it looks like a Pantheon. From other angles the chapel resembles a mausoleum, an effect which

[1] For this rare subject see R. Rosenblum, *Transformations*, 14, and in addition to the authorities there cited, Whinney, *Sculpture in Britain*, 188.

[2] Hussey, op. cit. 245.

[3] See M. Whiffen, *Stuart and Georgian Churches*, 1947–8, and Basil F. Clarke, *The Building of the Eighteenth-century Church*, 1963.

[4] Whiffen, op. cit. 59 and fig. 78.

became increasingly fashionable.[1] One of the most original of all the sepulchral churches, to use a term coined by Soane, was designed by Joseph Bonomi for the park at Packington Hall, Warwickshire, for the 4th Earl of Aylesford and built in 1789–90. Bonomi adopted for his plan a Byzantine cross enclosed by a square. On the outside the massive block of brick faced with stone was given a centrifugal emphasis by four lead-domed towers at the corners. It is the interior, however, that is chiefly remarkable, Paestum-like in its monumental severity but less sinister than the sepulchral church for Tyringham, Buckinghamshire, designed by Soane c. 1796 but never built.[2]

For city and town churches a number of architects took up the circular body that Gibbs had proposed in conjunction with the towered entrance of St. Martin-in-the-Fields. In two handsome and important churches of the north, St. Andrew's, George Street, Edinburgh (1781–7), by David Kay and Captain Fraser, the first church built in the New Town, and All Saints, Newcastle (1786–96), by David Stephenson, the circle was converted into an ellipse.[3] Both ellipse and circle were ingeniously combined by the Scotsman George Steuart at St. Chad's, Shrewsbury [plate 112; 1790–2], a small circle for the staircase hall and a large oval for the body. The towered entrance is a high pile of geometric shapes, cubic and hexagonal, culminating in a slim temple in the skies. Splendidly sited above the Severn, it has been justly described as 'one of the most boldly conceived buildings of the whole Georgian epoch'.[4] As at Ickworth, Palladian expectations have to be dismissed before its complex geometry can be appreciated.

[1] Robert Adam deserves mention in connection with the cult of the mausoleum, for both his work at Bowood and David Hume's Tomb based on the Mausoleum of Theodoric at Ravenna (reproduced in Bolton, *Architecture of Robert and James Adam*).

[2] The design is analysed by Pevsner and Alexandra Wedgwood in B.E., *Warwickshire*, 1966, 297–8, who relate it not only to Boullée and Ledoux but Archer's St. John, Smith Square.

See the authoritative account in M. Binney, 'Packington Hall, Warwickshire', *C.L.* CXLVIII, 1970, 102–6, 162–6, 226–9, and *C.L.* CL, 1971, 110–15.

The design for Tyringham is reproduced in Whiffen, op. cit., plate 104.

[3] For St. Andrew's see A. J. Youngson, *The Making of Classical Edinburgh*, 1966, 84–6, and for All Saints, Whiffen, op. cit. 52.

[4] Whiffen, op. cit. 53.

The severe style of which Bonomi's Greek Doric interior in the church at Packington was a prophetic instance was applied to a nexus of civil buildings—country courts, prison, armoury, and exchequer—at Chester Castle (1793–1820) by Thomas Harrison (1744–1829), but here the story of innovation merges with the Greek revival of the following century. London continued to require new squares, the most notable of which, Bedford Square (begun *c.* 1774), splendidly closes the series commenced by the Palladians by its august interpretation of the standard type. It is tempting to ascribe its authorship to Thomas Leverton (1743–1824), who is known to have designed the interiors of several of the houses and to have completed No. 13, which he occupied from 1796.[1] Leverton employed Bonomi as his assistant. A new chapter of innovation in London's planning begins with Hans Town, laid out by Henry Holland from 1777 after he had acquired in 1771 from Lord Cadogan a lease of 89 acres south of Knightsbridge.[2] Aware that the area must inevitably be surrounded by suburban growth Holland planned his town from the beginning as a self-contained unit, its nexus of streets and open spaces to be occupied by the professional and middle classes, at the head of which he ultimately placed himself by designing his own residence, Sloane Place, with a park of 21 acres, as the great house. In the event houses were taken by the aristocracy and Members of Parliament as well as merchants and members of the professions. Hans Place, the central open space of the town, was a rectangle cut off at its corners with triple entry arranged to favour oblique viewpoints.

Meanwhile George Dance the Younger had also entered the field of planning for the expanding mercantile and professional classes, laying out American Square, the Crescent, and the Circus in the Minories (from 1768), followed by Finsbury Square (1777) and Alfred Place (1790–1814) off Tottenham Court Road, the last designed with terminal crescents.[3] A scheme (*c.* 1791) for

[1] Colvin, *D.E.A.* 364, and Summerson, *Georgian London*, 147–50.

[2] For this account I have drawn heavily on chapter IV, 'Hans Town', in Dorothy Stroud, *Henry Holland*, 1966, with much new material of the greatest interest for the historian of town-planning. Subsequent acquisitions enlarged the site.

[3] See M. Hugo-Brant, 'George Dance the Younger as Town-Planner', *Society of*

developing the Camden Estate in St. Pancras for Lord Chancellor Camden was unfortunately never carried out. Dance's imagination received its most powerful stimulus not from residential growth but the new challenge of urban replanning and development. In 1768-9 he prepared as City Surveyor a layout for the area south of the Thames between Westminster and Blackfriars Bridge, 'the boldest plan until then carried out in London'.[1] At St. George's Circus he designed an elaborate *rond-point*. The scheme was only partially realized. His chief claim to fame in the history of town-planning, however, is his series of megalo-maniac designs for the renewal of the Port of London, prepared from 1796 and published as an appendix to the 3rd Report of the Select Committee of the House of Commons (1800).[2] In one project (1799) he threw a bridge across the Thames in a single enormous span of 300 feet rising to 100 feet. In another and better-known one [plate 110A], for it was published in an engraving (1802) by William Daniell, from an oil painting of 1800, he abandoned the idea of a bridge high enough for shipping to pass underneath for *two* Tower Bridges of London, each with a drawbridge, one of which could be raised while the other was closed, so that river and road traffic could proceed simultaneously. At each end he designed vast piazzas crowned by crescents, the northern dominated by the Monument, the southern by a gigantic obelisk. Along the immense but regular stretch of the Thames below the bridge and the Tower of London he projected an even bolder design, the 'Legal Quays', so named because Courts of Law were placed centrally between long monolithic rows of warehouses, thus associating justice with commerce. The idea of matching buildings across the river may have been suggested by Patte's scheme for the Seine across the old Louvre, but he was no doubt influenced by the Adelphi and Somerset House. If the proposals had been adopted, the river-fronts of Adam, Chambers,

Architectural Historians Jnl., nos. 14-17, 1955-8, 13 ff.; N. Pevsner, B.E., *London except the Cities of London and Westminster*, 1952, 27 and 407-8; Summerson, *Heavenly Mansions*, 103-7; and Colvin, *D.E.A.* 165-6.

[1] It was approved in 1769. See Pevsner, op. cit. 391.
[2] Discussed and illustrated in M. Hugo-Brant, op. cit.

and Dance would together have given Georgian London some-
thing of the neo-classical magnificence of St. Petersburg.

The grand scheme irresistibly suggests a comparison with the
visionary projects of Boullée and Ledoux. The emphasis on
structural form, the denudation of ornament, and the organic
articulation of megalomaniacally extended geometric shapes are
common to both the English and the French architects. Never-
theless, Dance as a City Surveyor was more realistic. His most
fantastic idea of two gigantic drawbridges spanning the Thames
was sufficiently practical for half of it to be carried out by the
construction of Tower Bridge, by J. Wolfe Barry and Horace
Jones, in 1886–94. Not the least of his achievements was to keep
alive the idea of using the Thames as a foreground to architecture
between the building of Somerset House and the design of the
Houses of Parliament. When Pugin, who spent long hours at his
drawing-board on Utopian civic projects, was employed by
Charles Barry to design much of the medieval detail of the Palace
of Westminster, he disguised the true character of the general
design, which, it has been perceptively stated, 'owes much to
Barry's classical predilections'.[1] It was Barry who conceived the
spectacular alignment on the river front and the bold massing of
gigantic shapes.[2] The Gothic ornament enriches these shapes
without destroying their severe geometry, which is a neo-
classical feature. Neo-classical, too, is the aggregation of free
grouping of the severe masses, wholly emancipated from the
orthodox principles of classical composition. That Dance as well
as Wyatt should have prepared the way for this emancipation is
yet further evidence, if evidence be needed, of the powerful
romantic undercurrents of this revolutionary period in English
architecture.

[1] Colvin, *D.E.A.* 60. [2] O.H.E.A. X. 192.

XII

THE PICTURESQUE AND THE
TRANSITION TO ROMANTICISM

THE picturesque was a movement of taste for landscape
in art and nature, influencing architectural design as well
as painting, and culminating in the debate on the pic-
turesque as a separate aesthetic category.[1] Because it was a move-
ment of taste, it was never a precise style, in this respect resembling
romanticism, for which it prepares the way. With the growing
tendency of poets to introduce references to art in their extended
descriptions of natural scenery, a word which had been used by
Jonathan Richardson the Elder to evoke the most exalted responses
to history painting and by George Vertue to describe the free
inventions of the sculptor[2] acquired its decisive association with
landscape. In *The Castle of Indolence* (1748) James Thomson listed
in a much-quoted passage the beauties conjured up by the pencil
of the landscape painter: the gay bloom of spring, the brown
shades of autumn, the black tempest that 'astonished', the sun
with its light trembling on the waters of ocean, and rude moun-
tains frowning amid the skies:

> Whate'er *Lorrain* light touch'd with softening Hue,
> Or savage *Rosa* dash'd, or learned *Poussin* drew.[3]

[1] The pioneer treatise on the picturesque is Christopher Hussey, *The Picturesque:
Studies in a Point of View*, 1927, reprinted in Archon Books, Connecticut, U.S.A.,
1967. All later studies may be described as an extension of this work, still the standard
authority and the only one to embrace all the categories.

For the extensive bibliography of studies concentrated on the theory of the pic-
turesque see the last note to this chapter, and T. S. R. Boase, O.H.E.A. X. 16–21,
for a discussion of the romantic aspects of the picturesque.

[2] For Richardson's usage see *The Theory of Painting* (1719) in *Works*, 1792, 91,
and for Vertue, *Notebooks*, III. 162, Aug. 1752.

[3] For a fuller discussion of this and related passages see Elizabeth Wheeler Man-
waring, *Italian Landscape in Eighteenth Century England: a Study chiefly of the Influence*

If his reference to the ethereal space fleeced with clouds in Titian's landscape be added, the list comprises the main sources of the picturesque categories admired in the eighteenth century.

The movement may be dated from about 1750, when the word 'views' first comes into prominence.[1] By that time it had acquired anti-classical associations with asymmetry, the irregular, and the painterly, partly as a result of its usage in the context of the French rococo, the most extravagant phase of which had been entitled the *genre pittoresque*.[2] As a term of stylistic or formal reference it continued to be used outside the sphere of landscape. In 1771 Tobias Smollett described Sir Thomas Bulford in *The Expedition of Humphrey Clinker* as so impressed by the 'very picturesque appearance' of a ludicrous character that he cried out, 'O, what *caricatura!*—O, for a Rosa, a Rembrandt, a Schalken!'[3] Rembrandt's flayed ox was later to become a test case of the picturesque debate.[4]

Just as Giedion's phrase, a 'coloration', has been suggested in preference to a stylistic concept of neo-classicism, another manifestation of the hydra-headed appearance of art in the second half of the century,[5] so an account of the picturesque as the last and most profoundly anti-classical of the movements before romanticism must take into consideration not only shifting attitudes but a variety of categories and sub-categories. It may help the student to grasp certain guide-lines before entering the picturesque wilderness. First, the prevailing shift of taste in landscape during the period 1750 to 1800 was towards the irregular and romantic, so

of *Claude Lorrain and Salvator Rosa on English Taste 1700–1800*, 1965 (1st ed., 1925), and Hussey, op. cit., chapter II.

[1] S. T. Prideaux, *Aquatint Engraving: a Chapter in the History of British Book Illustration*, London, 1909, 84. Hussey's earlier date for the commencement, *c.* 1730, refers to the literary origins.

[2] For the French usages see Fiske Kimball, *The Creation of the Rococo*, Philadelphia, Pa., 1943, 152–3.

[3] The full passage is discussed in Walter J. Hipple, *The Beautiful, The Sublime and The Picturesque in Eighteenth-century British Aesthetic Theory*, Carbondale, Ill., 1957, 187. [4] Ibid. 279.

[5] Robert Rosenblum, *Transformations in Late Eighteenth Century Art*, Princeton, N.J., 1967, 4 and viii. His fundamental analysis of neo-classicism by categories is also valuable for students of the picturesque.

that the associations with Savage Rosa inevitably triumph over those with Vergilian Claude. Mountain glory replaces mountain gloom.[1] Secondly, there are two paths that lead through the maze towards the romantic landscape painting of the nineteenth century. The first is the grand picturesque, which can be highly dramatic and artificial, and was dominated initially by the influence of Claude-Joseph Vernet and subsequently by Philip James de Loutherbourg. This category principally promoted the picturesque cult of storms, shipwrecks, volcanic eruptions, avalanches, waterfalls, etc., and did not separate itself from the Sublime and the traditions of *istoria*.[2] The second, more quietist path leads from the cottage or rural picturesque of Gainsborough to Morland and Bewick, and includes amongst its followers the 'modesty of nature' school and those topographical painters who explored less dramatic scenery than the mountains of Wales, the Lake District, and the Highlands of Scotland. Artists in this second category could be no less romantic by virtue of a deeply felt poetic sentiment (Gainsborough) and attitude of reverence before nature (the Cozenses and Girtin). Broadly speaking, the grand path conducts to Turner and the 'modesty of nature' one to Constable, but sometimes they cross and even unite for short distances.[3]

In architecture, the main divisions are between the castle, the abbey, and the cottage picturesque. The asymmetry of Vanbrugh's castle and Walpole's Strawberry Hill was due to later additions, as much an outcome of organic growth as that of the Middle Ages. Strawberry Hill was built over decades, so that the champion of the Gothic merges insensibly into the pioneer of the picturesque. Its creator hailed Wyatt's Lee Priory (1783–90) as 'a child of Strawberry prettier than the parent',[4] and could equally

[1] See Marjorie Hope Nicolson, *Mountain Gloom and Mountain Glory: the Development of the Aesthetics of the Infinite*, Cornell University Press, 1959, a major study of the background of ideas and the first to do justice to the role of science.

[2] For the picturesque origins of Turner's art see John Gage, 'Turner and the Picturesque', *Burl. Mag.*, Jan. and Feb. 1965.

[3] For Constable and the picturesque see a major review article on Graham Reynolds's *Catalogue of the Constable Collection, Victoria and Albert Museum*, 1960, by Louis Hawes, jun., in *Art Bull.*, June 1961, 160–5.

[4] Letter to the Miss Berrys, 28 Sept. 1794.

well have claimed the paternity of Fonthill Abbey (1796–1807) by the same architect, despite those neo-classical features that look forward to Barry's Houses of Parliament—the megalomaniac tower and free grouping of elongated rectilinear shapes. By contrast with Vanbrugh's castle and Walpole's abbey, Downton Castle, Herefordshire (1772/3–1778) [plate 113A], was built entire and at once to its original plan, with irregularity as an aesthetic goal, and as such may be claimed as a landmark in the history of irregular architecture.[1] It was designed by its owner, Richard Payne Knight, who drew his inspiration partly from Claude. One is reminded of the bold geometry of Seaton Delaval rather than the 'charming irregularities' that Walpole admired in Gothic.[2] The exterior is Gothic, the interior classical, precisely the formula followed by Robert Adam in the next landmark of picturesque castle architecture, Culzean Castle (1770) [plate 113B]. Adam's immense activity as a picturesque draughtsman and his admiration of the picturesque in Vanbrugh can be matched by many other examples of neo-classical enthusiasm for the anti-classical taste. Even George Dance the Younger in the London Guildhall (1788–9) tried his hand at an essay in abbey picturesque, this time with a combination of the Gothic (the west front of Bath Abbey) and the Indian (a Mosque at Chunar Gur).[3]

In the closing decades of the century the cottage became a veritable stylistic battleground. The estates laid out by philanthropic landowners like John Howard the prison reformer at Cardington, Bedfordshire, after 1756 (surviving examples dated 1763–4) and the paternalistic Lord Harcourt at Nuneham Courtenay, Oxfordshire, where he built a new village in 1764 in order to enlarge his park, followed the vernacular.[4] Sir William Chambers and Capability Brown were both concerned in the

[1] See the accounts of Downton in Hussey, *M.G.*, and Pevsner, B.E., *Herefordshire*, 1963, the latter noting (p. 117) that the Shrewsbury architect Thomas Farnolls Pritchard was at least consulted.

[2] Letter to Sir Horace Mann, 25 Feb. 1750.

[3] The Indian source was detected by Dorothy Stroud. See 'The Novelty of the Guildhall Facade', *C.L.*, 2 Apr. 1964. The Mosque had been illustrated in William Hodges's *Select Views of India* (1786).

[4] Nicholas Cooper, 'The Myth of Cottage Life', *C.L.*, 25 May 1967.

model village laid out by Lord Milton at Milton Abbas (1773–9), a classic example of Georgian good taste under thatch.[1] These were all functional, like the plans for model cottages published by Nathaniel Kent in 1775 and the designs in John Wood the Younger's *A Series of Plans, for Cottages or Habitations of the Labourer* (1781).[2] The housing estates of the industrialists, e.g. Richard Arkwright and Jedediah Strutt, conspicuously avoided the luxuries of the picturesque.[3] The impetus to architectural fantasy came from the cottage as a genteel habitation, a symbol of virtue in distress or virtue without riches, promoted by Rousseau and in England especially by Oliver Goldsmith's *Vicar of Wakefield* (1766), from which the *Laetitia* series of Morland stems. The Rousseauesque association with primitivism, later carried to almost surrealist lengths by J. M. Gandy in his visionary architecture, appears in 1788, when Sir John Soane illustrated in his *Plans of Buildings* not a cottage, but a rustic dairy at Hammels, Hertfordshire, and later published designs for cottages described as 'roughcasted, and the roof . . . covered with reeds: the pillars are the trunks of trees, with the bark on, decorated with woodbine and creepers.'[4] Henceforth woodbine and its satellites, honeysuckle and the briar rose, were to adorn the cottage, as ivy the castle or abbey, but the design itself was neat, and on the whole a taste for genteel neatness prevails in the cottage publications which become numerous in the 1790s, notably Charles Thomas Middleton's *Picturesque and Architectural Views for Cottages, Farm Houses and Country Villas* (1793), John Plaw's *Ferme Ornée or Rural Improvements* (1795), and James Malton's *Essay on British Cottage Architecture* (1795). Both neo-classical neatness and picturesque irregularity were still combined in that miniature museum of cottage styles, John Nash's Blaise Hamlet (1811).[5]

[1] Arthur Oswald, 'Market Town into Model Village,' *C.L.*, 29 Sept 1966.

[2] Nicholas Cooper, op. cit.

[3] Cf. Roy Christian, 'A Derbyshire Cotton Empire', *C.L.*, 10 Nov. 1966.

[4] *Sketches in Architecture, containing Plans, Elevations, and Sections of Cottages, Villas and other Useful Buildings*, 1793.

[5] For Blaise Hamlet see John Summerson, *John Nash, Architect to George IV*, London, 1935, 100, and John Steegman, 'Repton at Blaise Castle', *Burl. Mag.*, Nov. 1926.

In choosing a style to decorate his interiors the patron of castle, abbey, and cottage picturesque had little to fall back on except the Gothic in the interregnum between the rococo Chinese and the Indian tastes, unless he aimed at contrast. One new mode may be noted, the illusionistic landscape room celebrating picturesque mountain scenery. The Painted Room at Drakelowe Hall (signed 1793), by Paul Sandby, and the Landscape Room at Norbury Park, Surrey, for William Locke by George Barret, Sawrey Gilpin, and others (c. 1781) have been described as 'the high water-mark of the cult of the picturesque'.[1] At Drakelow Hall [plate 115A] real palings and trellis-work were projected a few inches from the room to create the illusion that the Lake District could be entered from little wicket-gates, also real and left half-open.[2]

The empire of landscape gardening in the reigns of George III and George IV was governed in almost dove-tailing succession by Lancelot Brown (1716–83) and Humphrey Repton (1752–1818), nicknamed respectively 'Capability' and 'Amenity'. Brown was roughly handled by the picturesque theorists Price and Payne Knight, understandably enough, for he is the least pictorial of the great English designers of gardens.[3] This is precisely his merit. He used Claudian temples and Gothic ruins sparingly, and denied the necessity of architectural settings. His great gifts were for space and the handling of water, the first exercised so expansively that Knight denounced him as the 'thin, meagre genius of the bare and bold'.[4] 'Thames, Thames, you will never forgive me!' was his reputed exclamation as he admired his master-work at Blenheim, the conversion of the Glyme into half river, half lake.[5]

[1] C. Hussey, 'Two Eighteenth-century Painted Rooms', C.L., 17 Feb. 1934, 161.
[2] Thus following the example of Claude in painting on four walls of a Roman palace a set of landscapes which united in one whole. See E. W. Manwaring, *Italian Landscape in Eighteenth Century England*, 1925, 75.
See chapter VI, 'The Panoramic Room', in E. Croft-Murray, *Decorative Painting in England*, II.
[3] Cf. Christopher Hussey in the Introduction to Dorothy Stroud, *Capability Brown*, 1950, 14–17, and Walter Hipple, *The Beautiful, The Sublime and The Picturesque*, 1957, 250.
[4] *The Landscape, a Didactic Poem in Three Books addressed to Uvedale Price Esq.*, London, 1794, line 284. [5] Cited by Hussey, op. cit. 18.

His formula of stretched-out serpentine contours accented by clumps of trees rather than continuously bordered by boscage exactly suited the taste of horse-riding owners who enjoyed nature as a background to exercise and the inspection of prize livestock, and indeed it is only through movement through them that his greatest parks from Longleat (begun 1757) to Nuneham Courtenay (begun 1778) can be appreciated. Five years after Brown's death Humphrey Repton made his decision to take up landscape gardening, a term he was the first to use professionally.[1] On 28 August 1788 he described Gilpin and other writers on the picturesque as his breviary, and the gardens of Kent and Brown as his places of worship.[2] His goal was to combine the best from the two schools. He reintroduced the pictorial principles of Kent, working from water-colour sketches as well as plans; like Brown, he played down association, so that the garden was in no danger of being restored as an Elysium studded with ornamental temples and monuments; and he reintroduced formality in restricted areas near the house, particularly those flanking it. He had a flair for collaboration with architects, so that the garden at Kenwood is as perfect a foil to Adam's mansion as his major work in the nineteenth century is to those of Nash. Unlike his predecessors, he was a prolific writer, illustrating his text with the famous 'Before' and 'After' pictures, and because in his enthusiasm for the picturesque he came down on the side of the 'modesty of nature' school rather than Salvator Rosa, he promoted the survival of the English garden by adapting it to the taste of an age which distinguished sharply between mountain glory and the smoother charms of cultivated landscape.[3]

The influence of the picturesque in town-planning bore its main fruits in the nineteenth century, but a few landmarks may be noted. In 1767 the young architect James Craig presented a revision of his prize-winning plan for Edinburgh New Town to the Town Council. Princes Street was conceived as a terrace or scenic platform overlooking the Old Town with its almost

[1] Dorothy Stroud, *Humphrey Repton*, London, 1962, 12.
[2] Letter to the Reverend Norton Nicholls, cited in Stroud, op. cit. 28.
[3] Cf. T. S. R. Boase, O.H.E.A. X. 19.

complete repertory of picturesque objects—castle, an ancient and irregular city, precipice, etc.—the whole to be viewed above water sparkling in the middle distance of the vale.[1] A 'great army of crescents' sprang up in the 1780s.[2] At both Bath and Bristol the crescent climbed to the summit of the hills. An interesting innovation was the inversion of the crescent, that is, with its back to the view. By this ingenious but simple device it was possible for the residents to enjoy the vista without being made conscious of their neighbours' houses. A fine early example is the Paragon (*c.* 1780–90) at Blackheath; but by far the most spectacular is the Paragon at Clifton (begun 1809) by the builder John Drew with a view that must originally have rivalled that from Princes Street in Edinburgh.[3]

In tracing the course of the grand picturesque in painting a convenient starting-point is the art of Claude-Joseph Vernet (1714–89), who was accessible to English artists visiting Rome, where he encouraged Richard Wilson and taught Alexander Cozens.[4] Engravings of his work also familiarized stay-at-home artists with the drama of shipwrecks, conflagrations, and eruptions and the mysteries of moonlight, as well as the grandeur of the Ports of France. Wilson, whose Vernet-like melodramas have already been noted, had met in Venice in 1750/1 the *veduta* painter Francesco Zuccarelli (1702–88), who shortly afterwards came to England.[5] His prettily fluent landscape style with its

[1] For Craig's plan see the documentations and maps published by the Royal Scottish Geographical Society in *The Early Views and Maps of Edinburgh 1544–1852,* Edinburgh, 1919, and the account in A. J. Youngson, *The Making of Classical Edinburgh,* 1966, chapter IV. [2] Summerson, *Heavenly Mansions,* 107.

[3] For the Blackheath Paragon see Pevsner, B.E., *London except the Cities of London and Westminster,* 1952, 160, and for the Clifton Paragon, Walter Ison, *The Georgian Buildings of Bristol,* 1952, 235–7.

The picturesque in architecture is notably discussed by Boase, O.H.E.A. X, chapters 1 and 3, Summerson, *Architecture in Britain,* chapter 28, 'The Picturesque and the Cult of Styles', Henry-Russell Hitchcock, *Architecture, Nineteenth and Twentieth Centuries,* 1958, chapter I, and C. L. V. Meeks, 'Picturesque Eclecticism', *Art Bull.* XXXII, 1950, 226–35.

[4] For Vernet and Cozens see 'A Roman Sketch-Book by Alexander Cozens', *Wal. Soc.* XVI, 1928, 90, and *Alexander and John Robert Cozens,* London, 1952, 14–15, both by the late A. P. Oppé.

[5] See Wart Arslan, 'Considerazioni su' Francesco Zuccarelli', *Bollettino d'arte,*

dainty impasto lacks the freedom and sensitivity to atmosphere of his younger contemporary Guardi, but his Arcadian pastorals and rustic scenes with old buildings and ruins caught the fancy of George III and he became a Foundation Member of the Royal Academy in 1768. In 1760 he painted *Macbeth and the Witches* in a Gaspard–Poussinesque landscape agitated by a lively rococo storm; the mêlée of fleeing horsemen is not unreminiscent of Battle of the Standard groups by Salvator Rosa, reduced to a toy-like scale.[1] That the Italian should have chosen Shakespeare and not a classical myth like the daughters of Niobe for his essay in the sublime picturesque points to a future trend. Seven years later a Scotsman working in Rome, John Runciman, painted *King Lear in the Storm* (1767), a far more advanced painting by romantic standards with its echoes of Rembrandt's configuration and the painterly technique of Rubens, and strikingly original in 'its violent interplay of human emotions and natural elements'.[2] Unfortunately he died at the age of twenty-four, and therefore had no chance of competing with Wright of Derby in raising the level of picturesque landscape in Boydell's Shakespeare Gallery.

The crucial link between Vernet and the grand manner of Turner is Philippe Jacques (later anglicized to Philip James) de Loutherbourg (1740–1812), the father of Drury Lane picturesque. Born at Fulda in Hesse-Nassau, the son of the Court Painter at Darmstadt, he studied first under his father and J. H. Tischbein, then in Paris under Carlo Vanloo and François Casanova, becoming, as Diderot noted, an accomplished imitator of Berchem, Wouverman, and Vernet.[3] He brought to England in 1771 the

11 May 1934, and two articles by M. Levey, 'Wilson and Zuccarelli at Venice', *Burl. Mag.*, Apr. 1959, 139–43, and 'Francesco Zuccarelli in England', *Italian Studies*, 1959, 1–20.

[1] The painting is reproduced and discussed in W. Moelwyn Merchant, *Shakespeare and the Artist*, Oxford, 1959, plate 14*b* and p. 65.

[2] Ibid., chapter 12, 'John Runciman's *King Lear in the Storm*, 1764'.

[3] The best account of de Loutherbourg is still Austin Dobson's 'Loutherbourg R.A.' in *At Prior Park, and Other Papers*, London, 1912, 94–127. But see also C. H. S. John, *Bartolozzi, Zoffany and Kauffmann with other Foreign Members of the Royal Academy 1768–1792*, London, 1924, chapter XIII, 'Loutherbourg, I, Life', and chapter

most august credentials, 'Painter to the King of France and
Member of his Royal Academy, and of the Academy of Paint-
ing at Marseilles',[1] and within two years of his arrival Garrick ap-
pointed him principal stage and scenery designer at Drury Lane.
Although Anthony Pasquin abusively described his chromatic for-
mula as 'brick-dust foregrounds, red fields, brass trees and a
copper horizon',[2] and Walpole and Peter Pindar were no less
witty at his expense, he could paint realistically as well as with the
artifices of scenic bravura, reserving the latter for the grand
picturesque [plate 117A].[3]

Henry Angelo in his *Reminiscences* takes as his starting-point
for his account of innovators in stage scenery, notably Servandoni,
de Voto, and de Loutherbourg, *le tableau mouvant* or *les ombres
chinoises*, and claims that a pictorial stage constructed by his
father, who had seen *les tableaux mouvants* in Venice, was much
admired by Gainsborough, Wilson, and other landscape painters.[4]
The basic plan was to show figures in black silhouette moving
against scenes painted and lit as transparencies. The spectacles were
popular in France, where de Loutherbourg had worked with
stage appliances for simulating sunlight, starlight, and running
water.[5] In England he scored his most spectacular success with
the Eidophusikon, which he exhibited for the first time on 26 Feb-

XIV, 'Loutherbourg, Work', and the article by H. A. Hammelmann in *C.L. Annual*,
1956, 152, and *C.L.*, 4 Dec. 1958. For de Loutherbourg and the stage see Anthony
Oliver, 'De Loutherbourg and Pizarro', *Apollo*, Aug. 1967, 135–7; R. Thomas,
'Contemporary Taste in the Stage Decorations of the London Theatres 1770–1800',
Modern Philology, XLII. 65–78, and Richard Southern, *Changeable Scenery*, 1953.

[1] A. Graves, *The Royal Academy of Arts*, under de Loutherbourg.

[2] In *Memoirs of the Royal Academicians*, 1796, part II. 80.

[3] For the strictures on his colouring by Diderot, Walpole, and Peter Pindar see
Austin Dobson, op. cit.

[4] *The Reminiscences of Henry Angelo with an Introduction by Lord Howard de Walden
and Notes and Memoir by H. Lavers Smith, B.A.*, 2 vols., 1904, 8–12. For *les ombres
chinoises* see Austin Dobson, *Side Walk Studies*, 1902, 93–100. Cf. also four articles
on little-known scenery painters by Thomas Lediard, *Theatre Note-Book*, Apr.–June
1948, E. Croft-Murray, 'John Devoto', in *Society for Theatre Research*, 1952.

[5] France was an ever more important centre for colour-light experiments than
Venice. See Wilton Mason, 'Father Castel and his Colour Clavicin', in *Journal of
Aesthetics and Art Criticism*, XVII, 1958, 103 ff. and Appendix A; also 'Carmontelle's
Transparencies', in Austin Dobson's study noted below.

ruary 1781.[1] It was arranged in five scenes: *Aurora*, or dawn over London, viewed from Regent's Park; *Noon over Tangier*, with a distant view of Gibraltar; *Sunset near Naples*; *Moonlight on the Mediterranean*; and *The Conclusive Scene, a STORM at Sea, and Shipwreck*. Music for this romantic anticipation of *Son et Lumière* was specially composed and performed on the harpsichord by Michael Arne, the son of the famous composer. A second showing, opening on 10 December, concluded with *Satan arraying his Troops on the Banks of the Fiery Lake, with the Raising of the Palace of Pandemonium; from Milton*. Four years later, on 30 January 1786, the Eidophusikon was reopened with *The Wreck of the Halsewell, East Indiaman*, as its chief attraction.

De Loutherbourg could not literally raise Pandemonium, but he certainly liberated romantic impulses among both the older and the younger generations. Reynolds recommended his friends to take their daughters to see it. Gainsborough, infatuated to the extent of going evening after evening, made his own peep-show box of scenes painted on glass (*c.* 1783–4), lit by candles from within. Characteristically, his illuminated landscapes excluded the violent, but they are among the closest of all his paintings to the romantic mood of Wordsworth's nature poetry.[2]

Pandemonium was repeated in the 1786 exhibition, where it was seen by W. H. Pyne, whose description brings out its melodramatic character:

> In this tremendous scene, the effect of coloured glasses before the lamps was fully displayed; which, being hidden from the audience, threw their whole influence upon the scene, as it rapidly changed, now to a sulphurous blue, then to livid red, and then again to a pale vivid light, and ultimately to a mysterious combination of the glasses, such as a bright furnace exhibits, in fusing various metals.[3]

In 1828 memories were sufficiently vivid for a reviewer of the

[1] I have followed the fullest account given by Austin Dobson in *At Prior Park, and Other Papers*, 1912, Appendix B (Exhibitions of the Eidophusikon), but see also W. T. Whitley, *Artists and their Friends in England*, I. 353, II. 352–3.

[2] Gainsborough's peep-show box is now in the Victoria and Albert Museum. For illustrations see E. K. Waterhouse, *Gainsborough*, London, 1958, plates 261–8.

[3] *Wine and Walnuts*, 2nd ed., 1884, I, chapter XXI, cited by Austin Dobson, *At Prior Park and Other Papers*, 113.

Royal Academy exhibition to describe John Martin's style as 'Loutherbourg outheroded'.[1] The practice of Turner in publishing Miltonic texts to accompany his works was similarly foreshadowed by the rendering of the passage from *Paradise Lost* beginning

> Anon out of the earth a Fabrick huge
> Rose like an Exhalation . . .

In 1786 Turner was eleven years old, and his home was near the reasonably priced exhibition.

Meanwhile the Industrial Revolution was bringing about spectacular effects no less horrific. In 1776 Arthur Young observed of the Ironworks at Coalbrookdale in Shropshire that the whole edifice was 'horridly sublime' and specified as 'altogether sublime' the noise of the forges, mills, etc., 'with all their vast machinery, the flames bursting from the furnaces with the burning of the coal and the smoak of the lime-kilns'.[2] Cyclopean imagery and the Miltonic sublime were invoked by other writers describing the dark satanic mills of industry. For de Loutherbourg it was a natural transition from Drury Lane picturesque to Industrial Revolution picturesque. In 1805 a coloured aquatint after his drawing of Coalbrookdale [plate 114B] was published in his *Romantic and Picturesque Scenery of England and Wales*, the first title in which 'picturesque' appears as a corollary of 'romantic'. The rider with his sled and dog approaches the Ironworks and its tower-like chimneys emitting flame and smoke like an enchanted Cyclopean fortress or forge of Vulcan, and the discarded fragments of cast iron are scattered like broken columns on an ancient site. But the heroic sublime is muted in this forecast of industrial archaeology, for in his topographical records the artist was notably more restrained than in his work for the stage.

The panoramic picturesque, which came to the fore in the last decade of the century, belongs in the main to the quietest stream with its source in the prospect views from the hills outside London

[1] In a criticism of *The Paphian Bower* in *A Descriptive and Critical Catalogue to the Royal Academy*, 1823, cited by Thomas Balston, *John Martin 1789–1854: His Life and Works*, London, 1947, 75.

[2] In *Annals of Agriculture*, vol. IV, 1776, cited by F. D. Klingender, *Art and the Industrial Revolution*, London, 1947, 74.

—Greenwich, Richmond, and Cooper's Hill or from terraces commanding the sweeps of the Thames beloved by Paul Sandby. But megalomaniac and sometimes dramatic tendencies can be noted besides topographical illusionism. In 1789 Robert Barker, described by J. L. Roget as the founder of panoramas, opened his semi-circular *View of Edinburgh*, hailed by Benjamin West as 'the greatest improvement in the art of painting that had yet been discovered'.[1] Reynolds stated that the illusionistic 'invention' was capable of producing effects and representing nature in a manner far superior to 'the limited scale of pictures in general'.[2] When Queen Charlotte visited Barker's 1793 exhibition, the wholly cylindrical view of the Grand [Russian] Fleet at Spithead under the name, then first adopted, of *ΠΑΝΩΡΑΜΑ*, at Leicester Fields, she complained that its realism made her feel sea-sick.[3] Meantime the son Henry Aston Barker had shown in 1792 a three-quarter circle *View of London* viewed from the top of the Albion Flour Mills, burnt down in 1791, and Girtin's *Eidometropolis* (1802) was similarly taken from the top of an industrial building. Its size, 108 feet by 18 feet, is evidence of a megalomaniac ambition culminating in Samuel James Arnold's *Picture of London* (1802), covering no less than 1,944 square feet. Mr. Turner's *Naumachia*, opened in Bouverie Street in February 1800 and playing for nearly a year to packed audiences, included an Eruption of Vesuvius, a theme which haunted the imagination of artists as well as writers both as a scientific marvel and a symbol of insecurity.[4]

The feats of science and the wonders of nature figure prominently in the marvellous picturesque. Philip Reinagle's painting of *The Perilous Situation of Major Money*, engraved in mezzotint

[1] W. T. Whitley, *Artists and their Friends*, II. 106–7. For the panoramic picturesque, and especially Girtin's Eidometropolis, cf. Boase, O.H.E.A. X. 33–4.

[2] Whitley, loc. cit.

[3] Ibid. See also J. L. Roget, *A History of the 'Old Water-Colour' Society*, 1891, I. 103–6, and W. T. Whitley, 'Girtin's Panorama', *Conn.*, May, 1924.

[4] Cf. John Gage, 'Turner and the Picturesque—I', *Burl. Mag.*, Jan. 1965, 24, where reference is made to a suggestion by W. T. Whitley (Whitley papers, British Museum) that this Turner was none other than J. M. W. Turner. It is difficult to believe that this identification, if correct, would have escaped those who have investigated the records of his life.

by John Murphy [plate 93B], commemorates the exploit of a
balloonist who surfaced on the sea off Norwich on 22 July 1785.
Here the artist had no Old Master precedents to fall back on in
depicting the collapse of a balloon, although in the attitude of
the hero there is perhaps an echo of the Falling Titan or Giant, a
theme which obsessed Prince or 'Giant' Hoare and was so memor-
ably rendered by Banks. The ropes of the balloon combine with
the chiaroscuro to make an almost surrealist impact, heightened
by the sharply abstract pattern of unfamiliar shapes, while the
solitary hero of this strange scene is depicted in as romantically
uncertain a predicament as the massed survivors in Géricault's
Raft of the Medusa.

The Cataract of the Niagara in de Loutherbourg's second season
of the Eidophusikon in 1781/2, like Wilson's painting of the
same theme, can only have been made at second hand. When
O'Keefe's *Omai; or, a Trip round the World* was shown at Covent
Garden in 1785, de Loutherbourg was paid £100 for designing
costumes, accessories, etc.[1] He was assisted by the landscape
painter John Webber, who served as a draughtsman on Captain
Cook's third voyage (1776). Pacific exploration opened up a new
world of exotic wonders to the romantic imagination. One of the
most exciting Coleridge discoveries of recent years is that the
imagery of *The Ancient Mariner* (1798) closely follows the order
of phenomena recorded in the manuscript journal kept by William
Wales on the second voyage (1772).[2] Wales not only taught the
poet at Christ's Hospital, but served on the same voyage with
William Hodges (1744–97), the outstanding practitioner of the
marine picturesque.[3]

A pupil of Richard Wilson and like de Loutherbourg a scene
painter for the theatre, Hodges had made a reputation for views

[1] Austin Dobson, *At Prior Park*, 108–9.

[2] Bernard Smith, 'Coleridge's *Ancient Mariner* and Cook's Second Voyage',
J.W.C.I. XIX. nos. 1–2, 1956, 117–54. The journal was purchased by the Mitchell
Library, Sydney, in London in 1923.

[3] For the best account of Hodges and his work see Bernard Smith, *European
Vision and the South Pacific 1768–1850: a study in the history of art and ideas*, Oxford,
1960, chapter 3, with a select bibliography and illustrations of his Pacific paint-
ings.

of English, German, and Swiss scenery before joining the *Resolution* in 1772. In his *View of Cape Stephens* [plate 116A] there is a distinct resemblance to Wilson's Vernet-like manner, appropriate enough for the New Zealand coastal scenery that reminded his friend the scientist George Forster of Salvator Rosa.[1] But the shipwrecked figures of Wilson's *Ceyx and Alcyone* are replaced by wondering natives, and the *Resolution* is shown behind a gigantic waterspout. It is an example of a new genre, aptly described as *typical* landscape.[2] Ship, waterspout, seals, the varieties of wild-fowl, a Maori *pa* or stronghold with its signalling flashes, and the onlooking natives in the foreground have each a right to appear on the scene, but would scarcely do so all at the same time. In typical landscape the observations may be synchronized to give the maximum amount of information. Humboldt wrote that the paintings of the Ganges by Hodges that he saw in the house of Warren Hastings in London in 1790, together with George Forster's descriptions of Pacific islands, awakened in him the first beginnings of 'an inextinguishable longing to visit the tropics'.[3]

Hodges anticipates Constable in his interest in meteorology. The masterpiece of the series that he was commissioned to paint by the Admiralty is *The Cape of Good Hope with the Adventurer seen offshore* [plate 116B; 1772]. It differs from the others in that it was possibly painted *before* he returned, from the deck of the *Resolution*.[4] The meteorological phenomenon here chosen as typical was the dispersal of 'vast quantities of Moist vapour' on the top of Table Mountain by 'Violent Gusts' or 'Strong Gales', a dispersal which took place every two or three hours on a typi-cal day.[5] The time was the late afternoon, when the sun not only illuminated the stormy sky but revealed the outline of the moun-tains with telescopic clarity, thus enabling Hodges to convert the coastal profile he had been trained to record as a nautical draughtsman into a sublime image elevated by Miltonic exhala-

[1] Bernard Smith, *European Vision*, 48–50.

[2] The term 'typical landscape' was coined by Bernard Smith. For his definition and examples see ibid. 4–5, 11–12, 56–7, 147–57, 238–9.

[3] Ibid. 151, citing Alexander von Humboldt, *Cosmos* (trans. Sabine), London, 1848, II. 5.

[4] Bernard Smith, *European Vision*, 41. [5] Ibid. 42.

tions. With marvellous concentration he has depicted the clouds in the *process* of transformation, before the contradictions between one stage and another were resolved. At the same time he has synchronized this *tour de force* of immediacy with what still today chiefly impresses the traveller by sea, the unusual shapes of the grand geological formations.

The pupil of Wilson proved an admirable servant of art and science, raising scientific topography to new heights and training the camera of his eye on exotic scenes that Claude, Poussin, and Salvator Rosa could have admired. *The Monuments of Easter Island* could *mutatis mutandis* figure as an archaeological scene from Baalbek or Palmyra.[1] When in 1778 he went to India, where he gained the patronage of Warren Hastings, he stayed about six years, publishing *Select Views in India, drawn on the Spot* in 1786, the work that Reynolds admired for revealing 'the Barbarick splendour of those Asiatick Buildings'.[2] The image of India that he and the Daniells presented was a splendid one of wide rivers, gorges, cataracts, forts, and ruins, wholly acceptable to picturesque taste in architecture, of which Nash's Brighton Pavilion and Cockerell's and Repton's Sezincote in the next century are the classic examples.[3]

The reliance on *fact*, on what actually happened and could be reported in order to excite sensations of wonder, becomes more common towards the close of the century. *Aberglaslyn: the Flash of Lightning* [plate 117B] by Julius Caesar Ibbetson (1753–1817), whose range covered topographical landscape, genre, balloon ascents, and caricature, is dated 1798 and inscribed on the back: 'An Actual Scene. The Honble. Robert Greville's Phaeton between Pont Aberglaslyn and Tan-Y-Bwleh crossing the Mountain Range in a Thunder Storm. Painted by Julius Ibbetson, who was passenger.'[4] The romantic theme of horses terrified by lightning here involves two travellers in search of the picturesque, at just that point in the lovely pass where the dangers of avalanche above and precipice below are nicely balanced.

[1] Ibid., plate 51.　　　　　　　　　　[2] *Discourses*, ed. R. Wark, 242.

[3] For the Daniells see Thomas Sutton, *The Daniells: Artists and Travellers*, 1954.

[4] Rotha Mary Clay, *Julius Caesar Ibbetson 1759–1817*, London, 1948, 36.

The quietest stream of the picturesque runs parallel to the grand, and is equally varied. Gilpin had opposed a rural style with cottages to a grand one with castles, a distinction already apparent in Wilson and Gainsborough, the father of the cottage picturesque. George Morland (1763–1804) never attempted the grand style but appealed to a simpler taste described by a contemporary: 'Even Sir John, or my Lord himself, at times, with a heart-felt satisfaction, quits the melancholy magnificence of his paternal seat, for the natural and simple enjoyments of the cottage, or the snug chimney corner at the Anchor, or the Plow.'[1] The sources of his cottage style are to be found in his early activity as a prodigy forced ahead by two ambitious artist parents.[2] In 1773 sketches by 'Master George Morland' were exhibited at the Royal Academy; two years later his father had his work entered in the catalogue of the Free Society as by 'Master George Morland, ten years old', although he was in fact twelve. From 1777 he exhibited at the Society of Artists as well. In 1782, when he was still bound to his father, he showed no fewer than twenty-five paintings and drawings at the Free Society. Collins Baker, by no means sympathetic to Morland, singled him out as a repertory of influences, specifying among the French Greuze, Chardin, Fragonard, and Boilly; among the Dutch A. van Ostade, Paul Potter, A. van de Velde, and Cuyp; and in England Gainsborough and Wilson.[3] He is recorded as having copied most of these artists during his apprenticeship, as well as works by Vernet. The combination of realism and rococo, with a bias to the latter, seems to have formed his taste. On a later visit to Macklin's Poets' Gallery in Pall Mall he was reported to have looked at nothing but the work of de Loutherbourg.[4]

A powerful factor in his career was his association with mezzo-

[1] *OIKIDIA*, by Jose Mac Packe, 1785/6, 4.

[2] For Morland see G. C. Williamson, *George Morland: his Life and Works*, London, 1907, and B. L. K. Henderson, *Morland and Ibbetson*, London, 1923; and for more recent assessments Denys Sutton, 'The Significance of Morland', *C.L.*, Feb. 1953, G. B. Hughes, 'Painter of Rustic English Scenes', *C.L.* 4 July 1963, and David Thomas, *George Morland*, Arts Council Exhibition Catalogue, Tate Gallery, 1954.

[3] *British Painting*, 1933, 131–2.

[4] George Dawe, *The Life of George Morland* (1807), ed. J. J. Foster, 1904, 58.

tint engravers who were independently active in the cottage category.[1] He married the sister of William Ward, A.R.A., who together with his more distinguished younger brother James and J. R. Smith engraved his work. When the Morland Picture Gallery was opened by a young dealer named Irwin, the pressure on his output increased. He painted more than 4,000 canvases, and at least sixty-five contemporary engravers were engaged at some time or other in reproduction of them, before his early death.

In his excursions into the countryside he seems to have relied on a powerful visual memory. His innovations in studio practice have been described in some detail in a chapter by his biographer George Dawe.[2] Briefly, he eliminated as far as possible all those procedures in oil painting which required time and preparation, so that the picture grew more spontaneously like a sketch. His didactic paintings and scenes of elevated cottage life have been noted under the heading of sentimental genre. But he appears to better advantage as the leading exponent of the rustic picturesque. In 1791 he exhibited the well-known *Interior of a Stable* in the National Gallery, and confirmed its success by showing the equally fine *Higglers Preparing for Market* at Christie's in 1792. In both these highly finished paintings technical virtuosity is equalled by the power of observation. *Winter Landscape with Skaters* in the Mellon Collection is typical of a miniature and sketch-like style, its calligraphic fluency and delight in texture wholly enhancing the picturesque imagery of hovel, ramshackle bridge, withered oaks, and Teniers-like figures. *Hunting Scene: a Fall* [plate 115B] in the Victoria and Albert Museum, also signed and undated, is equally free and rich, and equally legible. In both the humorous accident of a fall is noted by an alert dog. His hedonistic approach, frank admiration of health and occasionally a poetic awareness of the stillness and solemnity of the rustic scene appealed particularly to English taste, and the name of Morland will always be identified with the Englishness of the English scene. One can almost smell a farmyard by Morland, something that can never be said of Gainsborough's pigs.

[1] Cf. A. Bury, 'William Ward', *Conn.*, May 1957, 257–9.

[2] Op. cit., chapter XVI.

His rival for the notice of posterity as an interpreter of contemporary rural life is Thomas Bewick (1753–1828), who was as truly a product of the Provincial Enlightenment as Wright of Derby and Stubbs.[1] His classic autobiography gives a vivid picture of the intellectual ferment to which he was exposed at Newcastle upon Tyne during the heyday of philosophical and literary societies. There the clever apprentice and later assistant to the engraver Ralph Beilby borrowed books on natural history, attended debates on the American Revolution, plays and concerts with visiting performers from London, and was noticed and encouraged by the learned clergy, doctors, and radical philanthropists like Thomas Spence, afterwards famous in London as the head of the 'Spenceans'.[2]

Bewick is the Hogarth of the countryside in the age of the picturesque. Like Hogarth, with whose career his own has some instructive parallels, he began by copying ornaments and made his pleasures, in his case field sports and natural history, go hand in hand with his studies. Unlike Hogarth, he stuck to engraving and book illustrations. An innovator in techniques, he cut the wood-block in intaglio, working from dark to light.[3] Once he had mastered the process, he poured his creative energies into illustrating his own works on natural history. Ruskin, who bought six of his water-colours and forty-three of his drawings, described him as 'the Burns of painting', a surprising identification until its point is grasped, the mixture of pathos and satire in his art.[4] Among his recurrent themes have been noted the passing of Time; Time's revenge; the futility of war; the evils of improvidence and intemperance; and cruelty to animals.[5] For the most part, however,

[1] For Bewick see Austin Dobson, *Thomas Bewick and his Pupils*, London, 1903, S. Roscoe, *Thomas Bewick: a Bibliography Raisonnée*, 1953, John Rayner, *A Selection of Engravings on Wood by Thomas Bewick*, King Penguin, 1947, Reynolds Stone, *Wood Engravings of Thomas Bewick*, London, 1953, and Montagu Weekley, *Thomas Bewick*, 1953.

[2] *A Memoir of Thomas Bewick written by Himself*, London, 1862, 71.

[3] His original technique is well described in W. A. Chatto, *A Treatise of Wood Engraving*, 1839, 482. Cf. Boase, O.H.E.A. X. 287.

[4] For Ruskin and Bewick see Reynolds Stone, *Wood Engravings of Thomas Bewick*, 1953, 43, and John Rayner, *A Selection of Engravings on Wood by Thomas Bewick*, 1947, 6.

[5] Reynolds Stone, op. cit. 45–6.

he celebrated the joys of the countryside, the games of children, and the excitement of field sports. In his tailpiece to the Long-Eared Owl in the *History of British Birds* (2 vols., 1797–1804) the motto is *sero sed serio*, driving home a favourite Hogarthian motto 'Too Late to Mend' [figure]. The suicide hangs from the branch of an oak, pathetically watched by a dog who still guards his master's hat and stick. The peaceful scene by the bank of a stream hardly prepares the spectator for the macabre discovery of the tragic details. Bewick is rich in such subtle discoveries of tragedy, e.g. the tiny gallows which is generally introduced into the background when cruelty to animals is the theme.

Bewick shares with the modesty-of-nature school a faithful attachment to the region in which he grew up or which he knew best. He could have echoed the sentiment of Constable, who wrote of the banks of the Stour, 'those scenes made me a painter, and I am grateful'.[1] In 1763 John Baptist Malchair, drawing-master of Oxford, published twelve etched views around Oxford, faithful, sensitive, and contemplative, like the work of Paul Sandby (1725–1809), among whose favourite sketching-grounds were the London Thames-side and Windsor Great Park.[2] Although not the Father of the English water-colour school in the sense of originator, Sandby perhaps deserves the title for his promotional activities on behalf of the medium as a Foundation Member of the Royal Academy, Chief Drawing-Master at the Royal Military Academy, Woolwich, from 1768 to 1799 and drawing-master to the royal princesses.[3] He regularly opened his home for meetings of artists and amateur enthusiasts. His style, like that of others who had been trained to record scientifically, combines the picturesque embellishments of broken surfaces and rich washes with a neo-classical precision of line and awareness of abstract

[1] *Memoirs of the Life of John Constable, Esq., R.A.*, by C. R. Leslie, R.A., 2nd ed., 1845, 93.

[2] A. P. Oppé, 'John Baptist Malchair', *Burl. Mag.*, Aug. 1943.

[3] For Sandby and his brother Thomas see 'The Memoir of Paul Sandby by his Son' reprinted in *Burl. Mag.*, June 1946, E. H. Ramsden, 'The Sandby Brothers in London', *Burl. Mag.*, Jan. 1947, and A. P. Oppé, *The Drawings of Paul and Thomas Sandby in the Collection of His Majesty the King at Windsor Castle*, Phaidon Press, London, 1947.

and irregularly grouped geometric shapes, particularly notable in his renderings of Windsor Castle [plate 114A].

Among his important predecessors and contemporaries were William Tavernor (1703–72), who tinted landscape drawings of pencil or chalk with sepia, adding washes of pale colour and lastly touches of black ink, and Jonathan Skelton (c. 1735–59), who fully developed the stained drawing with its shaded under-painting of Indian ink as the basis for the application of local colour.[1] With a little expert tuition and practice it was possible for the amateur with a gift for drawing to convert his open-air sketches into passably pretty pictures by extra work at home. This charming discovery led to an unprecedented explosion of amateur activity, historically important not merely for its influence on the taste for landscape but in furnishing records of remote places and vanishing scenes wherever imperial expansion led the zealous practitioners.

The economic foundations on which the flourishing and *avant-garde* English water-colour school arose were the salaries and fees paid to drawing-masters, and the profits from the publication of picturesque views. Aquatint, which Paul Sandby had intro-duced into England in 1775, provided not merely a lucid means for reproducing water-colours but models for amateur imitation, for 'the final result resembles a wash drawing'.[2] Artists like John 'Warwick' Smith (1749–1831), Thomas Barker of Bath (1769–1847), and William Williams of Norwich (active 1758–94) were oil painters who practised in water-colour; the last two, strongly influenced by Gainsborough, may be said to have brought the cottage style to its apotheosis. But long before the foundation of the Society of Painters in Water-Colours in 1804, a new fellow-ship of artists had come into being, as recognizably independent as the engravers. Many were drawing-masters at one stage of their careers, and published their works as well as selling originals. Their total achievement was almost as complete as if they had been

[1] Martin Hardie, *Water-Colour Painting in Britain. 1. The Eighteenth Century*, ed. by D. Snelgrove with Jonathan Mayne and Basil Taylor, London, Batsford, 2nd ed., 1967, 69–71.
[2] Ibid. 161.

commissioned by the State to record the historic monuments and natural beauties of the British Isles. Indeed one such commission did come from a state overseas. In 1768 Josiah Wedgwood wrote to his partner Thomas Bentley, 'I have waited upon Lord Cathcart, the Ambassador appointed for Russia, to bring about the plan we settled of introducing my manufactures at the Court of Russia.'[1] The outcome was the famous creamware service commissioned in 1770 by the Empress Catherine II for *La Grenouillère* and decorated by different views of 'the ruins, country-houses, parks, gardens and picturesque landscapes of Great Britain'. Wedgwood immediately ransacked the stocks held by the print-sellers Boydell, Major, Cadell, and Hooper, and commissioned artists to go on tour, among them Anthony Devis, James Barret, 'Warwick' Smith, and John Pye. The service, which was begun in 1773 and finished in 1774, consisted of 952 pieces decorated with 1,282 scenes from the collection. Its exhibition for a month in June and July 1774 in London was described by J. L. Roget as 'an epoch in the history of British topographic art'.[2]

An analysis of the categories of the picturesque might well begin with a study of the satires of Thomas Rowlandson, for despite the dominance of his own idiosyncratic style there was hardly a species which he did not successfully parody: the grand, the antiquarian, the cottage, the panoramic, the spectacular (military parades, fairs, fashionable promenades) in a park, landscape or architectural setting, and the sporting.[3] Before the ancient building, ruin, and hovel artists broke their line and applied their washes almost impressionistically, to capture the prized effects of roughness and irregularity. Among those who excelled in the antiquarian picturesque may be mentioned Samuel Hieronymus Grimm (1733–94), Moses Griffith (1747–c. 1809), Theodosius Forrest (1728–84), William Marlow (1740–1813), Michael Angelo Rooker, A.R.A. (1743–1801), Thomas Hearne

[1] Cited by Wolf Mankowitz, *Wedgwood*, London, 1953. See also S. T. Prideaux, *Aquatint Engraving*, 1909, 86–8, and the catalogue of the *Wedgwood Bicentenary Exhibition 1759–1959*, V. & A., 1959.

[2] *A History of the 'Old Water-Colour' Society*, 1891, I. 33.

[3] Especially in his illustrations to William Combe, *Dr. Syntax in Search of the Picturesque*, 1812.

(1748–1817), and Edward Dayes (1763–1804).[1] But each covered a much wider range, and varied his style accordingly. Thus Edward Dayes, in his military parade and fashionable promenade pictures, like *Buckingham House, St. James's Park* (Victoria and Albert Museum; s. and d. 1790), used the sketch-like background or framework of trees as a foil to delicately drawn architecture and figures in elegant silhouette.[2]

The central clearing-house for innovations in technique and the main intermediary between the picturesque and romanticism was the 'academy' of Dr. Thomas Monro in Adelphi Terrace, where he had assembled a store of pictures and drawings by Gainsborough, Canaletto, Piranesi, Morland, Hearne, and especially the younger artists.[3] The emphasis of his collection was on water-colours and drawings, which he regarded as ends in themselves, not an interesting by-product of genius, and which he used to encourage the rising generation: 'In winter evenings, he encouraged young men to make a studio of his house. There they put their sketches into pictorial shape under the doctor's eye, and he gave them their supper and half-a-crown apiece for their work.'[4] Between 1794 and 1798 both Girtin and Turner were working for the doctor, producing *inter alia* finished versions of Alexander Cozens's sketches.[5]

With the name of Alexander Cozens (*c.* 1717–86) the history of the water-colour school as a forerunner of romanticism gains a new dimension of experimental excitement.[6] In an undated pen-and-ink drawing with wash showing *Sir George Beaumont and Joseph Farington Sketching a Waterfall*, Thomas Hearne depicted

[1] In addition to the accounts of these artists in Martin Hardie, op. cit., there are excellent characterizations in Iolo A. Williams, *Early English Watercolours*, 1952.

[2] Illustrated in Hardie, op. cit., plate 194.

[3] For Monro's Academy see the historical introduction by C. F. Bell and Thomas Girtin to 'The Drawings and Sketches of John Robert Cozens', *Wal. Soc.* XXIII, 1935, C. F. Bell, 'A Postscript Concerning Dr. Thomas Monro, James Moore F.S.A. and John Henderson and Some of the Artists who worked for them', *Wal. Soc.* XXVII, 1939, and Boase, O.H.E.A. X. 31–2.

[4] J. L. Roget, *A History of the 'Old Water-Colour' Society*, 1891, I. 78–9.

[5] C. F. Bell and T. Girtin, *Wal. Soc.* XXIII, 1935, 24.

[6] The definitive study is A. P. Oppé, *Alexander and John Robert Cozens*, London, Black, 1952.

the three artists, each with his umbrella (a climatic accessory glee-
fully seized on by Rowlandson in his satires) and two with large
easels, before a rock-face. Its irregular surface, not the waterfall, is
the main theme.[1] This was about as far as most picturesque artists
went in their search for abstract qualities of pattern and texture.
But in *A New Method of assisting the Invention in drawing Original
Compositions of Landscape* (advertised in 1784, published about
1786) Cozens went even further than Leonardo da Vinci, whom
he quoted as a sanction, in taking an abstract shape as his point
of departure.[2] For where Leonardo took his ideas from nature,
Cozens enlisted the medium itself. By using blobs of ink and
wash, not to start but to stimulate the inventive process, he
anticipated the well-known 'material' methods of some modern
teachers from Klee onwards. The revolutionary idea became
popular with his pupils, and earned him the abusive title of
'Blotmaster-General to the Town'.[3] 'To form a BLOT . . .', he
instructed his readers, 'possess your mind strongly with a subject
. . . and with the swiftest hand make all possible variety of shapes
and strokes upon your paper'. After the student had made a
number of blots, preferably on previously crumpled paper to
produce 'a great variety of the smaller accidental shapes', he was to
choose one from the general collection, transfer it by tracing
with a hair-brush on to paper made transparent by a varnishing
process, and 'in the whole proceeding preserve the spirit of the
blot as much as possible'. What especially distinguishes the method
of Cozens is that he insisted on his students' starting with a con-
trolling idea, so that in the interplay between accident and inven-
tion the latter was given first play [plate 119B].[4]

His greatest pupil was his own son John Robert Cozens (1752–
97), who is said to have been chosen by Richard Payne Knight
to accompany him on a tour of Switzerland and Italy in 1776, at a
time when it was a not uncommon practice for noblemen and other

[1] Illustrated in Hardie, op. cit., plate 181.

[2] *A New Method* is reprinted in full in A. P. Oppé, op. cit.

[3] Coined by Edward Dayes in *Professional Sketches of Modern Artists* published in
The Works of the late Edward Dayes, ed. E. W. Brayley, 1805.

[4] Much nonsense still appears in print about the method, despite the corrections
published by A. P. Oppé, op. cit., chapter IV, 'Systems'.

wealthy dilettanti to take painters on their travels in order to record antiquities and scenery, e.g. Lord Palmerston engaged William Pars to accompany him in Switzerland and Italy, and the Earl of Warwick John 'Warwick' Smith in Italy.[1] Before Cozens left he made his first appearance at the R.A. with *Hannibal in his March over the Alps, Showing to his Army the Fertile Plains of Italy* (1776), a lost work of which Turner, who must have seen it later, said that it taught him more than any other picture.[2] The turning-point in his career was his romantic experience of the Swiss Alps. Henceforth immensity and infinity were sufficient themes in themselves, without recourse to classical story or picturesque stage properties. The magnificent *View in the Island of Elba* [plate 118B] in the Victoria and Albert Museum stands out as one of the few wholly romantic masterpieces of the late eighteenth century. Man is not depicted, but his presence is felt as an observer of the solitude of mountains.

For Constable John Robert Cozens was 'the greatest genius that ever touched landscape'.[3] That he should have appealed so strongly to Turner as well indicates his achievement in fusing the Wonders of the Sublime with the Modesty of Nature [plate 119A]. One might well conclude that at this point the romantic imagination, at least in its confrontation with nature, was wholly emancipated from the classical tradition. But this would be to misunderstand the nature of that tradition, and underestimate its inexhaustible capacity to influence even those who broke away from it. Francis Towne (1739/40–1816) of Exeter was a more revolutionary painter of landscape than J. R. Cozens, one who in his search for purity of form and clarity of contour represented nature as 'a distilled, immutable ideal, shed of sensuous qualities and fixed for eternity through the precision of drawn . . . outlines'.[4] In so doing he achieved a powerful tension between a surface pattern

[1] Oppé, op. cit.

[2] C. R. Leslie, *Handbook for Young Painters*, 1855, 263.

[3] Letter to William Carpenter, 1835, published in C. R. Leslie, *Memoirs of the Life of John Constable*, 1845, 263.

[4] The quotation from Robert Rosenblum, *Transformations in Late Eighteenth Century Art*, Princeton, N.J., 1967, 186, refers to the figurative art of Flaxman, Blake, and Carstens, but is equally applicable to Towne.

of abstract shapes and the illusion of monumental forms receding into distance. Like Cozens, he had grown up with the picturesque movement towards irregularity, and had depicted stories in a landscape, e.g. *Macbeth and the Witches*.[1] Again like Cozens, he experienced the strong excitements of his tour not in the Roman Campagna celebrated by Claude and Wilson, but in the Alps, which he sketched on his homeward journey through Switzerland with 'Warwick' Smith in 1781.[2] Unlike Cozens, he shared the involvement of neo-classical artists with line both intrinsically and as an indicator of plane and volume, its dual significance for Flaxman. This is evident in many water-colours executed before his tour, like the *Salmon Leap* of 1777.[3] *The Source of the Arveiron* [plate 120; 1781] in the Victoria and Albert Museum shows the heights he could reach when working under controlled excitement as well as the discipline he could bring to the expression of his sensations. An account of eighteenth-century English art which has chosen as its unifying theme the continuing interaction between classical and anti-classical forces from the momentous creation of the landscape garden by the Burlingtonians can appropriately stop with this masterpiece by a water-colour artist still excluded from Continental and even English dictionaries of art. For the movement towards romanticism liberated creative energies among minor artists in categories and media which lacked visible antique models, and in its first stage could only invoke the classical past by associations with myth and ancient history. *The Source of the Arveiron* is drained of such associations. And yet in its order and the noble simplicity of its dominant forms it comes closer to the spirit of Greek art as romantically defined by Winckelmann than any earlier landscape peopled by gods or heroes: 'as the bottom of the sea lies calm beneath a floating surface, a great soul lies calm beneath the passions in Greek figures.'[4] Each of these images is reversed in Towne's water-colour: for the bottom of the sea we read the peaks of mountains; for the agitation

[1] In the collection of T. S. R. Boase and illustrated in W. Moelwyn Merchant, *Shakespeare and the Artist*, 1959, plate 36a.

[2] Hardie, op. cit. 121. [3] Coll. Mr. D. L. T. and Miss Armide Oppé.

[4] *Reflections on the Painting and Sculpture of the Greeks*, tr. H. Fuseli, 1765.

of the floating surface, the stillness of a glacier; and for the passions visibly expressed in man's bodily action, the sensations of the unseen artist contemplating an awe-inspiring scene in the Alps:

> The Sounding Cataract
> Haunted me like a passion; the tall rock,
> The mountain, and the deep and gloomy wood,
> Their colours and their forms, were then to me
> An appetite; a feeling and a love
> That had no need of a remoter charm
> By thought supplied, nor any interest
> Unborrowed from the eye.[1]

All these images, cataract, rock, mountain, and wood, were depicted by Towne in other water-colours without the intrusion of man or reference to anything other than nature itself. Wordsworth, who disliked the picturesque and described it in *The Prelude* as

> . . . a strong infection of the age
>
>
>
> Bent overmuch on superficial things,

has in these two passages identified the dividing line between the Rule of Taste and the liberty of nature, crossed by artists as well as poets well before the close of the century in which he spent the first thirty years of his life.[2]

[1] Wordsworth, *Lines, composed a few miles above Tintern Abbey, on revisiting the Banks of the Wye during a Tour*, 13 July 1798.

[2] The debate on the picturesque as a separate aesthetic category is discussed in Boase, O.H.E.A. X. 17–18. The fundamental study is Walter J. Hipple, *The Beautiful, The Sublime and The Picturesque in Eighteenth-century British Aesthetic Theory*, Carbondale, Southern Illinois University Press, 1957, with a comprehensive bibliography up to that date. For Gilpin see Carl Paul Barbier, *William Gilpin. His Drawings, Teaching, and Theory of the Picturesque*, Oxford, 1963, with later references. Marjorie Hope Nicolson, *Mountain Gloom and Mountain Glory: The Development of the Aesthetics of the Infinite*, Cornell University Press, 1959, has enriched the study with much new material. Esther Moir, *The Discovery of Britain: The English Tourists*, London, Routledge and Kegan Paul, 1964, usefully supplements C. Hussey's comprehensive study of art as well as theory, *The Picturesque*, 1927, reprinted 1967, on the side of picturesque travel. An important recent publication is *The Picturesque Garden and its influence outside the British Isles*, ed. Sir Nikolaus Pevsner, Harvard University Press, 1974, with an article by Marcia Allentuck on 'Sir Uvedale Price and the Picturesque Garden'.

BIBLIOGRAPHY

T H E following select bibliography is a guide only to the most important sources for the study of English art in this period. References to the literature on individual artists and specific topics are given in footnotes to the major entries in the text.

The periodicals consulted and cited in the footnotes are too numerous for separate listing, but special mention must be made of *Country Life* because its numbers over the years have provided the leading corpus of illustration not only for architecture and the crafts but also for painting and sculpture, including many works of which it is difficult to find photographs elsewhere.

Where subject bibliographies are attached to standard works, some space has been saved by referring the reader to them.

Unless otherwise stated, the place of publication is London.

BIBLIOGRAPHIES AND DICTIONARIES

ABELL, LOLA M., Ph.D. 'A Bibliography of some 18th Century Books on Architecture (British Palladians), 1715–1780.' Thesis presented in the School of Librarianship, University of London, 1959. The copy in the University of London Library has notes by Rudolf Wittkower.

Bryan's Dictionary of Painters and Engravers, revised by G. C. Williamson, London, 1903/4 and several later reprints, is handy and informative for minor artists, but articles in Thieme–Becker, *Allgemeines Lexikon der bildenden Künstler* (1907–47), and the *Dictionary of National Biography* are generally to be preferred for their bibliographical references.

COLVIN, H. M., *A Biographical Dictionary of English Architects 1660–1840*, London, 1954. This sets a higher standard than any other dictionary in the field of English Art, with references to articles in periodicals as well as monographs and much unpublished manuscript material.

Courtauld Institute of Art, University of London, *Annual Bibliography of the History of British Art*, Cambridge, I, 1934 (1936) to VI, 1946–8 (2 parts 1956). This covers secondary literature on architecture, painting, sculpture, the graphic arts, and the applied arts.

DRAPER, JOHN W., *Eighteenth Century Aesthetics: A Bibliography*. Heidelberg, 1926.

GRANT, COLONEL M. H., *A Chronological History of the Old English Landscape Painters: (in oil)*, I and II, London, 1926; III, Leigh-on-Sea, 1947.

GRANT, COLONEL M. H. *Dictionary of British Landscape Painters from the six-teenth century to the early twentieth century*. Leigh-on-Sea, 1952. Because Colonel Grant's comprehensive works of reference are unsupported by bibliographical sources, the information they contain is not easily checked. A large number of reproductions provide an admirable corpus for illustrating the categories and range of landscape painting.

GUNNIS, R. *A Dictionary of British Sculptors 1660–1851*, London, 1953.

LEVINE, J. *Bibliography of 18th Century Art and Illustrated Books* [English and French], 1898.

MACQUOID, P., and EDWARDS, H. C. R. *The Dictionary of English Furniture*, revised and enlarged by H. C. R. Edwards, 3 vols., London, 1954.

STRICKLAND, WALTER G. *A Dictionary of Irish Artists*, 2 vols., Dublin, 1913.

CATALOGUES

The main catalogues are listed in Waterhouse, *Painting in Britain*, and O.H.E.A. VIII. The first two listed below are specially important because they give the titles of many works now untraceable and thus indicate the main trends and innovations in the choice of subject.

GRAVES, ALGERNON. *The Royal Academy of Arts*, 8 vols., London, 1905/6. This lists the works exhibited from 1769 to 1904 under the names of artists.

—— *The Society of Artists of Great Britain (1760–91); The Free Society of Artists (1761–83)*, London, 1907.

Commemorative Catalogue of the Exhibition of British Art, Royal Academy of Arts, London, January–March, 1934, Oxford, 1935. Although necessarily restricted in the case of monumental sculpture, this is the best single corpus of illustration for the fine and applied arts.

Painting in England 1700–1850. Collection of Mr. and Mrs. Paul Mellon. Illustrated Catalogue by Basil Taylor, 2 vols., Virginia Museum of Fine Arts, Richmond, Virginia, 1963. This major collection is particularly impor-tant because it has concentrated on the subject pictures of the eighteenth century.

In addition to the catalogues of exhibitions of groups and individual artists organized by the leading national Galleries and Museums in the United Kingdom and the U.S.A., those sponsored by the Arts Council of Great Britain, the Mellon Foundation, and the Iveagh Bequest at Kenwood frequently incorporate original research.

The Age of Neo-Classicism, R.A. Exhibition Catalogue, The Arts Council of Great Britain, 1972. Although the scope of this exhibition was inter-national, the articles on English artists are especially valuable because they are supported by up-to-date bibliographies.

GENERAL HISTORIES

BAKER, C. H. COLLINS, and JAMES, M. R. *British Painting*, 1933. Still useful for the assessment of minor painters.

FREY, DAGOBERT. *Englisches Wesen in der bildenden Kunst*, Stuttgart, 1942. Especially valuable for the analysis of style and movements of taste.

SUMMERSON, SIR JOHN. *Architecture in Britain 1530 to 1830*, 1953.

WATERHOUSE, ELLIS K. *Painting in Britain 1530 to 1790*, 1953.

WHINNEY, MARGARET. *Sculpture in Britain 1530 to 1830*, 1964.

Summerson, Waterhouse, and Whinney have excellent bibliographies. For porcelain, silver, glass, and furniture see the brief but usefully up-to-date paperbacks by George Savage, Gerald Taylor, E. Barrington Haynes, and Ralph Fastnedge published by Pelican Books, citing standard authorities. The best stylistic accounts of English porcelain are in two general histories, F. H. Hoffmann, *Das Porzellan*, Berlin, 1932, and Emil Hannover, *Pottery and Porcelain*, 1925, but W. B. Honey, *English Pottery and Porcelain* (1933 and later editions), remains a classic appreciation. Charles Oman, *English Domestic Silver* (1934 and later editions), also gives an excellent critical and stylistic account. The most up-to-date and reliable account of porcelain is *English Porcelain 1745–80*, edited by R. J. Charleston, 1965.

For style in furniture see the masterly introduction by Peter Ward-Jackson in his *English Furniture Designs of the Eighteenth Century*, 1958.

CROFT-MURRAY, EDWARD. *Decorative Painting in England 1537–1837*, 2 vols., Country Life, 1962, 1970. The second volume contains an authoritative account of history painting in England in the eighteenth century, together with a comprehensive bibliography.

ROGET, J. L. *A History of the 'Old Water-Colour' Society*, 2 vols., 1891.

MOVEMENTS OF TASTE

ALLEN, B. SPRAGUE. *Tides in English Taste 1619–1800*, Cambridge, Mass., 2 vols., 1937. This is the only comprehensive history of movements of taste in the eighteenth century, based largely on contemporary sources.

CLARK, KENNETH. *The Gothic Revival*, London, 1928, revised and enlarged edition, 1950.

HONOUR, HUGH. *Chinoiserie: The Vision of Cathay*, London, 1961. The English sections are authoritative and supported by useful bibliographical guides.

—— *Neo-classicism*, Harmondsworth, 1968. This general account of European neo-classicism valuably supplements and extends the detailed and authoritative study of Irwin because it embraces English architecture and establishes the decisive links with the Enlightenment.

Hussey, Christopher. *The Picturesque: Studies in a Point of View*, London, 1927, new impression 1967. A magisterial account of the actual practitioners of the picturesque, it should be read in conjunction with the standard authority on picturesque theory, Walter J. Hipple, *The Beautiful, The Sublime & The Picturesque in Eighteenth-century British Aesthetic Theory*, Carbondale, Illinois, 1957, and the relevant sections in Marjorie Hope Nicolson, *Mountain Gloom and Mountain Glory: The Development of the Aesthetics of the Infinite*, Ithaca, N.Y., 1959, especially stimulating for the background of scientific ideas.

Irwin, David. *English Neoclassical Art: Studies in Imagination and Taste*, London, 1966. With an excellent bibliography.

Rosenblum, Robert. *Transformations in Late Eighteenth Century Art*, Princeton, N.J., 1967. The key study of the final and most revolutionary phase of the eighteenth century, with important observations on the English contribution and especially valuable bibliographical footnotes.

Steegmann, John. *The Rule of Taste from George I to George IV*, London, 1936, reprinted 1968. A sensitive and sympathetic introduction to the dominant classical movement.

OTHER WORKS OF REFERENCE

Sir Nikolaus Pevsner, *The Buildings of England*, Harmondsworth, 1951– is an illustrated guide-book survey which supplements the authoritative articles on individual country houses in the Georgian series of *English Country Houses*, Country Life, London, 3 vols., 1955–8, by Christopher Hussey. *The Survey of London* (vols. 26–34, ed. F. H. W. Sheppard; in progress) by the London County Council and London Survey Committee is a monumental undertaking unrivalled both for documentation and for illustration.

A useful work of reference for dating paintings where there is no documentary evidence is Francis M. Kelly and Randolph Schwabe, *Historic Costume: A Chronicle of Fashion in Western Europe 1490–1790*, London, 1925, because the text and illustrations identify innovations in fashion recorded by photographs of dated paintings, especially English, in the Witt Collection, thus establishing by costume or accessory a *terminus a quo*.

Much unpublished manuscript material can still be traced by reference to the volumes of the Royal Commission on Historical Monuments and the catalogues of the Department of Manuscripts in the British Museum. It has been the policy of the Walpole Society to give a high priority to the publication of manuscript sources.

CONTEMPORARY AND EARLY SOURCES

Vertue's *Notebooks* published by the Walpole Society begin in 1713 and conclude after the middle of 1752. The correspondence of Horace Walpole

from 1735 to 1792 and the Farington Diary from 1793 to 1821 continue a contemporary record which extends over the whole of the reigns of George I, George II, and George III. Taken in conjunction with the growth of aesthetic theory, the abundance of letters, memoirs, and institutional records, and the discussion of art in pamphlets and contemporary periodicals, notably the *Gentleman's Magazine* from 1733, the first-hand materials for the study of English Art in the eighteenth century are richer than those of any preceding one.

The debt to Walpole is paramount. He wrote the history that Vertue had planned after acquiring his notebooks, and widened its scope to include architecture. He was equipped with a special insight into the wit of his age, and therefore understood its artistic manifestations. He brilliantly described country houses and especially their landscape gardens, the theme of his most original contribution to art history. Moreover, his labours inspired others to follow in his path, Edward Edwards in *Anecdotes of Painters who have resided or been born in England*, 1808, intended as 'a continuation to the *Anecdotes of Painting* by the late Horace, Earl of Orford', and the Revd. James Dallaway in *Observations on English Architecture*, 1806. The list may worthily conclude with John Pye, whose *Patronage of British Art*, 1845, marks the climax of the Vertue tradition of *pietas* in faithful and accurate recording and compilation.

Among the bibliographies previously listed Colvin is the authoritative guide to contemporary publications by architects. The major writings on art and art theory published by painters and others are included in Draper, with the exception of those manuscripts that have subsequently been published in the Walpole Society.

SECONDARY SOURCES

Because bibliographies on specific topics and artists have been given in the footnote reference to the main entry, the criterion of selection has been a distinguished contribution to scholarship, appreciation, or criticism, including key and seminal articles and recent monographs which cover a wide range of contemporary and secondary sources. Titles already given earlier in this bibliography have not been repeated.

Books

ADDLESHAW, G. W. O., and ETCHELLS, FREDERICK. *The Architectural Setting of Anglican Worship*, 1948.
ANTAL, FREDERICK. *Hogarth and his Place in European Art*, 1962.
BAKER, C. H. COLLINS, and BAKER, MURIEL I. *The Life and Circumstances of James Brydges, First Duke of Chandos, Patron of the Liberal Arts*, Oxford, 1949.

BARBIER, CARL PAUL. *William Gilpin. His Drawings, Teaching, and Theory of the Picturesque*, Oxford, 1963.

BECKETT, R. B. *Hogarth*, 1949.

BELL, C. F. *Annals of Thomas Banks*, Cambridge, 1938.

BLUNT, ANTHONY. *The Art of William Blake*, 1959.

BOLTON, A. T. *Robert and James Adam*, 2 vols., 1922.

CHASE, ISABEL. *Horace Walpole: Gardenist*, Princeton, N.J., 1943.

CLARK, H. F. *The English Landscape Garden*, 1948.

CLAY, ROTHA MARY. *Julius Caesar Ibbetson 1759–1817*, 1948.

COLVIN, HOWARD, and HARRIS, JOHN (ed.), *The Country Seat: Studies in the History of the British Country House*, 1970.

CONSTABLE, W. G. *Richard Wilson*, 1953.

COOK, CYRIL. *The Life and Work of Robert Hancock*, 1948.

COX-JOHNSON, ANNE. *John Bacon, R.A., 1740–1799*, St. Marylebone Society Publications No. 4, 1961.

CROFT-MURRAY, E. *Decorative Painting in England 1537–1837*, 2 vols., Country Life, 1962, 1970.

CUST, LIONEL, and COLVIN, SIDNEY. *History of the Society of Dilettanti*, 1898.

DOBSON, AUSTIN. *Thomas Bewick and his Pupils*, 1903.

EDWARDS, RALPH. *Early Conversation Pictures from the Middle Ages to about 1730*, 1954.

—— and JOURDAIN, MARGARET. *Georgian Cabinet-Makers*, 1944.

ESDAILE, KATHERINE A. *The Life and Works of Louis François Roubiliac*, Oxford, 1928.

FLEMING, JOHN. *Robert Adam and his Circle*, 1962.

FOSKETT, DAPHNE. *British Portrait Miniatures*, 1963.

—— *John Smart: The Man and his Miniatures*, 1964.

GEORGE, DOROTHY M. Vol. 1 to 1792, vol. 2, 1792–1832, *English Political Caricature: a study of opinion and propaganda*, Oxford, 1959.

GRIGSON, GEOFFREY. *The Harp of Aeolus and other Essays in Art, Literature and Nature*, 1946.

HARDIE, MARTIN. *Water-Colour Painting in Britain*, ed. Dudley Snelgrove with Jonathan Mayne and Basil Taylor, 2 vols., 1966–7.

HARRIS, EILEEN. *The Furniture of Robert Adam*, 1963.

HARRIS, JOHN. *English Decorative Ironwork from Contemporary Source Books 1610–1836*, 1960.

HAYWARD, HELENA. *Thomas Johnson and English Rococo*, 1964.

HAYWARD, J. F. *Huguenot Silver in England*, 1959.

HILLES, F. W. *The Literary Career of Sir Joshua Reynolds*, New York and Cambridge, 1936.

HUDSON, DEREK, and LUCKHURST, KENNETH W. *The Royal Society of Arts 1754–1954*, 1945.

HUSSEY, CHRISTOPHER, *English Gardens and Landscapes 1700–1750*, 1967.

HUTCHISON, SIDNEY C. *The History of the Royal Academy 1768–1968*, 1968.

ISON, WALTER. *The Georgian Buildings of Bath from 1700 to 1830*, 1948.

—— *The Georgian Buildings of Bristol*, 1952.

JACKSON, CHARLES JAMES. *An Illustrated History of English Plate*, 2 vols., 1911.

JOURDAIN, MARGARET. *English Decoration and Furniture of the Late XVIII Century*, 1922.

—— *The Work of William Kent*, 1948.

KAINEN, JACOB. *John Baptist Jackson, 18th Century Master of the Colour Woodcut*, Washington, 1962.

KLINGENDER, FRANCIS. *Art and the Industrial Revolution*, 1947.

LANE, ARTHUR. *English Porcelain Figures of the Eighteenth Century*, 1961.

LEES-MILNE, JAMES. *The Age of Adam*, 1947.

LEWIS, WILMARTH S. *Horace Walpole*, 1961.

LITTLE, BRYAN. *The Life and Work of James Gibbs 1682–1754*, 1955.

LONG, BASIL S. *British Miniaturists*, 1929.

MARILLIER, H. C. *English Tapestries of the Eighteenth Century*, 1930.

MERCHANT, W. MOELWYN. *Shakespeare and the Artist*, Oxford, 1959.

MICHAELIS, ADOLF. *Ancient Marbles in Great Britain*, Cambridge, 1882.

MILLAR, OLIVER. *Zoffany and his Tribuna*, 1967.

NICOLSON, BENEDICT. *John Hamilton Mortimer 1740–1779: Paintings, Drawings and Prints*, a catalogue of an exhibition arranged by the Paul Mellon Foundation, 1968.

—— *Joseph Wright of Derby: Painter of Light*, 2 vols., 1968.

NISSER, WILHELM. *Michael Dahl and the Contemporary Swedish School of Painting in England*, Uppsala and London, 1927.

OGDEN, H. V. S. and M. S. *English Taste in Landscape in the Seventeenth Century*, Ann Arbor, 1955.

OPPÉ, A. P. *Thomas Rowlandson, His Drawings and Water-colours*, 1923.

—— *The Drawings of Paul and Thomas Sandby in the Collection of His Majesty the King at Windsor Castle*, 1947.

—— *Alexander and John Robert Cozens*, 1952.

PASTON, GEORGE. *Social Caricature in the Eighteenth Century*, 1905.

PAULSON, RONALD. *Hogarth's Graphic Works*, 2 vols., New Haven, Conn., 1965.

PHILLIPS, A. S. *Paul de Lamerie*, 1935.

PHYSICK, JOHN. *Designs for English Sculpture 1680–1860*. H.M.S.O. for the Victoria and Albert Museum, 1970.

PIPER, DAVID. *The English Face*, 1957.

PRIDEAUX, S. T. *Aquatint Engraving: A Chapter in the History of British Book Illustration*, 1909.

RAINES, ROBERT. *Marcellus Laroon*, 1966 (Paul Mellon Foundation Studies in British Art).

REYNOLDS, GRAHAM. *English Portrait Miniatures*, 1952.

ROGET, J. L. *A History of the 'Old Water-Colour' Society*, 2 vols., 1891.

SCHIFF, GERT. *Johann Heinrich Füsslis Milton-Galerie*, Zürich, 1963.

SMART, ALISTAIR. *The Life and Art of Allan Ramsay*, 1952.

SMITH, BERNARD. *European Vision and the South Pacific*, Oxford, 1960.

SOUTHERN, RICHARD. *Changeable Scenery*, 1953.

SOUTHWARK, J. G. *Vauxhall Gardens*, New York, 1941.

STROUD, DOROTHY. *Capability Brown*, 1950.

—— *Humphrey Repton*, 1962.

—— *Henry Holland: His Life and Architecture*, 1966.

STUTCHBURY, HOWARD E. *The Architecture of Colen Campbell*, Manchester, 1967.

SUMMERSON, JOHN. *Georgian London*, 1943.

—— *Heavenly Mansions*, 1949.

SWARBRICK, JOHN. *Robert Adam and his Brothers: their Lives, Work and Influence on English Architecture, Decoration and Furniture*, 1915.

TINKER, CHAUNCEY BREWSTER, *Painter and Poet*, Cambridge, Mass., 1938.

WATERHOUSE, E. K. *Reynolds*, 1941.

—— *Gainsborough*, 1958.

WEBB, M. I. *Michael Rysbrack, Sculptor*, 1954.

WHIFFEN, MARCUS. *Stuart and Georgian Churches: the Architecture of the Church of England outside London 1603–1837*, 1947–8.

WHITLEY, W. T. *Thomas Gainsborough*, 1925.

—— *Artists and their Friends in England 1700–1799*, 2 vols., 1928.

WILLANE, G. L. *Laurent Delvaux*, Brussels, 1914.

WILLIAMS, IOLO A. *English Book Illustration 1700–1775*.

—— *Early English Watercolours*, 1952.

WOLF, EDWARD C. J. *Rowlandson and his Illustrations of Eighteenth-century Literature*, Copenhagen, 1964.

WOODALL, MARY. *Gainsborough's Landscape Drawings*, 1939.

WOODFORDE, CHRISTOPHER. *English Stained and Painted Glass*, Oxford, 1954

YOUNGSON, A. J. *The Making of Classical Edinburgh 1750–1840*, 1966.

Articles

BOASE, T. S. R. 'Illustrations of Shakespeare's Plays in the Seventeenth and Eighteenth Centuries', *J.W.C.I.* X, 1947, 83–103.

—— 'Macklin and Bowyer', *J.W.C.I.* XXVI, 1963.

CLARK, KENNETH, 'English Romantic Poets and Landscape Painting', *Memoirs and Proceedings of the Manchester Philosophical Society*, LXXXV, also privately printed at the Curwen Press, Jan. 1945.

COLVIN, HOWARD. 'Gothic Survival and Gothick Revival', *Arch. Rev.*, 1948.

DOBSON, AUSTIN. 'Loutherbourg, R.A.' in *At Prior Park, and Other Papers*, 1912.

GIROUARD, MARK. 'English Art and the Rococo', *C.L.* I. 13 Jan., II, 27 Jan., and III, 3 Feb. 1966.

GOMBRICH, E. H. 'Reynolds's Theory and Practice of Imitation' in *Norm and Form: Studies in the Art of the Renaissance*, 1966.

GOWING, L. 'Hogarth, Hayman and the Vauxhall Decorators', *B.M.*, Jan. 1953.

HAMMELMANN, H. A. 'Eighteenth Century English Illustrators: Francis Hayman; Henry Fuseli; J. Vanderbank', *Book Collector*, II, 1953, 116–32; VI, 1957, 350–60; XVII, 1968, 285–99.

HONOUR, HUGH. 'Antonio Canova and the Anglo-Romans', *Arch. Rev.*, May 1958.

HUGO-BRANT, MICHAEL. 'George Dance the Younger as Town-Planner', *Society of Architectural Historians Jnl.*, nos. 14–17, 1955–8, 13 ff.

HUTCHISON, SIDNEY C. 'The Royal Academy Schools, 1768–1830', *Wal. Soc.* XXXVIII, 1960–2.

KITSON, MICHAEL. 'Hogarth's *Apology for Painters*', *Wal. Soc.* XLI, 1968.

LAURENCE, LESLEY. 'Stuart and Revett: Their Literary and Architectural Careers', *J.W.C.I.* II, 1938–9, 128–46.

MITCHELL, CHARLES. 'Benjamin West's "Death of General Wolfe" and the Popular History Piece', *J.W.C.I.* VII, 1944, 20–3.

PEVSNER, N., and LONG, S. 'Apollo or Baboon', *Arch. Rev.*, Dec. 1948.

ROSENAU, HELEN. 'George Dance the Younger', *R.I.B.A. Jnl.*, Aug. 1947.

SUMMERSON, JOHN. 'The Classical Country House in 18th-Century England', Three Cantor Lectures published in the *Journal of the Royal Society of Arts*, July 1959.

WATERHOUSE, ELLIS K. 'The British Contribution to the Neo-classical Style in Painting', *Proceedings of the British Academy*, XL, 1954, 55–74.

WATSON, FRANCIS. 'English Villas and Venetian Decorators', *R.I.B.A. Jnl.*, March, 1954.

WHIFFEN, MARCUS. 'The Progeny of St. Martin's-in-the-Fields', *Arch. Rev.*, July 1946.

WIND, EDGAR. 'Humanitätsidee und heroisiertes Porträt in der englischen Kultur des 18. Jahrhunderts' in *Vorträge der Bibliothek Warburg*, 1930–1, Leipzig/Berlin, 1932, 157–229.

—— 'The Revolution of History Painting', *J.W.C.I.* II, 1938–9, 116–27.

—— 'Penny, West and the "Death of Wolfe"', *J.W.C.I.* X, 1947, 159–62.

WITTKOWER, R. 'Lord Burlington and William Kent', *Archaeological Journal*, CII, 1945.

—— 'Pseudo-Palladian Elements in English Neo-classical Architecture' in *England and the Mediterranean Tradition*, edited by the Warburg and Courtauld Institutes of the University of London, Oxford, 1945.

—— 'Burlington and his Work in York' in *Studies in Architectural History*, ed. W. A. Singleton, London and York, 1954.

—— 'Diffusione dei modi palladiani in Inghilterra', *Bollettino del Centro Internazionale di Studi d'Architettura Andrea Palladio*, Vicenza, 1959.

APPENDIX

A NOTE ON RECENT RESEARCH

ALTHOUGH one of my aims in writing this history has been to quote as extensively as possible from contemporary sources, I have also tried to summarize the findings of recent scholarship, especially in so far as they affect interpretation. The up-dating of references has proved a difficult task in so wide a field, and some of the sections have been unchanged since they were written many years ago. Moreover, it would be misleading to refer to authorities when they were read too late to influence the substance of the text and its argument. For example, Mary Webster's fine study, *Francis Wheatley* (1970), came to hand only after I had already discussed the work of this talented artist in the context of the genre portrait. This note has therefore been added both for general guidance and to advise caution to those who use the volume as a bibliographical starting-point.

Recent research has been heavily concentrated in the second half of the eighteenth century, partly in consequence of the revival of interest in neo-classicism. Before the work of the late Emil Kaufmann, scholars tended to regard the English manifestation of the movement in isolation. Today there is a more critical interest in the comparison with Italian, German, and especially French neo-classicism, leading to a revaluation of artists hitherto neglected or described as eccentric. The second major area of research has been the Picturesque; the theoretical debate on this area lies outside the scope of this volume and has been discussed in the succeeding one. Much ground has still to be charted, notably in genre and landscape. Luke Herrmann's *British Landscape Painting of the Eighteenth Century* (1973) is a valuable survey which takes account of recent research.

When this history was first undertaken in 1949 there was a dearth of specialist studies on the minor artists of the century, especially those who worked outside London. Credit must be given to John Jacob for organizing the special exhibitions with scholarly catalogues at Kenwood, a lead which has been followed by many of the regional art galleries. Unfortunately, the Courtauld Bibliography of the History of British Art was not continued after 1948, but the learned staff have embodied

much of its system in the author, subject, and periodical catalogues of the Library of the Courtauld Institute. The Mellon Centre for Studies in British Art has sponsored or assisted a large number of exhibitions as well as publications, and students can obtain access to up-to-date lists on application. A number of important new journals have been launched since the inception of this study; some of the more specialist ones, e.g. the *Journal of the Furniture History Society*, also contain material of general interest to the art historian of the period. Most of the new secondary sources can be readily identified in standard works of bibliographical reference; but unless financial support can be obtained for the revival of the Courtauld Bibliography the amount of material increasingly appearing in Gallery and Museum bulletins in many countries and in local antiquarian journals, to name only two examples, sets the student a formidable task of investigation.

At my request Dr. Michael McCarthy, who with George Clarke and Michael Gibbon has done so much to advance the knowledge of Stowe and its gardens, had generously prepared a list of articles of substance on eighteenth-century architecture which have recently appeared. Its length unfortunately precluded inclusion, but it may be cited as evidence of the rapid growth of studies, for similar lists could be provided in other categories.

'This country, which does not always err in vaunting its own productions.' When this quotation from Horace Walpole's *Anecdotes of Painting* was placed by the Walpole Society at the head of its first volume in 1912 the intention was to encourage the study of British artists by their own countrymen. It was characteristic of the late T. S. R. Boase to choose contributors to the series he planned and edited from Canada and Australia as well as the United Kingdom. There are no national boundaries in scholarship; and this volume has been in no small part shaped by the research and critical perception of American scholars, many of whom have been associated with the Yale edition of Horace Walpole's correspondence edited by Dr. Wilmarth Sheldon Lewis. This transatlantic contribution embraces not only the U.S.A. but Canada as well, and the fortunate tenure of a Commonwealth Visiting Fellowship at Queen's University, Kingston, Ontario, in the winter of 1974–5 enabled me to make contact with some of the younger scholars who have entered the field, notably Dr. Pierre du Prey, who is engaged on an important study of Sir John Soane. Both he and Professor Gerald Finley were kind enough to read my manuscript and detect some errors. There is as yet no bibliographical aid to the growing American and

Canadian literature on English art in the eighteenth century comparable in scope to the Courtauld Bibliography before it terminated, and in drawing attention to this gap it is tempting to express the hope that it may one day be filled by a co-operative venture.

INDEX

PLATE 1

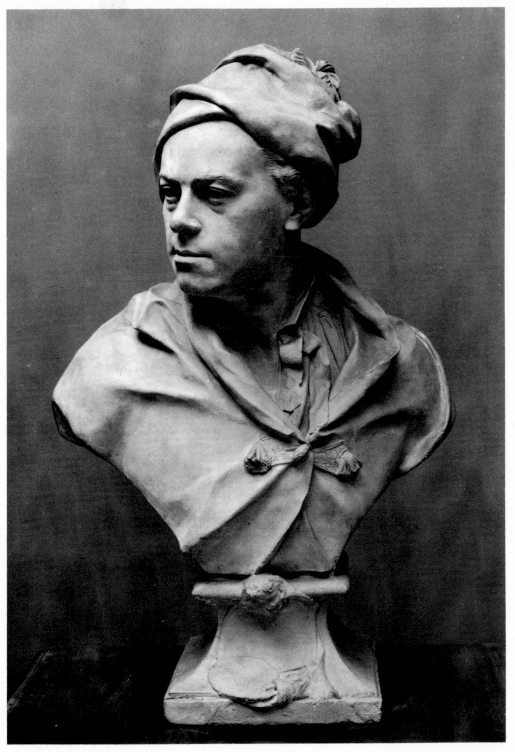

LOUIS FRANÇOIS ROUBILIAC: WILLIAM HOGARTH. *c.* 1741. Terracotta. (Height: 29 in.)

PLATE 2

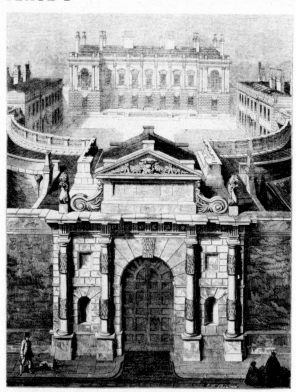

A. COLIN CAMPBELL: BURLINGTON
HOUSE, PICCADILLY. 1718–19

B. LORD BURLINGTON: CHISWICK
HOUSE, MIDDLESEX. c. 1725

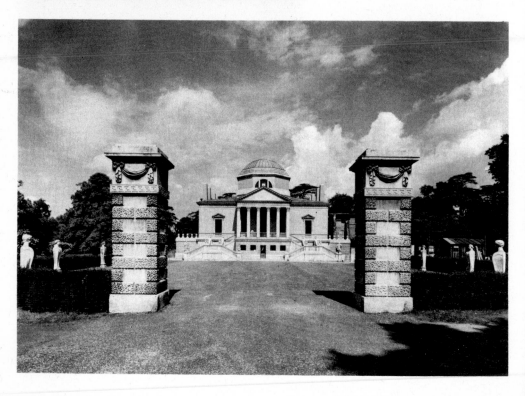

PLATE 3

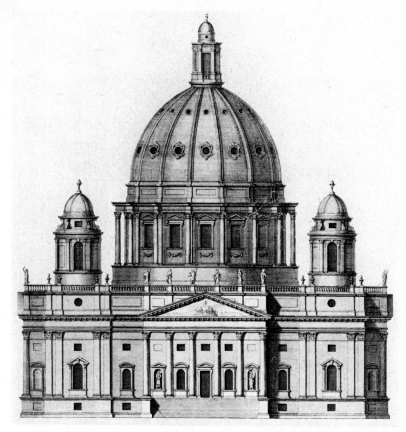

A. COLIN CAMPBELL: DESIGN FOR A NEW CHURCH IN LINCOLN'S INN
FIELDS. 1712

B. COLIN CAMPBELL: DESIGN FOR A CHURCH IN THE VITRUVIAN STYLE. 1717

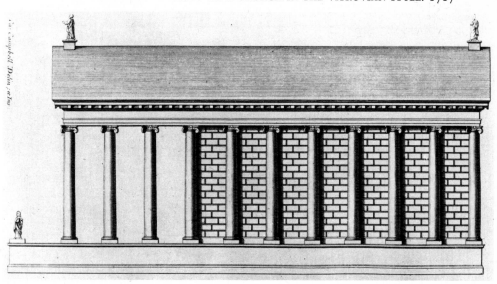

PLATE 4

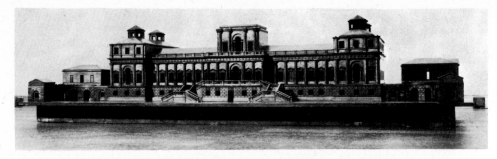

A. WILLIAM KENT: DESIGN FOR A ROYAL PALACE AT RICHMOND. *c.* 1732

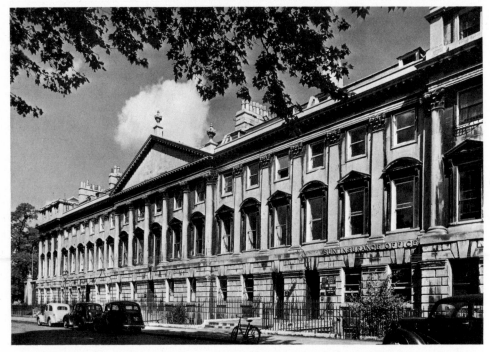

B. JOHN WOOD THE ELDER: QUEEN SQUARE, BATH: THE NORTH SIDE. 1729–36

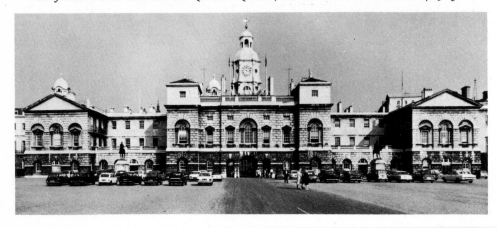

PLATE 5

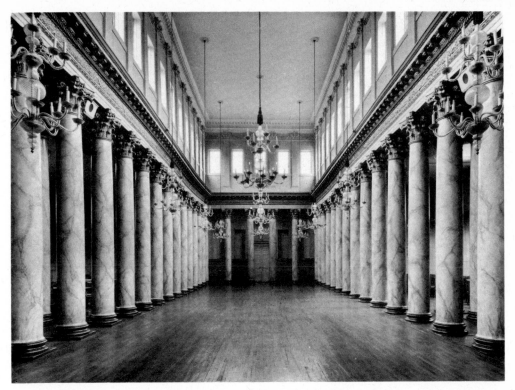

A. RICHARD BOYLE, 3RD EARL OF BURLINGTON: THE ASSEMBLY ROOMS, YORK. 1731-2

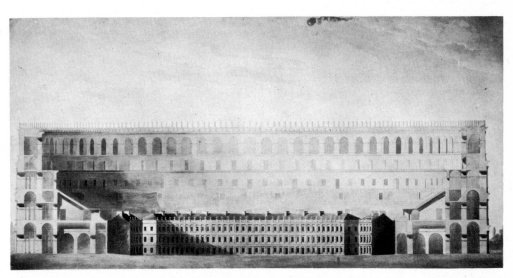

B. COMPARATIVE DRAWING BY SIR JOHN SOANE OF THE CIRCUS, BATH, IN RELATION TO THE COLOSSEUM, ROME. *c.* 1809

(*left*) 4C. WILLIAM KENT AND JOHN VARDY: THE HORSE GUARDS: BEGUN 1751

PLATE 6

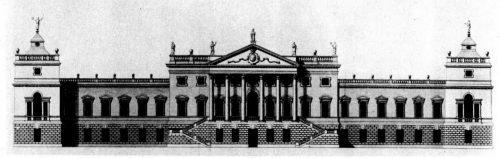

A. COLIN CAMPBELL: WANSTEAD HOUSE, ESSEX: THE THIRD DESIGN OF 1721, ADDING THE
TOWERS, DESIGNED 1720, TO THE FIRST DESIGN OF 1715

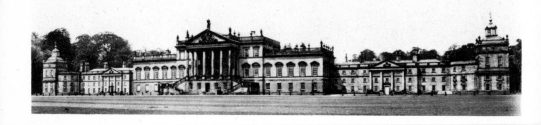

B. COLIN CAMPBELL: HOUGHTON HALL, NORFOLK: THE WEST FRONT, INCLUDING THE
WINGS, SHOWING THE TOWERS BY JAMES GIBBS: BEGUN 1722

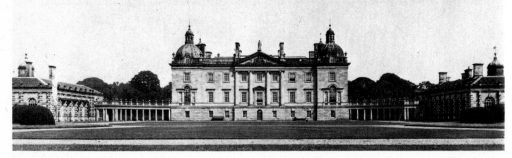

C. WILLIAM KENT: HOLKHAM HALL, NORFOLK: THE SOUTH FRONT. 1731–64

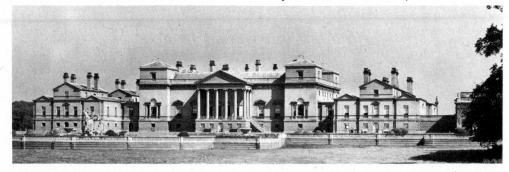

PLATE 7

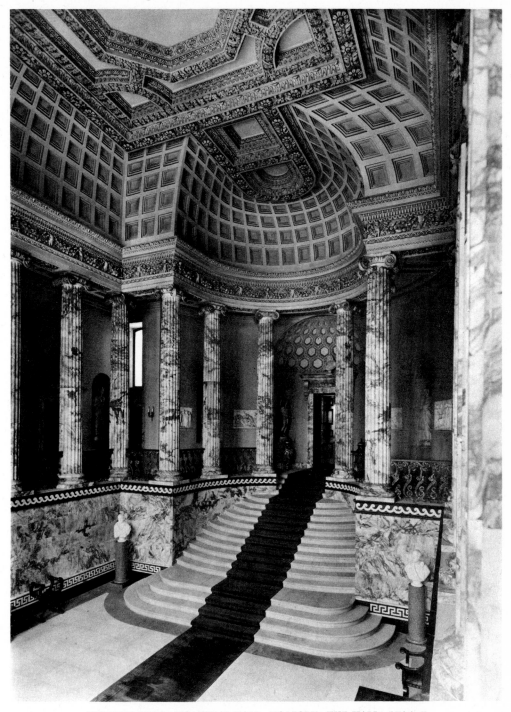

WILLIAM KENT: HOLKHAM HALL, NORFOLK: THE HALL: 1734–7

(left) 6D. HENRY FLITCROFT: WENTWORTH WOODHOUSE, YORKSHIRE: THE EAST FRONT. 1760

PLATE 8

A. COLIN CAMPBELL: EBBERSTON LODGE, YORKSHIRE: THE SOUTH ENTRANCE FRONT. 1718

B. COLIN CAMPBELL: MEREWORTH CASTLE, KENT: THE SOUTH FRONT. *c.* 1722–5

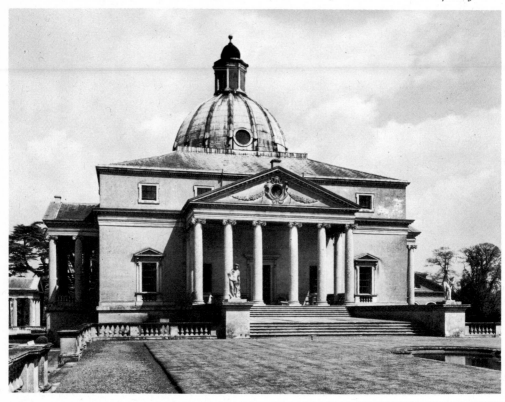

PLATE 9

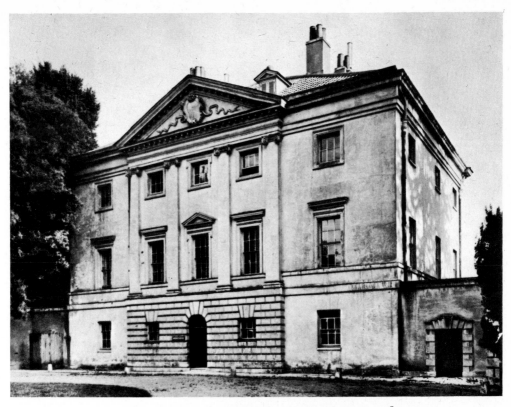

A. ROGER MORRIS: MARBLE HILL, TWICKENHAM. 1728–9

B. JOHN VARDY: SPENCER HOUSE, GREEN PARK, LONDON. 1756–65

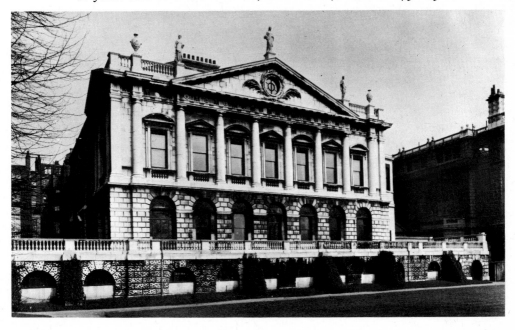

PLATE 10

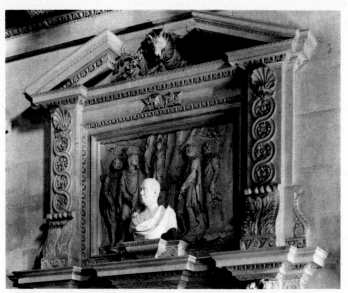

A. JOHN MICHAEL RYSBRACK: FIREPLACE WITH 'DIANA'; THE STONE HALL, HOUGHTON, NORFOLK. 1738

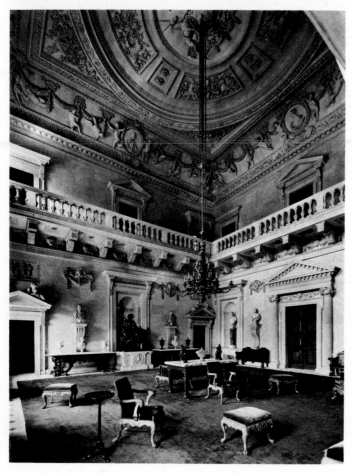

B. COLIN CAMPBELL: HOUGHTON HALL, NORFOLK: THE STONE HALL. c. 1726–31

PLATE 11

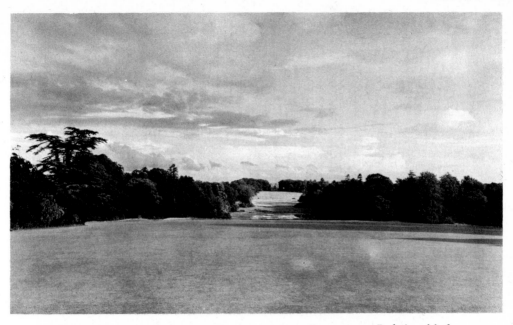

A. LORD TEMPLE AND WILLIAM KENT: THE GREAT VISTA, STOWE. Redesigned before 1734

B. WILLIAM KENT: PRAENESTE, ROUSHAM, OXFORDSHIRE. 1738–41

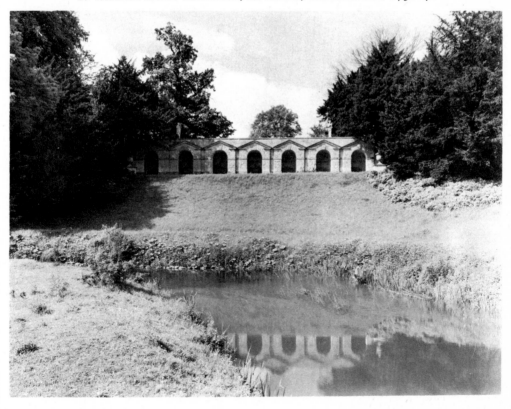

PLATE 12

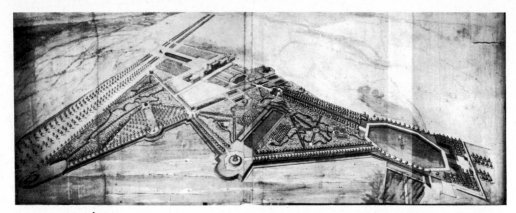

A. A BIRD'S-EYE VIEW OF THE VANBRUGH–BRIDGEMAN LAYOUT IN STOWE. 1720–5

B. PLAN OF ALEXANDER POPE'S GARDEN, TWICKENHAM

'As it was left at his death, 1744'. Engraving from John Searle, *A Plan of Mr. Pope's Garden*, London, 1745

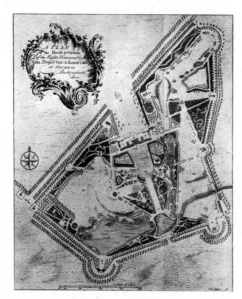

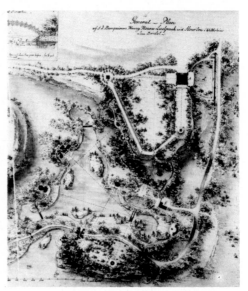

C. A PLAN OF THE HOUSE AND GARDENS AT STOWE

By J. C. Miller, 1769, showing the extent of Kent's alterations, from 1734

D. GENERAL PLAN OF THE PLEASURE GARDENS AT STOURHEAD

By F. M. Piper, 1779, showing the design by Henry Hoare and Henry Flitcroft

PLATE 13

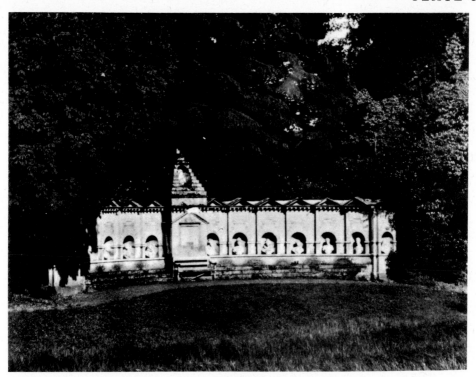

A. WILLIAM KENT: STOWE HOUSE, BUCKINGHAMSHIRE: THE TEMPLE OF BRITISH WORTHIES. 1733

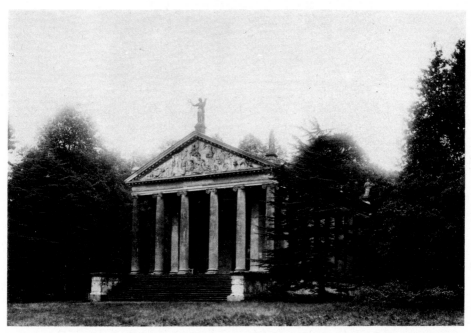

B. LORD TEMPLE AND WILLIAM KENT: THE TEMPLE OF CONCORD AND VICTORY, STOWE HOUSE, BUCKINGHAMSHIRE. Begun before 1748, completed by J. B. Borra, 1763

PLATE 14

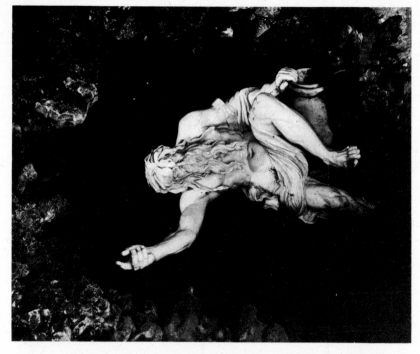

B. JOHN CHEERE: NEPTUNE, STOURHEAD, WILTSHIRE. 1751

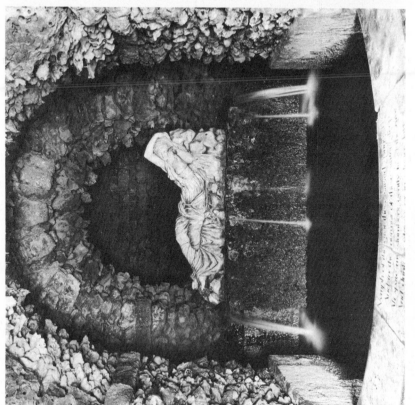

A. THE NYMPH OF THE GROTTO AT STOURHEAD, WILTSHIRE

After the Vatican *Ariadne*. Attributed to John Cheere

PLATE 15

A. WILLIAM KENT: CENTRE ALLEY AT CHISWICK HOUSE, MIDDLESEX
After 1730

B. HENRY FLITCROFT: THE TEMPLE OF HERCULES AT STOURHEAD, WILTSHIRE. 1755–6.
Based on the Pantheon

PLATE 16

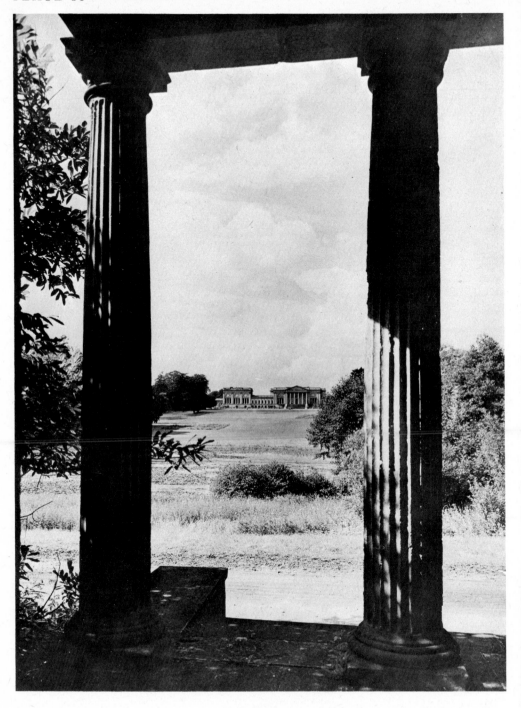

STOWE HOUSE, BUCKINGHAMSHIRE. View looking back from the Great Vista after its remodelling
by Lord Temple and William Kent from 1730

PLATE 17

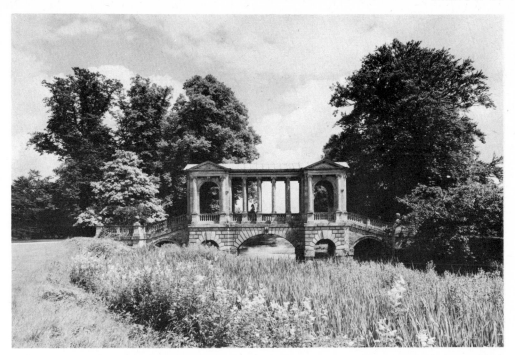

A. LORD PEMBROKE AND ROGER MORRIS: THE PALLADIAN BRIDGE, WILTON, WILTSHIRE. 1736–7

B. WILLIAM AISLABIE: THE CONCLUSION OF THE WATERWORK GARDEN AT STUDLEY ROYAL, YORKSHIRE, FACING FOUNTAINS ABBEY. The gardens planned after 1718, completed by 1768

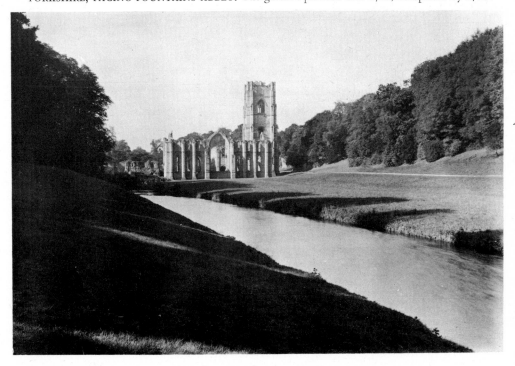

PLATE 18

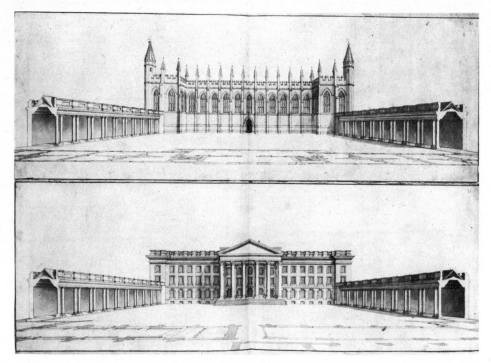

A. PERSPECTIVE DRAWINGS FOR THE NORTH QUADRANGLE, ALL SOULS COLLEGE, OXFORD
IN GOTHIC AND CLASSICAL STYLES. Attributed to John James. Before 1715

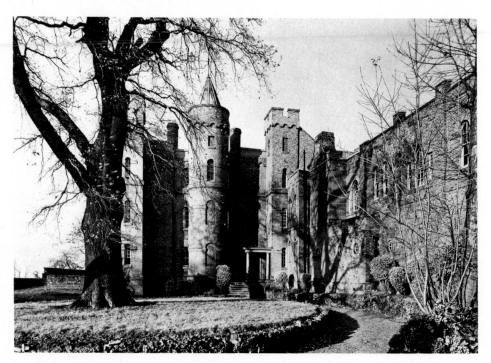

B. SIR JOHN VANBRUGH: VANBRUGH CASTLE, GREENWICH. 1717

PLATE 19

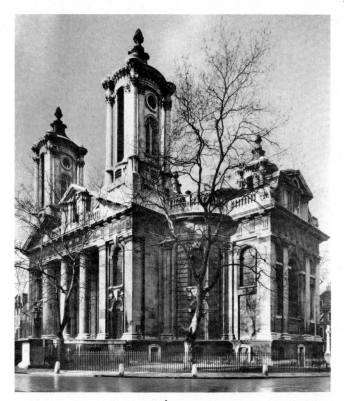

A. THOMAS ARCHER: ST. JOHN'S, SMITH SQUARE, WESTMINSTER.
1714–28; gutted by enemy action, 1941

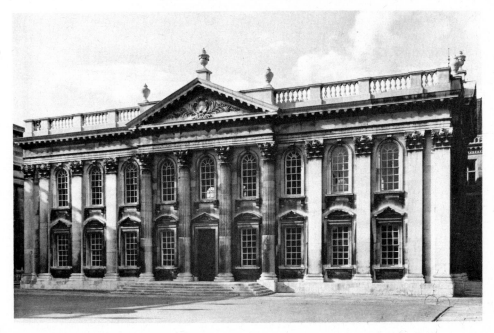

B. JAMES GIBBS: THE SENATE HOUSE, CAMBRIDGE. 1722–30

PLATE 20

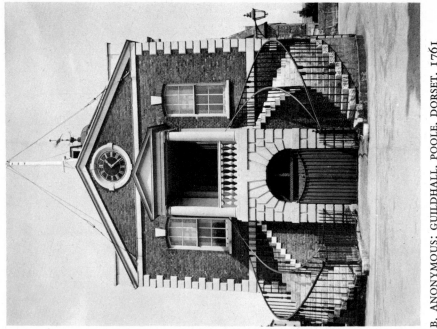

B. ANONYMOUS: GUILDHALL, POOLE, DORSET. 1761

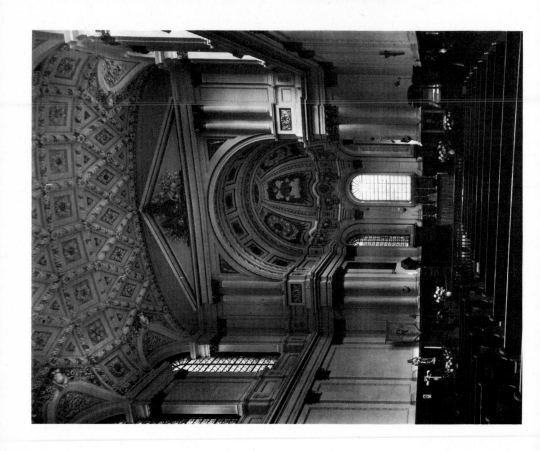

A. JAMES GIBBS: ST. MARY-LE-STRAND: THE APSE. 1722–6

PLATE 21

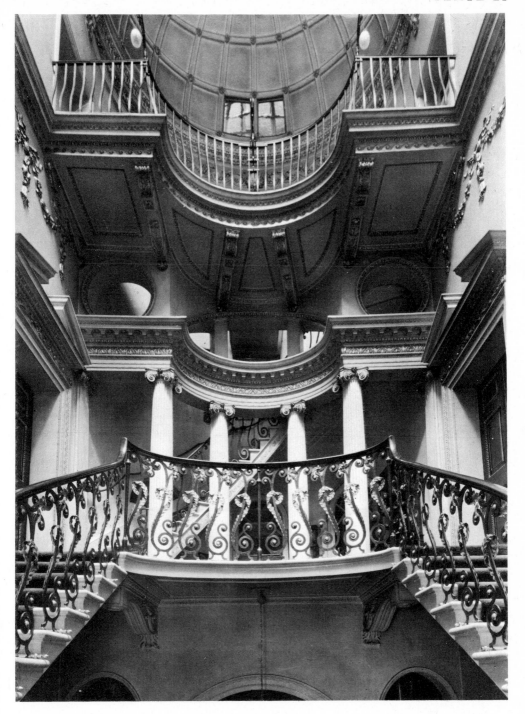

WILLIAM KENT: 44 BERKELEY SQUARE, LONDON: THE STAIRCASE. 1742–4

PLATE 22

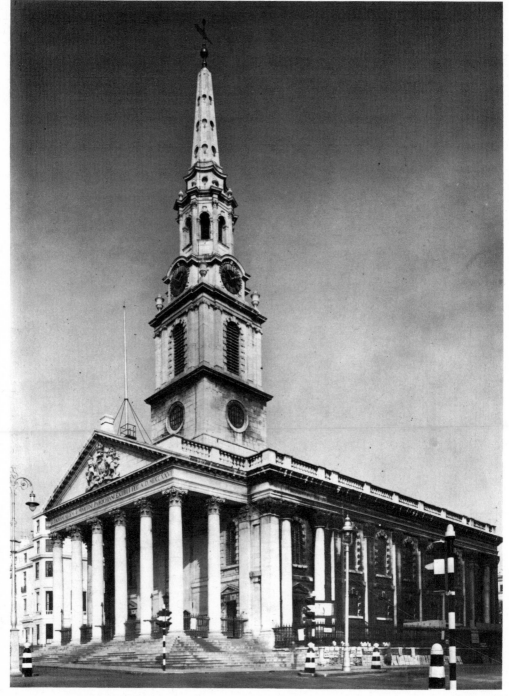

JAMES GIBBS: ST. MARTIN-IN-THE-FIELDS, TRAFALGAR SQUARE, WESTMINSTER. 1721–6

PLATE 23

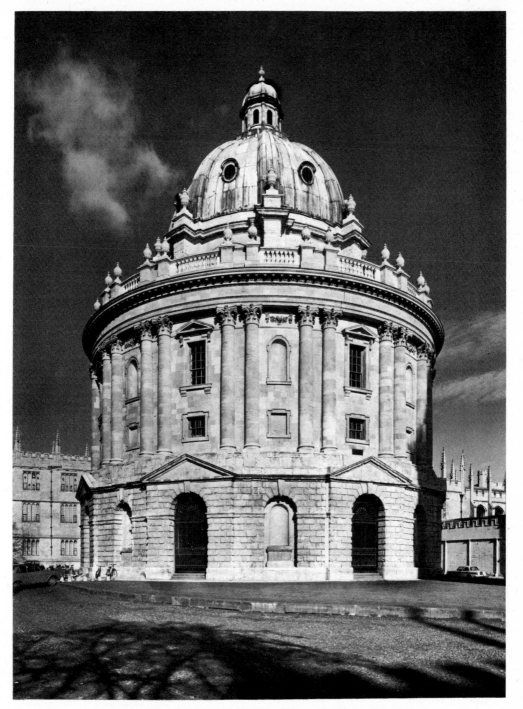

JAMES GIBBS: THE RADCLIFFE CAMERA, OXFORD. 1739–49

PLATE 24

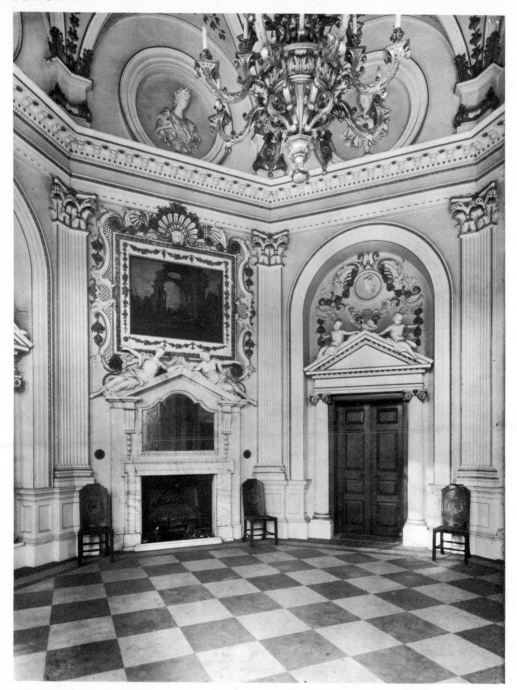

JAMES GIBBS: THE OCTAGON ROOM, ORLEANS HOUSE, TWICKENHAM. 1720. Stucco by G. Artari and G. Bagutti

PLATE 25

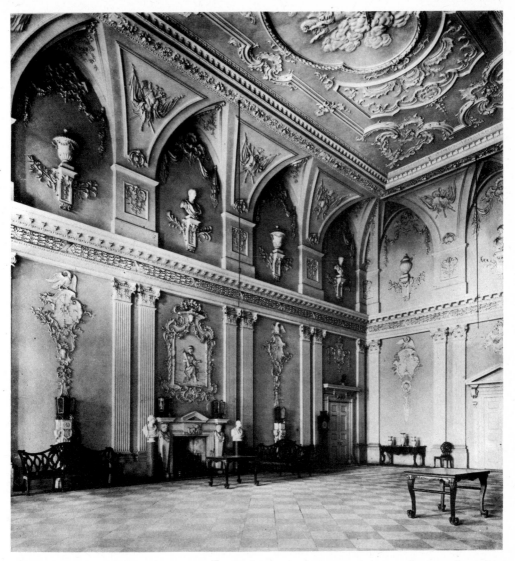

JAMES GIBBS: THE GREAT HALL, RAGLEY HALL, WARWICKSHIRE. *c.* 1725 and rococo decoration
of the 1750s. The remodelling of an older hall, begun 1680

PLATE 26

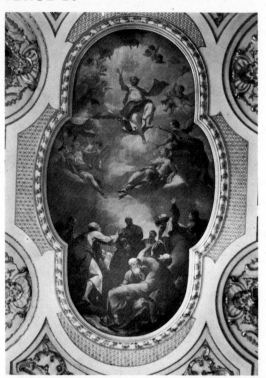

A. ANTONIO BELLUCCI: THE ASCENSION PAINTED FOR CANONS, MIDDLESEX *c.* 1719–20. Transferred by Lord Foley to Great Witley Church, Worcester, after 1747

B. SIR JAMES THORNHILL: THE PAINTED CHAPEL: WIMPOLE HALL, CAMBRIDGESHIRE. 1724

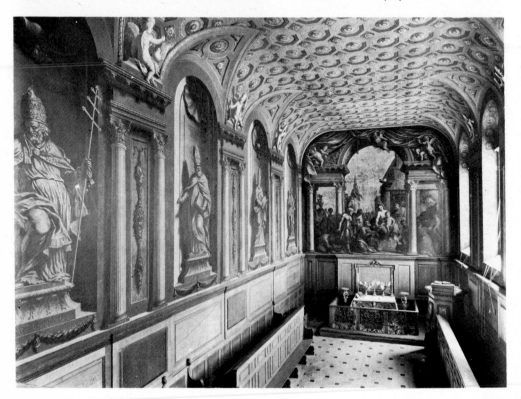

PLATE 27

A. WILLIAM KENT: THE PAINTED
STAIRCASE: KENSINGTON
PALACE, LONDON. 1726

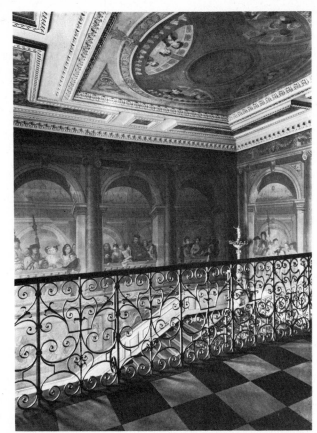

B. WILLIAM HOGARTH: THE
PAINTED STAIRCASE
ST. BARTHOLOMEW'S HOSPITAL,
LONDON. 1735–7

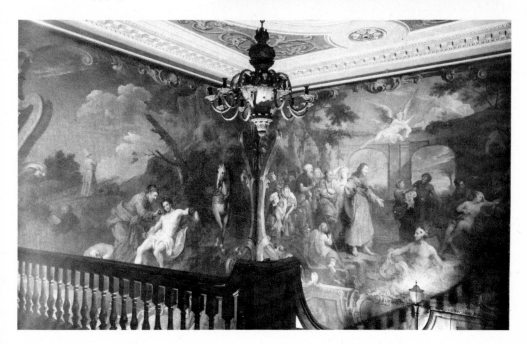

PLATE 28

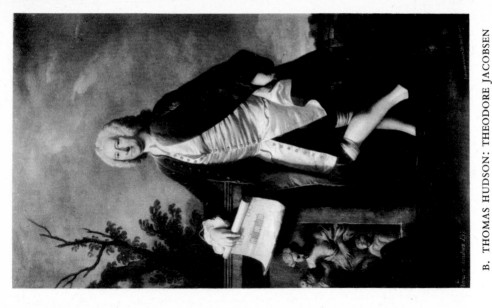

B. THOMAS HUDSON: THEODORE JACOBSEN
1746. The Foundling Hospital

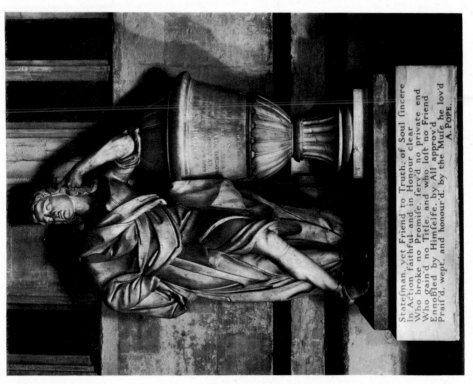

A. GIOVANNI BATTISTA GUELFI: MONUMENT TO JAMES CRAGGS
WESTMINSTER ABBEY. 1727. (Height of Figure, 5 ft. 9 in.)

PLATE 29

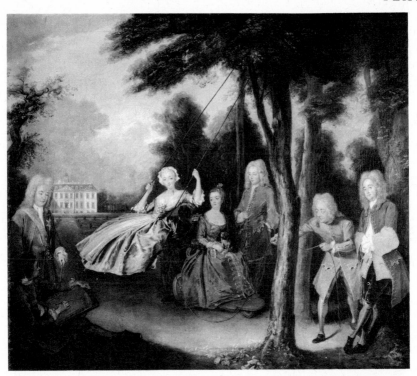

A. PHILIP MERCIER: VISCOUNT TYRCONNEL'S FAMILY PARTY IN THE
GROUNDS OF BELTON HOUSE, LINCOLNSHIRE. 1725–6. (Canvas: 24×29 in.)

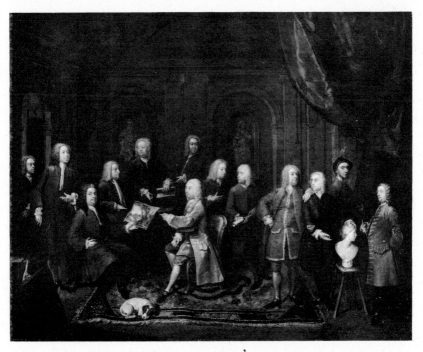

B. GAWEN HAMILTON: AN ARTISTS' CONVERSATION: 1735

PLATE 30

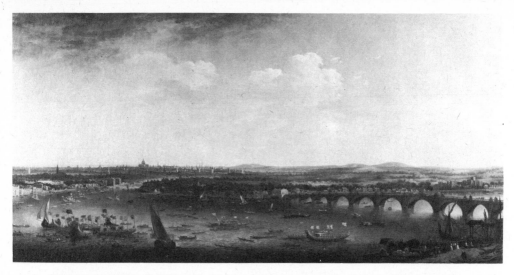

A. ROBERT GRIFFIER: PANORAMA OF THE CITY OF LONDON FROM MONTAGU HOUSE
Signed and dated 1748

B. JOHN WOOTTON: THE BEAUFORT HUNT. 1744. (Canvas: 78×95 in.)

PLATE 31

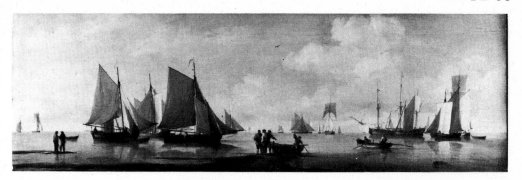

A. CHARLES BROOKING
 SHIPPING IN A CALM.
 c. 1750. (Canvas: $10\frac{3}{4} \times 33$ in.)

B. WILLIAM HOGARTH
 EMBARKING FROM GRAIN
 1732. (The Fifth drawing
 $8 \times 12\frac{5}{8}$ in.)

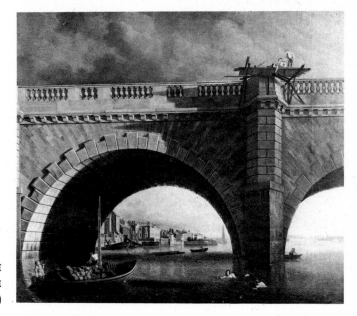

C. SAMUEL SCOTT: AN ARCH
 OF WESTMINSTER BRIDGE
 1748. (Canvas: $50\frac{1}{2} \times 64$ in.)

PLATE 32

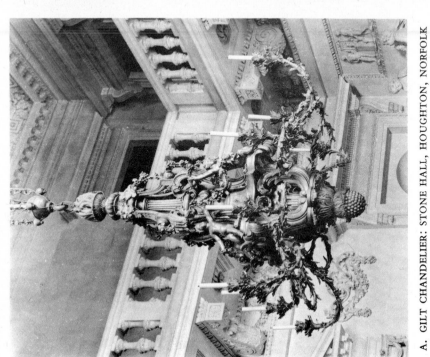

A. GILT CHANDELIER: STONE HALL, HOUGHTON, NORFOLK

c. 1740

B. Attributed to ROBERT
BAKEWELL: THE ARBOUR
MELBOURNE HALL, DERBYSHIRE

c. 1708–11

PLATE 33

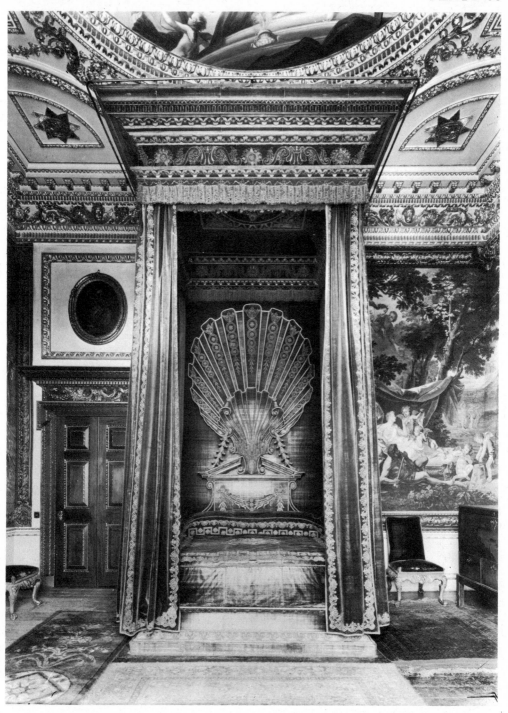

WILLIAM KENT: GREEN VELVET STATE BED: HOUGHTON HALL, NORFOLK. 1732

PLATE 34

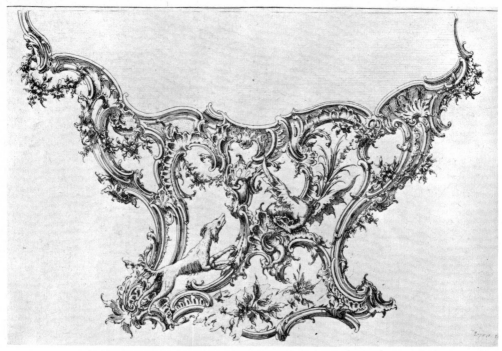

A. MATHIAS LOCK: DESIGN FROM 'SIX TABLES'. 1746. (Etching: $7 \times 11\frac{3}{8}$ in.)

B. THE JERNINGHAM–KANDLER WINE CISTERN. 1734. Designed by George Vertue
(Height to rim only 3 ft. 3 in., length 5 ft. 6 in. from elbow to elbow)

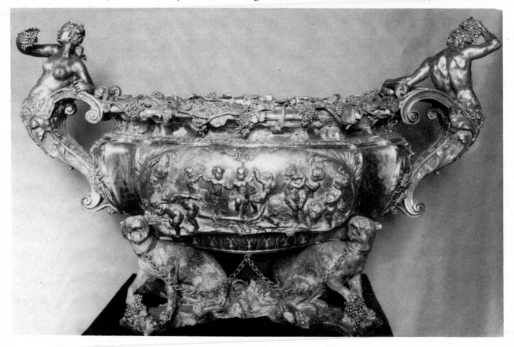

PLATE 35

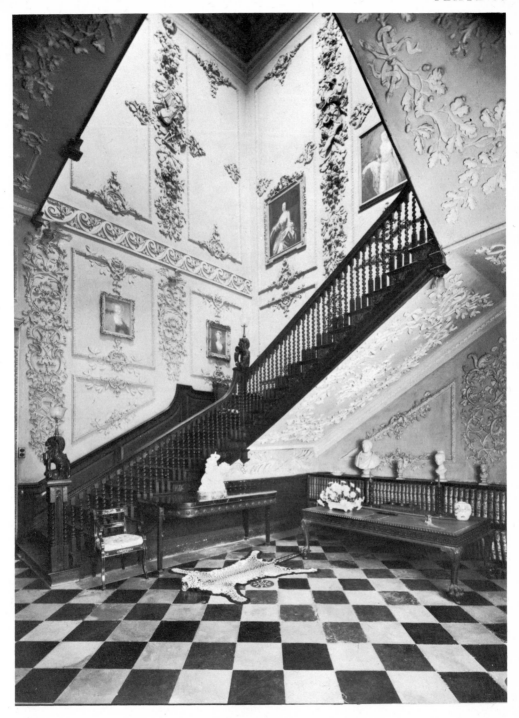

THE GREAT STAIRCASE: POWDERHAM CASTLE, DEVONSHIRE. Plasterwork by John Jenkins, 1754–6

PLATE 38

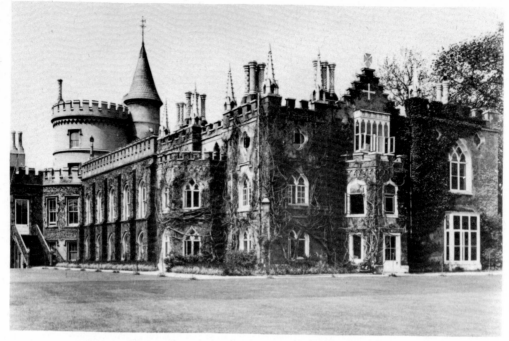

A. STRAWBERRY HILL, TWICKENHAM: FROM THE SOUTH. Begun 1748

B. STRAWBERRY HILL, TWICKENHAM: THE HOLBEIN CHAMBER. 1759

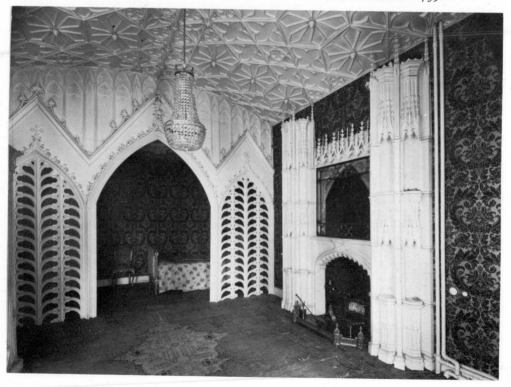

PLATE 39

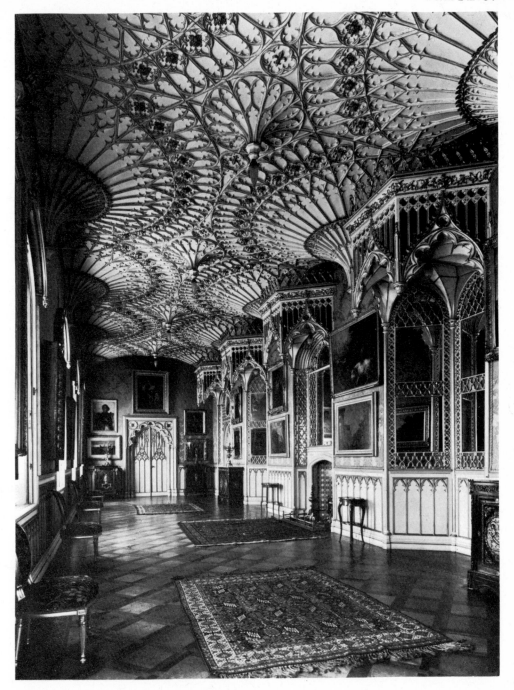

STRAWBERRY HILL: THE GALLERY. Decorations supervised by Thomas Pitt, *c.* 1762

PLATE 40

A. THE MUSIC LESSON: GROUP IN CHELSEA
PORCELAIN. Adapted from François
Boucher's *L'Agréable Leçon*, engraved by
J. E. Nilson. *c.* 1765

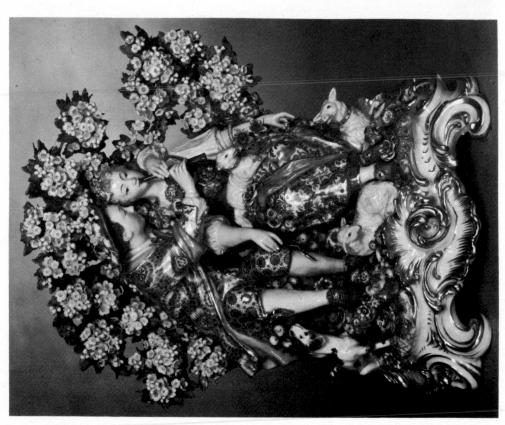

B. DISH, PORCELAIN PAINTED IN COLOURS. CHELSEA. *c.* 1755

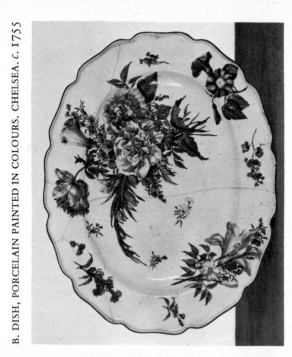

PLATE 41

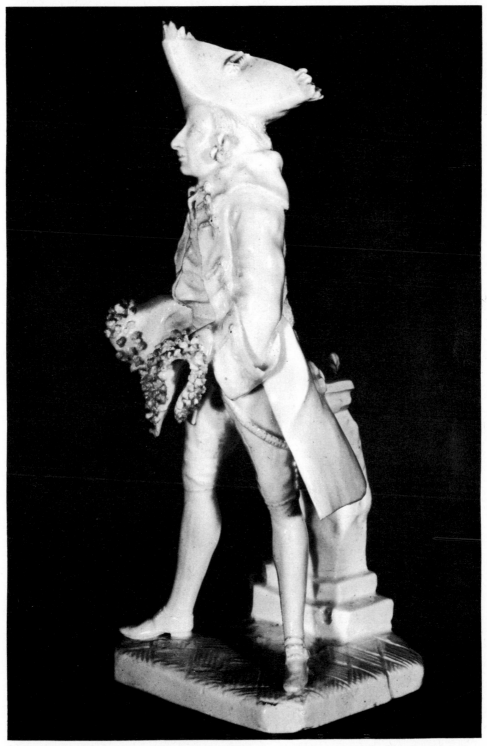

HENRY WOODWARD AS THE 'BEAU' IN GARRICK'S 'LETHE'. BOW. *c.* 1755. (Height: 10¾ in.)

PLATE 42

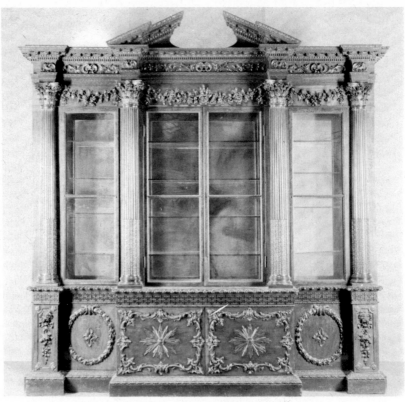

A. MAHOGANY BOOKCASE. Made by Vile and Cobb. 1762
(Length: 103½ in., height: 76 in.)

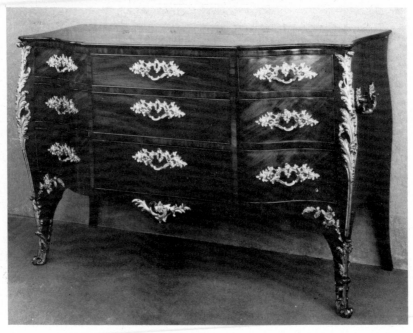

PLATE 43

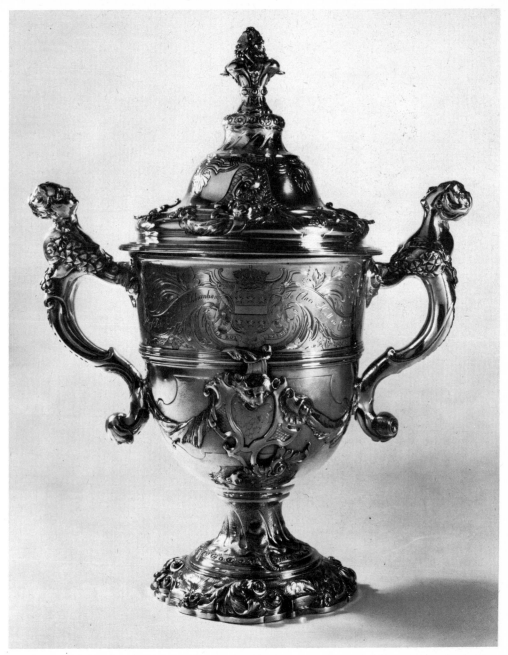

PAUL DE LAMERIE: TWO-HANDLED CUP AND COVER. 1739. Inscribed 'The Gift of John, Earl of Ashburnham to Clare Hall in Cambridge, 1744'. (Height: 14½ in.)

(left) 42B. MAHOGANY COMMODE WITH ROCOCO GILT BRASS MOUNTS. c. 1765

PLATE 44

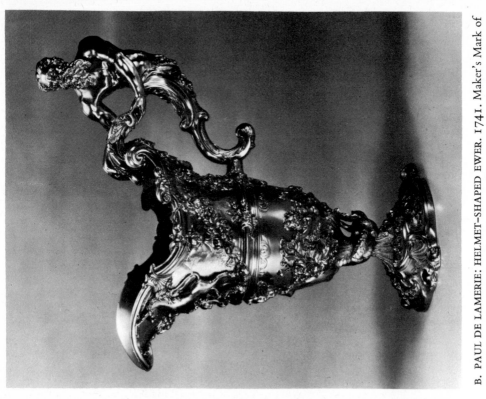

B. PAUL DE LAMERIE: HELMET-SHAPED EWER. 1741. Maker's Mark of Paul de Lamerie. Gilt, chased with arms of the Company. (Height: 14¾ in.)

A. VASE AND COVER ENCRUSTED WITH FLOWERS AND BIRDS. c. 1755. (Height: 16 in.)

PLATE 45

A. WILLIAM HOGARTH: FINIS, or THE BATHOS, OR MANNER OF
SINKING IN SUBLIME PAINTINGS, INSCRIBED TO THE DEALERS IN
DARK PICTURES. 1764. (Engraving: $12\frac{3}{4} \times 10\frac{1}{4}$ in.)

B. LOUIS FRANÇOIS ROUBILIAC
MONUMENT TO GENERAL WILLIAM
HARGRAVE. Engraving by Philip
Dawe. 1757

C. WILLIAM HOGARTH: FIAMMINGO'S HEAD
Before 1753

PLATE 46

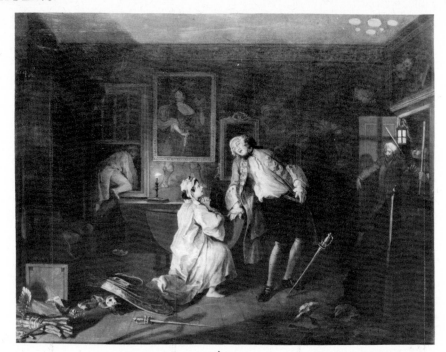

A. WILLIAM HOGARTH: MARRIAGE-À-LA-MODE: THE DEATH OF THE EARL
1743-5. (Plate 5 of the series: 27 × 35 in.)

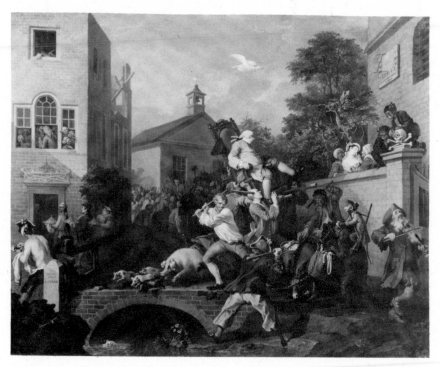

B. WILLIAM HOGARTH: THE ELECTION: CHAIRING THE MEMBER. 1754
(Canvas: 40 × 50 in.)

PLATE 47

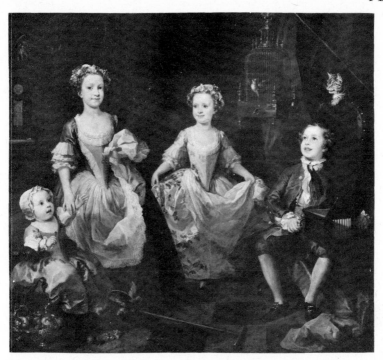

A. WILLIAM HOGARTH: THE GRAHAM CHILDREN. 1742
(Canvas: $63\frac{3}{4} \times 71\frac{1}{4}$ in.)

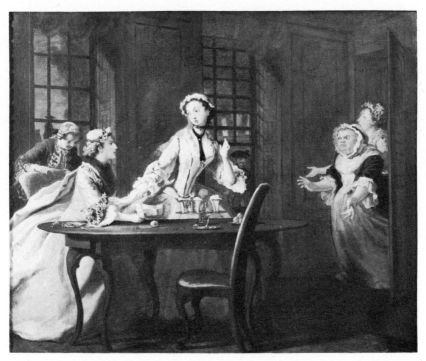

B. JOSEPH HIGHMORE: PAMELA AND LADY DAVERS. 1741–5. No. 8 of the series
for Samuel Richardson's 'Pamela'. (Canvas: $24\frac{7}{8} \times 30\frac{1}{8}$ in.)

PLATE 48

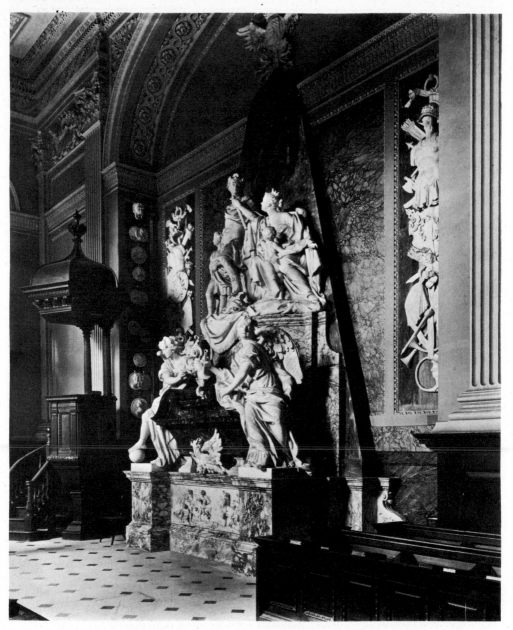

JOHN MICHAEL RYSBRACK: TOMB OF THE 1ST DUKE OF MARLBOROUGH. 1732

PLATE 49

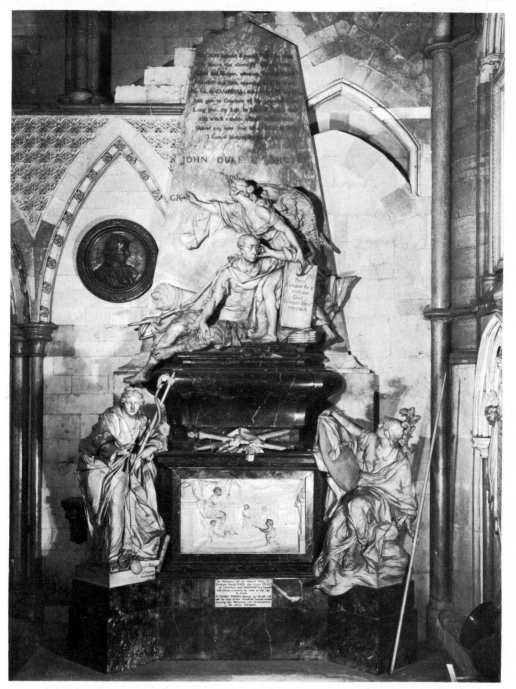

LOUIS FRANÇOIS ROUBILIAC: MONUMENT TO JOHN, 2ND DUKE OF ARGYLL. 1745–9

PLATE 50

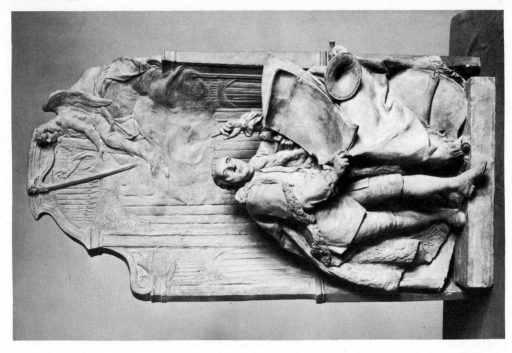

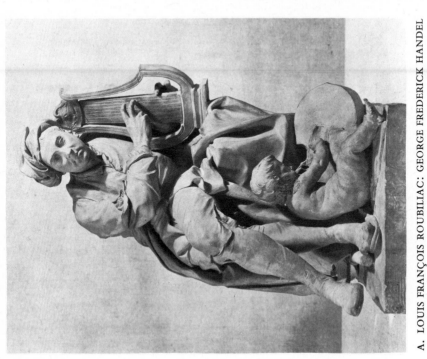

A. LOUIS FRANÇOIS ROUBILIAC: GEORGE FREDERICK HANDEL
Before 1738. Terracotta model for the statue in Vauxhall Gardens

B. LOUIS FRANÇOIS ROUBILIAC: MODEL FOR THE MONUMENT TO
GEORGE FREDERICK HANDEL IN WESTMINSTER ABBEY. c. 1759
(Height: c. 38 in.)

PLATE 51

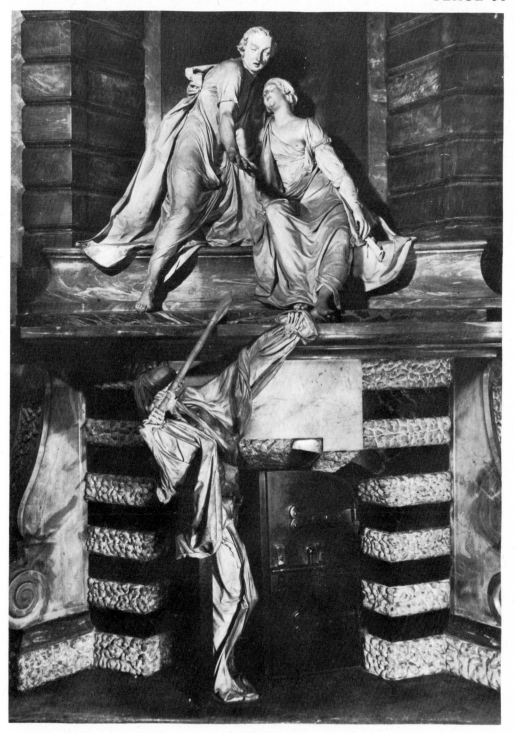

LOUIS FRANÇOIS ROUBILIAC: MONUMENT TO LADY ELIZABETH NIGHTINGALE. 1761

PLATE 52

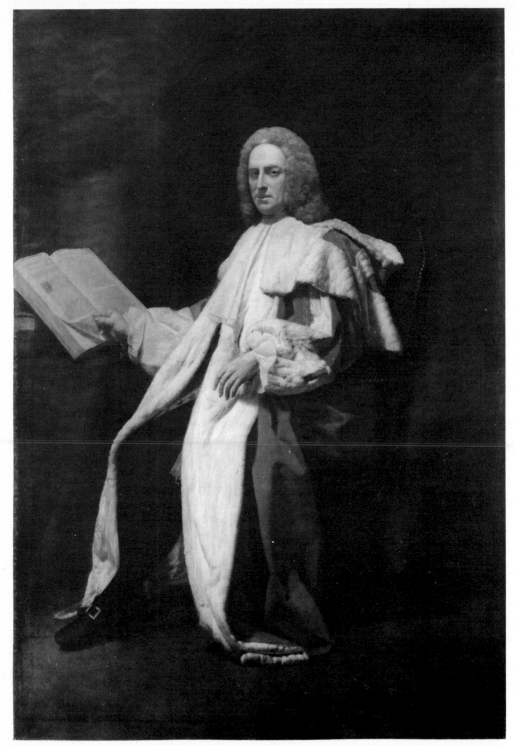

ALLAN RAMSAY: ARCHIBALD, 3RD DUKE OF ARGYLL, AS LORD JUSTICE OF SCOTLAND. 1749
(Canvas: signed 'A. Ramsey', 94×61½ in.)

PLATE 53

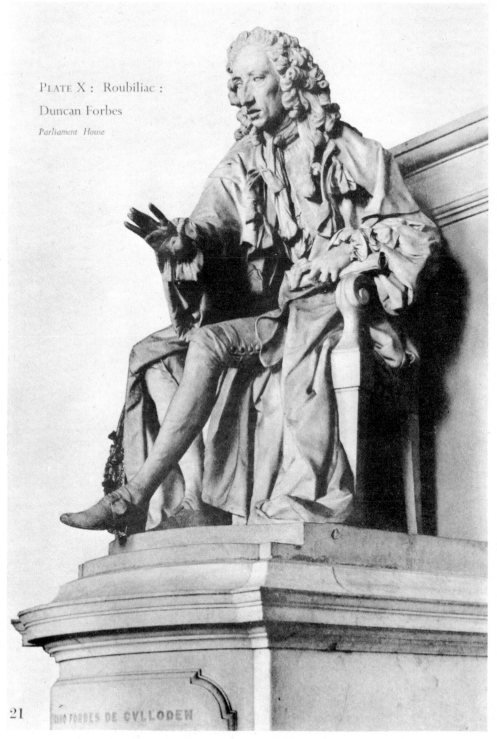

PLATE X : Roubiliac :

Duncan Forbes

Parliament House

21

LOUIS FRANÇOIS ROUBILIAC: LORD PRESIDENT DUNCAN FORBES. 1752

PLATE 54

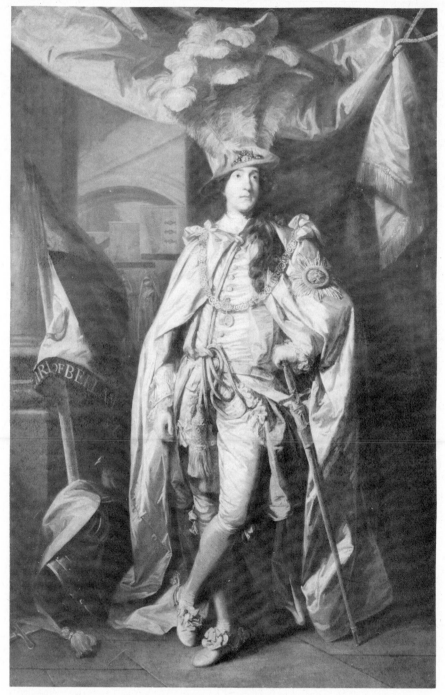

SIR JOSHUA REYNOLDS: CHARLES COOTE, EARL OF BELLAMONT, K.B. R.A. 1774
(Canvas: 245 × 151 in.)

(*right*) SIR JOSHUA REYNOLDS: COLONEL BANASTRE TARLETON. R.A. 1782
(Canvas: 87 × 57 in.)

PLATE 55

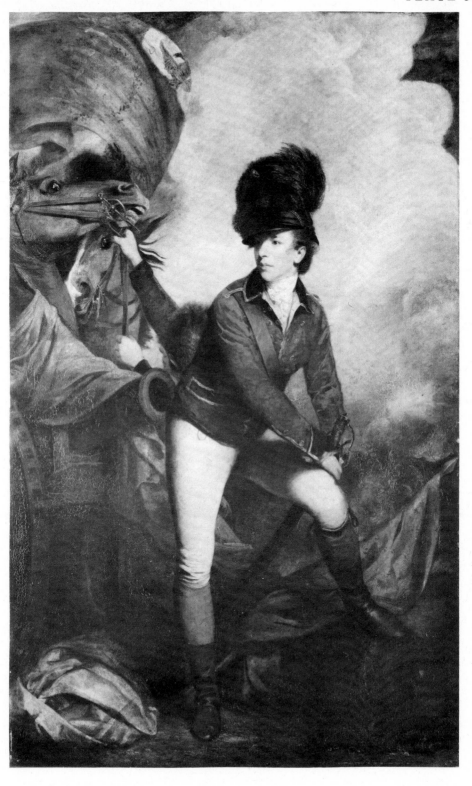

PLATE 56

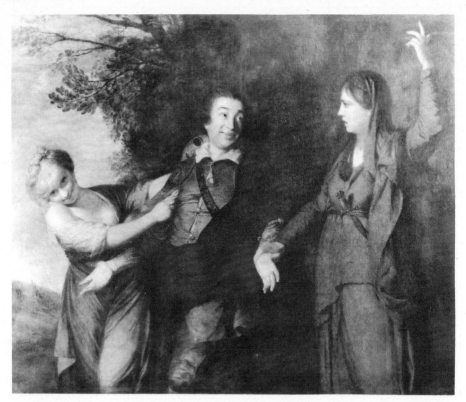

A. SIR JOSHUA REYNOLDS: GARRICK BETWEEN COMEDY AND TRAGEDY. 1760–1
(Canvas: 148 × 183 in.)

B. Studio of SIR JOSHUA REYNOLDS: DR. SAMUEL JOHNSON. A replica of the painting shown at the R.A. 1770. (Canvas: 29¾ × 24¾ in.)

C. SIR JOSHUA REYNOLDS: MRS. ABINGTON AS MISS PRUE IN 'LOVE FOR LOVE'. R.A. 1771. (Canvas: 74 × 62 in.)

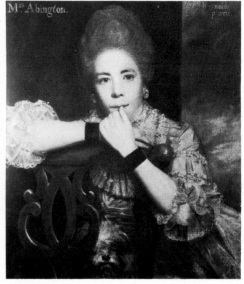

PLATE 57

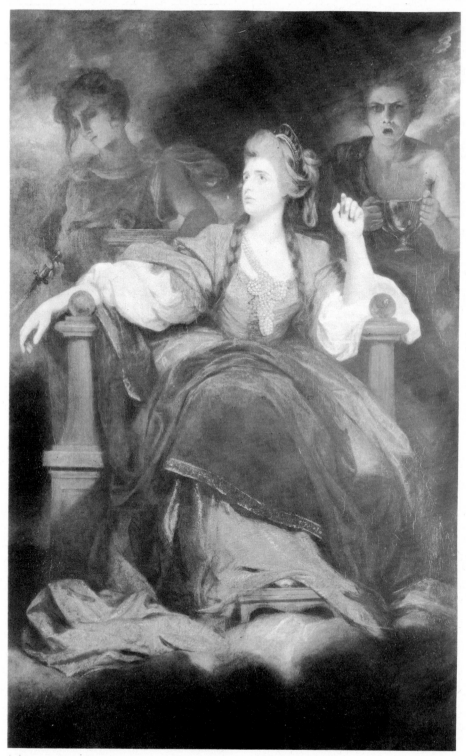

SIR JOSHUA REYNOLDS: SARAH SIDDONS AS 'THE TRAGIC MUSE'. R.A. 1784
(Canvas: 93 × 57½ in.)

PLATE 58

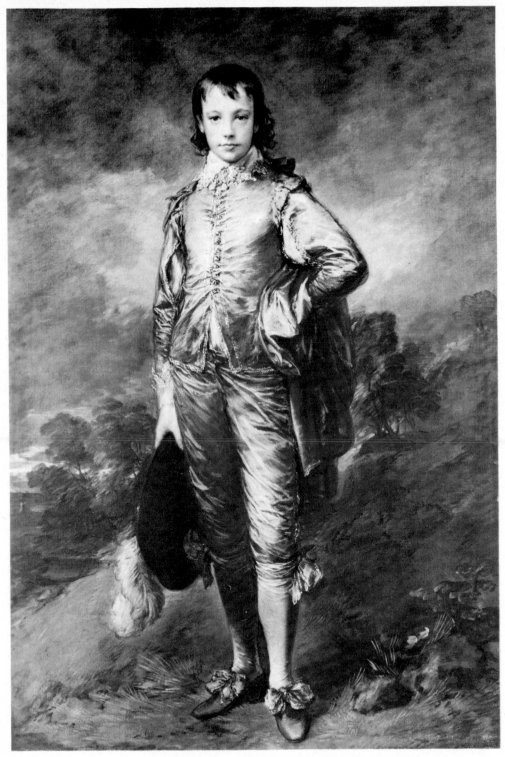

THOMAS GAINSBOROUGH: THE BLUE BOY. R.A. 1770. (Canvas: 70 × 48 in.)

PLATE 59

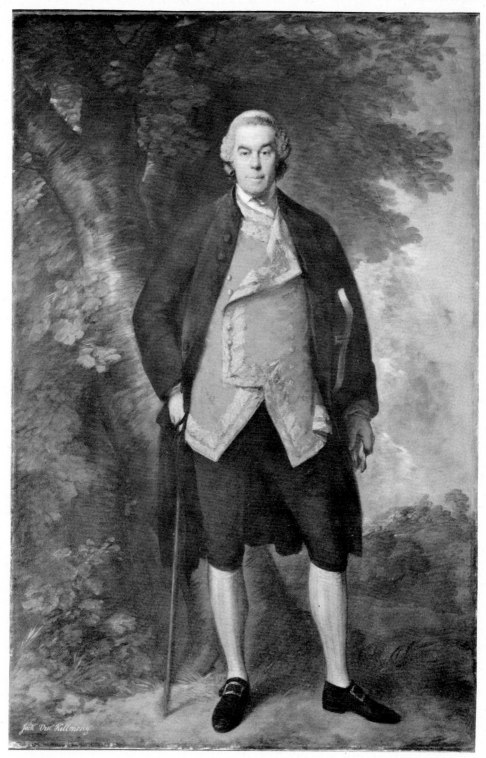

THOMAS GAINSBOROUGH: JOHN NEEDHAM, 10TH VISCOUNT KILMOREY. 1768
(Canvas: 92×61 in.)

PLATE 60

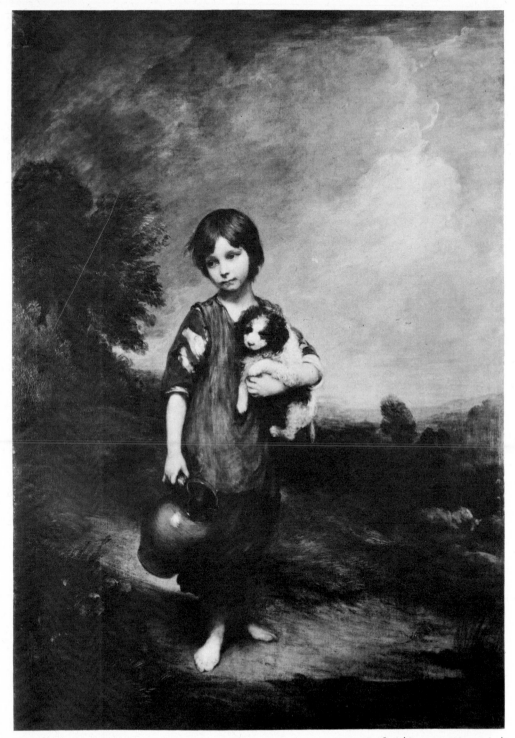

THOMAS GAINSBOROUGH: COTTAGE GIRL WITH DOG AND PITCHER. 1785. (Canvas: 68½ × 49 in.)

PLATE 61

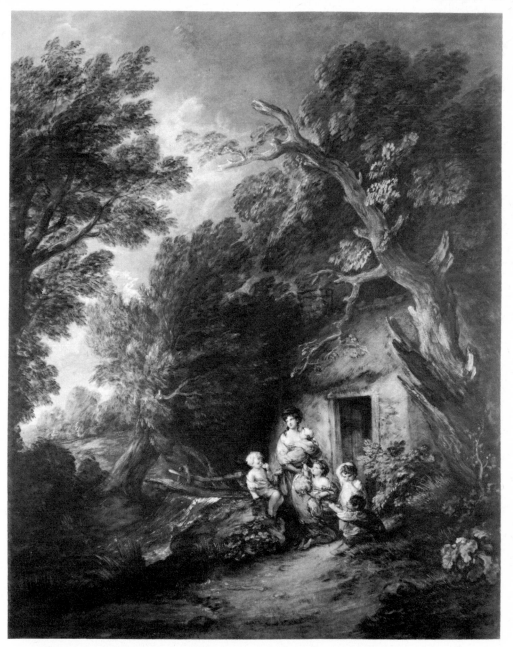

THOMAS GAINSBOROUGH: THE COTTAGE DOOR. R.A. *c.* 1780. (Canvas: 58×47 in.)

PLATE 62

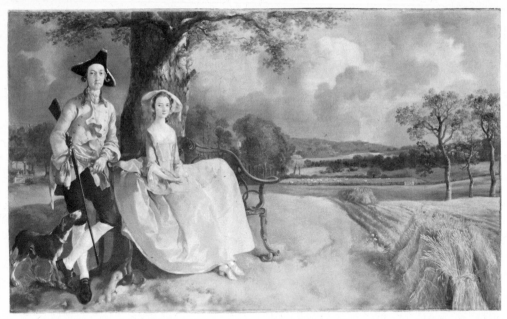

A. THOMAS GAINSBOROUGH: ROBERT ANDREWS AND HIS WIFE MARY. After 1748
(Canvas: $27\frac{1}{2} \times 47$ in.)

B. THOMAS GAINSBOROUGH: A VIEW OF THE MOUTH OF THE THAMES.
c. 1783. (Canvas: $61\frac{1}{2} \times 75\frac{1}{4}$ in.)

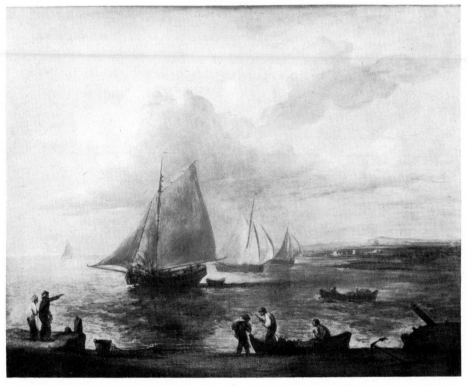

PLATE 63

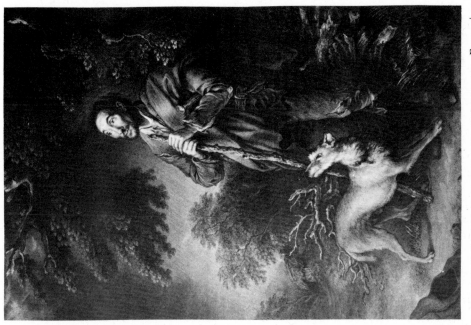

B. THOMAS GAINSBOROUGH: THE WOODMAN. Engraving in stipple by P. Simon, 1791, from the painting of 1787 destroyed by fire, 1810

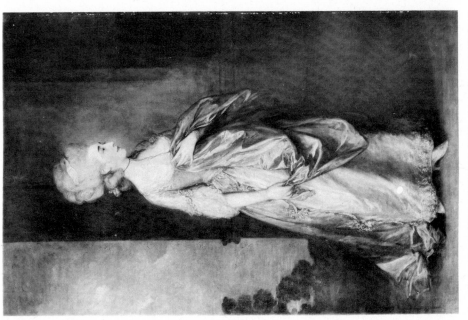

A. THOMAS GAINSBOROUGH: MRS. GRACE DALRYMPLE ELLIOTT. R.A. 1778. (Canvas: $92\frac{1}{4} \times 60\frac{1}{2}$ in.)

PLATE 64

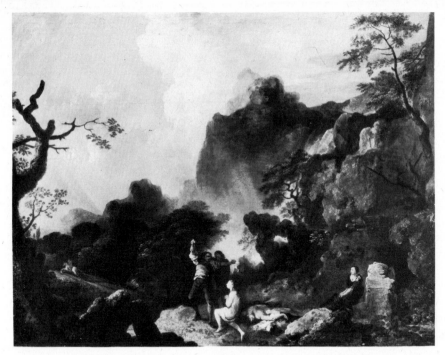

A. RICHARD WILSON: THE MURDER. 1752. (Canvas: 27½ × 37¾ in.)

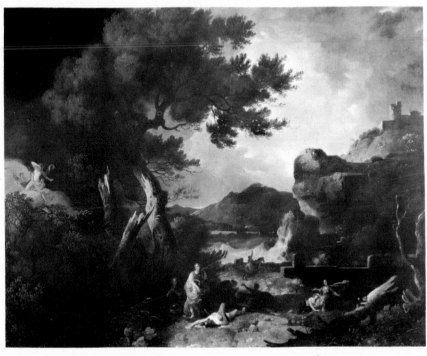

B. RICHARD WILSON: THE DESTRUCTION OF NIOBE'S CHILDREN
Before 1760. (Canvas: 58 × 74 in.)

PLATE 65

RICHARD WILSON: TEMPLE OF MINERVA MEDICA, Rome. c. 1754. (Canvas: 19×24½ in.)

PLATE 66

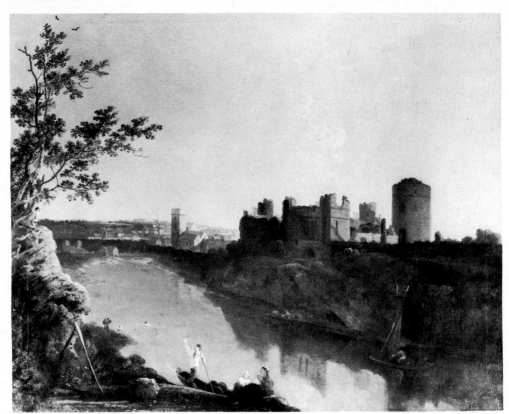

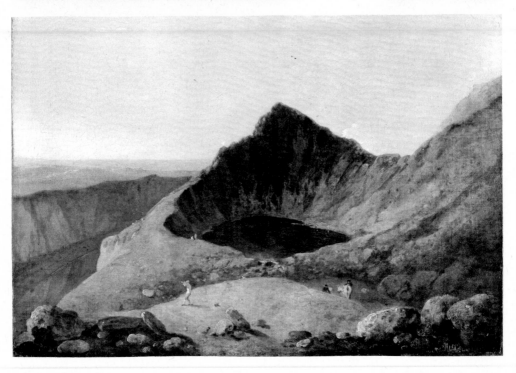

PLATE 67

SIR JOSHUA REYNOLDS: THE INFANT HERCULES STRANGLING THE SERPENTS. 1786–8. R.A. 1788
(Canvas: 303 × 297 cm.)

(*left*)

A. RICHARD WILSON: PEMBROKE CASTLE AND TOWN. *c.* 1774. (Canvas: $38\frac{1}{4} \times 48\frac{1}{4}$ in.)

B. RICHARD WILSON: CADER IDRIS: LLYN-Y-CAU. *c.* 1774. (Canvas: $19\frac{5}{8} \times 28\frac{3}{8}$ in.)

PLATE 68

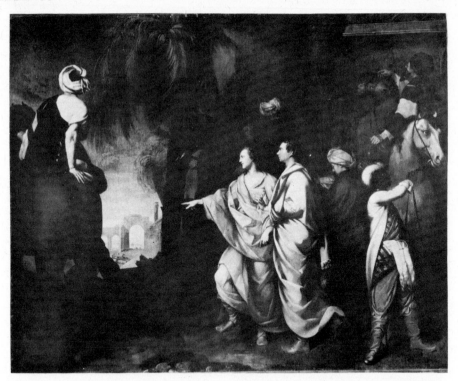

A. GAVIN HAMILTON: THE DISCOVERY OF PALMYRA BY WOOD AND DAWKINS
1758. (Canvas: 10 ft. 2 in. × 12 ft. 9 in.)

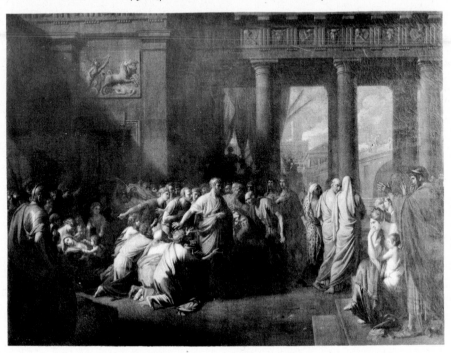

B. BENJAMIN WEST: THE DEPARTURE OF REGULUS. 1769

PLATE 69

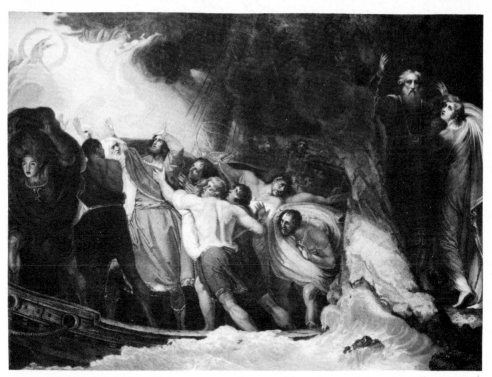

A. BENJAMIN SMITH after GEORGE ROMNEY: THE TEMPEST. |Engraving after the painting
Begun 1787

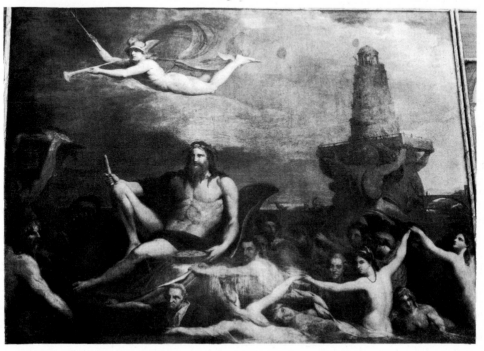

B. JAMES BARRY: NAVIGATION, OR THE TRIUMPH OF THE THAMES. 1777–83
(Canvas: 11 ft. × 15 ft. 2 in.)

PLATE 70

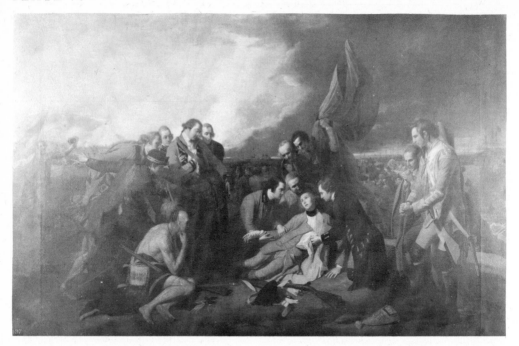

A. BENJAMIN WEST: THE DEATH OF GENERAL WOLFE. R.A. 1771

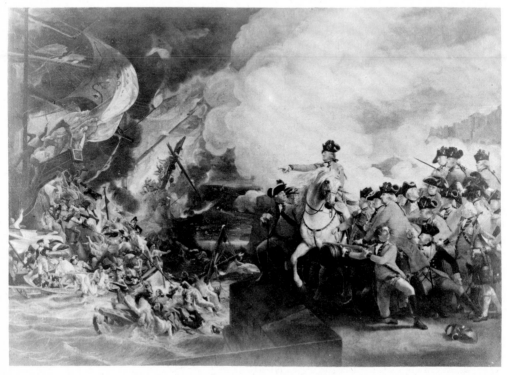

B. JOHN SINGLETON COPLEY: THE SIEGE AND RELIEF OF GIBRALTAR, 13TH SEPTEMBER, 1782
1783. (Study for the painting in the Guildhall: 52 × 74 in.)

PLATE 71

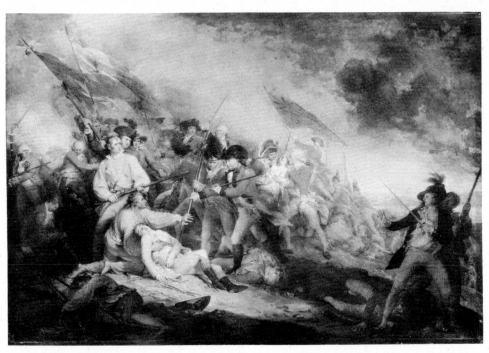

A. JOHN TRUMBULL: THE DEATH OF GENERAL WARREN AT THE BATTLE OF BUNKER'S
HILL, CHARLESTOWN, JUNE 1775. 1786. (Canvas: 2 × 3 ft.)

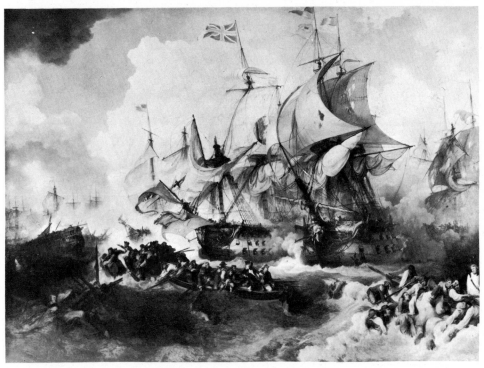

B. PHILIP JAMES DE LOUTHERBOURG: THE BATTLE OF THE 1ST JUNE, 1794. 1795.
(Canvas, signed and dated: 105 × 147 in.)

PLATE 72

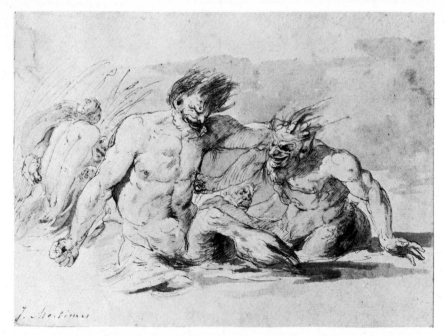

A. JOHN HAMILTON MORTIMER: MONSTERS FIGHTING. *c.* 1775–9
(Pen and brown ink and water-colour, inscribed 'J. Mortimer': $5\frac{7}{16} \times 7\frac{1}{2}$ in.)

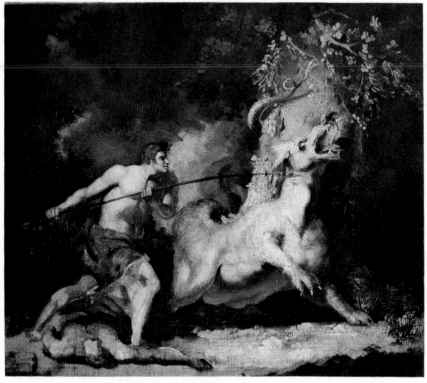

B. Attributed to JOHN HAMILTON MORTIMER: MAN ATTACKING
A MONSTER. Probably before 1779. (Canvas: $11\frac{3}{4} \times 14$ in.)

PLATE 73

A. ROBERT BLYTH: THE CAPTIVE, FROM STERNE'S SENTIMENTAL JOURNEY, BY JOHN HAMILTON MORTIMER. Etching after a lost drawing, 1781. ($12\frac{3}{16} \times 15\frac{1}{8}$ in.)

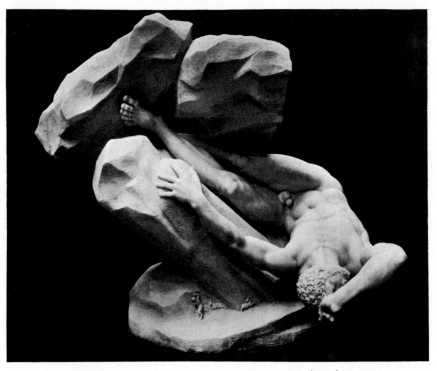

B. THOMAS BANKS: THE FALLING TITAN. 1786. (Height: 33 in.)

PLATE 74

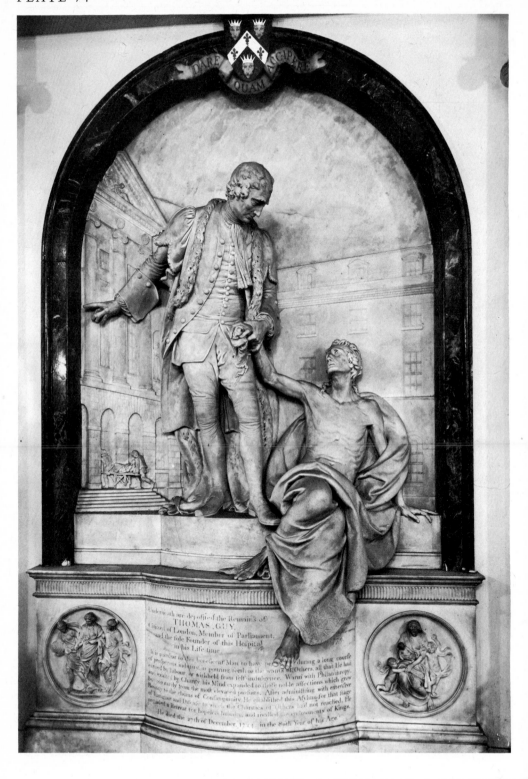

PLATE 75

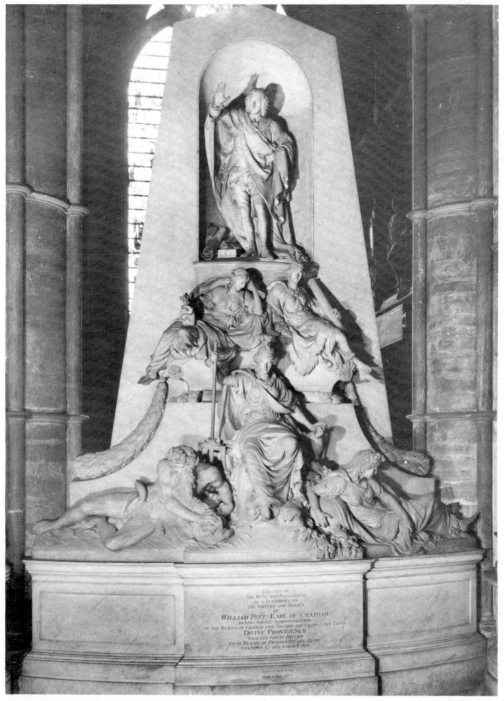

JOHN BACON: MONUMENT TO THE EARL OF CHATHAM. 1779–83. (Height: 27 ft. 6 in.)

(*left*) JOHN BACON: MONUMENT TO THOMAS GUY. 1779

PLATE 76

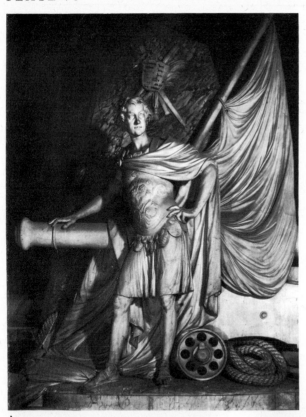

A.

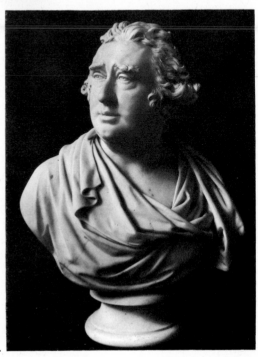

B. C.

(right) GEORGE ROMNEY
MRS. NATHANIEL LEE ACTON
1791. (Canvas: 93¾ × 57½ in.)

A. JOSEPH WILTON: REAR–ADMIRAL
 HOLMES. 1761. (Height of statue:
 6 ft.)

B. JOSEPH NOLLEKENS: WILLIAM
 PITT. 1807

C. JOSEPH NOLLEKENS: CHARLES
 JAMES FOX. 1792

PLATE 77

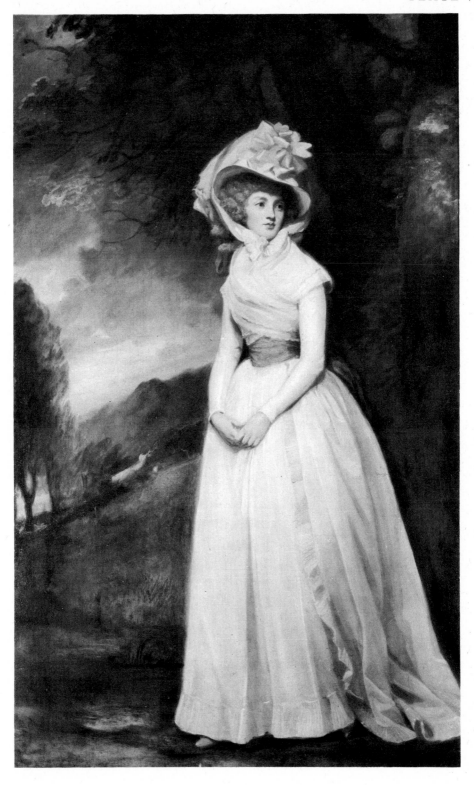

PLATE 78

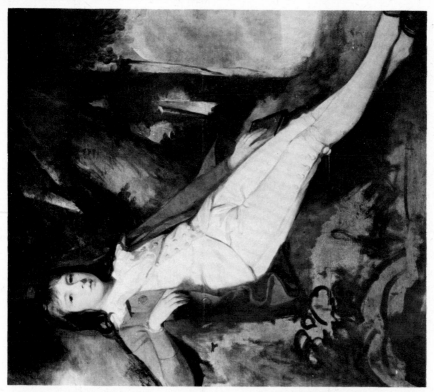

B. GEORGE ROMNEY: PORTRAIT OF A BOY. c. 1783

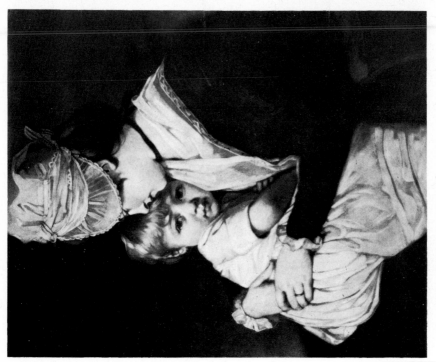

A. JOHN RAPHAEL SMITH after JOHN ROMNEY: MRS.
CARWARDINE AND CHILD. Mezzotint, after 1755

PLATE 79

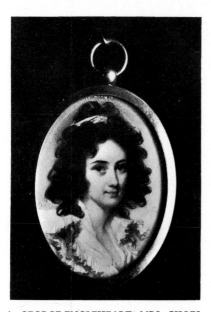

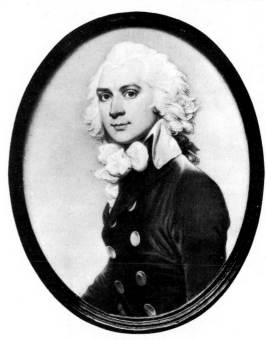

A. GEORGE ENGLEHEART: MRS. GILLES-
PIE. *c.* 1793. (Ivory: 1¾ × 1⅜ in.)

B. RICHARD CROSSE: JAMES CROSSE. 1778
(Enamel: 4 × 3⅛ in.)

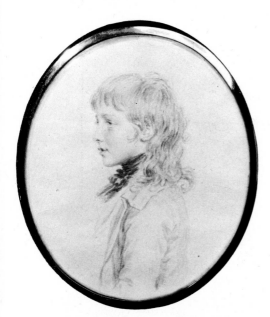

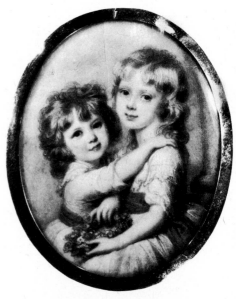

C. JOHN SMART: MASTER IMPEY. 1785
(Water-colour, signed and dated: 3¾ × 4¼ in.)

D. RICHARD COSWAY: THE LADIES
GEORGIANA AND HENRIETTA
CAVENDISH, DAUGHTERS OF THE
FIFTH DUKE OF DEVONSHIRE. 1789
(Ivory, signed and dated: 3¼ × 2¾ in.)

PLATE 80

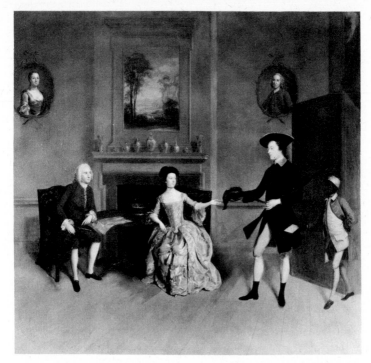

A. ARTHUR DEVIS: JOHN ORDE AND HIS FAMILY. *c.* 1750–5
(Canvas: 37 × 37⅞ in.)

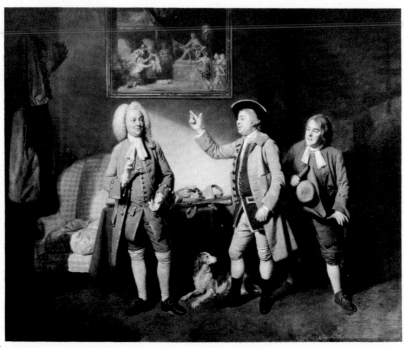

B. JOHANN ZOFFANY: LOVE IN A VILLAGE. 1767. (Canvas: 40 × 50 in.)

PLATE 81

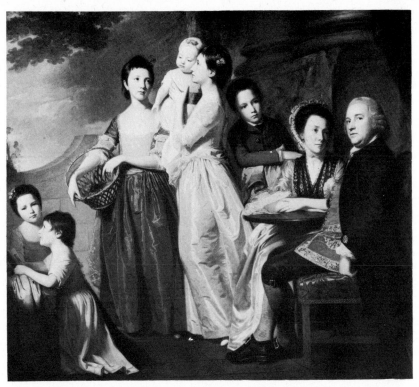

A. GEORGE ROMNEY: THE LEIGH FAMILY. 1768. (Canvas: $72\frac{3}{4} \times 79\frac{1}{2}$ in.)

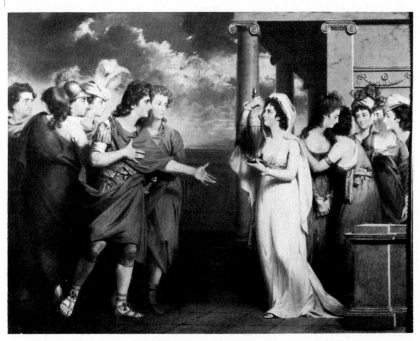

B. JOHN DOWNMAN: THE RETURN OF ORESTES. R.A. 1782. A record of the performance of Voltaire's 'Oreste', 1774. (Canvas: 20×25 in.)

PLATE 82

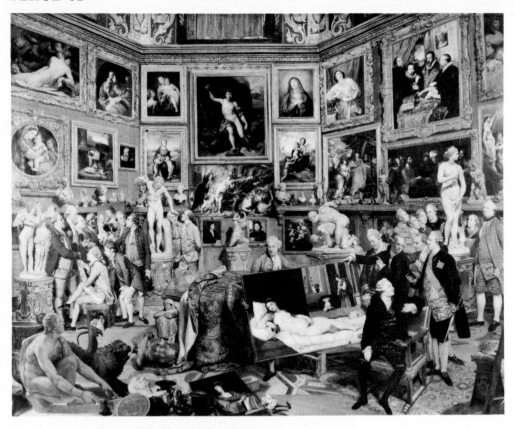

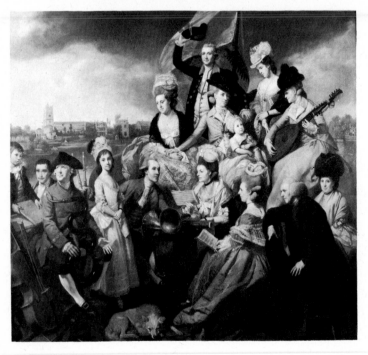

A. JOHANN ZOFFANY
THE TRIBUNE OF THE
UFFIZI. 1772–6
(Canvas: 47 × 59 in.)

B. JOHANN ZOFFANY
MUSIC PARTY OF THE
SHARP FAMILY ON THE
THAMES. R.A. 1781
(Canvas: $45\frac{1}{2} \times 49\frac{1}{2}$ in.)

PLATE 83

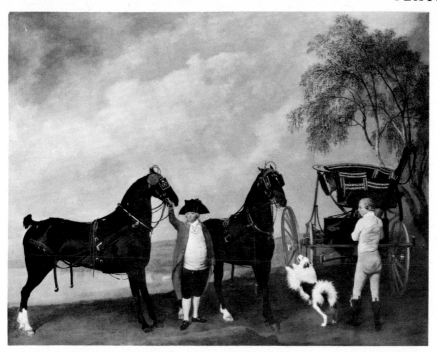

A. GEORGE STUBBS: THE PRINCE OF WALES'S PHAETON AND STATE COACHMAN.
1793. (Canvas: 40 × 50¼ in.)

B. SIR WILLIAM BEECHEY: GEORGE III REVIEWING THE 10TH DRAGOONS. R.A.
1798. (Canvas: 164 × 198 in.)

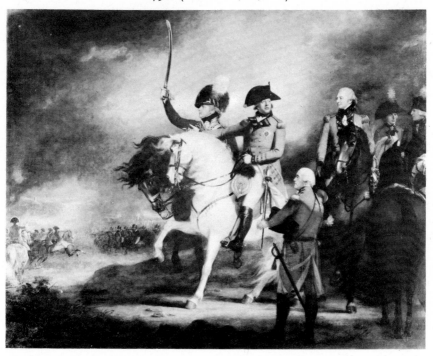

PLATE 84

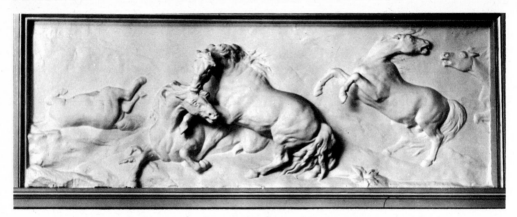

A. GEORGE GARRARD: DUNCAN'S MADDENED HORSES. 1797

B. WILLIAM SAWREY GILPIN: HORSES FRIGHTENED IN A THUNDERSTORM. 1798
(Canvas, signed and dated: 33 × 49 in.)

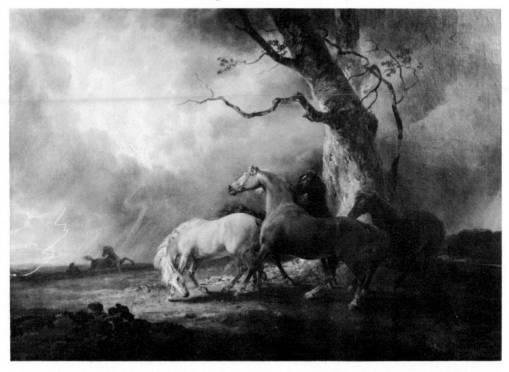

PLATE 85

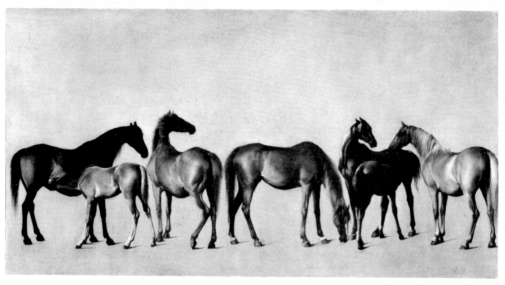

A. GEORGE STUBBS: BROOD MARES AND FOALS. (Canvas: 75 × 40 in.)

B. GEORGE STUBBS: A LION ATTACKING A HORSE. 1768–72. (Canvas: $27\frac{1}{4}$ × $39\frac{3}{4}$ in.)

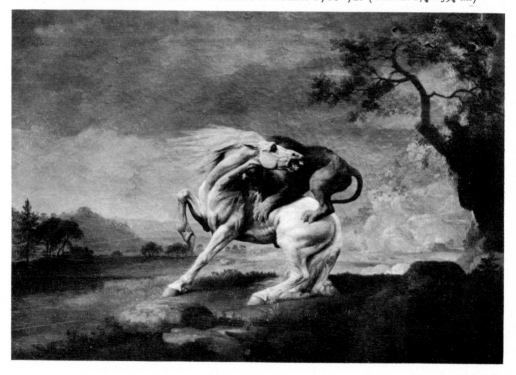

PLATE 86

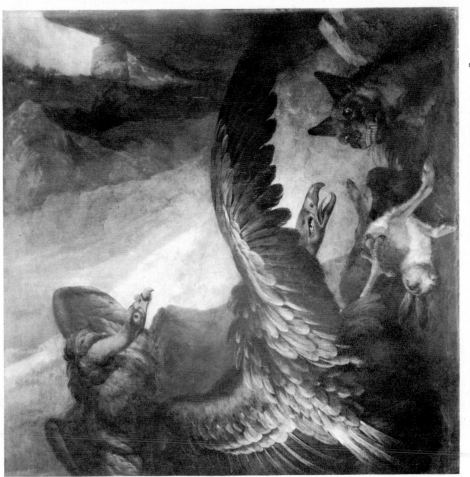

B. PHILIP REINAGLE: VULTURE DISPUTING WITH A HYENA. R.A. 1801

(Canvas: 57½ in. square.)

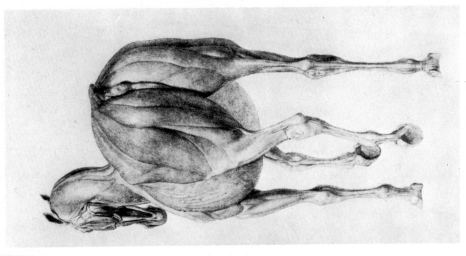

A. GEORGE STUBBS: DRAWING FOR 'THE ANATOMY OF THE HORSE'. 1759–60

(Black chalk: 18½ × 11½ in.)

PLATE 87

JOSEPH WRIGHT OF DERBY: AN ACADEMY BY LAMPLIGHT. *c.* 1768–9. (Canvas: 50×39$\frac{7}{8}$ in.)

PLATE 88

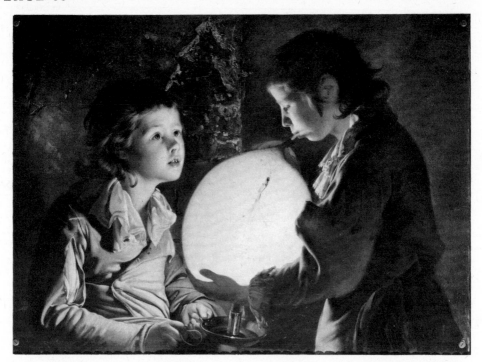

A. JOSEPH WRIGHT OF DERBY: TWO BOYS BLOWING ON A BLADDER. 1772

B. JOSEPH WRIGHT OF DERBY: THE ORRERY. *c.* 1764–6. (Canvas: 58×80 in.)

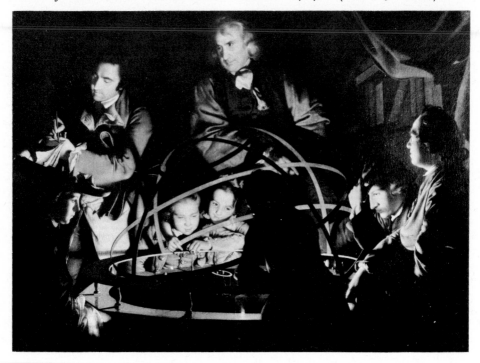

PLATE 89

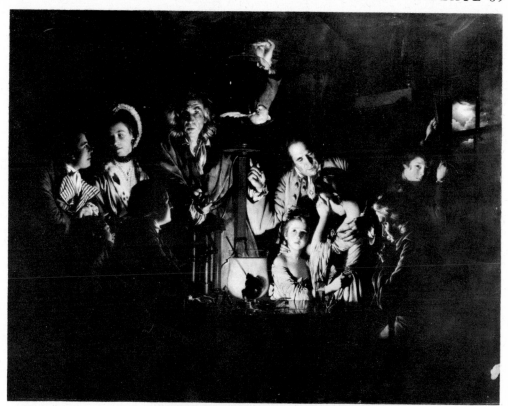

A. JOSEPH WRIGHT OF
 DERBY: AN EXPERI-
 MENT ON A BIRD
 IN AN AIRPUMP
 c. 1767–8.
 (Canvas: 72×96 in.)

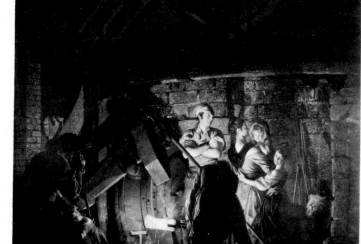

B. JOSEPH WRIGHT OF
 DERBY: THE IRON
 FORGE. 1772
 (Canvas: $53\frac{3}{4}\times60\frac{5}{8}$ in.)

PLATE 90

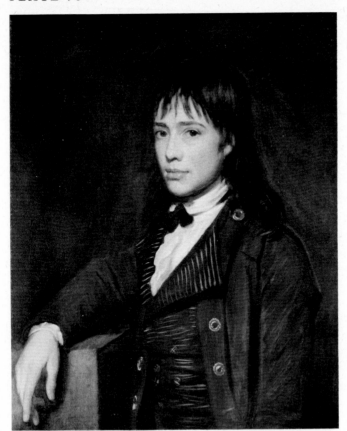

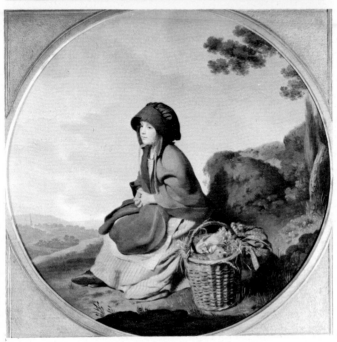

B. HENRY WALTON: THE
SILVER AGE. c. 1774
(Canvas: 23¾ in. circular.)

PLATE 91

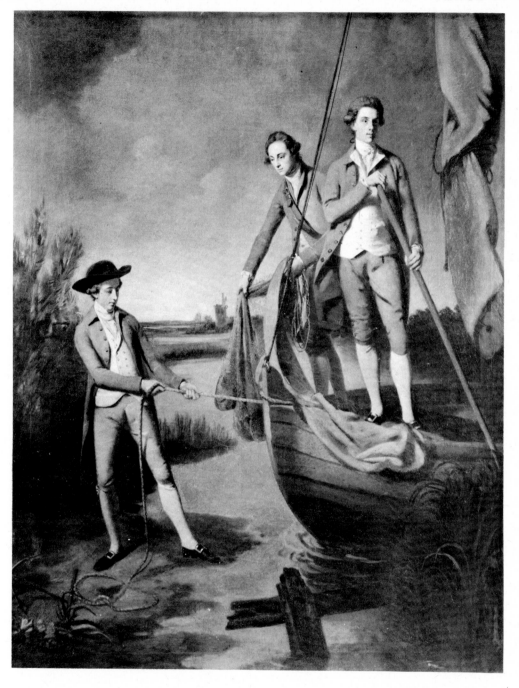

HENRY WALTON: THREE YOUNG MEN WITH A BOAT ON THE WAVENEY. *c.* 1780

PLATE 92

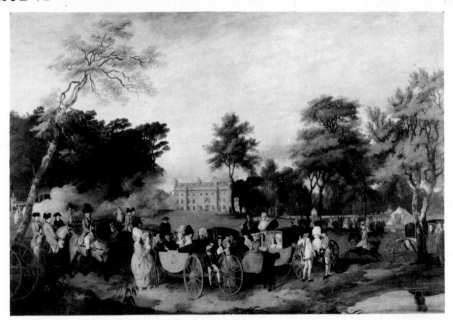

A. FRANCIS WHEATLEY: THE EARL OF ALDBOROUGH, ON POMPOSO, REVIEWING
IRISH VOLUNTEER TROOPS AT BELAN PARK, COUNTY KILDARE. *c.* 1783
(Canvas: 5 ft. × 7 ft. 7 in.)

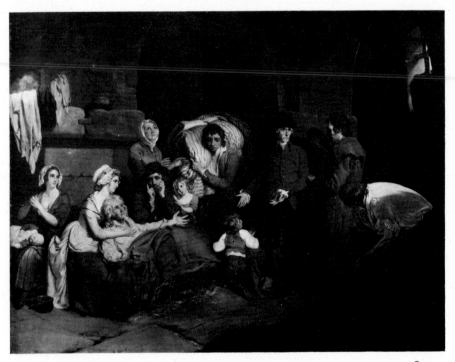

B. FRANCIS WHEATLEY: MR. HOWARD OFFERING RELIEF TO PRISONERS. 1787

PLATE 93

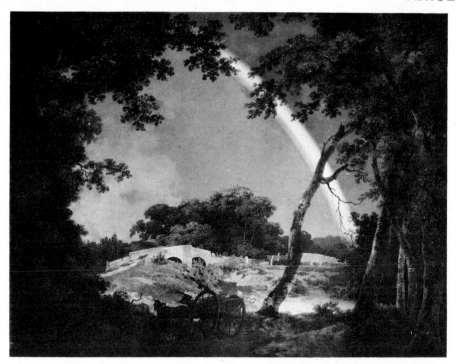

A. JOSEPH WRIGHT OF DERBY: LANDSCAPE WITH A RAINBOW. *c.* 1794
(Canvas: 32 × 42 in.)

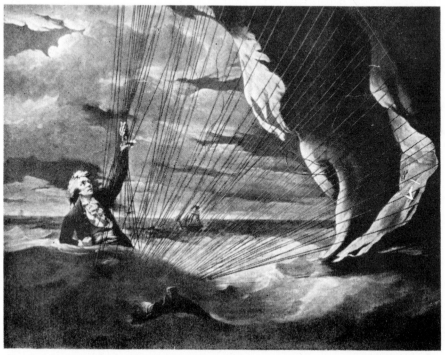

B. JOHN MURPHY after PHILIP REINAGLE: THE PERILOUS SITUATION OF
MAJOR MONEY AND HIS BALLOON AT SEA. After 1783. Mezzotint

PLATE 94

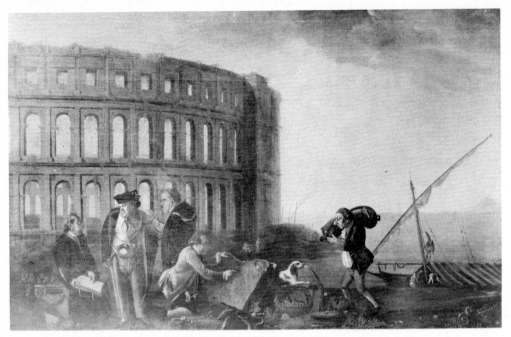

A. THOMAS PATCH: ANTIQUARIES AT POLA. 1760. (Canvas: 46×69 in.)

B. JOSHUA REYNOLDS: PARODY OF RAPHAEL'S 'SCHOOL OF ATHENS'. 1751. Painted in Rome
(Canvas: 107×90 in.)

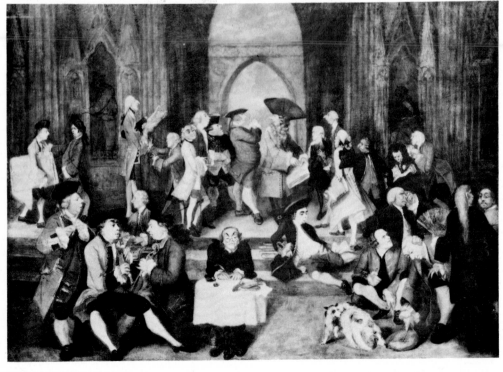

PLATE 95

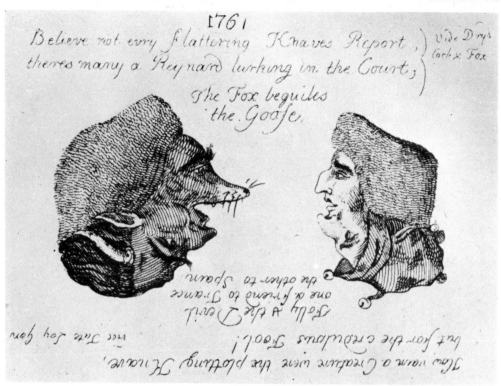

A. DARLY AND GEORGE TOWNSHEND: THE FOX BEGUILES THE GOOSE. 1761. Engraving from *A Political and Satirical History of the Years 1756, 1757–1761,* 4th ed., n.d.

B. RICHARD NEWTON: NYMPHS BATHING. 1792. Coloured engraving

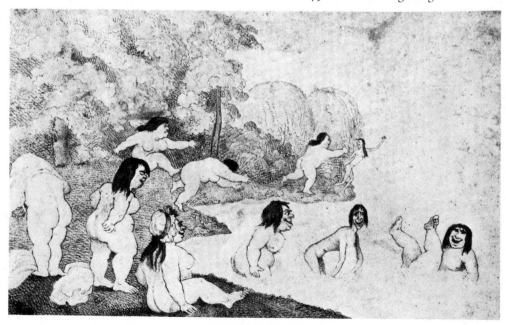

PLATE 96

A. ISAAC WARE: WROTHAM HALL, MIDDLESEX. 1754

B. SIR ROBERT TAYLOR: HEVENINGHAM HALL, SUFFOLK. 1778

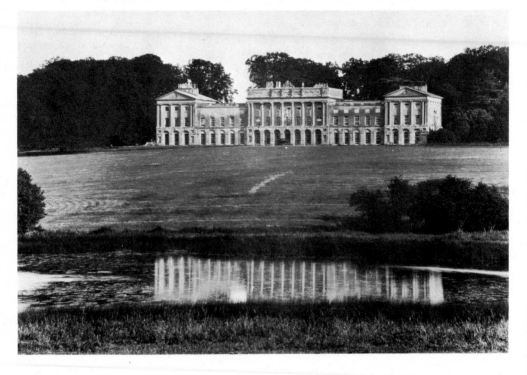

PLATE 97

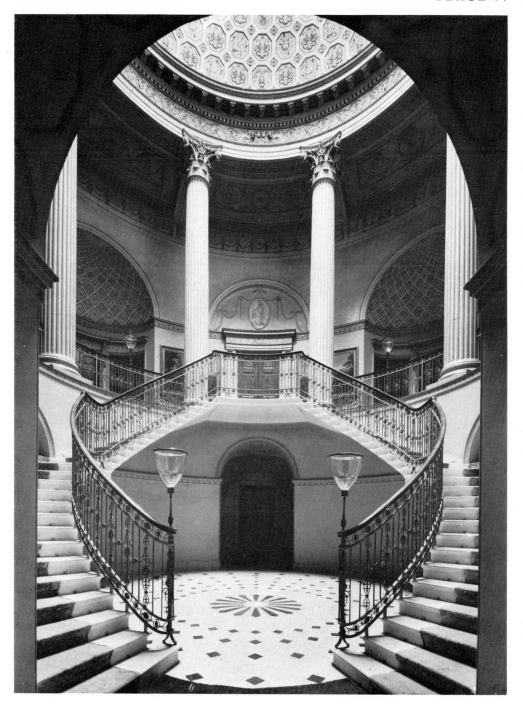

JAMES PAINE: THE STAIRCASE, WARDOUR CASTLE, WILTSHIRE. 1768–76

PLATE 98

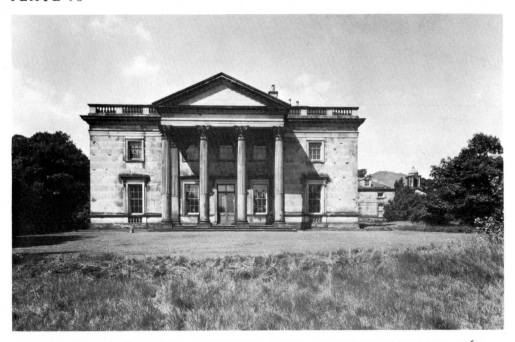

A. SIR WILLIAM CHAMBERS: DUDDINGSTON HOUSE, EDINBURGH: EAST FRONT. 1763

B. SIR WILLIAM CHAMBERS: DUDDINGSTON HOUSE, EDINBURGH: THE GRAND STAIRCASE
1763

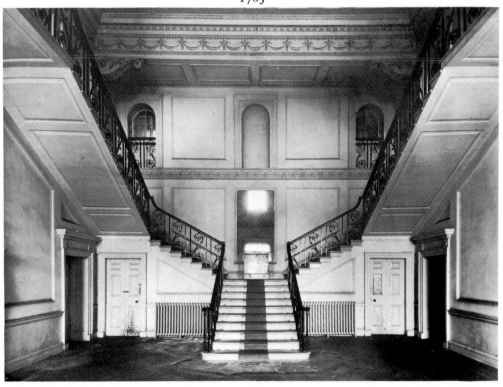

PLATE 99

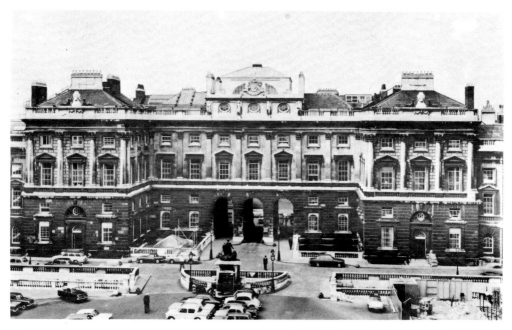

A. SIR WILLIAM CHAMBERS: SOMERSET HOUSE: THE GRAND PAVILION. 1776–86

B. JOHN BACON: GEORGE III AND THE RIVER THAMES: SOMERSET HOUSE 1789. (Bronze: over life-size)

C. SIR WILLIAM CHAMBERS: SOMERSET HOUSE: THE PALLADIAN BRIDGE MOTIF. 1776–86

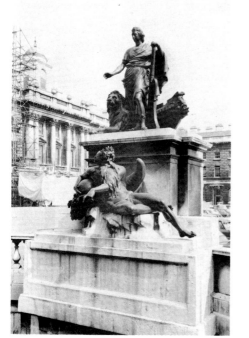

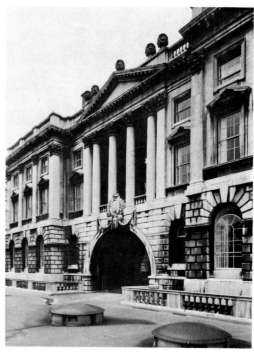

PLATE 100

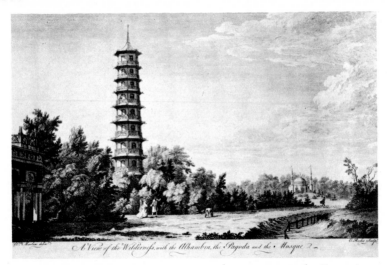

A. A VIEW OF THE PAGODA AND MOSQUE AT KEW. 1761. Engraving
after water-colour drawing by William Marlow, from Sir William
Chambers's *Plans, and Perspective Views of The Gardens and Buildings
at Kew in Surrey*, 1763

B. THE NEO-CLASSIC PARK: SHUGBOROUGH, STAFFORDSHIRE. Laid
out after 1762. Painting by N. T. Dall, *c.* 1769

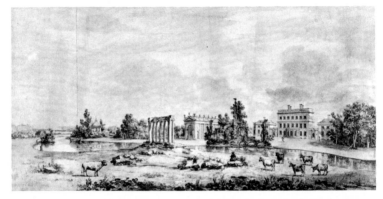

C. THE ARCHAEOLOGICAL RUINS AND WEST FRONT: SHUGBOROUGH,
STAFFORDSHIRE. Laid out after 1762. Water-colour, attributed to
N. T. Dall, *c.* 1770

PLATE 101

A. ROBERT ADAM: A CAPRICCIO. 1757. (Pen, ink, and wash)

B. NICHOLAS REVETT: AYOT ST. LAWRENCE. 1778–9

PLATE 102

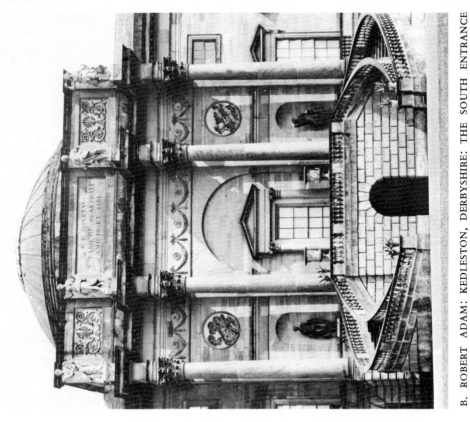

B. ROBERT ADAM: KEDLESTON, DERBYSHIRE: THE SOUTH ENTRANCE
After 1761

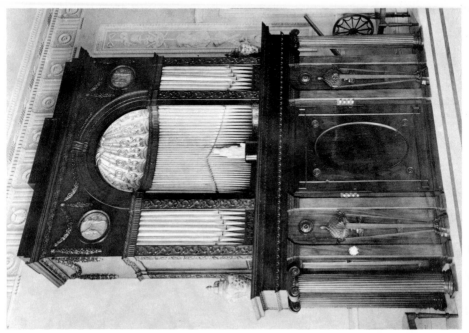

A. Attributed to ROBERT ADAM: THE ORGAN: NEWBY
HALL, YORKSHIRE. c. 1780

PLATE 103

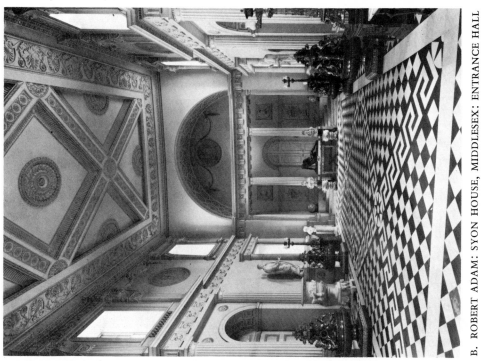

B. ROBERT ADAM: SYON HOUSE, MIDDLESEX: ENTRANCE HALL
1762–70

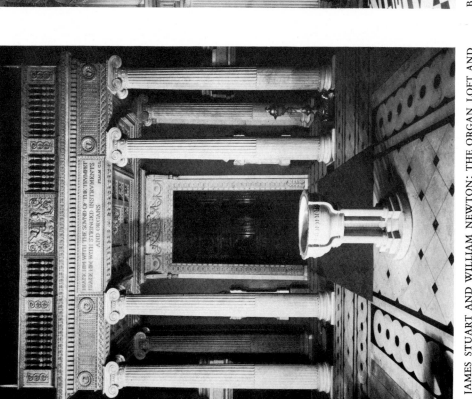

A. JAMES STUART AND WILLIAM NEWTON: THE ORGAN LOFT AND
FONT, GREENWICH HOSPITAL CHAPEL. 1779–88

PLATE 104

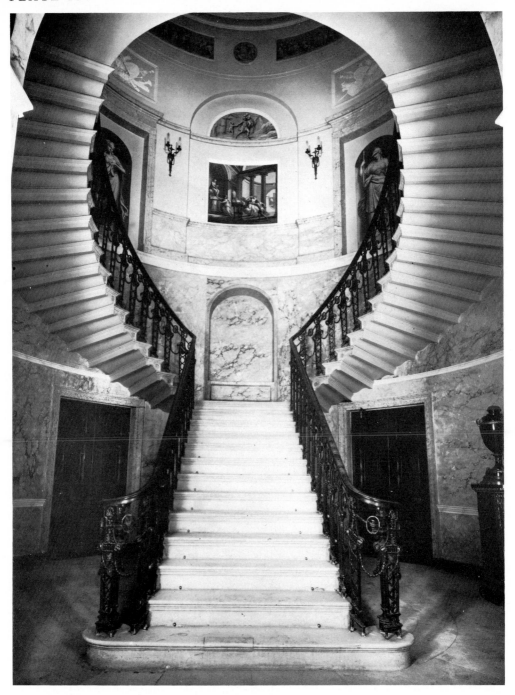

ROBERT ADAM: HOME HOUSE, PORTMAN SQUARE, LONDON: THE STAIRCASE. 1773–7

PLATE 105

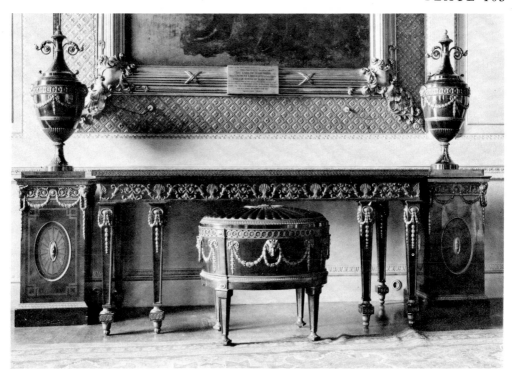

A. THOMAS CHIPPENDALE THE ELDER
after ROBERT ADAM: ROSEWOOD
INLAID SIDEBOARD, WINE-COOLER
AND PEDESTALS, MOUNTED WITH
ORMOLU. c. 1770

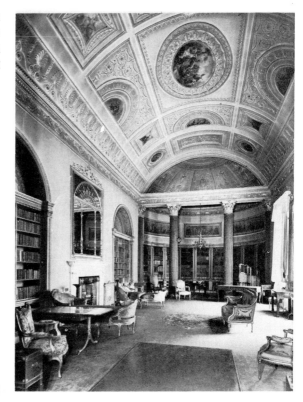

B. ROBERT ADAM: KENWOOD
MIDDLESEX: THE LIBRARY. 1767–9

PLATE 106

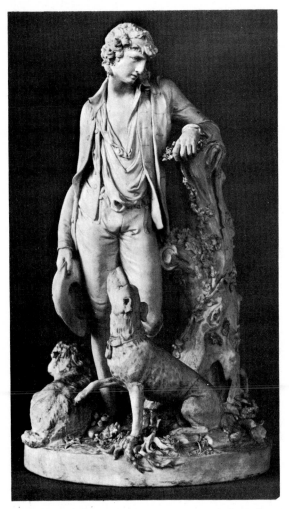

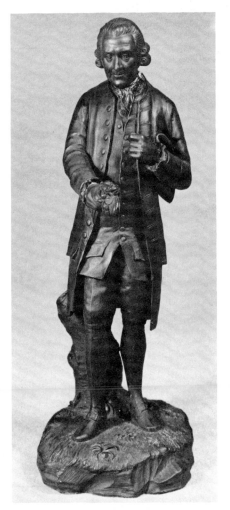

A. DERBY GROUP: MODEL BY W. T. COFFEE. Late eighteenth century. (White biscuit porcelain, mark, a crowned 'D' with a cross, also no: 396 and a triangle, height: 13¾ in.)

B. FIGURE OF JEAN-JACQUES ROUSSEAU: MODEL BY HACKWOOD. MARK OF WEDGWOOD. c. 1779. (Black basalt, impressed 'Wedgwood and Bentley', height: 11⅝ in.)

PLATE 107

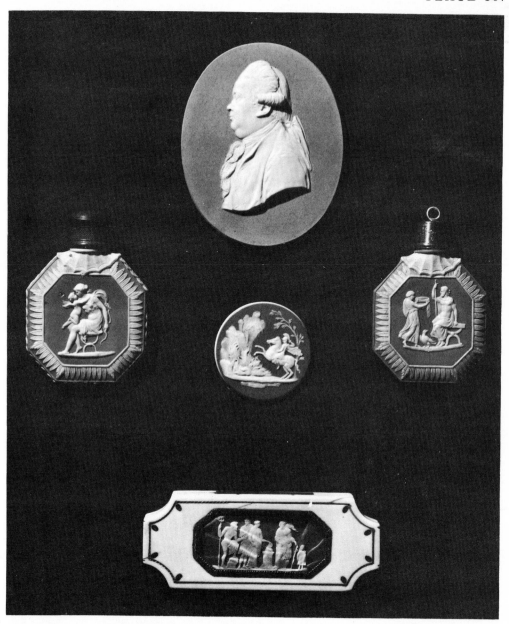

THE FACTORY OF JOSIAH WEDGWOOD: TWO CAMEOS, Edward Gibbon and the *Devotion of Marcus Curtius*, TWO SCENT-FLASKS AND A PATCH-BOX WITH INSET CAMEO. Blue jasperware. Etruria, late eighteenth century

PLATE 108

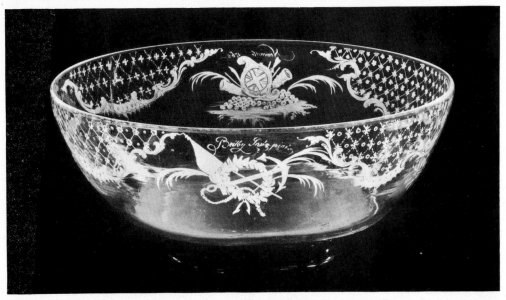

A. WILLIAM BEILBY: GLASS BOWL. 1765. (Signed 'Beilby Invt. & pinxt', and dated 'Newcastle, 1765': $9\frac{7}{8}$ in. diameter)

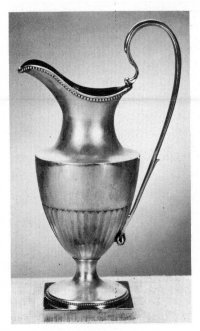

B. GILT CREAM-JUG: MARK OF ROBERT HENNELL: LONDON HALLMARK. 1785–6 (Height: $7\frac{1}{8}$ in.)

C. VASE: CREAMWARE MODELLED WITH MARBLED GLAZE AND GILT RELIEF Etruria. *c.* 1770. (Height: 14 in.)

PLATE 109

A. HENRY HOLLAND: THE
 GREAT SUBSCRIPTION ROOM,
 BROOKS'S CLUB,
 LONDON. 1776–8

B. MAHOGANY DRESSING-
 TABLE. *c.* 1790

PLATE 110

A. VIEW OF THE PORT OF LONDON WITH TWO BRIDGES, AS PROJECTED BY GEORGE DANCE THE YOUNGER. 1802. Engraving by William Daniell after Dance's painting of 1800

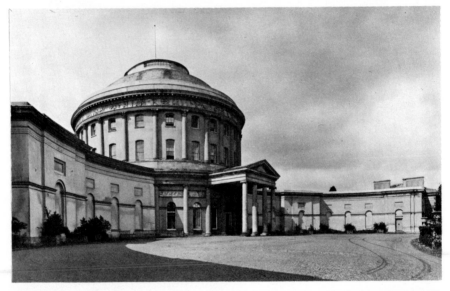

B. FRANCIS SANDYS: ICKWORTH, SUFFOLK: THE NORTH FRONT FROM THE EAST WING. *c.* 1793

C. GEORGE DANCE THE YOUNGER: NEWGATE PRISON. The prison begun 1769, demolished 1902 (Water-colour: $28\frac{7}{8} \times 15\frac{5}{8}$ in.)

PLATE 111

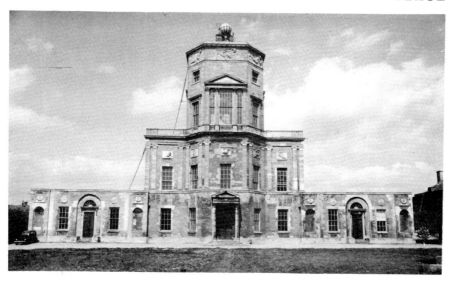

A. JAMES WYATT: RADCLIFFE OBSERVATORY, OXFORD. 1776–94. Begun from Henry Keene's design, finished by James Wyatt and John Bacon

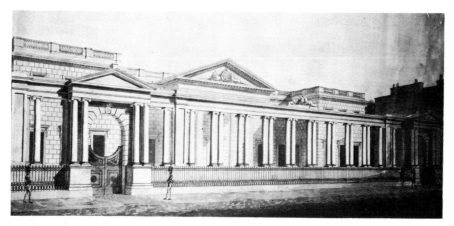

B. HENRY HOLLAND: CARLTON HOUSE: THE SCREEN. 1788–90. The screen demolished 1826 (Water-colour: 49¼ × 24⅜ in.)

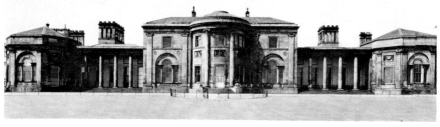

C. JAMES WYATT: HEATON HALL, LANCASHIRE: THE SOUTH FRONT. 1772

PLATE 112

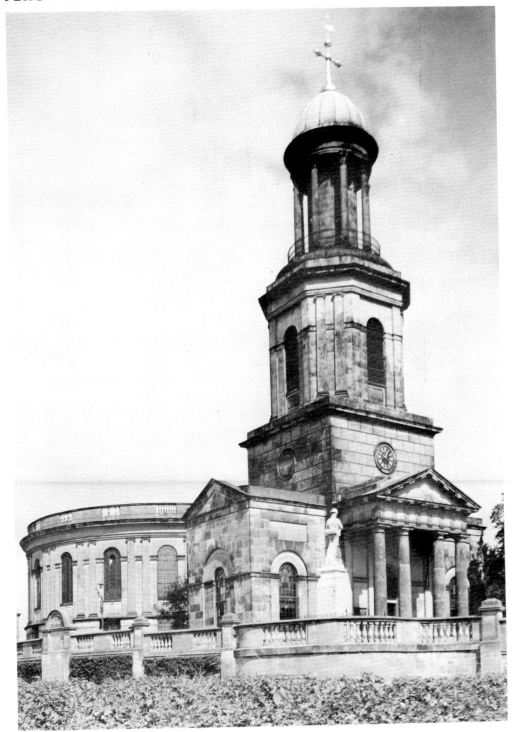

GEORGE STEUART: ST. CHAD'S, SHREWSBURY, SHROPSHIRE. 1790–2

PLATE 113

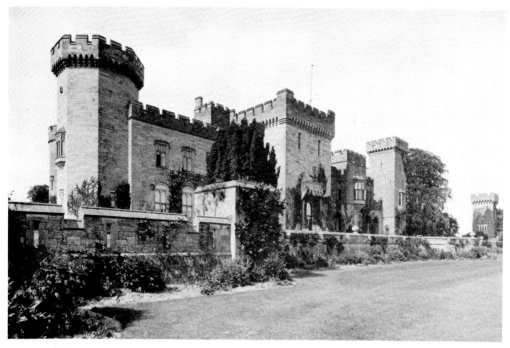

A. RICHARD PAYNE KNIGHT: DOWNTON CASTLE, HEREFORDSHIRE. 1772–3

B. ROBERT ADAM: CULZEAN CASTLE, AYRSHIRE. 1770

PLATE 114

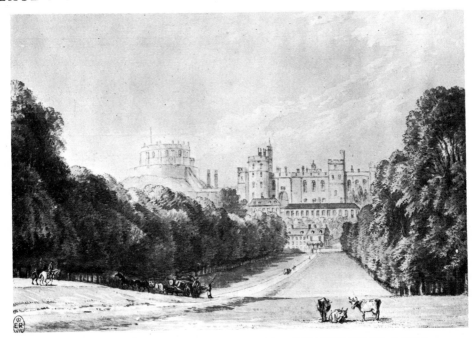

A. PAUL SANDBY: WINDSOR CASTLE FROM THE LONG WALK. *c.* 1770
(Pen and water-colour: 6 × 8 in.)

B. IRONWORKS AT COALBROOKDALE. Aquatint by William Pickett, coloured by John Clarke, after a drawing by Philip James de Loutherbourg, 1805. From P. J. de Loutherbourg, *Picturesque Scenery in England and Wales*, 1805

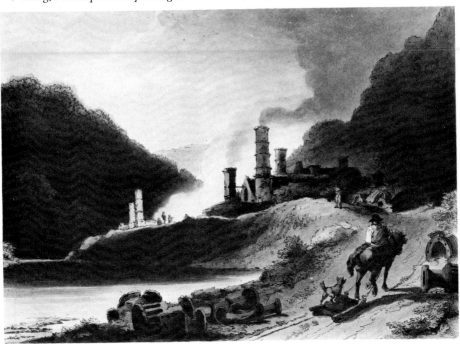

PLATE 117

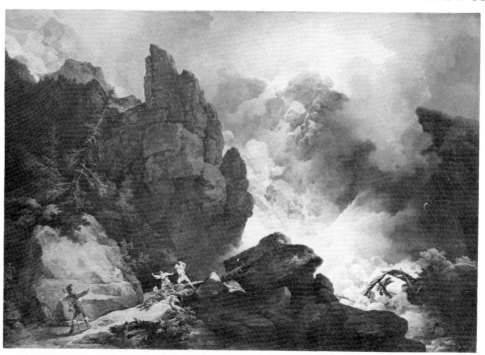

A. PHILIP JAMES DE LOUTHERBOURG: AN AVALANCHE OR ICE FALL IN THE ALPS. 1803
(Canvas: 43¼ × 63 in.)

B. JULIUS CAESAR IBBETSON: A PHAETON IN A THUNDERSTORM. Also entitled
ABERGLASLYN: THE FLASH OF LIGHTNING. 1798. (Canvas: 26½ × 36½ in.)

PLATE 118

A. JOSEPH WRIGHT OF DERBY: THE INDIAN WIDOW. 1785. (Canvas: 40×50 in.)

B. JOHN ROBERT COZENS: VIEW IN THE ISLAND OF ELBA. 1780 or 1789. (Water-colour signed and dated indistinctly: $14\frac{1}{2} \times 21\frac{1}{8}$ in.)

PLATE 119

A. JOHN ROBERT COZENS: THE GOATHERD, VIEW ABOVE THE LAKE OF ALBANO. 1778. (Water-colour: $21\frac{1}{2} \times 17\frac{1}{4}$ in.)

B. ALEXANDER COZENS: BLOT LANDSCAPE. From *A New Method of Assisting the Invention in Drawing Original Compositions of Landscape Composition*, 1785–6

PLATE 120

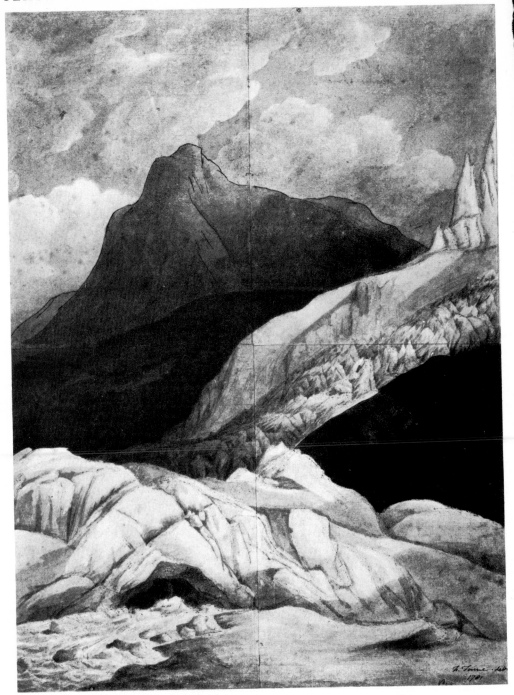

FRANCIS TOWNE: THE SOURCE OF THE ARVEIRON. 1781
(Water-colour: $16\frac{3}{4} \times 12\frac{1}{4}$ in.)